AMERICANISMS

AMERICANISMS

A Dictionary
of Selected Americanisms
on Historical Principles
by
MITFORD M. MATHEWS

Phoenix Books

THE UNIVERSITY OF CHICAGO PRESS
CHICAGO & LONDON

This book, an abridgment of Mitford M. Mathews, *A Dictionary of Americanisms on Historical Principles* (The University of Chicago Press, 1951), is also available in a clothbound edition from The University of Chicago Press.

THE UNIVERSITY OF CHICAGO PRESS, CHICAGO & LONDON
The University of Toronto Press, Toronto 5, Canada

I approve Jefferson's word "belittle" and hope it will be incorporated into our American Dictionaries— We ought to have an American Dictionary: after which I should be willing to lay a tax of an eagle a volume upon all English Dictionaries that should ever be imported.

<div align="right">JOHN ADAMS to BENJAMIN RUSH
February 10, 1812</div>

PREFACE

All the entries in this dictionary are taken from the much larger *Dictionary of Americanisms*, published in 1951. They were selected by the author in an effort to assure the reader the widest possible range of examples within the limits of this edition. For each word and its senses there are dated and otherwise identified quotations showing the use of the word. In this way some historical information about words and senses or meanings is provided.

An explanation of the peculiarities of construction of this dictionary may be of help to those not accustomed to the larger work, or, perhaps, unacquainted with the methodology of historical dictionaries.

First, this is a dictionary of "Americanisms." This means that its scope is restricted to words and meanings of words that first came into English use in the United States. A few words that do not, strictly speaking, fall into this class are included. For example, **corral,** *n.*, is included although it was used much earlier in England. The reason for its inclusion here is that our use of it seems clearly to be the result of a new borrowing and not a continuation of its earlier use in England. **Cooky,** *n.*, not included here, but found in the larger *DA*, was given for the same reason. People in Scotland had added this Dutch word to the English language long before we did, but with us it came in, not from Scotland, but from the Dutch in New York.

Many of the words are preceded by asterisks. This symbol is used to denote words that are old in English but that have in this country entered into new combinations or taken on new meanings. Entries such as ***answer,** *n.*, ***bake,** *n.*, ***baking,** *n.*, show this use of the asterisk.

Entries preceded by asterisks are not pronounced. They are well-known words and other dictionaries show their pronunciations. Other entries have pronunciations, not because these are

lacking in dictionaries of the usual type, but by way of further emphasizing the fact that they are additions to the language made in this country.

It will be seen that many of the entries are combinations of well-known words: **ascension robe, baking powder, baking soda,** are expressions of this kind. English, like other languages, has always been given to adding to its vocabulary in this way.

Many quite common words now appear to have had their first use in this country. Good examples are **electrician, fedora, fire-cracker,** and **gasoline.** Attention to terms of this kind is likely to prevent one from thinking that the only words added to the language in this country have been slang terms or expressions of questionable standing.

A large percentage of the words here brought together are of considerable interest. **Ascension robe, covenant chain, cut money, deacon seat** serve as good examples. Students of history and sociology often find the *DA* of use in their studies because of its inclusion of a large number of such terms.

The abbreviations used in the following pages are standard; therefore, it has not been felt necessary to include a list of them. The sources of quotations given to show the uses of words in their different senses are often sufficiently clear as they stand; for those that are not a bibliography is provided in the back of the book.

MITFORD M. MATHEWS

CHICAGO

EXPLANATION OF SPECIAL LETTERING AND SYMBOLS

All entry words are given in boldface. When reference is made to them in the definitions or etymologies, they are in lightface if followed by *q.v.*

✳ indicates that the word or expression before which it appears did not come first or independently into English in the United States. In the lists of combinations the star on the second element denotes that the combination is not of United States origin.

() are sometimes used in entry words to inclose a letter which may or may not be found in the spelling. In phrases parentheses are used about a word to indicate that it may or may not occur in the expression. Regularly, in the definitions of transitive verbs, parentheses are used for the direct object or to indicate the nature of the object.

[] regularly contain the etymologies. Brackets are also used to inclose matter supplied by the editor. Quotations are inclosed by brackets when they have some bearing upon, but do not contain, just the term being illustrated or when the quotation can hardly be cited as a legitimate or valid occurrence of the word in question.

† is used before spellings that are obsolete.
> is used for "whence," i.e., from which is derived.
< is used for "from, derived from."
+ is used for "and" in etymologies.
* is used before a hypothetical form.

The quotations are given in the form usual in historical dictionaries. Large capitals indicate volumes or other large divisions,

small capitals parts or sections, and lower-case letters chapters or prefatory pages, e.g., III, ii, xxi. When a subordinate sense marked **b** follows a sense which is not marked **a,** this signifies that the subordinate sense is regarded as being derived from the antecedent one.

PRONUNCIATION

The pronunciations are given in the International Phonetic Association notation with the addition of ɜ and ɝ, well known through their use by Kenyon and Knott in their pronouncing dictionary, the magazine *American Speech*, and numerous other works. The symbols and their values are as follows:

VOWELS

[i]	see si	[ɑ]	ah	ɑ	[ɜ]	word	wɜd	(in accented syllables)
[ɪ]	city ˈsɪtɪ	[ɔ]	raw	rɔ	[ɝ]	murder ˈmɝdɚ		(only in unaccented
[e]	day de	[o]	doze	doz	[ə]	above	əˈbʌv	syllables)
[ɛ]	egg ɛg	[ʊ]	pull	pʊl	[ʌ]	cut	kʌt	
[æ]	hat hæt	[u]	moon	mun				

DIPHTHONGS

[aɪ]	five faɪv	[ɔɪ]	joy dʒɔɪ
[aʊ]	how haʊ	[ju]	fuse fjuz

CONSONANTS

[p]	pity ˈpɪtɪ	[s]	song	sɔŋ	[n]	gnat	næt	
[b]	bee bi	[z]	zeal	zil	[ṇ]	sudden ˈsʌdṇ		
[t]	tooth tuθ	[ʃ]	shall	ʃæl	[ŋ]	sang	sæŋ	
[d]	dash dæʃ	[ʒ]	vision	ˈvɪʒən	[l]	lull	lʌl	
[k]	king kɪŋ	[h]	how	haʊ	[ḷ]	saddle ˈsædḷ		
[g]	good gʊd	[tʃ]	cheap	tʃip	[w]	watch	watʃ	
[f]	full fʊl	[dʒ]	jaw	dʒɔ	[hw]	while	hwaɪl	
[v]	voice vɔɪs	[m]	men	mɛn	[j]	yet	jɛt	
[θ]	theft θɛft	[ṃ]	keep 'em ˈkipṃ		[r]	rate	ret	
[ð]	then ðɛn							

The stress mark [ˈ] is used before a syllable having the principal accent. A corresponding mark below the line indicates that the syl-

lable before which it stands has a weaker accentuation than that which receives the main stress. Secondary stress marks are regularly omitted in dissyllabic words unless each element of the term is recognizable as a word in its own right. Parentheses are used to indicate that the pronunciation of the word varies, being sometimes with and sometimes without the sound indicated by the inclosed symbol.

A

* **A. B.** *Hist.* In combs: **A. B. conspirator, papers, plot,** (see quot. 1893).

1824 in *Ann. 18th Congress* 1 Sess. II. 2432 Notwithstanding all the canting about an 'A.B. plot,' . . . I assert . . . that it is known to your honorable body that neither of those committees extended their investigations into those statements. *Ib.* 2452 The charges . . . contain nothing but a reiteration of those made by the A.B. conspirators. **1854** BENTON *Thirty Years' View* I. xiv. 35/1 The A.B. papers . . . were a series of publications made in a Washington City paper, during the canvass, to defeat his [M. Crawford's] election. **1893** JAMESON *Dict. U.S. Hist.* (1931) 1 'A.B.' Plot, a plot to destroy Secretary of the Treasury Crawford's popularity and political power by accusing him, in 1824, of malfeasance in office. A series of letters appeared in a Washington newspaper signed 'A.B.,' reflecting upon Crawford's integrity, and demanding investigation. They were written by Ninian Edwards, who acknowledged their authorship. He failed to sustain his charges, so Crawford was exonerated.

* **ab,** *n.* Usu. *pl.* One of the first two-letter combinations formerly found in elementary spelling books (see quot. 1899). — **1821** HOWISON *Sketches* 294 Yes, sir, only three years old, and knows his letters.—He was in the *abbs* and *ebbs* last week. **1899** GREEN *Va. Word-Book* 37 Ab, ab's and ba, ba's. The beginnings of spelling lessons; used to show that a person is in the very beginning of things, and has everything to learn. 'Why he is hardly in his *ab* and *ab's*, and *ba ba's* yet.' **1913** *American Mag.* Nov. 57/2 Louise-Marie, to do her credit, was a game little cluck-cluck when it come to a showdown and, more'n that, she'd learned her little a, b, abs, and, still more, she was a good woman.

* **aboard,** *adv.*
In British use *aboard* is used only nautically, but in Amer. English it has, as some other terms originally nautical, been extended to land use.

1. *All aboard,* the call of a conductor directing passengers to enter a train, streetcar, etc., that is about to start. Also transf.

1837 J. T. SMITH *Journal* 18 They describe a situation by the compass 'talk of the voyage' of being 'all aboard' &c this doubtless arises from *all* their ancestors having come hither over ocean & having in the voyage acquired nautical language. **1878** I. L. BIRD *Rocky Mts.* 148 'Head them [= cattle] off, boys!' our leader shouted; 'all aboard! hark away!' and . . . away we all went at a hand-gallop. **1902** MCFAUL *Ike Glidden* xxxi. 297 He and his bride boarded the train, and the conductor announced 'All aboard.' **1947** *Nat. Geog. Mag.* Feb. 157/2 (caption), All Aboard the Oxcarts.

2. On or into a train.

1856 M. J. HOLMES *L. Rivers* iv. 33 [She told] him that 'the trunks, box, feather bed, and all, were every one on 'em left!' 'No, they are not,' said John; 'I saw them aboard myself.' **1901** MERWIN & WEBSTER *Calumet K* xv. 297, I . . . jumped for the lever and hollered for him to get aboard. **1947** *Atlantic Mo.* Nov. 45/2 We're trying to . . . get us a special car on the eight-thirty. How about getting aboard?

b. On horseback. *Jocular.*

1884 SWEET & KNOX *Through Texas* v. 63 At one o'clock we were all aboard. **1946** *Outdoor Life* Oct. 7/1 You can hit the trail aboard a cayuse; hike or hunt . . . thrill to dude ranch life.

acequia əˈsekɪə, *n. S.W.* [Sp. in same sense.] An irrigation ditch. Cf. **irrigating acequia, sequia.**

1844 JAMES J. WEBB *Memoirs* 123 Following down the main Acequia for some distance towards the town, I was surprised to see beaver sign, so near a large town. **1891** Union Pac. R.R. *Utah* (ed. 4) 26 Ten years ago there were 10,000 miles of acequias, large and small, watering as many small farms in the valleys of Utah. **1941** FERGUSSON *Southwest* 278 They have saved . . . its acequias running clear mountain water, its trees, and a respect for its Spanish-speaking folk.

b. acequia madre, a main ditch.

1844 GREGG *Commerce of Prairies* I. 151 One *acequia madre* (mother ditch) suffices generally to convey water for the irrigation of an entire valley, or at least for all the fields of one town or settlement. **1887** *Overland Mo.* Aug. 159/2 The plough lands lay on a sort of natural terrace, and were all watered by numerous channels and runlets, which had their sources in the great *acequia madre.*

adding machine. A machine that performs arithmetical addition, and sometimes subtraction. — **1874** KNIGHT 12/2. **1911** HARRISON *Queed* viii. 102 He was as definite as an adding-machine, as practical as a cash register. **1947** *Denver Post* 2 Mar. 2c/5 But thou gavest me no adding machine, and the sum of the letters giveth the same answer on two sides of the post.

Adirondack ˌædəˈrɑndæk, *n.* [f. Mohawk Indian term meaning "they eat trees" applied to a tribe of Canadian Indians.] *attrib.* Designating or with reference to things found in, or regarded as characteristic of, the Adirondack mountain region.

1870 *Rep. Comm. Agric.* 84 So far as they have been sufficiently tested, the Catawba, Iona, . . . and Adirondack [grapes] are the best. **1942** PEATTIE *Friendly Mts.* 235 To carry his duffle the hiker will need a pack, which may be an Adirondack pack basket. **1948** *Richmond* (Va.) *News Leader* 6 May 8/4 Sturdy Adirondack Chairs as shown, made of selected white pine ready to varnish or paint any color you choose.

alamo ˈæləˌmo, *n.* [Sp. *álamo,* poplar.]

1. (*cap.*) Used with reference to the overwhelming and slaying of about 140 Texans and Americans at the Alamo,

a Franciscan mission at San Antonio, Texas, in 1836.
Now *hist.*

1836 *Niles' Reg.* 25 June 293/2 Colonel Sherman with his regiment,
having commenced the action upon our left wing, the whole line, at
the centre and on the right, advancing in double quick time, rung the
war cry 'Remember the Alamo.' **1836** in *American War Songs* (1925)
59 And 'Alamo' hereafter be In bloodier fields, the battle cry. **1948**
Chi. Tribune 2 May 1. 22/2 Wake was not another Alamo, for, as has
been said, 'Thermopylae had its messenger of defeat, The Alamo had
none.'

2. *S.W.* A poplar. Also **alamo tree.**

1854 *H. Rep. Executive Doc. No. 91*, IV. (1856) 11 The alamos grow
to a good large size and are quite abundant. **1893** DONALDSON *Moqui
Pueblo Indians* 65 He repeated 'lena, lena' (firewood), but whether
'alamo' (cottonwood), or some other tree like the cedar or pine, I
could not make out. **1910** *Century Mag.* March 767/1 Along its
branches grow big alamo-trees. **1948** *D. Oklahoman* (Okla. City) 31
Oct. D. 8/5 The name came from a grove of cottonwoods (alamos)
which once grew on the site.

all-America, *n.* A player, as in football or baseball,
regarded as one of the best in the U.S. in his class. Also
attrib. or as adj.

1904 *Independent* 27 Oct. 951/1 The selection of 'All-America' teams
seems to have become a mania. **1944** *Reader's Digest* Feb. 56 He was
persuaded to try football in his last year at Yale, and was chosen as
an end on Walter Camp's first All-America eleven. **1947** *Denver Post*
2 Mar. 3E/7 Alex, a three-time all-America at guard, becomes a star
in the pro ranks.

b. Also **all-American,** *a.* and *n.*

1888 *Outing* Nov. 166/2 The All-American team . . . is composed
of men picked from the ranks of the representative ball teams of
America. **1920** *Outing* Nov. 84/3 The little cripple, none other than
Eddie Dillon, sometime All-American, caught the ball and ran with
it through the entire opposing eleven for another touchdown. **1948**
Atlantic March 24/1 You can't be an All-American on a losing team.

allocochick ˈæləkəˌtʃɪk, *n.* [f. the native name.] (See
quot. 1909.) Cf. **hiaqua.**

1851 in SCHOOLCRAFT *Indian Tribes* (1853) III. 142 This, under the
name of the 'ali-qua-chick,' or Indian money, is more highly valued
among them than any other article. **1872** *Overland Mo.* Apr. 329/2 This

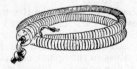

Allocochick, hiaqua, or shell money

shell money is called *álli-cochick*, not only on the Klamath, but from
Crescent City to Eel River, though the tribes using it speak several

different languages. **1909** *Cent. Supp.* 33/2 Allocochick. . . . The name of Indian shell-money used in northern California.

alumna əˈlʌmnə, *n. pl.* **-nae.** [L., fem. of *alumnus.*] A female pupil, esp. a graduate of a school or college.

1882 M. HARLAND *Eve's Daughters* 177 The statistics of the comparative death-rates of the Alumnæ and Alumni of Oberlin. **1910** *Vassar College Cat.* 3 The editors . . . have tried to obtain the information necessary for a complete record of the alumnae. **1946** *Chi. D. News* 20 May 13/7 She is an alumna of Wilson College in Chambersburg, Pa.

attrib. **1896** *Century Mag.* March 798/1 The average salary of the alumna teacher would be below rather than above $1000 a year. **1944** *Evanston Review* 2 Oct. 12/3 Members of the Northwestern chapter of Delta Omicron, music sorority, were guests of the North Shore Alumnae association.

✻ **Ananias,** *n.* Used, in allusion to the biblical Ananias (Acts v. 1–2), for a lie. Also **Ananias Club,** a club or group of liars. *Slang.*

"Ananias Club" attained wide popularity in connection with Theodore Roosevelt, but he did not coin the expression. See *N.Y. Times,* Nov. 25, 1923, Sec. 9, p. 16.

[**1878** *Gold Hill* (Nev.) *News* 15 March, It is a record of lies told in the Sazerac Lying Club, whose object, as its name implies, was lying.] **1888** *Kansas Hist. Coll.* IV. (1890) 273 An Ananias historian has tried to write a history that would make John Brown a demon, a thief and a murderer, and Lane a blackguard and a roustabout. **1896** J. F. B. LILLARD *(title),* Poker Stories as Told by Statesmen, Soldiers, . . . Members of the Ananias Club and the Talent. **1948** *Penna. Mag. Hist.* April 157, I have no wish for posthumous election to the Ananias Club.

A No. 1, A number 1. First-class, superior, A 1, originally of ships (see quot. 1857). *Colloq.*

[**1835** in *Am. Sp.* XXII. 201/1 He is a splendid man, that; we class him No. 1, letter A.] **1857** BUTLER *Goodrich's Fifth School Reader* 55 Vessels are classified according to their age, strength, and other qualities. The best class is called A, and No. 1 implies that the Swiftsure stands at the head of the best class of vessels. **1886** MARK TWAIN *Speeches* (1923) 137 (R.), Tons of A No. 1, fourth-proof, hard-boiled, hide-bound grammar. **1947** *Sports Afield* Dec. 59/3 It's an A-No. 1 type of project for any club to sponsor.

✻ **answer,** *n.* (See quots.) *Obs.*

1789 *Ann. 1st Congress* II. 32 The committee appointed to prepare an answer to the President's speech, delivered to the Senate and House of Representatives of the United States. **1816** PICKERING 32 *Answer* . . . is always used by us to signify the Reply of the Senate or House of Representatives to the Speech of the President (or of the Governor of a state) at the opening of a session of the Legislature. **1856** BENTON *30 Years* II. 32 The change from the address delivered in person, with its answer, to the message sent by the private secretary, and no answer, was introduced by Mr. Jefferson, and considered a reform.

✳ **antagonize,** *v. tr.* "In England, antagonizing forces must be of the same kind, but in the political phraseology of the U.S. a person may antagonize (i.e., oppose) a measure" *OED*.

1882 *Boston Ev. Transcript* 4/3 Ex-Secretary Windom did not hesitate openly to antagonize ex-Secretary Sherman's Bill. **1904** L. O. BRASTOW *Repr. Mod. Preachers* 148 He antagonized theology and denied the rational possibility of it. **1932** *DAB* VIII. 226 This highly protectionist measure, antagonizing many voters as much as it pleased ardent protectionists like Hanna, led to a serious Republican setback.

anti-prohibition. Opposition to prohibition, *q.v.* Also **anti-prohibitionist.**

1883 *Harper's Mag.* Oct. 804/1 Anti-Prohibition resolutions were passed. **1855** *N.Y. Herald* 6 Nov. 5/3 If anti-prohibitionists wish to know why it is necessary for them to defeat the fusion or republican ticket, we will refer them to the resolution adopted by the Prohibitionist State Convention. **1942** *Va. Q. Rev.* XVIII. 68 As for the Democratic party, Southerners have learned through the politically solid years to vote for it without liking everything it does or all of the people allowed in it—Tammany, the anti-Prohibitionists, the Catholics, and such.

aparejo ˌæpəˈreho, *n. S.W.* [Sp. in same sense.] A kind of packsaddle consisting chiefly of a square pad of stuffed leather or canvas. Cf. **arapajo.**

1844 J. GREGG *Commerce Prairies* I. 180 It is necessary too for the *aparejo* to be firmly bound on to prevent its slipping and chafing the

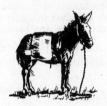

Aparejo in place on a pack animal

mule's back. **1878** HART *Sazerac Lying Club* 51 We got a aparayho and put it on the burro. **1929** CHALFANT *Death Valley* 34 A pair of strong hickory shirts were sewed together at the tails, the necks were sewed up, and the combination put astride the ox, with a child in each, serving as what the Californians called '*aparejos.*'

b. aparejo grass, (see quots.).

1894 COULTER *Bot. West. Texas* 519 S[porobolus] *depauperatus.* . . . Aparejos grass. **1912** WOOTON & STANDLEY *Grasses N.M.* 69 Aparejo Grass (*Muhlenbergia utilis*) . . . receives its common name because it is used to stuff the pads (*aparejos*) used in certain parts of Mexico in lieu of pack saddles.

Appalachia ˌæpəˈlætʃɪə, *n.* [See prec.]

1. The highland region in the southeastern portion of the U.S.

[**1705** HARRIS *Navigantium atque itinerantium* I. 806/1 *Soto* march'd toward *Apalache*, a very large and fruitful Province, as he was inform'd. *Ib.* 799/1 The *Indians* gave them to understand, by signs and words, that it came from a far distant Province call'd *Apalachen*.] **1913** *Outing* Feb. 551/1 Every stranger in Appalachia is quick to note the high percentage of defectives among the people. **1948** MENCKEN *Supp.* II. 16 Even the dialect of Appalachia, though it differs from General American, differs from it less than it differs from any regional variety.

2. (See quots.) Now *hist.*

1839 *Knickerb.* Aug. 161 We might still use the phrase, 'The United States,' substituting Appalachia, or Alleghania, (I should prefer the latter,) in place of America. **1947** *Amer. Sp.* Dec. 243 In 1839 . . . Washington Irving suggested . . . that *United States of America* be abandoned for *United States of Appalachia* or *Alleghania*, with *Appalachian*, or *Alleghanian* for a citizen thereof.

＊**aristocratic,** *a.* (See quots.) *Obs.* See also **anti-aristocratic.**

1846 COOPER *Redskins* x, Ravensnest was termed an 'aristocratic residence.' The word 'aristocratic,' I find since my return home, has got to be a term of expansive signification, its meaning depending on the particular habits and opinions of the person who happens to use it. **1859** BARTLETT 12 *Aristocratic*, strangely misapplied in those parts of the country where the population is not dense. The city, in the surrounding country towns, is deemed 'aristocratic.' The people in the villages consider the inhabitants of the towns 'aristocratic,' and so on. The term is . . . very common in small country newspapers and in political speeches in out of the way places.

armonica arˈmɒnɪkə, *n.* [Ital., fem. of *armonico* harmonious.] The "musical glasses" invented by Franklin. Now *hist.* Cf. **harmonica.**

1762 FRANKLIN *Wks.* (1887) III. 204 In honor of your musical language, I have borrowed from it the name of this instrument, calling it the Armonica. *c*1775 CARTER in Fithian *Journal* I. 59 *note*, An armonica, being the musical glasses without water, framed into a complete instrument. **1936** MORSE *Furniture* 305 Franklin invented an instrument for the musical glasses, which he called the Armonica, for which famous composers wrote music, and in which the glasses were arranged upon a rod which turned with a crank, while below was a trough of water which moistened the glasses as they dipped into it.

Ascension robe. The garment donned by the Millerites *q.v.* on the day in 1843 when they expected the end of the world. *Obs.*

1843 *Nauvoo* (Ill.) *Neighbor* 7 June 3/5 Several Millerites in that city walked the streets and fields all day arrayed in their ascension robes. **1869** MARK TWAIN *Innocents Abroad* xxxix. 416 A multitude of people in America put on their ascension robes . . . and made ready to fly up

into heaven. **1880** *Harper's Mag.* LX. 185/1 In New York, as Mrs. Child records, at a shop in the Bowery, muslin for ascension robes was offered. **1948** *Time* 22 Nov. 15/1 The Millerites, a religious sect, expected the world to end, and thousands of their members bought muslin Ascension Robes for the event.

assignation house. A house of prostitution that caters to the well-to-do. Cf. **house of assignation.**

1854 BUSCH *Wanderungen* I. 107 'Nun aber könnte ich Sie in unsere *Assignationhouses* führen, wo diese jungferngoldnen Tugendspiel hinterm Rücken des Gemahls ihrem Liebhaber ihr Stelldichein geben, und Tomback, verdammtes Tomback würden Sie sagen, wie ich es thue.' **1882** BUEL *Metropolitan Life Unveiled* 167 The assignation houses of Washington are sustained almost wholly by members of the two houses of Congress. **1943** OTTLEY *New World* 28 Don't come . . . bothering me with any more protests about assignation houses until you can bring concrete evidence of such houses.

atlatl ˈɑtlɑtl, *n.* [Nahuatl.] A throwing stick of any one of various types from sixteen to thirty inches long used by Indians and Eskimos.

1910 HODGE *Amer. Indians* II. 746/1 This implement, called also throwing board, dart sling, and atlatl, is an apparatus for hurling a

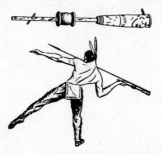

One form of atlatl, shown in detail and in use

lance, spear, or harpoon at birds and aquatic animals. **1934** MORRIS *Digging in Southwest* 44 The bow and arrow had not yet come into use, but instead game and enemies were reduced by long darts hurled with an *atlatl*.

Auburn system. A system of prison management originating in the prison at Auburn, N.Y., about 1824, involving solitary confinement of the prisoners at night, shop work, and complete silence except at meals. *Obs.*

1833 E. T. COKE *Subaltern's Furlough* xxv, The Concord [N.H.] prison . . . was conducted partly on the Auburn system. **1842** BUCKINGHAM *E. & W. States* II. 306 The system of discipline pursued here, is that which is called the Auburn, or Silent System, in contradistinction to the Philadelphia, or Solitary System. **1869** HALL *Hist. Auburn* 352 The famous Auburn system then [1825] began to receive a careful trial.

* **availability,** *n.* "That qualification in a candidate which implies or supposes a strong probability of his success, apart from substantial merit—a probability resulting from mere personal or accidental popularity" (B. '48).

1844 *Cong. Globe* 4 June 663/3 The *Eastern Argus* . . . describes the following as the traits of character which, in the estimation of the whigs, constitute the *ne plus ultra* of 'availability.' **1905** *N.Y. Ev. Post.* 13 Oct. 6 An illustration of the way in which what is called 'availability' is preferred to character and efficiency. **1948** *Chi. D. News* 6 Jan. 1/1 Gen. MacArthur's message congratulating Wisconsin upon her centennial celebration had no bearing on his political availability.

* **azure,** *n.* (1) A bluefish. *Rare.* (2) **azure bluebird,** (see quot.). (3) **azure warbler,** the cerulean warbler, *Dendroica cerulea*, of the eastern U.S.

(1) **1720** *Broadside Verse* (1930) 161 Beside the Salmon. . . . Vast Shoals of Azures swim the Quinebauge. — (2) **1917** *Birds of Amer.* III. 243/2 The Azure Bluebird (*Sialia sialis fulva*) wanders over the Mexican border into Arizona. — (3) **1828** BONAPARTE *Ornithology* II. 28 The Female Azure Warbler is four and three-quarter inches long. **1946** HAUSMAN *Eastern Birds* 517 Cerulean Warbler *Dendroica cerulea*. . . . Other Names—Blue Warbler, Azure Warbler.

B

* **B,** *n.*

1. a. (See quot. and cf. **A, 1.** above.) **b.** (See quot.) Both *obs.*

(a) **1657** *Plymouth Col. Rec.* III. 112 Katheren Aines . . . for the blasphemos words that shee hath spoken, is centanced . . . to were a Roman B cutt out of ridd cloth and sowed to her vper garment on her right arme. (b) **1873** ALDRICH *Marj. Daw.* etc. 122 Big Bethel and Bull Run and Ball's Bluff (the bloody B's, as we used to call them) hadn't taught us any better sense.

2. As a mark or grade given a student in school.

1877 [Provided for in June faculty minutes of Augustana College where B was equivalent to a grade of 60%–70%. See **A, 3.** note.] **1948** *Time* 1 Mar. 34/3 At school, where she always gets As or Bs, no one else is much impressed either.

b. As a grade for commodities.

1865 *Balt. Dly. Commercial* 4 Oct. 4/2 The refiners . . . now quote . . . 19 1/4 cts for A White; . . . 18 5/8 cts for B. **1886** *Harper's Mag.* June 93/1 'A' sugar is simply a term to designate the higher grades. . . . 'B' sugar is more brown. **1912** *American Mag.* Aug. 415/2 All milk

sold in grades A and B must comply with high special requirements or else be pasteurized. **1945** *Newsweek* 4 June 31/3 About two days a week some Grades B and C beef to early or preferred customers.

ba, see **ab.**

∗**baccalaureate,** *n.* A sermon or other address delivered on the occasion when a class is receiving the baccalaureate degree. In full **baccalaureate address, discourse, sermon.**

1851 *Harper's Mag.* III. 560/2 At Rutgers College the Baccalaureate Address was delivered to a graduating class of 18 members. **1864** HOLMES *Soundings* 72 A baccalaureate sermon of President Hopkins. **1871** L. H. BAGG *At Yale* 666 A third or more of every class were always absent from the 'baccalaureate discourse' and graduation exercises. **1892** E. A. TANNER *Baccalaureate & Other Sermons* 6 All of the baccalaureates of the ten years of his presidency at Illinois College are published. **1945** *Gunnison* (Colo.) *Courier* 26 July 1/1 Because of college baccalaureate, Sunday morning, there will be no eleven o'clock service at the Church.

bach bætʃ, *n.* Abbreviation of "bachelor," an unmarried man. Usu. with *old. Colloq.*

1855 *Golden Era* (S.F.) 15 April 1/3 You will soon be . . . a 'dried up' old bach., and in fact, 'good for nix.' **1911** LINCOLN *Cap'n Warren's Wards* xvii. 278, I'm an old bach, you say, and ain't had no experience. **1947** *Chi. D. News* 14 May 18/4 No, I'm no old bach but a middle-aged father of two kids.

b. *To keep bach (hall),* = next.

1879 I. L. BIRD *Rocky Mts.* 157 A cabin where two brothers and a 'hired man' were 'keeping bach.' **1904** DAY *Kin o' Ktaadn* 76 Ye've kept bach hall since seventy-three!

bach bætʃ, *v.* Also **batch.** [f. **bach,** *n.*] *intr.* Of a man or men: To keep house without the aid of a woman. Also *to bach it,* = *to keep bach. Colloq.*

1870 *Repub. Dly. Jrnl.* (Lawrence, Kans.) 29 Jan. They 'bach.' **1888** *Century Mag.* Jan. 412/2 He had always 'bached it' (lived as a bachelor). **1948** *Chi. Tribune* 3 Apr. 1. 16/3 He told how he was batching in a small apartment.

badland ˈbæd͵lænd, *n.*

1. *pl.* (*cap.*) A region in South Dakota and Nebraska where erosion has resulted in varied and fantastic land masses (see quot. 1882). Usu. **Bad Lands.**

1851 OWEN *Geol. Surv. Wis.,* etc. (1852) 195 J. Evans . . . finally reached . . . the country of the 'Bad Lands' (*Mauvaise Terres*), lying high up on White River. **1882** *Cent. Mag.* XXIV. 510 The term Bad Lands does not apply to the quality of the soil. The Indian name was accurately rendered by the early French voyageurs as *Mauvaises Terres pour traverser*—bad lands to cross. The ground between the buttes is fertile, and the whole region is an excellent cattle-range, the rock formations affording the best possible winter protection. **1948** *Range Riders Western* May 44/1 He entered the intricate maze of the badlands.

b. *transf.* A slum section in Chicago. *Slang.*

1892 *Scribner's Mag.* July 8/1 'The Bad Lands' is a quarter more repellent because more pretentious than 'The Dive,' but being the abode of vice and crime rather than of poverty, it can properly be omitted here. **1947** *Chi. Tribune* 7 Dec. IV. 47/2, I remember a Christmas eve . . . when I toured the west side bad lands, tough saloons and brothels.

2. *attrib.* Designating formations, areas, etc., where erosion has been of a characteristic intricate and sculptural nature.

1876 DODGE *Black Hills* 17 All the country south is 'bad land' or tertiary formation, much cut by deep and abrupt ravines. **1899** *U.S. Geol. Surv., Water Supp. Paper* 19, 36 Among the first lands sold in small subdivisions was a tract of about 4,000 acres, located in the bad-land strip on the base of the hills about 6 miles north of Merced [Calif.]. **1927** JAMES *Cow Country* 54 The country kept a-getting rougher and rougher as we rode, and pretty soon we begin to get in some bad-land breaks.

 * **bake,** *n.*

1. A social gathering at which a meal, esp. of baked food, is partaken of by those present, a clambake, *q.v.*

1846 *Spirit of Times* (N.Y.) 6 June 174/3 In search of that five pound pickerel which he was bound to pull in every year, for the grand 'bake' at the village hotel. **1904** *Providence Jrnl.* 8 Aug. 8 The bake was prepared under the supervision of John Babbitt, and, with the 'fixings' which accompanied it, was pronounced excellent. **1948** *Nat. Geog. Mag.* Aug. 170/2 If Rhode Island had never produced anything but a bake like that . . . it would have been enough.

2. An act or the result of baking. *Rare.*

1851 *Knickerb.* XXXVIII. 187 Saint Peter [in stained glass] is a little cracked . . . ; but I've got a first-rate bake on Paul.

 baked Alaska. A brick of ice cream inclosed within pieces of sponge cake, covered with meringue, and hurriedly baked in an oven until brown, before the center has time to melt.

[**1802** MITCHILL in *Harper's Mag.* (1879) Apr. 744/1 Among other things ice-creams were produced in the form of balls of the *frozen* material enclosed in covers of *warm pastry*.] **1909** FARMER *Boston Cook Book* 448 Baked Alaska. . . . Make meringue of eggs and sugar . . . , cover a board with white paper, lay on sponge cake, turn ice cream on cake . . . , cover with meringue, and spread smoothly. Place on oven grate and brown quickly in hot oven. **1948** *Time* 26 July 16/3 The party supped on roast beef and Baked Alaska.

 * **baking,** *n.*

1. baking powder, a white powder one of the elements of which is bicarbonate of soda used as a quick-acting leavening agent.

1853 *S.F. Whig* 28 July 3/6 (*advt.*), Judd's Baking Powders, extra

superior. **1887** C. B. GEORGE *40 Yrs. on Rail* 81 Dr. Price, of whom I have just spoken, was the originator of the famous Price's baking powder. **1948** *Dly. Ardmoreite* (Ardmore, Okla.) 12 May 5/1 It takes face powder to catch 'em, but it takes baking powder to hold 'em!

attrib. **1900** *Harper's Mag.* Mar. 500 We cooked a loaf of baking-powder bread in a frying pan. **1944** *This Week Mag.* 7 Oct. 18 On the square is the way to cut baking-powder biscuits and cookies when time saving counts big.

2. baking soda, sodium bicarbonate.

1881 *Rep. Indian Affairs* 49 For weeks at a time, their storehouses were empty, with the exception of corn, baking soda, and soap. **1946** *This Week Mag.* 7 Sep. 27/1 Sift together flour, salt, baking powder and baking soda.

* **bald-headed,** *a.* In combs.: (1) **bald-headed eagle,** the bald eagle; (2) **mountain,** a bald mountain, *rare;* (3) **row,** (see quot. 1889 and cf. **bald head row**).

(1) **1836** M. A. HOLLEY *Texas* v. 100 The bald-headed eagle and the Mexican eagle . . . are among the birds of prey, and are very common. **1873** *Newton* (Kansas) *Kansan* 19 June 3/2 Let patriots everywhere . . . prepare to do the clean thing by Uncle Sam and his bald headed eagle.— (2) **1854** HAMMOND *Hills, Lakes,* etc. 79 One day we came to an old baldheaded mountain. — (3) **1889** FARMER 34 Bald-headed Row —The first row of stalls at theatres, especially those which make a feature of ballets. The term is a cynical allusion to the fact that these seats are generally occupied by men of mature age; the innuendo is obvious. **1943** ERNIE PYLE *Brave Men* 82 One night I went to a USO show given in a rest area and was put in the bald-headed row up front.

b. *To snatch (jerk) bald-headed,* to manhandle, "use up," treat with dispatch. *Colloq.*

1869 *Overland Mo.* Feb. 190/2 None but a wild and savage animal, of course, would 'snatch a gentleman bald-headed,' as the old man expressed it. **1909** MARK TWAIN *Is Shakespeare Dead?* i. 6 Can't you keep away from that greasy water? Pull her down! snatch her! snatch her baldheaded. **1945** *Jefferson Co. Republican* (Golden, Colo.) 28 Feb. 2/2 Just let me get hold of em, I'll jerk 'em bald-headed!

* **balk,** *n. Baseball.* (See quot. 1887.) Also attrib. See also **claw balk.**

1845 in *Appleton's Ann. Cyclo.* (1886) X. 77/2 A runner can not be put out . . . when a balk is made by the pitcher. **1887** *Lippincott's Mag.* May 839 A *balk* is . . . any motion made by the pitcher to deliver the ball to the bat without delivering it, . . . *and any motion calculated to deceive a base-runner,* except the ball be accidentally dropped. **1913** *Amer. Mag.* Sep. 24/1 Out of the first nine men who reached first base, Kilroy caught seven by his balk motion, and turned their own game against the champions. **1948** *Dly. Ardmoreite* (Ardmore, Okla.) 14 May 8/6 They were disputing a balk called on Pauls Valley Pitcher Chuck Liska.

ballyhoo ˈbælɪˌhu, *v.* [f. the noun, sense 3.] *tr.* and *intr.* To praise extravagantly, to indulge in ballyhoo. Also **ballyhooer,** *n.,* **ballyhooing,** *n.*

1901 *World's Work* Aug. 1100/2 Last of the professions on the Midway are those of the 'barker,' 'ballyhooer' and 'spieler' **1922** *Collier's* 4 March 7/1, I don't like to ballyhoo myself, Mickey, but here's a picture which will make you and Mr. D. Griffith bite your nails. **1924** *Amer. Mercury* Feb. 255/1 Unperturbed by the ballyhooing at other and more pretentious booths, Mrs. Watts continues to do business at the old stand. **1948** *Atlantic Mo.* March 24/1 They are ballyhooed, pushed, yelled, screamed, and in every way propagandized into the consciousness of the voters.

balsa ˈbɑlsə, *n*. [Sp. in same sense.] (See quots.) Also attrib.

[**1780** CLAVIGERO *Storia della Messico* II. 168 Oltre alle barche si servivano per valicare i fuimi d'una macchina particolare, appellate *balsa* degli Spagnuoli dell' America.] **1806** LANGSDORFF *Voyages* (1817) 459 The Indians, are very seldom under the necessity of trusting themselves to the waves, and if such a necessity do occur, they make a sort of boat for the occasion of straw, reeds, and rushes, bound together so close as to be water-tight . . . these sort of boats are called by the Spaniards walza. **1907** HODGE *Amer. Indians* I. 920 The Mohave made no canoes, but when necessary had recourse to rafts, or balsas, made of bundles of reeds. **1948** *Reader's Digest* Jan. 105/1, I was able to float a balsa raft down to the Rio Negro.

✳ **bamboo**, *n*.

1. Short for next. Also **bamboo vine**.

1709 LAWSON *Carolina* 101 The small Bamboo is . . . a certain Vine, . . . growing in low Land. . . . Their Root is a round Ball, which the Indians boil . . . and eat them. **1853** P. PAXTON *Yankee in Texas* 22 [I aided] his rude attempts at road-making whenever a mass of bullbrier or bamboo-vines . . . called for action. **1934** *Nat. Geog. Mag.* LXV. 602 The 'hoorah bushes,' sweet gallberries, and other shrubs are interlaced with the thorny vines of 'bamboo' or smilax.

2. bamboo brier, *S.* an American climbing plant of the genus *Smilax*. See also **bay bamboo**.

1835 LONGSTREET *Ga. Scenes* 74 This came . . . over me, like a rake of bamboo briers. **1945** *Democrat* 4 Jan. 2/2 His progress was slowed up by a multitude of bamboo briers.

✳ **band**, *v*.

1. *tr.* (See quot. 1902.)

1878 B. F. TAYLOR *Between Gates* 266, I leave him to 'band' his sheep and herd his bees as he pleases. **1902** CLAPIN 36 In prairie parlance, *to band* means to form, to assemble cattle, sheep, into vast flocks.

2. To attach an identifying band to the leg of a bird in studying its range, habits, etc. Also ✳ **banding**, *n*. Cf. **bird banding**.

1914 *Lit. Digest* 17 Jan. 102/2 Last year over 150 young American and snowy egrets were banded. **1937** *Bird Lore* Jan.–Feb. 84/2 After . . banding is only *one* of the methods of studying birds. **1948** *Nat.* Apr. 173/3 In a single season, 3000 ducks were banded.

ˈber, *n*.

Eng. A keen cold wind driving frozen snow

crystals so violently as almost to cut one's face.

1833 M'GREGOR *British Amer.* I. 133 The keen north-west wind, during winter, is often called the 'Barber' in America. **1892** H. F. REDDALL *Fact and Fable* 57 Barber, The. A severe storm, accompanied by intense cold, peculiar to the Gulf of St. Lawrence. . . . The name is also applied to a phase of cold along the coasts of Nova Scotia and New England.

2. barber house, =next. *Rare.*

1889 BRAYLEY *Boston Fire Dept.* 86 A fire at Gold's barber-house, in Southick's court, was put out by engine 6 during April.

3. barbershop, the shop of a barber.

One ex., 1579, of this term appears in *OED.* It was apparently formed anew in this country.

1832 KENNEDY *Swallow Barn* I. Int. Ep. 8 A thorough-going violin . . . in an illuminated barber-shop, struggled in the contortions of a Virginia reel. **1947** *Duluth* (Minn.) *News-Tribune* 19 Jan. B. 4/7 More fish are 'caught' in a barber shop on an average winter afternoon than are taken in many lakes all summer.

b. barbershop quartet, a male quartet, orig. associated with barbershops, meeting occasionally to sing in close harmony.

1925 WITWER *Roughly Speaking* 302 Then there . . . [were] the barber shop quartette harmonizers and moonlight necking parties on the boat deck. **1948** *Dly. Ardmoreite* (Ardmore, Okla.) 2 May 12/3 Songs and music were provided by the barber shop quartet of Oklahoma City.

barlow ˈbɑrlo, *n.* [f. the maker's name.] A pocket knife of a make so designated embracing single-bladed knives of various sizes. Also **barlow (pocket) knife, Russell Barlow knife.**

1819 *Mass. Spy* 29 Dec. (Th.), A barlow knife, bloody, and another knife, rusty, lay along side of him. **1873** HOLLAND *A. Bonnicastle* iii, Before her, on the table, were a Barlow pocket-knife, a boy's playing-ball [etc.]. **1884** SWEET & KNOX *Through Texas* xxxiv. 463 By the sale of a damaged barlow, . . . and a tailless kite, I became the possessor of twenty-five cents. **1944** WILSON *Passing Insts.* 59 A Russell Barlow knife can be used for all sorts of things. [**1946** —— *Fidelity* 11 Boxes had to be whittled to their basic elements; Russell Barlow, whose knives we used for whittling, had he lived in earlier times, would have been made the patron saint of whittlers.]

b. Also **barlow penknife.**

1779 *N.J. Jrnl.* 12 Oct., To be sold by Stephenson and Canfield, In Morris Town, . . . Barlow penknives, knives and forks. **1830** J. F. WATSON *Philadelphia* 201 The buck-handled Barlow penknives [were] . . . a source of great gratification to the boys.

Barnburner ˈbɑrnˌbɜnɚ, *n.* A member of a faction of the Democratic party in N.Y. State (*c*1840–50) so zealous for reforms that they would "burn the barn to get rid of the rats." Cf. **Hunker.**

1841 *Greene Co. Torchlight* (Xenia, O.) 19 Aug. 2/2 The meeting

Bartramia longicauda, of the eastern states, also **Bartramian sandpiper;** (3) **Bartram's tattler,** =prec.

(1) **1810** MICHAUX *Arbres* I. 24 Bartram's Oak . . . , sur la rivière Schuylkill. **1868** *Exp. U.S. Comm. Agric.* (1869) 202 Bartram oak. . . . This unique plant forms one of the most beautiful as well as the most interesting of all the oaks. **1901** MOHR *Plant Life Ala.* 473 Bartram Oak . . . [is] sparsely diffused and local from Staten Island to Delaware, North Carolina, northern Alabama, and northeastern Texas. — (2) **1813** WILSON *Ornithology* VII. 63 Bartram's Sandpiper . . . being as far as I can discover a new species, . . . I have honored it with the name of my very worthy friend, near whose Botanic Gardens . . . I first found it. **1942** *Nat. Pk. Service, Fading Trails* 259 The increase of the upland plover (commonly known as the Bartramian sandpiper) in Oregon would be a biological miracle. — (3) **1839** PEABODY *Mass. Birds* 370 Bartram's Tattler . . . is considered a great luxury. **1844** *Nat. Hist. N.Y., Zoology* II. 247 The Grey Plover. . . . In the books it is described under the names of Bartram's Tatler and Sandpiper.

* **basement,** *n.*

1. basement apartment. An apartment in a basement.

1863 C. C. HOPLEY *Life in South* I. 4 Vast hotels rise bodily to admit a new foundation and a new suite of 'basement' apartments. **1948** *Chi. Tribune* 26 June 1. 10/7 An advertisement in a neighborhood paper last week read, '2 1/2 Rm. Unfurn. Basement Apt., call Anonymous 0000.'

2. basement house. A house in which the rooms for receiving company are one story above the ground level, having an entrance at the basement level.

1852 BRISTED *Upper Ten Th.* ii. 43 Even in a double house, or a house and a half, or a basement house, three different styles which would all admit of cloaking-rooms on the lower floor, no one ever thinks of having them there. **1886** *Cent. Mag.* Feb. 549/1 We have since built basement-houses in not inconsiderable numbers, but they have never been really popular in New York.

basketball 'bæskɪt,bɔl, *n.* [The name and the sport were brought into use in 1891 by James Naismith at the Y.M.C.A. College at Springfield, Mass.] A game, usu. played indoors and chiefly in winter, in which the players, commonly five on a side, try to toss a large inflated ball through an elevated basket or goal.

1892 NAISMITH in *Triangle* Jan. 144 Basket Ball [*article heading*]. We present to our readers a new game of ball. . . . It fills the same place in the gymnasium that foot ball does in the athletic field. Any number of men may play at it, and each one get plenty of exercise. **1893** *Physical Education* April 21 Basket Ball as an In-door Game for Winter Amusement and Exercise. **1947** *Chr. Sci. Monitor* 16 Jan. 6/1 Basketball remains the only major sport of purely American origin, and the sport which, year in and year out, attracts more spectators than any other.

attrib. **1913** *Outing* Feb. 639/1 The Princeton basket ball team defeated the New York University five. **1921** HALL *Yosemite Nat. Park* 280 Basket-ball or similar shoes with heavy rubber soles are good for smooth rock surfaces. **1948** *P. C. C. Chronicle* (Pasadena, Calif.) 31 Mar. 2/1 Handball courts, top basketball courts, and other physical improvements have been recently made.

b. The ball used in this game.

1902 *Sears Cat.* (ed. 112) 325/2 Victor Official Basket Ball, made of the best English grain leather 30 1/2 to 30 inches circumference, the best basket ball made. **1948** *Athletic Jrnl.* April 3/1 We have done 'miracles' in taking old basketballs, footballs . . . and punching bags and returning them beautifully reconditioned.

bathinette ˌbæθəˈnɛt, *n.* A small bath, supported on a stand, and provided with conveniences needed in bathing a baby. Also attrib. — **1936** *Sears Cat.* (Ed. 173) 173 Genuine Bathinette. . . . Pull hand grip, white duck dressing table comes over Dupont rubber coated fabric tub. Safety strap. Towel rack, enameled hardwood stand. Rustproof metal parts. Rubber hose, shut-off. **1947** *Chi. Sun* 14 Oct. 10/4 Back on the bathinette table I patted her dry, again making sure to get into the creases of loose skin.

bayou ˈbaɪu, *n.* S. Also formerly **bayoue, bayoe, bayeau, bayau,** etc. [Amer. F. from Choctaw *bayuk*, river, creek. See *The Nation*, 59 (1894), 15 Nov. 361, and Read, *La. Pl.-Names*, p. xii.]

1. A sluggish stream or body of water, often connecting larger waters or emptying into adjacent streams. See also **blind, dry, pine bayou.**

Various applications of this term are shown in some of the quots. [**1699** in READ *La. Pl.-Names* p. xii, A cinq lieues plus loin, en tournant tousjours à la gauche sur le lac, on trouve une eau dormante, que les Sauvages appellent Bayouque.] **1766** H. GORDON in *Travels Amer. Col.* 484 We left New Orleans . . . and lay that night at the Bayou. **1792** *Amer. Philos. Soc.* III. 217 A place called the Bio-Piere. **1841** W. KENNEDY *Texas* I. 25 The word *bayou* . . . is rather loosely applied in the topography of Texas and the West. In strictness, I believe it means a deep inlet, which affords a channel for the water in time of flood, and remains dry, or nearly so, at other seasons. **1914** R. S. TARR *Physiography* 150 Some abandoned [river] courses along the lower Mississippi are called *bayous.* **1947** *Sat. Ev. Post* 17 May 19/1 At first there had been some land along the bayou.

2. bayou blue, an alcoholic drink, *slang, obs.* Also **bayou cabin, road, State, steamboating, version.**

1870 NOWLAND *Indianapolis* 36 He thought (especially if he had taken a little 'bayou blue') he would weigh several ton. — **1888** CABLE *Bonaventure* 106 Sitting and pondering one evening in the . . bayou cabin. — **1850** H. C. LEWIS *La. Swamp Doctor* 161, I saw . . up the bayou road shaken up by a half-naked negro. — **1867** . . *mer. Lit. Rec.* Aug. 41/1 Maine is popularly known as . . Pine-Tree State; . . . Mississippi as the Bayou State. . . *ws* 29 Apr. 4/3 Mississippi is the Bayou state, and . . . s. both for obvious reasons. — **1946** *Reader's* . . *eamboating* was steamboating at its worst.

— **1886** *Harper's Mag.* Aug. 483/1 The following bayou version of one of the negro folk-lore stories is translated by a lady.

3. Bayou Salade, the name given, poss. by early French trappers, to South Park, Colo. Also attrib.

A. Matthews, in *Mass. Col. Soc. Pub.* VIII. (1904) 392, explains this expression as coming from Sp. *Valle Salado*, South Park having long been noted for its salt springs.

1848 ALLEN *Ten Yrs. in Ore.* 381 [The Arapahoes] in summer hunt the buffalo in the New Park, or 'Bull Pen,' in the 'Old Park,' on Grand river, and in 'Bayou Salade,' on the south fork of the Platte. **1948** *Chi. Tribune* 29 Feb. IV. 6/4 The novel reaches a peak in both interest and writing during the years Johnny spends with the Ute Indians in the Bayou Salade region of the Rockies.

bazooka bə'zukə, *n.* [App. f. **bazoo.**] (See quots.) Also **bazookist.**

1935 *Newsweek* 14 Dec. 29/1 (*caption*), A Local Bazookist Makes Good in Some Big Cities. *Ib.* 29/2 Burns peps up his lengthy yarns with periodic outbursts on his own invention, the bazooka, a trombone-like instrument confected of two gaspipes and a whisky funnel. **1943** *Pop. Sci. Mo.* Dec. 69 By developing the bazooka, our Army Ordnance Department modernized an old and almost forgotten weapon— the artillery rocket.... Resemblance to comedian Bob Burns's famous 'bazooka' inspired the modern launcher's name. **1948** *Chi. Tribune* 2 May 1. 45/2 The army ... will be in the market for improved guns, [and] rocket launchers like the bazooka.

***BB,** *n.*

1. BB gun, an air rifle that shoots BB shot.

1932 *Kansas City Times* 2 April 28 They put bird baths and bird boxes in their yards to attract the birds and then equip their small sons with B. B. guns. **1945** WALLACE *Barington* 13 His favorite pastime with the high-powered Benjamin BB-gun was shooting the buttons off Lee Graham's coat.

2. BB shot, a size of shot intermediate between B and BBB, measuring .18 of an inch in diameter.

[**1874** LONG *Wild-Fowl* 240 B or BB may with propriety be used in large or very close shooting guns.] **1891** *Scribner's Mag.* X. 460 A Canada goose ... had been struck with one 'BB' shot, which had penetrated the left ventricle. **1947** *Chi. D. News* 21 July 12/1 The University of Chicago law library had an adventure with a trespassing bird, which was finally abated by a BB shot.

beardtongue 'bɪrd͵tʌŋ, *n.* An herb of the genus *Penstemon.*

1821 *Mass. Hist. Soc. Coll.* 2 Ser. IX. 153 *Pentstemon pubescens,* Beard tongue. **1847** WOOD *Botany* 400 Beard-tongue ... [grows on] river banks, bluffs, hills, and barrens, Western N.Y. to Ohio, Iowa and Illinois. **1940** JAEGER *Desert Wild Flowers* 235 This tall (2–5 ft.), extraordinarily sweet-scented beard-tongue comes to perfection in mid-May.

Bear Flag. A white flag having a grizzly bear as its device raised in June, 1846, by a small group of American

insurgents in California, who, in defiance of the Spanish authorities, proclaimed "The California Republic." Now used as the California state flag.

[**1848** *Calif. Claims* (Senate Rep. 23 Feb.) 27 A settler ... had hoisted a flag—a grizzly bear upon a white field—as the insignia of the new State.] *Ib.* 50 The most valuable portion of the beautiful valley ... and the wealthy missions of the country would have been ceded and granted away, but for the opportune hoisting of the bear flag. **1880** IDE *California* 47 The said 'Bear Flag'—made of plain cotton cloth, and ornamented with the red flannel of a shirt from the back of one of the men, and christened by the words 'California Republic,' in red-paint letters on both sides—was raised upon the standard where had floated on the breezes the Mexican flag aforetime. It was on the 14th of June, '46. **1946** R. PEATTIE *Pac. Coast Ranges* 82 Not even a hint of an echo of his growl comes down the winds, flutter-

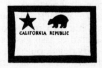

Bear Flag of the California Republic

ing proudly the Bear Flag which, as California's official State flag, floats beside the national colors. **1948** *Chi. Tribune* 25 April 1. 24/3 They marched on the local presidio and on June 14, 1846, raised the famous Bear Flag.

attrib. **1856** *Wide West* (S.F.) 1 Oct. 2/1 The bear which forms a portion of the present escutcheon of the State of California, was introduced as a memento of the Bear Flag movement, by the Constitutional Committee. **1880** in IDE *California* 127 During these twenty days there was no obstruction, by a conflicting party, to the exercise by the Bear Flag Government, of its entire functions and prerogatives of National Independence. **1943** DEVOTO *Year of Decision* 461 They were afraid of such half or wholly irregular military forces as the Bear Flag stalwarts and the California Battalion.

beaten biscuit. *S.* A hard biscuit made of dough consisting of flour, shortening, and water, lightened by thorough beating and frequent folding.

1876 M. F. HENDERSON *Practical Cooking* 69 Little machines ... for the purpose of making beaten biscuit. **1908** LORIMER *J. Spurlock* 207 There was a chicken gumbo soup, and then cold boiled Virginia ham, and hot fried chicken, ... beaten biscuits. **1948** *Chi. D. News* 23 Feb. 12/7 The famous beaten biscuit deserved just what it got— a beating.

bee gum.

1. A hollow gum tree or log which houses a swarm of bees or from which beehives are made. Also **bee gum tree.**

Bee gum or honey gum of an early type

1817 WEEMS *Letters* III. 215 To be run . . . round & round the circumference of a Bee-Gum like a Dog in chase of his tail, is enough to try the patience of ten Jobs. **1852** REGAN *Emigrant's Guide* 85 Thar I . . . tore up Sam. Kirkham's Grammar, and hid it in a bee gum. **1888** C. D. WARNER *On Horseback* 92 Big Tom was always on the alert to discover and mark a bee-gum. **1926** ROBERTS *Time of Man* 130 Erastus found a bee-gum tree and robbed the wild bees of their fruit.

2. A beehive, orig. one made of a section of a hollow gum tree.

[**1818** PALMER *Journal* 126 The environs of the house are often ornamented with a peach or apple orchard, a small garden, patch of tobacco, cotton or indigo, and bee-hives (made of hollow pieces of logs, or square boxes).] **1846** *Quincy* (Ill.) *Whig* 28 Feb. 2/5 Is it not a delightful picture for a high-souled democrat to contemplate, to see a Mormon, with a stolen pig under one arm, a stolen sheep under the other, and a bee-gum strapped on his back, pointed to, by the whigs, as a member of our party? **1913** M. W. MORLEY *Carolina Mts.* 180 Neither are there 'hives' in the mountains, only 'bee-gums,' which the bees fill with 'right smart of honey.' **1939** HARRIS *Purslane* 10 Dele rolled rags into smokers for the bee gums.

b. (See quot. 1904.) *Colloq.*

1880 HARRIS *U. Remus* (1884) 230 One er deze yer slick-lookin' niggers, wid a bee-gum hat an' a brass watch ez big ez de head uv a beer bar'l, come 'long an' bresh up agin me—so. **1904** *D.N.* II. 416 Beegum hat, n. Silk hat.

belittle bɪˈlɪtl̩, *v.*

1. *tr.* To make small, reduce in size.

1781–2 JEFFERSON *Notes on Va.* (1788) 69 So far the Count de Buffon has carried this new theory of the tendency of nature to belittle her productions on this side the Atlantic. **1816** PICKERING 48 To *Belittle* . . . is sometimes heard here in conversation; but in writing, it is, I believe, peculiar to that gentleman [= Jefferson]. **1910** *Bookman* May 290/2 The pictures seldom fail to put 'Mutt' in the same class with his name, proving his belittled compatriot, 'Jeff,' to be the cleverer man.

2. To disparage, speak of slightingly.

1797 *Independent Chron.* 30 March, [He] is . . . an honorable man, . . . let the writers . . . endeavour to belittle him as much as they please. **1844** *Republican Sentinel* (Richmond, Va.) 8 June 3/1 The Whigs may attempt to 'belittle' our candidates—that is a favorite game with them. **1948** *America* 24 April 44/2 The Communist smear technique . . . has been used to belittle certain supporters of the strike.

3. To cause to appear small.

1850 S. COOPER *Rural Hours* I. 127 The hills . . . [do not] belittle the sheet of water. **1883** H. GEORGE *Social Problems* (1884) 20 We have already corporations whose revenues and pay-rolls belittle those of the greatest States. **1947** *Chi. Sun* 2 June 11/1 Long Line Bra styled to belittle generous proportions.

Belshnickle ˈbɛlʃˌnɪkḷ, *n.* Chiefly *Pa.* [G. (Palatinate and Saar) dial. *Pelznickel*, f. *pelz*, fur, *Nickel*, Nicholas.] Santa Claus, Christmas.

1823 JAMES *Long's Exped.* I. 188 This dance is called *La Gineolet*, and may have had its origin in the same cause that produced our Belshnickles, who make their appearance on Christmas-eve. **1830** WATSON *Philadelphia* 242 The 'Belsh Nichel' and St. Nicholas has been a time of Christmas amusement from time immemorial among us. **1869** *Atlantic Mo.* Oct. 485/2 Pelznickel is the bearded Nicholas, who punishes bad ones; whereas Krisskringle is the Christkindlein, who rewards good children. **1936** MENCKEN *Amer. Lang.* 159 Santa Claus, in such areas, is usually *Belsnickel*, as indeed he was among the Germans of Baltimore when I was a boy [c1890].

attrib. **1940** WRIGHT *Pioneer Life* 90 Among the Germans the Beltznickel Man, a member of the community disguised in a panther skin with trailing tail, black bearskin cap, and mask, romped with the children and filled their stockings with apples and nuts.

belt line.

1. A railroad that goes wholly or partially around a city. Also attrib. and transf.

1894 *Cent. Mag.* Dec. 290 De Belt Line stables ain't no Hoffman House, but dey're Vanderbilts 'longside o' Kansas. **1903** *N.Y. Times* 24 Oct. 2 George B. McClellan and Edward M. Grout were scheduled for a belt line tour of speechmaking last night. **1935** HORWILL 27 The term *belt line* is applied in Am. to a tram-line which takes a circular route. It is also used fig.

2. A highway.

1922 *Dly. Ardmoreite* (Ardmore, Okla.) 6 Jan. 6/5 A belt line of gravel highway is now under construction around the city of Ardmore. **1948** *Chi. Tribune* 15 Apr. III. 1/3 The Illinois highway department decided to by-pass the community with a belt line for route 150 coming from the east.

Ben Day. 1. In photoengraving, a pattern effect produced on a zinc etching by a process developed by Benjamin Day (1838–1916), a N.Y. printer. **2. Ben Day process,** (see quot. 1949).

(1) **1927** PAUL D. HUGON *Morrow's Word Finder s.v. Cut.* A Ben Day, shaded printing surface on a line cut. — (2) **1912** F. WEITENKAMPF *Amer. Graphic Art* 217 The 'Ben Day' process of quick mechanical production of tints by 'rapid shading mediums' has also been a time-saver. **1949** *Manual of Style* 245 Ben Day Process—An engraving process for producing a variety of shaded tints by the use of gelatin films, particularly in connection with line (zinc) etchings.

Hence **Ben Dayed,** *a.,* produced by the Ben Day process.

1931 *Retailing* 7 Nov. The Ben Dayed design, in conjunction with the panels, gives the ad the perfect illusion of greater depth than it actually has.

* **benefit,** *n.*

1. *To take the benefit,* to take advantage of bank-ruptcy laws. *Obs.*

1823 I. HOLMES *Account* 215 To shew the extreme facility of obtaining the benefit of the Insolvent Act, an attorney . . . informed me, that a person applied to him to assist him 'in taking the benefit,' as it is termed, of the act. 1846 COOPER *Redskins* xii, I took 'the benefit,' as it is called, myself.

2. benefit bridge (party), luncheon, a bridge party or luncheon the proceeds of which are donated to some cause.

1931 *K.C. Star* 11 Nov., One woman went home from the benefit bridge party last night just before the scores were tallied. 1932 *Durant* (Okla.) *D. Democrat* 27 Oct. 5/5 Mrs. J. T. May will be hostess for the Garden club benefit bridge. 1947 *Chi. D. News* 13 Sep. 11/3 Arden Shore-ites are hereby abolishing benefit luncheons in favor of the cocktail hour.

berm bɜm, *n.* [f. G. *Berme* (Du. *berm*) a path or strip of ground along a dike.] The bank of a canal opposite the towing path. Also the side or shoulder of a road. Orig. **berm-bank.**

1854 in *N. & Q.* 1 Ser. IX. 12/2 The bank of a canal opposite to the towing-path is called the birm-bank. 1883 *Williamsport* (Pa.) *Gaz.* 30 March (Th.), The horse plunged over the berm bank into the bed of the canal. 1943 POWELL *Home Again* 54 It tilted the car into the air and pitched the passengers off on to the berm of a cut through which the train was passing.

b. (See quot.)

1947 *Nat. Geog. Mag.* Sep. 326/1, I listened to Coast Guardsmen expounding . . . how to climb a steep bank and cross the soft berm, or crest.

berrying ˈbɛrɪ·ɪŋ, *n.* The gathering of berries. Also attrib. or as adj. See also **buffalo berrying, huckleberrying.**

1845 COOPER *Chainbearer* xxi, It's berryin' time now. I'll run and get a basket. c1853 MISS SEDGWICK in *Life & Lett.* (1871) 44, I went with herds of school-girls nutting, and berrying, and bathing by moonlight. 1868 *Amer. Naturalist* May 133 A man who had been out berrying stated that he suddenly came across a Rattlesnake with her young. 1880 *Harper's Mag.* March 546/1 With no companions but another woman, who had 'gone berrying.' 1890 MARAH E. RYAN *Told in Hills* v. 58 A berrying crowd from the Kootenai tribe.

bifocal ˌbaɪˈfokl, *a.* Having two foci, used of spectacles the lenses of which give assistance for both near and distant vision. Also as noun. Cf. **double spectacles, Franklin spectacles.**

1894 GOULD *Dict. Med.* 205/1 Bifocal lens. **1895** *Pop. Science Mo.* Aug. 470 Ordinary bifocal glasses. **1948** *Hygeia* Jan. 38/1, 1888 or 1889 are the dates of the Morck patents on cement bifocals and 'perfection'. bifocals. . . . The invention of the Kryptok, or fused bifocal, is accredited to an American by the name of Borsch in 1899 and a short time after this the solid or one piece bifocals were invented by another American, Connor.

* **binder,** *n.* A machine that cuts and binds grain into bundles.

1857 *Ill. Agric. Soc. Trans.* II. 120 A self raker, and even a binder, may be just as simple in its structure as some *hand raker*, considering what it does. **1948** *Life* 23 Aug. 103 On every farm . . . reapers and binders churned the crop, shockers in straw hats followed behind to set up the bundles into rows of shocks.

b. binder twine, = **binding twine.**

1946 *Reader's Digest* Jan. 141/2 They flew it with five balls of binder twine. **1946** WILSON *Fidelity* 183 In fact, the cracker that came on the whip was usually replaced, when it wore out, with a piece of binder twine.

* **blackberry,** *n.*

1. blackberry cobbler, a cobbler the chief ingredient of which is blackberries.

1936 KROLL *Share-cropper* 106 Maw then would bake a huge blackberry cobbler. **1945** *Chi. Tribune* 3 June VII. 1/3, I have fresh blackberry cobbler and things like that.

. 2. blackberry winter, (see quots.).

1905 JOHNSON *Highways* 162 Then, later, when the blackberries are in blossom, we have another cold spell what we call the blackberry winter. **1920** THOMAS *Ky. Super.* 189 Cool weather in May is called blackberry winter. **1933** *Amer. Sp.* Feb. 80 In addition to *blackberry winter, dogwood winter,* and *snowball winter* mentioned in preceding issues of *American Speech,* Oklahoma has *whippoor-will storms.*

Bland dollar. The standard silver dollar of 412½ grains coined in accordance with the Bland-Allison Silver Act of 1878. *Obs.*

From 1873–78 there had been no coining of standard silver dollars, the trade dollar (1873–87) *q.v.* having been coined during this time. By 1878 there had arisen a need for the standard silver dollar.

[**1876** *Chi. Tribune* 3 Aug. 5/1 The morning hour was occupied with useless filibustering upon the Bland Silver bill.] **1879** *Congress. Rec.* 15 May 1369/2 Notwithstanding this sad fate of the Bland silver dollar, it is now seriously proposed to repeat that folly on a much larger scale. **1896** *Cong. Rec.* 15 May 4935/2, I simply call the attention of the Senate to the fact that the so-called Bland dollar was never a full legal tender.

* **bleacher,** *n.* **1.** A vessel used in processing almonds for the market. *Rare.* **2.** *pl.* The low-priced, sometimes roofless, seats for spectators at outdoor events, esp. base-

ball and football games, also attrib. (in the sing.); those who occupy these seats. Cf. **bleaching boards.**

(1) **1883** *Cent. Mag.* Oct. 812/2 The nuts are then poured into bleachers—boxes with perforated bottoms. — (2) **1889** *Chi. Tribune* 18 May 6/1 The grand stand and bleachers were well filled with something over 2,000 spectators. **1889** *Sporting Life* (Phila.) 10 July 3/6 There is one thing in which Gloucester 'beats' the world, and that is in the 'bleacher.' There that irrepressible blooms unregenerate and develops his lungs to their full fog-horn capacity. **1917** MATHEWSON *Sec. Base Sloan* xviii. 238 More than half of the bleacher seats were empty. **1948** *Chi. Tribune* 20 Apr. 1. 20/4 They didn't whoop it up like the crowd in the grandstand and bleachers.

blondine blon'din, *a.* and *n.* [f. * *blond, a.*] **1.** *n.* A preparation for making the hair blond. **2.** *a.* Artificially blond. Also **blondined.**

(1) **1909** F. CALHOUN *Miss Minerva* 73 Jimmy . . . returned with a big bottle of a powerful 'blondine' in one hand. — (2) **1920** LEWIS *Main Street* 312 'You know this new dressmaker, Mrs. Swiftwaite?—swell dame with blondine hair? **1931** *K.C. Star* 5 Aug., Did you notice . . . the hula dancer . . . —the blondined Hawaiian?

∗blueback, *n.*

1. Any one of various fishes, birds, etc., so called from their color.

1812 BENTLEY *Diary* IV. 125 Mrs. Osgood . . . had taken great numbers of the Herrings called Bluebacks at the mills this season. **1843** *Nat. Hist. N.Y., Zoology* v. 24 There is a variety of the Lobster, termed Blue-backs, on account of their dark bluish color. They are derived from the coast about Cape Cod, have comparatively thin shells, and are highly prized by epicures. **1883** *Cent. Mag.* Sep. 684/1 The blue-back's nest was scarcely a foot from the ground. **1945** *Md. Conservationist* 8/1 There are five species of Pacific salmon: . . . the sockeye, also known as blue-back and red salmon. **1948** *Scientific Mo.* April 283/2 It is often assumed that the blueback salmon spawn rather generally throughout the upper Columbia Basin.

2. One of the notes or bills issued by the Southern Confederacy. *Obs.*

1869 in MATHEWS *Beginnings* 156 The Rebels had their 'bluebacks' for money; but in Texas, . . . they made slow progress. **1871** DE VERE 47 During the Civil War, . . . the original Blue Backs of the Confederacy (so-called in opposition to *Green Backs* of the Union) soon became known as Shucks.

3. Used attrib. or as adj. to designate a well-known elementary spelling book written by Noah Webster and first published in 1783. Also **blue-backed.**

1858 *Harper's Mag.* May 724/1 The scholars sat on rough-hewn benches conning their well-thumbed primers, or blue-backed spelling books. **1916** MASSEY *Reminisc.* 47 From a Webster's blue-back spelling book my father taught me the alphabet. **1947** LUMPKIN *Southerner* 160 Instead of the 'Blue Back' speller, we studied spelling from the dictionary.

∗ blue coat, *n.*

1. A U.S. soldier, used esp. during the Civil War. Cf. *boys in blue s.v.* ∗ **boy.**

1833 CATLIN *Indians* I. 240 The United States and British governments . . . paid them [*sc.* Indians] . . . for every 'scalp' of a 'red' or a 'blue coat' they could bring in! **1864** CATE *Two Soldiers* 46 During the day I remained about the premises, though in constant anticipation of seeing the blue-coats coming. **1945** MARSHALL *Santa Fe* 9 Then the Texans came rampaging west and whipped the bluecoats in the Glorietas.

2. A policeman. *Colloq.*

1875 *Chi. Tribune* 29 Aug. 5/4 Occasionally one of the blue coats would attempt to put back the crowd, but they would not be put back. **1947** *Denver Post* 23 Feb. A. 7/1 While the bluecoats lately have had only 'God's Little Acre' to cover, the risque scribblers of the pioneer era were turning out miles of blood-and-thunder copy.

3. A bluish color-stage in the coats of deer at a certain season. *Rare.* Cf. **blue,** *n.* **4.**

1870 *Amer. Naturalist* May 1908 The spike-horn was shot just as deer were attaining the 'blue coat.'

blue jay. Any one of various North American jays, esp. the common jay, *Cyanocitta cristata.* See also **mountain blue jay.**

1709 *Bristol Rec.* in *Narrag. Hist. Reg.* III. 211 The same order shall extend to the killing of blew Jawes [*sic*]. **1808–14** WILSON *Ornithology* I. 12 The Blue Jay is an almost universal inhabitant of the woods, frequenting the thickest settlements, as well as the deepest recesses. **1944** DUNCAN *M. Graham* 17 Faintly hearing the blue jays that called and scolded near the cabin, Mary stirred and woke.

b. blue-jay camp meeting, a group of chattering jays. *Colloq.*

1907 LINCOLN *Old Home House* 12 Everybody was togged up till Jonadab and me, in our new cutaways, felt like a couple of moulting blackbirds at a blue-jay camp-meeting.

blues bluz, *n. pl.* [Short for ∗ *blue devils.*]

1. Depression of spirits, despondency, melancholy, usu. with *the.*

1807 IRVING *Salmagundi* xv, [He] concluded his harangue with a sigh, and I saw he was still under the influence of a whole legion of the blues. **1873** HAYCRAFT *Elizabethtown, Ky.* 148 One evening in winter he was walking out to relieve ennui and a heavy spirit, warmly clad, but as miserable as he could be—that is, completely in the *blues.* **1945** *Chi. D. News* 17 May 23/2 (*heading*), The Old Medicine Man Still Cures the Blues.

2. A type of mournful, haunting Negro folk song adapted and often burlesqued for use in music halls, vaudeville shows, etc. Also attrib.

1917 *Lit. Digest* 25 Aug. 29/2 Jazz crept slowly up the Mississippi from resort to resort until it landed in South Chicago at Freiburg's, whither it had been preceded by the various stanzas of 'Must I Hesitate?' 'The Blues,' 'Franky and Johnny,' and other classics of the levee underworld. **1921** *Outward Bound* May 58/2 These 'labour songs,' . . . like the 'blues' of to-day, were rather humorous. **1948** *Time* 1 Mar. 34/2 The words were written specially for her, to an old blues tune.

b. blues singer, one accustomed to sing such songs.

1931 *K.C. Star* 23 Oct., Twin girls, age 4, rendered a program as blues singers at a dime store in Emporia the other day. **1947** *Chi. Sun* 14 Oct. 43/4, I got her a job understudying the blues singer in the show I'm handling.

bluff blʌf, *n.*¹ [See note.] A steep river bank or shore, or the top of such a bank.

This noun use is poss. f. the adj., or short for **bluff land.** See **c.** below. All the early examples refer to South Carolina and Georgia, and many of them relate to Savannah.

1687 in *S.C. Hist. & Gen. Mag.* (July, 1929) 26 April 131 . . . We landed on a Bluffe where some shads were. . . . At night with the Ebb we came to a Bluffe. *Ib.* 30, 132. This morning . . . we came . . . to ane old Indian plantation on a Bluffe. **1737** JOHN WESLEY *Journal* I. (1910) 402 Savannah stands on a flat *bluff* (so they term any highland hanging over a creek or river), which rises forty-five feet perpendicular from the river. **1801** *Hist. Review* II. 307 The river forms a half moon, with banks on the south-side 40 feet high, having on the top a flat which sailors call a *bluff*. **1881** *Rep. Indian Affairs* 37 The bottom lands here are about one and one-fourth of a mile wide, the land rising with a gentle slope from the river to the bluffs in the rear. **1948** *So. Sierran* May 1/1 Before us were limestone cliffs, red sandstone walls, spectacular views of the gorge with its fantastic crags and bluffs.

attrib. **1765** J. BARTRAM *Diary* 24 July, Water ouseth thro ye strata of sand shels or gravel so that they cant dig very deep excep it is in bluf banks near ye river. **1850** DRAKE *Treatise* 168 This is another bluff-town on the same right-hand bank of the river, fifty miles higher up, and one hundred and eighty-seven from the mouth of the Missouri. **1861–4** *Ill. Agric. Soc. Trans.* V. 628 The term loess is applied to a deposit which . . . has been sometimes called the 'bluff' deposit. **1886** *Outing* May 131/1 One of my foremen shot a mountain ram on a ragged bluff-crest but half a mile away.

b. Bluff City, (see quots.).

1859 *Harper's Mag.* March 591/2 The Shelby Agricultural Society's fair grounds, a mile and a half from this, the 'Bluff City' [= Memphis]. **1871** DE VERE 663 Hannibal, in Missouri, is known as the *Bluff City*, being built on high bluffs overhanging the river.

c. bluff land(s), land that rises steeply, high land.

1666 *S.C. Hist. Soc. Coll.* V. 62 The North East side is a bluffe land, rounding from the River. **1685** *Let.* in *S.C. Hist. & Gen. Mag.* April (1929) We settled ourselves altogether in a verie convenient place for a town . . . a high bloffe land excellently weel [*sic*] watered. **1884** *Encycl. Brit.* XVII. 309/2 These so-called 'bluff-lands,' [are] composed of loess materials.

blurb blᴈb, *n.* [See note.] A brief and highly commendatory notice or advertisement, esp. of a book. Also attrib.

Said to have been originated in 1907 by Gelett Burgess in a comic book jacket embellished with a drawing of a pulchritudinous young lady whom he facetiously dubbed Miss Blinda Blurb. See Mencken, *Supp.* I. 329.

1923 *Nation* 1 Aug. 121/2 The publishers . . . clapped on a jacket containing a blurb. **1924** *Spectator* 27 Sep. 426 The note of vanity is ominously accentuated by the publisher's blurb on the dust-cover, as silly and vulgar as the present writer has ever seen. **1947** *Sat. Review* 18 Oct. 10/2, I suppose it is too much to expect that the publisher should have shown its faith in the work to the extent of making its blurb-writer read it. **1948** *Good Housekeeping* Jan. 9/1 Blurbs insult their intelligence and they want no part of them.

B'nai B'rith bə'ne·bə'riθ, *n.* [Heb., "sons of the covenant."] A Jewish fraternity founded in New York City in 1843 and now widely extended.

1879 *Chi. Tribune* 14 May 6/1 (*heading*), B'nai B'rith. **1883** *Chi. Tribune* 1 July 9/2 The Jewish benevolent order of B'nai B'rith has ten lodges. **1909** *Cent. Supp.* 147/3 B'nai B'rith. . . . [Heb., 'children of the covenant' (i.e., circumcision).] An independent Jewish order. **1948** *Dly. Ardmoreite* (Ardmore, Okla.) 23 April 10/1 He helped to organize the B'nai B'rith fraternal group here.

boatable 'botəbḷ, *a.* Navigable by boat.

1683 PENN *Descr. Pa. Wks.* (1782) IV. 315 The Schuylkill being an hundred miles boatable above the Jules. **1804** *Fredericktown* (Md.) *Herald* 4 Feb. 4/2 The Potomack is already boatable, without risque, below the mouth of the river Monocasy. **1888** *Harper's Mag.* Sep. 510/1 Occasionally a caribou is killed . . . while seeking the grass growing in some boatable stream. **1941** BALDWIN *Keelboat Age* 39 When Thomas Hart Benton and Governor William Clark of the Missouri Territory undertook to estimate the extent of the 'boatable waters' of the Mississippi Valley they arrived at a grand total of fifty thousand miles.

bob bab, *interj.* An intensive particle. *Colloq.*

1856 *Iroquois Republican* (Middleport, Ill.) 29 May 1/5 He can't get me with his big words, nosiree bob. **1859** *No. Californian* (Union) 22 June 1/5 A witness before Judge H—— of Missippi [*sic*], in answer to a question, replied 'Yes, siree, Bob!' **1909** *D.N.* III. 362 No, siree, Bob! **1947** *Amer. Wkly.* 2 Nov. 21/2 No sirree, Bob! Not me, boys.

bobolink 'babə‚liŋk, *n.* Also **bob-o-lincoln, boblink,** etc. [f. its call.] The skunk blackbird, *Dolichonyx oryzivorus,* an American songbird found chiefly in the eastern and central states. Also transf. Cf. **prairie bobolink.**

1774 J. ADAMS *Works* II. 401 Young Ned Rutledge is a perfect Bob-o-Lincoln,—a swallow, a sparrow, a peacock. *a*1801 FESSENDEN *Orig. Poems* (1806) 146 In strains as sad as you can think on, In unison with bob-o-link horn. **1826** FLINT *Recollections* 243, I saw early

in the spring a flock of those merry and chattering birds, that we call bob-a-link, or French black-bird. **1903** *Mich. Ornith. Club Bul.* March 11 In some sections the Bobolink is known only as the Skunk-head Blackbird, while the Towhee or Chewink is called Bobolink. **1947** *Sports Afield* Dec. 26/3 A bobolink poured out its tiny jugful of rhythmic melody.

b. The call-note of this bird.

1839 *Boston Transcript* 8 June 2/4 The songster then varied his note, 'Boblink—Boblink!' **1855** BRYANT *Robert of Lincoln* i, Robert of Lincoln is telling his name: Bob-o'-link, bob-o'-link, Spink, spank, spink.

bobwhite 'bɑb'hwaɪt, *n.* [Imitative.]

1. The call or note of the quail or partridge.

1812 WILSON *Ornithol.* VI. 25 The quail . . . will sometimes sit, repeating, at short intervals, 'Bob White,' for half an hour at a time. **1884** ALDRIDGE *Life on Ranch* 195 The cheerful 'Bob White' of the quails can be heard any day during the breeding season without going out of doors. **1917** EATON *Green Trails* 112 He could sit down in a field by the edge of the woods, motion me to silence, and then whistle 'Bob White' till sometimes a whole flock of quail would be gathered on the ground about us.

2. A quail of the genus *Colinus*, esp. *C. virginianus*. Cf. also **masked bobwhite.**

1837 *N.Y. Mirror* 18 Nov. 164/3 Only thou, dear Bob White . . . will remain. **1886** VAN DYKE *So. Calif.* 77 Bob White is one of nature's noblemen. **1945** *N. Eng. Homestead* 13 Oct. 6/4 The bob-white is a special friend as well as a popular game bird and will readily take advantage of bushy fence rows.

Also as a plural. — **1948** *Sierra Club Bul.* Mar. 16 Working with bobwhite, he was able to demonstrate that the number of birds present in the spring is determined by the suitability of the winter range.

b. Also **bobwhite quail.**

1920 *Outing* Oct. 15/1 No birds in the United States . . . lie as well to the dog as bob-white quail. **1948** *Durant* (Okla.) *Dly. Democrat* 4 July 2/2 Artificial propagation of bob white quail at the state game farm may mean more this year than ever before.

c. (See quot.)

1894 *Outing* xxiv. 227/1 Bass flies of proved merit include the bob white, grizzly queen, grizzly king.

bogus 'bogəs, *a.* [f. **bogus**, *n.*¹] Spurious, counterfeit, fraudulent.

1838 in HUNT *Hist. Mormon War* (1844) 206 During the free career of Oliver Cowdery and David Whitmer's bogus-money business, information got abroad into the world that they were engaged in it. **1857** *Lawrence* (Kansas) *Republican* 11 June 2 They ask us to *humble* to those bogus laws. **1880** MARK TWAIN *Letters* (1917) I. xx. 377 The small bogus king has a . . . cussed time of it on the throne. **1948** *Chi. D. News* 8 Sep. 1/7 She was sentenced to a year in the County Jail . . . for cashing bogus checks.

✳**bologna**, *a.* Designating or referring to bulls suitable

for converting into beef of an inferior quality. Cf. * *Bologna sausage.*

1899 *Chi. D. News* 7 June 11/5 Choice fat light bulls went at stronger prices but the heavy bologna stock was dragging at the bottom. **1904** *Cin. Enquirer* 2 Feb. 8/1 Bulls—Good bologna grades active and 10 @ 15c higher; fat bulls unchanged and slow. **1947** *Chi. Tribune* 14 June 18/3 Cattle Pr[i]m[e] steers . . . $28.00 — 30.00 . . . Bulls, bologna, com-choice $15.50 @ 18.00.

bonanza bə'nænzə, *n.* [See note.]
From Sp. (prosperity, success) app. in Amer. Sp. senses shown in **1.** and **3.**, though the *Diccionario de la Real Academia Española* records *bonanza* in sense **3.** without ascribing it to Amer. Sp.

1. *In bonanza,* of a mine: Producing very profitable ore.

1844 GREGG *Commerce of Prairies* I. 170 The Placer was in its greatest *bonanza*—yielding very large profits to those engaged in the business. **1888** J. J. WEBB *Adventures* 50 The products of the gold mines . . . did not amount to more than $200,000 dollars a year when in bonanza, and very seldom to anything near that amount.

2. In mining, the accidental discovery of a rich vein or pocket, good luck. Also transf.

1844 GREGG *Commerce of Prairies* I. 173 The progress of the foreign adventurer is always liable to be arrested by the jealousy of the government, upon the first flattering *bonanza,* as the cited instances abundantly demonstrate. **1881** RAYMOND *Mining Glossary, Bonanza,* in miners' phrase, good luck. **1886** *Stamp Collector* (Chi.) July 11 At one small bookshop . . . I ran across what some would consider a bonanza.

3. An especially rich vein or pocket of ore. Also transf.

1864 MOWRY *Ariz. & Sonora* 131 Their successors no sooner struck a *bonanza* than . . . they commenced to enjoy life in pretty much the same manner. **1880** *Custer* (Dakota Terr.) *Chronicle* 31 Jan. 1/8 This mine situated about seven miles west from town is fast proving itself a bonanza. **1948** *Colo. Mag.* March 88 Loading a stamp mill on to a wagon at St. Joseph, Smith and Chaffee started for the new bonanza.

4. Used attrib. of persons who have become rich through mining operations or to properties yielding rich returns or conducted on a large scale, as **bonanza family, king, mine, mine owner, property, state, stock.**

1898 ATHERTON *Californians* 61 A 'Bonanza' family, whose huge fortune, made out of the Nevada mines, had recently lifted it from obscurity to social fame. — **1876** *Boston Post* 5 May (B.), The Bonanza king was bitterly indignant at the means employed to depreciate his mines. **1947** *Time* 27 Oct. 106/2 Mackay hated the title of 'Bonanza King.' — **1876** DE GROOT in Powell *Nevada* 73 The 'Bonanza Mines' of the Comstock occupy a section of that lode situate near the northerly extremity of what has thus far proved to be the more fertile portion thereof. — **1884** *Cent. Mag.* Sep. 796 The railroad king, . . . the bonanza mine owner, the Texas rancher, and the Pennsylvania iron prince. — **1902** LONDON *Daughter of Snows* 66 A Bonanzo property, or a block of Bonanzo properties, does not entitle you to a pound

more than the oldest penniless 'sour-dough.' — **1893** WAGNER *More About Names* 35 Montana is The Bonanza State, in allusion to its many Bonanza mines, the word *Bonanza* being Spanish for prosperity. **1948** MENCKEN *Supp.* II. 635 Montana, in its earlier days, was the *Bonanza State.* — **1876** *Boston Post* 5 May (B.), The recent decline in Bonanza stocks in the San Francisco market. **1883** MRS. FOOTE *Led-Horse Claim* i. 9 The ark of the mining interest . . . had drifted about unsteadily after the break in bonanza stocks in the summer of 1877.

Hence, transf., **bonanzist.** *Rare.* — **1879** *Chi. Tribune* 8 Feb. 5/2 The market must be stiffened or values will go down to such a figure that the average price will not allow the great bonanzist to come out with what was originally put in the deal.

b. Esp. **bonanza farm, farmer, farming.**

1878 CONKLIN *Picturesque Ariz.* 32 One can get an extended . . . and at least a flattering idea of a bonanza farm of Southern California. **1904** *Minneapolis Times* 8 July 4 The 'bonanza' farm, not many years ago a subject of much boasting in the west, is a thing of the past, and from now on intensified instead of expansive farming will prevail. **1943** HOWARD *Montana* 175 As a matter of fact, up to this time the famous 'bonanza' farms in Montana were primarily livestock operations. — **1882** *Uncle Rufus & Ma* 46 The large 'bonanza' farmers in Cass County have been successful. **1937** M. D. WOODWARD *Checkered Years* 10 One bonanza farmer alone had, at one time, 600,000 bushels of No. 1 hard in the elevators which he was holding for better prices. — **1909** *Sat. Ev. Post* 30 Jan. 30/2 What bonanza-farming is in any way equal to that? **1945** GRAY *Pine, Stream & Prairie* 17 The soil is rich and deep; great dramas of bonanza farming have been enacted on it.

Bonnie Blue Flag. Prob. the secession flag of South Carolina, consisting of a blue field with at first a single star for that state. Also as the title of a song popular in the South during the secession period.

1861 H. MACARTHY *Song, The Bonnie Blue Flag* i, Hurrah for the Bonnie Blue Flag that bears a Single Star! **1865** SALA *Diary* I. 260 The young lady who wore the Union flag in her bosom begins to hum the 'Bonnie Blue Flag.' **1889** FARMER 75 *Bonny Blue Flag*, the Blue Flag, the standard of the Confederates, was thus affectionately named. Round it gathered the whole sentiment and earnestness of the Southern cause. **1947** *Atlantic Mo.* Aug. 70/2 Some East Texans, in particular, still have vague romantic feelings about the Bonny Blue Flag.

booby prize. A prize given to the one who has the lowest score in a game, contest, etc. Also transf. and fig.

1893 DANA *Wild Flowers* 170 It seems as though the flowers of the witch-hazel were fairly entitled to the 'booby-prize' of the vegetable world. **1932** *K.C. Star* 1 Feb. 18 The Pulitzer committee gives an annual award for the best news story of the year, but offers no booby prize for the worst. **1948** *Southern Wkly.* 3 July 18/1 In spite of all the recent booby-prize nominations, no one has thought to accuse Henry of being the worst third-party candidate the country has ever seen.

✶ **booming,** *n.*[2] [Cf. **boom,** *n.*[2] **2.** and *v.*[2] **4.**]

1. The fact of flourishing by a boom; the creation of a boom or the attempt to make one. Also attrib.

1873 *Newton Kansan* 3 July 1/6 'Booming' is the name of an operation with which probably our readers are not generally familiar. **1880** *Harper's Mag.* Feb. 383 This little town [Rosita, Colo.] was founded in 1872, and led a quiet existence, with occasional episodes of what is here called 'booming.' **1888** *Chicago Herald* (F.), Ben Butterworth, of Ohio, one of the mainstays of John Sherman's booming squad.

2. *W.* A method of using impounded water in placer mining (see first quot.).

1874 RAYMOND *6th Rep. Mines* 299 The practice of booming has permitted the successful working of poorer ground than has been before worked in the county. [*Note.*] A rude form of hydraulic mining, in which a torrent of water, obtained by the accumulation of smaller supplies, is suffered to escape from the reservoir at intervals. *Ib.* 302 Booming may be considered as the best labor-saving invention introduced into the country of late years.

boondoggle 'bun₁dɑgl, *v.* [Origin unknown.] *intr.* To engage in trifling, inconsequential, or piddling work. Also as a noun and in derivatives, as **boondoggler, boondoggling.** *Slang.*

1935 *Chi. Tribune* 4 Oct., To the cowboy it meant the making of saddle trappings out of odds and ends of leather, and they boondoggled when there was nothing else to do on the ranch. **1942** *Ib.* 20 April 8/3 No good American wants to see our form of government or our system of economy overturned by boondogglers or social experimenters. **1947** *Ib.* 8 June 1. 22/2 The cost of this boondoggle has been estimated at perhaps 50 million dollars. **1947** *Steamboat* (Colo.) *Pilot* 2 Jan. 1/4 Nor do I believe in worldwide boondoggling or free and easy loans from our treasury to support decadent empires.

bootee bu'ti, *n.* [*boot* + *-ee*.] A half-boot or high shoe.

1799 *Aurora* (Phila.) 15 Nov. (Th.), For sale, 180 pairs of bootees. **1819** *Ky. Herald* (Louisville) 30 June 1/5 (*advt.*), Just received . . . Children's leather and morocco Bootees and Shoes. **1854** *Pioneer* (S.F.) Jan. 57 In came Sally with her bootees on,—A hundred years ago! **1929** A. ELLIS *Life* 279 She got a pencil and drew three designs on her booty.

b. A baby's boot or shoe of knitted wool.

1929 *Sears Cat.* Fall 76 These bootees make a warm and cozy place to tuck little feet. **1945** *This Week Mag.* 3 March 5/3 On all his missions he carried a pair of knitted baby bootees.

Bostonese ₁bɔstən'iz, *n.* **1.** (See quots. 1809, *c*1818), also inhabitants of Boston. **2.** (See quot. 1889.) Also attrib.

(1) [**1809** GRAY *Letters* 367 *Les sacra* [*sic*] *Bostonois*, is the usual epithet [in Canada] for all Americans, from whatever part of the country they may come.] *c*1818 HADFIELD *Diary* 61 He asserted he had tomahawked and scalped 50 Bostonese, a name they [*sc.* Indians in Canada] give generally to the Americans of the states. **1888** *N.Y.*

Herald 29 July 7/6 There were a number of people present, principally Bostonese. **1925** *N.Y. Times* 8 Sep. 24/3 The real culprit was Squire Sam Jones, who in the second inning surrendered four runs to the Bostonese. — (2) **1876** *Cinci. Enquirer* 17 June 3/2 His reply was not negro at all, it was purest Bostonese. **1889** FARMER 79/2 Bostonese . . . is a method of speech or manners supposed to be specially affected by the residents of that city. **1914** BRININSTOOL *Trail Dust* 246 I'm tryin' to tame my rough manner To fit with her Bostonese style. **1948** MENCKEN *Supp.* II. 179 The educated speech of the State . . . , though 'not as harsh as the Middle Western' variety, is 'untainted by Bostonese.'

Bourbonism 'bʊrbən͵ɪzəm, *n.* Conservatism in politics.

1876 *Arcola* (Ill.) *Record* 26 Feb. 4/2 The ancient Courthouse Bourbons . . . helped to start the *Review* in this county, for the purpose of building up Bourbonism and breaking down the Independent Reform movement. **1904** *Buffalo Commercial* 22 Nov. 8 The young and liberal men in the South are encouraged to throw off the yoke of Bourbonism. **1944** *Christian Cent.* 12 July 823/1 The Democratic convention will reveal quite as much bourbonism on the part of its powerful southern state and northern city machines as did the Republicans in their cheers for 'free enterprise.'

breezeway 'briz͵we, *n.* (See quots.) Also attrib. Cf. **dogtrot.**

1931 K. N. BURT *Man's Own Country* 39 A small log building attached to the end of his own ranch-house by means of what is known to the Far West as a breeze-way. This construction is a floored and roofed-over passage, open at the sides. It is used for the protection of buckets of water, washtubs, firewood, stray tools, fishing-tackle, guns, skiis, and occasionally for a clothesline. **1944** *D.N.* Nov. 8 *dog-trot,* also called *breeze-way:* n. A wide, floored passageway running between two halves of a house, built, except for a common roof and floor level as two separate structures. **1948** *Household* March 14/1 The breezeway porch is an extension of the main roof.

Britisher 'brɪtɪʃɚ, *n.* A native of Great Britain, a person of British origin.

The question of the place of origin of this term has been debated without decisive results. According to the evidence at present available it is of American origin.

1829 MARRYAT *F. Mildmay* xx, [American mate speaking:] 'Are we going to be bullied by these . . . Britishers?' **1863** RUSSELL *Diary* II. 97 Why even the Northern chaps get angry with a Britisher, as they call us, if he attempts to say a word against those cursed niggers. **1947** *Denver Post* 28 Feb. 10/4 They must be forever on the qui vive not to do anything that will offend the critical Britishers back home.

Bronx braŋks, *n.* [A part of N.Y. City, so named after Jonas Bronck, an early landholder.]

1. A kind of alcoholic drink. Also attrib.

1909 *Sat. Ev. Post* 10 April 37/2 The first-night death-watch, . . . in its sophistication could recognize a block away a Bronx, Martini or Manhattan cocktail by its color. **1921** *Collier's* 24 Sep. 4/1 How d'ye

mix a Bronx cocktail? **1931** F. L. ALLEN *Only Yesterday* 11 He finds
there a group of men downing Bronxes and Scotch highballs.

2. Bronx cheer, a sound of contempt made by vibrating the tongue between the lips.

1929 *Collier's* 23 Feb. 10/4 Maxim give him a Bronx cheer. **1948**
Sat. Ev.Post 22 May 145/3 There were quite a few Bronx cheers when
my name was announced over the public address system.

Brunswick stew. (See quot. 1899.)

1856 DAVIS *Farm Bk.* 56 Our dinner consisted of the following Bill
of Fare.... Soup Gumbo Brunswick Stew. **1899** GREEN *Va. Word-
Bk.* 71 Brunswick Stew, *n.* A stew made of squirrel or chicken meat,
lima beans and green corn cooked together and seasoned with pepper
and salt. **1947** BEROLZHEIMER *Regional Cookbook* 200 Brunswick
Stew [was] originated by one of the race of 'born cooks' . . . Dr. Has-
kins' 'Uncle Jimmy' of Brunswick County, Virginia.... The original
stew was made of squirrel with no vegetables, but onions.

buckwheat notes. In music, notes having the heads
of various shapes somewhat suggestive of buckwheat
kernels. Cf. **shaped notes.**

Such notes were used in Albany, N.Y. as early as *c*1800. See
G. P. Jackson, "Buckwheat Notes," in *The Musical Quarterly* XIX.
(1933), 393–400.
1853 GOULD *Church Music* 55 After making two attempts without
success, he [Andrew Law] desisted; and others profited by the form of
the characters, which were afterwards by way of reproach, called, by
some, buckwheat notes. *Ib.* 140 Still, however, we have reason to be-
lieve that *buckwheat* notes are not all eaten up, but are to this time
preserved and used in many places in the great west. **1895** HOWELLS
Recollections 143 The books were printed in what they called patent
notes, or, in ridicule, *buckwheat* notes. Instead of having the note-
heads round, they were made of different shapes, the seven notes of
the scale being made up by repeating three of the notes. **1933** *Amer.
Sp.* Feb. 52 Shape Notes, n. The peculiar notation which the Ozark
singing-teachers still use rather than the ordinary *round* or *sol* notes.
Sometimes called *buckwheat notes.*

buffle-headed duck. Also **buffelheaded, †buf-
fel's head duck, bufflehead,** =prec.

1731 CATESBY *Carolina* I. 95 *Anas minor purpureo capite.* The Buf-
fel's Head Duck.... These Bird's frequent fresh waters, and appear
in Carolina only in Winter. **1813** WILSON *Ornithology* VIII. 51 The
Buffel-headed Duck, or rather as it has originally been, the Buffaloe-
headed Duck, . . . is fourteen inches long, and twenty-three inches
in extent. **1946** STANWELL-FLETCHER *Driftwood Valley* 179 Two pairs
of little bufflehead ducks arrived last week.

bugologist ˌbʌgˈɑlədʒɪst, *n.* An entomologist. *Jocu-
lar.*

1881 *Nat. Republican* 24 Feb. 2/4 Mr. Riley, the eminent bugolo-
gist, has had an interview with General Garfield on the subject of
agriculture. **1901** G. S. HALL *Confess. Psychol.* 110 The 'Bugologist'
. . . has long been the stalking horse or awful example of . . . nar-
rowness. **1910** *Sat. Ev. Post* 2 July 49/2 Government bugologists

camped on his trail and studied his habits until they got so they could read his mind.

burglarize 'bɜglə‚raɪz, *v. tr.* and *intr.* To steal, break into (a house) and rob, to practice burglary. Also **burglarizing,** *n.*

1871 *Southern Mag.* April (De Vere), The Yankeeisms donated, collided, and burglarized, have been badly used up by an English magazine writer. **1871** DE VERE 655 In like manner the burglar's occupation has been designated as burglarizing. **1947** *Jrnl. Crim. Law & Criminology* Nov.–Dec. 319, I tried to resist the urge to get outside and burglarize.

∗ **Burley,** *n.* [App. f. proper name.] A variety of tobacco grown esp. in Kentucky, often **white Burley.** See also **Kentucky burley.**

1881 in B. W. ARNOLD *Tobacco Ind.* (1897) 35 The White Burley produced in the West has now thoroughly substituted our dark grades. **1909** *Cent. Supp.* 177/1 *Burley,* a well known American variety of tobacco, having two subvarieties, red and white. **1945** *Chi. D. News* 8 Jan. 6/2 From here it looks as if the typical Victory garden in '45 will have to include five rows of Kentucky burley, five of Carolina types, two of latikia and one of perique.

bushed buʃt, *a.*

1. Tired, worn out. *Colloq.*

1870 *Nation* July 57/1 To be 'bushed' was to be tired [in Penna.]. **1885** M. D. WOODWARD in *Checkered Yrs.* (1937) 67 Walter owned, for once in his life, that he was nearly bushed. (That expression will not apply on our Dakota farm where there is not a bush on the whole two sections.) **1948** *Dly. Ardmoreite* (Ardmore, Okla.) 13 Apr. /44 Whew! I'm bushed!

2. Confused, bewildered, frightened by being in the woods.

1920 *Outing* Nov. 77/1 Soundless and wonderful he floated . . . through the unspeakable tangle that would have pulled you or me up in half-a-dozen yards, hopelessly 'bushed.' **1946** STANWELL-FLETCHER *Driftwood Valley* 1 8 If I hadn't gone crazy 'bushed,' I knew that something alive was there, close to me, in the deep snowy woods.

butcher knife. A large knife now used chiefly as a kitchen utensil.

[**1714** *Boston News-Letter* 1–8 March 2/2 To be sold by public vendue . . . fans, butchers knives [etc.].] **1822** *Mass. Spy* 25 Dec. (Th.), Her foot slipt, and she fell upon a large butcher-knife which she had in her hand. **1866** GOSS *Soldier's Story* 125 We had a pocket compass, which was intrusted to me, a small quantity of salt, and a butcher-knife, such as was issued to Massachusetts soldiers at Readville. **1948** JOHNSTON *Gold Rush* 11/2 Butcher knives which miners used to dig gold from crevices [were] thirty dollars each.

b. *attrib.* Used of the vicious, illiterate, butcher-knife-wearing element in the early population of Illinois. *Obs.*

1847 T. FORD *Hist. Illinois* 88 These 'butcher knive boys,' as they were called, made a kind of balance of power party. *Ib.*, Most of the elections in early times were made under 'butcher knife influence.'

B.V.D. The trade-mark of an undergarment for men.
Also beeveedees.

1908 *Sat. Ev. Post* 4 July 1 All B.V.D. Garments are made of thoroughly tested woven materials selected for their *cooling* and *wearing* qualities. **1915** in *Sooner Mag.* (1947) Nov. 14/1 The 'frosh' started a 'back to nature' movement but compromised on 'beeveedees.' **1947** COFFIN *Yankee Coast* 71 He rushed out on the parade grounds in his B.V.D.'s.

C

∗**C, n.**

1. A hundred dollars, esp. a bill of that denomination.
Also C note. Cf. century note. *Colloq.*

1839 *Spirit of Times* 13 April 66/3 (We.), I had no idea of betting more than an 'L,' or a 'C.' **1845** SOL. SMITH *Theatr. Apprent.* 149 So there's my hundred—and as my pocket-book's out, and my hand's in, there's another C. **1946** *Science Digest* Aug. 23/2 Barney Baruch likes to start out each day with a goodly supply of crisp C-notes.

b. C speck, a hundred-dollar bill. *Rare.*

*a*1846 *Quarter Race Ky.* 117 Sol. Lauflin matched his bay four year old colt . . . to run a quarter, in the lane near this place, for a C speck.

2. (See quot.) *Rare.*

1848 N. AMES *Childe Harvard* 33 These last six stanzas, I suppose, may seem Rather out of place, and should be marked with 'C'; That is, 'want of connection' in 'the theme.'

3. Used to denote the grade or quality of a commodity.

1865 *Balt. D. Commercial* 4 Oct. 4/2 The refiners . . . now quote . . . 18 5/8 cts for B, and 18 1/4 cts for C extra. **1912** *Amer. Mag.* Aug. 415/2 Lederle laid down the law that all milk sold in the city should be classified into three grades: (A)—suitable for infants and children. (B)—suitable for adults. (C)—suitable for cooking and manufacturing purposes. **1945** *Newsweek* 4 June 31/3 About two days a week some Grades B and C beef to early or preferred customers.

b. Used as a grade or mark in school. See also high C.

1889 *Harvard Faculty Rec.* in M. L. Smallwood *Exams. & Grading Systems* 59 Any member of the graduating class who has attained Grade C or a higher grade in eighteen courses . . . will be recommended for a degree. **1948** *Dly. Ardmoreite* (Ardmore, Okla.) 31 Mar. 14/4 On her last report card she received 4 A's and 4 B's and only one C.

cabestro kə'bɛstro, *n.* Also **cabresta, cabresto, caberos.** *S.W.* [Sp., halter; Amer. Sp., hair rope.] A hair rope, esp. one used as a halter or lariat. Cf. **cabras.**

1846 *Knickerb.* XXVII. 251 He felt himself violently seized from behind, his arms pinioned, his mouth filled with the end of a hair ca-bresta. **1902** CLAPIN 90 The *cabestro* is also employed for fastening animals to stakes or pegs driven into the ground. **1936** RIDINGS *Chisholm Trail* 371 Many of them carried a *cabestros* or hair-rope, and at night time, when they lay down on their blankets on the prairie, would lay the hair-rope on the ground, entirely encircling their beds.

* **cactus,** *n.* In combs.: (1) **cactus candy,** candy made by boiling the pulp of certain cacti with sugar; (2) **forest,** an extensive growth of arborescent cacti; (3) **mouse,** a white-footed mouse, *Peromyscus eremicus,* found in the Southwest; (4) **rat,** =prec.; (5) **woodpecker,** = Gila **woodpecker;** (6) **wren,** any one of various large wrens found in the Southwest.

(1) [**1858** VIELE *Following Drum* 186 Then came the dessert, dulcies of candied cactus and melons.] **1895** *Amer. Folk-Lore* Jan.–Apr. 51 This is the best kind of cactus candy. **1925** BRYAN *Papago Country* 47 The pulp of bisnaga is not bitter like that of sahuaro and is used in making the cactus candy, a famous Arizona product. — (2) **1910** *Cent. Mag.* March 763/1 A moment's walk . . . took me to the heart of the giant cactus forest. **1921** *Outing* May 68/2 These sites are . . . in the cactus forest on the Gold Roads route, six or eight miles south-west of Kingman, Arizona, and at Newberry Springs in the Mohave desert. — (3) **1939** *Mammalogy Jrnl.* 14 Nov. 443 On the plain, cactus-mouse burrows were grouped around the base of the mesquite. **1946** HALL *Mammals Nev.* 510 The cactus mouse . . . is a species of the Lower Sonoran Life-zone. — (4) **1904** BURDICK *Mystic Mid-Region* 63 A common creature in the portions of the desert with cacti is the cactus rat.

(5) **1914** *U.S. Nat. Museum Bul.* No. 50, 254 *Dryobates scalaris cactophilus* Oberholser. Cactus Woodpecker. **1940** JAEGER *Desert Wild Flowers* 22 The dried stems of this agave are used as nesting sites by the cactus woodpecker. — (6) **1869** *Amer. Naturalist* III. 183 The Rock Wren and Cactus Wren . . . chirrup loudly from the tiled roof or dense thickets. **1948** *Desert* Feb. 28/1 The cactus wrens were friendly and curious.

cakewalk 'kek͵wɔk, *n.*

1. Orig. a parade or walk-around, poss. first indulged in by Negroes, in which the reward for the fanciest steps was a cake. Now a walk in which those participating pay for the privilege of walking to music on a numbered floor, each one hoping that when the music stops he will be on a lucky number and thus receive a cake as a prize. Also at-trib.

1879 *Harper's Mag.* Oct. 799/1 Reader, didst ever attend a cake walk given by the colored folks? **1930** *Randolph Enterprise* (Elkins, W. Va.)

18 Dec. 1/1 After the supper a cake walk program was carried out. **1948** *Lisle* (Ill.) *Advertiser* 21 Oct. 5/1 A fortune teller, fish pond, cake walk, country store, spook house, and refreshment room—that's a list of the many things to happen on the night of November 5.

b. *transf.* and *fig.*

1863 in *Mont. Hist. Soc. Contrib.* III. (1900) In the center of the lodge there was a bush planted,—the medicine bush—and around and around that bush we went. At last their curiosity was satisfied. ... We had a good laugh over our cake walk. **1894** MARK TWAIN in *Critic* 7 July 8/1 This Shelley biography ... is a literary cake-walk. **1904** in *Birds of Amer.* (1917) I. 79 Speaking of the peculiar dance of the Albatrosses, Mr. Fisher says, 'The old birds have an innate objection to idleness, and so for their diversion they spend much time in a curious dance, or perhaps more appropriately a "cake-walk." ' **1948** *New Yorker* 25 Sep. 24/1 Among such old songs are ... 'Who Dar!' (a cakewalk).

2. A dance, sometimes as a stage performance, in which some of the steps and figures are adapted from the earlier form of cakewalk.

1895 *N.Y. Dramatic News* 19 Oct. 16/1 On Thursday, Friday and Saturday nights a cake walk will take place in conjunction with the regular performance, open to all comers.**1902** HARBEN *A. Daniel* 53, I was doing the cake-walk with that fat Howard girl. **1947** PAUL *Linden* 336 The members of the Wenepoykin Bicycle Club agreed to give a blackface minstrel show with an olio featuring a prize cake-walk after intermission.

calaboose ˈkæləˌbus, *n.* Chiefly *S.* [Sp. *calabozo*, dungeon.] A jail, a prison. Also attrib. Cf. **calabozo, village calaboose.**

1792 J. POPE *Tour S. & W.* 43 Their Fate will be confinement ... in the Callibouse at Mobille. **1866** *Eastern Slope* (Washoe, Nev.) 13 Oct. 1/6 Now he is a poor drunkard, and earns barely a ... living as a calaboose shyster. **1898** *Dly. Ardmoreite* (Ardmore, Okla.) 15 July 3/3 Workmen are busy erecting the calaboose for the city. **1948** *Chi. Tribune* 9 March 9/5 Once you turned me loose, Freed me from the calaboose.

calaboose ˈkæləˌbus, *v. tr.* To imprison. *Obs.* — **1840** *N.O. Picayune* 30 Oct. 2/3 He calaboosed him— ... Charley took him in. **1857** *Cin. Commercial* (B.), Col. Titus ... was calaboosed on Tuesday for shooting at the porter of the Planters' House.

calliope kəˈlaɪəpɪ, *n.* [f. Gr. *kalliopē*, the beautiful-voiced.]

1. A musical instrument consisting of a series of steam whistles operated from a keyboard. Cf. **musical steam engine.**

The spelling in quot. 1927 is indicative of the common pronunciation [ˈkælɪˌop.]

1858 J. COOK *Letters* (1946) 19 Sep. 45 On board the *Armenia* ... is a Calliope, or an instrument resembling an organ & played in connection with the engine. **1863** RUSSELL *Diary* I. 265 On the metal roof was a 'musical' instrument called a 'calliope,' played like a piano

by keys, which acted on levers and valves, admitting steam into metal cups, where it produced the requisite notes—high, resonant, and not unpleasing at a moderate distance. **1927** SANDBURG *Songbag* 349 The last wagon in the parade, [was[the steam 'kallyope.' **1948** *Newsweek* 30 Aug. 18/1 To the accompaniment of exploding fire-crackers and a calliope's groaning, [he] hailed Dewey.

2. calliope hummingbird, a hummingbird, *Stellula calliope,* of the western U.S. and Mexico.

1878 *U.S. Nat. Museum Proc.* I. 426 *Stellula calliope.*—Calliope Humming-bird.

cambric tea. [See quot. 1891.] A drink, esp. for children, consisting of weak tea to which milk and sugar have been added. Cf. **hot water tea.**

1888 *Union Signal* (Chicago) 21 Jan. 3 [She] offered me tea, cambric tea to be sure, but in a beautiful cup. **1891** *N. & Q.* VI. 174 Cambric Tea . . . is so called because it is thin, white and weak. **1903** BURNHAM *Jewel* 225 'Is there going to be some cambric tea for this baby?' inquired Dr. Ballard. **1944** *Greeley* (Colo.) *D. Tribune* 28 Sep. 6/4 Many children dearly love cambric tea, which is made by pouring about two tablespoons of weak tea into a cup of hot milk and adding a dash of sugar.

camp meeting.

1. An assemblage, usu. of Methodists, for holding in the woods or other retired spot a series of religious meetings. See also **general, Negro camp meeting.**

Meetings of this kind, often lasting for several weeks, arose in Kentucky in 1799, and were popular for nearly a century.

1803 L. Dow *Travels* Wks. 1806 II. 21 We went on to the camp-meeting which I had appointed last August. **1883** *Harper's Mag.* Aug. 483/2 A great camp-meeting had been going on for more than a week among the negroes. **1929** E. W. HOWE *Plain People* 6 In addition to his circuit riding, every summer father held camp meetings, where collected people from a large territory.

2. Used in combs., as **camp meeting district, ground, hymn, season, singing.**

1910 J. HART *Vigilante Girl* 121 Those chronic backsliders in the camp-meeting districts. — **1804** *Phila. Gazette* 28 Sep. 3/2, 38 Carts were counted on the camp-meeting ground on Sunday last. — **1863** B. TAYLOR *H. Thurston* 286 Melinda at once strode away, . . . muttering fragments of camp-meeting hymns. **1900** *Musical Courier* 30 May 20/2 A camp meeting hallelujay hymn . . . reeks of the forests of equatorial Africa. — **1882** *N.Y. Tribune* 7 Aug. 4/3 The camp-meeting season has set in with vigor so far as the crowds in attendance are concerned. — **1947** *Democrat* 17 July 8/2 Everyone shall enjoy these services, filled with camp meeting singing, and soul stirring messages.

campus 'kæmpəs, *n.* [L., field, theater of action, arena.]

1. The principal grounds of a university, college, or other school, the open space between or around the

buildings. See also **back, college, university campus.**

First used at Princeton and probably introduced by President Witherspoon. See A. Matthews in *Pub. Col. Soc. Mass.* III. 431–37.

1774 in J. F. HAGEMAN *Hist. Princeton* (1879) I. 102 Having made a fire in the Campus, we there burnt near a dozen pounds [of tea]. **1835** *Vade Mecum* (Phila.) 10 Jan. 3/3 'Between the hours of recitation,' says a pedagogue's circular, 'the pupils may recreate themselves on the *campus!*' **1898** *Mo. So. Dakotan* I. 6 He donated ten acres of valuable land for the university's site and campus. **1946** *Sat. Ev. Post* 3 Aug. 16/3 The place where he stopped was a corner from which the whole campus spread out before and below him.

b. A field for athletic sports. *Obs.*

Cf. *OED* †*Campo* in this sense.

1887 *Lippincott's Mag.* Sep. 453 The Campus, or play-ground, is several miles off. **1897** A. MATTHEWS in *Pub. Col. Soc. Mass.* III. 433 At twenty of these [colleges] . . . Campus is applied to an athletic field alone. **1902** CLAPIN 94 *Campus*, a student's word meaning the college grounds; also, the athletic field.

2. A place of action, a battleground. *Obs.*

1835 LONGSTREET *Ga. Scenes* 73 She brought her hands to the campus this time in fine style. **1840** *Cong. Globe* App. 17 Jan. 144/1 We are told that the Abolition battle must be fought at the North; that we must deal kindly here, to afford a campus for their chivalry at home.

canebrake ˈkenˌbrek, *n.* Also **-break.** *S.*

1. A thicket of canes, a region overgrown with canes. Also attrib. See also **Mississippi, prairie canebrake.**

1769 in *Amer. Sp.* XV. 162/1 As we ascended the brow of a small hill, a number of Indians rushed out of a thick cane brake. **1796** B. HAWKINS *Letters* 41 Here commence large swamps and between them and the river are some rich flat canebrake land. **1876** in GUILD *Old Times* (1878) 391 These cane-brake women always manage their husbands. **1946** *Chi. D. News* 24 June 16/2 Mob violence is no less reprehensible on a Northern picket line than it is in a Georgia cane-brake.

b. Designating the banded rattlesnake, *Crotalus horridus,* of the southern states. Cf. **Seminole, 1. b.**

1933 DITMARS *Reptiles of World* 260 This variety lives along the coastal region and is called the Cane-Brake Rattlesnake. **1944** *Sat. Ev. Post* 9 Sep. 13/2 Big diamond rattlesnakes as thick as a man's arm, and the bright-colored canebrake rattlers or 'Seminoles,' [are] as beautiful as they are deadly.

2. Used to name particular regions once noted for canebrakes, esp. that portion of Alabama of which Uniontown, Demopolis, and Faunsdale are the leading towns. Also attrib.

1850 in BOYD *Alabama* 129 (*title*), Canebrake Female Institute Catalogue, *1850.* *c***1850–8** O'NEALL-CHAPMAN *Annals* 51 The parts of Newberry first occupied and settled by the white man, were as follows: the Dutch Fork in 1745: . . . the Canebrake, on Enoree,

(Pennington's grant;) 1751, or possibly earlier. **1884** *True Democrat* 19 March 3/2 Canebrake roads are still very bad. *c***1898** CHRISTIAN *Days* 79 There were no Railroads in the Canebrake at that time.

cannery ˈkænərɪ, *n.* An establishment where meats. fruits, etc., are canned.

1870 *Dept. Agric. Rep. 1869* 600 Aside from the canneries about one hundred men are engaged in salmon fishing, . . . who have their own nets, [etc.]. **1883** R. RATHBUN in *U.S. Nat. Museum Bul. No. 27* 115 In 1880, there were twenty-three canneries in Maine, . . . giving employment to about 650 factory hands and 2,000 fishermen. **1948** *Green Bay* (Wis.) *Press-Gazette* 13 July 14/5 She said the Green Bay cannery was getting only 60 per cent of a normal yield.

✳ **canvasback,** *n.*

1. A wild duck or species of duck, *Nyroca valisineria,* so called from the color of the back. In full **canvasback duck.** Cf. **Washington canvasback.**

1782 JEFFERSON *Virginia* vi. 77 Besides these [birds], we have The . . . Widgeon, Sheldrach, or Canvas back. **1791** MACLAY *Deb. Senate* 282 Canvass back ducks, ham, and chickens, . . . all amazingly fine, were his constant themes. **1835** in M. B. SMITH *Forty Yrs. Washington Soc.* (1906) 359 After the soup, Ma'am, boil'd fish, and after the Fish, canvas-backs, the Bouilli to be removed. **1944** FOOTNER *Rivers of East. Shore* 155 The most highly prized is of course the canvasback; the most plentiful the black duck, no mean substitute.

b. canvasback grass, = **tape grass.**

1839 in AUDUBON *Ornith. Biog.* V. 137 The food they are most partial to, is the canvass-back grass (*Valisneria Americana*), . . . and shell-fish.

2. A sailing vessel as contrasted with a steamship. *Colloq.*

1930 CUTLER *Greyhounds* 137 A few barnacled old captains stuck to their guns, but on the whole the year started badly for the 'canvas backs.' **1938** ALBION *Square-Riggers* 256 They lured away from the sailing liners most of the transportation of passengers, of specie, and of some of the fine freight, but enough heavy freight was left to keep the 'canvasbacks' busy right down to the Civil War.

caramba kəˈrɑmbə, *interj. S.W.* [Sp.] An exclamation of vexation, admiration, etc.

1838 *N.Y. Mirror* 6 Jan. 217/2 *Carramba,* why do you speak thus. **1870** DUVAL *Big-Foot Wallace* 240 Carrambo! look at that fellow's teeth, will you! **1947** *Time* 20 Jan. 75/2 'Caramba,' he muttered.

Carborundum ˌkɑrbəˈrʌndəm, *n.* [*carbon*+*corundum.*] A trade-mark for certain abrasives, as silicon carbide. Also (not *cap.*) the product bearing this trade-mark. Also attrib.

1892 *Official Gazette U.S. Patents* LIX. 1914/1 [Trade-mark registered by] The Carborundum Company, Monongahela City, Pa. *Ib.,* Trade-marks registered June 21, 1892 [include] Carborundum. **1900** *Sci. Amer.* 16 June 378/1 The cross section of a carborundum furnace now presents a remarkable appearance. **1943** GEIST *Hiking* 149 A

carborundum sharpening stone is convenient on a long tour where your instruments may require sharpening.

carload 'kar͜lod, *n.*

1. A load for a railroad car. Also attrib., sometimes in the sense "brought in or sold by the carload."

1854 THOREAU *Walden* 130 This car-load of torn sails is more legible and interesting now than if they should be wrought into paper and printed books. **1879** *Bradstreet's* 17 Dec. 1/3 Packers are paying $4.35 to $4.50 for car-load hogs, and $4 to $4.35 for wagon hogs. **1884** *Rep. N.M. Terr.* 75 Other herds were slaughtered in the woods and the dressed meat shipped by car-load lots. **1945** *Tracks* June 56/1 Thus the section foreman who ordered a carload of cross-ties had his message rendered 'carload of lies.'

b. As a measure of quantity (see quots.).

1875 *Chi. Tribune* 16 Sep. 8/7 Nominally a car-load is 20,000 pounds. **1889** *Cent.* 826/1 Car-load, . . . a customary unit of measure in the United States, equal to 70 barrels of salt, 90 barrels of flour, 9,000 feet of boards, 340 bushels of wheat, 430 bushels of potatoes, etc. **1893** *Stand.* 287/2 [A] car-load . . . varies on different railroads . . . , and . . . also with different substances. **1948** *Capital-Democrat* (Tishomingo, Okla.) 17 June 1/6 Sufficient quantity of sawdust, shipped by the carload, and sodium fluosilicate can be ordered by next week.

2. *fig.* A large number or quantity. *Colloq.*

1867 *Ball Players' Chron.* 11 July 1/1 The large majority of these were visitors from the city, . . . the car loads which came up from Harlem, . . . contributing the greater portion. **1882** SWEET & KNOX *Texas Siftings* 16 It is estimated that one first-class conductor has more sense than a car-load of legislators. **1934** *Reader's Digest* August 103 Here I am with a smoker's throat and a hacking cough which the ads tell me there is not one in a carload of.

carpetbagger 'karpɪt͜bægɚ, *n.*

1. One of the poor northern adventurers who, carrying all their belongings in carpetbags, went south to profit from the social and political upheaval after the Civil War.

1868 ROSE *Great Country* 181 Many of them are what the Southerners call 'carpet-baggers,' men travelling with little luggage and less character, making political capital out of the present state of affairs. **1885** *Cent. Mag.* April 956/1 The carpet-baggers, who so largely assumed its command, despite some honorable exceptions, were for the most part unprincipled men. **1948** *Green Bay* (Wis.) *Press-Gazette* 30 June 20/3 It was an old law passed after the civil war to create unwonted voting power for carpetbaggers in Negro areas, where the white man was disenfranchised.

2. A term of contempt or humor applied to a stranger, foreigner, transient, etc.

1869 *Republican D. Jrnl.* (Lawrence, Kans.) 3 Nov., Fifty loaded teams between Burlington and Emporia [included] coaches heavily loaded with passengers, besides several *carpet-baggers* on foot. **1901** CHURCHILL *Crisis* II. xviii. 279 There's lots of those military carpet-baggers hanging around for good jobs. **1948** *Chi. Tribune* 3 April 1.

2/6 They have brought swarms of out-of-state orators and carpet-baggers to tell us in Wisconsin how to vote next Tuesday.

carreta kəˈretə, *n.* *W., S.W.* [Sp. in same sense.] A crude wagon or cart.

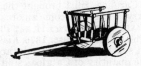

Carreta of the Southwest

1844 GREGG *Commerce of Prairies* I. 96 Large parties of New-Mexicans, some provided with mules and asses, others with *carretas* or truckle-carts and oxen, drive out into these prairies to procure a supply of buffalo beef. **1888** LINDLEY *Calif. of South* 83 There was a Mexican *carita*, drawn by two oxen. **1941** FERGUSSON *Southwest* 79 He carried with him, enshrined on her own carreta, an image of the Virgin, La Conquistadora, to whom he prayed for success.

carryall ˈkærɪˌɔl, *n.* [In sense **1.** from F. *carriole*, but in **2.** app. based on the verb * *carry*.]

1. Orig. a light one-horse vehicle, later used of a large, heavy carriage as well.

1714 J. STODDARD in *N.E. Hist. & Gen. Reg.* V. 27 Mr. Longuille sent a carryall to us, which carried us to Montreal. **1811** *Colonial Centinel* 5 June 3/1 For sale a Carryall, that is very convenient to carry five or six persons to their places of visitation. **1897** TERHUNE *Old Field* 170 Mr. Grigsby had come to the landing in a blue-bodied "carryall." A plank laid across the front served him for a seat. Two splint-bottomed chairs were set for the children, leaving room behind them for their trunks. **1945** F. ROWE *Chapin Sisters* 6 The stage . . . was little more than an elongated carry-all.

2. A bag or other receptacle for carrying a miscellaneous assortment of things. Also transf. and attrib.

1884 H. HABBERTON *My Friend Moses* 216 A haversack; could he find one of these carry-alls. **1912** *Nation* 27 June 641/3 There are frequent lapses due to over-hasty condensation which reduces the sentence to a disparate carry-all. **1945** *Chi. D. News* 12 Feb. 6 For youngsters who tote huge conglomerations of unrelated matter . . . there are some attractive little canvas carryall bags in navy blue.

cashier's check. (See quot. 1881.)

1867 *Comm. & Fin. Chron.* 29 June 807 Mr. Hulburd, it will be remembered, condemns in his letter the use of 'cashiers' cheques.' **1881** *Bradstreet's* III. 305 Cashiers' checks, or checks issued by the cashier or president upon the bank itself. **1948** *Capital-Democrat* (Tishomingo, Okla.) 10 June 4/4 A Certified or Cashier's Check in the amount of $1,700.00 shall be submitted with the proposal.

catalpa kəˈtælpə, *n.* ["W. R. Gerard says that catalpa is derived from *kutuhlpa*, signifying 'winged

head,' in reference to its flowers, in the Creek language"
(Hodge).] Any one of various trees of the genus *Catalpa*
belonging to the trumpet-creeper family. Also attrib. See
also **common, western catalpa.**

*c*1730 CATESBY *Carolina* I. 49 The Catalpa Tree . . . was unknown
to the inhabited parts of Carolina, till I brought the seeds from the
remoter parts of the country. . . . It is become an ornament to many
of their gardens. **1785** WASHINGTON *Diaries* II. 347 Planted . . . two
catalpas (large) West of the Garden House. **1876** *Field & Forest* II.
27 Can anybody living in southeast Illinois render account concern-
ing the above considerable quantity of Catalpas split for rails? **1945**
Prairie Farmer 8 Dec. 4/2 Hedge, Catalpa, red cedar, chestnut, and
black locust are most durable woods for fence posts.

b. catalpa worm, a worm found in the early summer
on the leaves of the catalpa and valued as fish bait.

1908 *D.N.* III, 297 catawba, n. 1. Catalpa. 2. The catalpa worm.
'We fished with *catawbas*.' (Cf. patalpa, D.N. ii, 324.) **1948** *Democrat*
4 Nov. 1/3 He opened its stomach and found inside two large catalpa
worms.

catlinite ˈkætlɪnˌaɪt, *n.* [George *Catlin* (1796–1872),
noted painter of, and writer about, Amer. Indians.] A
handsome claystone varying in color from pale grayish-
red to a dark red, obtained in southwest Minnesota and
formerly used by Indians for making pipes. Also attrib.

1841 in *Executive Doc. No. 237* 17 According to Professor Jackson,
of Boston, who has analysed it, and applied to it the name of cat-
linite, after Mr. Catlin, it is composed of [etc.]. **1857** DANA *Mineral-
ogy* 358 The Pipestone of the North American Indians was in part a
red claystone or compacted clay from the Coteau de Prairies. It has
been named *catlinite*. **1907** HODGE *Amer. Indians* I. 613 The Iowa
early manufactured and traded catlinite pipes. **1948** *Ill. State Arch.
Soc. Jrnl.* April 39 Note the Siouan Catlinite pipe at the Upper Left
Hand Corner of the Picture.

cattle range.

1. An unsettled or sparsely settled region over which
cattle graze. Used esp. of the prairie regions of the West.

1640 *Essex Inst. Coll.* V. 170/1 Ordered that none of the land within
the cattle range shall be granted . . . to any man. **1882** *Cent. Mag.*
Aug. 510/1 The ground between the buttes is fertile, and the whole
region is an excellent cattle-range. **1948** *Southwestern Rev.* Summer 272
They were in sheep country, but had passed across a forbidden cattle
range to get there.

2. (See quots.) *Obs.*

1835 HOFFMAN *Winter in West* II. 130 We entered at once upon a
large and beautiful park or chase.[*footnote*], Called 'a cattle-range,' if
I mistake not, in Kentucky. **1889** FARMER 129/1 Cattle-range. Parks,
even those attached to country-residences, are so called in Kentucky;
this State is famous for its pasture and grazing lands.

∗**catty,** *n.* =**catfish.** *Obs.* — **1836** *Franklin Repository* (Cham-
bersburg, Pa.) 4 Oct. 1/3 If you don't sashay as I said before I'll fetch

you up like a catty on a corn [*sic*] line—jerk? **1856** *Spirit of Times* 4 Oct. 71/2 When I fish for catties I want catties, and don't want nothin' else.

caucus ˈkɔkəs, *v. intr.* To meet or assemble as a caucus. Also **caucusing,** *n.*

1788 W. GORDON *History Independence U.S.* 365 The word *caucus,* and its derivative *caucussing* are often used in Boston. The latter answers much to what we stile parliamenteering or electioneering. **1848** *Rough & Ready* (Louisville) 1 Jan. 2/2 No caucusing—no wireworking—no bickering or strife will be visible. **1948** *Time* 14 June 15/2 Favorite-son backers who know they have no chance caucus endlessly, listening for the first rumble of a bandwagon.

b. Also, rarely, *tr.*

1893 *Dly. Ardmoreite* (Ardmore, Okla.) 12 Nov. 1/1 By the tariff revision talk now raging Culberson and Bland want the matter caucused.

Celluloid ˈsɛljəˌlɔɪd, *n.* Also **celluloid.** [f. *cellul*ose+ *-oid*, like.] A trade-mark for an artificial substance with a cellulose base used in place of ivory, coral, etc., in the manufacture of many small objects. Also attrib.

1871 *Amer. Dental Assn. Trans.* XI 152 We have many so-called cheap materials . . . : rubber, celluloid, pyroxyline, porcelain base, aluminum, and the alloys of tin. **1882** SWEET & KNOX *Texas Siftings* 9 He is usually swung to a satchel containing a comb and brush, . . . a clean celluloid collar, and a newspaper. **1903** *Sears Cat.* (ed. 113) 635/1 Celluloid Waterproof Collars for Men and Boys, 11 Cents. **1947** *Atlantic Mo.* Oct. 52/2 Celluloid . . . was discovered by John Wesley Hyatt as the accidental and undesired result of his effort to produce from wood pulp a substitute for ivory billiard balls.

b. *transf.* Used attrib. with reference to motion pictures.

1922 *Frontier* Nov. 18 As the celluloid hero flashed his impartial smile across the screen—it was the stolid Indian who stamped, whistled, and clapped, while the white man sat in half-bored silence. **1947** *Redbook* July 20/1 The difference between celluloid fame and oblivion is foot-upon-foot of motion-picture film lying discarded and forgotten in the cutting-room barrel.

* **certified,** *a.* In combs.: (1) **certified (public) accountant,** an accountant who holds a state certificate of competency in accounting, often abbreviated C.P.A.; (2) **check,** a bank check certified as valid by the bank upon which it is drawn, also transf.; (3) **copy,** a copy attested by the proper persons as being a correct reproduction of an original.

(1) **1913** *Indian Laws & Tr.* III. 565 To enable the Secretary of the Interior to employ a chartered and certified accountant, . . . $10,000. **1948** *Woman's Day* March 18/3 George is a certified public accountant. — (2) **1849** *Hunt's Merch. Mag.* XXI. 353 The system of certified or marked checks, does not prevail here [London]. **1906** O. HENRY *Four Million* 198 The bride is the certified cheque among the

wedding presents that the gods send in when man is married to mortality. **1948** *Chi. Tribune* 2 May 1. 6/4, I used to carry a couple of million in my pockets, in certified checks and cash. — (3) **1902** PIDGIN *Quincy A. S.* 301, I hold in my hand three documents. The first one is a certified copy of the war record of Wallace Stackpole.

chaps tʃæps, *n. pl. W.* Short for **chaparajos,** or **chaparreras.**

1844 W. SHEPHERD *Prairie Exper.* 41 The cow-boys, with their *schaps,* i.e. leather-leggings and flopping wide-brimmed hats, are trooping off. **1884** NYE *Baled Hay* 139 'Chaps,' as they are vulgarly called, . . . are made of leather with fronts of dog-skin with the hair on. . . . The seat of the garment has been postponed *sine die.* **1948** *Time* 26 Jan. 20/2 In the summer, he donned chaps and a big hat, and tooted his brass on horseback with traveling Wild West shows.

charge account. A credit account at a store. — **1909** O. HENRY *Options* (1916) 96 I've got more power here than . . . a charge of dynamite, and a charge account at Tiffany's combined. **1948** *Dly. Oklahoman* (Okla. City) 28 Dec. 8/1 Stores are seeking new charge accounts . . . because the charge customer will buy more at a time, but less often, which is an advantage to the retailer.

*** checking, *n.***

1. The consigning of baggage in return for a check. Cf. **check,** *v.*[2] 2.

1870 W. F. RAE *Westward by Rail* 77 Excited passengers are rushing about in quest of the luggage which, despite the system of 'checking,' is often going astray or getting out of sight. **1886** B. P. POORE *Reminisc.* I. 41 Baggage checks and the checking of baggage were then unknown.

2. a. checking account, a bank account against which checks may be drawn. **b. * checking room,** = **check room.**

(a) **1926** *Springfield W. Republican* 19 Aug. 10 She preferred the more generous way, and they had a joint checking account. **1948** *So. Bend* (Ind.) *Tribune* 15 Aug. 1. 4/2 An additional $800,000 cash was in her personal checking account. — (b) **1910** *N.Y. Ev. Post* 13 Dec. 7 Mr. Spottford arrived at the station carrying a small grip, and asked Charles where the checking-room was.

cheer leader. One who leads the cheering, esp. at college athletic events.

1909 *Dly. Maroon* (Chi.) 2 Oct. 4/3 The cheer leaders for the year will take the student body in hand and will give it the first training of the year in yelling and singing. **1918** *Chi. Herald-Examiner* 2 Oct. 11/3 (*heading*), Cheer Leaders. **1946** *Life* 18 Nov. 114/2 Cheerleader Aldreda Young, 16, calls for a 'Hey, gang, are we gonna win!' during football game with Shaw college.

Cherokee strip.

1. A strip of land about three miles wide along the northern boundary of the Cherokee outlet but included in

what is now the state of Kansas. Also, by confusion, the Cherokee outlet *q.v.*

1869 *Cong. Globe* 8 Dec. 29/2 Settlers on certain lands within the State of Kansas known as the 'Cherokee Strip.' **1936** BARNARD *Rider* 131 The distinction between the Cherokee Strip and the Cherokee Outlet having now been pointed out, the lands heretofore designated as the Cherokee Outlet will be called the Cherokee Strip. **1944** *U. of C. Mag.* May 4 Her father rode a race horse at the opening of the Cherokee Strip from the Kansas border to near the present town of Perry, which he later laid out as a park-studded community.

attrib. **1930** FERBER *Cimarron* 222 After all, a hundred other men in Osage were going to make the Cherokee Strip Run. **1945** M. JAMES *Cherokee Strip* 24 Dick Yeager was any Cherokee Strip youngster's ideal of what an outlaw should be and do.

2. In the House Chamber at Washington, that portion of the rear of the Republican (or Democratic) side of the chamber occupied by members of the opposite party when such a seating arrangement is made necessary by a preponderance of members of one of the two parties.

1905 *Baltimore American* 7 March 4 On the boundary of what is known as the 'Cherokee Strip,' or, in other words, the section on the Democratic side occupied by Republican Senators who cannot find desks on the Republican side. **1919** *Speech of J. L. Slayden in House of Representatives* 15 Jan. 7, I sat in the 'Cherokee strip,' now abolished.

* **chest,** *n.*

1. chest protector, a padded or inflated protective piece of equipment worn on the front of the body by a baseball catcher or plate umpire.

1889 *Cin. Comm. Gazette* 17 March 7/2 [When] he sprained the bosom of his pants . . . it was worth a gold medal to see Jim shift his chest protector around to his rear. **1948** *This Week Mag.* 1 May 14/2 [He] rubbed his chest protector and glanced up.

2. chest-(up)on-chest, an article of furniture so made as to resemble two chests of drawers placed one upon the other.

1819 NOAH *She would be a Soldier* I. i, I had put my house in such nice order—painted my walls—got a new chest upon chest. **1930** *Old Time N. Eng.* Oct. 87/1 An even richer chest-on-chest in the same style is privately owned.

chickadee 'tʃɪkə͵di, *n.* [Imitative.] Any one of various titmice, esp. the black-capped titmouse.

1839 AUDUBON *Synopsis* 79 *Parus atracapillus*, . . . Black-cap Tit. —Black-cap Titmouse, or Chicadee. . . . Never [seen] in the southern parts. **1904** WALLER *Wood-Carver* 73 The chicadees are fairly singing somersaults over one another. **1948** *Reader's Digest* March 148/1, I would busy myself about the cabin, feeding the chickadees that came to the tray on the windowsill.

transf. **1860** HOLLAND *Miss Gilbert* 62 When a feller gets tied to a wife and has a lot of little chickadees around him. **1889** K. MUNROE

Golden Days xxv. 272 Ain't he just a chick-a-dee-dee with the cheek of a government mule!

Chihuahua tʃɪˈwɑwɑ, *n.* [Amer. Sp. in sense 1. Cf. *Chihuahua*, a state and city in Mexico.]

1. A small dog native in Mexico believed to antedate Aztec civilization in that region.

1858 VIELE *Following Drum* 185 The Chihuahua are rare, even here in such close vicinity to Mexico. **1948** *Dly. Ardmoreite* (Ardmore, Okla.) 1 June 7/7 Here's the new claimant to the world's smallest-dog crown. This chihuahua from McAllen, Texas, weighs one and three-quarter ounces, and likes to take naps on a lemon.

2. (See quots.)

1889 H. H. McCONNELL *Five Yrs. a Cavalryman* 187 The 'Chihuahua' wagon is much like the old 'Conestoga' wagon . . . of the East. **1925** J. B. GILLETT *Six Yrs. with Texas Rangers* 89 At that time each frontier post had its chihuahua or scab town, a little settlement with gambling halls, saloons, etc., to catch the soldiers' dollars. **1939** ROLLINS *Gone Haywire* 110 Th' hombres that skedaddled jus' now musta bin sheepherders, for two o' 'em was wearin' only one spur, an' the rowels was Chihuahuas. . . . What do I mean by Chihuahuas? Why, big rowels like th' Mexicans mostly uses.

chili colorado. *S.W.*

1. Red or cayenne pepper, or the pod yielding this.

1844 KENDALL *Santa Fe Exped.* II. 160 Seated upon the ground, a female might be seen with a few chiles colorados, or red peppers, for sale. **1884** HILL *Colo. Pioneers* 283 The scarlet ribbons in her dark hair rivaled in brilliancy the wreathes of 'chili-colorado' that festoon the walls of a Mexican plaza in the Indian summer time. **1910** O. HENRY *Strictly Business* 25 There [= El Refugio] only will you find a fish . . . baked after the Spanish method. . . . Chili colorado bestows upon it zest, originality and fervour.

2. A dish seasoned with chili, as chile con carne *q.v.*

1869 BROWNE *Adv. Apache Country* 78 We had Chili colorado and onions and eggs, and wound up with preserves and a peach-cobbler. **1888** J. J. WEBB *Memoirs* 19 Our bill of fare was the usual dishes of Chili Colorado, beans, atole, tortillas, &c. Americanized by the addition of bacon, ham, coffee, and bread.

chipmunk ˈtʃɪpmʌŋk, *n.* [f. Algonquian. Cf. Chippewa *atchitamon*, "head first," from the way the animal descends trees.] Any one of various small, striped, squirrel-like rodents of the family Sciuridae.

1832 TRAILL *Backwoods* 86 The shrill whistling cry of the little striped squirrel, called by the natives 'chitmunk.' **1857** *Rep. Comm. Patents: Agric.* 71 The chipmuck exists throughout the Eastern, Middle, as well as in some of the Western States, and as far north as latitude fifty degrees in the British Possessions. **1948** *Sierra Club Bul.* Mar. 11 Who has not paused at a turn in the trail . . . to watch a nervous chipmunk jerking its tail as it chatters on a stump?

chiropractic ˌkaɪrəˈpræktɪk, *n.* [See note.] A drugless curative system based upon the manual adjustment

of the joints, esp. those of the spine. Also attrib. or as adj.
"The name chiropractic was suggested for the new science by
the Rev. Samuel H. Weed of Bloomington, Ill., an early patient. The
name (Greek *cheir*, hand, and *praktikos*, efficient) was freely trans-
lated by Palmer as 'done by hand' " (*Dict. Amer. Biog.* XIV. 177/1).
 1898 *Stone's Davenport* (Iowa) *City Directory* 384 Dr. Palmer
Chiropractic School & Cure, Daniel D. Palmer propr. **1908** *U.S. Cong.*
April 6 A bill to regulate the practice of chiropractic, to license
chiropractic physicians, [etc.]. **1947** *Denver Post* 2 Mar. c. 3/3 The
other (amendment) was a 'chiropractic' amendment which would
have given the chiropractors about the same status as medical doc-
tors.

Chisholm Trail. The most famous of the western
cattle trails, leading from San Antonio, Tex., to Abilene,
Kans., so named for Jesse Chisholm (*c*1806–68), a cele-
brated scout and plainsman.
 1874 *Forest & Stream* 15 Jan. 359/2 In 1872 there were four hundred
and fifty thousand cattle driven . . . up the famous 'Chisholm trail.'
1926 COOPER *Oklahoma* 18 Long-horned cattle still raised the dust of
the Chisholm Trail on their tedious journey from Texas to the
shipping points of Kansas. **1948** *Dly. Oklahoman* (Okla. City) 16 May
E. 3/2 Many freight-hauling and cattle-driving trails were blazed and
used until the middle 80's, these including the Chisholm trail, the
Jones and Plummer trail, . . . and others.

 choosy 'tʃuzɪ, *a.* Particular, fussy. *Colloq.* — **1862** *Harper's
Mag.* Dec. 100/2 But so I'm sure enough thar at last, I'm noways
choosy about the road. **1948** *Chi. Tribune* 11 July (Grafic Mag.) 18/1
Gerold Gray was choosy about his rooming houses.

 chop suey 'tʃap'suɪ, *n.* [Chinese *tsa-sui*, odds and
ends.] A food first served in Chinese restaurants, consist-
ing of a mélange of various ingredients, particularly bean
sprouts, vegetables, chipped or sliced meat, and flavored
with sesame or peanut oil, or with soy sauce.
 1928 ASBURY *Gangs of N.Y.* 301 The tongs are as American as chop
suey—the latter is said to have been invented by an American dish-
washer in a San Francisco restaurant, while the first tong was organ-
ized in the Western gold fields about 1860. **1947** *Democrat* 7 Aug. 8/1
Chop suey, unknown in China, was originated in New York City by
an American chef. The word chop suey in Chinese means 'hash.'
 attrib. **1903** G. ADE *People You Know* 16 The next Picture that
came out of the Fog was a Chop Suey Restaurant and everybody
breaking Dishes. **1936** MCKENNA *Black Range* 220 Every time I went
into a chop suey joint in the Southwest, the owner would give me the
glad hand.

 chowder 'tʃaʊdɚ, *n.* [F. *chaudière*.]
 1. A stew or thick soup composed of game, fish, or
clams, together with salt pork, onions, potatoes, crackers,
milk, etc. Cf. **clam chowder.**
 1751 *Boston Ev. Post* 23 Sep. 2/1 Directions for making a chouder.
1868 ROSE *Great Country* 247, I found out, on enquiry, that it was one

of the excursions that are made daily, during the summer, from Providence to Rocky Point, one of the attractions being 'clams' and 'chowder.' **1945** COLCORD *Sea Lang.* 53 Chowder is made with milk in Maine and Massachusetts, with water and added tomatoes in Rhode Island and further south.

transf. **1870** *Cong. Globe* 22 Dec. 281/2 This [amnesty] bill may be called a 'chowder' of rare and varied ingredients. **1918** in *Liberty* 11 Aug. (1928) 8/2 Battery D found the straw pile first, and that led to a tired cat and dog fight. We won, and retired in a variety of straw chowder.

b. *By chowder!* a mild imprecation. *Colloq.*

1827 *Nat. Gazette* (Phila.) 13 Oct. 4/1 Once in our Bay, I vum by chowder The Tea was made of good Gunpowder.

c. *To run a chowder mill*, (see quot.). *Colloq.*

1874 *Atlantic Mo.* Sep. 309/2 All keeping beach hotels, . . . with the collateral occupation of 'running a chowder mill,' as the phrase goes here [at Coney Island].

2. A social gathering at which those present partake of chowder, in full **chowder party.**

1826 FLINT *Recoll.* 354 We had public chowder-parties, where sixty people sat down under grape-vine arbours, to other good things beside fish. **1848** BARTLETT 82 Nearly 10,000 persons assembled [at a political mass-meeting] in Rhode Island, for whom a clambake and chowder were prepared. **1906** *N.Y. Ev. Post* 6 Nov. 8 The Bowery . . . went about the business . . . with as much good nature as if it were 'Big Tim's' annual 'chowder.'

* **Christian Science.** A religion and system of healing, founded by Mary Baker Eddy in 1866, based upon the teaching that all cause and effect is mental and that a full understanding of Jesus' healing and teaching will result in abolishing sin, sickness, and death. Also attrib.

*c*1867 EDDY *Science of Man* (MS) 10 Jehovah cannot be understood so as to demonstrate Christian Science when interpreted through a belief or doctrine. **1895** *Outlook* 19 Jan., A great Christian Science church was dedicated in Boston on Sunday, the 6th inst. **1914** *N. Eng. Mag.* April 59/1 Perhaps the most prominent factor in promoting the growth of Christian Science is the healing work accomplished by the Christian Science practitioner. **1947** *Chr. Sci. Mon.* 1 Mar. 3/4 He withdrew from private business in 1929 to become a Christian Science practitioner in Chicago.

Christmas tree. A small evergreen, usu. a spruce or fir, set up at Christmas and ornamented with lights, tinsel, etc., and bearing Christmas gifts or presents.

The 1855 quot. below refers to the practice in Germany. The custom may have been introduced here by Germans. See "Our First Christmas Tree" in *Reader's Digest* Dec. 1944, 31–34.

1838 H. MARTINEAU *Retrospect of Western Travel* II. 178, I was present at the introduction into the new country of the spectacle of the German Christmas-tree. **1855** *Rural New Yorker* 49/1 The last thing attended to is the selection and adornment of the Christmas

tree. **1856** *S.F. Call* 25 Dec. 2/1 Who can think . . . of the anxious children gathered round the Christmas tree—the fabulous visits of Santa Claus . . . without feeling that man has other ends than those that characterize every day life? **1864** *Alta California* (S.F.) 7 Feb. 1/7 [In Philadelphia,] as in California, the stocking-hanging system has exploded in favor of the Christmas tree, and the churches were lighted and brightened by green boughs and young faces, awaiting for the kindly remembrances of older and richer people. **1948** *Reader's Digest* March 153/1 We cut a Christmas tree and decorated it with pieces of red string and rabbits' fur tassels.

transf. **1947** *Time* 27 Jan. 76/1 In oil fields . . . a 'Christmas Tree' means a series of pipes, valves and fittings. It is mounted on top of a well and meters the flow of oil.

chuck-will's-widow. [Imitative.] The largest of the American goatsuckers, *Antrostomus carolinensis,* found in the eastern states.

1791 BARTRAM *Travels* 154 *Caprimulgus rufus* called chuck-will's widow, from a fancied resemblance of his note to these words. **1871** *Harper's Mag.* July 188 At one time there were several species of hawks, a flock of butcher-birds, whip-poor-wills, chuck-will's-widows, and a host of smaller birds. **1945** MATHEWS *Talking* 52 The first notes of the chuck-will's-widow come plaintively from the east ridge as the moon rises.

cienaga ˈsɪnɪgə, *n. S.W.* [Sp. *ciénaga,* marsh, swamp.] A small marshy or miry area, often less than an acre in extent, generally located on sloping ground where a spring issues from a mountainside or where there are seepages.

1846 ABERT *Exam. N.M.* 45 After a short march we reach 'Cienaga,' a very well watered place, as its name denotes. **1866** MELINE *Two Thousand Miles on Horseback* (1867) 58 You hear, too, of *chenegays* (one or more springs together; a corruption of the Spanish *cien aguas*—one hundred fountains). **1888** LINDLEY *Calif. of South* 236 The waters emerge from the side of low lime-hills, and, filtering through the earth, form a sort of limited *cienaga* or marsh. **1939** *Jrnl. Mammalogy* 14 Nov. 434 The largest area was the San Simon Cienega, located on the Arizona-New Mexico State line in the middle of the valley.

cigar store.
1. A shop that specializes in the sale of cigars and smoking accessories.

1848 E. JUDSON *Mysteries N.Y.* II. 23 Are you going back to that hateful cigar store? **1948** *Chi. D. News* 17 Nov. 26/1 The retailer and the buyer in the cigar store, however, are operating in a 'free economy.'

2. cigar-store Indian, an Indian figure, usu. carved of wood, often used as a sign before a tobacco shop. Cf. **wooden Indian.**

1937 MITCHELL *Horse & Buggy Age* 32, I concluded that it must have been given to a cigar store Indian in search of a mount. **1948** *Ill. State Arch. Soc. Jrnl.* April 37/1 The old type of Cigar Store Wooden Indian is rapidly vanishing from the American scene! **1949** *This Week*

Mag. 9 Jan. 4/4 A cigar-store Indian was chosen justice of the peace in Allentown, N.J., some years ago.

⁂ **cinnamon,** *n.*

1. Short for **cinnamon bear.**

1855 MARRYAT *Mts. & Molehills* 253 The cinnamon's weight was quoted at 400 lbs. **1892** LUMMIS *Tramp Across Continent* 59 A cinnamon dies hard; and before the hunter could reload . . . the brute was upon him. **1946** R. PEATTIE *Pac. Coast Ranges* 82 Some of the bears formerly called cinnamons were undoubtedly grizzlies.

2. In combs.: (1) **cinnamon bear,** a dark-brown variety of the black bear (see also quot. 1946 in **1.** above, and cf. **cinnamon grizzly**); (2) **fern,** a large fern, *Osmunda cinnamomea,* so called from the color of its fronds, also **cinnamon-colored fern;** (3) **grizzly,** a grizzly bear; (4) **honeysuckle,** an azalea, *Azalea viscosa,* found in swamps in the eastern states; (5) **teal,** the red-breasted teal, *Querquedula cyanoptera,* found in the western U.S.

(1) **1829** J. RICHARDSON *Fauna Bor. Amer.* I. 15 The Cinnamon Bear of the Fur Traders is considered by the Indians to be an accidental variety of this species (*Ursus americanus*). **1945** MATHEWS *Talking* 164 This great cinnamon bear had taken his sheep. — (2) **1847** WOOD *Botany* 634 Cinnamon-colored Fern. . . . This is among the largest of our ferns, growing in swamps and low grounds. **1917** BAILEY *Sand Dunes Indiana* 156 The brakes and cinnamon ferns are hip high. — (3) **1872** *Harper's Mag.* LXVI. 20 The sportsman looks to his rifle as he sees the monstrous tracks of the cinnamon grizzly. — (4) **1894** *Amer. Folk-Lore* VII. 93 *Rhododendron viscosum* . . . Gray, cinnamon honeysuckle, West Va. **1901** MOHR *Plant Life Ala.* 653 *Azalea viscosa glauca.* . . . Cinnamon Honeysuckle. . . . Mountain region. Rocky banks of brooks. — (5) **1891** *Cent.* 6206/1 Cinnamon teal, *Querquedula cyanoptera,* of western North America . . . , [is] so called from the color of the under parts of the adult male. **1948** *Green Bay* (Wis.) *Press-Gazette* 12 July 22/7 Improvements [were] noted among mallards, gadwalls, shovellers, cinnamon teal and Canada geese.

citified ˈsɪtɪˌfaɪd, *a.* Accustomed to or suggestive of the city. *Colloq.*

1828 *Yankee and Boston Lit. Gazette* 16 July I. 227 There is a deal more comfort in playing with a country lass . . . than with a cityfied girl. **1902** HARBEN *Abner Daniel* 254, I reckon you've got too citified for us. **1945** *La Junta* (Colo.) *Tribune-Democrat* 14 Feb. 2/1 Roger Lewis and Frankie O'Connor found the escalators great fun in Denver when they went up there for the stock show and it bothered them not a bit when a citified dame gave them the cool once over and said . . . 'hicks.'

citrange ˈsɪtrɪndʒ, *n.* [f. *ci*trus *tri*foliata or*ange.*] A hybrid citrus plant or its fruit produced by crossing the common sweet orange with the trifoliolate orange.

1904 H. J. WEBBER in *Yearbk. U.S. Dept. Agric.* 227 The Citrange, a new group of Citrus plants. . . . It . . . becomes necessary to refer

these hybrids to a new group of citrus fruits, and it is proposed to call them 'citranges.' **1928** BAILEY *Cyclo. Horticulture* 778/2 The citranges are very cold-resistant if in a dormant condition, being able to stand temperatures as low as 15° or even 10° F. without injury. **1948** *Calif. Citrograph* May 299/2 Tangelo, citrange, and many others have not yet been proved . . . as a first-class citrus rootstock.

civil rights.

1. The rights for all citizens, esp. Negroes, contemplated in the 13th and 14th Amendments to the Constitution. Also attrib.

1874 FLEMING *Hist.Reconstruction* II. 201 The mere mention of civil (negro) Rights has almost destroyed the public schools and colleges in some of the Southern States. **1875** *Statutes at Large* XVIII. 335 An Act to protect all citizens in their civil and legal rights. **1948** *Time* 17 May 25/2 Thirteen were pledged to bolt the convention if a civil-rights plank were adopted.

2. civil rights bill, any one of various bills passed by Congress in 1866, 1870, and 1875, in an effort to secure equal rights for all citizens.

1866 A. JOHNSON in Fleming *Hist. Reconstruction* I. 225 The Civil Rights bill was more enormous than the other. **1867** in *Ib.* II. 15 Who gave us the Civil Rights Bill? **1875** *43d Congress* 2 Sess. H. R. Rep. No. 262, 1262 The thieving crew known as carpet-baggers . . . regardless of the . . . consequences to ensue from the passage of said odious civil-rights bill. **1876** *Pacific Appeal* (S.F.) 9 Sep. 2/1 The party passed the defective Civil Rights Bill.

clamming ˈklæmɪŋ, *n.* The gathering of clams. Also attrib.

1675 *Wyllys Papers* 217 A party of Ninecrafts men sent out in Canooes to keepe ye enemy from fishing & claming. **1774** *Huntington Rec.* II. 526, I will Not Hinder any Person whatsoever from fishing oystering claming or gunning anywhere in the mill pond. **1894** *Youth's Companion* 22 Nov. 562/3 The bulk of the eeling and quahaug clamming as well as the lobstering was done in its vicinity. **1947** *Denver Post* 2 Mar. A. 8/2 It is causing serious damage to the clamming industry, while clam diggers can't even resort to a little duck hunting on the side.

clapper rail. A large rail, *Rallus longirostris crepitans*, found in salt marshes along the Atlantic Coast—prob. so named from its note.

1813 WILSON *Ornithology* VII. 112 The Clapper Rail, or, as it is generally called, the Mud Hen, soon announces its arrival in the salt marshes, by its loud, harsh and incessant cackling. **1870** *Amer. Naturalist* III. 48 Off the coast of Cape Charles, Va., I found the nest of the Clapper-rail . . . built in a bush. **1947** *Sports Afield* Dec. 20/2 The principal game bird of the marshes is the clapper rail.

classmate ˈklæsˌmet, *n.* A student who is in the same class with another. Cf. **college classmate.**

1713 SEWALL *Diary* 5 June, He had spoken for my Classmate Capt. Saml Phipps to the Gov[erno]r. **1895** WILLIAMS *Princeton Stories* 81,

I thought I was coming to my own room—. . . I mean my classmate's room. **1948** *Chi. Tribune* 26 June 11. 1/2 Memories That Linger. . . . Class mates assembled for the last time on commencement day.

clean-up ˈklinˌʌp, *n.*

1. *W.* In mining, the process of periodically separating the valuable mineral from the gravel and rock which have collected in the sluices or at the stamping mill.

1866 *Cong. Globe* 18 June 3231/1 When what they technically call in mining the clean-up comes, very often the clean-up exhibits the lofty sum of nothing, while thousands have been expended in the effort. **1876** BOURKE *Journal* 8 Sep. 22 In speaking of the 'clean-up,' the Deadwooders always said so many 'pounds,' in other 'diggings,' the word 'ounces' is used. **1936** *Colo. Mag.* July 139 One hundred and twenty-five pounds of quicksilver was required for the cleanup, which usually netted about 50 pounds of coarse, 'shot' gold.

2. An exceptional financial success; a big "haul." *Colloq.*

1878 HART *Sazerac Lying Club* 21 (We.), At the same time make a nice little clean-up for himself. **1907** WHITE *Arizona Nights* 181 He and Simpson had made a pretty good clean-up, just enough to make them want to get rich. **1928** *Sat. Ev. Post* 4 Feb. 121/3 This development project ought to be a clean-up for us.

* **clearing,** *n.*

1. A piece of forest land cleared of trees for cultivation.

1678 in *Amer. Sp.* XV. 165/1 A bottom on ye lower side of the clearing of John Rabon. **1724** *Ib.,* At the Mouth of a Small Branch below his Clearing. **1812** MELISH *Travels* II. 282 A little beyond Grand river we came to a *clearing,* and looking into it, saw a handsome house about 500 yards distant. **1947** *Chr. Sci. Mon.* 1 Mar. III. 7/3 On up past an abandoned farmhouse in its small clearing.

b. (See quot. 1929.)

1859 TALIAFERRO *Fisher's R.* 218 Nor could a man clear a piece of ground without inviting his neighbors, and having a 'clearin'.' **1929** *Amer. Sp.* V. 17 clarin', n. A social gathering, the real purpose of which is to clear the host's land of timber and underbrush. People bring axes and saws and work hard all day, while the owner's part is to provide good food, and perhaps some whiskey for the frolic in the evening. [Ozark Mts.]

2. *W.* A clean-up, *q.v.*, in mining. *Obs.*

1851 KINGSLEY *Diary* 168 We kept the machine running on the top dirt in the last clearing and got 13 ounces 11 dollars in amalgam. *Ib.* 172 This begins to pay as we anticipated the whole clearing would.

3. clearing sale, a sale for disposing of merchandise preparatory to getting in a new stock.

1891 *Memphis Appeal-Avalanche* 26 April 3/1 We begin tomorrow (Monday), the most extraordinary clearing sales of silks ever offered. **1899** *Chi. D. News* 30 May 5/3 Clearing Sale Jackets and Suits.

* **clipping,** *n.*

1. An item cut out from a newspaper or magazine. Cf. **newspaper clipping.**

1865 *Lafayette* (Ind.) *D. Courier* 27 Sep. 2/2 We give below a few clippings from our exchanges concerning the condition of the crops in the various localities. **1948** *Carpenter* May 16 A Philadelphia correspondent sent us the following clipping from the help-wanted columns of the Inquirer.

2. clipping bureau, an organization that supplies to customers clippings from newspapers and magazines. Cf. **press clipping bureau.**

1910 *Sat. Ev. Post* 30 July 6/2 The latter has been posted on Antioch affairs by the girl who runs the clipping bureau. **1948** *This Week Mag.* 14 Aug. 18/3 One of America's oldest clipping bureaus, Allen's in San Francisco, was founded by Will Clemens in 1888. Helping him get a start was his cousin Sam, who did some writing—under the name of Mark Twain.

clothing store. A store in which clothing is sold.

1829 *Va. Herald* (Fredericksburg) 28 Feb. 3/1 He was then keeping a Clothing Store in Cincinnati, Ohio. **1865** *Atlantic Mo.* XV. 616 The clothing-store . . . paying so little that every tailor's working woman seeks . . . opportunity of changing her employment. **1945** *Jefferson Co. Republican* (Golden, Colo.) 26 Dec. 1/2 He worked for the Hudson's Men's Clothing Store for nine more years.

attrib. **1869** MARK TWAIN *Innocents* xxvi. 278 The clothing-store merchant wished to consume the corner-grocery man with the envy. **1940** MENCKEN *Happy Days* 101 They made no more impression upon him than if they had addressed a clothing-store dummy.

clubbing ˈklʌbɪŋ, *n.* Subscription to a periodical by each of a group of people, or to a group of magazines by a single subscriber, at a reduced rate. Also attrib.

1856 DERBY *Phoenixiana* 123 Inducements For Clubbing. Twenty copies furnished for one year, for fifty cents. **1880** *Boston Journal Chem.* (*O.E.D.*), The clubbing price of any American or foreign periodical not on the list will be furnished on application. **1907** *Pearson's Mag.* Jan. (Contents-page), The face value of a subscription bill may be applied to any combination or clubbing offer advertised.

coal road. A railroad engaged chiefly in transporting coal. Also a railroad on which coal-burning locomotives are used.

1887 *Courier-Journal* 8 Jan. 4/1 In the last sixteen years the combination coal roads have sustained the rate of transportation at 1¾ cents per ton per mile. **1903** *Cin. Enquirer* 2 Jan. 1/4 If the coal roads would compel all independent mining companies to live up to their contracts and would take more than half their output to be sold at $5 a ton at tidewater, I have no doubt prices would be lower. **1947** *Time* 29 Dec. 56/2 Though diesels comprise only 10% of all locomotives, they have already begun to invade coal roads like the Pennsylvania.

∗ **coconut,** *n.* Also ∗ **cocoanut.**

1. A variety of squash, in full **coconut squash.** *Obs.*

1834 *Amer. R.R. Jrnl.* III. 152/2 The cocoanut squash . . . is found to be fully equal to them. **1857–8** *Ill. Agric. Soc. Trans.* III. 509 The Lima cocoanut, long and blue, is [an] excellent [variety of squash].

2. *attrib.* Designating **cake, candy, pudding,** of which coconut is an ingredient.

1828 E. LESLIE *Receipts* 17 Cocoa-nut Pudding. **1830** *York* (Pa.) *Gazette* 6 July 1/3 He has just received a complete and general assortment . . . consisting of . . . Mint Drops, Cocoanut Cake, and Lady Fancy's, &c. **1877** *Harper's Mag.* April 693/1 He didn't get me any cocoa-nut candy. **1891** CHASE & CLOW *Industry* II. 145 There were tiers of cocoanut cakes, some baked to a delicate brown.

coeducation ˌkoɛdʒəˈkeʃən, *n.* The education of male and female students jointly at one institution.

1852 *Pa. School Journal* Jan. I. 9 Co-education of the sexes. The instruction of males and females in the same room and in the same class, is supposed by many to be an evil; and, as such, it is avoided in large towns, by the separation of the sexes into different schools. **1870** MACRAE *Americans* II. 395 The effect of co-education on the female students is not so easily determined. **1947** *Democrat* 6 Nov. 4/4 Auburn was the first institution in the state [i.e., Alabama] to provide for co-education and the second in the entire South.

cohonk kəˈhɔŋk, *n.* [Imitative.] The Indian name for the Canada goose, *Branta canadensis.* Also as a measure of time. *Obs.*

*c*1655 FORCE *Tracts* III. No. 10, 28 It [the sun] is all the clock they have for the day, as the coming and going of the *Carbunks* (the geese) is their almanack or prognostick for the winter and summer seasons. **1705** BEVERLEY *Virginia* III. 43 They reckon the Years by the Winters, or *Cohonks,* as they call them; which is a Name taken from the Note of the Wild Geese. **1728** W. BYRD *Writings* (1901) 146 The Indians call these Fowl Cohunks, from the hoarse Note it has, and begin their year from the Coming of the Cohunks, which happens in the Beginning of October. **1841** *S. Lit. Messenger* VII. 219/1 Cohonk. . . . Indian term for Winter.

coleslaw ˈkolslɔ, *n.* [Du. *kool sla,* cabbage salad.] A salad of sliced or shredded cabbage.

1794 *Mass. Spy* 12 Nov. 4/2 A piece of sliced cabbage, by Dutchmen ycleped cold slaw. **1867** DE VOE *Market Ass't* 325 There is also the 'early dutch,' 'flat dutch,' which the Dutch commonly slice and call it kohl-slaw, or salat, meaning simply cabbage salad; but the progress here has corrupted it to be cole or cold slaw. **1941** *Yankee* Dec. 19/2 The tables were set with bowls of pickles and salad and coleslaw.

Columbus Day. Oct. 12th, observed as a holiday in most of the states to commemorate the discovery of America by Columbus in 1492.

[**1892** *Lit. Digest* V. 668/2 This complete and fervid American sentiment . . . at this Columbus celebration . . . is even more striking.] **1893** *N.-Eng. Hist. & Gen. Reg.* XLVII. 164 The following paper is a portion of an article which was prepared by the author, apropos of the approach of Columbus day. **1948** *Chi. D. News* 15 Sep. 3/3 (*heading*), Truman Asks Columbus Day Observance.

combine ˈkɑmˌbaɪn, *v.* [f. the noun.] *tr.* To harvest (grain, esp. wheat) with a combine. Hence **combiner,** *n.*

1926 *K.C.* (Mo.) *Star* 23 June, The first wheat combined in this vicinity was from the 100-acre field of A. E. Rudd. **1948** *Chi. Tribune* 26 June 1. 6/2 The grain is beginning slowly to turn color and it won't be too long before it is time to combine it. *Ib.* 11 Aug. 6/2 The wheat that can't be handled by that fleet is moved to storage by 28 smaller trucks owned by contract combiners.

* **comforter,** *n.* A warm bed cover, usu. made of gay-colored fabric filled with down or wool and either scroll-stitched or tacked with wool thread. See also **tow comforter.**

1832 S. G. GOODRICH *Univ. Geog.* 107 The females also have similar meetings called 'quilting bees,' when many assemble to work for one, in padding or quilting bed coverings or comforters. **1913** A. B. EMERSON *R. Fielding at Snow Camp* 28 Later Aunt Alvirah made up the couch with plenty of blankets and thick, downy 'comforters.' **1947** *Chi. D. News News-Views* 29 March 5/2 Country activities for the Mrs. includes a quilting bee with neighbors. . . . It's a pleasant way to spend an afternoon as well as finish a comforter.

commuter kə'mjutɚ, *n.* [f. prec.] One who commutes.

1865 *Atlantic Mo.* XV. 82 Two or three may be styled commuters' roads, running chiefly for the accommodation of city business-men with suburban residences. **1898** *Harper's Weekly* 26 Feb. 205/3 Of all criminally good-natured individuals the New York commuter is the worst offender. **1947** *Chi. D. News* 14 Oct. 1/3 Commuters . . . were delayed briefly this morning when a metal rim on one of the locomotive's wheels became loosened.

Comptonia ˌkamp'toniə, *n.* [After Henry *Compton* (1632–1713), an English prelate.] The North American sweet fern, *Comptonia asplenifolia*, having fern-like leaves.

1823 CRABB *Technol. Dict. s.v.*, Fern-leaved Comptonia, a shrub, native of New England. **1889** *Cent.* 1157/1 Comptonia. . . . The only species, *C. asplenifolia*, is the sweet-fern of the United States. . . . It is said to be tonic and astringent, and is a domestic remedy for diarrhea. **1942** TEHON *Native Ill. Shrubs* 59 Comptonia . . . has the general characteristics of the family.

Comstocker 'kʌmˌstɑkɚ, *n.* One associated with the famous Comstock lode mines at Virginia City, Nev.

1876 *Gold Hill* (Nev.) *News* 7 Dec. It would be hard to find a jury of generous Comstockers who would convict them. **1877** WRIGHT *Big Bonanza* 356 A Comstocker . . . dropped in at a chop-house where about a dozen newcomers had just settled in a flock, at two or three adjoining tables. **1948** *Nev. Highways* July–August 4/2 Comstockers even grew fearful that production would upset the world's monetary balance.

condensed milk. Milk that has been evaporated and sweetened to preserve it and make it easier to transport.

1863 NORTON *Army Lett.* 177 We buy condensed milk of the sutlers. **1876** *Avalanche* (Silver City, Ida.) 25 April 3/2 When the waiter

handed around 'condensed milk' put up in Maine, to go into my tea,
I was dumfounded. **1947** *Chi. Tribune* 4 July 5/1 Milk powder plants
erected in the south could ship powdered or condensed milk to north-
ern areas cheaper than when produced here.

* **confiscation,** *n. attrib.* Designating a congressional
act or *bill* providing for the appropriation of the property
of persons supporting the Southern cause during the Civil
War. *Obs.*

*c*1862 GRANT in Penniman *Tanner-Boy* 108 The interpreting of con-
fiscation-acts by troops themselves has a demoralizing effect. **1864**
Harper's Mag. March 559/1 The confiscation Act, passed July 17,
1862, apparently provided for the confiscation of the entire rights of
property of all persons in rebellion. **1863** RUSSELL *Diary* II. 274 The
Confiscation Bill, for the emancipation of slaves and the absorption
of property belonging to rebels, has, indeed, been boldly resisted in
the House of Representatives; but it passed with some trifling
amendments.

* **contour,** *n.* **1.** *fig.* General appearance, prospect.
Rare. **2. contour plow,** a plow used in giving a desired
contour to a piece of ground. Hence **contour plowing.**

(1) **1904** *Charlotte D. Observer* 21 Aug. 1 Mr. Blackburn is jubilant
over the contour of things, and says he is confident of election. —
(2) **1941** S. V. BENÉT *Listen to the People* (1942) 479 People whose
contour-plows bring back the grass To a dust bitten and dishonored
earth. **1941** FERGUSSON *Southwest* 148 In the same region, farmers who
had tried rotation of crops and contour plowing found their fields
secure after torrential spring rains. **1945** *Reader's Digest* Nov. 27/2
They . . . learn modern farm methods such as terracing and contour
plowing.

cookee '**kŭ**kɪ, *n.* [dim. of * *cook, n.*] A camp cook or
cook's helper. *Colloq.*

1846 *Spirit of Times* 4 July 218/2 We embarked . . . in company
with . . . a cookie who was lord and master of the culinary depart-
ment. *a*1904 S. E. WHITE *Blazed Trail* i. 12 A fat cook, two bare-
armed cookees, . . . were the only human beings in sight. **1944** W.
BLAIR *Tall Tale America* 174 Paul always gave any cook as many
cookees to help as he needed.

coonskin '**kŭn**₍skɪn, *n.*
1. The skin of a raccoon. Also attrib.

[**1624** *Smith Generall History* III.ii. 48 *Powhatan* . . . sat covered with
a great robe, made of *Rarowcun* skinnes.] **1818** A. ROYALL *Lett. from
Ala.* 103 He . . . axed Marchant if he didn't want to trade for some
coonskins. **1895** *Cent. Mag.* Aug. 620/2 The darkies used to drag a
coon-skin through the woods, and run mongrels after it. **1947** *Sports
Afield* Dec. 31/3 Coon fur is not as valuable as it was in the heyday
of the coonskin coat.

b. Used as a party symbol by the Whigs, esp. in the
presidential campaign of 1840. Also attrib. *Obs.*

1840 *Niles' Reg.* 14 March 21/2 The delegation from Fairfield
county . . . came, carriages, horsemen, music; . . . then the 'Mad

river trappers' in their lodge, . . . 'coon skins' nailed on the sides. **1841** *Cong. Globe* 3 Feb. 147 The log cabins and coon skin banners, which you used so successfully in the late contest, will not avail you now. **1846** CORCORAN *Pickings* 154 If I find they are locofocos, I damn coon skins, log cabins, and hard cider. **1885** *Harper's Mag.* Oct. 743/1 This law grew out of the 'log-cabin, hard-cider, and 'coon-skin' campaign of 1840.

2. coonskin cap, a round cap made of the skin of a coon or coons, usu. with the tail of the animal hanging down the wearer's back. Hence **coonskin-capped.**

1836 SIMMS *Mellichampe* i, He gathered up his rifle, drew the 'coon-skin cap over his eyes, and at once fell in procession with the rest.

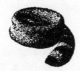

Coonskin cap

1881 *Harper's Mag.* April 712/1 As for . . . plains-men and coon-skin-capped hunters . . . of the 'West,' . . . you see no more of them. **1948** *Chi. D. News* 9 Aug. 10/2 Kefauver posed for campaign pictures wearing a coon-skin cap.

cordelle kɔr'dɛl, *n.* [F.] A rope or line used in towing a boat. Also **cordelle rope.** Now *hist.*

1811 BRACKENRIDGE *Louisiana* 214 Continued until eleven, with cordelle, or towing line—the banks being favorable. **1863** *Washoe* (Nev.) *Times* 11 July 1/5 Seven of the deck hands went out in a yawl to adjust the cordell rope to a tree. **1946** RICHTER *Fields* 281 Several hands jumped out in the water with the cordelle and pulled it to the bank.

core drill. To drill with a core drill which removes a cylindrical core from the object penetrated. Also **core drilling.**

1903 *Sci. Amer.* 18 July 44/1 Core drilling is indispensable in a great variety of engineering and mining enterprises, affording, as it does, a means for drilling out a sample core or column of rock. **1927** EUBANK *Horse & Buggy Days* 116 They geologized it and they core drilled it, and reported 'no trace of oil and no structure.' **1948** *Sat. Ev. Post* 28 Aug. 68/4 During the last winter the Atlantis spent two months core-drilling the Gulf of Mexico.

corn blade. The leaf of corn, esp. as cured and used as forage. Usu. *pl.*

1688 CLAYTON *Acc. Va.* in *Phil. Trans.* XVII. 947 Their Indian Corn-blades, which they gather for their Fodder. **1775** ADAIR *Indians* 407 The women . . . knead both [chestnuts and corn] together, wrape them up in green corn-blades of various sizes, about an inch-thick, and boil them well. **1843** *Amer. Pioneer* II 233 Horses here are very small and spirited; they live chiefly on cornblades, brought every

day to market in bundles for six cents. **1926** ROBERTS *Time of Man* 43 The cornblades were brown and hard.

corn hill. The spot or portion of ground where one or more stalks of corn are or may be grown.

[**1622** MOURT *Relation* 30 We marched to the place where we had the corne formerly, which place we called Corne-hill.] *a***1676** JOHN WINTHROP in *Philos. Trans.* No. 142 (1678) 1066 Where the Ground is bad or worn out, the Indians used to put two or three of the fore-mentioned Fishes, under or adjacent to each Corn-hill, whereby they had many times a Crop double to what the Ground would otherwise have produced. **1873** *Newton Kansan* 1 May 1/5 Rhode Island farmers will plant miniature torpedoes in their corn-hills as a substitute for scare-crows. **1948** *New World* (Chi.) 2 July 13/3 Indian corn hills or 'squaw hills' as they are sometimes called, are plainly visible in the park.

cornplanter ˈkɔrnˌplæntɚ, *n.*

1. (*cap.*) *attrib.* Designating a division of Seneca Indians under the influence of a celebrated half-breed Seneca chief named Cornplanter.

[**1794** *Gazette of U.S.* 20 June (Th., p. 930), Corn-planter [sends commodities to Lt. Polhemus]]. **1824** BUCHANAN *Sketches* I. 55 Cornplanter's Letter Allegheny River, 2d mo. 2d, 1822. [Speech of Cornplanter to the Governor of Pennsylvania.] **1834** H. BRACKENRIDGE *Recoll.* vii. 74 The arrival of Cornplanter Indians, on the bank of the Alleghany. **1907** HODGE *Amer. Indians* I. 338/2 Both villages belonged to the division of the Seneca known as Cornplanter's band.

2. One who raises Indian corn.

1832 *Cong. Deb.* 9 Feb. 339 The corn planter and wheat grower understand their interests. **1845** SIMMS *Wigwam & Cabin* 2 Ser. 104 One of a tribe [*sc.* crows], of which the corn-planter has an aversion.

3. A machine or device for planting corn. Cf. **hand cornplanter.**

1839 BUEL *Farmer's Companion* 151 Some of them, under the name of corn-planters, are employed in planting Indian corn. **1948** *Democrat* 28 Oct. 3/2 Two-Row Corn Planter. . . . This machine could plant 15 to 20 acres per day if the area previously had been marked by cross-plowing.

corral kəˈræl, *n.* Orig. *W.* [Sp. in same sense. An Amer. borrowing.] An inclosure for horses, cattle, etc. Also attrib.

1829 *Amer. Turf Reg.* Oct. 101 They procure from a great distance, and by almost incredible labour, a quantity of wood palisades, with which they form a *corral*, of great size. **1928** BREAKENRIDGE *Helldorado* 24 With the help of the corral boss I got the pick of the saddle horses in the corral. **1947** *Reader's Digest* Oct. 111/1 He roared to the cowboys at the corrals.

fig. **1890** RYAN *Told in Hills* 336 He first led us out of that corral in the hills. **1946** *Progress* March 30/1 When the draft all but depleted the male element, the possibility of meeting some vulnerable lad at the drugstore corral became an all-important motive.

cosmic ray. A term first applied by Robert A. Millikan to any one of many very penetrating rays of extremely high frequency, apparently resulting from nuclear transformations, and reaching the earth with equal intensity day and night. Also attrib. —**1925** MILLIKAN in *Science* 20 Nov. 447/1 The experiments with the sounding balloons indicates [*sic*] that the frequencies of these cosmic rays do not extend over into the X-ray region of frequencies. **1948** *Time* 5 July 44/3 A whole galaxy of cosmic ray experts gathered last week . . . to honor Nobel Prizeman Dr. Robert A. Millikan, 80, principal discoverer and namer of cosmic rays.

costumer 'kɑstjumɚ, *n.*

1. One who deals in costumes or dresses.

1864 WEBSTER. **1887** *Lippincott's Mag.* Aug. 295 Costumers from New York are employed, and much time is spent in rehearsing for the presentations. **1948** *So. Bend* (Ind.) *Tribune* 15 Aug. (Comics) 3 Who's your costumer?

2. = hat tree.

1926 *Sears Cat.* 863. **1935** *Montgomery Ward Cat.* 484 Made of solid Oak in Golden finish . . . this costumer should last for years.

coulee 'kulɪ, *n.* [See quot. 1931.] A small stream, or the bed of such a stream when dry.

1807 in *Amer. State P., Pub. Lands* (1832) I. 313 Bounded in front by the river Detroit, and in rear by a *coulee* or small run. *Ib.* 346 Bounded . . . above by a creek (or coulee) called *ventre de boeuf.* **1881** *Chi. Times* 14 May (*O.E.D.*), These 'coolies' are dry during the summer season, but are flooded in the spring of the year. **1931** READ *La.-French* 166 *Coulée*, a substantive from the feminine past participle of Fench *couler*, 'to flow,' is generally used in Louisiana of a small stream that may become dry in summer. *Coulée* is also written *coulee*, *-ie, coolie, -ey*, as an English word. **1948** *Kananaskis Ranch Cat.* 3 They may be huddled together down in a sheltered couley, out of the wind, waiting the storm out.

country store.

1. A store situated out in the country.

1741 in *N.J. Archives* 1 Ser. XII. 92 To be sold. . . . Three Hundred Acres of Land . . . with a very good Landing Place, and well situated for keeping a Country Store. **1889** MELLICK *Story Old Farm* 9 The small structure on the corner, opposite the tavern, is that magazine of wonders, a country store. **1946** *This Week Mag.* 17 Aug. 18/2 In this old country store she bought her food from bins and barrels.

b. country storekeeper, one who keeps such a store.

1742 *Pa. Gazette* 13 Jan. [Franklin offers his goods to] country storekeepers. **1840** *Hunt's Merch. Mag.* II. 532 The country store-keepers all keep open accounts with the large dealers in Havana. **1945** *This Week Mag.* 1 Dec. 2/3 Then there is Walt, who left a showy advertising job in New York to become a country storekeeper.

county agent. An agent whose activities are limited to one county, esp. one employed by a state to promote agriculture in a county.

1705 *Va. State P.* I. 96 It is proposed. . . . That in every County a

person of good reputation and Knowledge in the tobacco trade be appointed, under the name of the County Agent, to view ... all tobacco paid away for discharge of publick or private Debts in that County. **1894** *Dept. Agric. Yearbook* 55 State and County Agents. A fundamental objection to the present system of gathering agricultural statistics in the United States is the fact that correspondents, who are expected to furnish reliable data, are paid nothing for their work. **1949** *Democrat* 10 Feb. 1/3 County Agent Advises Early Planting For Hog Grazing.

coup ku, *n. W.* [F., in Amer. sense shown here.] Among plains Indians, a personal deed of daring and victory, esp. the first blow or wound given an enemy. Now *hist.*

1832 CATLIN *Indians* I. 27 Each one took a smoke of the pipe, and recited his exploits, and his 'coups' or deaths. **1897** GRINNELL *Indian* 2 Some of the lodges are painted in gay colours with odd angular figures which tell in red, black, or green, of the coups of the owner. **1939** VESTAL *Old Santa Fe Trail* 243 His rating in the tribe depended on his proven *coups*.

b. coup stick, (see quot. 1876).

1876 BOURKE *Journal* 15 June, Making 'coup' sticks, which are long willow branches, about 12 feet from end to end, stripped of leaves and

Coup stick such as the Crow Indians used

bark and having each some distinctive mark in the way of feathers, bells, [etc.] ... in dividing the spoil, each man claims the animals first struck by his 'coup' stick. *a***1918** G. STUART *On Frontier* II. 122 Some Indian has scratched a crude picture of an Indian with a war bonnet on and a 'coup' stick in his hand seated on a horse.

c. *To count coup,* to be the first to strike an enemy with an object held in the hand, to recount one's exploits. Now *hist.*

[**1742** in FRIEDERICI (1947) 216/1 Ces Sauvages n'avoient mis que deux nuits à se rendre de l'endroit où ils avoient fait coup.] **1831** *Illinois Mo.* July 459 The visiters were smoked as usual, feasted on fat dogs; and then they danced and counted their *coups*. **1876** BOURKE *Journal* May 10 We have our way of fighting. We will run in and count 'coo' (corruption of the French 'coup' = blow or stroke) 'and the soldiers can do the fighting.' **1947** DEVOTO *Across Wide Missouri* 81 War

chief: any brave who had counted enough coups to entitle him to lead a war party on his own.

covenant chain. In colonial times, a chain belt symbolizing the bond of peace between colonists and Indians, usu. in fig. contexts. *Obs.* Cf. **chain 4. b.** (1), **chain belt.**

1696 *Doc. Hist. N.Y. State* (1849) I. 342 We underwritten have mett & considered about the properest methods* for . . . renewing with them and the rest of the Five Nations the Covenant Chain. **1715** *Boston News-Letter* 22 Aug. 2/1 His Excellency our Governour is this Week bound for Albany to meet our Five Nations of Indians, to renew the Covenant Chain. **1745** *Pa. Col. Rec.* V. 14 We are all united with You in the same Covenant Chain, which as long as we preserve it free from Rust must remain impregnable. **1754** *Mass. H.S. Coll.* 3 Ser. V. 41 We return you all our grateful acknowledgments for renewing and brightening the covenant chain. This chain belt is of very great importance to our United Nations.

cover charge. In some dining places, a charge made for service and accommodations over and above the cost of the food served. Also attrib.

1921 *Nation* 21 Sep. 320/2 As levied here, the cover charge is a compulsory blanket assessment for nothing in particular; it commonly includes bread and butter, but the supply is meager. **1932** *Variety* 22 Mar. 1/3 Cover charge places have virtually disappeared from Broadway. **1948** *Miami* (Okla.) *D. News-Record* 4 July 20/3 The night clubs of Manhattan are like a thousand other night clubs throughout the land—smoky second-hand air sold with a cover charge.

* **crab grass.**

1. Any one of various grasses, esp. of the genus *Digitaria*, having creeping stems that root freely at the nodes.

1743 CLAYTON *Flora Virginica* 134 Panicum spicis alternis oppositisve [etc.] . . . Crab-grass. **1781–2** JEFFERSON *Notes Va.* (1788) 40 Our grasses are lucerne, . . . greenswerd, blue grass, and crab grass. **1948** *Holland's* June 47/3 If permitted to grow high enough, Bermuda grass will shade out crab grass and protect it from gaining much headway.

2. Yard grass, *Eleusine indica.* Cf. **sprouting crab grass.**

1857 GRAY *Botany* 554 *Eleusine.* Crab-grass. Yard-grass. **1878** KILLEBREW *Tenn. Grasses* 231 *Elusine Indica*, Crab grass, yard grass. . . . It forms very good and lasting picking for all stock. **1883** VASEY *Grasses U.S.* 33 *Eleusine Indica*, . . . Yard-grass, Crab-grass. Extensively naturalized.

crackerjack ˈkrækɚˌdʒæk, *n.* Also **crackajack.** [App. of fanciful origin.]

1. An especially fine thing or person. Also attrib. or as adj.

1896 *N.Y. Herald* 2 April 7/4 There are so many crackajacks in the

lot that it is going to be very hard to make up the regular team, because some good men will have to sit on the bench and wait for a chance. **1911** SAUNDERS *Col. Todhunter* 123 You've given me a cracker-jack talk on Missouri politics. **1948** *Dallas Morn. News* 2 May 11. 1/7 Except for one end and center he has lost a crackerjack line-up among last season's letter men.

2. (*cap.*) A manufacturer's trade-name for a confection composed of popcorn, and sometimes peanuts, glazed with molasses. Also attrib.

1902 *Sears Cat.* (ed. 112) 20/3 Cracker Jack. . . . Price, per case of 100 packages 2.85. **1944** *Nat. Geog. Mag.* June 680/1 At noon they stopped . . . [and] ate Forestry K rations—a palatable, sustaining meal out of a heavily waxed carton the size of a Cracker Jack box. **1947** BASKINS *Dr. Has Baby* 131 She dangled a red balloon, ate popcorn, peanuts and Cracker Jacks.

crevasse krə'væs, *n.* [F. in the La. F. sense shown here.] A break in a levee, usu. with reference to the lower Mississippi.

1813 *Pittsburgh Alman. 1814* 57 The numerous crevasses (breaks) above, are supposed to have added to the safety and perhaps prevented the city from experiencing inundation. **1891** *Scribner's Mag.* Oct. 465 Every crevasse that bursts a levee is an effort of the river to escape from the high-lying channel to which man would confine it. **1941** BALDWIN *Keelboat Age* 77 A similar danger was the crevasse, formed in time of high water when the river broke through a levee.
transf. **1850** *Cong. Globe* App. 149/2 A moral crevasse has occurred: fanaticism and ignorance . . . have accumulated into a mighty flood.

criminal lawyer. A lawyer who specializes in criminal law.

1869 TOURGEE *Toinette* ii. 19 They knew the weak point of the old man, his repute as a criminal lawyer. **1889** *Cent. Mag.* Feb. 634/1 The failure of criminal justice, . . . and the evolution of a class of 'criminal lawyers' whose perfect flower was the royal type of 'jury fixer,' were antecedent circumstances sufficient to show that a heavy responsibility belongs to the public men who had permitted criminal law to break down. **1947** *True* Nov. 69/1 Criminal lawyers did not keep charts and graphs of their acquittals.

Croatan kro'tæn, *n.* [Name of a village and formerly of an island off the coast of North Carolina.] *pl.* A group of several thousand people evidently of mixed Indian and white blood, found in eastern N.C., esp. in Robeson County. Also **Croatan Indians.**

"In 1911 the legislature, at the insistence of the mixed-bloods, struck out the word 'Croatan,' and the official name of the group became 'Indians of Robeson County N.C.' " (*Amer.Sp.*, April 1947, 86).

1907 HODGE *Amer. Indians* I. 365/2 About 20 years ago their claim was officially recognized and they were given a separate legal existence under the title of 'Croatan Indians,' on the theory of descent from Raleigh's lost colony of Croatan. **1923** LINDQUIST *Red Man in U.S.* 108 The Croatans may not in the strictest sense be classed as

Indians. **1947** *Time* 3 Nov. 24/3 A 33-year-old member of the Croatan Indians was jailed for slashing two of his fellow tribesmen and drinking their blood.

crocus ˈkrokəs, *n.* Also **crocos, crokass, croker.** [See note.]

The origin of this term is obscure. The *OED s.v. crocus*, the plant name, has a British example of 1710 of "Two Bales of Crocus," and under sense 5, "Crocus Ginger-bag" occurs taken from the same source as our 1699 quot. below. These quots. suggest that as the name of a material the term may not have been first used in this country, though the *OED* does not recognize such a sense.

1. "A coarse stuff worn by slaves and working people" (McClellan, *Dress*, 385).

1689 *Maine Doc. Hist.* IV. 458 Here is great want of . . . Some beds or Crocos to make Straw beds. **1764** in A. E. BROWN *J. Hancock, His Book* 44 Please to send . . . a Bale of crocus for Bread Bags, 7 or 800 yds., yd. wd.

2. Attrib. with **apron, bag, breeches, ginger-bag, shirt.** Chiefly *obs.*

1699 J. DICKENSON *God's Protecting Providence* 35 He gott some Canvass and Crocus ginger-baggs, which they had gott out of the Vessell. **1704** *Boston News-Letter* 13 Nov. 2/2 Ranaway on Wednesday last, the 8th. Currant from his Master in Boston, a Sirranum Indian: . . . has on a black broad Cloath Jacket, . . . a Crocus Apron, [etc.]. **1733** *N.J. Archives* XI. 322 Taken up . . . a New-Negro Man, . . . he had on nothing but a crocus Shirt. **1738** *Virginia Gaz.* 22 Sep., Ran away . . . Mulatto Slave . . . had on an old Felt Hat, a Canvas Shirt, a Cotton Jacket, and a Pair of Crocus Breeches. **1790** in CHALKLEY *Scotch-Irish Settlement Va.* I. 509 [After dissecting the body they] did sew him up in a crokass bag and put him in the cave within mentioned. **1904** STERLING *A Belle* 233 We therefore collected the silver, piece by piece, secreting it in 'crocus' bags.

b. **crocus sack, croker-sack,** (see quot. 1908).

1908 *D.N.* III. 302 croker-sack, n. A bag made of burlap or coarse brown hemp. Universal. The first element was doubtless originally *crocus*, the final *s* being absorbed by the initial *s* of sac. **1942** RAWLINGS *C. Creek* 103 As I came to the door, he held up one hand in command, unfurled a crocus sack, and with great drama rolled a large king snake onto the grass.

＊**cruiser,** *n.*

1. (See quot. 1900.) Cf. **landlooker** (*b*), **timber cruiser.**

1893 *Scribner's Mag.* June 695/1 My first day's experience as a 'Cruiser' or 'Landlooker.' **1900** E. BRUCKEN *N. Amer. Forests* 81 This has given rise to a peculiar class of people variously known as woodsmen, cruisers, landlookers, whose business it is to give information as to the existence of pine timber, its location, amount, value. **1946** R. PEATTIE *Pac. Coast Ranges* 232 With his cruiser's eye, he could measure the quantity and the quality of the timber from the water's edge.

2. A high-topped laced boot such as timber cruisers often wear.

1902 White *Blazed Trail* 131 They were . . . dressed in broad hats, flannel shirts, coarse trousers tucked into high laced 'cruisers.' **1946** *Sat. Ev. Post* 11 May 41/1 He was wearing Tillamook light cruisers from Portland.

3. A police squad car or prowl car.

1929 *Sat. Ev. Post* 7 Dec. 68/2 The cruisers are high-powered seven-passenger touring cars manned by a crew of four.

cum laude. [L., with praise.] Used in, or with reference to, diplomas given students who have done superior work. Also **magna cum laude, summa cum laude,** indicating grades of superior work.

1893 Post *Harvard Stories* 274 Jack . . . lost a *cum laude* and had to 'take his A.B. straight.' **1925** *Harvard Quinquennial Cat.* 257 From 1872 to 1879 inclusive there were two grades of distinction at graduation, summa cum laude and cum laude. *Ib.* 277 Since 1880 there have been three grades of distinction at graduation, summa cum laude, magna cum laude, and cum laude. **1946** *Reader's Digest* March 168/1 There is a message for all Americans in the last thoughts of this brilliant and sensitive youth—a graduate *summa cum laude* from Yale.

transf. **1946** *Chi. D. News* 24 April 14/2 It should go further and make him a motorman cum laude.

cushaw kə'ʃɔ, *n.* [See note.]

The origin of this word is somewhat obscure, but it is prob. f. an American Indian term. Hodge is slightly in error in ascribing to Hariot the form *escushaw*. See quot. 1588 below.

A winter crookneck squash, *Cucurbita moschata*, or a variety of this.

1588 Hariot *Briefe & True Report* c4ᵛ Coscushaw, some of our company tooke to bee that kinde of roote which the Spaniards in the West Indies call *Cassauy*. **1698** G. Thomas *Pa. & N.J.* 21 Cucumbers, Coshaws, Artichokes, with many others; . . . besides what grows naturally Wild in the Country. **1763** tr. DuPratz *Hist. Louisiana* (1758) II. 8 The *Cushaws* are a kind of pompion. There are two sorts of them, the one round, and the other in the shape of a hunting horn. **1868** W. N. White *Gardening for South* 214 The best variety [of squash] for family use is the Cashaw, a long, cylindrical, curved variety. **1947** *Democrat* 11 Sep. 1/7 Grover states that he has also had cushaws and an ample supply of vegetables.

✳ **cuss,** *n.*

1. A good-for-nothing fellow or creature, usu. with a qualifying word, and often applied good-naturedly or humorously. *Colloq.* Cf. **bobtail cuss.**

1775 *Narrag. Hist. Reg.* III. 263 A man that . . . was noted for a damn cuss. **1845** *Cincinnati Misc.* 226, I gave the child to its mother, and taking my rifle down, started out after the old cuss [a bear]. **1883** *Harper's Mag.* Oct. 706/2 The 'horned toad' is distinctly an 'amoosin' cuss.' **1932** *K.C. Times* 18 March 18 Some up-to-the-minute newspaper man tell a dern ignorant cuss of a country editor why.

b. *To take the cuss off,* to improve matters somewhat. *Colloq.*

1843 STEPHENS *High Life N.Y.* II. 55 The men begun to stream into the theatre like all possessed, with a small sprinkling of the feminine gender, jest enough to take the cuss off and no more.

2. cuss word, a profane word, an oath. *Colloq.*

1872 MARK TWAIN *Roughing It* xlvii. 334 He didn't give a continental for anybody. Beg your pardon, friend, for coming so near saying a cuss-word. **1911** *Chi. D. News* 23 Sep. 9/4 'What is it that Col. Goethals ain't going to allow to be used in the digging of the Panama canal?' 'Cuss words,' said Sandow.

cut money. (See quots. 1816, 1824.) *Obs.*

1809 *Kentucky Statutes* IV. (1814) 45 When any collector of public money shall be about to pay cut money into the public treasury, [etc.]. **1816** D. THOMAS *Travels Western Country* (1819) 110 In this district [Ky.] *cut money* is very common. If change cannot be made, the chisel and mallet are introduced. . . . One fifth is often palmed off on the traveler for a quarter. **1824** W. N. BLANE *Excursion U.S.* 257, I was obliged to cut a silver dollar, into quarters, and even into eighths; a practice so common in the Western States, that the *cut-money*, as it was called was the only change that could be had in Missouri. **1874** R. H. COLLINS *Kentucky* I. 26 Feb. 8 [1809]—Act providing for exchange of 'cut money' at three per cent. discount.

cyclery 'saɪklərɪ, *n.* A bicycle shop.

1897 *Trans-Mississippian* (Council Bluffs, Ia.) 20 April (*advt.*), Council Bluffs Cyclery. **1899** FRASER *Round World on Wheel* xxxvii. 484 There is a cyclery—that's an American word—where machines are hired out at a shilling an hour. **1912** *Out West* April 271 Neal Sorenson, Owner Alhambra Cyclery. **1936** MENCKEN *Amer. Language* 176 In Pasadena, Calif., there is a *hattery*, in South Pasadena a *cyclery*.

* **Czar,** *n.* A nickname for T. B. Reed (1839–1902) of Maine, from his rigid application of parliamentary rules while Speaker of the House of Representatives. *Obs.*

1893 *McClure's Mag.* I. 375, I remember asking the ex-Speaker [T. B. Reed of Me.] how he felt . . . when he was being held up as 'The Czar'—a man whose iron heels were crushing out American popular government. **1895** *Munsey's Mag.* XX. 418 When Mr. Reed put through the rules which have come to be known by his name he was . . . denounced furiously as 'czar,' as 'tyrant.' **1896** *Cong. Rec.* 23 Jan. 936/1 In . . . 1890, . . . the whole Democratic party were railing against our benign and amiable 'Czar.'

Hence **Czarism.**

1892 *Cong. Rec.* 27 Jan. 600/1 We have heard it here time and again . . . that we are here as a protest against the czarism of Mr. Reed, of the last Congress.

D

*** D, *n.***

1. An abbreviation for Drunkard or Drunkenness, used as a badge or symbol which, in colonial New England, those convicted of drunkenness were condemned to wear. Now *hist.*

1634 in A. M. EARLE *Curious Punishments* 89 Robert Coles, for drunknenes by him comitted at Roksbury, shalbe disfranchised, weare about his necke . . . a D. made of redd cloth & sett vpon white. **1636** in *Pub. Col. Soc.* III. 57 To stand att the nexte Genall Court one houre in publique vewe with a white sheete of pap on his brest, haveing a greate D made vpon it. **1895** *Amer. Antiq. Soc. Proc.* April 112 He was also ordered to wear the D outwards and was enjoined to appear at the next general Court. **1947** DOWNEY *Lusty Forefathers* 123 *D* was the stigma for drunkards who must wear it a year and might in addition be disenfranchised, forbidden to hold office, flogged and given a term in a work gang.

2. Abbreviation for Dollar or Dollars. *Obs.*

1791 JEFFERSON in *Harper's Mag.* LXX. 535/1 Recd. from Fra. Hopkinson an order on in the bank for 120D. *Ib.*, A pound of tea making 126 cups cost 2 D. **1885** *Harper's Mag.* LXX. 534 It will be observed that the modern symbol of the dollar was not then in use, a capital D being uniformly used by Jefferson.

3. (See quot.) *Rare.*

1867 DEVENS *Pictorial Bk.* 203 [In] branding deserters . . . in Richmond . . . the culprit was fastened to a large table, with his face downward, and a large 'd' scarred upon his posteriors.

4. Used as a grade or mark in school. Also attrib. Cf. **A, B, C.**

[**1890** in M. L. SMALLWOOD *Exams. & Grading Systems* 53 In each of their courses students are now divided into five groups, called A, B, C, D, E. . . . To graduate a student must have passed in all his courses, and have stood above the group D.] **1897** *Mount Holyoke Faculty Minutes* 7 Feb., [Mount Holyoke's plan of marking:] D—80–84; E—75–79; F—Failed. **1945** *Beloit College Bul.* June 11 It is my conviction that no team with D grades will ever win a championship.

Dalton plan. A method of individual instruction in public schools in which students complete work at their own speed in instalments, so called in allusion to Dalton (Mass.) High School, where the plan was first used.

1922 HELEN PARKHURST *Educ. on Dalton Plan* ii. 15 The Dalton Laboratory Plan provides that means by diverting his energy to the pursuit and organization of his own studies in his own way. **1944** *Vogue* 1 Oct. 175 Miss Parkhurst, originator of the progressive Dal-

ton plan, is now conducting a research project in the education of children of from one to three years.

Hence **Daltonians, Daltonism, Daltonize.**

1924 A. J. LYNCH *Individual Work & Dalton Plan* 47 Convinced Daltonians recognise at once that assignments are the heart and centre of the plan. **1927** ALDOUS HUXLEY *Proper Studies* 133 These ancient seats of learning [*sc.* Oxford and Cambridge] were Daltonized long before Daltonism was invented.

damned Yankee. Also **damyankee.** A term of contempt for an American, esp. one from New England, much used since the Civil War by Southerners for an inhabitant of the northern states. Also attrib. Now *jocular*.

1812 *Niles' Reg.* III. 45/1 Take the middle of the road or I'll hew you down, you d'—d Yankee rascal. **1865** *N.Y. Ev. Post* 28 Sep. 1/1 They swore to some men of a cavalry patrol camped across the river, that they would shoot the first d——d Yankee who tried to cross the bridge. **1909** O. HENRY *Options* 95 You've had to go to work just as we 'damyankees,' as you call us, have always been doing. **1949** *Democrat* 13 Jan. 4/1 Our balmy Southern climate has refused to be dominated by the damyankee type of weather.

D.A.R. Abbreviation for Daughters of the American Revolution. Also a member of this organization. Also attrib. Cf. * **Daughters.**

1906 *Washington Post* 29 April 44 Two D.A.R.'s attending the local convention were waiting for the elevator to take them to their meeting rooms. **1944** *Democrat* 14 Dec. 4/3 The Elizabeth Bradford Chapter of the D.A.R. held its regular meeting at the home of Mrs. L. R. Tucker. **1947** *N. & Q.* July 55/2 Collection of American Revolutionary documents circulated among D.A.R. societies.

Davis Cup. [f. Dwight F. *Davis* (1879–1945), Amer. statesman who instituted the custom in 1900.] A cup presented as a national trophy to that country whose team of four players wins in an international

Davis Cup

championship contest in lawn tennis. Also attrib. — **1901** *Outing* June 320/1 Another challenge has now been received from them and accepted, and a second attempt to 'lift' the Davis Cup will be made this season. **1948** *New Yorker* 25 Sep. 52/2 The Davis Cup will remain in the United States . . . practically forever.

deacon seat. Also deacon's seat.

1. A seat in church reserved for deacons, usu. immediately in front of the pulpit.

1667 *Dorchester Rec.* IV. 146 [Men] to take care about ordering the worke about the gallery and likewise a table before the Deacons

Deacon's seat (sense 1)

Seate. **1687** SEWALL *Diary* I. 178 Mr. Danforth sat in the Deacon's Seat. **1857** *Atlantic Mo.* I. 96/1 This important functionary was accustomed . . . to take his place in the deacon's seat.

2. A long bench in front of the fire in a log cabin or in front of the sleeping bunks in a lumber camp. Also transf.

1851 SPRINGER *Forest Life* 71 Directly over the foot-pole, running parallel with it, and in front of the fire, is the deacon seat. **1868** *Harper's Mag.* March 412/2 At the foot of the bed . . . was a long, flat beam, called the 'Deacon's Seat.' This Deacon's Seat is one of the representative places in a lumberman's camp. **1947** *Harper's Mag.* July 81/1 At the opening of the tent we had a bench made from saplings, or from a board if we had one, which Mr. Teare called the 'deacon seat.'

* **deadening,** *n.* An area where the trees have been killed by girdling (see also quot. 1823). Also the process of girdling.

1785 in *Amer. Sp.* XV. 170/2 1000 Acres commonly called the poplar level and Including a pawpaw deadening. **1823** JAMES *Exped.* II. 94 Large bodies of timber are so frequently destroyed in this way [by the burning of weeds nearby], that the appearance has become familiar to hunters and travelers, and has received the name of *deadening*. **1880** BURNETT *Old Pioneer* 14 The large trees were belted around with the axe, by cutting through the sap of the tree, which process was called 'deadening' **1947** BROWN *Outdoors Unlimited* 105 Coupled with the fact that its waters are usually shallow, progress through the deadening is almost impossible.

* **deadfall,** *n.*

1. A saloon or low gambling dive. *Slang.*

1837 WETMORE *Gaz. Missouri* 337 At a small pot-house **grocery or**

dead-fall of the village . . . there was a lingerer. **1874** in FLEMING *Hist. Reconstruction* II. 318 A 'Dead-fall' is simply a small shop or store where for a few pounds of stolen cotton or a measure of corn, white thieves give whiskey to black ones. **1941** ASBURY *Gem of Prairie* 51 The little nest of gamblers dominated by the patrician John Sears had become, in 1857, a large and discordant colony of deadfalls and skinning joints, with a few square houses struggling desperately for survival.

2. An area in a forest encumbered with blown-down trees; also a tree that has fallen across a trail.

1884 *Cent. Mag.* Dec. 195 We spent more than three days in getting through the woods, intersected as they were by bits of burnt forests and numerous extensive 'dead-falls' of trees thrown pell-mell over, under, and astraddle. **1947** *Mazama* Mar. 2/1 On this trip we want to do a little work on the trail removing deadfalls, making a bridge or two across the creek, and plant a few more trees.

* **dean,** *n. Educ.* Used in the titles of administrative officers who have general supervision over students, or who serve as liaison officers between the president of a university and the heads of the departments, as **dean of men, of women, of the faculty, of social sciences,** etc. Cf. **junior dean.**

1892 *Chicago Univ. Quarterly Calendar* 6 Julia E. Bulkley, Associate Professor of Pedagogy, and Dean (of women) in the Academic Colleges. **1921** *Outing* Nov. 66/2 The present Dean of Men in the same school dates back as far as does Huff. **1943** *U. of Chi. Announcements* 5 President Harper . . . was succeeded by Harry Pratt Judson, who had been closely associated with him as Dean of the Faculties. **1945** *New Yorker* 10 Feb. 28/3 Ruml was . . . Professor of Education and Dean of the Social Sciences at the University of Chicago. **1948** *Miami* (Okla.) *D. News-Record* 4 July 10/1 It is important that the student have his transcript of credits . . . sent to the dean of administration as early as possible.

* **deed,** *v. tr.* To transfer (property, esp. land) by deed. Also absol.

"We sometimes hear this word used colloquially; but rarely, except by illiterate people" (Pickering). "A popular use of the word in America" (W. '28).

1806 WEBSTER 79 Deed, to give or transfer by deed. **1845** COOPER *Chainbearer* vii, Old Andries found out that the man who deeded to us had no deed to himself, or no mortal right to the land. **1902** HARBEN *Abner Daniel* 33 The farm you was going to deed to Alan? . . . You didn't include that?

Hence **deeded land.**

1872 *Newton Kansan,* 29 Aug. 3/3 (*advt.*), City Property exchanged for farms, homesteads or deeded lands. **1900** DRANNAN *Plains & Mts.* 575 A man . . . had a ranch for sale, consisting of three hundred and twenty acres of deeded land.

dehorn di'hȯrn, *v.*

1. *tr.* To remove the horns from (cattle). Also fig.

1888 *Voice* 12 Jan. 2 [H. H. Haaff] is the champion of dehorning cattle. **1914** *Boston Ev. Transcript* 6 June III. 2/1 Four years ago they dehorned the speaker. **1948** *Democrat* 11 March 4/6 Calves can best be dehorned when they are young.

Hence **dehorning, dehorning clipper(s).**

1888 *Missouri Republican* 15 Feb. (F.), Dehorning is performed when the calf is young, and the tips of horns movable. **1903** *Sears Cat.* (ed. 113) 501/2 Leavitt's V-shape Blade Dehorning Clipper, cuts all around horn as handles are closed. **1913** BARNES *Western Grazing Grounds* 180 This is easily done by either throwing or snubbing them up to a strong post or fence and taking the points off with a pair of dehorning clippers or an ordinary meat saw.

2. (See quot.)

1905 *Forestry Bureau Bul.* No. 61, 35 Dehorn, to saw off the ends of logs bearing the owner's mark and put on a new mark.

Dells dɛlz, *n. pl.* [Variant of "Dalles."] The rapids of a river, or the place where these are occasioned by a stream's cutting through a rock formation, used esp. of the Wisconsin River. Cf. **Dalle.**

1846 *Quincy* (Ill.) *Whig* 16 April 2/5 The wagons can come as far as the Delles, then by water the balance of the way. **1884** *Among the Dells* 5 The Dells of the Wisconsin river are known as one of the attractive summer resorts of the Northwest. They are about five miles in length, and are formed by the converging of the river's banks, through which the broad expanse of water above is forced with great rapidity. **1945** GRAY *Pine, Stream & Prairie* 15 It has spectacular moments when it passes through the Dells between high rocky cliffs full of curious formations to which the prosy poets of our times have given such names as 'the devil's punchbowl.'

demoralize dɪ'mɔrəl͵aɪz, *v.* [See note.] *tr.* To weaken the moral principles of, to destroy temporarily the courage or spirit of (a person), to upset the normal functioning of.

Noah Webster first used this word, in the form "demoralizing" (see quots. 1794, 1841 below). In his dictionary of 1828 he etymologized it as being derived from *de* and *moralize* or *moral*. The usual derivation from F. *démoraliser* is erroneous.

1806 WEBSTER 81/1 Demoralize, . . . to corrupt, undermine or destroy moral principles. **1841** LYELL *Travels* I. 65 When the lexicographer, Noah Webster, whom I saw at Newhaven, was asked how many new words he had coined, he replied one only 'to demoralize,' and that not for his dictionary, but long before in a pamphlet published in the last century. **1903** *Cin. Enquirer* 2 May 9/4 The hog market has been greatly demoralized. **1948** *Chi. D. News* 11 June 16/7 On their side of the aisle, the Democrats are demoralized.

Also **demoralizing,** *a.*, tending to weaken moral principles.

1794 WEBSTER *Revol. in France* 32 All wars have, if I may use a new but emphatic word, a demoralizing tendency. **1943** *This Week Mag.* 28 Aug. 4/2 It is . . . demoralizing in world affairs to let systematic cruelty and crime go unpunished.

* **derrick,** *n.* A towerlike structure erected over a deep bored well, esp. one for oil, in the process of boring it.

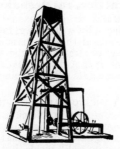

Derrick over a well

1861 *Dly. Dispatch* (Richmond, Va.) 30 April 1/4 At the time of the explosion, everything in the neighborhood—sixty or seventy rods—took fire, and shanties, derricks, engine-houses, and dwellings, were at once enveloped in flames. **1909** RICE *Mr. Opp* 11 We'll sink a test well, get up a derrick and a' engine, and have the thing running in no time. **1948** *Time* 21 June 1/2 When they finish drilling an oil well, they ordinarily dismantle the derrick, move it piece-meal to a new location.

b. derrick house, a house in connection with, and adjacent to, a derrick.

1901 *Munsey's Mag.* XXV. 743 The hillsides along Oil Creek were thickly dotted with derrick houses.

detassel dɪˈtæsl, *v. tr.* To deprive (corn) of its tassels. — **1892** *Irrigation Age* 15 Sep. 175/3 The average yield per acre was one bushel less on the detasseled row than on the rows undisturbed. **1947** *Chi. Tribune* 17 July 7/3 More than 100 girls are soon to arrive from Chicago to start detasseling the seed corn.

Hence **detasseler. Cf. corn detasseler.** — **1944** *Chi. D. News* 14 July 9/1 The detasselers, most of them of bobby-sock age and foreigners to rural life, left farm labor headquarters at 226 W. Jackson blvd. today in three . . . busses. **1948** *Chi. D. News* 9 Aug. 3/2 Most of the detasselers are 14 to 16 years of age.

* **diamondback,** *n.*

1. A turtle of a variety found along the Atlantic Coast having diamond-shaped markings on the shell. In full **diamondback terrapin.**

1877 BARTLETT 699 *Terrapin, (Palustris),* a name given to a species of tide-water tortoise, common in Connecticut and the Atlantic States south of New York, and considered an article of luxury. . . . The most celebrated is the diamond-back. **1887** *Lippincott's Mag.* Sep. 456 Baltimore, . . . the home of the soft-shell crab, the diamond-back terrapin, and the canvas-back duck. **1947** SESSIONS *Cities of Amer.* 52 There are few sections that would dare to claim a greater under-

standing of what to do with a díamond-back terrapin.

2. A rattlesnake of a species, *Crotalus adamanteus*, having diamond-shaped markings on the back. In full **diamondback rattler, rattlesnake.**

1894 CABLE *J. March* xxvii, Di'mon'-back rattlesnake hisself cayn't no mo' scare me 'n if I was a hawg. **1908** DITMARS *Reptile Book* 449 The flattened trails of the big Diamond-backs across the dry sandy roads . . . were as straight as the course of a wheel. **1948** *Popular Western* June 27/1 A diamondback rattler, sunning himself on the rocks there, buzzed its lethal warning as it snapped itself into a coil.

dill pickle. A pickle flavored with dill. Also attrib.

1904 O. HENRY *Heart of West* 224 No more long hairs in the comb or dill pickles lying around in the cigar tray. **1940** EARLY *N. Eng. Sampler* 279 Alice Longworth denied that she said the President [Coolidge] was weaned on a dill pickle, but it was a good line anyhow. **1948** *Fargo* (N.D.) *Forum* 19 Sep. 19/7 Little did she guess what the result would be when she tried a new dill pickle recipe.

*** disk, *n.*** Also * **disc.**

1. Short for "disk harrow" or "disk plow" *qq.v.*

1930 *Randolph Enterprise* (Elkins, W.Va.) 30 Oct. 8/2, 1 Deering binder; 1 two-horse disc; 1 manure spreader.

2. *attrib.* Designating agricultural implements having concave steel disks for pulverizing or breaking land, as (1) **disk cultivator,** (2) **drill,** (3) **harrow,** (4) **plow,** (5) **pulverizer.**

(1) **1894** *Irrig. Age* Jan. 34/1, I have found one of the best tools that we have yet used to be the disc cultivator. — (2) **1907** L. H. BAILEY *Cyclo. Amer. Agric.* I. 207 The disc drill is also used very extensively in many sections of the country where the soil is loose. — (3) **1896** *Vt. Agric. Rep.* XV. 101 The tools best suited to orchard use are the plough and wheel or disc harrow. **1949** *Reader's Digest* Feb. 119/1 The disk harrow, the cultivator, the hay rake, the hay loader and scores of other farm tools followed. — (4) **1881** *U.S. Patent* 15 March 9603 Disk plow. **1948** *Pauls Valley* (Okla.) *D. Democrat* 1 July 11/6 Several farmers in the Garvin-Murray soil conservation district plant bermuda roots from a platform built on a moldboard or disk plow. — (5) **1884** *Vt. Agric. Rep.* VIII. 282 Gang plows, disk pulverizers and sulky cultivators.

district school. A public elementary school within a particular district, esp. a school district. Also attrib.

1793 FRANCIS ASBURY *Journal* II. (1821) 158, I consulted the minds of our brethren about building a house for conference, preaching, and a district school. **1851** *Knickerb.* XXXVII. 66/1 These lands ought to be let out and pastured and buy district-school libraries. **1946** PARTRIDGE & BETTMAN *As We Were* 19 Only in the backward regions of the country does the district school still survive.

Hence **district schoolhouse.**

1843 *Knickerb.* XXII. 430 Interspersed in every few miles are the district school houses. **1872** HOLMES *Poet* i. 26 Beyond . . . [was] the district school-house, and hard by it Ma'am Hancock's cottage.

dog town. Also dogstown.

1. a. (See quot.) *Rare.* **b.** (See quot.) *Slang.*

(a) **1841** *Spirit of Times* 21 Aug. 299/1 (We.), This is emphatically a Dog Town, a town literally overrun by dogs. — (b) **1898** *N.Y. Herald* 4 Oct. 13/5 Washington is becoming quite a 'dog town,' as theatrical people call a city in which they 'try on' plays before bringing them to New York.

2. *W.* An area occupied by a community or colony of prairie dogs. Also attrib.

1843 in *Utah Hist. Quart.* II. (1929) 103 We are now past all the dog towns . . . saw plenty on the South Platte. **1850** *Western Journal* IV. 236 We were traversing a bare dogstown prairie. **1913** CATHER *My Antonia* 33 The dog-town was a long way from any pond or creek. **1942** Nat. Pk. Service *Fading Trails* 255 Now, the huge 'dog towns' of fifty years ago are present only in the memories of grizzled old-timers.

b. dogtown grass, (see quots.).

1913 W. C. BARNES *Western Grazing Grounds* 43 Owing to the presence in many portions of both these desert regions of a grass known as needle or dogtown grass (Aristida) and porcupine grass (Stipa spp.), the sharp awns of each of which work into the wool and finally into the very skin of the animals, sheep cannot be successfully grazed in these lower desert ranges. **1937** *Range Plant Hdbk.* G-20 Red three-awn, also known as dogtown grass, . . . is perhaps the most easily recognized species of the genus.

donate 'donet, *v.* [Prob. a back formation f. *＊donation.*] *tr.* To give (something) freely or as a donation.

This term occurs nearly a century earlier here than in British usage. "*Donate* . . . is a word which in Eng. is eschewed by good writers as a pretentious and magniloquent vulgarism. In Am. on the other hand, it has acquired a place in the vocab. of quite reputable terms" (Horwill).

1785 HILTZHEIMER *Diary* (1893) 23 April 72 Went to the State House yard to look at the rows of trees Samuel Vaughan, Esq., donated and is directing the planting of. **1852** *Harper's Mag.* IV. 692/1 In the Senate a bill has been reported . . . to establish a branch mint in the city of New York, on condition that the city donate land for a site. **1947** *Chr. Sci. Monitor* 16 Jan. 12/1 Funds to finance the scholarship program were donated by persons interested in the work of the Association.

absol. **1846** *N.Y. Tribune* 6 Nov. (B.), The friends of the cause in Massachusetts and other places donated liberally. **1904** *Baltimore American* 1 Dec. 14 He donated liberally to the church.

＊doodle, *v. intr.* To draw doodles during moments of absent-mindedness or enforced idleness. *Colloq.*

1937 *Lit. Digest* 26 June 19/3 'But everybody doodles.' So Gary Cooper, as Longfellow Deeds, in 'Mr. Deeds Goes to Town,' defended himself. He wasn't crazy because he drew squares and circles on scraps of paper—he was just 'doodling.' **1948** *Chi. Tribune* 27 Mar. 1. 8/3 A pencil and a pad; I doodle and reveal a skill I never knew I had.

Hence **doodler, doodling.**

1938 *Topeka* (Kans.) *Journal* 29 Oct 3A–2 Howard Hughes is an inveterate doodler with a preference for little inter-locking squares. **1944** *Chi. Tribune* 6 Aug. VII. 3/1 Even the telephone has not escaped a coat of canary yellow and some artistic 'doodling.' **1948** *Time* 19 Jan. 93/1 Now, there's a model doodler for our money!

Dorothy Perkins. A variety of rambler rose introduced by the Jackson & Perkins Nursery, Newark, N.Y., in 1901.

1915 *Country Life* March 49 Dorothy Perkins roses run riot over the rough poled superstructure of the pergola. **1928** *My Okla.* Feb. 7/2 This rose is no other than the beloved Dorothy Perkins. **1948** *Household* Feb. 74/2, I would suggest Dorothy Perkins and American Pillar as quicker to take hold than most of the more refined varieties.

* **doubtful,** *a.* Designating a state or county likely in an election to favor either or any candidate or party.

1824 *Commentator* (Frankfort, Ky.) 2 Oct. 3/1 New Jersey is one of the most doubtful states. **1887** *Cong. Rec.* App. 20 Jan. 50/1 They may appoint an agent in every doubtful county, in every doubtful State of the Union. **1917** *Ohio Arch. & Hist. Quart.* XXVI. 160 Of the more important states only New York and Ohio were really doubtful. **1948** *Chi. Tribune* 25 June 2/1 It is a doubtful state and will probably lose its state ticket.

draftee ˌdræf'ti, *n.* One who is drafted or conscripted for military service.

1866 F. KIRKLAND. *Bk. Anecdotes* 162 The young draftee appeared a little bewildered. **1930** MARK SULLIVAN *Our Times*, iii, 330 When the Great War combed the South for young men, from 12 to 33 per cent of the draftees were found to have the disease. **1948** *L.A. Times* 30 July 8/2 Each draftee will receive eight weeks basic military training after he has been processed and assigned.

drawbar 'drɔˌbar, *n.*

1. A bar or rail in a fence that may be let down or drawn out to afford passage.

1670 *Groton Rec.* 36 Out of that way . . . a sufficient pair of draw barrs to (be) kept and maintained at the end (of) Natha(niel) Lawrences field. **1836** *S. Lit. Messenger* II. 162 On every side I was met by gates, drawbars, and gaps. **1903** STILES *Four Years* 225 Right there abreast of the wagon was an enticing set of draw-bars.

2. A device for coupling railroad cars. Also transf.

1839 *Franklin Inst. Jrnl.* XXIV. 156 The bumpers or elastic cushions are to be attached . . . to the front and rear drawbar. **1918** *Essex Inst. Coll.* LIV. 213 The cars were shackled together by means of the link and pin, with wrought iron draw bars. **1947** *Chi. D. News* 22 Jan. 14/7, I took the suit back to F st. the next day and showed the man where it had pulled a draw-bar.

* **dressing,** *n.* In combs.: (1) **dressing bureau,** a dresser or bureau; (2) * **case,** (*a*) a dressing table, (*b*) a traveling case somewhat like a suitcase; (3) **comb,** a comb for dressing the hair; (4) **sack, sacque,** a loose

jacket worn while making one's toilet; (5) **stand,** a dressing table.

(1) **1841** *Spirit of Times* 10 July 218/1 (We.), Dressing bureaus. **1851** CIST *Cincinnati* 204 Fancy dressing bureaus, . . . corner etagers. **1906** MARK TWAIN *Autob.* (1924) (R.), I. 342 He noticed a bottle on his uncle's dressing bureau. — (2) (*a*) **1834** *Amer. R.R. Jrnl.* III. 726/1 Fine specimen of Portable Writing Desk and Dressing Case—a diploma. **1899** CHESNUTT *Wife of His Youth* 49 She went to the maple dressing-case, and opened one of the drawers. (*b*) **1838** COOPER *Home as Found* (1873) xxvi. 443 The dressing-case was complicated and large, having several compartments. **1931** FINLEY *Lady of Godey's* 20 And who is not familiar with Godey's reproductions that depict impossible ladies cavorting in voluminous gowns over wall-papers . . . dressing cases, waste-baskets? — (3) [**1790** *Pa. Packet* 19 April 4/2 John Murduck . . . has likewise for Sale . . . Dressing, rake, and tail combs.] **1830** *21st Congress* 1 Sess. H.R. State P. No. 16, 11 [An improvement] in the mode of making or manufacturing dressing combs, of wood [was patented by] Nathaniel Bushnell [of] Middletown, Conn. [on] April 14 [1829]. **1878** *Decorum* 287 The flasks can be carried with dressing-combs and the like in the satchel. — (4) **1865** A. D. WHITNEY *Gayworthys* xxiii. 217 Aunt Rebecca had on a striped dimity 'short-gown,' old-fashioned for 'dressing-sack.' **1916** DU PUY *Uncle Sam* 105 Sprawled across its floor was the form of a disheveled woman, frowsily blonde, shapely, clad in a dressing sacque. (5) **1886** *Delineator* Nov. 391 On the dressing-stand there should always be kept a small bottle containing camphor.

drip coffee. A drink prepared by allowing boiling water to drip through finely ground coffee. Also **dripped coffee.**

1884 F. E. OWENS *Cookbook* 307 Dripped Coffee. . . . Put the amount of ground coffee required in the bottom of the dripper. **1895** SALA *Life* II. 382 In the old French market on Sunday mornings we used to have an irreproachable French *déjeuner à la fourchette*, followed by the renowned 'drip' coffee, which is so strong that it is said to stain the saucer into which it is poured. **1909** O. HENRY *Options* (1916) 50 But if you're ever in the Middle West just mention my name and you'll get foot-warmers and dripped coffee.

b. *attrib.* Designating a receptacle or pot adapted for making coffee of this kind.

1897 *Outing* XXIX. 574/1 He . . . produced a jar of coffee and the drip coffee-pot. **1936-7** *Sears Cat.* Fall & Winter 650 8-Cup Drip Coffee Maker makes coffee by the French drip method, believed by many to produce a superior flavored brew. **1946** *This Week Mag.*6 April 23/1, I happened to have the bottom of the drip coffee pot in my hand.

* **dropper,** *n.*

1. (See quot. 1864.)

1864 WEBSTER 415/2 *Dropper,* . . . (*Mining*), a branch vein which drops off from, or leaves, the main lode. **1878** BEADLE *Western Wilds* 66 At a hundred feet or more in depth . . . there are whims, droppers, feeders.

2. A reaping machine having an attachment for depositing the grain at intervals.

1874 KNIGHT I. 754/2 With the bringing into action of the dropper, a cut-off is brought down to arrest the falling grain. **1886** *Sci. Amer.* LV. 373/3 It causes a Westerner to laugh to see small grain being cut with a 'dropper' or a self-raking reaper.

3. A medicine dropper. Also attrib.

1889 *Internat. Annual, Anthony's Photogr. Bul.* 12 The dropper is filled with alkali solution from the wide-mouthed bottle, a few drops run into the developer. **1944** *Sears Cat.* (ed. 189) 557 *Oleum Percomorphum.* . . . Handy dropper cap included. *Ib.* 558B Sears Approved Nose Drops . . . 1 oz. dropper bottle.

* **dump,** *n.*

1. A place where the waste and refuse of a city is dumped. See also **log dump.**

1784 HILTZHEIMER *Diary* (1893) 10 April 63 Attended the sale of the street dirt at the dumps. **1891** *Youth's Companion* 9 July 13/1 The emptied cans . . . are thrown by housekeepers into the domestic ash-barrel, and from there are taken to the town or city 'dump.' **1945** *Jefferson Co. Republican* (Golden, Colo.) 21 Nov. 1/6 This dump will serve residents of Lakewood and adjacent territory, including Montair.

b. *transf.* A place (house, town, etc.) that is unattractive or ill-kept. *Slang.*

1903 *Cin. Enquirer* 9 May 13/1 Dump—A house; saloon, hang-out for a gang. **1920** LEWIS *Main Street* 216 One thing I will say for that dump: they had it warm enough. **1945** WILLIAMS *It's a Free Country* 112 You better get used to it. She'll never come back to this—never come back here. To this hole, to this dump.

2. A hay mound. *Rare.*

1898 *Mo. So. Dakotan* I. 87 Fletcher and Watson followed at a slower pace and with forks piled the hay into dumps.

Duncan Phyfe. Used attrib. to designate furniture of a type designed by Duncan Phyfe (1768–1854), a New York cabinet-maker. Also transf.

1926 *Ladies' Home Jrnl.* Nov. 123/3 There were two Chippendale chairs, . . . a Duncan Phyfe mahogany table, and a special French chair upholstered in rose and ivory. **1935** *Montgomery Ward Cat.* (ed. 123) 392 Choice of Duncan Phyfe or 10-leg Heppelwhite Table, One Arm Chair and five Side Chairs. **1948** *Savings News* April 13 This lovely Duncan Phyfe extension table . . . is appropriate as an occasional table, for writing and for card games.

b. Duncan Phyfe log, (see quots.).

1915 *Country Life* April 48/3 Even in the West Indian forests the unlettered natives, who knew no English, had knowledge of his reputed judgment of wood, so that when a particularly fine tree was felled it was called by them a Duncan Phyfe log, was marked 'D.P.,' and put aside for his cargo. **1941** A. TRAIN, JR. *Story Everyday Things* 230 Exporters from Santo Domingo and Cuba would refer to their choicest pieces of timber as 'Duncan Phyfe logs.'

* **Durham,** *n.*

1. Short for "Bull Durham tobacco," a popular brand of smoking tobacco the trade-mark sign of which is a large Durham bull.

1877 RUEDE *Sod-House Days* 187 After dinner I chopped wood for exercise and then retired to the dugout and smoked all that was left of the Durham that Syd sent me. **1948** *Sat. Review* 28 Aug. 37/1 He pulled a bag of Durham from his breast pocket and quietly rolled one.

2. Durham boat, (see quots. 1915, 1935).

1769 SMITH *Tour* 78 We saw many of those long vessels called Durham Boats so useful to the Upper Parts of the [Delaware] River. **1915** S. DUNBAR *Hist. Travel in Amer.* I. 282 The Durham boat was a keel-boat shaped much like an Indian bark canoe, and it acquired its name from a celebrated eastern builder of river vessels. He was Robert Durham, of Pennsylvania, who began turning out his product about the year 1750 for use on the Delaware River, where the craft became very popular. **1935** DUNAWAY *Hist. Penn.* 290 The first real advance in transportation on the Delaware dates from 1750, when the Durham boats, named from the Durham iron furnace near Easton, began to be constructed.

Dutchy ˈdʌtʃɪ, *n.* Familiar form of "Dutch." Often used in address.

1835 HOFFMAN *Winter in West* II. 165 Where's Yankee and Dutchee? the bacon and greens are smoking on the table. **1864** TROWBRIDGE *Cudjo's Cave* 39 See here, Dutchy! ye hain't been foolin' us, have ye? **1941** SETON *Trail of Artist-Naturalist* 329 Dutchy's knowledge of German gave him a great advantage.

Also as *adj.*

1862 A. GRAY *Lett.* (1893) 495, I was . . . copying out Grisebach's manuscripts for the printer (for the printer won't touch the Dutchy-looking thing). **1893** J. H. Ross in *King's Business* (New Haven, Conn.) 127 The faces [in Rembrandt's Scripture pictures] are not ideal but Dutchy.

* **dyed-in-the-wool,** *a.* In a political or partisan sense: Thoroughgoing, uncompromising.

1830 *Mass. Spy* 10 Feb. (Th.), In half an hour [he can] come out an original democrat, dyed in the wool. **1906** BELL *C. Lee* 225, I am a dyed-in-the-wool Presbyterian, and I've fought, bled, and died for my religion in a family who believe that God created the Church of England. **1948** *Dly. Ardmoreite* (Ardmore, Okla.) 29 April 1/1 The same is true of the ordinary dyed-in-the-wool republican.

E

*E, n.

1. Used with various significations as a grade or mark in school (see quots.).

[**1890** in M. L. SMALLWOOD *Exams. & Grading Systems* 53 In each of their courses students are now divided into five groups, called A, B, C, D, E. . . . To graduate a student must have passed in all his courses, and have stood above the group D.] **1896** MOE *Harvard* 45 It is the place where many an unsuspecting Freshman has gone into with lightsome heart, only to emerge with wan cheeks, and eyes that picture despair. For many E's have here been made. **1899** *Western Reserve Univ. Cat.* 67 Students are graded in their studies by letters which have value . . . as follows: E (excellent) [etc.]. **1943** *Lake Forest Cat.* 33 Students' grades are recorded in letters. A signifies excellent scholarship. . . . An E is given for withdrawal from a course without permission.

2. An abbreviation for "error" in baseball.

1880 *Dly. Inter Ocean* (Chi.) 3 June 6/3 The Score: Chicago. AB R · BH HR PO A E. **1902** *Chi. Record-Herald* 1 Sep. 10/1 Chicago R. H. P. A. E. **1921** *St. Louis Globe-Dem.* 5 June 14/8 Cleveland . . . AB. H. O. A. E. **1945** *Athol* (Mass.) *D. News* 24 May 4/1.

Easterner ˈistənɚ, *n.* A native or inhabitant of the eastern part of the U.S.

1840 LOWELL *Letters* (1894) I. 59, I am on the best of terms with 'Southerners,' 'Westerners,' and 'Easterners.' **1890** *Voice* 7 Aug., These amounts may seem small to Easterners. **1949** *This Week Mag.* 5 March 28/2 The pinto bean is a stranger on the easterner's table.

Eddyism ˈɛdɪˌizəm, *n.* [After Mary Baker *Eddy* (1821–1910), founder of Christian Science.] = **Christian Science.** — **1903** *N.Y. Times* 29 Sep. 8 The description of Eddyism is accurate enough, but we are vastly mistaken if this 'unique product' has not had innumerable predecessors. **1924** *Amer. Mercury* Jan. 104/1 The New Thought was derived originally from the same well of wisdom as Eddyism.

efficiency expert. One who does things efficiently, esp. one whose profession is to devise more effective, economical methods of doing things.

1922 *Outing* Dec. 133/1 Gently I led him within reach of the net, and the 'Efficiency Expert,' true to form, landed him with a flourish. **1924** SHEPHARD *P. Bunyan* 184 Paul hired a kind of efficiency expert to help him on that, and that fellow, Gerber, used to walk around among the different camps and keep tab on the men and count up how they spent their time, and he certainly could make up some big figgurs, all right. **1948** *Dly. Ardmoreite* (Ardmore, Okla.) 1 April 6/6 Before the war, one efficiency expert figured it cost the government over $100 to answer a letter.

El ɛl, *n.* Short for "elevated railroad" or "elevated train." Also attrib. or as adj. *Colloq.* Cf. **L.**

1929 *New Yorker* 17 Aug. 21/2 People said 'the El' . . . , the brevity and humor of the name being another evidence of the metropolitan spirit. **1938** WHITE *One Man's Meat* 2 At that instant an El train joined us and I had to start again and shout. **1946** *Time* 23 Dec. 20/2 Along Third Avenue, blacked out and shaken by the thundering El, Irish bars and French bistros alternate with English and Swedish restaurants.

electrician ɪˌlɛkˈtrɪʃən, *n.* Originally one who studied and experimented with electricity; now one whose business is to instal and repair electrical equipment.

1751 FRANKLIN in *Phil. Trans.* XLVII. xliv. 291, I have not heard that any of your European electricians have been able to . . . do it. **1806** WEBSTER 99 *Electrician,* . . . one versed in electricity. **1885** *Cent. Mag.* XXX. 581/2 The shop staff commonly includes . . . upholsterers, silversmiths, and an electrician. **1947** *Time* 16 June 33/1 The electrician had to work overtime.

Elmira system. A system of prison management adopted at the reformatory at Elmira, N.Y., in 1876, based upon sentences of indeterminate length with possible commutations.

1891 WINTER *N.Y. State Reformatory* iv, The Elmira system is by no means yet in a perfect or final shape; it is still in course of growth. [**1900** FLYNT *Itinerant Policeman* 92, I visited but one reformatory during my pilgrimage, but it was representative of the latest of these institutions. I refer to the Elmira, N.Y., type.] **1935** FLICK *Hist. State N.Y.* VIII. 295 The Elmira system was unquestionably a real step forward a half century ago.

* **emery,** *n.*

1. = next. *Rare.*

1864 *Hist. North-Western Soldiers' Fair* 71 [Donations include] 2 soldiers' reticules, 3 pin cushions, 5 emeries, 1 crochet tidy.

2. emery bag, a small bag filled with powdered emery, used for keeping needles clean and bright.

1845 *Lowell Offering* V. 200 The strenuous application, by which I drove the perspiration from every pore of the hand, soon taught me the value of an emery-bag. **1893** MARK TWAIN *P. Wilson* ii., They would smouch provisions, . . . or a brass thimble, . . . or an emery-bag.

b. Also **emery ball, strawberry.**

1864 *Hist. North-Western Soldiers' Fair* 101 [Donations include] 3 bead bracelets, 2 emery balls, 6 scissors cases. **1903** WIGGIN *Rebecca* vi. 69 She polished her needles to nothing, pushing them in and out of the emery strawberry, but they always squeaked.

* **employment,** *n.* In combs.: (1) **employment agency,** = next; (2) **bureau,** an office or agency that facilitates employment by establishing contact between the employee and the employer; (3) **office,** = prec., cf.

public employment office and see **house of employment.**

(1) **1888** *12th Rep. Ohio Bur. Labor Statistics* 263 'Employment agencies' . . . have very appropriately been characterized as 'a class who trade on the needs of the inexperienced searcher for honest employment.' **1949** *Dly. Oklahoman* (Okla. City) 13 Feb. D. 8/5 Later she established an employment agency. — (2) **1886** *Standard Guide of Washington* 204 Dondore and Morse, Attorneys, prosecute claims before all the departments, also Employment Bureau. **1916** DU PUY *Uncle Sam* 208 The employment bureau immediately supplied her demand. — (3) **1858** *Varieties* (S.F.) 29 May 5/3 M. J. Smith & Co., have opened at 203 Clay street, opposite the Plaza, an employment and general agency office. **1948** *Gainesville* (Tex.) *D. Register* 2 July 5/2 Employers, including farmers, who are needing assistance, are urged to contact the employment office.

English corn. Any one of various cereals, esp. wheat, in contradistinction to Indian corn or maize. Now *hist.*

1629 *Mass. H.S. Coll.* I. 118 They have tryed our English corne at New Plimmouth plantation. **1696** *First Planters of N. Eng.* 17 Both the English and Indian Corn being at ten shillings a strike . . . we made laws to restrain the selling of Corn to the Indians. **1780** *Warren-Adams Lett.* II. 136 We have lately had fine rains, but they came too late for Hay, and a full Crop of English Corn. **1884** *Cent. Mag.* Jan. 431/1 The device on the seal of East Jersey is wrought of 'English Corn' and 'Indian Corn,'—wheat and maize,—symbols of the soberer expectations at the period of the Scotch and Quaker migrations. **1906** *Old Dartmouth Hist. Sk.* XIII. 14 He sold his homestead for 22 pounds sterling, to be paid in . . . English corn.

enumerated powers. Powers of a governmental kind which are expressed as distinguished from those that are implied.

1791 JAS. MADISON in *Deb. Congress* (1834) 1947 The essential characteristic of the U.S. Government, as composed of limited and enumerated powers. **1819** in *Sp. & Doc. Amer. Hist.* II. (1844) 6 This government is acknowledged by all to be one of enumerated powers. **1895** in *Doc. & Sp. Amer. Hist.* III. (1943) 185 The powers of government are distributed between the State and the nation, and while the latter is properly styled a government of enumerated powers, yet within the limits of such enumeration [etc.].

equestrian drama. A type of play in the action of which one or more horses are featured. *Obs.* Cf. **horse drama.**

1841 *Spirit of Times* 22 May 144/1 (We.), In the equestrian drama, Mr. Creswick did himself much credit. **1844** JOE COWELL *Thirty Yrs. Among Players* 49, I received an offer . . . to undertake the principal character in a magnificent equestrian drama, called 'Gil Blas.' **1880** N. M. LUDLOW *Dramatic Life* 337 This lady had been away on a short 'starring' excursion, but returned . . . to perform in these equestrian dramas.

escalator ˈɛskəˌletɚ, *n*. [From "Escalator," a trademark made from *escala*de and eleva*tor*.] A continuous

moving stairway by which passengers are carried from one floor to another, usu. in large stores.

1900 *N.Y. Jrnl.* 25 Nov. 59/2 To those who do not know what the escalator is the information is vouchsafed that it is a movable stairway built by the Otis Elevator Company for the use of passengers of the Manhattan Elevated Railway. **1948** *Newsweek* 8 March 44/1 You have probably ridden on an escalator, those so-called 'moving stairways' that carry throngs of shoppers from one floor to another in busy department stores.

fig. **1943** HICKS *Amer. Dem.* 729 Always a dependable regular, he climbed aboard the political escalator in 1899 when he became a councilman. **1948** *Time* 7 June 21/3 Labor leaders have never liked cost-of-living 'escalator' contracts, on the grounds that they tie the worker to a fixed standard of living.

* **Eskimo,** *n.*

1. Eskimo curlew, the now extinct, or nearly extinct, doebird, *Numenius borealis* (Forster); in earlier use, a curlew of a related species.

1813 WILSON *Ornithology* VII. 22 The Esquimaux Curlew . . . is called by our gunners on the sea-coast, the Short-billed Curlew. **1839** PEABODY *Mass. Birds* 366 The Esquimaux Curlew, *Numenius Hudsonicus* . . . are shot in Boston Harbor. **1921** *Outing* May 65/1 For that reason the passenger pigeon, the great auk, the heath hen, the Carolina parakeet, the Eskimo curlew are no more.

2. Eskimo Pie, a trade name for a chocolate-covered ice cream bar.

1928 TURNBOW & RAFFETTO *Ice Cream* 57 Chocolate-coated ice cream bars were introduced in 1921 as 'Eskimo Pies.' **1949** *Time* 14 Mar. 31/1 In the '30s he visited the U.S., brought back to Russia the Eskimo Pie.

* **evaporator,** *n.* A shallow rectangular receptacle, usu. with wooden sides and a metal bottom, used on an arch (sense **2.**) in converting sugar cane juice or maple sap into sirup or sugar.

1822 *Farmer's Diary* (1823) (Canandaigua, N.Y.) C3ʳ The evaporators are not removed during the summer, but only turned bottom upwards and exposed to the weather. **1892** *Outing* March 461/2 We draw near the blazing fire and watch the men pour into the great mysterious evaporators the sap which runs its tortuous course and comes out syrup at the other end. **1948** *Democrat* 5 Aug. 1/4 Galvanized Evaporators for syrup making, sizes 7½, 9 and 10½ ft. lengths.

Evaporator in place on an arch (sense 2)

everglade 'εvə͵gled, *n*. [See note.]

App. f. *＊ever+glade*, but if so the formation is somewhat irregular and the intended etymological sense uncertain, unless *ever* was used loosely in the sense of "interminable."

1. A low, marshy region, usu. under water and overgrown with tall grass, cane, etc. Chiefly *cap*. and *pl*., with reference to the extensive region of this nature in Florida.

1823 TANNER *Map Florida*, Extensive Inundated Region . . . generally called the Everglades. **1893** *Harper's Mag*. March 508 Many of them [Seminole Indians] have rescued white men who have become lost in the interminable mazes of the grassy and island-cluttered Everglades. **1947** *Nat. Geog. Mag*. Feb. 232/2 Experimental plantings have been made in the Everglades and other points in Florida.

b. Everglades National Park, (see quot.).

1947 *So. Sierran* Aug. 1/1 On June 20, Secretary of Interior Krug signed the order establishing 710 square miles in southern Florida as Everglades National Park.

2. everglade kite, (see quot. 1889).

1889 *Cent*. 2040/2 *Everglade kite, Rostrhamus sociabilis*, having a long, very slender, and much-hooked bill. **1895** *Dept. Agric. Yrbk. 1894* 218 The everglade kite is found within our borders in Florida only, where it is restricted to the middle and southern portions. **1942** Nat. Pks. Service *Fading Trails* 169 In fact, there are only one or two spots in the entire State where, with luck, an Everglade kite may be seen.

＊excavator, *n*. A machine for excavating earth, a steam shovel. Cf. **digging machine.**

Patents for such machines began as early as 1820 and by 1873 over one hundred patents had been issued for devices of many kinds called "excavators."

1843 *Niles' Reg*. 25 Nov. 200/1 With this excavator he is levelling hills. **1848** *Rep. Comm. Patents 1847* 72 Two patents have been granted for excavators. **1878** *Pat. Off. Gazette* XIV. ᐧ 654/2 Excavators [patented by] Anderson W. Terrill. **1910** *Ib*. CLIV. 280/1.

experience meeting. A meeting for the telling of one's religious experiences. Also transf.

1868 BEECHER *Sermons* (1869) I. 239 He . . . is at last persuaded to go to an 'experience meeting.' **1883** *Cent. Mag*. Sep. 785/1 The great literary symposium on the novel has resolved itself into a general experience-meeting. **1887** *Nation* 5 May 375/3 Just before he [Blaine] went out to the Indian Territory there had been a sort of 'experience meeting' among the editors of the Republican organs of that part of the country.

expressage ɪk'sprεsɪdʒ, *n*.

1. The fee charged for transporting goods by express. Also fig.

1857 in *Calif. Hist. Soc. Quart*. IX. (1930) 143 Paid Farley $5 for expressage. **1891** *Memphis Appeal-Avalanche* 22 April 6/5 Parties ordering must pay expressage both ways. **1909** O. HENRY *Roads of*

Destiny viii. 133 What'll the expressage be to take me out there with you?

2. The sending of articles by express; articles or goods sent in this way.

1887 GEORGE *40 Years on Rail* ii. 41 He looked on expressage as an intruder and an antagonist. **1905** *N.Y. Ev. Post* 17 May 14 The result is expected to be that Cuba will admit foreign expressage under regulations similar to those in force in the United States.

eye-opener.

1. A drink of whisky or wine, esp. one taken early in the morning. Also transf. *Slang.*

1818 FEARON *Sks.* 252 Drinking . . . is effected by individuals taking their solitary 'eye openers,' 'toddy,' and 'phlegm dispensers,' at the bar. **1873** HOWELLS *Chance Acquaintance* (1882) 56 For an eye-opener there is nothing like a glass of milk. **1948** DICK *Dixie Frontier* 189 Ministers regularly took their morning eye-opener and their nightcap in the evening.

2. Something most surprising or enlightening. *Colloq.*

1863 *Rio Abajo Press* (Albuquerque, New Mexico) 3 Feb. 2 Quite a catalogue of similar examples of injustice and meanness . . . might be made . . . , but we merely allude to them as an 'eye-opener' to the public. **1897** *Outing* XXX. 553/2 After this effectual 'eye-opener' we both hurried into our clothes.

3. (See quot.) *Rare.*

1868 *Putnam's Mag.* II. 47 A slight furrow is opened on the 'cotton-bed' with a rude implement which my Irish overseer called an 'eye-opener.'

F

*F, *n.* Used as a mark in schools, usu. to indicate failure.

1897 FLANDRAU *Harvard Episodes* 278 To give him an E—the lowest possible mark . . . always excepting . . . F—would be to bring upon himself Prescott's everlasting anger. **1898** in SMALLWOOD *Exams. & Grading* 52 [Mt. Holyoke] adopted a . . . [modified] plan of marking: A—95-100, . . . F—Failed. **1947** *Jrnl. Crim. Law & Criminology* Nov.-Dec. 315 The school report showed grades of 'A' and 'B' in all subjects for his sophomore year, from 'A' to 'F' (English) in junior year.

*faculty, *n.* A body of persons responsible for the governing and the teaching in an educational institution, consisting usu. of the president or principal, certain other

administrative officers, and the teaching staff. Also attrib.
Cf. **college faculty.**

1767 in J. MACLEAN *Hist. College N. Jersey* (1877) I. 292 They find
those gentlemen . . . still heartily desirous of concurring with the
Trustees of this College in the establishment and support of a Faculty.
1839 HENRY CASWALL *America* 200 [The professors] form a body de-
nominated the Faculty, and conduct the government of the institu-
tion by regulations and laws established by themselves in 'Faculty
meetings' from time to time. **1911** H. S. HARRISON *Queed* 218 The
president sat up late . . . going over and over his faculty list. **1945**
Life 16 July 72/1 On these pages are pictured members of Chicago's
faculty, one of the most awesome collections of brains ever set before
the camera.

b. faculty adviser, a member of the faculty of a
school, one of whose duties is to advise students, a
counselor.

1942 *Hiram Coll. Cat.* 33 All freshman students are assigned to spe-
cific faculty advisers.

fakir 'fekɜ, *n.* [App. erron. for *⁎faker*, in a somewhat
similar sense.] A peddler of cheap, worthless goods, esp.
in the street or at fairs.

1882 in POE *Buckboard Days* (1936) 99 Notice: To Thieves, Thugs,
Fakirs and Bunkco-Steerers. . . . If Found within the Limits of this
City after Ten O'Clock P.M. this Night, you will be Invited to at-
tend a Grand Neck-tie Party. **1891** QUINN *Fools of Fortune* 42 Here
it was opened in the presence of a large crowd of 'fakirs' who had
been drawn to Columbia by the fair then in progress. **1932** WILSON
Amer. Jitters 95 (Horwill), They find the patent-medicine fakir on
his motor-truck still holding a considerable crowd.

fallfish 'fɔl,fɪʃ, *n.* (See quots.) Cf. **red fallfish.**

*a*1811 HENRY *Camp. Quebec* 32 Several of our company angled
successfully for trout, and a delicious chub, which we call a fall-fish.
1820 RAFINESQUE in *Western Rev.* II. 241 Baiting Fallfish. *Rutilus
compressus* . . . a small fish from two to four inches long, called Fall-
fish, Bait-fish, Minny, &c. It is found in the Alleghany Mountains.
. . . The name of Fall-fish arises from its being often found near falls
and ripples. **1884** GOODE *Fisheries* I. 617 The Fall-fish—*Semotilus
bullaris.* The 'Fall-fish,' 'Chub,' 'Roach,' or 'Dace' is abundant in the
streams of the Eastern and Middle States east of the Alleghanies.
1947 DALRYMPLE *Panfish* 321 The Fallfish, *Semotilus corporalis*,
though much smaller, stands in about the same relationship to the
Trout, in waters east of the Alleghanies.

fan fæn, *n.*² [Usu. derived from *⁎fanatic*, but poss. f.
⁎fancy, collect. for those who frequent prize fights.] An
enthusiastic devotee or follower of a sport, hobby, etc.,
esp. baseball; an admirer of a writer, actor, etc. *Colloq.*

1896 ADE *Artie* xvii. 158, I'm goin' to be the worst fan in the whole
bunch. **1903** *Cin. Enquirer* 1 Jan. 4/2 Within a fortnight the work on
the new stands in the Land of Bleach at League Park and all other
improvements adjacent to the Palace of the Fans are expected to be

fasola

under way. **1948** *Capital-Democrat* (Tishomingo, Okla.) 3 June 7/1
Local fans will get their first home glimpse of league action Sunday
afternoon when the locals meet the Durant juniors.

b. fan mail, mail received by a celebrity from fans.
Also **fan letter.**

1925 WITWER *Roughly Speaking* 228 [He] stopped . . . to leave me
the morning paper and my fan mail. **1947** *Parade* 23 Feb. 21/1 Long
before she could read, she was receiving 15,000 fan letters per week.
1948 *Time* 10 May 85/1 The place was snowed under with fan mail.

c. fanfest, see **fest,** *n.*

＊ **farewell,** *n.*

1. ＊ **farewell-(to-)summer,** any one of various
late-blooming asters, as the calico aster, *Aster lateriflorus*.

1894 *Amer. Folk-Lore* VII. 91 *Aster diffusus*, farewell-summer,
nail-rod, West Va. **1940** STUART *Trees of Heaven* 49 Farewell-to-
summer is blooming on the cliffs in purple and white masses.

2. farewell-to-spring, a showy-flowered annual,
Godetia amoena.

1902 *Out West* May 512, I love the parted lips Of that weird flower
folk call 'farewell-to-spring.' **1948** *Nat. Hist.* June 260/2 Here was . . .
a Joseph's coat of golden poppies, blue lupines, white primroses, and
mauve godetia, those tissue-petaled Farewells to Spring.

Farmers' Alliance. Any one of several associations
of farmers for mutual benefit, sometimes acting as a dis-
tinct political party. Also attrib.

At first local associations, farmers' alliances were subsequently
combined into state and regional organizations, most important of
which were the National Farmers Alliance of the Northwest and the
Farmers' Alliance and Industrial Union of the South.

1880 in DUNNING *Farmers' Alliance Hist.* 28 We as the Farmers' Al-
liance . . . should set forth our declaration of intentions. **1893** THANET
Stories 52 Nelson . . . had been an Abolitionist, a Fourierist, a Social-
ist, a Greenbacker, a Farmers' Alliance man. **1904** in *Kansas Hist.
Soc.* IX. 1 The first Farmer's Alliance originated in Lampassas
county, Texas, in 1874 or 1875, and was organized for the purpose of
protecting the farmers from the encroachments of the wealthy cattle-
men, who sought to prevent the settlement of farmers in that section
and to keep the lands in pasture for the use of their ranch herds. **1943**
HICKS *Amer. Dem.* 561 The National Farmers' Alliance representing
the Northwest, and the Farmers' Alliance and Industrial Union
representing the South.

fasola ˈfasoˌla, *n. S. Music.* [A term made up of *fa,
sol,* and *la,* the fourth, fifth, and sixth tones of a diatonic
scale.] Usu. attrib. in expressions referring to singing in
which buckwheat notes *q.v.* are used and to those who
sing by these notes. *Colloq.*

1933 JACKSON *(title)*, White Spirituals The Story of the Fasola Folk.
Ib. 3 The word 'Fasola' is not of my making. . . . But ask almost any

[85]

real country person of mature years anywhere in the wide stretches of the southern states . . . if he knows anything about fasola singers, and he will very likely be able to direct you to one of them. **1933** *Musical Quart.* Oct. 397 The 'Fasola Folk,' those who still apply the Elizabethan names to the notes of songs made in pre-Revolutionary America and sing them with the help of the 132-year-old 'patent notes,' still number from about 30,000 to 50,000 souls. **1943** POWELL *Home Again* 72 We called it 'do-ra-me' or 'fa-so-la' singing.

F.B.I., FBI. Abbrev. for "Federal Bureau of Investigation," so named in 1935. Also attrib. Cf. **G-Man.**

1936 *Lit. Digest* 21 Nov. 36 The outlaws shot their way out killing one FBI man while 'Little Mel' traded shots with 'Baby Face' Nelson. **1947** *Denver Post* 8 June (Mag.) 2/1 The FBI showed the 'students' how the bureau's great laboratory in Washington, D.C., may be used to best advantage. **1948** *Woman's Day* March 9/1 The F.B.I. and all the other investigators get on the scene to search for subversive causes.

fedora fɪˈdorə, *n.* [See note.] A soft hat, usu. for men, with a low crown creased lengthwise; formerly one with the brim rolled high on the sides. In full **fedora hat.**

In 1882 the French playwright Victorien Sardou produced a tragedy, *Fédora*, named from its heroine, Fédora Romanoff, a Russian princess. In 1883 this play became quite popular in this country with Fanny Davenport as the leading lady. It was app. the name of the Russian princess in the play that inspired the use of "fedora" here shown.

1899 ADE *Doc' Horne* 59, I had on a new white Fedora hat, cost me three-fifty. **1910** *N.Y. Ev. Post* 21 April, Then one forgot the coffee-

Fedora, Stetson, and derby hats

stained coat and the fedora dented at wrong angles. **1948** *Dly. Ardmoreite* (Ardmore, Okla.) 29 April 1/2 These new creations will soon replace the old fedora.

Also *transf.*

1946 *Newsweek* 14 Jan. 87/1 The caption, 'Under the Hat,' was decorated by a cut of the famous ten-gallon Fiorello fedora.

* **female,** *n.*

1. female suffrage, suffrage for women. Also attrib.

1867 in *Kans. Hist. Quart.* VIII. 212 We consider the subject of female suffrage before the people of Kansas in so grave a shape as to warrant the candid consideration of what may be said, pro or con. **1893** *Harper's Mag.* April 707/2 Prohibition, female suffrage, fiat

money, free silver, every incoherent and fantastic dream of social improvement.

b. female suffragist, a woman who advocates women's suffrage.

1871 *Billings' Farmer's Allminax* II. Q.—Who iz the coming man? A.–The female suffragist. **1872** *Chi. Ev. Jrnl.* 30 Nov., The aim of the author has been to burlesque the female suffragists.

2. female tom, (see quot. and cf. **tom**). *Obs.*

1851 *True Standard* (S.F.) 6 Mar. 2/4 The miners near Placerville . . . now haul their earth a distance of two or three miles to be washed, using a tom of new construction called a female tom. It works on the same principle as the long tom's of olden time, but the dimensions are greatly increased. Instead of being a foot in width, the modern tom is two or three feet wide.

Ferris wheel. [G. W. G. *Ferris*, Amer. engineer, who designed the first such wheel for the World's Columbian Exposition in Chicago in 1893.] A large, vertical, power-driven wheel revolving on a stationary axis and having passenger cars suspended around its rim, used as an amusement device.

*c*1894 IVES *Dream City* n. p., The Ferris Wheel.—The chief wonder of the Fair of 1893 was the work of George Washington Gale Ferris. . . . At a Saturday afternoon club dinner, in a city chop-house, while the Fair was building, Mr. Ferris conceived the idea of the wheel. **1938** WHITE *One Man's Meat* 13 It was a fine clear day for the Fair this year, and I went up early to see how the Ferris wheel was doing and to take a ride. **1948** *Reader's Digest* Dec. 150/2 But she loved the Ferris wheel.

fest fɛst, *n.* [G., festival.] Used as the second element in miscellaneous expressions denoting spirited gatherings of an indicated kind, as **bund-, fun-, saenger-, schuetzen-, volksfest.** *Colloq.*

More established combinations of this kind are **gabfest, talk-fest, turnerfest,** *qq.v.*

1865 *Harper's Wkly.* 5 Aug. 490/2 Arrangements were made for the Saengerfest, which will be celebrated at Philadelphia in 1867. **1870** *N.Y. Tribune* 15 June 5/5 Second Day of the Schuetzen Fest. **1880** *Dly. Inter-Ocean* (Chi.) 1 June 7/6 The bundesvost was located at St. Louis for the next two years, and the same city was chosen for the bundesfest next year. **1893** *Chi. Tribune* 10 July 4/1 A volksfest was given yesterday for the benefit of the German Old People's Home. **1948** *Lawton* (Okla.) *Constitution* 30 June 2/1 Lawton Rotarians and their Rotary Anns turned the annual installation of officers into a funfest last night.

b. In expressions relating to baseball, as **fanfest, slugfest, swatfest.** *Colloq.*

1904 *N.Y. Ev. Amer.* 27 July, There was a regular fanfest over the rumors of difficulties among the Giants. **1904** *St. Louis Globe-Democrat* 5 July 7/1 Schlei took advantage of the swatfest to get a single.

1930 *Dixon* (Ill.) *Ev. Telegraph* 24 Sep. 7/1 The slugfest . . . produced 26 hits for the winners and 16 for the defeated Phillies.

fetterbush ˈfɛtəˌbuʃ, *n.* A plant belonging to any one of several genera of ericaceous shrubs, as *Neopieris nitida,* of the southern states. Cf. **evergreen fetterbush.**

1857 GRAY *Botany* 254 *A[ndromeda] nitida,* . . . the Fetterbush, . . . may grow in S. Virginia. **1860** CURTIS *Woody Plants N.C.* 95 *Fetter-Bush* (*Andromeda nitida.*) Found only in the Lower District in low Pine barrens. **1942** VAN DERSAL *Ornamental Amer. Shrubs* 257 *Leucothoe catesbaei* . . . is variously known as fetterbush, switch-ivy, doghobble, and ivy.

fiesta fɪˈɛstə, *n.* [Sp. in same sense.] A festivity or celebration. Now used loosely to designate any party where Spanish food, decorations, or costumes are featured.

1844 GREGG *Commerce of Prairies* I. 208 These *carretas* . . . [are] the 'pleasure-carriages' of the rancheros, whose families are conveyed in them to the towns, whether to market, or the *fiestas,* or on other joyful occasions. **1882** SWEET & KNOX *Texas Siftings* 91 The Mexicans have received considerable assistance from the Americans in properly celebrating the fiestas. **1948** *Sat. Ev. Post* 31 July 16/2 Reckon you came here to see our big fiesta, huh?

* **findings,** *n. pl.* Supplies, trimmings, tools, etc., used by shoemakers, dressmakers, etc. (see quot. 1847). Also attrib. Cf. **shoe findings.**

1833 *Boston Directory* 13 (*advt.*), Findings and trimmings, . . . lasts, boot trees, . . . shoe horns, [etc.]. **1847** WORCESTER 453/1 *Findings,* . . . the tools together with thread and wax, which a journeyman shoemaker is to furnish in his employment. **1862** ASHCROFT *Railway Directory* 22 (*advt.*), Railroad and car findings. **1896** *Godey's Mag.* Feb. 222/2 The cost of findings for a waist, . . . silk, . . . binding [etc.], . . . $2.09.

attrib. in *sing.* **1885** *Harper's Mag.* Jan. 280/1 The houses which sell these different component parts of a shoe are known as leather, stock, or finding dealers.

firecracker ˈfaɪrˌkrækə, *n.*

1. A paper cylinder containing a fuse and a small amount of explosive. Also attrib. and transf.

1829 *N.Y. Journal of Commerce* 4 July 4/2 (*heading*), Fire Crackers. **1852** STOWE *Uncle Tom* xxiii, The boy is . . . a perfect firecracker when excited. **1872** *Rep. Comm. Patents 1870* II. 681/1 Fire-cracker Holder. . . . A fire-cracker pistol, having a swinging breech-piece. **1948** *Okla. City Times* 14 June 2/2 The firecracker sizzled but nothing else happened.

2. Designating a California *flower* or *plant* of the genus *Brodiaea* (see also quot. 1942).

1907 LYONS *Plant Names* 510 Brodiaea coccinea. . . . Firecracker Flower. **1925** JEPSON *Flowering Plants Calif.* 229 B[rodiaea] ida-maia. . . . Fire-cracker Plant. **1942** VAN DERSAL *Ornamental Amer. Shrubs*

191 The red buckeye, *Aesculus pavia* . . . has bright red clusters of small flowers that appear in March or April in the South and as late as June in the North. . . . It is also known as scarlet buckeye and firecracker plant.

fireless cooker. A well-insulated apparatus for cooking by means of the stored-up heat from an initial heating. Also, sometimes, in colloq. use, a pressure cooker.

1908 E. A. HUNTINGTON (*title*), The Fireless Cooker. [**1912** *Out West* Jan. 96/1 The appliance is designed to burn the waste by means of a very powerful gas fire in a stove that is insulated as thoroughly as a first rate fireless cook stove.] **1945** MOLLOY *Pride's Way* 291, I believe Mrs. Wilson approves of a fireless cooker.

firewater ʹfaɪrˌwɔtɚ, *n.* [See note.]

In the earliest examples of the use of this term it is ascribed to Indians. It is prob. a translation of some Indian expression. Cf. Algonquin *scoutiouabou*, firewater.

1. Any strong or hard liquor, whisky.

1817 BRADBURY *Travels* 156 He informed me that they [the Indian chiefs] called the whiskey fire water. **1868** WHYMPER *Alaska* 37 The importation of 'fire-water' is not the only evil. **1947** COFFIN *Yankee Coast* 230 We stole the Abenakis' hunting grounds, cut their tall pines, ruined their sons with firewater.

fig. **1846** CHILD *Fact & Fiction* 169 They too learn that love is the glowing wine, the exhilarating 'fire-water' of the soul.

2. Water to be used for extinguishing fires. *Rare.*

1887 *Courier-Journal* 11 Feb. 3/5 Fire Extinguishers and Fire Water.

Five Civilized Tribes. "A term used both officially and unofficially in modern times to designate collectively the Cherokee, Chickasaw, Choctaw, Creek, and Seminole tribes in Indian Ter., applied on account of the advance made by these tribes toward civilized life and customs" (Hodge).

Under the government of the former "Indian Territory" their institutions combined tribal features with features of American state governments. Their own government, however, is now largely superseded by the government of Oklahoma.

1876 *Rep. Indian Affairs* 61 The Cherokees occupy and own perhaps the best reservation among the five civilized tribes. **1900** *Cong. Rec.* 3 Jan. 627/2 An agreement concluded by the Commission to the Five Civilized Tribes, on behalf of the Government of the United States, with a commission representing the Choctaw and Chickasaw nations on September 5, 1899. **1948** *Dly. Ardmoreite* (Ardmore, Okla.) 11 May 10/4 The president has approved senate joint resolution 189 to provide for the issuance of a special stamp in honor of the Five Civilized Tribes in Oklahoma.

*fixer, *n.* One who fixes (an election board, etc.); an adjuster of matters generally. *Colloq.* Cf. **jury fixer.**

1889 *Amer. Mission.* Dec. 363 Where the 'boss' and the fixer of elections are unknown. **1912** COBB *Back Home* 149, I'm the fixer for

this show—the legal adjuster, see? **1938** ASBURY *Sucker's Prog.* 306
Johnny Fix-'Em Condon was one of Mike McDonald's protégés, and
first appeared in Chicago as handy man and fixer for the McDonald-
Varnell-Hankins syndicate.

flame azalea. An ornamental plant, *Azalea lutea,*
having showy orange-colored flowers. Also **flame-
colored azalea.**

1847 WOOD *Botany* 376 R[*hododendron*] *calendulaceum.* . . . Flame
Azalea. . . . A splendid flowering shrub, in mountains and woods,
Penn. to Ohio. **1857** GRAY *Botany* 257 *A. calendulacea.* Flame-colored
Azalea . . . [is a] shrub . . . covered when the leaves appear with a
profusion of large orange blossoms, usually turning to flame-color.
1947 *Nat. Geog. Mag.* July 65/1 Both of these, the Catawba Rhodo-
dendron and Flame Azalea, belong to the same group of plants, the
Ericaceae or Heath Family.

* **flash,** *n.*

1. A brief news report, usu. received by telegraph or
teletype. Cf. **news flash.**

1857 *Richmond* (Va.) *D. Whig* 31 Aug. 3/1 The first flash came
across the ocean by the Submarine Telegraph at noon to-day. **1900**
Everybody's Mag. Nov. 226/1 Another device for beating time is the
'flash.' **1946** *This Week Mag.* 21 April 2/4 Flash. Here's a newspaper
story we heard the other day.

2. In combs.: (1) **flashback,** in motion pictures, a
cutback; (2) * **light,** a small electric torch operated on a
battery or batteries, also the light of this.

(1) 1918 V. O. FREEBURG *Photoplay Making* 19 The devices of lead-
ers, cut-ins, close-ups, flash-backs, visions, dissolving views, fade-
outs, fade-ins, double-exposures, dual rôles, etc., have a strong appeal
of novelty. **1948** *Chi. Tribune* 20 April 1. 22/5 Flashbacks depict the
relationship of the two men, which goes back to childhood. — (2)
1901 *Field & Stream* Jan. 774/2 The Comet Baby Flash Light. **1946**
Mazama Dec. 18/2 After some very unpleasant and awkward rock
climbing with our heavy packs by flashlight, we finally . . . compro-
mised on a little shelf at least 500 feet short of our goal. **1949** *Chi. D.
News* 18 Feb. 1/7 Using flashlights, they permitted no house lights to
be turned on.

Fletcherism ˈflɛtʃərɪzəm, *n.* The dietary principles of Horace
Fletcher (1849–1919), who advocated eating only when hungry and
taking only very small quantities of food thoroughly masticated. —
1906 *Suburban Life* Aug. 101/1 It is really an account of his investiga-
tion of what has been known as Fletcherism. **1913** *Ladies' Home Jrnl.*
March 69 A woman . . . who weighed more than two hundred pounds
has also undertaken Fletcherism and is getting good results.

flivver ˈflɪvɚ, *n.* [Origin unknown.]

1. A fizzle, a failure, *Slang.*

1915 H. L. WILSON *Ruggles of Red Gap* xiii. (1917) 230 He's the
human flivver. Put him in a car of dressed beef and he'd freeze it be-
tween here and Spokane.

2. A small, cheap car, esp. a Ford. *Colloq.*

*c*1914 in SULLIVAN *Our Times* (1932) 71 There was a fat man of Fall River, Who said as he drove his Ford 'flivver' [etc.]. **1949** *Mazama* Feb. 3/2 Just crank up that old flivver.

b. *attrib.* Designating things small of their kind (see quots.).

1918 in C. A. SMITH *New Words* 72 He commanded a flivver, which is the service name for the smaller class of destroyers, the 750-ton ones. In our navy there are plenty of your officers who tell you that they never built destroyers which keep the sea better than that same little flivver class. **1929** *Forum* March 160/2 For example, after flying to a city, it will be possible to land outside its limits and then use the plane as an automobile. Fundamentally this is the flivver air plane which I visualize. **1944** *Chi. D. News* 14 July 10/2 Despite the tremendous technological advances incidental to the war, the public must not expect revolutionary new automobiles, houses, . . . television sets or flivver helicopters in the immediate future.

float gold.

1. Gold that escapes during refining.

1873 RAYMOND *Silver & Gold* 17 We have a yearly loss in 'float gold' alone . . . of $84,960 from two single mills!

2. Gold brought down from a vein or lode by the action of water. Also **floated gold.**

1873 MILLER *Amongst Modocs* 204 They had found only a few bars with float gold. **1883** ERNEST INGERSOLL *Knocking Round Rockies* 85 Therefore placer-gold is sometimes known as 'floated' gold. **1931** WILLISON *Here They Dug Gold* 55 At the mouth of the gulch soon to take his name, Gregory stops to dig for 'float' gold washed down from veins on the mountains above. [**1947** CHALFANT *Gold, Guns, & Ghost Towns* 142 I've picked up some of the richest float [ore] over there that has ever been seen in these parts.]

flowage ˈflo·ɪdʒ, *n.* The flooding or overflowing of lands. Also attrib. and the proper name of a place overflowed.

1830 *Mass. Spy* 3 Feb. (Th.), The flowage, which would be occasioned by a dam to turn the water into the Feeder. **1860** *Mass. Bd. Agric. Rep.* I. 243 The subject of the flowage of low lands . . . was referred to a committee of three. **1884** *Harper's Mag.* Sep. 621/1 Flowage line [of a reservoir]. **1948** *Wis. Fishing Regulations* 2 A closed season is established for the taking, catching, or killing fish of any variety or fishing for fish from December 1 to the following April 30, both dates inclusive, on all waters commonly known as the Chippewa Flowage.

fluoroscope ˈflʊrəˌskop, *n.* [*∗fluor*escence+-(*o*)*scope.*] An instrument used for observing fluorescence, or, with X rays, in diagnostic medical examinations.

1896 *Lancaster* (Pa.) *D. New Era* 2 April 2 [Edison] calls his instrument the fluoroscope. **1898** *Pop. Science Mo.* LII. 569 Any variation in the size or position of the heart are [*sic*] readily made out by the use of the fluoroscope. **1948** *Sat. Ev. Post* 13 Nov. 121/2, I wonder if you

realize how much more can be accomplished in the laboratory; the uses of the fluoroscope, the spectrograph, and other equipment.

Also as a verb.

1948 MENJOU & MUSSELMAN *It Took 9 Tailors* 172 A couple of eminent specialists poked, stethoscoped, X-rayed, and fluoroscoped me but failed to diagnose or cure my pains.

* **flush,** *n.* and *a.*

1. flush tank, a tank for water forming part of a sewerage system.

1879 *Harper's Mag.* June 133/2 At the upper end of each main sewer there is placed a Field's flush tank. **1910** GERHARD *Water Supply of Modern City Buildings* 403 Flush tanks shall be constructed of hard burned brick laid in cement mortar and built perfectly water-tight.

2. flush times, *pl.*, a period of unusual prosperity.

[**1840** W. IRVING *Life & Lett.* (1866) III. 153 If times ever again come smooth and flush with me.] **1852** *S. Lit. Messenger* XVIII. 435/1 Such a spendthrift never made a track even in the flush times of 1836. **1949** *Chi. Sun. Tribune* (Book Sec.) 20 Feb. 4/1 In flush times there is great emphasis on novelty and quick turnover.

* **Folsom,** *n.* [*Folsom*, N. Mex.]

1. Folsom man, a Stone Age man thought to have lived in North America about 15,000 B.C.

1933 HARRINGTON *Gypsum Cave, Nev.* 190 [The] Late Pleistocene, 15,000 to 13,000 B.C., . . . was the day of 'Folsom man.' **1947** BROWN *Outdoors Unlimited* 183 They're still searching for the mysterious Folsom man whose distinctive weapons and other artifacts were found in New Mexico.

2. Folsom point, a flint point, probably for a javelin, thought to have been used by Folsom man.

1933 HARRINGTON *Gypsum Cave, Nev.* 176 The Texas specimens, although suggesting the Folsom points in chipping and general form,

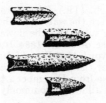

Types of Folsom points

lack this groove. **1947** *Chr. Sci. Monitor* 3 Dec. 1. 4/6 Many sites are listed in Arizona, Alaska, California, Colorado, Kentucky, and New Mexico, all containing artifacts of the so-called exquisite Yuma points or Folsom points.

fool hen. Any one of various grouse or quail which are remarkably unsuspicious and hence easily killed.

[1838 PARKER *Exploring Tour* 116, I saw . . . a new species of pheasant. . . . It is remarkably tame, as if unacquainted with enemies; and when assailed with stones by the Indians, appeared to be amazed, and made scarcely any effort to escape.] 1877 STANLEY *Rambles in Wonderland* 144 They will often sit or run by the road-side and the driver slays them with his whip, or knocks them over with a club. From this remarkable trait they are frequently known as 'fool-hens'—a suggestive title. 1912 WHEELER *Selkirk Mts.* 176 Immediately below is the habitat of Franklin's Grouse (*Dendrogapus franklinii*), the 'fool-hen' of the prospector and so called because it sits complacently on a branch until killed by a stick or a stone. 1945 MATHEWS *Talking* 112 Immature quail . . . are . . . like the dusky grouse in the Rockies called by the natives 'fool hens.'

attrib. 1880 *Rep. Supt. Yellowstone Nat. Pk.* (1881) 43 The fool-hen variety of the grouse is numerous around the margins of hot springs.

* **forestry,** *n.* In combs.: (1) **forestry cloth,** (see quot.); (2) **commissioner,** = forest commissioner; (3) **preserve,** = forest reserve (*a*).

(1) 1922 *Outing* Feb. 226/1 Forestry cloth, a dark brownish green, is becoming to everyone, shows soil as little as anything and comes in three weights—heavy and light serge, and flannel. It is tough and closely woven and catches on stubs and twigs less easily than any other fabric. — (2) 1907 ANDREWS *Recoll.* 13 [He served] as Forestry Commissioner or as secretary of the board of forest commissioners. — (3) 1942 *Gen. Cat. U. of Wis.* 415 The University Arboretum, Wild Life Refuge, and Forestry Preserve is a tract of 1137 acres of land on the shore of Lake Wingra, on the outskirts of Madison.

fourth class.

1. The freshman class, esp. in the Naval and Military academies. Also attrib.

1862 STRONG *Cadet Life W. Point* 116 We were evidently appearing too comfortable to suit a second or third classman's ideas of fourth-class propriety. 1905 LINCOLN *Partners* 70 At the end of the year he was 'promoted'—that is, he was no longer a member of the fourth class, but instead proudly left his seat when the third was called. 1908 *D.N.* III. 312 *Fourth* class, freshman class. Also *fourth* classman, etc. [e. Ala.]

2. One of the classifications for mail, domestic parcel post exceeding eight ounces in weight and including, chiefly, merchandise, farm and factory products, and printed matter. Also attrib.

1879 *Statutes at Large* XX. 360 All matter of the fourth class shall be subject to examination. 1901 RYAN *Montana* 87 The mail came every two weeks, and its magnitude was of the fourth-class order. 1948 *Chi. Sun-Times* 11 July 24/5 Fourth class, parcel post over eight ounces, earns 15 per cent of total revenue and costs 18.2 per cent of total expenses.

fox trot.

1. A smooth and easy trotting gait of a horse.

1872 ROE *Army Lett.* 70 He has a fox trot, which is wonderfully easy. 1911 WRIGHT *Winning Barbara Worth* 386 They went on . . . without

pause or check save the occasional change in gait from the swinging lope to the shuffling fox-trot. **1945** MATHEWS *Talking* 178 He does not need to be urged to strike a foxtrot down the backbone of the ridge.

2. A ballroom dance in four-four time. Also the music for this.

1915 *Victor Record Cat.* May, Dance Records. . . . Fox Trots. **1920** E. SCOTT *All about Latest Dances* 68 The true basis of the American Fox-Trot is an alternation of four slow and four or eight quick movements, depending on the step chosen. **1946** STANWELL-FLETCHER *Driftwood Valley* 127 They played mostly fox trots and we occasionally recognized the familiar strain of a modern tune.

frankfurter ˈfræŋkfətə, *n.* Also **frankfurt, frankfort.** [G. *frankfurter*, pertaining to *Frankfurt*, Frankfort, Ger.] A smoked, highly-seasoned link sausage composed chiefly of pork and beef. Also a small roll of bread made into a sandwich with a piece of this garnished to taste.

1894 *S.F. Midwinter Appeal* 17 Feb. 2/1 Four bits for a Frankfurter seems rather steep. **1901** *Cosmopolitan* Sep. 537/1 In the 'Alt Nurnberg' . . . the American girl gathers in force for dinner and nibbles imported frankfurters at forty-five cents each. **1948** *Parents' Mag.* March 161/2 Is outdoor cooking confined to frankfurters and marshmallows or will he learn to prepare a complete meal or cook on a rock?

attrib. **1899** *Chi. D. News* 16 May 5/4 Agar Bros.' Frankfurt Sausage, per lb. 7c. **1904** *Brooklyn Eagle* 9 June 4 People swelter and puff to get near a merry-go-round or a frankfurter stand. **1905** *Nation* 19 Jan. 42/2 The messenger boys, cab drivers, and frankfurter-peddlers of Broad Street [N.Y.].

b. frankfurt roll, a long raised roll which may be split to hold a frankfurter.

1941 *L.A.* Map 283. **1945** *Athol* (Mass.) *D. News* 5 July 3/6 (*advt.*), Frankfort or Dinner Rolls 13¢.

free delivery. The delivery of mail matter without charge. Also attrib. Cf. **rural free delivery.**

1871 BAGG *At Yale* 213 A branch post-office was connected with the Bookstore. . . . There was no 'general delivery' in connection with it. . . . New Haven has a 'free delivery.' **1919** CUNNINGHAM *Chronicle* 145 A few hours after the free delivery man left, old Thad come a foamin'. **1924** *Frontier* Nov. 23 It is true that the automobile, the free delivery, the telephone, and radio are all useful and wonderful.

✻ freestone, *n.*

1. Freestone State, a nickname for Connecticut, in allusion to its freestone quarries.

1846 *Warrock's Alman. 1847* (Richmond, Va.) 22 Connecticut, Freestone [State]. **1886** *Chi. Wkly. News* 29 April 4/3 Connecticut is the Nutmeg state, and its people are Nutmegs from their success in selling wooden for genuine nutmegs, it is also called the Freestone state.

2. freestone water, water in which there is little or no dissolved substance such as calcium, magnesium, etc.

1805 LEWIS in *L. & Clark Exped.* II. (1904) 269 We passed a number

of . . . springs which burst out underneath the Lar[boar]d clifts near the edge of the water; they wer[e] very cold and freestone water. **1849** *Rep. Comm. Patents 1849: Agric.* 135 Our free-stone water [i.e., in Cumberland County, Va.] is not well suited to irrigation. **1934** VINES *Green Thicket World* 70 And the men . . . drank mellow whiskey and good freestone water.

freeze-up ʹfriz₁ʌp, *n.* The freezing fast of lakes, rivers, and streams. Also transf.

1876 *The Dalles* (Ore.) *Tribune* 29 Jan. 3/2 We hope to see the day when . . . all the inhabitants east of the Cascades will not be detrimentally affected by any freeze-up which may occur. **1882** *Golden* (N.M.) *Retort* 28 July 3/2 He says a freeze-up occurred from insufficient fluxing, but thinks the smelter will start up again soon. **1904** J. LYNCH *3 Yrs. Klondike* 129 A couple of steam-engines had been . . . brought to Dawson last October just before the freeze-up.

freight train.

1. A railroad train that carries freight. Also attrib. Cf. **double-header 3, way freight train.**

1847 *Hunt's Merch. Mag.* XVII. 303 The total number of miles run by passenger, freight, and other trains, during the year 1846, amounted to 48,910. **1898** *McClure's Mag.* X. 395 The poor fellows on freight . . . must not exceed the regular schedule of freight-train speed. **1948** *Newsweek* 19 April 68/2 Watch a freight train pounding past and you'll see a miracle in the making.

2. A wagon train engaged in hauling freight.

1869 J. R. BROWNE *Adv. Apache Country* 450 Freight trains were drawn up in front of the tavern, the teams tied to the wagon-poles. **1900** DRANNAN *Plains & Mts.* 386 The second day's travel after crossing the summit of this mountain we met a freight train on its return to Salt Lake City.

frijol friʹhol, *n. S.W.* [Sp. in same sense. An Amer. borrowing.] Any bean of the genus *Phaseolus*, esp. the kidney bean, *P. vulgaris.*

1759 tr. VENEGAS *Nat. Hist. Calif.* I. 45 Father Francisco Maria Picolo . . . relates, that they have . . . the red frixoles, or kidney beans. **1831** BEECHEY *Voyage to Pacific* II. 50 Having served them with what he termed the *viatico*, consisting of a plentiful supply of cold fricole beans, bread, and eggs, he led the party to their sleeping apartment. **1949** *This Week Mag.* 5 March 28/2 That's the bean called pink, called frijole, called the Mexican strawberry.

b. A poker chip. *Rare.*

1903 *Cin. Enquirer* 2 May 12/2 Do these 18 blue frijoles that I hold go for Hogan?

frosh fraʃ, *n.* Colloq. for "freshman," "freshmen." Also attrib.

1915 in *Sooner Mag.* (1947) Nov. 14/1 The 'frosh' started a 'back to nature movement.' **1944** *Chi. D. News* 29 Nov. 3/1 Dr. Snyder followed her dutifully, after donning the frosh cap she had brought for him. **1949** *Ib.* 5 March 15/6 (*heading*), Frosh-Soph Hold Meet At Wheaton.

frost grape. The chicken grape, *Vitis cordifolia*, or its fruit (see also quot. 1862).

1789 *Amer. Philos. Soc. Trans.* I. 261 The frost or winter grape is known to every body, both the bunches and berries are small, and yield but little juice. **1862** *Rep. Comm. Patents 1861: Agric.* 481 The common names given to this species [*Vitis labrusca*] and *æstivalis* and *V. cordifolia* are not uniformly constant. All three are called in different sections 'Frost grape' and 'Fox grape,' and both æstivalis and cordifolia are often named 'Frost grape' and 'Chicken grape' in the middle States. . . . The Frost grape has long, compound racemes, with a smaller thinner skin, and fruit more acid. **1875** BURROUGHS *Winter Sunshine* ii. 48 If the weather is cold, he eats the frost grapes and the persimmons. **1942** TEHON *Native Ill. Shrubs* 191 The Frost Grape ranges, in woods and thickets, from New York to Nebraska, and south to Florida and Texas.

*** frying,** *n.*

1. frying chicken, = *** fryer.**

1897 THANET *Missionary Sheriff* 171 Therefore she bought her eggs and her 'frying chickens' of George Washington, a worthy colored man. **1905** MILES *Spirit of Mts.* 29 A frying chicken (the creature called a 'broiler' in northern and eastern communities), camping on Baby's trail of crumbs, chirps querulously.

2. frying size, used with reference to young chickens of the proper size for frying. Also absol. Also **frying-sized chicken.**

1904 HARBEN *Georgians* 119 They was the best fryin' size I ever raised. **1926** ROBERTS *Time of Man* 141 Say you had twenty hens to start, you could raise two hundred or three hundred frying-sizes in no time. **1946** WILSON *Fidelity* 80 You recall certain homely foods, foods associated with the old-fashioned country home, with its well-stocked smokehouse and with plenty of frying-sized chickens running around.

transf. **1884** C. H. SMITH *Peace Papers* 314 When I wer a fryin size chicken the biggest thing out was a trip to Augusty. **1904** HARBEN *Georgians* 99 He had a wife, some little fryin'-size children, an' a beautiful young daughter. **1943** POWELL *Home Again* 99 He . . . was much annoyed by a bunch of 'frying-sized' girls who kept going in and out of the church with the obvious purpose of showing off their new Sunday frocks. **1948** *N.O. Times-Picayune Mag.* 24 Oct. 7/3 Figuring that it takes two to four years for them to sprout again, these six- to eight-inch diameter trees are from 95 to 97 years old. Why, they're just frying size!

full blood.

1. An Indian of unmixed racial ancestry, a full-blooded Indian.

1846 SAGE *Scenes Rocky Mts.* xx, [The half-breed children] were more beautiful, interesting, and intelligent than the same number of full-bloods,—either of whites or Indians. **1898** CUSHMAN *Hist. Indians* 172 The young half-breeds mingle with the whites ninety per cent more than the full-bloods. **1949** *Dly. Oklahoman* (Okla. City) 13 Feb. D.

14/5 The notice listed more than 150 Cherokee Indians, mostly full-bloods, as owners.

2. An animal of an unmixed or pure breed.

1863 RANDALL *Pract. Shepherd* xi. 102 The full blood, or pure blood, or thorough-bred animal . . . can inherit from its parents . . . only the same family characteristics. **1884** *Cent. Mag.* Feb. 517/2 Almost every Vermont farmer was a shepherd, and had his half hundred or hundreds or thousands of grade sheep or full bloods dotting the ferny pastures of the hill country. **1894** *Vt. Agric. Rep.* XIV. 104 The terms 'thoroughbred,' 'full-blood,' and 'pure-bred,' are generally used in this country as practically synonymous.

functionalize ˈfʌŋkʃənlˌaɪz, *v. tr.* In business management, to distribute or assign (work) with due regard to the special function of the individual worker. Hence **functionalization,** *n.*

1923 R. H. LANSBURGH *Indust. Management* 55 Functionalization has brought with it basic changes in the structure of industrial organizations. *Ib.* 60 These functionalized foremen. *Ib.* 63 Functionalized departments working through one foreman. **1925** W. H. LEFFINGWELL *Office Management* 108 As business grows ever larger and becomes increasingly functionalized and specialized. *Ib.* 118 The functionalization of all industrial departments.

fundamentalist ˌfʌndəˈmɛntlɪst, *n.* (See quot. 1931.) Also transf.

1922 *N.Y. Times* 2 July III. 4/5 It is not only upon beliefs like the Virgin birth, the miracles, the resurrection of the body and the atonement that the Fundamentalists insist. **1931** F. L. ALLEN *Only Yesterday* 199 Those who believed in the letter of the Bible and refused to accept any teaching, even of science, which seemed to conflict with it, began in 1921 to call themselves Fundamentalists. **1947** *Christian Cent.* 24 Dec. 1597/2 A one-man 50-year fight in Minnesota against religious 'liberalism' ended with the death on Dec. 5 of William B. Riley, widely known Baptist fundamentalist.

attrib. **1929** PAUL DOUGLAS *Church Comity* 149 They make selective appeals; one, for example, to fundamentalist constituents, another to people of advanced theological position. **1948** CHAPLIN *Wobbly* 369 Isn't it strange that a state as beautiful as Tennessee should produce such simple, unquestioning fundamentalist faith?

* **funeral,** *n.*

1. funeral director, one who prepares the dead for interment and conducts burials, an undertaker. Cf. **mortician.**

1886 *Standard Guide of Washington* 178 Charles E. Carter, Jr., General Furnishing Undertaker and Funeral Director. **1945** *Ledger-News* (Antonito, Colo.) 19 July 1/2 Morticians and Funeral Directors must also adjust the sales tax charges to comply with the present law and regulations thereto.

2. funeral home, a building or rooms in a building which may be rented for funeral services, an undertaker's parlors.

1936 MENCKEN *Amer. Lang.* 287 A *mortician* never handles a *corpse;* he *prepares* a *body* or *patient*. This business is carried on in a *preparation-room* or *operating-room*, and when it is achieved the patient is put into a *casket* and stored in the *reposing-room* or *slumber-room* of a *funeral-home*. **1948** *Capital-Democrat* (Tishomingo, Okla.) 10 June 11/2 The Chapman Funeral Home, established by Russell's father, has been operating under the same name for 50 years.

3. In various colloq. phrases (see quots.), to denote that a matter is (or is not) the concern or worry of the person indicated.

1854 *Oregon W. Times* 25 Nov. (Th.), A boy said to an outsider who was making a great ado during some impressive mortuary ceremonies, 'What are you crying about? It's none of your funeral.' **1916** BOWER *Phantom Herd* 200 She's none of my funeral; I don't know her from Adam. **1948** *Sat. Ev. Post* 26 June 82/4 I assured LaGuardia that it was 'his funeral, and not mine.'

fyke faɪk, *n.* [Du. *fuik*, a bow net.]
1. = **fyke net.** Cf. **shad fyke.**

1832 in DE VOE *Market Ass't* (1867) 197 While some men were rowing up Newtown Creek, day before yesterday, they discovered a sea-dog stealing bass from a fuik of a bass-net. **1871** *N.Y. Laws 1685* The meshes . . . of fykes set in any of the waters surrounding Long Island, Fire Island, Staten Island . . . [shall be] not less than four and one-half inches in size. **1903** *N.Y. Ev. Post* 20 Oct. 3 He stopped up the stream with the exception of one narrow outlet, in which he placed his fyke. **1942** WEYGANDT *Plenty of Penna.* 45 They snig many an eel from the little ponds and they set fykes for the up-stream run of suckers in March.

2. In combs.: (1) **fyke fence,** (see quot.); (2) **fisherman,** (see quot.); (3) **net,** a hoop net for taking fish.
(1) **1858** *Harper's Wkly.* 24 April 267/1 To the uninitiated I would describe a fyke fence as a string of twigs, of a heavy growth, made like the panels of a fence and fastened to poles driven into the mud. An opening is left in the centre of this contrivance, to which a circular net is affixed, so that all fish coming with the tide, finding a barrier before their further progress up or down the river, turn aside, and pass into this inevitable net. — (2) **1889** *Cent.* 2422/2 *Fyke-fisherman,* . . . one who fishes with a fyke. — (3) **1842** *Nat. Hist. N.Y., Zoology* 1. 54 Mr. Everson . . . has taken them [*sc.* common seals or sea dogs], almost every year, in the River Passaic, in the fyke-nets. **1908** BAILEY *Harmful & Beneficial Mammals* 13 This is practically the fyke net used for catching fish.

G

gabfest ˈgæbˌfɛst, *n.* (See quot. 1919.) *Colloq.* Cf. **fest.**

1897 *Boston Transcript* 7 Jan. 15/7 A Chicago paper speaks of the speechmaking on Andrew Jackson's day as 'the Democratic gabfest.' **1919** *Editor & Publisher* 25 Dec. 30 (Mencken '36), McCullagh coined the word while writing a comment upon an unusually prolonged and empty debate in Congress. . . . As a great percentage of the readers of the *Globe-Democrat* throughout the Central West were of German birth or origin, *gabfest* was seized upon with hearty zest, and it is to-day very generally applied to any protracted and particularly loquacious gathering. **1949** *Ev. Northwestern* (Chi.) 11 April 2/4 Plans are made for a combination food-fest and gab-fest.

gachupin ˌgɑtʃuˈpin, *n. S.W.* [See note.] A Spaniard.
This term passed into American English from the Spanish of the Southwest. Santamaría favors deriving the Sp. *gachupín* from a Nahuatl expression meaning "a man with prickers," a term the natives may well have applied to Spanish horsemen in allusion to their wearing spurs.

1811 tr. HUMBOLDT *Political Essay* I. 153 Whites born in Europe . . . bear the name of *Chapetones* or *Gachupines*. **1842** *Texas Times* (Galveston) 7 Dec. 1/3, I do not like to oblige the *gachupins;* they never pay me. **1886** H. H. McLANE *Irene Viesca* 79 (Bentley), They took a large caballada of horses and mules belonging to the Gauchipins. **1931** M. AUSTIN *Starry Adventure* 100 He was a gauchapin, whatever that meant.

gambusino ˌgæmbəˈsino, *n. S.W.* [See note.]
A Spanish dialect term used in Amer. Sp. in the sense of a prospector, gold hunter. The suggestion by Santamaría that the word originated from the efforts of Mexican miners to pronounce the English "gamble-business" is interesting but app. quite without value.

A prospector, petty miner; an ore thief.

1844 GREGG *Commerce of Prairies* I. 173 The [New Mexican] gold regions are, for the most part, a kind of common property, and have been wrought chiefly by an indigent class of people, known familiarly as *gambucinos*, a name applied to petty miners who work 'on their own hook.' **1864** MOWRY *Ariz. & Sonora* 44 It still yields a good profit to the '*Gambussino*,' a sort of mining filibuster, who works regardless of the future of the mine. **1932** D. COOLIDGE *Fighting Men of West* 147 He made such an impression that he was invited to join the gambusinos.

gangster ˈgæŋstɚ, *n.* A member of a gang of roughs, criminals, etc. Hence **gangsterdom, gangsterism.**

1896 *Columbus* (O.) *Dispatch* 10 April 4/2 The gangster may play all sorts of pranks with the ballot box, but in its own good time the latter will get even by kicking the gangster into the gutter. **1923** *Nation* 26 Dec. 743/1 'Haunch Paunch and Jowl' is the autobiography of one who has come up in the world from sneak-thiefery and gangsterdom. **1927** *New Masses* March 19/4 Gangsterism reigned supreme, both in and out of the convention hall. **1947** *Chi. Sun* 30 June 8/1 Before I left Kentucky for my first visit to Chicago my mother warned me facetiously 'to be careful about the Chicago gangsters.'

Gardenia gɑr'dinɪə, *n.* [Dr. Alexander *Garden* (1730–91), Amer. botanist.] A genus of tropical shrubs and trees cultivated, esp. in the South, for its fragrant white or yellow flowers. Also (usu. not *cap.*) the flower of a plant of this genus.

1757 in *Scientific Mo.* (1948) July 18/2 Mr. Miller has called it Basteria. But if you will please to follow my advice, I would call it Gardenia, from our worthy friend Dr. Alexander Garden of S. Carolina. **1758** LINNAEUS in *Scientific Mo.* (1948) July 19/1 If Dr. Garden will send me a new genus, I shall be truly happy to name it after him, Gardenia. **1817** *N.Y. Herald* 29 March 3/5 William Price has for sale . . . a few hundred very flourishing plants of the Gardenia Florida or Cape Jasmine. **1941** DANIELS *Tar Heels* 95 A grammar grade school-teacher, from the tiny town of LaGrange, came, with a gardenia against her brown curls. **1947** *Nat. Geog. Mag* July 17/1 At Otranto, Alexander Garden, physician and plantsman, was carrying on a correspondence with Linnaeus, the great Swedish botanist. The *Gardenia* was named for him.

attrib. **1949** *Chesterton* (Ind.) *Tribune* 7 April 8/5 The bride's mother also wore a gardenia corsage.

*** garrison,** *n.*[2]

1. garrison flag, (see quot.).

1889 *Cent.* 2247/1 *Garrison flag*, a large flag furnished to the principal military posts in the United States, to be displayed on occasions of national importance.

2. garrison house, in frontier times, a strongly fortified log house serving as a refuge for settlers during Indian uprisings. *Obs.*

1676 SEWALL *Diary* 1. 12 The said Town burned, Garrison houses except. **1722** *N.-Eng. Courant* 10–17 Sep. 2/2 The Indian Rebels, to the Number of 7 or 800, did on Monday last burn all the Houses at

Garrison house

Arrowsick, except the 3 Garrison-Houses and 2 others. **1857** E. STONE *Life of Howland* i. 23 On this lot there then stood the old garrison house. **1927** *Old-Time New Eng.* Oct. 63/2 When all is summed up, it appears that the oldest log structures now standing in the United States are in New England, of which the McIntire 'garrison house' near York, Me., may be the earliest.

gasoline ˌgæsəˈlin, *n.* [f. * *gas* + * *-ol* + * *-ine*.] A volatile, highly inflammable liquid usu. obtained by refining petroleum.

1865 *Appleton Ann. Cyclo. for 1864* 669/2 The lightest naphtha . . . to this the name gasolene has been given. **1871** SOMERS *Southern States since War* 264 Among the novelties of manufacture, one of the two gas companies of the town [*sc.* Memphis] supplies gasoline made by vaporisation from the mineral oil of Pennsylvania. **1922** CATHER *One of Ours* 11 Occasionally a motor dashed along the road toward town, and a cloud of dust and a smell of gasoline blew in over the creek bottom. **1949** *N.O. Times-Picayune Mag.* 22 May 5/3 Black oil, yellow sulphur and crystal gasoline flow . . . through the massive gates along with other treasures, bound for the far places of the world.

attrib. **1881** *Harper's Mag.* May 815/1 The street hawkers, with gasoline torches, are crying their wares. **1927** JAMES *Cow Country* 171 There was stores along that highway too, and gasoline stations, school houses, and high elevators for the farmers' grain. **1949** *Desplaines Valley News* (Summit, Ill.) 8 April 1/3 Funds from the gasoline tax will be utilized to purchase and maintain 15 street light standards of the latest type.

* **Gatling,** *n. Mil.* A light, rapid-fire gun of a type perfected about 1862 by an American inventor, R. J. Gatling (1818–1903). In full **Gatling gun.** Also **Gatling battery.** Cf. **hopper mine, Union gun.**

1867 in C. B. NORTON & W. J. VALENTINE *Rep. Munitions* 96 The large bore Gatling gun . . . is said to make a good target up to 2,000 yards. **1867** *Ib.* 95 The only field gun in the American Section [at the

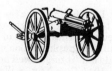

Early type of Gatling gun

Paris Universal Exhibition, 1867] is the 'Gatling Battery,' exhibited by Mr. R. J. Gatling, of Indianapolis, Indiana. **1880** *Harper's Mag.* May 917/1 The artillery is almost entirely the old brass Napoleon, no breech-loading field-pieces being in the hands of the National Guards, and but few Gatlings. **1947** *Westerner's Brand Book* 29 He not only refused five troops of the Second Cavalry but also Gatling guns; they would slow down his march.

b. =**gat.** *Slang.*

1880 *Amer. Punch* April 56/1 Is this yer a goll durned Republic where every sole kin kerry a gatlin under his cote tale an' vote as often as he pleezes? **1867** A. H. Lewis *Wolfville* 99 The victim . . . brings his gatlin' into play surprisin'.

geological survey. The preparation of topographic and geologic maps and similar data.

For an account of the history of the state and federal surveys, see *Bulletin of the National Research Council*, no. 88 (1932).

1835 *N.J. Acts 1834–5* 90 The Governor . . . is hereby empowered to employ some suitable and scientific person or persons to make a Geological and Mineralogical survey of the state. **1895** *N. Dakota Laws* 97 The geological survey shall be carried on with a view to a complete account of the mineral kingdom, as represented in the State.

b. (*cap.*) A bureau that gathers and publishes such data.

1867 (*title*), Annual Report of the United States Geological and Geographical Survey of the Territories. **1903** *Dept. Agric. Yrbk. 1902* 735 The Department of the Interior, through the Hydrographic Division of the Geological Survey, deals with questions relating to the water supply. **1947** *Mazama* Sep. 1/2 On June 30 he retired from the United States Geological Survey where he has served for many years.

✳ Gertrude, *n.* A long, loose slip of cotton or flannel for an infant. Also **Gertrude skirt.**

1926 *Mont. Ward Cat.* (ed. 105) 84 A long Gertrude Skirt of high quality white flannelette with white shell crochet stitching around neck, armholes and bottom. **1940** Eastman *Expectant Motherhood* 99 [Layette:] 4 *Gertrudes.* Depending on the season, flanelette, cotton and wool, silk and wool, and nainsook are the materials most commonly employed. **1947** *Infants' & Children's Review* Nov. 144/1 (*advt.*), Cotton Gertrudes, Embroidered Top & Bottom.

ghostwrite, *v. tr.* and *intr.* To write (something) for an employer who is the ostensible author; to write as a ghost writer for another. Also **ghostwriting, ghostwritten.** *Colloq.*

1928 *Forum* LXXIX. 27 Take for instance the rapid development of the phenomenon known to the trade as 'ghost writing.' **1932** *New Republic* 10 Feb. 347 He even reaches a point of enthusiasm where he is able to say of the autobiographical boloney ghost-written by Samuel Crowther for Ford that 'it might well be the Bible, as Ford is the prophet, of business.' **1947** *True* Nov. 8 We can assure that this story is not ghost-written. **1949** *Time* 30 May 64/3 Huie later ghost-wrote an attack on the 'obsolete' Navy for an Air Force general.

b. To write (a supposedly factual account) entirely from imagination.

1931 *K.C. Times* 17 July, Farm board, to the reporter, suggested Chairman Legge, and the hot weather suggested staying in off the dusty roads, and so he 'ghost-wrote' the interview which turned out to be an exhortation on legs.

gilsonite ˈgɪlsənaɪt, *n.* Uintaite, a kind of asphalt found in abundance in Utah, and first brought into prominence as an article of utility by S. H. Gilson, of Salt Lake City. Also attrib.

1890 *N. & Q.* V. (28 June) 101 Gilsonite is a mineral wax found in Utah, and mined to some extent. It was named from its discoverer, a Mr. Gilson. There is a Gilsonite Company in Salt Lake City, which handles the commercial product. **1903** *Indian Laws & Tr.* III. 18 In the lands within the former Uncompahgre Indian Reservation, in the state of Utah, containing gilsonite, asphaltum, elaterite. **1947** *Steamboat* (Colo.) *Pilot* 16 Jan. 3/3 Buckley M. Harrison, Uintah county horseman and ranch hand, was found dead at the old Rainbow gilsonite mine.

* **girl,** *n.*

1. girl friend, a female companion or sweetheart. *Colloq.*

1945 *Democrat* 24 May 4/3 We used to visit our girl friends back in the states. **1947** *Science Illust.* July 92/3 The steering wheel is a nuisance when one is parked with the girl friend observing the scenery on a moonlit Saturday night.

2. girl scout, a member of the Girl Scouts, an organization (known orig. as Girl Guides) formed in 1912 at Savannah, Ga. Often (*cap.*), in the *pl.*, the organization itself. Also attrib.

1920 *Ladies' Home Jrnl.* June 145/1 In 1912 Mrs. Juliette Low, now president emeritus of the Girl Scouts in America, started the first troop in Savannah, Georgia. *Ib.* 146/4 In Philadelphia the Girl Scout troops compete in a monthly banner contest, points for which are won almost entirely for 'homekeeping.' **1945** *Somerset News* 19 April 2/1 Girl Scouts will give out pamphlets and receive donations. **1949** *Lisle* (Ill.) *Eagle* 10 Mar. 2/3 This is the first verse of a Girl Scout song written about the Chalet.

Hence **Girl Scouting.**

1949 *Lisle* (Ill.) *Eagle* 10 Mar. 2/3 Each year, March 12, is a red letter day in Girl Scouting.

gnatcatcher ˈnætˌkætʃɚ, *n.* Any one of various small singing birds of the genus *Polioptila.*

1869 *Amer. Naturalist* III. 474 Not found westward of this [i.e., the Colorado] valley . . . [was] the lead-colored gnat-catcher. **1883** *Cent. Mag.* Sep. 685/1 The nest of the humming bird and the little gray gnat-catcher. **1934** *Nat. Geog. Mag.* LXV. 596 Gnatcatchers as a group are active and vivacious little birds that move rapidly through the branches.

gold brick.

1. Gold in the form of a brick or bar.

1853 *S.F. Sun* 7 June 2/2 (*heading*), Gold Brick. **1876** RAYMOND *8th Rep. Mines* 354 Individuals are constantly carrying out bags of gold and gold bricks and some silver bricks. **1899** *Mo. So. Dakotan* I. 196 [He] commenced looking around and found in a water hole a gunny sack in which was a gold brick.

2. A valueless brick that appears to be made of gold; hence, anything that appears to have value, but really has none. Usu. attrib. and in the phrase *to sell* (one) *a gold brick*, to swindle, cheat.

1887 *Courier-Journal* 29 Jan. 5/3 Gilmore swindled Patrick Burke, a citizen of St. Louis, out of $3,700 by the gold-brick trick. **1900** ADE *More Fables* 180 He began to think that in making any Outlay for Lutie's Vocal Training he had bought a Gold Brick. **1901** WHITE *Westerners* 94 Bunco men can clean him out in a gambling joint, but who ever heard of their selling him a gold brick? **1947** *Chi. D. News* 16 May 18/5 It used to be the city slicker who sold gold bricks to the hick from the country.

3. (See quots.)

1914 *D.N.* IV. 107 Gold-brick, n. Applied to army lieutenants appointed from civil life. 'The gold-bricks are overbearing.' **1943** *Reader's Digest* Oct. 97 The wise guy always complains when there is work to do. Sometimes [in the army] he is called a Gold Brick.

goldbug ˈgoldˌbʌg, *n.*

1. Any one of various beetles having a golden luster. Also "The Gold Bug," the title of a well-known story by Edgar A. Poe.

1843 POE (*title*), The Gold Bug. **1895** *Standard Dict.* 776/2. **1909** *N.J. State Museum Rep.* 355 It is one of the the 'gold-bugs,' the larvae of which are known as 'peddlers.'

2. An advocate of the gold standard. Also a badge or emblem worn by one of these. Also attrib. *Colloq.* or *slang.* Cf. **gold Democrat, gold Republican.**

1878 *Nation* 21 Feb. 126/1 [Our forefathers]˙carried on business in gold. . . . In short, they were 'goldites,' 'gold-bugs,' and 'gold-sharps.' **1893** *Ores & Metals* (Denver) 23 Aug. 396/2 There is not a goldbug paper in the whole Territory of New Mexico. **1896** *Cin. Enquirer* 30 July 1/7, I had a gold bug on my coat. A farmer came up to me and took hold of my coat collar and held the gold button up to view. 'That's the bug that got into our wheat,' he said, 'and reduced it 50 per cent.' **1942** LILLARD *Desert Challenge* 52 Bryan's inspired campaign, . . . the testimonials of Wall Street's 'goldbug' economists, the tension, the hysteria, and the final narrow victory for McKinley . . . is a chapter in the history of America.

Hence **gold-bugism.**

1895 *Voice* 11 July 4 We believe in the demonetization of both metals. If that is gold-bugism, tell it not in Wall Street.

gorilla gəˈrɪlə, *n.* [App. an African name. See note.]

This word, the name given by Hanno's African interpreters to the wild, hairy creatures found by the Carthaginian admiral in the Sierra Leone region of West Africa about 500 B.C., is preserved in the accusative plural form *gorillas* in the Greek translation of Hanno's account of his voyage. It is not clear what the creatures found by Hanno were.

1. The largest of the manlike apes, found chiefly in

forest regions of West Africa from the Cameroons to the Congo River.

1847 T. S. SAVAGE in *Boston Jrnl. Nat. Hist.* V. 419 The specific name, *gorilla*, has been adopted, a term used by Hanno, in describing the 'wild men' found on the coast of Africa, probably one of the species of the Orang. **1849** *Amer. Jrnl. Science* 2 Ser. VIII. 141 For the first recognition of gorilla (Engé-ena of the natives of Gaboon) as a new species, the scientific world is indebted to Dr. Thomas S. Savage. **1867** *Amer. Naturalist* I. 177 The Gorilla.... New England has the honor of having discovered this celebrated ape. The first specimen was brought to Boston by Dr. Savage. It was discovered by Professor Jeffries Wyman, and named by him after the wild men (*gorillae*) which Hanno mentions. **1949** *Reader's Digest* April 65/2 The supreme animal thinkers unquestionably are the three Great Apes— the orangutan, chimpanzee and gorilla.

2. (*cap.*) *transf.* A vituperative nickname applied to Abraham Lincoln during the Civil War. *Obs.* Cf. **Illinois gorilla.**

1861 *Richmond* (Va.) *Dispatch* 13 Nov. 3/3 He was long detained in Washington, having interviews with Abe, the Gorilla; Seward, the Raven; and Feathers Scott. **1881-5** McClellan *Own Story* 152 The extreme virulence with which he abused the President, the administration, and the Republican party.... [Stanton] never spoke of the President in any other way than as the 'original gorilla.'

b. As a general term of contempt for a person; in modern use, a highwayman or thug. *Slang.*

1869 MARK TWAIN *Innocents* iii. 36 Who is that spider-legged gorilla yonder with the sanctimonious countenance? **1910** *N. Eng. Mag.* July 587/1 The 'gorilla,' the strong-arm highwayman, ... holds up people on the roadside and relieves them of their valuables. **1947** *Chi. Tribune* 2 Nov. (Comics) 11 When the plane rolled to a stop 'The Head's' gorillas hid it under some bushes and took Jack into custody.

* **Gotham,** *n.* A nickname for New York City.

Usu. accredited to the authors of *Salmagundi*, who used it in allusion to certain inhabitants of New York who were regarded as wiseacres.

[**1806** *Lancaster* (Pa.) *Intelligencer* 6 May (Th.), The Man of Gotham, who prints the Freeman's Journal [published in Philadelphia], won't credit the Appointment.] **1807** IRVING *Salmagundi* xvii. 456 They all capered toward the devoted city of Gotham. **1883** *Pall Mall Gaz.* 9 July, John Jacob [Astor] has become, chiefly by the appreciation of the values of the property purchased by his father and grandfather, one of the three phenomenally rich men of Gotham. **1946** *Chi. Sun Book Week* 2 June 3/4 The lights of the city gleamed with impersonal brilliance on the good folk of Gotham hurrying home to their firesides and air-conditioned penthouses for the night.

* **gourdseed,** *n.* A variety of corn. In full **gourdseed corn.** Cf. **Virginia gourdseed.**

1780 DUNBAR *Life* 73 Planted white Corn & goard Seed Corn. **1819** THOMAS *Travels* 101 The gourd seed corn is generally cultivated....

The ears of this kind of corn are thick; and the grains so crowded as to be elongated like the seed of the gourd or calabash. **1870** *Rep. Comm. Agric.* 271 In the last made furrows the corn—a gourd-seed, red cob variety— . . . was drilled in, at distances of ten inches. **1947** *Ann. Mo. Botanical Garden* Feb. 15 The commonest name for these soft dents was 'Gourdseed,' since the flat kernels with a collapsed and more or less pointed tip resembled a pumpkin seed or gourd seed.

* **graded,** *a.*

1. Of roads and railroads: Made level or reduced to practicable gradients.

1835 in *S. Lit. Messenger* IV. 303/1 Several vehicles . . . were dashing along the well graded road. **1882** *Harper's Mag.* Dec. 60/2 A half mile of graded road-bed alone remains.

2. Of animals: Improved by careful crossbreeding.

1879 WILLIAMS *Pacific Tourist* 185/2 The immense range fenced in at this point is occupied by a select herd of graded stock. **1891** *Fur, Fin, & Feather* March 150 'Buffalo' Jones . . . has a very large ranch at Garden City, on which he has some two hundred full-blooded and graded bisons. **1948** *Chi. Tribune* 11 July 11/2 His herd is not registered, altho all his stock is graded.

3. **graded school,** an elementary school in which the pupils are grouped into grades according to their advancement.

1852 *Ind. Hist. Soc. Pub.* II. 615 Union, or graded schools, for the terms are synonymous, are simply the schools of a given township, village or city, classified and arranged according to the attainments of the pupils. **1889** *Union Pac. R.R.,Ore. & Wash.* 42 Among the schools worthy of mention is one first-class graded school, costing $20,000. **1945** *Democrat* 30 Aug. 3/3 The Grove Hill Graded School will also open on the above named date.

* **graduate,** *n.*

1. One who has finished at a school of lower rank than a college.

1773 J. ADAMS *Diary* Works II. 321 Their academy [in Phila.] emits from nine to fourteen graduates annually. **1852** *Boston City Doc.* No. 32, 19 Graduates from the City Schools. *Ib.* App. 4 The proposed Normal School will prepare from eighty to one hundred graduates every year. **1945** *Chi. D. News* 28 June 8/5 School bells of 45 years ago rang again last night in the memories of the living graduates of the 1900 class at the Burr Elementary School.

2. In combs.: (1) **graduate chapter,** (see quot.); (2) **course,** in a college or university, an advanced course, open, usu., to graduate students only; (3) **department,** a department in a college or university concerned entirely with advanced or graduate work; (4) **school,** a school, or a department in a college or university, in which only graduate work is given; (5) **studies,** studies or courses of

study in a graduate department; (6) **work,** work in a graduate course or department.

(1) 1871 BAGG *At Yale* 112 Delta Phi has also four alumni associations, or 'graduate chapters.' — (2) 1880 *Harvard Cat.* 190 Any Graduate course which is taken by less than three students may be withdrawn at the option of the Instructor. — (3) 1880 *Harvard Cat.* 190 (*heading*), Graduate department. — (4) 1895–6 *Univ. Nebraska Calendar* 37 The Graduate School provides for advanced University work on the basis of completed undergraduate studies.

(5) 1947 *This Week Mag.* 17 May 7/2, I gave up tournament golf the day I began my graduate studies. — (6) 1944 *New Yorker* 7 Oct. 63/1, I was an undergraduate at a little place in the Middle West that you never heard of, but then I went to business school at Harvard. Graduate work, of course. 1948 *Chi. D. News* 29 Jan. 27/2 He . . . later did graduate work at Harvard and the University of Chicago.

Grahamism 'greəm‚ɪzəm, *n.* The principles regarding diet advocated by Sylvester Graham (1794–1851). Now *hist.*

1837 GREENE *Glance at N.Y.* 191 This system, . . . commonly called *Grahamism*, from the Rev. Sylvester Graham, who first taught it here, five or six years ago—is now, we believe, very much fallen into disfavor. 1845 LOWELL *Letters* I. 87, I am becoming more and more inclined to Grahamism every day. 1870 *N.Y. Med. Jrnl.* XI. 567 (*Cent.*), Grahamism was advocated and practised by many. 1947 DOWNEY *Lusty Forefathers* 299 Grahamism could concentrate on other much-needed reforms.

* **grandfather,** *n.*

1. grandfather clause, a clause in the constitutions of some southern states designed to disfranchise Negro voters by means of an educational qualification from which only those are exempt whose fathers, grandfathers, etc., voted before 1867.

1900 *Cong. Rec.* 22 Jan. 1033/1 The grandfather clause will not avail those citizens who . . . are unable to pay their poll tax. 1948 *Ga. Hist. Quart.* March 1 In 1898, Louisiana wrote the notorious 'Grandfather Clause' into its constitution.

2. grandfather graybeard, the southern fringe tree. Also **gransy graybeard.**

[1910–12 *Trans. Tex. Acad. Sci.* (1913) 87 *Chionanthus Virginiana* L. (Grandfather's Beard).] 1931 CLUTE *Plants* 88 Old man's whiskers . . . may merely suggest an elderly gentleman, especially as *Chionanthus Virginica* is also known as grandfather graybeard. 1946 *Democrat* 13 June 2/3 Every street in Grove Hill should be lined with gransy graybeards (fringe trees), redbuds, crape myrtles and mimosas.

graphophone 'græfə‚fon, *n.* [See note.]

Prob. f. Gk. *grapho-*, writing + *phone*, voice, sound, but if so, of slightly unusual formation. Poss. an inversion of the considerably earlier * *phonograph, q.v.* Cf. **Gramophone.**

An instrument for recording and reproducing sounds, esp. one bearing the trade-mark name of Graphophone.

Graphophone (*c*1900)

1886 *Boston Herald* 16 July, The 'graphaphone' or improved phonograph. **1891** *Appleton's Ann. Cyclo. 1890* 709/1 In 1886, J. S. Taintor, working along the lines followed by Mr. Edison, produced a talking machine, which was called the *graphophone*, or *phonograph-graphophone*. **1944** CLARK *Pills* 92 A customer wished to buy a sewing machine or a graphophone on the installment plan.

attrib. **1902** *Sears Cat.* (ed. 112) 261 While these songs are being sung by the graphophone and sung in such a manner as possibly was never heard before from a graphophone record, beautiful colored slides from life posings are thrown on the screen.

b. A disk or cylinder that could be folded and sent through the mail and used on such a machine. *Obs.*

1890 *Boston Transcript* 3 Feb. 2/5 'Drop me a graphophone,' instead of 'drop me a line,' will soon be the good-bye word at railway partings.

Hence **graphophonic**, *a. Rare.*

1901 *N. Amer. Review* Feb. 216 It executes with a marvellous mechanism the orders it receives; it transmits with a graphophonic accuracy the communications made to it.

* **grass-roots**, *n. pl.*

1. *Mining.* The soil immediately below the surface of the ground. Also attrib.

1876 DODGE *Black Hills* 104 Gold is found almost everywhere, in the bars, in the gravel and sand of the beds, even in the 'grass roots.' **1906** *Out West* Feb. 85 Yet this era of 'grass-root bonanzas' was enough to turn the brains of the wildest dreamers. **1926** *Amer. Mercury* Feb. 149/2 Struck hard rock below the grass roots, 'n' had ter use chisels. **1948** WESTON *Mother Lode* 160 Discovered in 1848, 'grass-root gold' and a rich strike in 1850 were responsible for Grass Valley growing into a large and important gold camp.

b. Also *to get down to grass-roots*, to get down to basic facts.

1945 MENCKEN *Supp.* I. 297 (*note*), The late Dr. Frank H. Vizetelly told me in 1935 that he had been informed that *grass-roots*, in the verb-phrase, *to get down to grass-roots*, was in use in Ohio *c.* 1885, but he could never track down a printed record of it, and neither could I.

Hence **grass rooter.**

1947 *Chi. Times* 28 June 13/4 Other straw polls in other states indicate that Republican 'Grass rooters' quite generally feel the same way.

2. *attrib.* Basic, fundamental, rustic. *Colloq.*

1932 *Durant* (Okla.) *D. Democrat* 24 Feb. 1/2 Oklahoma's picturesque governor, W. H. (Alfalfa Bill) Murray, put his grass roots

candidacy for the Democratic president nomination before the citizens of Indiana here today. **1947** *Time* 20 Jan. 76/2 Most of them have found real satisfaction in the Friends' experiment in grassroots international relations. **1949** *This Week Mag.* 9 Jan. 5/2 Occasionally grassroots justices do double duty.

Greenbackism ˈgrinbæk͵ɪzəm, *n.* The economic philosophy of the Greenback party. Now *hist.*

1876 *Chi. Tribune* 4 Aug. 2/2 The Democratic managers, for this year at least, are solicitous to suppress the greenbackism that would array Democrats in hostility practically to Tilden. **1882** *Nation* 4 Sep. 231/2 The Mississippi alliance with Greenbackism is as disgraceful as the Virginia alliance with repudiation. **1932** Grayson *Leaders* 279 For a time greenbackism was a real menace to the welfare of our country. **1949** *Social Studies* May 216/1 Many of its members embraced greenbackism.

gringo ˈgrɪŋgo, *n.* [Sp. in Amer. Sp. sense shown here. See Bentley, 141 f.] A term used contemptuously by Spanish Americans for a person from the U.S.

1849 Audubon *Western Journal* (1906) 13 June 100 We were hooted and shouted at as we passed through, and called 'Gringoes.' **1863** *Rio Abajo Press* 14 July 4/1 The principal part of his patronage is derived from Americans, Germans, Irish, Scotch,—to all of whom the natives apply the generic term 'Gringo,' and whom they consider Americans. **1948** *Chi. D. News* 11 June 16/7 Us native Peruvians never cease to marvel at the ingenuity of the gringo.

attrib. **1871** *Republican Rev.* 14 Jan. 2/2 Three Mexicans from Socorro . . . calling her a *gringo* bitch, finally threw her on the body of her husband. **1897** *Outing* XXIX. 596/1 Tender bits of *gringo* ears being sent to our several friends with the grewsome admonition that the rest of the consignment would follow if sundry fat ransoms were not instantly forthcoming. **1947** *Time* 20 Jan. 75/2 Such invitations from gringo-distrusting, Catholic Mexico are high testimony to the special approach of the Quakers.

∗ **gritting,** *n.* **1.** The action of grinding (the teeth). **2.** The grating of immature corn into coarse meal.

(1) **1823** *Mass. Spy* 30 April (Th.), The harmony arising from the filing of a saw, or the gritting of teeth. **1849** Poe *Works* VI. 222, I could have sworn that it was the gritting of this vagabond's teeth. —
(2) **1848** Robinson *Santa Fe Exped.* 28 It is a very quick method of grinding, and I think quite preferable to gritting, which is frequently practiced in the west. **1948** Dick *Dixie Frontier* 289 When the kernels grew more mature and hard, the ears were rubbed over the rough side of a piece of tin studded with nail holes. This was called 'gritting' (grating) and made the sweetest corn meal imaginable.

groggery ˈgrɑgərɪ, *n.*
1. A low tavern or grogshop. Cf. **corner groggery.**

1822 Quitman in Claiborne *Life Quitman* I. 71 [Natchez is] a straggling town . . . , consisting of warehouses, low taverns, groggeries, dens of prostitution, and gaming-houses. **1884** Roe *Nature's Story* 287 Lumley had to pass more than one groggery on his way to the mountains.

2. groggery-keeper, one who keeps a groggery. Now *obs.* or *hist.*

1863 E. KIRKE *Southern Friends* 68 A young man . . . should be 'bout better business than gittin' inter brawls with low groggery keepers. **1892** A. E. LEE *Hist. Columbus, O.* II. 127 A groggery keeper . . . was implicated with Price.

grubstaker ˈgrʌbˌstekə, *n. W.* One who gives, or one who receives, a grubstake. *Colloq.*

1881 HAYES *New Colorado* 107 Here does the whilom grub-staker and present millionaire purchase his corner lot. **1901** GRINNELL *Gold Hunting in Alaska* 45 We may have to foot it home just like . . . prodigal sons who have wasted their substance and that of our grub-stakers in 'riotous living.' **1942** LILLARD *Desert Challenge* 175 By now, if not before, he was ready to try to induce a grubstaker to finance him in sinking a shaft a hundred feet or more. **1949** WYNN *Desert Bonanza* 262 The grubstaker usually receives half of anything found or developed.

gubernatorial ˌgubənəˈtorɪəl, *a.* [f. L. *gubernator*, governor.] Of or pertaining to the governor of an American colony or state.

1734 *N.J. Archives* XI. 368, I thought it very unlikely that the Governor in his gubernatorial Capacity, should refuse His essential Assent. **1824** *Green River Correspondent* (Bowling Green, Ky.) 25 Sep. 1/3 Nothing can be more fallacious, on this question, than the Gubernatorial election. **1948** *Time* 17 May 25/2 He won his gubernatorial primary handily.

b. gubernatorial chair, the office of the governor of a state.

1809 IRVING *Hist. N.Y.* IV. i. 177 Wilhelmus Kieft . . . in 1634 ascended the Gubernatorial chair, (to borrow a favourite, though clumsy appellation of modern phraseologists). **1859** GRATTAN *Civilized Amer.* I. 139 His proper sphere was the Presidency of the neighbouring college, rather than the 'Gubernatorial chair' (as the phrase goes) or a seat in Congress.

gullywasher ˈgʌlɪˌwɑʃɚ, *n.* A tremendous rain. Also *transf. Colloq.*

1923 *K.C.* (Mo.) *Star* 23 April, He meant to say that what Kansas needs now is a regular 'gully-washer'; a rain that will fill all the small streams bank full, start the water to running in the pasture creeks, and cause the springs at the head of the draws to flowing. **1945** *Reader's Digest* March 84/2 If a man's terraces break when the gully-washers come . . . then he might as well have no terraces at all. **1948** *Capital-Democrat* (Tishomingo, Okla.) 17 June 1/7 The drouth of senatorial candidates in Johnston county will be broken with a 'gulley washer' here this week.

gumbo filé. (See quot. 1931.) Cf. **filé,** *n.*

1823 G. A. McCALL *Lett. from Frontiers* (1868) 121 In a few minutes the door opened, and black François entered with a tureen of *gombo file*, a special favorite in the South. **1880** HEARN *Creole Sketches* (1924) 103 Gombo Filé . . . is made exactly like the other, but with pulver-

ized okra instead of fresh green okra. **1931** READ *La.-French* 122 Gombo . . . now applied . . . to other kinds of gumbo thickened with a powder prepared from sassafras leaves. This powder goes by the name of *filé*, the past participle of French *filer*, 'to twist'; hence *gombo filé* signifies properly 'ropy or stringy gumbo.' **1942** HARLOW *Trees Eastern U.S.* 191 The Choctaw Indians of Louisiana powdered the leaves (then called 'gumbo filet,' 'gumbo file,' or 'gumbo zab') and used them for flavoring and giving a ropy consistency to soup.

gyp dʒɪp, *n.*[1] [Poss. f. *Gypsy* or *Gyp*, used as a proper name for a bitch.] A bitch.

1890 J. COOKE in G. O. Shields *Big Game N. Amer.* 48 Old Tige had filled up on the first Deer's inwards. He looked like a gyp, and near her time. **1895** A. HUNTER in *Outing* XXVII. 75/2 One of the pack— a long-limbed gyp named Queen . . . covered with black pitch-like mud. **1927** BIRNEY *King of Mesa* 19, I see a little fox-terrier gyp one time lick the living daylights outa a bull-dog.

gyp dʒɪp, *n.*[2] *W.* [App. f. *⁕gypsum.*]

1. Water that is alkaline or otherwise brackish and unusable. In full **gyp water.** *Colloq.*

1904 D. H. BIGGERS *From Cattle Range to Cotton Patch* (1944) 30 The water in the Clear Fork . . . was 'gyp' and wholly unfit to drink. **1909** *Pioneer Days Southwest* 314 We all started up the river to the water and when we got there it was alkali or jip. **1948** *Neb. Hist.* June 101 'Gyp water' was a sore trial to many a family, while livestock often died from the effects of drinking 'alkali water.'

b. Also **gyp well.**

1942 PHILIPS *Big Spring* 187 The dry creek on the road to the Spring had several gyp wells of shallow water. When this water was first drawn, it was extremely cold and had no taste at all, but the result was the same as Epsom salts.

2. gyprock, ?gypsum.

1943 L. V. HAMNER *Short Grass* 7 Walls were whitewashed by baking 'gyprock,' crushing it, and mixing it with water to form a plaster.

H

⁕**haberdasher,** *n.* A dealer in men's wear.

1887 (*title*), The Haberdasher. **1917** McCUTCHEON *Green Fancy* 78 The names of the haberdasher, the hat dealer and the book maker had been as effectually destroyed. **1949** *Time* 13 June 17/3 The one-time haberdasher whipped off his four-in-hand, skillfully knotted the bow tie without looking in a mirror.

hackee ˈhækɪ, *n.* [Prob. f. its note.] A chipmunk or ground squirrel.

1849 AUDUBON *Quadrupeds N. Amer.* I. 75 The *Tamias striatus* differs . . . widely from our American Chipping Squirrel or Hackee. **1863** WOOD *Illust. Nat. Hist.* I. 599 The Hackee . . . is one of the most familiar of North American quadrupeds. **1947** CAHALANE *Mammals* 379 Other names applied rarely are 'hackie,' chipping squirrel, striped ground squirrel, and just ground squirrel.

half dime. A silver coin worth five cents, the coining of which ceased in 1873. Also attrib.

1792 *Ann. 2nd Congress* 71 [Coins to be minted include] half dimes; each to be of the value of one-twentieth of a dollar. **1820** *Niles' Reg.* XVIII. 274/2 It is ardently to be wished that they [certain Spanish coins] should be superceded by our dismes and half dismes. **1901** JAMESON & BUEL *Encycl. Dict. Amer. Ref.* I. 257 Some silver half-dimes were the first coins struck by the U.S. Mint in 1792. **1947** *Denver Post* 23 Feb. A. 7/2 The half-dime novel fell into evil ways in 1889 when a speaker used a dime novel as the theme of a commencement address at Harvard.

half section. A tract of land embracing half of one square mile or 320 acres. Also attrib.

1806 *Ann. 9th Congress* 2 Sess. 1032 The public lands are now sold in sections, half sections, and quarter sections. **1872** *Newton Kansan* 12 Dec. 2/1 All settlers . . . may enter a half section of land under the homestead law. **1910** *Okla. Session Laws* 3 Legisl. 5 The permanent capitol of the state shall be erected on the following described lands: Fifteen acres of land surrounding a point on the half-section line.

halitosis ˌhælə'tosɪs, *n.* [f. L. *halitu*s, breath, +*-osis*.] The condition of having offensive breath.

1885 BUCK *Handbook Med. Sci.* I. 695/2 Toxic halitosis. **1926** *Chi. Tribune* 22 Sep. 27/3 How many people actually have halitosis? **1948** *Time* 1 Mar. 96/3, 150 coal miners walked off the job when a pit pony developed halitosis, reconsidered when the management offered to mix fragrant musk in its feed.

Hamiltonian ˌhæml'tonɪən, *n.* A follower of, or a believer in the political doctrines of, Alexander Hamilton (1757–1804).

1797 JEFFERSON *Writings* IX. 382 These machinations will proceed from the Hamiltonians by whom he [President Adams] is surrounded, and who are only a little less hostile to him than to me. **1906** *Cin. Enquirer* 14 April 1/6 The people of the United States are becoming Hamiltonians very rapidly. **1946** *Newsweek* 17 June 106/2 His book can be read by Jeffersonians, Jacksonians, and Hamiltonians alike without shock.

b. Also as an adj.

1843 in HAMBLETON *Biog. Sk.* (1856) 43 You would see no little dipping and doging [*sic*] in the crowd, among the old Hamiltonian National Republican Federalists. **1861** *Richmond* (Va.) *Examiner* 7 Dec. 2/2 The old Hamiltonian maxim of a *government debt, a public blessing* . . . is the philosophy of the first thoroughly Yankee administration that has acceded to power. **1896** *N. Eng. Mag.* ns. XIV. 703/1 It is not necessary, however, in perceiving the failure of the Hamil-

tonian scheme . . . to overlook the fact that there are features of the
plan which will be suggestive and useful.

hand game. *W.* An Indian gambling game wherein
one player guesses in which hand another has concealed
a stone or other small object. Also transf. Now *hist.*

1740 *S. Car. Hist. Soc. Coll.* IV. 92 We will play a Hand Game upon
them, and do not Doubt to restrain the Spanish Garrison, keeping
them in and till the Craft is Safe. **1910** MOORHEAD *Stone Age N.
Amer.* I. 437 The native game called 'hand-game' or 'guessing-game'
was played. **1947** DEVOTO *Across Wide Missouri* 101 Cards, the hand
game, drinking, brawling, an attempt at lynching, . . . engaged the
interest of Edward Warren, Stewart's surrogate, in the first days of
this rendezvous.

hang-over ˈhæŋˌovɚ, *n.*
1. One who remains or is left over.

1894 *Outing* XXIV. 67/2 Then there are a few 'hangovers' who have
tried before, and two or three green candidates. **1932** LEWINSON *Race*
272 One candidate was branded as a hangover from the corrupt alder-
manic machine.

transf. **1947** *Redbook* Oct. 100/3 Maybe it was a hangover from the
day when dreaming mammas thought *Fauntleroy* was the beau ideal
for little lads.

2. The aftereffect of alcoholic dissipation. *Slang.*

1912 W. IRWIN *Red Button* 93 This was the first time in his life that
Tommy North had ever admitted a 'hangover.' **1947** *Chi. Tribune* 22
July 2/7 I've got a hangover from a party that lasted until five
o'clock this morning.

Hannahills ˈhænəˌhɪlz, *n. pl.* Also **hannahills.** (See
quots.)

1814 MITCHILL *Fishes N.Y.* 416 Black harry, hannahills, and blue-
fish, are some of the names by which he [=sea bass] is known. **1842**
Nat. Hist. N.Y., Zoology IV. 25 Sea Bass . . . is sometimes called
Blue-fish, Black Harry, Hannahills, and Black Bass. **1884** GOODE
Fisheries I. 407 In the Middle States the Sea Bass is called . . .
'Hannahills.'

* **hard cider.**
1. hard cider campaign, the presidential campaign
of Gen. William Henry Harrison in 1840, in which his
supporters used hard cider and log cabins as symbols of
the frontier hardihood and democratic simplicity of their
candidate. Cf. **log cabin 1. b.**

1857 *Spirit of Times* 3 Jan. 281/1 It was not infrequent, as late as the
hard-cider campaign of 1840, (in which I took an active part for Mar-
tin, *le Renard,*) that I heard some old farmer remark . . . 'Stop a little,
and let's hear what the *boy* has to say.' **1890** HOWELLS *Boy's Town* 4
The wild hard-cider campaign roared by my boy's little life without
leaving a trace in it.

2. In expressions alluding to this campaign or to the

supporters of Harrison, as **hard cider congress, demo-
crat, quilting.** Also **Hard Ciderism, -ite.** *Obs.*

1840 *Spirit of Times* 20 June 187/3 (We.), Hard cider democrat;
Hard cider quiltins. 1840 *Rough Hewer* (Albany, N.Y.) 13 Aug. 207/1
The hard ciderites, it would seem, have joined in a league with the
Prince of Darkness himself, to decry and ridicule even the holy rites
of religion. 1841 *Kendall's Expositor* (Wash., D.C.) 17 Feb. 19/2 A
political rhymester in Ohio has the following touch at Hard Ciderism.
1842 F. Wood in *Cong. Globe* App. 20 May 413/1 The people . . .
thought best to substitute a *hard cider* Congress.

harmonica har'mɑnɪkə, *n.* [L., fem. of *harmonicus*,
harmonic.]
1. A musical instrument, invented by Benjamin
Franklin, consisting essentially of tuned or musical
glasses so arranged as to be conveniently played upon,
orig. by rubbing their edges with the moistened finger.
Obs. Cf. **armonica, harmonicon.**

*c*1765 *Lett. to Franklin* (1859) 24 Now for the room we call yours:
there is in it your desk, the harmonica made like a desk, a large chest
[etc.]. 1786 JEFFERSON *Writings* VII. 21, I am much pleased with
your project on the Harmonica, and the prospect of your succeeding

Harmonica (*c*1820)

in the application of keys to it. 1861 J. S. ADAMS *5000 Musical Terms*,
Harmonica, a musical instrument, the tones of which are produced
from globular glasses.
2. A small reed musical instrument played by blow-
ing; a mouth organ. Cf. **harmonicon b.**

1873 BAILEY *Life in Danbury* 237 A Danbury boy of ten winters . . .
stole a harmonica Friday evening to serenade his girl with. 1908
Sears Cat. (ed. 118) 351 The Hohner Chromatic Harmonica is the re-
sult of many years of thought and experimenting and is the first and
only practical instrument of its kind. 1949 *Sat. Ev. Post* 9 April 80/4
As children, she and her harmonica-playing brother, Danny, danced
for the family and neighbors and in school entertainments.

* **harvester,** *n.* A machine used in harvesting a crop.

1850 *Rep. Comm. Patents 1849* I. 209, [I have] thus described the construction and operation of my improved harvester. **1887** M. D. WOODWARD in *Checkered Yrs.* (1937) 182 Walter bought a new harvester, and the experts are here to set it up and overhaul the five old ones. **1945** *N. Eng. Homestead* 22 Sep. 20/3 The hay baler and Fox Field Harvester play a big part.

attrib. **1859** *Rep. Comm. Patents 1858: Agric.* I. 414 Improvement in Harvester Fingers. **1913** *Commoner* 10 Jan. 7/2 The harvester trust is spending that million in order that it may get back more millions from the farmer.

* **hawkeye,** *n.*

1. (*cap.*) A nickname for a native or an inhabitant of Iowa, allegedly from the name of an Indian chief.

1839 (*title*), Hawk-eye and Iowa Patriot [founded at Burlington, 5 Sep.]. **1845** *St. Louis Reveille* 14 May 2/4 The inhabitants of . . . Iowa [are called] Hawk-eyes. **1878** BEADLE *Western Wilds* 36 We was as much skeered of each other as we was of the Hawkeyes. **1888** WHITMAN *Nov. Boughs* 406 Those from . . . Iowa . . . [were called] Hawkeyes. **1949** *Amer. Sp.* Feb. 26 Almost every American has heard . . . *Hawkeye* for an Iowan.

b. Hawkeye State, a nickname for Iowa.

1859 *Harper's Mag.* June 140/2 The Solons of the Hawk-eye State . . . were not all in the Legislature of 1851. **1894** *Chi. Record* 1 May 1/7 The large store . . . was filled with persons who wanted a near view of the little man who is raising such a commotion in the Hawkeye state. **1948** *Chi. Tribune* 29 Aug. 23/3 To residents of the Hawkeye state Pike's Peak is a 500 foot bluff of the Mississippi near here [*sc.* McGregor, Iowa].

2. One of the sobriquets of Natty Bumppo, the central character in Cooper's *Leatherstocking Tales.*

1839 TOWNSEND *Narrative* xiv. 337, I can sit for hours and hear old Maniquon relate the particulars of his numerous campaigns . . . and his 'scrimmages,' as old Hawk-eye would say.

hayride 'he₁raɪd, *n.* A ride taken by a pleasure party in a large wagon partially filled with hay. Also attrib.

[**1856** *Spirit of Times* 8 Nov. 154/2 The invitations he had at first received to join pic-nics, boating excursions on the river, and hay-wagon rides, after a while became intermittent, and towards the end of the summer were dropped altogether.] **1896** *Advance* 19 March 414/2 Everybody being as comfortable as hay-ride etiquette permitted, the word was given, and away they went. **1949** *Ev. Northwestern* (Chi.) 11 April 4/1 Phi Gams weren't daunted recently when hayride plans were flooded out.

Hence **hayrider.**

1947 *Chi. D. News* 15 Nov. 1/1, 20 Hayriders In Auto Mishap.

haywire 'he₁waɪr, *n.*

1. Smooth wire used in baling hay.

1921 *Outing* Dec. 101/1 You can't run a logging camp without snuff and hay wire. **1941** WHITE *One Man's Meat* 240 So into the village

in the truck, after wiring the tailboard up with a piece of haywire, to prevent wholesale loss of life.

2. haywire outfit (or **rig**), (see quots. 1905, 1942). *Slang.*

1905 *Forestry Bureau Bul.* 61 B, hay wire outfit. A contemptuous term for loggers with poor logging equipment. **1942** RICH *We Took to Woods* (1948) 254 Anything that is held together with haywire is a haywire rig. Broadening the scope of the term, so is any makeshift expedient whatever. If you run out of corn starch and have to thicken a chocolate pudding with flour, that's a haywire rig. **1944** BINNS *Timber Beast* 269 Roberts is dead, and Larry Jones is starting over again with a haywire outfit over on the Peninsula.

3. *To go haywire,* to get out of order, to become confused or unreasonable. *Slang.*

1929 *N.Y. Times* 13 Oct., When some element in the recording system becomes defective it is said to have gone haywire. **1948** *Ice Cream Trade Jrnl.* Sep. 22 Some of them have gone completely haywire on their retail prices.

headlight ˈhɛdˌlaɪt, *n.*

1. A powerful light on the front of a locomotive to light up the track at night.

1861 *Remin. Life Locomotive Engineer* 124, I saw the glimmer of his head-light when he first turned the curve and entered upon the

Headlight or head lamp for locomotive

straight track. **1892** GUNTER *Miss Dividends* 63 The train . . . passes with illuminated Pullmans and flashing headlight into the night of the plains. **1944** *Chi. D. News* 14 July 10/8 His vision travels like a locomotive headlight far down the aisles of time, illuminating the lives even of the unborn.

2. A light on an automobile, bicycle, or motorcycle.

1939 *These Are Our Lives* 37 The headlights of the automobile pick up the bush of red roses lush and beautiful under the artificial glare. **1944** *Vogue* 1 Oct. 188 The powerful beam of a motorcycle's mud-flecked headlight pinned him in an inappropriate glare. **1947** *Nat. Geog. Mag.* Sep. 349/1 The beams of my headlight seemed to be absorbed into the sand.

3. A light for use on the head as a miner's lamp.

1944 *Speleological Soc. Bul.* July 35/2 If a head light is not desired, nothing is lost; whereas it is exceedingly difficult later to add a light bracket to a hat that did not originally have one.

*heathen, *n.*

1. *collect.* The American Indians. *Obs.*

1645 WILLIAMS *Christenings* (1881) 4 Men stand upon their tearmes of high opposition between . . . the Christian and the Heathen, that is the naked American. **1689** *Mass. H.S. Coll.* 4 Ser. V. 203 The present distressed state and condition of the eastern parts, by the barbarous murders and outrages committed by the heathen upon the inhabitants there. **1711** *Boston News-Letter* 31 Dec. 2/2 They write from North-Carolina, that they are distressed there with Intestine Broils, the Fury of the Heathen, and a Mortal Distemper.

2. heathen Chinee, a jocose term for a Chinese, after a character in Bret Harte's poem "Plain Language from Truthful James." Also attrib.

1870 HARTE *Plain Language* line 5 The heathen Chinee is peculiar. **1890** *Cong. Rec.* 7 June 5791/2 [It seems to me that this bill] has something of a Heathen Chinee flavor about it. **1949** *Wis. Mag. Hist.* Mar. 322 Remember how the 'heathen Chinee' of the dim past discovered roast pork—and thereafter burned down his house every time he wanted some.

hell-diver 'hɛl₁daɪvɚ, *n.* (See quots.)

1839 IRVING in *Knickerb.* Oct. 344 He could live under water like that notable species of wild duck, commonly called the Hell-diver. **1917** *Birds of Amer.* I. 7 Pied-billed Grebe. . . . Other names [include] Hell-diver; Devil-diver; Water-witch; Dabchick [etc.]. **1941** SETON *Trail of Artist-Naturalist* 89, I traced them to the pied-bill grebe, or little helldiver.

***Henry,** *n.* [Benjamin Tyler *Henry* (1821–98). For some account of the Henry family of gunmakers see Dillin, *The Ky. Rifle*, 20.] (See quot. 1944.) Also attrib.

1869 in *Frontier* IX. (1929) 157 One of them . . . lost one of our Henry carbines. **1927** RUSSELL *Trails* 71 From the copper rim-fire cattridges in his belt, I guess his weapon's a Henry. **1944** ADAMS *W. Words* 75 Henry An early repeating breech-loading, lever-action rifle first used by the Union Army in the Civil War. This type of rifle never became popular as a military weapon, but was used to some extent upon the frontier.

b. Esp. **Henry rifle.**

1859 in F. HALL *Hist. Colorado* II. App., Got Oake's Henry rifle for Phil. I take my old Hawkins. **1876** *Pioche* (Nev.) *D. Jrnl.* 23 Sep. 3/1

Henry rifle or carbine (*c*1865)

He carried a Henry rifle on the occasion. **1948** *Chi. Tribune* 7 March 1. 38/5 Its predecessor was the Henry rifle, made by the New Haven Arms company, and grandfather of the repeating arms.

*Henslow, *n.* [See quot. 1831.] **1. Henslow's bunt-
ing,** =next. **2. Henslow's sparrow,** a plain striped
sparrow (see quot. 1917) found chiefly in the eastern
states. Cf. **Eastern Henslow's sparrow.**

(1) **1831** AUDUBON *Ornith. Biog.* I. 360 Henslow's Bunting. . . . In
naming it after the Rev. Professor Henslow of Cambridge, . . . my
object has been to manifest my gratitude for the many kind atten-
tions which he has shewn towards me. **1874** COUES *Birds N.W.* 133
Coturniculus Henslovii, (Aud.) Bp. Henslow's Bunting [inhabits] . . .
Eastern United States to Massachusetts. West to the Loup Fork. —
(2) **1870** *Amer. Naturalist* III. 632 Henslow's Sparrow. *Coturniculus
henslowi.* This species must still be considered a rare summer visitor
[in Mass.]. **1917** *Birds of Amer.* III. 28 Henslow's Sparrow. *Passer-
herbulus henslowi henslowi.* . . . Other Name.—Henslow's Bunting.

hex hɛks, *v.* [f. Pa.-G. Cf. **hex,** *n.*] *tr.* To place a spell
on (someone). Also absol.

1857 WATSON *Ann. Phila.* I. 270 A decent shopkeeper once got him
to hex for his wife, who had conceited that an old Mrs. Wiggard had
bewitched her, and made her to swallow a piece of linsey woolsey.
[**1882** GIBBONS *Pa. Dutch* 402 They still speak of horses and animals
being bewitched (verhext).] **1948** *Dly. Ardmoreite* (Ardmore, Okla.)
7 April 7/3 John Henson says this reporter must have hexed him.

Hence **hexer,** *n.*

1938 HARK *Hex Marks Spot* 140 After that, the three strings used in
'measuring' were placed on the floor while the 'hexer' walked solemn-
ly back and forth across them, repeating more magic words as she
did so.

hickory bark. The bark of the hickory tree. Also at-
trib.

[**1716** in *Memoirs Huguenot Family* (1872) 276 They [Indians] make
a roof with rafters, and cover the house with oak or hickory bark,
which they strip off in great flakes, and lay it so closely that no rain
can come in.] **1775** *Jrnl. Nicholas Cresswell* (1925) 103 We crossed the
River in a Canoe made of Hickory Bark, stretched open with sticks.
1846 *N.O. Picayune* 31 Aug. 648/2 An Arkansas man dressed in a
hickory-bark coat. **1946** WILSON *Fidelity* 147 Hickory-bark whips left
over from the preceding spring . . . made the drudgery pretty hard.

b. hickory bark borer, a beetle, *Eccoptogaster
quadrispinosa,* that burrows under the bark of some spe-
cies of hickory.

1911 *Country Life* 15 Oct. 35/2 All of the white-banded trees are
hickories of various kinds killed by the hickory bark borer.

hick town. A small country town. Also attrib. *Slang.*

1924 H. CROY *R.F.D. No. 3* 220 You ought to get out of this hick
town. The city is the place for you. **1938** NIXON *Forty Acres* 41 Sum-
mer revivals and all-day singings 'with dinner on the ground' make
strong appeal to hillbillies, farm villagers and hick-town men. **1949**
Sat. Ev. Post 12 Feb. 21/2 More are resentful of the implication that
'Peoria' is synonymous with 'hick town.'

highboy ˈhaɪˌbɔɪ, *n.* [Var. of *tallboy*. Cf. **lowboy**.] A tall chest of drawers mounted on a base having legs from about eighteen inches to two feet high. Also attrib. and transf.

1891 *Scribner's Mag.* Sep. 353/2 These Lafayette plates had always been kept in the top drawer of a high chest of drawers, a 'high boy,' wrapped in a hand-woven 'flannel sheet.' **1906** *Harper's Mag.* Oct. 707 She brought out a fine white napkin from the highboy. **1947** *Newsweek* 6 Oct. 17/3 You know, we have a 'highboy' government in Washington—one bureau on top of another.

** **high-bush**, *n. attrib.* Designating high or bushlike varieties of various plants or shrubs, or the fruit of these, as (1) **high-bush blackberry**, (2) **blueberry**, (3) **cranberry**, (4) **huckleberry**, (5) **laurel.**

(1) **1867** HOLMES *Guardian Angel* 230 High-bush blackberries and low-bush blackberries,—you understand,—just so everywhere,—high-bush here and there, low-bush plenty. **1947** *U.S. Dispensatory* 972/1 *Rubus argutus* Link, or high-bush blackberry, is an erect shrub growing wild from New England to Florida and Arkansas. — (2) **1913** EATON *Barn Doors & Byways* 179 There used to be a swamp into which we youngsters penetrated for a mile or so, finding high-bush blueberries, hornpout pools and wet feet. **1945** PEARSON *Country Flavor* 31 There is an area of high-bush blueberries, which mean juicy pies in late July. — (3) **1805** CLARK in *Lewis & C. Exped.* III. (1905) 169 They gave us High bush cramburies. **1949** *Mo. Bot. Garden Bul.* April 92 Some desirable shrubs which need very little care are Mento barberry . . . , highbush cranberry [etc.]. — (4) **1889** *Cent.* 2909/1 The common high-bush huckleberry or black huckleberry of the markets. **1938** MATSCHAT *Suwannee River* 33 Around the swollen bases of the trees grow high-bush huckleberries. — (5) **1860** CURTIS *Woody Plants N.C.* 65 Yellow Wood. (*Symplocos tinctoria.*)—Also called *Sweet Leaf* and *High Bush Laurel.*

high spot.

1. An outstanding or prominent part or feature.

1928 *Wis. Alumni Mag.* Dec. 85 The high spot of the season was unquestionably the Iowa game. **1947** *West. Pa. Hist. Mag.* March–June 9 A high spot of his first professional season . . . was his famous eighth-inning home run on May 2, 1878, which defeated pitcher Tommy Bond and the Boston Nationals, 1 to 0.

2. *To hit* (or *touch*) *the high spots*, to go with great speed; to mention briefly. Also transf. *Colloq.*

1910 W. M. RAINE *B. O'Connor* 12 Here come your train a-foggin'—also and likewise hittin' the high spots. **1921** *Outing* Sep. 244/2 Two wiry, middle-aged Canadian alpine members . . . had come West for the sole intention of donning hobnail boots and hitting the high spots. **1948** *Pacific Discovery* May–June 31/2 The author handles the problem by concentrating intimately on the Cascades, where he is thoroughly at home, and only touching the high spots in the other mountains.

** **hip**, *n.* In combs.: (1) **hip boot**, a high boot, usually of rubber, reaching to the hip; (2) **flask**, a small whisky

flask suitable for carrying in the hip pocket; (3) **pocket,** a rear pocket in a pair of trousers, first used as a place for carrying a weapon; (4) **shot,** *W.* one who fires a revolver from the hip without taking formal aim.

(1) **1893** *Outing* XXII. 124/2 Gossamer hip-boots are good if of reliable stock. **1946** *Washington Outdoors* June 10/2 The tools necessary for one to participate in this sport consists of a clam gun, surf sack and hip boots. — (2) **1923** ELIZ. MARBURY *My Crystal Ball* lxxi. 352 Let these same people frequent ballrooms . . . and they will find the hip flasks in evidence and the consequent conditions a sorry spectacle. — (3) [**1867** LATHAM *Black & White* 161 A large proportion of the men here [in New Orleans] carry arms; you see trousers hanging up in the tailors' shops with a pocket on the hip behind for knife or pistol under the skirt of the coat.] **1880** *Cimarron News & Press* 22 July 3/2 Lee snatched Armstrong's revolver from his hip pocket and pointed it at Armstrong. **1948** *This Week Mag.* 9 Oct. 22/2 People who carry their life savings in their hip pockets usually go down fighting. — (4) **1904** *McClure's Mag.* Feb. 362 None but the dwarf of Bar X could have lived, for he was the deadliest hip shot in the territory.

Hitchcock chair. Any one of various chairs made by Lambert H. Hitchcock (1795–1852) or produced in his chair factory established in 1818 at Barkhamsted, Conn.

Such chairs are of many designs and sizes. In general they are characterized by strong front legs, curved-top backs, and seats (prob. orig. rush-bottomed) wider at the front than at the back.

*c*1828 in MOORE *Hitchcock Chairs* (1933) 5 Hitchcock chairs, . . . flag and wooden seats, warranted well manufactured. **1933** MOORE *Hitchcock Chairs* 3 The first Hitchcock chairs probably had the rush seat, but very soon were added the cane and solid wood seats. **1945** *Springfield* (Mass.) *Union* 13 Mar. 8/1 Hand-painted Hitchcock chairs, old fans from foreign countries . . . displayed the talents and hobbies of members of the Arts Club. **1949** *Cleveland Plain Dealer* 13 Feb. (Pict. Mag.) 9/1 The study . . . remains exactly as she left it at her death almost 75 years ago. The same wallpaper, and carpet, . . . and the dozen perfect Hitchcock chairs.

hobo 'hobo, *v.* [f. the noun.] *intr.* and *tr.* To live as a hobo, to make one's way in the manner of a hobo. Also **hoboing,** *n.*

1906 SINCLAIR *Jungle* xxv. 298 Then he explained how he had spent the last summer, 'hoboing it,' as the phrase was. **1907** LONDON *Road* 48 In all my hoboing it is the best bit of train-jumping I have done. **1939** *These Are Our Lives* 311 The boy left the country and was later killed while hoboing his way on a freight train.

hogan 'hogən, *n.*² [f. Navaho *qoghan*, house.] A Navaho Indian lodge or wigwam, usu. built of earth walls kept in place by upright or slanting timbers. Cf. **summer hogan.**

1871 *Rep. Indian Affairs* (1872) 379 When a member of a family dies, in most cases they immediately leave their hogan (or wigwam) with the dead body in it. **1904** *N.Y. Ev.Post* 2 July 2 The North Amer-

Hogan such as Navaho Indians occupied

ican Indians in their primitive state, living in the tepees, hogans, sod-lodges and grass houses. **1948** *Chi. D. News* 9 Nov. 18/6 The palm-thatched Seminole 'chickee' is as fascinating as a Navajo 'hogan.'

holy tone. A method of utterance, often used in their sermons by Primitive Baptist preachers, in which the sound "ah" occurs at the end of each breath pause and the taking of a fresh breath is intentionally made audible. Also **holy whine.**

[**1858** *Salem Advocate* 27 Jan. 1/2 You can no more get to heaven without it, than a jay bird can fly without a tail—ah!] **1881** H. W. PIERSON *In the Bush* 74 They would have gone away worse than disappointed—grievously outraged—if they could not have heard this sermon with the 'holy tone.' **1931** SWEET *Religion* 10 One of the peculiar mannerisms developed by the preachers was the 'holy whine,' a sing song method of speaking which seems to have arisen with outdoor preaching, and which continued to be practiced by the less educated Baptist ministers on the frontier for many years. **1948** DICK *Dixie Frontier* 191 Often the preacher had no idea what he would say from one 'ah' to the next. This 'holy tone' had charms for the audience and they preferred such a sermon to that by a learned college president.

home demonstration. *attrib.* Designating an *agent* who gives instruction to country women in the arts and skills of homemaking. Also used of a *club* composed of women receiving such instruction.

1928 *Dly. Ardmoreite* (Ardmore, Okla.) 4 March 15/1 Miss Maude Andrews, home demonstration agent, took an active part in the show. **1947** *Ib.* 14 Nov. 7/2 The County Agent and Home Demonstration Agent furnish supervision and assistance to 4-H Club boys and girls and farm men and women's clubs. **1948** *Durant* (Okla.) *D. Democrat* 1 July 5/1 A new home demonstration club has been formed in the county, the 46th such club.

Homogenized milk. (See quot. 1909.)

[**1904** *Sci. Amer.* 16 April 315/2 To the many methods of purifying ... and preserving milk must now be added a process for *homogenizing* so that it will keep almost indefinitely without change in its physical condition.] **1909** *Cent. Supp.* 596/1 Homogenized milk, a trade-name for milk which has been heated to 185° F. and forced by

heavy pressure through a number of very fine openings, the jets impinging upon a porcelain plate. **1949** *Chesterton* (Ind.) *Tribune* 7 April 14/5 Infants, children and adults, known as 'milk shunners,' drink Homogenized Milk with self-evident enjoyment.

honky-tonk ˈhɔŋkɪˌtɔŋk, *n.* [Origin unknown.] A cheap burlesque show, a place of low amusement. Also attrib. *Slang.*

1894 *Dly. Ardmoreite* (Ardmore, Okla.) 24 Feb. 1/4 The honk-a-tonk last night was well attended by ball-heads, bachelors and leading citizens. **1927** SANDBURG *Songbag* 232 It was moaned by resonant moaners in honky tonks of the southwest. **1947** *Haverford News* (Ardmore, Pa.) 5 Nov. 1/1 The play's locale is laid in the honky-tonk atmosphere of Nick's North Pacific Street Saloon. **1949** *Boston Globe Mag.* 29 May 7/3 Across the narrow street a honkatonk orchestra blared from the open door of a saloon.

hooked rug. A rug that is handmade of yarn or strips of cloth hooked back and forth through a burlap back. Cf. * **hook**, *v.* 1.

1880 HOWELLS *Undisc. Country* 415 Hooked rugs and embroidered tidies, were as worthy a place in Mrs. Ford's simple house as most of the old-fashioned things. **1894** —— *Traveler from Altruria* 163 Home-made hooked rugs, in rounds and ovals, [were] scattered about the clean floor. **1949** *Amer. Photography* April 236/2 Don't forget . . . the hooked rugs hanging out for sale in the Carolinas, or Indian blankets similarly displayed through the southwest.

Hopi ˈhopɪ, *n.* [f. a native name meaning "peaceful ones."] "A body of Indians, speaking a Shoshonean dialect, occupying 6 pueblos on a reservation of 2,472,320 acres in N.E. Arizona" (Hodge). Cf. **Moqui.**

1877 *Buffalo Soc. Nat. Sci. Bul.* 170 The title of '*Moquis*' has been applied to this confederacy by its enemies, and signifies the dying race. I understand that they usually speak of themselves as '*Ho-pees*' (our people). **1893** DONALDSON *Moqui Pueblo Indians* 13 The name which they call themselves by is Ho-pi, or Ho-pi-tuh-lei-nyu-muh, meaning 'peaceful people.' **1907** HODGE *Amer. Indians* I. 654/2 The Hopi are rather small of stature, but muscular and agile. . . . In mental traits the Hopi are the equal of any Indian tribe. **1947** *Dly. Ardmoreite* (Ardmore, Okla.) 13 Aug. 13/7 In the land of the Hopis some wedding ceremonies still last for weeks.

attrib. **1933** HARRINGTON *Gypsum Cave, Nev.* 159 Finally we come to 'cotton,' which is cotton and nothing else, probably of the variety now called 'Hopi cotton' (*Gossypium hopi*) long raised by the Hopi Indians and by ancient Pueblo peoples. **1945** *Pueblo* (Colo.) *Star-Journal* 3 June 8/2 The program this year will include the Hopi snake dance. **1948** *Our Dumb Animals* May 5/3 We moved about like Hopi Rain Dancers.

horn snake. A harmless snake, *Farancia abacura*, found in the southern states, formerly alleged to have an

extremely poisonous horn stinger at the end of its tail. Cf.
bastard horn snake, hoop snake.

1688 CLAYTON *Acct. Va.* in *Phil. Trans.* XVIII. 134 The Horn-
Snake is, as they [= Virginians] say, another sort of deadly Snake.
1764 in FRIES *Rec. Moravians in N.C.* II. 581 It is said that when the
Horn Snake gets angry it will drive its sting into a tree, and the tree
will die within twenty-four hours. **1896** P. A. BRUCE *Econ. Hist. Va.*
I. 129 Other varieties of snakes were common, such as the puff adder,
the moccasin, the corn, the black, the water, and the horn. **1949**
Scientific Mo. Jan. 53/1 When we speak of the hoop snake, horn snake,
or stinging snake, a single species, *Farancia abacura*, is implied.

horse show. A competitive public exhibition of horses
and horsemanship. Also, rarely, **horse-and-corn show.**

1856 *Porter's Spirit of Times* 181/2 The performances at the horse
show . . . were very interesting. **1921** *Rural Organization* 98 In several
communities there are such committees as these: . . . exhibit com-
mittee to look after horse-and-corn show. **1945** *Chi. D. News* 10 Sep.
15/4 Sept. 17, 18 and 19 are dates of a society horse show and harness
and running races here.

hot tamale. A Mexican food consisting of highly
seasoned ground meat coated with corn meal and
steamed in cornhusks. Also transf. and attrib.

1893 *Outing* April 27/2 Nice hot *tamales!* dear little *tamales!* very
nice, very hot! **1896** *Cin. Enquirer* 21 Aug. 6/7 Thomas Gates [was
arrested] . . . on the charge of passing a counterfeit silver dollar on
. . . an old colored hot tamale man. **1936** MCKENNA *Black Range* 163
Some of the young miners . . . gave it out that she was 'a red-hot
tamale.' **1948** *Coronet* July 42/2 Such Mexican female characters as
escape half-caste roles are presented as 'hot tamales from below the
Rio Grande,' with the social graces of a Kansas tornado.

Hubbard squash. A well-known dark-green or
golden-yellow winter squash.

1868 *Mich. Agric. Rep.* VII. 349 Thos. Smith, Hamtramck, [ex-
hibited] 8 Hubbard squashes. **1919** CADY *Rhymes of Vt.* (1923) 100
To raise a head of Hubbard squash. **1948** *Fargo* (N.D.) *Forum* 28 Sep.
2/1 A giant hubbard squash was the pride of the youngsters at the
Children's hospital.

huckleberrying ˈhʌkḷˌbɛrɪ·ɪŋ, *n.* The seeking or
gathering of huckleberries; an outing for this purpose.

1779 T. B. HAZARD *Nailer Tom's Diary* (1930) 9/2 Went ahuckling
Berring. *c*1845 *Big Bear Ark.* 103 Who went blackberryin and
huckleberryin with me? **1884** ROE *Nature's Story* 336 A party of
children who were out huckleberrying on the mountain were separated
from home by the swollen brook. **1943** *L.A.* Map 671.

hull-gull ˈhʌlˌgʌl, *n.* (See quot. 1899.) *Colloq.* — **1833** GREENE
Dod. Duckworth I. 30 There was no obstruction to the pleasant games
of-. . . hull-gull. **1899** GREEN *Va. Word-Book* 195 Hull-gull, *n.* A
guessing game for children. One player takes a number of chinkapens
in his closed hand, saying '*hull-gull.*' Another says: 'Hand full.' Then
the first says: 'How many?' The other player then guesses at the num-

ber, taking all if the guess is correct, otherwise making up the discrepancy. They play alternately.

humdinger 'hʌm'dɪŋɚ, *n.* [Origin obscure.] A person or thing of superior excellence. *Slang.* — **1916** BOWER *Phantom Herd* vi. 100 That pit'cher's a humdinger! **1943** LYON *And So to Bedlam* 16 But whoever thought them up is a humdinger.

Hunkerism 'hʌŋkɚˌɪzəm, *n.* The political philosophy of the Hunkers, extreme conservatism. *Obs.* Cf. **Old Hunkerism.**

1843 *Western New Yorker* (Rochester, N.Y.) 23 Oct. 1/4. **1847** *Semi-Wkly. News* (Fredericksburg, Va.) 21 Oct. 2/2 But for . . . the cunning Hunkerism in the 'democratic party,' . . . this overwhelming Whig majority . . . would be shown in every election. **1865** S. ANDREWS *South Since War* (1866) 186 The cold hunkerism of this people, however, stands immovably in his way, and gives him [*sc.* the Negro] little chance.

hunting knife. A large, strong knife suitable for a hunter's use.

1803 in *Minn. Hist.* XXI. (1940, June) 126 When the defendant came to pierce his tent with his hunting knife . . . the larger part of the goods had already been moved to the spot agreed upon. **1884** *Cent. Mag.* Oct. 803/2 Northern and Southern soldiers were alike in their fondness for hunting-knives and revolvers. **1946** *Sears Cat.* 609 4½-inch Hunting Knife. Saber ground. Keen-edged. **1949** *Chi. Tribune* 22 June 11. 1/4 A policeman took a 6 inch hunting knife from the waist of one of the white boys.

Huron 'hjʊrən, *n.* [See note.]

"From French *huré*, 'bristly,' 'bristled,' from *hure*, 'rough hair' (of the head). . . . So it is quite probable that the name was applied to the Indians in the sense of 'an unkempt person,' 'a bristly savage,' 'a wretch or lout,' 'a ruffian' " (Hodge).

An Indian belonging to any one of four confederated tribes formerly occupying a region adjacent to Lake Huron. In *pl.*, this confederation of tribes.

[**1632** *Relat. Jésuites* (1858) I. 14 Ie vy arriuer les Hurons.] **1658** GORGES in *Maine H.S. Coll.* II. 67 The Hiroons, who being neuters are friends both to the one [the Iroquois] and the other [the French]. **1721** *Mass. H. Rep. Jrnl.* III. 111 The Algonquins, The Hurons, The Mikemaks, The Mountainiers on the North-side. **1826** COOPER *Mohicans* iv, He is one of those you call a Huron. **1841** —— *Deerslayer* x, The Iroquois, or Hurons, as it would be better to call them, were entirely ignorant of the proximity of her lover. **1949** *Newsweek* 25 July 36/3 Iroquois of the Mohawk tribe and descendants of the scattered Hurons gathered in full regalia.

attrib. **1786** *Mem. Acad.* II. 1. 125 The Huron, or Wyandot language having no affinity to the Shawanese, Delawares, and other nations. **1888** *Amer. Naturalist* XXII. 803 Jerusalem Artichoke, *Helianthus tuberosus,* . . . was cultivated by the Huron Indians.

hush puppy. *S.* (See quots.) Also attrib. *Colloq.*

1918 *D.N.* V. 18 *hushpuppy,* a sort of bread prepared very quickly

and without salt. [N.C.] **1947** *This Week Mag.* 4 Oct. 27/1 What's a hush puppy? You mean you don't know that Southern fried bread like a miniature corn pone—but glorified? It's made of the white cornmeal of the South, smooth and fine as face powder. In Florida and Georgia women like their pones scented with onion. In the Carolinas and Virginia, they prefer them plain. **1949** *N.O. Times-Picayune Mag.* 15 May 10/2 Fishing parties, dances, hush-puppy suppers and fish fries left the MGMers almost too pleasantly busy to proceed with their filming.

* **hustle,** *n.* Energetic effort, briskness, animation. *Colloq.*

1892 *Home Missionary* (N.Y.) July 120 The hustle and stir of our day. **1906** *N.Y. Ev. Post* 7 Sep. 6 What the Kaiser hopes from Herr Dernburg is what is popularly known as American 'hustle'—the ability to go right to the point, to decide quickly, to act aggressively by means of simple and direct methods. **1923** *Nation* 26 Sep. 313/2 A country with no 'pep,' no 'hustle.' **1949** *Sat. Ev. Post* 25 June 32 The business [is] now headed by his grandson, who displays all the founder's hustle but eschews the whiskers.

* **hybrid,** *a.* Denoting corn produced by crossing selected varieties. Also absol.

1944 *Nat. Geog. Mag.* June 688 Idaho produces nearly 85% of all hybrid sweet corn seed in the United States. Its crop amounted to more than 5,300,000 pounds in 1942. **1948** *Savings News* Jan. 7/1 He went upstairs to the storeroom, selected the finest ears of hybrid, dropped them in a gunny sack and started for town. **1948** *Fargo* (N.D.) *Forum* 19 Sep. 23/2 Plans call for harvesting rows of the hybrid corn and piling the yields at the ends to permit easy comparison.

hystericky hɪsˈtɛrɪkɪ, *a.* Hysterical, given to having hysterics. *Colloq.*

1823 COOPER *Pilot* II. xiv. 239 In order that the women need not be 'stericky in squalls. **1867** HOLMES *Guardian Angel* xi. 127 That queer woman, the Deacon's mother,—there's where she gets that hystericky look. **1894** WILKINS in *Harper's Mag.* Sep. 605/2 You'd better go to bed, Sophy Anne; you're gittin' highstericky.

I

* **I,** *n.* Abbreviation of Incest, which, in the form of a badge, those convicted of that crime in colonial New England were sentenced to wear. Now *hist.* Cf. * **A,** *n.*

1743 *Suffolk Co.* (Mass.) *Files* 557 That he forever after wear a

capital I, two inches long and of a proper proportionate bigness, cut out in cloth of a contrary color to his coat, and sewed upon his upper garment on the outside of his arm, or upon his back in open view. **1895** *Proc. Amer. Antiq. Soc.* April 106 The penalty [for incest] was in substance the same, the only change being that the letter which the convict was ordered to wear upon his upper garment was an I instead of A. **1947** DOWNEY *Lusty Forefathers* 123 *F* was the brand of forgery or of fornication, and *I* of incest, guilty ones being also whipped on a gallows.

ice road. [Cf. Du. *ijsbaan.*]

1. A road from an ice pond to an ice house. *Obs.*

1879 *Harper's Mag.* July 211 The old ice-road, which leads from the house to the pond, . . . was cleaned out [and] gravelled.

2. A road the surface of which is ice.

1881 *Harper's Mag.* Jan. 231/2 There was a track over the ice. . . . Beyond these there were no other ice roads. **1884** DAWSON *Canada* 122 The ice-roads [across the St. Lawrence in the Province of Quebec] are always marked-out by spruce-trees stuck in the snow. **1946** NEWTON *P. Bunyan* 102 Then he ordered the cookees to pump the gravy into a water tank which we used to sprinkle the ice roads in winter.

ice storm. A storm in which rain freezes on the objects it falls upon (see also quot. 1886).

1877 MARK TWAIN *Speeches* (1910) 63 (R.), One feature . . . compensates for all its bullying vagaries—the ice-storm: when a leafless tree is clothed with ice from the bottom to the top . . . and becomes a spraying fountain, a very explosion of dazzling jewels. **1886** GEIKIE *Outline Geol.* 50 Should one [ice-laden tree] be overthrown it collides against its neighbour, and this in turn falls upon another, until shortly the trees are seen crashing to the ground in all directions. This is what is known in North America as an ice-storm. **1947** COFFIN *Yankee Coast* 317 We have days in January, after an ice-storm, when living in Maine is living inside a diamond with all the walls cut and polished so they flame.

imperial ɪm'pɪrɪəl, *n.* [F. *impériale*, in same sense.] A form of goatee.

1841 *Knickerb.* XVII. 460 Two wigs, moustaches, an imperial, a gay vest. **1896** HASWELL *New York* 69 A full beard, or even an imperial or goatee, was unknown [in N.Y. *c*1816], except when a native of an Eastern country would appear with the former. **1946** *N. & Q.* May 31/2 The 'Imperial' of Napoleon III was widely copied in this country, and popularized by William F. Cody (Buffalo Bill). It was adopted in the South, especially among 'Kentucky colonels' after the Civil War.

implied power. Power not specifically granted by the U.S. Constitution but implied from enumerated powers. Usu. *pl.*

1791 *Ann. 1st Congress* 1909 He did not pretend that it [i.e., the last paragraph of Section 8 of the Constitution] gives any new powers; but it establishes the doctrine of implied powers. **1819** MARSHALL in *Supreme Ct. Rep.* XVII. 357 The implied powers of the constitution may be assumed and exercised, for purposes not really connected

with the powers specifically granted, under color of some imaginary relation between them. **1883** WAITE in *Supreme Ct. Rep.* CX. 432 Otherwise the assertion and exercise by Congress of any implied power, irrespective of facts or circumstances, would destroy all limitations, and give to the implied powers a greater force than the express powers themselves.

* **improved,** *a.* Of land: In use, under cultivation, fenced and provided with farm buildings. Cf. **unimproved land.**

1643 *Plymouth Laws* 74 By ymproved lands are understood meddow land plowed land and howed lands. **1703** *N.J. Archives* III. 20 A hundred or Fifty Acres of improved Land (as it's call'd). **1832** WILLIAMSON *Maine* II. 159 The school tax was from a half-penny to a penny per acre on improved lands. **1870** *Dept. Agric. Rep. 1869* 8 The vague and meaningless distinctions of 'improved' and 'unimproved' land should be replaced by more . . . useful divisions. **1949** *Lubbock* (Tex.) *Morn. Avalanche* 23 Feb. 11. 8/5 $230 per acre. Fully improved, all conveniences.

b. Also **improved farm.**

1787 in *Mag. Amer. Hist.* I. 435 Stopped at a very beautiful improved farm . . . where one Craig lives in an excellent stone house.

Inauguration Day. The day upon which the President of the U.S. is inaugurated.

The 20th of January in every year next after a year divisible by four is now Inauguration Day, but before 1934 the ceremony was held on the 4th of March of such years.

1829 in M. BAYARD SMITH *Forty Yrs. Washington Soc.* (1906) 288 On the Inauguration day when they went in company with the Vice-President's lady. **1893** WIGGIN *Polly Oliver* (1894) xvii. 185 As it chances to be a presidential year, we will celebrate Inauguration Day. **1948** *Denison* (Tex.) *Herald* 1 July 4/3 That was when Inauguration Day was changed from March 4 to January 20, for Roosevelt's second term.

b. The day upon which a state governor is inaugurated (see quot. 1887).

1886 J. H. TRUMBULL *Memorial Hist. Hartford Co., Conn.* 189 It was the duty of a selected company . . . to escort the governor on 'Election Day' as inauguration day was always styled [in Conn.]. **1887** *Narragansett Hist. Reg.* V. 343 The day upon which state officers are engaged—the day called in other states [than Rhode Island] Inauguration day.

incommunicado ˌɪnkəˌmjunɪˈkado, *a.* [Sp. *incomunicado*, in same sense.] Without means of communication, usu. said of prisoners in solitary confinement.

1844 KENDALL *Santa Fe Exped.* II. 255 Now that I was incomunicado—now that all intercourse with my friends was cut off, . . . my situation became irksome in the extreme. **1931** *Nation* 24 June 689 (Bentley), As the courts are closed, one . . . may be held for three days incommunicado before being arraigned in court. **1949** *Sat. Ev. Post* 16 April 71/2 The only possible thing I can think of would be to

arrest those men on a murder charge and hold them incommunicado until the option time runs out.

Indian devil. The wolverine or the cougar.

1851 Springer *Forest Life* 66 A dangerous specimen of the feline species, known by woodsmen as the 'Indian devil,' had prowled from time immemorial. **1901** Thompson *In Maine Woods* 60 The cougar, or 'Indian devil,' is sometimes seen, but only rarely. **1942** Nat. Pk. Service *Fading Trails* 83 The wolverine's physical and mental traits have earned for it such names as 'skunk bear,' 'carcajou,' 'glutton,' and 'Indian devil.' **1949** *Sat. Ev. Post* 22 Jan. 98/2 Once the Indian Devil has found the line he will give up his wider wanderings and settle down to working it as persistently as the trapper, and several days earlier.

Indian grass. Any one of various wild grasses, esp. *Sorghastrum nutans.* Cf. finger Indian grass.

[**1749** Peter Kalm *Travels N. Amer.* I. (1937) 269 A grass which grows in great plenty here [Pa.], . . . the English call Indian grass and the Swedes wildgrass.] **1764** Hutchinson *Hist. Mass.* I. 480 The natural upland grass of the country commonly called Indian grass, is poor fodder. **1894** Coulter *Bot. W. Texas* III. 494 *Chrysopogon nutans.* (Indian Grass.) . . . Common in rather dry soil throughout the United States, but more abundant in the South. **1941** R. S. Walker *Lookout* 49 Indian grass is a tall wild grass, quite ornamental, and grows in various places on the side of the mountain near the base.

attrib. **1810** Cuming *Western Tour* 137 In an Indian grass hammock, lay Mr. Hunt.

Indian razor. Orig. a pair of clam shells with which Indians pulled out their hair, later a metal device for this purpose obtained from traders.

1775 Adair *Amer. Indians* 6 Holding this Indian razer between their forefinger and thumb, they deplume themselves, after the manner of the Jewish novitiate priests. **1776** Hadden *Journal* 13 The sprouts [of hair] on a certain part are carefully pulled out with what is called an Indian Razor. This resembles a cork Screw except in having many more turns; and being made of wire when compressed together lays hold of the devoted Hairs. [**1937** Lincoln *Wilmington, Del.* 13 They

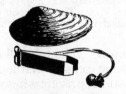

Types of Indian razors

[men of the Lenni-Lenapes tribe] plucked out their beards with tweezers made of mussel shells, in order that they might lay the paint on more smoothly.]

Indian summer. [See note.]

Many theories, none of them convincing, have been advanced to account for this expression. For the most competent discussion of the term see Albert Matthews in the *Monthly Weather Review* for Jan. and Feb., 1902.

1. A period of mild, warm weather in late October or early November, after the first frosts of autumn. Cf. **smoke summer.**

1778 CRÈVECOEUR *Sk. 18th Cent. Amer.* (1925) 41 A severe frost succeeds [the autumn rains] which prepares it [*sc.* the earth] to receive the voluminous coat of snow which is soon to follow; though it is often preceded by a short interval of smoke and mildness, called the Indian Summer. **1832** *Boston Transcript* 8 June 1/2 The Indian summer is so called because, at the particular period of the year in which it obtains, the Indians break up their village communities, and go to the interior to prepare for their winter hunting. **1948** *Richmond* (Va.) *News Leader* 26 Oct. 19/3 Four days of Indian summer were on tap for Richmond today.

attrib. **1832** KENNEDY *Swallow Barn* II. 92 The foggy tint which is said . . . to spread such a charm over an Indian-summer landscape. **1898** FORD *Tattle-Tales* 89 The young couple had enjoyed . . . a recurring Indian-summer honeymoon of two months in front of their own fireside. **1944** *Reader's Digest* May 127/1 Vacation would be nearing its end with the gentle melancholy which hung like an Indian summer haze.

b. *transf.* A period of happiness, serenity, or good fortune occurring toward the end of a life, career, etc.

1843 WHITTIER *Poetical Works* 387/1 The warm light of our morning skies,—The Indian Summer of the heart! **1881** *Harper's Mag.* Jan. 273/2 Perhaps in the Indian summer of his life he may put his heart into a poem. **1944** ROBSJOHN-GIBBINGS *Goodbye* 63 Far be it from me to cast a gloom over this brave Indian summer of the decorating and antique world.

2. Indian-summerish, like Indian summer.

1852 THOREAU *Autumn* 79 It is a warm, Indian-summerish afternoon. **1898** *Advance* (Chi.) 12 May 627/2 [Psalms] in the cradle-like rock of the Hebrew parallelisms . . . which . . . so calm body, mind & soul, that your thoughts become *Indian* summerish. *a*1915 MUIR *Travels Alaska* (1917) 370 The hazy air, white with a yellow tinge, gives an Indian-summerish effect.

Also **Indian-summery,** *a.*

1881 WHITMAN *Spec. Days* 189 Out here on a visit—elastic, mellow, Indian-summery weather.

Indian turnip. (See quot. 1907.)

1806 in *Ann. 9th Congress* 2 Sess. 1142 Persicaria, Indian turnip, wild carrot, wild onion, . . . and bastard indigo [grow near the Ouachita R.]. **1907** HODGE *Amer. Indians* I. 606/2 *Indian turnip.*— (1) The jack-in-the-pulpit (*Arisaema triphyllum*), also called three-leaved Indian turnip. (2) The prairie potato, or pomme blanche (*Psoralea esculenta*). **1949** *Nature Mag.* April 178 A few of these, like Indian turnip or jack-in-the-pulpit, cowslip and milkweed, may be considered mildly inedible.

indignation meeting. A public meeting held to express indignation at something regarded as an abuse.

1842 *Spirit of Times* 5 March 1/2 We have held an 'indignation meeting' and passed strong resolutions against Mexico. **1905** N. DAVIS *Northerner* 53 Indignation meetings were held daily at the different houses of the officials of the societies and guilds. **1948** *Sat. Ev. Post* 3 July 16/1 Mothers were holding indignation meetings about the schools.

*** insane,** *n.*

1. insane asylum, a public asylum, usu. state-supported, for the insane.

1830 *Mechanics' Press* (Utica, N.Y.) 9 Jan. 69/3 He proceeded at large to mention the Orphan, Deaf and Dumb, and Insane Assylums [*sic*]. **1884** *Lisbon* (Dak.) *Star* 31 Oct. 3/2 It is more than likely that he is kept out of the way in some insane asylum. **1948** *Chi. Tribune* 24 Mar. III. 7/5 Right now Buck is a good candidate for an insane asylum.

2. insane hospital, =prec.

1828 WEBSTER, Insane . . . 2. Used or appropriated to insane persons; as, an insane hospital. **1842** *Niles' Reg.* 16 July 318/3 The bill to establish an insane hospital in the District of Columbia was read a third time and passed.

*** ivy,** *n.*

1. The mountain laurel.

1743 CLAYTON *Flora Virginica* 160 *Andromeda*. . . . The common Laurel, vulgarly called Ivy. **1832** WILLIAMSON *Maine* I. 116 [The lambkill] has been called *mountain Laurel, Spoonwood, Ivy* and *Calico Bush.* **1888** WARNER *On Horseback* 29 In this region the rhododendron is called laurel, and the laurel (the sheep-laurel of New England) is called ivy. **1943** PEATTIE *Great Smokies* 196 They assert that the great-leaved common kind is laurel, while what I call mountain laurel they call ivy.

2. Poison ivy.

1788 MAY *Jrnl. & Lett.* 65, I have been clearing land for eight days, and now begin to feel the effects of poison—from ivy, doubtless. **1848** PARKMAN in *Knickerb.* XXXI. 4 In the morning Shaw found himself poisoned by ivy.

3. ivyberry, a local name for the wintergreen.

1849 *S. Lit. Messenger* VI. 518/2 There were the fringed polygala, the butter-cup, wild geranium, bunch-plum, ivy-berry. [**1892** *Amer. Folk-Lore* V. 100 *Gaultheria procumbens*, ivy-berry. N.B.]

J

* **jacket,** *n.*

1. (See quot. 1889.)

1843 in *W. & M. Coll. Quart.* 2 Ser XVI. 554 As the Dept. [of State] does not need a bearer of despatches, it cannot pay any thing for that service; but it is a very common practice to give to citizens whose interests strongly require it . . . a letter or jacket of papers. **1888** *Cong. Rec.* 12 June 5174/1 You can not get that information by taking one case or several cases, and taking the jacket down and getting an abstract. **1889** *Cent.* 3210/2 *Jacket,* . . . a folded paper or open envelop containing an official document, on which is indorsed an order or other direction respecting the disposition to be made of the document, memoranda respecting its contents, dates of reception and transmission, etc.

2. *attrib.* Of or pertaining to a suitably printed and ornamented detachable paper cover issued with a bound book.

1921 *Double Dealer* April 157/1 Concerning jacket eulogies of novels and writers, he said: 'That is one of the curious things I notice in America.' **1929** M. HOLLAND *Industrial Explorers* 3 As colorful as a futuristic jacket design of a best seller. **1944** *Sat. Review* 23 Sep. 27/3 There is a gay jacket cover, designed in black and white and red by Hugh Lofting. **1948** *Pacific Discovery* May–June 31/2 The title is provocative and the jacket design adds to the lure.

* **jack-in-the-pulpit.** Any one of various American plants, esp. the Indian turnip *q.v.*

1847 WOOD *Botany* 519 Jack-in-the-Pulpit. . . . A curious and well-known inhabitant of wet woodlands. **1949** *Nature Mag.* April 194/2 Jack-in-the-pulpit is the plant so commonly used by smart alecks to carry out what they think a practical joke.

b. jack-in-the-pulpit rock, (see quot.).

1879 WILLIAMS *Pacific Tourist* 117/1 Going a little farther, you notice what is called 'Jack-in-the-Pulpit-Rock,' at the corner of a projecting ledge.

jackknife ˈdʒækˌnaɪf, *v.* **1.** *tr.* To cut (someone or something) with a jackknife. **2.** *intr.* To double up like the folding blade of a jackknife.

(1) 1806 *Balance* V. 228/2 A sailor . . . Jacknifed (as he termed it) the poor creature in several places about the head. **1889** *Amer. Annals Deaf* Oct. 277 Some of the class-rooms had desks ink-stained and jack-knifed like those of a country school. — **(2) 1888** *Cent. Mag.* June 251/2 The practice, for instance, of dodging shots, 'jackknifing' under fire, proceeds from a nervousness which is often purely physical.

1946 *Reader's Digest* Aug. 171/2 Mrs. McGill jackknifed into her chair.

Jacksonism ˈdʒæksn̩ˌɪzəm, *n.* The political principles and policies advocated by Andrew Jackson and his followers. Now *hist.*

1827 *Amer. Sentinel* (Georgetown, Ky.) 16 Feb. 2/3 These attempts are evidently but the stages that precede the *dissolution* of Jacksonism in Pennsylvania. **1846** McKenny *Memoirs* I. 200 General Green . . . remained [in exile] till recalled by his ancient friend and ally in the cause of Jacksonism, Mr. Tyler. **1922** McCormac *Biog. Polk* 130 Admiration for the man had obscured the vision of many who would otherwise have been quick to detect the inherent evils of Jacksonism:

jake dʒek, *n.*² [App. in allusion to Jamaica ginger.] **1.** An alcoholic liquor, consisting largely of Jamaica ginger, sometimes used during the prohibition era (1920–33) as a beverage. *Slang.* Cf. **ginger jake.**

1931 *K.C. Star* 1 Oct., It must have been 'lit up' with some of that Wichita 'jake' about which we read so much not long ago. **1948** *Dly. Ardmoreite* (Ardmore, Okla.)' 11 Aug. 1/1 The popular bootleg beverage of the addicts was a mysterious drug popularly called 'jake.'

2. A form of paralysis caused by drinking this or some other alcoholic preparation. In full **jake-leg.** *Slang.*

1931 I. L. Reeves. *Ol' Rum River* 351 Much of the present liquor being poisoned, as a result of the Government's own acts, and thus directly responsible for thousands of cases of blindness, paralysis, 'jake,' and death. **1932** *K.C. Star* 4 Jan. 16 If one goes to a social party there is great danger of acquiring jake-leg. **1947** *Democrat* 22 May 4/5 That stuff not only gives you the jake leg, it gives you 'jake legs.'

jalopy dʒəˈlɑpɪ, *n.* [Origin obscure.] (See quots. 1929, 1936.) *Slang.*

1929 Hostetter & Beesley *It's a Racket* 229 Jaloppi—A cheap make of automobile; an automobile fit only for junking. **1936** *Amer. Sp.* XI. 306 A *jalopy* is an old, battered automobile. The word was used in Chicago about 1925; in western and northern Pennsylvania about 1934; in an Associated Press dispatch from Landisville (Lancaster Co., s.e. Pa.) in 1935. **1948** *Chi. Sun-Times* 20 April 3/4 In their earlier statements to police they had said the jalopy struck the girl.

jamboree ˌdʒæmbəˈri, *n.* [Origin unknown.] **1.** (See quot.) **2.** An unrestrained celebration or merrymaking. Also *transf.* Cf. **high, whoop jamboree.**

(1) 1864 Dick *Amer. Hoyle* (1866) 85 Jamboree signifies the combination' of the five highest cards, as, for example, the two Bowers, Ace, King and Queen of trumps in one hand, which entitles the holder to count sixteen points. — **(2) 1868** *N.Y. Herald* 10 July 8/3 The Seventh regiment has gone on a jamboree to Norwich, Connecticut. **1937** *Lit. Digest* 3 July 28/2 An international army of peace and brotherhood—an army of 27,000 boys—gathered from twenty-five nations for America's first National Boy Scout Jamboree. **1947** *Chr. Sci. Monitor* 1 March 10/4 The club will make its presentation at its football jamboree at the close of each grid season.

jeep jip, *n.* [See note.]

The history of this term is obscure. The word is app. a fanciful coinage by Elzie Crisler Segar in a comic strip ("Popeye") where on March 16, 1936, he introduced Eugene the Jeep, a small animal of supernatural powers. The word has been used of various devices. Its application to the Army vehicle may have been a verbalizing of GP (general purpose) inspired by a knowledge of its earlier use in the comic strip. See *Amer. Sp.* Feb. 1943, 68 f.; *Amer. N. & Q.*, June 1944, 43; and Mencken *Supp.* II. 782 ff.

A small, light motor vehicle orig. designed for, and widely used in, the U.S. Army, noted for its four-wheel drive and ruggedness. Also attrib.

1941 DANIELS *Tar Heels* 47 Beer wagons moved on the road with the brown jeeps of soldiers and marines. **1945** *Pueblo* (Colo.) *Chieftain* 18 June 5/4 Everything from X-ray films to jeep tires hastened victory over Germany. **1948** *Salt Lake Tribune* 17 Dec. 16/5 They were in a black jeep with a metal top.

Jehovah's Witnesses. The members of the International Bible Students' Association, a society composed of the followers of Charles T. ("Pastor") Russell (1852–1916). — **1941** *Amer. Guardian* (Okla. City) 15 Oct. 7/1 Remember . . . the fifth column hunt directed at Jehovah's Witnesses trying to establish the Four Freedoms before F. D. R. got the idea. **1947** *Chi. Sun* 25 Nov. 14/5 The majority held valid a regulation issued by the director of Selective Service which prescribed tests for determining whether Jehovah Witnesses were entitled to exemption as ministers.

jerky 'dʒɝkɪ, *n.*[1] (See quot. 1917.)

1850 COLTON *3 Years Calif.* 298 A tin cup of coffee, a junk of bread, and a piece of the stewed jerky. **1917** KEPHART *Camping* I. 277 'Jerky' or jerked meat has nothing to do with our common word 'jerk.' It is an anglicized form of the Spanish *charqui.* **1948** *Sat. Ev. Post* 25 Dec. 13/3 The jerky which filled one side [of the saddlebag] he distributed in his pockets.

jewelweed 'dʒuəlˌwid, *n.* Either of two American plants of the genus *Impatiens,* "so called from the earring-like shape of the flower, and the silver sheen of the under surface of the leaf in water" (*Cent.*).

1817–8 EATON *Botany* (1822) 317 *Impatiens nolitangers,* jewelweed, touch-me-not. **1893** DANA *Wild Flowers* 154 Jewel-Weed. Touch-Me-Not. . . . *Impatiens pallida.* **1949** *Chi. Tribune* 9 Jan. VI. 5/7 Then come the trumpet vine, followed by wild hydrangea, pale and spotted jewel-weed, and several species of water leaf.

jimson 'dʒɪmsn̩, *n.* [f. **Jamestown (weed).**]

1. Short for next. Also attrib.

1812 *Cramer's Alman. 1813* (Pittsburgh) 26 James'-town weed, from James'-town, on James' River, in Virginia, where the plant seem to have first attracted notice. It is also known by the name of Jimson, and Thorn-apple. **1867** G. W. HARRIS *Sut Lovingood* 177 They makes soup outen dirty towels an' jimson burrs. **1943** PEATTIE *Great Smokies* 118 Jimson root for ulcers and to help palsy . . . they went to the woods for them.

2. jimson weed, a tall, coarse, poisonous weed, *Datura stramonium,* from the leaves of which the drug stramonium is obtained. Also **jimpson weed.**

1832 BENTON *30 Years' View* I. 256/2 An eagle . . . [was] by a pig under a jimpson weed . . . caught and whipt. **1875** *Cin. Enquirer* 5 July 8/1 Gympson weeds are ripe. **1948** *Nat. Hist.* April 147/2 These [narcotic plants] included Jimson weed (*D. stramonium*) and Ololiuhqui (*D. meteloides*), both used by the Aztec priests.

John Brown, *v. tr.* To darn. *Slang.* — **1869** in MATHEWS *Beginnings* 160 You need apprehend nothing dreadful, for boobies seldom 'John Brown' each other. **1942** PHILLIPS *Big Spring* 1 I'll be John Browned if we didn't have a dry norther that would send you hunting for your long ones.

Jubilee Singers. A group of singers at Fisk University who go on singing tours in the interests of their school. Also **Jubilee song.**

1872 T. F. SEWARD (*title*), Jubilee Songs as Sung by the Jubilee Singers, of Fisk University. **1881** *Harper's Mag.* May 804/1 Thomas's Symphony concerts and the . . . Jubilee Singers all find an appreciative audience. **1949** *Reader's Digest* May 97/1 In two triumphal tours the Jubilee Singers took Europe by storm.

transf. **1946** HOLBROOK *Lost Men* 133 The Chautauqua offered no such strong meat as the Lyceum, but went in for bell ringers, jubilee singers, preachers, William Jennings Bryan, and assorted stuffed shirts.

juke dʒuk, *n.* [See note.]

This term is no doubt of African origin. L. D. Turner found "juke house," a disorderly house, a house of ill repute, in well-established use among the Gullahs c1930. He finds in Wolof and Bambara clear antecedents of the Gullah term "juke."

1. Short for **juke box** or **juke joint.** Cf. **2.** *Slang.*

1942 KENNEDY *Palmetto Country* 183 These jooks are tough joints. They'll murder you, caress you, and bless you. **1947** *Sat. Ev. Post* 8 March 91/1 As I watched, a man came from the direction of the bar and fed the juke a nickel. **1948** *Ib.* 9 Oct. 136/3 Here on the 'Gold Coast,' a squalid collection of jooks and honky-tonks, liquor may be bought openly by the case.

attrib. **1942** KENNEDY *Palmetto Country* 190 Jook organs are seldom quiet; bleary-eyed customers who take a fancy to a particular tune have been known to keep it playing continuously until dawn. **1947** *Chi. D. News* 16 Jan. 4/2 (*heading*), Juke Operator Surrenders in Shooting Quiz.

2. juke box, a nickel-in-the-slot electrically operated record-playing music box. Often attrib. Also **juke joint,** a place of low resort. *Slang.* Cf. **Negro juke (joint).**

1946 *Trail & Timberline* April 52/2 Back at the cars, the group decided to explore Crested Butte, an expedition which wound up behind high-collared glasses of beer in a Slovene Juke Joint. **1946** *N.Y. Times Mag.* 14 April 31/2 The price of most juke boxes is about $300—varying from $150 to $700. **1948** *Chi. D. News* 24 Feb. 1/7 [He was] erstwhile 1st ward Democratic committeeman and juke box boss

of the Loop and surrounding territory. **1949** *Ib.* 16 June 18/3 Most of the new automobiles look like animated juke boxes.

* **junket,** *n.* (See quot. 1886.) Also transf. and attrib.

1886 *Detroit Free Press* 4 Sep. 4/2 The term 'junket' in America is generally applied to a trip taken by an American official at the expense of the government he serves so nobly and unselfishly. **1912** MATHEWSON *Pitching* 229 At last, after the long junket through the South . . . is ended, comes a welcome day, when the new uniforms are donned. **1947** *Chi. Tribune* 19 July 3/1 Several rules committee members have opposed the resolutions on the ground that they would provide 'nice junket trips' for committee members

juzgado huz'ga·u, *n. S.W.* [Sp., court, tribunal.] A hoosegow *q.v.*

1919 C. G. RAHT *Romance of Davis Mountains* 168 As the prisoners were being led to the *juzgado*, they cast longing eyes across the River. **1931** *Lariat* April 122 (Bentley), And I had to stay in the nearest *jusgado* for three days. **1935** *So. Calif. Hist. Soc. Pub.* March 10 The southern part of the adobe, formerly separated from the rest by a narrow passageway, was the old *Juzgado*, or court room of the pueblo.

K

Kallikaks 'kælɪˌkæks, *n. pl.* [Gk. *kalli-* (combining form of *kallos*, beauty) + *kak*os, ugly, bad.] The fictitious name for the members of a family the history of which showed that heredity, rather than environment, was the cause of feeble-mindedness, as well as of intelligence and respectability. Also **Kallikak family.** Cf. **Jukes.**

1912 GODDARD *Kallikak Family* 71 There are Kallikak families all about us. They are multiplying at twice the rate of the general population. **1948** *Dly. Ardmoreite* (Ardmore, Okla.) 22 April 16 Jumping blue blazes . . . it's the Kallikak family!!
transf. **1947** PERRY *Cities of Amer.* 179 For those Boston visitors who look upon the cod and the bean as the Jukeses and Kallikaks of human fare, it's worth noting that the Hotels Vendome and Copley Plaza have genuinely gifted French chefs.

kazoo kə'zu, *n.* [Origin obscure.] A crude musical instrument used by children, consisting of a tube, inside of which is stretched a piece of catgut which vibrates and makes a sound when one hums or sings into the tube. Also transf.

1884 *Lisbon Dak. Star* 31 Oct. 3/2 When you hear a noise like the combined sound of a fish-horn and a runaway . . . it is only the small boy amusing himself peaceably with his kazoo. **1904** *N.Y. Sun* 2 Sep. 5 Dear Edna sang as usual out of tune and with a quality of voice that resembled a solo on the gentle kazoo. **1947** *Chi. Tribune* 1 Nov. 15/3 The New Deal is now playing hearts and flowers thru a kazoo instead of a Stradivarius.
 attrib. **1948** *Dly. Ardmoreite* (Ardmore, Okla.) 21 March 19/4 The 'Prairie Queen Kazoo band' furnished background music.

* **Keeley,** *n. attrib.* Designating a *cure* or *treatment* for alcoholism according to a system developed by Dr. Leslie E. Keeley (1832–1900), an American physician. Also fig.

1895 *N.Y. Dramatic News* 6 July 8 Keeley Cure Not Certain. The treatment for dipsomania invented by Dr. Leslie A. Keeley does not appear to be universally efficacious. **1922** *Collier's* 29 April 3/2 A little event which come to the pass whilst we are carving out our farewell picture was the Keeley Cure for me as far as believing in signs is concerned. **1948** *L.A. Times* 26 Dec. I. 10/2 The Keeley Treatment can be arranged so as to prevent loss of time from work or normal conditions.

b. Keeley institute, an institution for giving patients the Keeley treatment for alcoholism.

1892 *S.F. Enterprise* 12 May 4/1 A son of the late lamented Boss graduated from a Keeley institute and went directly on a howling drunk.

Kentucky boat. (See quots. 1818, 1847.) Now *hist.*

1785 E. DENNY *Journal* 57 Our fleet now consists of twelve small keels and batteaux, besides two large flats called Kentucky boats. **1818** PALMER *Jrnl.* 56 Our conveyance was one of the long Kentucky boats, in common use here for transporting produce and manufactures *down* the Ohio; they are shaped something like a box, forty or fifty feet long, having a flat bottom, with upright sides and end. Three-fourths of the boat nearest the stern is roofed in; two oars are occasionally worked at the bows; and a large sweep on a pivot serves as a rudder. **1847** in H. HOWE *Ohio* 210 Boats similarly constructed on the northern waters, were then called *arks*, but on the western rivers, they were denominated *Kentucky boats*. **1948** DICK *Dixie Frontier* 109 These were often known on Western waters as Kentucky boats. Farther north and east they were called arks.

kewpie ˈkjupɪ, *n.* [f. * *Cupid*.] A chubby, winged baby fairy with a topknot such as originally drawn by Rose O'Neill (d. April 6, 1944), also (*cap.*) the trademark name of a doll patterned after this drawing. Also attrib.

1912 *Ladies' Home Jrnl.* Oct. 109 The kewpies were invented by Rose O'Neill. They are always doing good, helping Dotty Darling and her Baby Brother to have a good time. . . . So Rose O'Neill has made the Kewpie Kutouts. **1931** *K.C. Star* 7 Aug., Why do the movie producers insist on playing Nancy Carroll's kewpie-doll face in tragic

parts? **1947** *Atlantic Mo.* Oct. 52/1 Familiar as the substance of fountain pens and kewpie dolls, they [plastics] turn up in bomber noses and auto finishes, toothbrush bristles and parachutes.

kibitzer ˈkɪbɪtsɚ, *n.* Also **kibbitzer.** [Yiddish modification of colloq. G. *kiebitzen,* to look on at cards, f. *Kiebitz,* a meddlesome looker-on, lit. a lapwing or plover. Cf. **pewit,** and see Mencken *Supp.* I. 433.] One who looks on, as at a card game, and offers gratuitous advice. *Colloq.*

1928 *Amer. Sp.* IV. 159 The trade journal . . . devotes an editorial . . . to the 'kibbitzer.' **1938** WHITE *One Man's Meat* 2 Two kibitzers stopped to attend the deal, and the El train went off down the block, chuckling. **1949** *N.Y. Times Mag.* 3 April 25 (*legend*), The prime entertainers of the Big Show go for a game of rummy, assisted by the usual kibitzers.

killdeer ˈkɪlˌdɪr, *n.* [Echoic.] The largest and commonest of the American ring-plovers, *Oxyechus* (syn. *Aegialitis*) *vociferus.* In full **killdeer plover.**

1731 *Phil. Trans.* XXXVII. 176 The Chattering Plover. In Virginia they are called Kildeers, from some resemblance of their Noise to the Sound of that Word. **1813** WILSON *Ornithology* VII. 73 Kildeer Plover. . . . This restless and noisy bird is known to almost every inhabitant of the United States. **1941** LOFBERG *Sierra Outpost* 74 Among the flock of Brewer's blackbirds, spotted sandpipers dipped and dug, and over there were four killdeers. **1949** *Nat. Hist.* May 233/1 The pantomime of a broken wing will usually be enacted. . . . Killdeer and nighthawks often alternate injuries from side to side and thus spoil the illusion.

b. The note of this bird.

1924 *Frontier* Nov. 7 'Kill-deer, kill-deer,' The snipe's wail rose and fell harshly in the hot quiet.

* **king crab.** Any one of various large marine arthropods, esp. *Xiphosurus sowerbyi,* found on the eastern and southern coasts of the U.S.

1698 *Phil. Trans.* XX. 394 The Molucca Crab *Mus. Regal. Soc.* 120 In *Virginia* and several parts of the Continent of *America,* they call it, *The King Crab.* **1796** MORSE *Univ. Geog.* I. 227 King Crab, or Horse Shoe *Monoculus polyphemus.* **1884** GOODE *Fisheries* I. 829 The curious form of marine animal called 'Horseshoe Crab' [and] 'King Crab' . . . is not, however, a true Crab. . . . Some naturalists regard it as a low type of crustacean, while others place it among the *Arachnida,* or scorpions and spiders. Its nearest allies all occur as fossils. **1935** LINCOLN *Cape Cod Yesterdays* 154 Hallett ignored and did not trouble himself to dip out . . . king crabs.

kitchen cabinet. A coterie of personal, unofficial advisers of President Andrew Jackson (1829–37). Also attrib.

1832 in A. C. COLE *Whig Party in So.* (1913) 13 If there be no other

mode of preventing its [a mission's] being given to the most despicable of all the Protegees of the Kitchen Cabinet [i.e., Van Buren.] **1842** UNCLE SAM *Peculiarities* I. 212 We will hurl the Kitchen cabinet tyrants from their stools. **1867** *Wkly. New Mexican* 30 March 2/2 [Gov.] Mitchell [of N.M.] having failed in his 'kitchen cabinet' diplomacy, Perea turned his eyes upon the Senate. **1948** *Sat. Ev. Post* 10 July 19/2 The bright idea of overriding this opposition by a well-managed convention originated with Maj. W. B. Lewis, a member of Jackson's 'Kitchen Cabinet.'

transf. **1886** *Cong. Rec.* 9 June 5721/2 Don't you think Mr. Adams, of New York, is one of the members of that kitchen cabinet? **1948** *Chi. D. News* 4 Dec. 4/4 One of the most important members of Gov. Stevenson's kitchen cabinet will be the new head of the State Department of Labor.

Kiwanis Club. [See note.]

Any one of various local clubs designed to promote civic interests and good fellowship, and patterned on the first such organization formed at Detroit in 1915.

1884 SARGENT *Rep. Forests* 114 *Ehretia elliptica.* . . . Knackaway. Anaqua. **1896** *Garden & Forest* IX. 282 *Knackaway* (*Ehretia elliptica*), a corruption of the Mex.-Span. anaqua, shortened from anacahuite, which is from Aztec *nanahuaquahuitl*, 'lues venera tree,' so called from the medicinal use of its roots. **1902** CLAPIN 18 *Anaqua* . . . (Sp.), a tree or shrub of the borage family (*Ehretia elliptica*), found in South-Western Texas. Also called *knackaway*.

Klieg klig, *n.* Also **Kleig**. [f. A. and John *Kliegl*, experts in stage lighting.] **1. Klieg eyes,** (see quots.). **2. Klieg light,** an intense incandescent light rich in actinic rays used in taking motion pictures.

(1) **1923** *Sci. Amer.* Oct. 243/1 The burning of the eyeballs by the ultra-violet rays is a form of conjunctivitis. . . . This malady occurs so freely among motion-picture actors—stars and supers alike—that a name, 'Klieg eyes,' has been coined for it. **1929** DORLAND *Amer. Ill. Med. Dict.* (ed. 12) 453/2 Klieg e[ye], a condition marked by conjunctivitis, lacrimation, and photophobia due to exposure to the intense lights (Klieg lights) used in making moving picture photographs. — (2)**1929** [see prec.]. **1948** *Ada* (Okla.) *Ev. News* 4 July 1/4 Kleig lights, had they been used, would have been subdued by the number of luminaries that gathered in the banquet room.

know-how 'no͵haʊ, *n.* The ability to do something. Also attrib. *Colloq.*

1857 *Spirit of Times* 26 Dec. 270/3 'No, no, Massa,' replied the gentleman from Africa, 'charge fifty cents for killing, and fifty for the know how.' **1898** *Me. Exp. Sta. Ann. Rep.* 170 Patience and a little of the 'know how' will overcome all of these. **1904** *Dly. Public Opinion* (Watertown, S.D.) 28 Dec. 8/6 Wanted—A 'know how man' for the Kellogg House, Hazel, S.D. A good place for one that can keep a good hotel. **1949** *Chi. D. News* 18 Feb. 5/2 But this authority needed, and still needs, Germans to apply the know how.

kyack ˈkaɪæk, *n. W.* [Origin obscure. Prob. f. an Indian or Sp. term.] A form of packsack consisting of two hollow containers swung on either side of a packsaddle.

1907 WHITE *Arizona Nights* 17 We skirmished around and found a condemned army pack saddle with aparejos, and a sawbuck saddle with kyacks. On these we managed to condense our grub and utensils. **1913** *Outing* Jan. 425/2 The alforjas are constructed of heavy duck and leather, and of the same dimensions as the kyack. **1948** *Sierra Club Bul.* Dec. 2/2 He must therefore plod on trails engineered for stock that don't like a steep ascent and don't mind getting wet up to the kyacks at a stream crossing.

L

* **L,** *n.*

1. A fifty-dollar bill. *Obs.*

1839 *Spirit of Times* 13 April 66/3 (We.), I had no idea of betting more than an 'L,' or a 'C.' **1845** *St. Louis Reveille* 2 May 2/1 'You are as lucky as a jailor,' I remarked, as my friend began to smooth down the V's, X's, L's and C's.

2. *attrib.* Short for "elevated," with reference to trains and railroads. *Colloq.* Cf. **El.**

1879 *N.Y. Herald* 19 Sep. 8/4 The crowds at the Park place station of the Metropolitan 'L' road, . . . have apparently been unprecedently large. **1899** *Chi. D. News* 15 May 1/2 Through trains to Oak Park over the Lake street 'L' extension are now running. **1946** *Ib.* 24 May 1/2 The 'L' jam was further complicated as riders found earlier tickets voided by the increase in fares.

laborite ˈlebəˌraɪt, *n.* A supporter of the interests of labor in politics, used first of the Populists. *Colloq.*

1889 *Denver Press* 9 Aug. 4/2 I believe that only two of the laborites were for prohibition. **1922** *Tom Mooney's Mo.* (S.F.) Nov. 3/6 [He] was well-known as a radical laborite and his petition has always been refused. **1949** *Time* 14 March 64/2 At least one powerful group of Catholic laborites, the Association of Catholic Trade Unionists, last week took sharp issue with His Eminence.

ladies' day. A day upon which special privileges are given to women (see also quot. 1882).

1787 WASHINGTON *Diaries* III. 225 Dined with a Club. . . . The Gentlemen . . . met every Saturday . . . accompanied by the females every other Saturday. This was the ladies' day. **1882** McCABE *New York* 329 January 2d . . . is 'Ladies' Day,' and is devoted by the fair sex to calling upon each other. **1906** *Amer. Mag.* Oct. 595 Ladies' Day in Carbury Mine. **1948** *Dly. Ardmoreite* (Ardmore, Okla.) 23

May 13/3 The league-leading Cleveland Indians recorded a 7 to 0 victory before a ladies' day crowd of 28,997.

lagniappe læn'jæp, *n.* [See note.]

Read in *La.-Fr.*, 142, thinks this word is composed of the French *la*, "the" and a French adaptation of Spanish *ñapa*, which is taken from Kechuan *yapa*, a present made to a customer. But Santamaría regards the base of the word as being of ultimate African, not South American, origin. See *Amer. Sp.* XIV. 93-6, *Zeitschrift* LXI. 77, and Santamaría.

A small present given when a purchase is made; a gratuity. Also transf. and attrib.

1849 *Knickerb.* XXXIV. 407/1 Ime sum pumkins in that line; but he's a huckleberry above my persimmon, and right smart lanyope too, as them creole darkies say. **1927** BENÉT *J. B.'s Body* 231 They come back with a scraping of this and a scrap of that and try to remember old lazy, lagnappe days. **1948** *Travel* Nov. 10/1 The Cajuns of Louisiana call it [Spanish moss] a 'lagniappe' crop. **1949** *N.O. Times-Picayune Mag.* 24 April 9/3 Mack is the old loquacious type of business man of 50 years ago and he will not only sell you one or 100 pictures, but give you the history of each vessel depicted there for lagniappe.

* **lambrequin**, *n.* A narrow valance for hanging from a shelf or from a casing at the top of a window.

1872 *Rep. Comm. Patents 1870* 40/2 Claim.—The construction of lambrequins in sections, which can be adjusted to windows of different sizes. **1929** A. ELLIS *Life* 152, I made a crazy-work lambrequin. **1942** THOMAS *Blue Ridge* 120 (Wentworth), I want a lamberkin all scalloped deep.

* **lamplighter**, *n.*

1. A slim roll of paper or similar device for lighting lamps.

1833 NEAL *Down-Easters* II. 115 One side is clean, said she—and it will do for lamplighters! **1893** *Harper's Mag.* April 760/1 Mrs. Franklin . . . knocked off a chair accidentally the lamplighters which she had just completed. **1938** DAMON *Grandma* 25 On every mantelpiece stood a vase filled with 'lamplighters.' These were cunningly twisted papers (no envelope fell to the floor that Grandma did not take notice of it).

2. Any one of various fishes (see quots.).

*a*1876 *Ohio Fish Comm. 1st Rep.* 77 P[omoxis] *hexacanthus* . . . Strawberry Bass; . . . Lamp-lighter, of Kirtland. **1892** LUMMIS *Tramp Across Continent* 33 For three years I had been fairly starving for a bout with these beauties—a hunger which the catfish and 'lamplighters' of Ohio had utterly failed to satisfy. **1947** DALRYMPLE *Panfish* 84 Here, my friend, are the various names by which you would address that little gamester, the Crappie, depending on where you happened to be at the moment: Bachelor, . . . Lake Bass, Lake Erie Bass, Lamplighter.

land agent.

1. In Massachusetts and Maine, an official who administers public lands. Now *hist.*

1828 *Maine Laws* III. (1831) 243 The Land Agent . . . is hereby
authorized to execute deeds [etc.]. **1833** in *Pres. Mess. & P.* III. 423
A letter . . . complaining of the 'conduct of certain land agents of the
States of Maine and Massachusetts in the territory in dispute be-
tween the United States and Great Britain.' **1937** WILSON *Aroostook*
85 Maine's land agent, Rufus McIntyre, . . . headed for far Aroos-
took, leading a force of two hundred militiamen.

2. An agent in charge of a government land office.
Also a broker or agent who helps settlers acquire title, to
public or private land. Cf. **general land agent.**

1829 BASIL HALL *Travels N. Amer.* I. 144 A settler . . . sets about
finding what are the marks upon the stakes nearest to him, and by
reference to these, the land-agent, who has maps before him, can at
once lay his hand upon the very spot. **1847** ROBB *Squatter Life* 124
The Land Agent . . . informed the unsuspecting squatter, that the
stranger had . . . entered the claim. **1890** *Stock Grower & Farmer* 22
Feb. 8 Upson and Garrett, Land Agents and Conveyancers, Roswell,
New Mexico. **1941** *Yankee* Dec. 48/2 In 1802, John Black, an im-
portant land agent, imported brick from Philadelphia.

b. An agent of a land-owning railroad.

1883 *Harper's Mag.* Nov. 943/2 To read the 'land agents' literature
of the railroads which have land to sell in it [Missouri] one would
think it a veritable land of Goshen. **1948** JOHNSTON *Gold Rush* vi/1
It was named in fact for B. B. Redding, first land agent of the Central
Pacific Railroad Company.

Land of Steady Habits.

1. Connecticut, app. in allusion to the strict morals of
its inhabitants. Cf. **blue law(s).**

1805 *Intelligencer* (Lancaster, Pa.) 20 Aug. (Th.), The significant
Essay of the Hero of the *Land of Steady Habits.* **1904** MORGAN *Conn.
as Colony & State* III. 106 Never had such a political cyclone swept
over the 'land of steady habits.' **1945** WEBSTER *Town Meeting Coun-
try* 223 This is the land of steady habits, and the landscape must not
be too lushly rich.

2. (See quots.) *Obs.*

1831 *Boston Transcript* 4 Jan. 3/2 In the good old days of our
fathers. . . . New England was *truly* the land of steady habits. *c*1873
DE VERE *MS Notes* 661 New England—The 'Land of Steady
Habits.'

lasso 'læso, læ'su, *n.* [Sp. *lazo*, in same sense. An
Amer. borrowing.] A long rope, often of rawhide, having
a running noose at one end and used chiefly for catching
cattle and horses. Also attrib. Cf. **rope lasso.**

1819 *Petersburg* (Va.) *Republican* 5 Oct. 3/1 He was equipt with a
lassau, a long knife, and sword; mounted on a high pummeled saddle.
1833 CATLIN *Indians* I. 253 The laso is a long thong, of rawhide. **1844**
in *Amer. Sp.* XVIII. 126/2 The Mexican troops disbanded, like wild
herds of mustangs, pursued in the prairie by the lasso-hunter. **1940**
MENCKEN *Happy Days* 284 They lay in wait in dark Greene street
with their dreadful hooks, saws, lassos, and knives.

* **Latrobe,** *n.* [f. J. H. B. *Latrobe*, its inventor.] A stove

which may be used in a fireplace in a lower room in such a way as to heat also the room above it. In full **Latrobe stove.**

[1846 *Sci. Amer.* 6 Nov. 49/4 A List of Patents. . . . To John H. B. Latrobe, of Baltimore, for improvement in Stoves. Patented 5th Sept. 1846.] **1905** *Washington Star* 24 Nov. 21 (*advt.*), We have for exchange for your old houses, with latrobe, furnace heat and basement kitchens, choice new homes. **1940** MENCKEN *Happy Days* 63 Our house in Hollins street, as I first remember it, was heated by Latrobe stoves, the invention of a Baltimore engineer.

* **Lawson,** *n.* [John *Lawson*, d. 1712.] **Lawson's cedar, cypress,** the Port Orford cedar, found in the West.

1874 HITTELL *Resources Calif.* 360 Lawson's cedar (*Chamaecyparis lawsoniana*) is a tree of little value in the forest, but as an ornament it is highly prized. **1884** SARGENT *Rep. Forests* 179 *Chamaecyparis Lawsoniana.* . . . Port Orford Cedar. . . . Lawson's Cypress. Ginger Pine. **1897** SUDWORTH *Arborescent Flora* 82 (*Chamæcyparis lawsoniana.* . . . [Commonly called] Lawson's Cypress (Cal., Oreg.). **1928** BAILEY *Cyclo. Horticulture* 730/2 Lawson's Cypress . . . is one of the most beautiful conifers and very variable, about 80 garden forms being cult[ivated].

* **lazuli,** *n.* In combs.: (1) **lazuli bunting,** = next; (2) **finch,** *Passerina amoena,* found in the West; (3) **painted bunting,** = prec.

(1) **1887** RIDGWAY *Man. N. Amer. Birds* 447 Western United States, east to Great Plains, south, in winter, to western Mexico, P[*asserina*] *amœna.* . . . Lazuli Bunting. **1917** [see **lazuli painted bunting**]. — (2) **1825** BONAPARTE *Ornithology* I. 61 Lazuli Finch. *Fringilla Amœna.* **1839** AUDUBON *Ornith. Biog.* V. 64 The Lazuli Finch, one of the handsomest of its tribe, and allied to the Indigo Bird, . . . was added to our Fauna by Thomas Say. **1874** COUES *Birds N.W.* 170 The prettily-colored and delicate little Lazuli Finch is found to be common. — (3) **1917** *Birds of Amer.* III. 72 Lazuli Bunting *Passerina amœna.* . . . [Also called] Lazuli Painted Bunting.

Leatherstocking ˈlɛðɚˌstɑkɪŋ, *n.* A wearer of stockings or leggings made of leather, usu. with particular reference to Natty Bumppo, the hero of Cooper's *Leatherstocking Tales,* whose sobriquet was "Leatherstocking."

1823 COOPER *Pioneers* xxxiii, The Leather-stocking made his appearance, . . . under the custody of two constables. **1829** *Va. Herald* (Fredericksburg) 11 March 2/4 Simeon Kendall, of Ohio, who is represented as the prototype of Cooper's inimitable Leatherstocking, has applied to Congress for a pension. **1831** HOLLEY *Texas* (1833) 43 The dress of these hunters is usually of deer-skin. Hence the appropriate name *Leather Stocking.* **1948** *Southwest Rev.* Summer 280/1 Young, handsome, and actually or potentially genteel trappers and hunters are almost as numerous [in Western fiction] as the older hunters who are replicas of Leatherstocking.

* **legal,** *a.* **1. legal cap,** ruled writing paper made in

long sheets folded at the top and often used for legal documents. **2. legal holiday,** a holiday established by a state statute or a governor's proclamation during which government and other business is usu. suspended.

(1) **1874** KNIGHT 455/2 *Cap-paper* . . . [Ruled] with red lines to form a margin on the left hand, and made to fold on the top, it is *legal cap.* **1904** HARBEN *Georgians* 104 Abner . . . drew out several sheets of legal-cap paper pinned together at the top. — (2) **1867** *Santa Fe Wkly. New Mexican* 30 March 1 New Jersey makes a legal holiday of President Lincoln's birthday. **1949** *Dly. Ardmoreite* (Ardmore, Okla.) 23 Feb. 15/4 Classes were resumed today at Carter seminary after the legal holiday Tuesday, due to Washington's birthday.

Lespedeza ˌlɛspəˈdizə, *n.* [D. *Lespedez,* Sp. governor of Fla.] A variety of Japan clover, used for forage in the South.

[**1803** A. MICHAUX *Flora Boreali-Americana* II. 70 Lespedeza. D. Lespedez, gubernator Floridæ, erga me peregrinatorem officiosissimus.] **1937** PARKS *Valuable Plants Texas* 54 There are ten other species of Lespedeza, all of which are called Bush Clover. **1949** *Mo. Bot. Garden Bul.* Feb. 51 As is commonly true of many lespedezas, this species seems well adapted to soils of low fertility.

levis ˈlivaɪz, *n. pl.* [See note.] Bibless overalls, orig. and properly applied to those of heavy blue denim reinforced at strain points with copper rivets and made by Levi Strauss and Company.

Orig. such overalls were known as *Levi's,* the maker's trade-mark name, from *Levi* Strauss, a pioneer overall manufacturer in the West.

1941 *Yankee* Dec. 39/1 Red-flannel underwear, Peavey axes, copper-riveted Levi's, etc. **1949** *Rocks & Minerals* May–June 226/2 This garb may consist of . . . miner's dress, Levis and gay colored shirt, or any dress that will enable the contestant to look the part.

Liberty Boys. Active supporters of the American Revolution. Now *hist.*

1774 in ASPINALL-OGLANDER *Admiral's Widow* (1942) 51 They are distinguished here by the name of Tories, as the Liberty Boys—the tarring feathering gentry—are by the title of Whigs. **1872** *Harper's Mag.* April 692/2 The close of the revolutionary war found New York politically in the hands of the Whigs of that day, who were controlled by the Liberty Boys, the most radical of their number. **1938** HART *New Yorkers* 23 Washington stormed at the organization of the people in the Democratic party by the Liberty Boys, caustically styling their local groups 'self created societies' which he apparently believed dammed them completely.

b. Those interested in freeing Texas from Mexican rule. *Obs.*

1858 *Texas Almanac 1859* 33 The Liberty boys, always on hand on an emergency, joined Austin's Company.

Liberty pole. A tall pole or mast, usu. having a cap

or banner on it, and serving orig. as a rallying place for the Sons of Liberty. Now *hist.*

1770 in *Mag. Amer. Hist.* (1890) Aug. 91 Our city [N.Y.] is yet in a ferment, and last Saturday night a party of soldiers attempted to cut down or blow up the liberty pole. **1794** *Balt. D. Intelligencer* 8 Sep. 3/2 They threaten to march to Middle-Town and Funks-Town, and put up Liberty-poles at those places. **1858** *N.Y. Tribune* 16 Nov. 7/4 The famous 'iron' Liberty-pole to be raised in West Broadway is to be of wood after all. It is over 200 feet high. **1945** McLEAN *Moment of Time* 17 It's a liberty pole, child.

attrib. **1774** in *Copley-Pelham Lett.* 281 The demolition of Liberty-Pole-Committee,—we could not come to, on that Day.

* **licking,** *n. attrib.* Designating places to which animals resort to lick the ground for salt, as **licking hole, place, pond.** Also transf. Cf. **salt lick.** See also **bootlicking.**

1727 in *Amer. Sp.* XV. 281/1 Thence to the Licking place, and from the Licking place across the Meadow and old Field to a Corner Tree. **1736** *Ib.*, Thence . . . to two Corner red Oaks and a black Oak by a Licking Hole. **1751** J. BARTRAM *Observations* 27 We found a *Liching* [*sic*] *Pond*, where we dined, the backs [*sic*] parts of our country are full of these liching ponds. **1840** MARRYAT *Diary* 44 'Why,' replied he, pointing to an hotel opposite, 'that is his *licking place,*' (a term borrowed from deer resorting to lick the salt).

lie detector. An instrument used by the proper authorities on those under suspicion of guilt or complicity in an effort to ascertain their guilt or innocence through changes in their blood pressure, respiration, etc., upon being questioned. Also attrib.

1931 *Durant* (Okla.) *D. Democrat* 13 May 1/1 Defense. attorneys announced that Kirkland would again testify and would submit to an instrument known as a lie detector. **1945** *Chronicle-News* (Trinidad, Colo.) 16 Oct. 8/1 A lie detector test holds no legal weight in Colorado. **1949** *This Week Mag.* 5 March 5/4 He said that he wanted to arrange for an immediate test on a lie detector.

* **limber,** *a.*

1. limber pine, a pine, *Pinus flexilis,* found chiefly on the Pacific Coast of the U.S.

1897 SUDWORTH *Arborescent Flora.* **1917** EATON *Green Trails* 53 Over her, dwarfed like a print by Hiroshige, a twisted limber pine flaunted its pink cone buds. **1938** *Famous Trees* 73 A limber pine (*Pinus flexilis*) 18.8 feet in circumference at breast height, and 67 feet tall, is on the Huerfano district of the San Isabel National Forest.

2. Limber-twig, a kind of inferior winter apple. Also attrib.

1852 FLEISCHMANN *Wegweiser* 171 Für die Breitengrade von Mississippi eignet sich besonders der Limber-Twig und Horse-apple. **1924** J. M. FRANKS *Seventy Yrs. in Texas* 122 They were small, but good eating—the Limber Twig. **1947** *Democrat* 6 Feb. 4/1 It was a cluster of three which she had just pulled from a Limbertwig tree.

* **lime-juicer.** A British sailor or ship (see also quot.
1936). *Slang.*

Regarded as an Americanism (see quot. 1945 below), but the
Australian use to designate an emigrant newly arrived from England
is as early as 1859. See *OED*.
 1884 *Pall Mall Gaz.* 26 Aug. 11/1 They would not go on a 'lime-
juicer,' they said, for anything. **1907** LONDON *Road* 13 He had sailed
always on French merchant vessels, with the one exception of a
voyage on a 'lime-juicer.' **1936** MENCKEN *Amer. Lang.* 295 The
American language offers. . . . For Englishman: *lime-juicer* or *limey.*
[Note:] A term borrowed from Navy slang. It refers to the fact that,
beginning in 1795, lime-juice was issued in the British Navy (and
later in the merchant marine) as an anti-scorbutic. **1945** BAKER
Australian Lang. 185 The Australian use for any Englishman is
taken from the U.S. slang *limey* and *limejuicer* for a British sailor.

Lincolnite ˈlɪŋkənˌaɪt, *n.* [Abraham *Lincoln* (1809–
65).] A believer in the political principles and policies
of Abraham Lincoln; a Northern soldier or sympathizer
in the Civil War.
 1861 *Dly. Dispatch* (Richmond, Va.) 22 July 1/4 Woe to the Lin-
colnites when they meet those chivalrous sons of Carolina in battle
array. **1861** *Richmond* (Va.) *Examiner* 2 Dec. 2/4 The Lincolnites are
loud and bitter in their denunciation of the South Carolinians. **1906**
in *Kans. Hist. Soc.* IX. 437 They shouted: 'That's right, you old
Lincolnites, come in and surrender; we welcome you.'

 Also attrib. or as adj.
 1862 in MOORE *Rebellion Rec.* V. ii. 181, I leave this office to any
Lincolnite successor. **1863** RUSSELL *Diary* II. 12 They denounced
Sam Houston as a traitor, but admitted there were some Unionists,
or as they termed them, Lincolnite skunks, in the State.

linotype ˈlaɪnəˌtaɪp, *n.* [f. *line of type.*] A typesetting
machine which sets matter in solid lines or slugs, orig. a
trade-mark name. In full **linotype machine.** Cf.
Mergenthaler linotype.
 1890 *Detroit Free Press* 5 July, The Linotype. . . . The Linotype
Machine made by this company under its patents, is now for lease or
sale; is capable of an average speed of 8,000 ems per hour. **1930**
FERBER *Cimarron* 277 She was proud of the linotype machine. **1949**
Dly. Oklahoman (Okla. City) 13 Feb. D. 4/2 She can hand set type
and run the press but not the linotype.
 attrib. **1947** *Chi. D. News* 21 Nov. 3/1 An office rule at all Chicago
papers is that linotype operators put their name on type they set.
1949 *N.C. Hist. Rev.* 30 This house maintains a complete plant, lino-
type department, . . . press room, and bindery.

 b. A bar of type that has been cast by such a machine.
 1888 *Pat. Off. Gaz.* XLV. 1103/2 The linotype . . . [has] on its side
face two or more ribs extending from top to bottom.

lipstick ˈlɪpˌstɪk, *n.* A stick or pencil of pomade or
rouge for use on the lips. Also attrib.
 1880 E. JAMES *Negro Minstrel's Guide* 4 Prepared burnt cork, ready

for use, 25 and 50 cents per box; lip sticks, 25 cts. *Ib.* 8 An application of lipstick . . . around the natural part of the lips will extend that feature to a size quite remarkable. **1919** WILSON *Ma Pettingill* 93 Metta was even using a lip stick! **1949** *Sat. Ev. Post* 10 Sep. 42/1 Please bring wave lotion, curl pins, . . . and if you won't be too sore, just a little lipstick pomade.

b. Hence **lipstick,** *v. tr.,* to paint (the lips) with a lipstick.

1926 *Ladies' Home Jrnl.* April 24 She . . . had recently lipsticked a red mouth into startling contrast to her natural pallor. **1944** PENNELL *Rome Hanks* 149 The lips were lipsticked a dark red following the curled outlines of a child's lips.

* **living room.** A family sitting room.

1860 OLMSTED *Back Country* 237 The interior consisted of one large 'living-room,' and a 'lean-to,' used as a kitchen. **1910** C. HARRIS *Eve's Husband* 310 She occupied one chair in the living room all day. **1949** *Sat. Ev. Post* 9 July 88/2 A beautiful birch paneled living room boasting period treatment and many home-like refinements are typical of the luxuries found in trailers.

loco ˈloko, *v.* [f. the noun.] *tr.* To poison with a loco-weed. Also **locoed,** *a.* Also transf.

1884 ALDRIDGE *Life on Ranch* 191 Cattle occasionally get locoed, but much more rarely than horses. **1897** LEWIS *Wolfville* 119 Wolfville intelligence is too well founded to let any law loco it or set it to millin'. **1912** *Out West* May 312/2 Darley has locoed a good many by his sperit round-ups, but he's flunked by the cow-punchers, you bet! **1938** G. BALCH *Tiger Roan* 229 You're locoed, man, plumb locoed.

loganberry ˈlogənˌberɪ, *n.* [J. H. *Logan* (1841–1928), Amer. jurist and horticulturist.] A variety of red berry, or the plant producing it (see quot. 1894).

1893 *Calif. Agric. Exper. Sta. Bul.* No. 103, 3 The Logan Berry . . . [has] the shape of a blackberry, the color of a raspberry, and a combination of the flavors of both. **1894** *Garden & Forest* VII. 465/2 The Loganberry originated several years ago [1881] in the garden of Judge J. H. Logan, of Santa Cruz, from self-grown seeds of the Aughinbaugh [a blackberry]. . . . The other parent is supposed to be a Raspberry of the Red Antwerp type. **1948** *L.A. Time* 5 Dec. (Home Mag.) 29/2 The blackberry family that includes young, boysen, nectar and loganberries, should have five or six of the most vigorous canes of this year's growth saved.

attrib. **1949** *Canning Trade* 28 March 20/1 Boysenberry jam is priced at $1.65 and Loganberry jam at $2.25.

log jam. A number of saw logs which, impeded in passing down a stream, have formed a compact entangled mass. Also transf.

1886 DORSEY *Midshipman Bob* I. 73 His father got killed in a log-jam the year Robertin . . . was born. **1900** BRUNCKEN *N. Amer. Forests* 85 A 'log jam' is formed, usually at one of the rapids with which most logging rivers abound. **1907** *Springfield W. Republican* 14 Feb. 8 The congressional log-jam which held back all legislation for

nearly a week was finally broken Thursday afternoon. **1947** *Chi. Sun* 30 June 4/5 Congress came up to the end of the government's fiscal year today facing one of the worst appropriations logjams in history.

loma ˈlomə, *n. S.W.* [Sp. in same sense.] A small hill or elevation. Often in place-names.

1849 *N.O. Picayune* 4 May 2/3 [They] were riding quietly along the Loma Blanca, (white hill,) when they came suddenly upon a party of eight or ten Indians. **1863** *37th Congress Sp. Sess.* Sen. Ex. Doc. No. 1, 20 The new road is to follow the bottom at the edge of the *lomas*. **1923** SAUNDERS *So. Sierras Calif.* 75 All about are rounded hills, or lomas, rising in baldness. **1941** *Harper's Mag.* Oct. 498/1 Stand on the 'knoll' at Yucca Loma, drink in the desert, and then look down at your feet.

* **long house.** Among the Indians, esp. the Iroquois, an exceptionally long wigwam or cabin serving as a communal dwelling and council house.

1643 R. WILLIAMS *Key* (1866) 197 [In the] *Long house*, sometimes an hundred, somtimes [*sic*] two hundred foot long . . . many thousands, men and women meet. **1826** COOPER *Mohicans* Pref., One branch of

Long house of the Indians

this numerous people [the Delawares] was seated on a beautiful river, . . . where the 'long house,' or Great Council Fire, of the nation was universally admitted to be established. **1906** RUTTENBER *Indian Names* 137 The Indian Long House was from fifty to six hundred and fifty feet in length by twenty feet in width, the length depending upon the number of persons or families to be accommodated, each family having its own fire.

b. Used with particular reference to the Five Nations.

1885 *Harper's Mag.* July 201/2 The Indians of the Long House to put out the camp fires of the Kahquahs and Eries. **1940** THOMPSON *Body, Boots* 454 Of the other two nations of the Longhouse, the Mohawks are remembered in the name of a noble river.

long sweetening. (See quots.) Now *hist.* Cf. **long lick, long sugar, long-tailed sugar.**

1714 *N.C. Col. Rec.* II. 132 Let who will go unpaid. Rum long sweet'n alias Mollasses, glystr. Sugar must be had. **1869** BOWLES *Our New West* viii. 170 The writer won his glory and victual by making the 'long-sweetening,' i.e. white sugar melted into a permanent syrup. **1943** CROW *Amer. Customer* 175 Sorghum molasses was more commonly used and was known as 'long sweetening.' Sugar was 'short sweetening.' **1948** DICK *Dixie Frontier* 291 The so-called 'long sweetening' was honey obtained from bee trees.

Lost Cause.
1. The cause of the South in the Civil War.

1866 E. A. POLLARD (*title*), The Lost Cause. **1876** *Petaluma* (Calif.) *Argus* 11 Aug. 2/2 The Southern Democracy are at least consistent in honoring veterans who suffered for the lost cause. **1948** KERWIN *Civil-Military Relationships* 31 Their late adversaries, the United Confederate Veterans, licked their wounds and dwelt lovingly upon the Lost Cause.

transf. **1905** N. DAVIS *Northerner* 71, I don't mind doing a little proselyting now and then, for the political 'Lost Cause'!

2. The Confederate States, the South.

1886 POORE *Reminiscences* II. 526 They receive the representatives of 'the Lost Cause' with every possible honor. **1905** N. DAVIS *Northerner* 4 It is a sacred tribute to the heroes of what they call 'The Lost Cause,' meaning the under dog in the 'late unpleasantness!'

*** Lowell,** *n.* Also **lowell**. *S.* A cheap cotton cloth manufactured at Lowell, Mass. Also attrib. *Obs.* or *hist.*

1852 in STOWE *Key* 417 Ran away . . . a negro man . . . ; Had on, when he left, Lowell pants and cotton shirt. **1855** DAVIS *Farm Bk.* 251 Went to Marion—carried the wagon & bought supplies of merchandize for the season—such as Lowells—Calicoes. **1945** BOTKIN *My Burden* 90 They spinned the cloth what our clothes was made of, and we had straight dresses or slips made of lowell.

lumberer ˈlʌmbərɚ, *n.* One who fells forest trees and brings them to market; a lumberjack.

1809 KENDALL *Travels* III. 33 To this mill, the surrounding *lumberers* or fellers of timber bring their logs. **1853** STRICKLAND *Twenty-seven Yrs.* I. 22 Rough in manners, and often only half-civilized, the lumberer, as an individual, resembles little the woodsman of other lands. **1883** *American* VI. 297 The condition to which the lumberer and the farmer have brought the Ohio valley.

lye hominy. Hominy, so called from the use of lye in its preparation.

1821 DEWEES *Lett. from Texas* 20 Our subsistence was principally upon . . . a kind of lye hominy seasoned with hickory nut kernels. **1919** DUNN *Indiana* II. 1170 A woman situated like Mrs. McCoy, in her Indian boarding school, with no food but lye hominy in the house for weeks at a time, 'degraded her soul' by cooking lye hominy. **1948** DICK *Dixie Frontier* 290 Lye hominy was made by soaking the whole grains of corn in lye water to remove the hulls.

lynch law. Also **Lynch law**. [Orig. Lynch's law *q.v.*]
Named after Captain William *Lynch* (1742–1820), of Pittsylvania County, Virginia, and later of Pendleton District, South Carolina. (See A. Matthews in *Mass. Col. Soc. Trans.* XXVII. 256–71 and quot. 1836 under **Lynch's law**.) The 1st quot. below is from the compact drawn up by Lynch and his neighbors.

The practice or custom by which persons are punished for real or alleged crimes without due process of law; the punishment so meted out.

[**1780** in *S. Lit. Messenger* (1836) II. 389 Whereas, many of the inhabitants of Pittsylvania . . . have sustained great and intolerable losses by a set of lawless men . . . that . . . we, the subscribers, being determined to put a stop to these iniquitous practices of those unlawful and abandoned wretches, do enter into the following association . . . and if they will not desist from their evil practices, we will inflict such corporeal punishment on him or them, as to us shall seem adequate to the crime committed or the damage sustained.] **1811** ELLICOTT in Mathews *Life A. Ellicott* 220 Captain Lynch just mentioned [residing on Oolenoy Creek, S.C.] was the author of the Lynch laws so well-known and so frequently carried into effect some years ago in the southern states in violation of every principle of justice and jurisprudence. **1835** *Md. Hist. Reg.* IX. 161 They then followed the example of the Vicksburg people in attempting to inflict the Lynch Law. **1902** LONDON *Daughter of Snows* 284 It's lynch law, you know, and their minds are made up. They're bound to get me.

attrib. **1840** GARRISON in W. P. & F. J. Garrison *W. L. Garrison* II. 365 [Several Englishmen] swore that Oxford 'ought to be strung up . . . ,' in true Lynch-law style. **1857** STIRLING *Lett. Slave States* 144 May not the Republicanism of Louisiana be characterized as a despotism, tempered by Lynch-law halters? **1887** *Macmillan's Mag.* March 348/1, I could hardly recognize the complacent judge of the afternoon, in the trembling creature who tried to assure his Lynch-law brother that Cobbett and Grobe had gone East.

M

McCarty məˈkɑrtɪ, *n.* Also **McCarthy.** [Amer. Sp. *mecate*, a rope.] (See quots.) Cf. **mecate.**

The identification of the name McCarty with the Spanish *mecate* can probably be attributed to the Eastern and Southern [məˈkɑːtɪ].

1904 STEEDMAN *Bucking Sagebrush* 48 Everything was there, sixshooter and belt, McCarty (or hair rope), sombrero. **1927** RUSSELL *Trails* 166 They all rode an' broke broncs with a hackamore. It wasn't a rope one like they're usin' to-day, but one made of braided leather an' rawhide. Looped to this was about fifteen or twenty foot of hair rope called a 'McCarthy.' **1947** *Westerners' Brand Book* 55 We were to get these horses well reined, gentle, taught to stand 'ground tied' (with reins or McCarty on the ground).

McGuffey's reader. Any one of a series of widely used school readers, noted for their moral lessons and their selections from great English writers, edited by Wm. H. McGuffey (1800–1873). Also **McGuffey reader.**

1836 McGUFFEY *(title)*, McGuffey's First Eclectic Reader. **1876** *Pioche* (Nev.) *D. Jrnl.* 23 Sep. 2/1 Fifteen years ago McGuffey's Fourth Reader sold for 27 cents apiece. **1948** *Forest Way* (Chi.) May 5 The most widely circulated American book of the past three centuries, the survey showed, is the McGuffey reader—125 million copies since 1834.

* **McKinley,** *n.* [See **McKinleyism.**]

1. McKinley prosperity, the period of hard times following the passage of the McKinley tariff. *Obs.*

1897 *Boston Jrnl.* 11 Jan. 5/3 The urgent necessity for them will appeal to the people, groaning under the weight of 'McKinley prosperity.'

2. McKinley tariff, the tariff of 1890, during McKinley's administration, which raised duties to a high point.

1893 *Cyclo. Rev. Current Hist.* III. 265 The silver faction of the Democratic party favor making large modifications in the McKinley tariff. **1943** HICKS *Amer. Dem.* 528 Consumers found that the higher rates of the McKinley Tariff meant higher prices for what they had to buy.

* **maiden,** *n.* In combs.: (1) **maiden cane,** a creeping grass, *Panicum hemitomon,* of the southern coastal regions; (2) **land,** (see quot.), *obs.;* (3) * **-'s blush,** a variety of apple.

(1) **1806** LEWIS in *L. & Clark Exped.* V. (1905) 107 Among the grasses of this country I observe a large species . . . [which] has much the same appearance of the maden cain as it is called in . . . Ge[o]rgia. **1947** *Jrnl. Wildlife Management* Jan. 55/2 Maidencane (*Paricum hemitomon . . .*) eventually is the dominant plant. — (2) **1859** BARTLETT, Maidenland. Land that a man gets with his wife, and which he loses at her death. Virginia. — (3) **1817** W. COXE *Fruit Trees* 106 Maidens Blush. This is an apple of large size, and great beauty **1944** *Chi. D. News* 25 Sep. 13/3 Right now Wealthies or Maiden's Blush are the choice varieties for cooking or pie.

* **Main Street.** *transf.* The most important street in any small American town regarded as typical and provincial. Usu. with reference to the novel by Sinclair Lewis. Also attrib.

[**1855** *N.Y. Tribune* 31 Dec. 4/4 It has risen to its present position of bloated arrogance and swaggering insolence by the liberal and unstinting patronage it has received from the full purses and free hands of Eastern men in Main street and elsewhere.] **1916** BOWER *Phantom Herd* 5 You'll have to let me weed out some of these Main Street cowboys. **1920** LEWIS *(title),* Main Street. **1948** *Time* 6 Dec. 20/3 Harry Truman has never lost his great respect for Marshall, nor is he unmindful of the prestige and authority Marshall carries on Main Street as well as in Moscow.

Hence **Main Streeter.**

1934 WEBSTER. **1945** *Sat. Review* 6 Oct. 8/2 His books started some Americans laughing at others and made it possible for people to

realize that somebody else was a Main Streeter. **1947** *Time* 27 Jan. 4/3
It has raised the hope of this Mainstreeter from Podunk to its highest
ebb since the era of Wendell Willkie's 'One World.'

b. (See quots.)

1927 *My Okla.* April 29/1. **1948** *Green Bay* (Wis.) *Press-Gazette* 30
June 1/4 'America's Main street' is the nickname often applied to
U.S. Highway 66 [between Chicago and Santa Monica, Calif.]. **1949**
N.O. Times-Picayune Mag. 11 Sep. 13 The Mighty Mississippi (Also
America's Main Street).

malted milk. [Orig. (*cap.*) a trade-mark name coined
and registered by Wm. Horlick (1846–1936), Amer.
manufacturer.] A powder made of evaporated milk and
malted cereals; a drink made from this powder, now esp.
one containing ice cream and flavoring as well.

1887 *Pat. Off. Gaz.* XLI. 358 Trade-Marks. . . . Food preparation
for infants and invalids.—*Horlick's Food Company*, Mount Pleasant
and Racine, Wis. . . . 'The words *Malted Milk* and the letters
"M.M."' **1901** *Everybody's Mag.* Oct. 433/1 There were honey-dew
mince pie and malted milk and cheese. [**1948** *Chi. Tribune* 25 Jan.
(Grafic Mag.) 15/2 Johnny and I 'fueled up' on cheeseburgers and
malteds for the long ride to the beach.]

∗**mandrake,** *n.* The May apple, *Podophyllum pel-
tatum;* the fruit of this.

1778 CARVER *Travels* 118 In the country belonging to these people
[the Pawnee Indians] it is said, that Mandrakes are frequently
found, a species of root resembling human beings of both sexes. **1807**
C. SCHULTZ *Travels* I. 144 The only fruits I have met with, with
which you are unacquainted, are the mandrake and papaw. **1850**
S. F. COOPER *Rural Hours* 91 The mandrakes, or May-apples, are in
flower. **1949** *Amer. Photography* Aug. 484/1 On a shady hillside not
far from a brook we find a patch of May apples, or mandrakes.

mano ¹mano, *n.* [Sp. in similar sense. Cf. *mano de
metate,—de piedra* in Santamaría.] A handstone used by
Indians in grinding grain on a metate *q.v.*

1899 *Smithsonian Rep.* 37 The grinding-stone concordantly changes
from a simple roller or crusher to a mano (or muller), and finally to a
pestle, at first broad and short, but afterwards long and slender. **1922**

Mano and metate

Outing Nov. 83/1 Now she sits, or rather, squats, in a position impos-
sible to one not trained from childhood, one foot extended to either
side and her metate, or flat stone mill at her knees, grinding the

parched wheat to a coarse meal or fine flour with her mano, or rubbing stone. **1947** *So. Sierran* March 4/1 A few metates (grinding bowls) and manos (grinders), arrow-points and other objects Mr. Edwards carefully charted.

maple sugar.

1. Sugar obtained by evaporating the sap of certain maples.

[**1705** HARRIS *Navigantium atque itinerantium* II. 929 The Maple Trees . . . yields a Sap. . . . Of this Sap they make Sugar and Syrup, which is so valuable, that there can't be a better Remedy for fortyfying the Stomach.] **1720** *Phil. Trans.* XXXI. 27 Maple Sugar is made of the juice of the Upland Maple, or Maple Trees that grow upon the Highlands. **1832** WILLIAMSON *Maine* I. 109 The method of making maple sugar . . . is learned from the Aborigines. **1947** *Amer. Sp.* April 152 Maple sugar. A further boiling of maple sirup produces a hard or creamy mass known as sugar. Usually molded into cakes.

b. A brown or brownish color.

1934 WEBSTER. **1936** *Sears Cat.* 397 [Colors:] Rose Pink, Maple Sugar, Alice Blue.

2. In combs. in which the meaning is obvious or is explained by the quots., as (1) **maple-sugar butternut candy,** (2) **cake,** (3) **camp,** (4) **capital,** (5) **eat,** (6) **industry,** (7) **land,** (8) **maker,** (9) **making,** also attrib., (10) **party,** (11) **sauce,** (12) **state,** (13) **works.**

(1) **1904** WALLER *Wood-Carver* 69 I'm waiting for the 'maple-sugar-butternut' candy and the spruce gum. — (2) **1941** LEE *Stagecoach North* 113 Their real unconfessed interest was focused on maple sugar cakes, dried whortleberries, fiddle music, and wild geese. **1949** *Downers Grove* (Ill.) *Rep.* 31 March 11/4 Maple sugar cakes (100 per cent pure) were made and real maple syrup was put into small bottles. — (3) **1884** ROE *Nature's Story* 156 We'll improvise a maple-sugar camp of the New England style a hundred years ago. — (4) **1943** *Nat. Geog. Mag.* April 405 Only town of its name in the United States, St. Johnsbury [Vt.] is the maple-sugar capital of the Nation. (5) **1907** *Springfield W. Republican* 9 May 16 The Holyoke canoe club opened the river year with a maple-sugar eat at their club-house. — (6) **1880** *Vt. Agric. Rep.* VI. 112 My object is to give a brief history of the maple-sugar industry. — (7) **1797** IMLAY *Western Territory* (ed. 3) 151 A single family, . . . on the maple-sugar lands, between the Delaware and Susquehanna, made 1800 lbs. of maple-sugar in one season. — (8) **1880** *Vt. Agric. Rep.* VI. 113 The present duty of maple sugar-makers is to educate consumers up to a higher standard. — (9) **1857** *Lawrence* (Kans.) *Republican* 11 June 4 Mr. Sloven electrified his family . . . with the announcement that he was going into the maple-sugar-making business. **1874** *Dept. Agric. Rep. 1873* 475 This letter is appended to the discussion on the subject of maple-sugar making. (10) **1939** WOLCOTT *Yankee Cook Book* 347 For a real Vermont maple sugar party, doughnuts and pickles are necessary to complete the menu. — (11) **1939** WOLCOTT *Yankee Cook Book* 197 Maple sugar sauce. ½ pound maple sugar, 4 tablespoons hot water, ¼ pound butter. — (12) **1935** MITCHELL *America* 155, I wanted to buy some Vermont

maple sugar to send to England and I wanted to buy it in Vermont so that I could truthfully say it came from the maple sugar state. — **(13) 1814** *Niles' Reg.* VI. 152/1 A vermont statement of the maple sugar works is [etc.].

Mardi gras 'mɑrdɪˌgrɑ, *n.* [F. ("fat Tuesday") in same sense.] Shrove Tuesday, the last day of carnival as celebrated in New Orleans; the festival ending on this day. Also attrib.

1832 *Boston Transcript* 13 June 1/3 Yesterday was '*Mardi Gras*'— the last day of the reign of Folly. **1899** ADE *Fables* in *Slang* (1900) 148 His Father was too serious a Man to get out in Mardi-Gras Clothes and hammer a Ball from one Red Flag to another. **1947** *Nation* 12 July 40/1 They come for the special holiday excitement, to take part in a Mardi Gras centering in a horse race.

b. A carnival or festival in imitation of the annual celebration in New Orleans.

1904 *N.Y. Ev. Post* 17 Sep. 3 At a special meeting of the Coney Island business men $25,000 was subscribed to pay the expenses of the semi-centennial celebration and mardi gras on September 21. **1930** *Dixon* (Ill.) *Ev. Tribune* 24 Sep. 1 (*heading*), Mardi Gras, Fireworks End Centennial Tonight. **1941** Z. GOLD in *Sat. Ev. Post* 15 March 14 Mardi Gras at Coney.

marlberry 'mɑrlˌbɛrɪ, *n.* [f. *marble-berry*, a name for *Ardisia crenulata*.] A small tropical American tree or shrub, *Ardisia paniculata*.

1884 SARGENT *Rep. Forests* 100 Marlberry. Cherry. . . . A small tree, sometimes 8 meters in height, . . . or often a shrub; reaching its greatest development in Florida. **1917** *Rep. Smithsonian Inst.* 384 In addition to these are the paradise tree or bitterwood; soapberry tree; . . . marlberry [etc.]. **1933** SMALL *Southeastern Flora* 1029.

∗ marsh hen. Any one of various American rails, as the king rail and the American coot (see also quot. **1917**). Cf. **fresh-water, salt-water marsh hen.**

1709 LAWSON *Carolina* 151 Marsh-Hen, much the same as in Europe, only she makes another sort of Noise, and much shriller. **1844** *Knickerb.* XXIV. 188 Next to this [hunting the turkey] perhaps, I prefer marsh-hens. **1917** *Birds of Amer.* I. 181 Bittern. *Botaurus lentiginosus.* . . . [Also called] Indian Hen; Marsh Hen; Poke. *Ib.* 214 Coot. *Fulica americana.* . . . [Also called] Water Hen; Marsh Hen; Moor-head.

Mason and Dixon. The boundary line between Pennsylvania and Maryland as laid out (1763–67) by the English surveyors Charles Mason and Jeremiah Dixon, in full **Mason and Dixon's line.** In later times the entire southern boundary of Pa., and regarded as the line separating the free and the slave states, or as the boundary between the North and the South.

1779 in W. B. REED *Life & Corr. Joseph Reed* II. 134 The Virginia

gentlemen offer to divide exactly the 40th degree with us. . . . Perhaps we [of Penna.] would be as well off with Mason and Dixon's line continued. **1834** C. A. DAVIS *Lett. J. Downing* 36 He tell'd me Georgia would go for me, arter the Gineral, as soon as any north of mason and dickson. **1861** *Vanity Fair* 25 May 251/2 Suffysit to say I got across Mason & Dixie's line safe at last. **1948** *Downers Grove* (Ill.) *Rep.* 21 Oct. 3/2 Two Dixiecrats, out of their element north of the Mason-Dixon, nevertheless registered their convictions on the States' Rights issue by giving their votes to James Thurmond.

transf. **1948** *Sat. Ev. Post* 30 Oct. 124/4 This same little band has long since adopted three war-ruined families in the old country—two in Bizonia, one on the other side of Europe's bitter Mason and Dixon's line.

match safe. (See quot. 1875.)

1864 *Hist. North-Western Soldiers' Fair* 81 [Donations include] 24 bottles perfumery, 1 match safe, 1 cigar case. **1875** KNIGHT 1410 *Match-safe*, a box to contain matches for use. Usually hung up near a gas-bracket or elsewhere within ready reach. **1893** *Outing* May 124/2 A water-tight match-safe . . . should be taken. **1902** *Sears Cat.* (ed. 112) 787/2 Twin Match Safes.

Types of match safes *c*1865

* **mayflower,** *n.*

1. Any one of various American spring-blooming plants, esp. the trailing arbutus, *Epigaea repens,* of the eastern U.S. Also attrib. Cf. **New England mayflower.**

1778 CARVER *Travels* 520 May Flowers, Jessamine, Honeysuckles, Rock Honeysuckles. . . . I shall not enter into a minute description of the flowers above-recited. **1884** HOWELLS *S. Lapham* iv, The tints of her cheeks and temples were such as suggested May-flowers and apple-blossoms. **1942** WHITE *One Man's Meat* 282 Mayflowers have been reported fifteen miles away in the mayflower country.

2. (*cap.*) Often used allusively with reference to those claiming descent from the colonists who reached Plymouth, Mass., in 1620, on the vessel known as the Mayflower. Also attrib. and transf.

1921 *Harper's Mag.* Jan. 138/1, I have talked to a number of people, literary, industrial, commercial, professional; . . . to *Mayflower* Americans, . . . to negroes, and to immigrants. **1925** *Woman's Home Companion* Nov. 34/1 They take no pride in being descended from a gentlewoman who came over in the Mayflower. **1930** FERBER *Cimar-*

ron 361 Now it was considered the height of chic to be able to say that your parents had come through in a covered wagon. . . . As for the Run of '89—it was Osage's *Mayflower.*

Also **Mayflower family, stock.**

1854 THORPE *Master's House* 149 The best half of me is the very pith of the Mayflower stock. **1861** *Dly. Dispatch* (Richmond, Va.) 26 July 2/1 It must be acknowledged that from the beginning, Jonathan, (meaning by that term the Mayflower family, and no other race of the North,) has 'done' John Bull exceedingly brown in every business transaction.

*❋**Mearns,** n.* [Dr. Edgar A. *Mearns* (1856–1916), army surgeon and naturalist.] Used, usu. in the possessive, in the names of animals: (1) **Mearns's coyote,** (see quot. 1917); (2) **quail,** a variety of the Massena quail *q.v.;* (3) **woodpecker,** a woodpecker, *Balanosphyra formicivora aculeata,* found in the Southwest.

(1) **1917** *Animals of Amer.* 66/2 Mearns Coyote. —*Canis mearnsi* Merriam. Size small, color bright, skull and teeth small. Southern Arizona. **1931** BAILEY *Mammals N. Mex.* 321 Specimens in the United States National Museum collection carry the range of Mearns's coyote across the Lower Sonoran valleys of New Mexico. — (2) **1903** *Condor* V. 113, I looked and became aware that I was staring at my first Mearns quail. **1949** *Pacific Discovery* Jan.–Feb. 11/1 Whereas turkeys had increased in the past decade, the Mearns quail had suffered a decrease of at least equal proportion. — (3) **1928** BAILEY *Birds N. Mex.* 387 The Mearns Woodpecker is the most abundant woodpecker in many parts of southern New Mexico.

medicine man. Among North American Indians, one who practices healing; a priest, prophet, magician, etc. Cf. **Panisee.**

Indian healers or physicians were of two classes. One class was composed of those who made use of herbs, sweatings, and other practical remedies. The other was made up of those who depended upon charms, fetishes, exorcism of evil spirits, etc. Members of this class served also as priests, prophets, magicians, conjurors, etc.

[**1709** LAWSON *Carolina* 213 You must know, that the Doctors or Conjurers, to gain a greater Credit amongst these People, tell them that all Distempers are the Effects of evil Spirits.] **1806** ORDWAY in *Jrnls. Lewis & O.* 349 Everry fiew minutes one of their warries made a Speech . . . which was all repeated by another meddison man with a louder voice. **1847** LANMAN *Summer in Wild.* 105 A medicine man would sooner die, than divulge the secrets of his order. **1949** *Nat. Geog. Mag.* Oct. 475/1 The most influential individuals among them were the shamans, or medicine men.

b. The chief character in a medicine show *q.v.*

1947 *Chi. D. Tribune* 2 Nov. IV. 4/2 He was one of the great fraternity of medicine men who went up and down the land, prior to the pure food and drug act. **1948** DICK *Dixie Frontier* 164 Each act closed at a most exciting point, giving the dapper, professional-looking medicine man an opportunity to sell various panaceas without fear of the crowd's dispersing.

✳ **Memorial Day.** **=Decoration Day.** Also attrib.

In most states May 30 is the date of this observance. The Confederate celebrations in the southern states, however, vary in date from April 26 to June 3.

1869 *G.A.R.* (R.I. Dept.) *3d Encamp. Proc.* 32 Those patriotic men and women . . . gave their aid . . . to make successful this National Memorial day. **1897** FLANDRAU *Harvard Episodes* 181, I was thinking of all the horrible . . . Baccalaureate Sermons and ghastly Memorial Day orators that are allowed to go on. **1904** *N.Y. Ev. Post* 30 May 2 Thousands of people gathered this morning to witness the Memorial Day parade of civil war veterans. **1949** *This Week Mag.* 28 May 2/2 On Memorial Day, this lesson is poignant and clear.

mescal button. (See quot. 1909.)

1895 *N.Y. Dramatic News* 7 Dec. 3/2 For introducing brilliant coloring into dreams it is as efficacious as the nerve stimulant known as the mescal button, contributed to science by the Kiowa Indians. **1909** *Cent. Supp.* 789/2 *Mescal-buttons,* . . . the dried tops of a succulent, spineless, turnip-shaped cactus growing in the arid regions of Texas and northern Mexico, known botanically as *Lophophora Williamsii,* and called by the natives in various localities *peyote, hikuli,* and *wokowi.* **1930** FERBER *Cimarron* 295 She held out her hand, shaking a little, the mescal button crushed in her palm. **1948** *Travel* Nov. 16/2 Peyote or mescal 'buttons' are the dried disc-like tops of the small spineless Mexican cactus.

Messiah craze, war. (See quot. 1940.) Cf. **ghost dance.**

1907 CURTIS *N. Amer. Indians* I. 20 Since the beginning of the present 'messiah craze' all baskets display the sacred symbols believed to have been revealed to Das Lan by Chuganaai Skhĭn—a combination of the cross and the crescent. **1923** J. H. COOK *On Old Frontier* 199 In the fall of 1890—just about the time the Messiah Craze started among the Sioux—a number of the old head men of the Ogallallas came from Pine Ridge Reservation on a hurried visit to my home. **1940** ADAMS *Dict. Amer. Hist.* III. 379 The Messiah War (1890-1) was an outgrowth of the Ghost Dance excitement which so affected the Sioux Indians that R. F. Royer, the agent at Pine Ridge, S. Dak., wired for troops.

✳ **mileage,** *n.*

1. An allowance of a fixed amount per mile to cover the expenses of traveling. Orig. for members of legislative bodies. Cf. **constructive mileage.**

1754 FRANKLIN *Writings* III. 197 Members' Pay . . . milage for travelling expenses. **1776** H. GATES in Sparks *Corr. Revol.* I. 281 The militia were promised their mileage and billeting-money. **1874** *Internat. Typog. Union Proc.* 41 None but delegates shall vote or receive mileage and per diem. **1945** MENCKEN *Supp.* I. 294 Of the political terms not already discussed or listed, *mileage,* signifying a legislator's allowance for traveling expenses, is probably the oldest.

2. In combs.: (1) **mileage allowance,** =**mileage;** (2) **book,** a book of mileage tickets; (3) **ticket,** a ticket entitling the holder to travel a specified number of miles

on a given railroad without restriction as to route or destination.

(1) **1935** *Time* 27 May 16/1 It rejected with one of the loudest *viva voce* votes on record, a proposal . . . to abolish Congressmen's mileage allowance. — (2) **1909** O. HENRY *Options* 277 'And you came mighty near missing the train!'. . . says she, with a laugh that sounded as good as a mileage-book to me. — (3) **1882** *Rep. Ala. R.R. Comm.* II. 207 We quit selling mileage tickets. **1898** *Boston Morn. Herald* 16 April 8/3 (Ernst).

military tract. A tract of public land where veterans of the Revolution were allowed to locate their landscrip, and where veterans of the War of 1812 were given land grants. Also, *cap.*, with reference to a particular tract of this kind. Cf. **Central Military tract.**

1798 PUTNAM in *Memoirs* 422 Two of the Surveyors employed in runing out the Military tract had completed there work in the woods. **1834** *Sangamo Jrnl.* (Springfield, Ill.) 18 Nov. 3/2 They were bound for the military tract. **1852** REGAN *Emigrant's Guide* 96 What is called the 'Military Tract,' runs through the centre of the State [Illinois], east and west, and consists of grants of land to the soldiers of the Revolution, and of the war with Great Britain in the early part of the present century. **1947** *Amer. Sp.* XXII. 207 The author left his home in Scipio, near the center of the 'Military Tract' in the Finger Lakes country of Central New York, lying between Owasco and Cayuga Lakes, and between the cities of Auburn on the north and Ithaca on the south.

Mimeograph 'mɪmɪə‚græf, *n.* [Gk. *mimeisthai*, to imitate, and *-graph*.] A trade-mark name for a device for duplicating written or printed matter by the use of a stencil; in popular use (not *cap.*), any such device.

1889 *Voice* 19 Sep., The 'mimeograph' and the 'autocopyist' . . . will give any number of copies of a letter. **1932** *K.C. Times* 27 Feb. 24 All he has is a second-hand typewriter and an 8×10 mimeograph to reproduce the little pages. **1949** *Gladewater* (Tex.) *Times-Tribune* 31 July 11. 5/2 A. B. Dick Mimeograph taken in trade on new Liberator Speed-O-Print.

minkery 'mɪŋkərɪ, *n.* A place where minks are bred for commercial purposes.

1877 COUES *Fur-bearing Animals* 182 Mr. Resseque's minkery consists of twelve stalls. **1897** *Boston Transcript* 11 Sep. 24/3 Minks have been bred for their skins in so-called minkeries. **1916** *Proc. Iowa Acad. Sci.* XXIII. 285 There are at present in this 'minkery' thirty-seven individuals.

Miss America. A title bestowed as the result of a national beauty contest held to find the most beautiful girl in the U.S. Also the girl winning this title.

The first Miss America was chosen in 1921 in a contest involving eight girls, though the term was not used in connection with this contest. See *Amer. N. & Q.* IV. 61, 140.

1922 *N.Y. Times* 5 Sep. 19/6 Miss Margaret Gorman of Washington, winner of the 1921 contest, will be known as 'Miss America.' **1944** *N. & Q.* IV. 61, I have been told that the practice of selecting a 'Miss America' came from the Ziegfeld Follies; but I have not explored this source. **1949** *World-Herald* (Omaha) 11 Sep. 1/5 The new Miss America told the audience she plans to go to Stanford University to study dramatics.

mist flower. A composite plant, *Eupatorium coelestinum*, with violet heads, widespread in the warmer parts of the U.S.

1857 GRAY *Botany* 188 *Conoclinium.* Mist-flower. [1 species:] *C. cœlestinum.* **1901** MOHR *Plant Life Ala.* 765 Mist flower. . . . A common weed in cultivated and waste places, and on roadsides. **1949** MOLDENKE *Amer. Wild Flowers* 220 Related to the thoroughworts and bonesets is the mistflower, *Conoclinium coelestinum*, so well known to all travelers in the South.

moccasin flower. The bastard hellebore, the lady's slipper, or any of various American orchids, as *Cypripedium acaule.*

1680 in RAY *Hist. Plant.* (1688) II. 1926/1 Helleborine flore rotundo luteo, purpureis venis striato. The Mockasine flower. **1700** PLUKENET *Opera Bot.* III. 101 *Helleborine Virginiana.* . . . The Molkasin Flower. **1784** CUTLER in *Mem. Acad.* I. 486 Lady's Slipper. . . . Catesby says, the flowers of this plant . . . were in great esteem with the Indians for decking their hair. They called it the Moccasin Flower. **1881** *Harper's Mag.* Dec. 20/2 All who love the hemlock woods will remember the common cypripedium, or moccasin-flower, also called lady's slipper. **1949** *Jrnl. N.Y. Bot. Garden* March 50 Through the drier area . . . are the pink slippers of the moccasin flower.

mockingbird ˈmakıŋˌbɜd, *n.* Any one of various American birds having an aptitude for mimicry, esp. *Mimus polyglottos,* found chiefly in the eastern and southern parts of the U.S.

1676 *Phil. Trans.* XI. 631 There are also divers kinds of small Birds, whereof the *Mocking-bird,* the *Red-bird,* and *Humming-bird,* are the most remarkable. **1741** LUCAS *Jrnls. & Lett.* (1850) 11, I promised to tell you when the mocking bird began to sing. **1817** E. P. FORDHAM *Narr.* 47 The Mocking-bird which is here, as the Robin is in England, esteemed sacred, would scarcely avoid us. **1949** *Reader's Digest* Aug. 97/2 It is colored in bluish grays and white, rather like a mockingbird.

transf. **1890** *Stock Grower & Farmer* 19 July 4/4 Arizona Nightingale; Otherwise 'burro,' sometimes termed 'mockingbird.'

b. Mockingbird State, Florida.

1948 *Newsweek* 7 June 27/1 To the surprise of the Mockingbird State politicos, he ran a very close third.

＊ **moneyed,** *a.*

1. moneyed corporation, (see quot. 1858).

1834 JACKSON in *Pres. Mess. & P.* III. 43 Were they bound . . . to subvert the foundations of our Government and to transfer its powers from the hands of the people to a great moneyed corporation? **1858**

N.Y. Rev. Statutes II. 526 The term 'moneyed corporation,' as used in this title, shall be construed to mean every corporation having banking powers, or having the power to make loans upon pledges or deposits, or authorized by law to make insurances. **1889** *Cent.* 1275/3.

2. moneyed institution, an institution rich in money.

1861 *Vanity Fair* 23 Feb. 96/1 The 'Presidents of Railroads and moneyed institutions' are stealing the Post Office and Custom House monies. **1900** *Cong. Rec.* 19 Jan. 992/2 A great moneyed institution which the court said had the right under the fundamental law of Louisiana to exist.

* **monotype,** *n.*

1. (See quot. 1890.)

1882 *Artist* 1 Feb. 60/1 A very interesting collection of monotypes executed by Mr. Charles A. Walker of Boston. **1890** *Cent.* 3846/1 *Monotype,* . . . a print from a metal plate on which a picture is painted, as in oil-color or printers' ink. Only one proof can be made, since the picture is transferred to the paper. **1897** *Cent. Mag.* Feb. 517/1 The name 'monotype' was given to this form of art print by Mr. Charles A. Walker, of Boston who, in 1877, with no knowledge of the fact that the art was known and practised by painters in former times, discovered the process independently.

2. (*cap.*) A trade-mark name for a machine for setting type (see quot. 1949).

1895 *Cyclo. Rev. Current Hist.* V. 961 The Lanston Monotype . . . marks an important advance in the development of typographical art. **1949** *Manual of Style* 256 Monotype—A composing machine invented by Tolbert Lanston (1844–1913) and developed about 1890. In this machine a ribbon of paper, which is perforated on a keyboard, operates a casting machine by bringing the single matrices in contact in the proper order with a mold, so that the letters are cast one at a time and arranged in lines automatically spaced to the proper length.

attrib. **1929** SNYDER *Blood Grouping* 156 The type must first be set; by the monotype method, there are two processes, the 'keyboarding' of the MS and the casting of the type from the perforated paper rolls thus produced.

moose horn.

1. The horn of a moose, or a medicinal preparation similar to hartshorn prepared from this.

1672 JOSSELYN *N. Eng. Rarities* 19 Moose Horns better for Physick use than Harts Horns. **1847** PARKMAN in *Knickerb.* XXIX. 506 The walls are plentifully garnished, he told us, with moose-horns and deerhorns, bear-skins and fox-tails. **1942** *Nat. Geog. Mag.* May 607 Scattered moose horns and traces of old campfires marked the place.

2. A trumpet, usu. of birchbark, used by a hunter for calling moose within range. Cf. **moose call.**

1902 *Amer. Folk-Lore* XV. 249 After moose have been named the following: . . . moose-horn, or moose-trumpet (bark 'trumpet' used to imitate the note of the moose).

moose yard. An area in the forest where moose herd

in winter and keep the snow trampled down for protection and feeding. Cf. **winter yard.**

1800 D'ERES *Memoirs* 117 The animals are overtaken in their retreats (for they herd together, sometimes a large number, just as it happens) which is called the Moose yard, formed by them in trampling down the snow. **1839** HOFFMAN *Wild Scenes* 58 The sagacious animal, so soon as a heavy storm sets in, commences forming what is called a 'moose-yard'; which is a large area, wherein he industriously tramples down the snow while it is falling, so as to have a space to move about in, and browse upon the branches of trees. **1946** STANWELL-FLETCHER *Driftwood Valley* 137 We've seen old trails leading through the forest near a moose yard where the moose feed on tall dead grasses under thick spruces.

moron ˈmorɑn, *n.* [Gk., neut. of *moros*, dull, stupid.]
1. A person possessing the highest degree of feeblemindedness; an adult having the intelligence of a normal child between eight and twelve. Also attrib.

1910 HENRY H. GODDARD lett. 29 April in *Jrnl. Psycho-Asthenics* Sep.–Dec. 65 The other [suggestion] is to call them [feeble-minded children] by the Greek word 'moron.' It is defined as one who is lacking in intelligence, one who is deficient in judgment or sense. All this differentiates him too from the lower grade of whom we cannot say they are simply deficient in judgment, there is something more than that. **1926** *Chi. Tribune* 28 Jan. 14/1 Legislation to provide for a moron colony has the support of County Judge Edmund K. Jarecki. **1949** *Amer. Jrnl. Mental Deficiency* July 31/1 Approximately 75% of all mental defectives belong in the moron classification.

2. A degenerate, a fool, a brutish person. *Colloq.*

1922 TITUS *Timber* iii. 37 So this backwoods moron, even, knew something about his affairs that John Taylor did not know. **1948** *Chi. Tribune* 4 April (Grafic Mag.) 20/3 We're intelligent and know what an optimist is, but how many of those morons are gonna know it's an eye doctor.

b. A sexual pervert.

1924 *Amer. Mercury* March 308/1 So long as morons are permitted to remain at large there will be crime waves. **1949** *Chi. D. News* 25 March 22/4 Removing shrubbery and lagoons will not improve the morals of a moron.

3. little moron, the feeble-minded hero of numerous jokes popular *c*1936.

1943 in BOTKIN *Amer. Folklore* 463 Did you hear about the little moron who cut his arms off? He wanted to wear a sleeveless sweater. **1948** *Savings News* March 18/3 There's the story about the little Swedish moron who heard about the atomic bomb and then went around the house throwing out all the pots of uraniums because they might split and blow up the place.

mortician mɔrˈtɪʃən, *n.* [f. * *mortuary* and *-ician,* prob. influenced by * *physician.*] An undertaker.

1895 *Columbus* (O.) *Dispatch* 14 Aug. (*advt.*), We, Mauk & Webb, are the only Morticians in the city who do not belong to the Funeral Director's Protective Association. **1932** BECK *Wonderland* 67 Some

ambitious, but none too busy, mortician will feel that his ancient and honorable profession has been neglected. **1948** *Christian Cent.* 4 Feb. 146/1 Give the morticians credit—their cosmetic arts are highly skilled.

mosquito hawk.

1. A nighthawk.

1709 Lawson *Carolina* 144 *East-India* Bats or Musquetc Hawks, are the Bigness of a Cuckoo, and much of the same Colour. **1850** *Conn. Public Acts* 5 It shall not be lawful . . . for any person to shoot . . . the robin, blue-bird, swallow, . . . night or mosquito-hawk, whip-poor-will. [etc.]. **1917** *Birds of Amer.* II. 172.

2. *S.* A dragonfly.

1737 Brickell *N. Carolina* 163 The Muskeetoe-Hawks, are Insects, so called, from their continually hunting after Muskeetoes, and killing and eating them. **1949** *Time* 25 July 34/2 Yankees in some part of New England call it a *devil's darning needle*, while some Southern Coast people go for *mosquito hawk*.

movie 'muvɪ, *n.* [f. *mov*ing picture.] A motion picture; a performance at which a moving picture is shown, often *pl.*

"The word *movie* appears to have come into the folk-tongue out of the gamin life of either New York or Chicago about 1906–1907. . . . By 1908 *movie* began to appear in the reports of social workers and contemporary newspaper accounts" (*Amer. Sp.* I. 357).

1913 *Lit. Digest* 4 Jan. 16/2 (*heading*), For More Brilliant 'Movies.' **1913** *Chi. D. News* 8 March 9/3 (*heading*), 'Movies' In A Small Town. **1949** *Reader's Digest* April 141/2 We . . . went to a movie, or bought tickets for a train or boat.

attrib. **1913** *Outlook* 5 April 784/1 The 'movie' fan lays himself open to overtired eye nerves, with the consequent headaches, indigestion, and general nervous complaints. **1917** *Chi. Defender* 22 Dec. 5 Watch for Our New Movie Palace to be Erected at a Cost of $250,000. **1918** *Current Opinion* Jan. 31 (*title*), Wonders of Camouflage that are Accomplished in Movieland. **1935** Lincoln *Cape Cod Yesterdays* 268 There were no movie cameras for amateur use in those days. **1948** *Chi. Sun-Times* 20 April 3/2 Howard was an ardent movie fan, who especially enjoyed the blood-and-thunder murder mystery type of drama.

✷ mucilage, *n.* A sticky solution of gum or a similar adhesive substance.

1859 *La Crosse Union* 15 Oct. 3/3 Mucilage, sealing wax, playing cards. **1923** Wiggin *My Garden of Memory* 112, I bought pencils, crayons, and mucilage of the local stationers. **1936** *Sears Cat.* 726/2 Mucilage with Rubber Spreader Top.

attrib. **1870** M. Twain *Sk. New & Old* (1875) 237 (R.), There is a mucilage-bottle broken.

muckraker 'mʌkˌrekɚ, *n.* [f. **muckrake,** *v.*] One who makes sensational and undiscriminating charges of corruption on the part of public men, corporations, etc.

In a speech on April 14, 1906 Theodore Roosevelt used the figure of the "Man with the Muckrak" mentioned in *Pilgrim's Progress*, to

describe persons given to charging individuals, corporations, and governments with corruption. Lincoln Steffens, who had already written several "muckraking" articles, and several of his friends seized upon this figure and *muckrake, muckraker, muckraking,* soon obtained wide currency.

[**1871** DE VERE 618 *Muckrakes,* a slang term in politics for persons who 'fish in troubled waters,' from the idea of their raking up the muck to see what valuable waifs and strays they may find in it. The term is generally used in the form of *muckrakes and place-mongers.* **1906** *Cin. Enquirer* 15 April 4/4 The men with the muck-rakes are often indispensable to the well-being of society; but only if they know when to stop raking the muck, and to look upward to the celestial crown above them, to the crown of worthy endeavor.] **1906** *Collier's* 22 Dec. 30/2 The muck-raker . . . is the man who has dared to knock to pieces the great American mud god, 'Success.' **1949** *Register* (Denver) 5 June 1/3 He is a professional muckraker.

mud wagon. (See quot. 1948.)
 1835 LATROBE *Rambler in N. Amer.* 259 We had to put up with an open 'mud-waggon,' with spring seats. **1896** SHINN *Story of Mine* 117

One type of mud wagon

[Stage drivers of the Nevada-California lines] drive 'mud-wagons' for the most part, that two or four horses can manage. **1948** RITTEN-HOUSE *Vehicles* 48 The 'mud wagon' was a type of stage-coach which might be called 'the poor man's Concord.' While it used thorough-braces, their method of attachment was simpler. One difference was in the body, with its flat sides and simpler joinery.

multicaulis ˌmʌltɪˈkɔlɪs, *n.* [f. the L. elements *multi+caulis,* "many stemmed."] A variety of white mulberry, grown esp. during the 1830's in the expectation of making profits in the silk industry. Also attrib. *Obs.* Cf. **morus multicaulis.**
 1833 *Niles' Reg.* XLIV. 332/2, I had the first opportunity of receiving from Paris, . . . three rooted trees of the Chinese multicaulis. **1840** *Farmers' Cabinet* 15 May 326/2 The multicaulis *fever* has passed, and we are *shivering* under its effects. **1857** *Iroquois Republican* (Middleport, Ill.) 12 Feb. 3/1 The Sorghum will prove a valuable addition to our crops, if we don't render it odious by some Multicaulis foolery. **1885** *Harper's Mag.* March 610/2 This 'multicaulis' or mulberry mania still furnishes a world of humor to the 'elders.'

mustanger ˈmʌstæŋɚ, *n. S.W.* One who makes a business of catching and selling mustangs.

1849 *N.Y. Wkly. Herald* 4 Aug. 245/6 The Indians had also attacked a party of Mustangers near San Patricio, killing two men and capturing three hundred mules and horses. **1929** DOBIE *Vaquero* 240 The professional mustangers were the only men who caught mustangs in considerable numbers. **1946** *Chi. D. News* 20 Aug. 12/6 It was a center for . . . mustangers, who hunted the wild horses, and for buffalo hunters.

myrtle wax.

1. = **bayberry wax.**

1700 *Va. State P.* I. 68, 26 pounds of Mirtle-wax, 01.06.00. **1755** FRANKLIN *Writings* III. 263 I'll put in a few Cakes of American Soap made of Myrtle Wax. **1880** CABLE *Grandissimes* 414 He removed the lid and saw within . . . the image, in myrtle-wax.

2. myrtle-wax candle, a candle made of the wax from wax myrtles.

1732 *Cal. State P. Amer. & W. Indies* 59 Carolina. Messieurs Boone and Barnwell, then Agents for this Province in their answers to said queries etc. 1720 mentioned no manufactures except mirtle wax candles. **1770** PITTMAN *Present State* 23 The different articles are indigo, cotton, rice, maiz, beans, myrtle wax-candles, and lumber.

3. myrtle-wax shrub, = **candleberry myrtle.**

1766 STORK *Acct. E. Florida* 48 The myrtle-wax shrub is, without doubt, the most useful of the spontaneous growth of America. **1828** *Western Mo. Rev* I. 729 A description is given of the myrtle-wax shrub. We believe it to be the same with what is called *bayberry* in New England.

b. Also **myrtle-wax tree.**

1763 in *Amer. Sp.* XX. (1945) 46 The *Myrtle Wax-tree* is one of the greatest blessings with which nature has enriched *Louisiana*. **1836** EDWARD *Hist. Texas* 66 The shrubs . . . which he could designate, as . . . the Myrtle Wax-tree, the Wild Plum [etc.].

N

N. A. An abbreviation of "National Academician" or "National Academy."

1867 *Harper's Wkly.* 4 May 273 (*caption*), Eastman Johnson, N.A. **1883** *Harper's Mag.* Nov. 843/2 [G. H. Boughton] enjoys . . . the unusual distinction of being an N.A. and an A.R.A. **1924** *Who's Who in Amer.* XIII. 1706/1 Inness, George, Jr., painter; . . . A.N.A., 1895 N.A., 1899. **1949** *L.A. Times* 11 July 11. 4/2 [signature:] Hugo Ballin, N.A.

Nantucket næn'tʌkɪt, *n.* [Amer. Indian. Hodge has variants *Mantukes, Mantukett, Nantukes.*]

1. Whale oil. *Rare.*

1826 *Va. Herald* (Fredericksburg) 25 Oct. 2/3 Hymen began to pour a little pure Nantucket into his lamp.

2. *attrib.* Denoting people or things belonging to, or associated with, the island or the town of Nantucket, Mass. Often *humorous.*

1707 *Boston News-Letter* 7 April 2/1 The Nantucket Whale-boats came up with a Sloop that was overset. **1848** *Knickerb.* XXXI. 225 Who has not seen the eyes of the boarding-school boy almost suffused with tears as he gazed upon the cod-fish dinner, alias 'Nantucket owls?' **1882** GODFREY *Nantucket* 69 The Cap-Codders and the Vineyarders retaliated by calling the Nantuckers 'Scrap Islanders,' or 'Nantucket Scraps.' **1891** *Cent.* 5692/2 *Nantucket sleigh-ride*, the towing of a whale-boat by the whale.

Natchez 'nætʃɪz, *n.* [Orig. the Indian name (of unknown significance) of a town near the present city of Natchez, Mississippi.] A tribe of Indians formerly living on and near St. Catherine's Creek, in Mississippi. Also attrib.

1775 ADAIR *Indians* 86 In the year 1747, a Nachee warrior told me, that while one of their prophets was using his divine invocation for rain . . . he was killed with thunder on the spot. **1845** *Cherokee Advocate* (Tahlequah, Okla.) 24 April 4/3 The tradition has been widely recorded, that the dominion of the Natchez once extended even to the Wabash. **1895** G. KING *New Orleans* 75 The revolt of the Natchez Indians . . . threw the colony into the hitherto unexperienced troubles of an Indian war. **1938** *Southwestern Lore* June 13 The laws of the Natchez pemitted more than one wife, although they seldom had more than one or two.

b. Natchez Trace, a once popular thoroughfare from New Orleans to Natchez and on to Nashville, a total distance of about seven hundred miles.

1899 H. B. CUSHMAN *Hist. Indians* 478 This road was long known, and no doubt remembered by many at the present time by the name of 'Natchez Trace.' **1949** *Nat. Geog. Mag.* Feb. 181/2 Original builders of the Natchez Trace were buffaloes. . . . Several of these trails, when joined together by the Indians, led southwesterly from Nashville to the Mississippi.

National Guard. (See quot. 1918.) Also attrib.

1847 *Santa Fe Republican* 18 Dec. 3/1 Some National Guards that were at San Antonio had a small fight. **1857** *Harper's Mag.* Aug. 402/1 The National Guard, a military company, . . . were drawn up in front of the Hall. **1918** FARROW *Dict. Mil. Terms* 404 *National Guard.*—A body of militia, or a local military organization. In the United States, the regularly commissioned and enlisted militia of the various states, organized, armed and equipped as provided for the corresponding branches of the service in the Regular Army. **1949** *Minot* (N.D.) *D. News* 22 July 1/3 The National guard force of 300 is expected to stay several days longer.

Hence **National Guardsman.**
1916 *Outlook* 2 Aug. 773/2 (*heading*), From A National Guardsman.
1948 *Dly. Ardmoreite* (Ardmore, Okla.) 24 June 1/2 Nationa' guardsmen patrolled streets against looters after the business district was under water.

Nauvoo nɔˈvu, *n.* [*Nauvoo*, Ill.]
1. Nauvoo fly, = **Mormon fly.** *Rare.*
1845 F. N. MOORE *Diary* (1945) 46, I heard one of the deck hands a little while ago cursing 'these damned Nauvoo flies.'
2. Nauvoo legion, a military force or militia organized by the Mormon community at Nauvoo, Ill. Now *hist.*
1841 *Times & Seasons* (Nauvoo, Ill.) 1 May 406/1 Previous to his death he held the offices of Quarter Master Sergeant in the Nauvoo Legion and Assessor for the city of Nauvoo. **1881** ROMSPERT *Western Echo* 346 General Joe Smith, and his brother Hiram, at the head of the Nauvoo legion, opposed the state militia which had been called out to enforce obedience to the law. **1947** *Time* 21 July 19/3 He [Joseph Smith] organized a Nauvoo Legion of 4,000 well-armed troops.

Navarino navəˈrino, *n.* [*Navarino*, Greece, made famous by a battle there in 1827.] A bonnet of a style popular about 1845. In full **Navarino bonnet.** Also **Navarino scoop.** *Obs.* or *hist.*
1846 FARNHAM *Prairie Land* 101 A capacious sugar-loaf Navarino scoop which had once vied with the raven hair. *Ib.* 103 [The monkey] winked a little quicker when he faced the Navarino. **1863** TAYLOR *H. Thurston* 345 We wore Navarino bonnets then, and sleeves puffed out with bags of down. **1900** KING *When I Lived* (1937) 134 She wore on her head what was called in those days a 'Navarino' bonnet, with green bows half a yard high.

✳ **navel,** *n.* An orange having a small navel-like formation at its apex, usu. grown in California. In full **navel orange.** Also attrib.
1882 *Harper's Mag.* Dec. 58/2 He can go into his orchard and concern himself about his Navel or Brazilian varieties . . . without let or hindrance. **1888** LINDLEY *Calif. of South* 349 The navel orange possesses a thin skin, few or no seeds, tender pulp, and a high, winy flavor, which gives it precedence over all other varieties, budded or seedling, grown in Southern California. **1891** *Harper's Mag.* Jan. 170/1 The prices for fruit in the spring of 1890 [were] $1.60 per box for seedlings and $3 per box for navels. **1949** HERTRICH *Huntington Bot. Gardens* 9 By this time the navel orchard adjoining my home property fortunately had been abandoned and planted to alfalfa.

b. navel orange tree, a tree producing navel oranges.

1846 BROWNE *Trees Amer.* 58 Navel Golden-fruited Orange-tree. The author of the present work claims the honour of first introducing this variety [from Brazil] into the [U.S.]. **1900** E. J. WICKSON *Calif. Fruits* 355 (*caption*), Budded Navel Orange Tree, about Five Feet High.

∗ needle, *n.*

1. = cypress knee. *Obs.*

1853 PAXTON *Yankee in Texas* 60 Around the foot of each tree are standing a number of those singular conical-shaped shoots, termed needles, resembling so many grave-stones.

2. a. needle grass, any one of several grasses, as the ant rice, *Aristida oligantha,* also attrib. **b. needle palmetto,** the blue palmetto, *Rhapidophyllum hystrix.*

(a) **1885** H. C. McCook *Tenants Old Farm* 341 A sort of grass known as ant-rice, or needle grass. **1944** BARBOUR *Eden* 124 Most characteristic feature of Florida is the needle-grass pond of the open piney-woods prairie. — (b) **1942** KENNEDY *Palmetto Country* 5 Another low-lying palmetto—variously called the dwarf, needle, porcupine, blue, or creeping palmetto—has an even wider range than the saw palmetto, extending from Florida to North Carolina and Texas.

Negro minstrel. One of a group of comedians, usu. white men in blackface, who give a performance consisting of Negro songs, dances, jokes, etc. Also any blackface comedian who uses Negro material.

1857 *Ladies' Repository* July 421/2 The negro minstrel may have a large audience. **1896** HASWELL *New York* 405 September [1843], the Chatham Theatre, in new hands, opened. A very notable attachment to the company was the 'Virginia Minstrels' . . . for this was the beginning of 'Negro minstrels.' **1948** MENCKEN *Supp.* II. 257 The Irishman and the German became standard types in American comedy, alongside the Negro minstrel introduced by Thomas D. Rice (1808–60) in the 30s.

attrib. **1889** MUNROE *Golden Days* 74 In one [gambling house] they found . . . a negro minstrel troupe. **1893** LELAND *Memoirs* 58 It is very commonly asserted that the first regular negro minstrel troupe appeared in 1842. This is quite an error. While I was at Mr. Greene's, in 1835, there came to Dedham [Mass.] a circus with as regularly-appointed a negro minstrel troupe of a dozen as I ever saw. **1948** *Ada* (Okla.) *Ev. News* 4 July 7/4 The Unit III group . . . gave a short negro-minstrel-type stunt, using padding and black-face, plus all the old clothes and old jokes they could put together.

b. Negro minstrelsy, the entertainment provided by Negro minstrels.

1855 *Western Citizen* (Paris, Ky.) 19 Oct. 3/2 Our town has been highly favored this week, with *negro minstrelsy,* as it is called, though to our notion, there was a good deal of 'white folks' about it. **1915** B. MATTHEWS in *Scribner's Mag.* June 754/1 Negro-minstrelsy is . . . absolutely native to these States.

new departure. The new regime in the South after the Civil War and Reconstruction; esp. (*cap.*) the policy, supported by the Democrats and the Liberal Republicans in the campaign of 1872, of regarding Reconstruction as completed and of granting universal amnesty. Also attrib.

1871 *Ku Klux Rep.* VIII. 425 The white people in our country, though they may accept what is known as the 'new departure,' are at heart unalterably opposed, in my opinion, to negro suffrage. **1871** *Harper's Mag.* Aug. 474/1 The following, [is] told by way of illustrating the significance of the 'new-departure' movement. **1872** J. SHERMAN in *Sherman Lett.* (1894) 335 There were five or six Republicans who . . . were inclined to support Cox as an Anti-Grant or new departure candidate. **1947** LUMPKIN *Southerner* 141 Back in Georgia Father had seen the post-Civil War shift from plantation-belt leaders to a new type entirely. These were called 'New Directionists,' or 'New Departure' Democrats.

New Orleans. [Name of a city in Louisiana.] In combs.: (1) **New Orleans boat,** (see quot. 1812), *obs.;* (2) **molasses,** molasses, comparatively light in color and high in sugar content, obtained as a by-product in the manufacture of sugar; (3) **moss,** the long moss, *Dendropogon usneoides;* (4) **sirup,** =New Orleans molasses.

(1) **1806** CRAMER *Navigator* 28 Kentucky and New Orleans' boats are generally to be had ready-made at the boat-yard of Sumrall and M'Collogh near the point. **1812** MELISH *Travels* II. 85 *Kentucky* and *New Orleans* boats are flats, with sides boarded like a house, about six or seven feet high, over which there is an arched roof. **1941** BALDWIN *Keelboat Age* 47 These craft, though they might vary very slightly in construction, were essentially alike whether they were called Kentucky or New Orleans boats for their intended destination. — (2) **1849** FOSTER *N.Y. in Slices* 82 The grocery-keeper . . . buys a barrel of common New Orleans molasses at twenty-five cents per gallon, and retails it to his customers at sixpence the pint. **1885** *Buckeye Cookery* 99 In making ginger-bread . . . always use New Orleans or Porto Rico molasses, and never syrups. — (3) **1877** BARTLETT 789 *New Orleans Moss,* . . . a moss which hangs from the boughs of trees in Louisiana, giving to the landscape a weird-like appearance, . . . is used in the South . . . for mattresses, cushions, &c. — (4) **1898** *Kansas Star* 18 Dec. 5/2 New Orleans Syrup, per gal, 19¢.

b. New Orleanian, a native or inhabitant of New Orleans.

1948 *N.O. Times-Picayune Mag.* 5 Dec. 11/2 What should New Orleanians do about their protest? **1949** *Ib.* 10 April 5/2 Why were 344 New Orleanians fatally injured in motor vehicle accidents during the past six years?

nickel-in-the-slot machine. A machine in which, by the insertion of a nickel in a slot, certain gears are, or may be, moved, thereby releasing gum, a bar of candy, etc. Also **nickel-in-the-slot scheme, nickel slot-machine.**

1889 *Tacoma* (Wash.) *News* 13 Dec. 3/5 The latest nickel-in-the-slot scheme is really a stroke of genius and is destined to revolutionize cheap literature in this country. **1893** *Harper's Mag.* March 494 [In Jacksonville] there were the same . . . nickel-in-the-slot machines [as in Asbury Park]. **1914** *Calif. Appellate Rep.* XXIII. 769 The statute under discussion relates only to gambling machines, and does not pur-

port to make the business of manufacturing 'coin operating machines commonly known as nickel-in-the-slot machines' unlawful. **1947** *So. Sierran* Nov. 1/3 In fact, my $1.10 is sitting in a nickel slot-machine there.

Nisei ˈnisɪ, *n.* [Jap., second generation.] An American-born Japanese, also as a *pl.*

1943 MENEFEE *Assignment* 191 The War Relocation Authority, after a delay of many months, finally began to release those Nisei, or American-born Japanese. **1948** *Newsweek* 30 Aug. 20/1 The 29-year-old Nisei claimed that she had taken a job with the Tokyo radio merely 'for the experience.' **1949** *Time* 20 June 25/2 He pushed the formation of the famed 442nd Combat Team, in which the Nisei in Italy gave distinguished proof of their loyalty to the U.S.

nominating convention. A party convention of delegates chosen to nominate candidates for political office.

1866 F. KIRKLAND *Bk. Anecdotes* 54 The following jaunty account is told of an interview with the Cabinet chiefs, just after the Baltimore Republican Nominating Convention. **1911** R. D. SAUNDERS *Col. Todhunter* iii. 43 This is the first time in the history of Mizzoorah that the Democrats nominate their candidate for governor at the polls, 'stead of in a nominatin' convention. **1946** ADAMS *Album Amer. Hist.* III. 90 With the Democratic Party divided within itself on the slave question, and with the new Republican Party opposing slavery, the nominating conventions of 1860 took place.

noon mark. Formerly, in the absence of a timepiece, a mark made to indicate the position of a noon shadow; hence, noon. Now *hist.*

1854 B. J. TAYLOR *Jan. & June* 131 The sun has driven the shadows around under the west and north walls; it has reached the noon-mark on the threshold. **1880** COOKE in *Harper's Mag.* Sep. 585/2 Noon-mark was straightened out by the great gnomon of a tulip-tree on the turf dial where the shanty stood. **1889** —— *Steadfast* 275 Goodness! 'tis most noon-mark and I haven't took a step towardst dinner. **1891** EARLE *Sabbath* 77 The time of the day was indicated to our forefathers in their homes by 'noon marks' on the floor or window-seats. **1948** *N. & Q.* Nov. 121/2, I should like to know whether ... the term 'noon mark' was once common.

nullifier ˈnʌləˌfaɪɚ, *n.*

1. An advocate of nullification *q.v.*, esp. with reference to the action of South Carolina in 1832. Now *hist.* Cf. **anti-nullifier.**

1830 *Mass. Spy* 7 July (Th.), This argument was considered by all the nullifiers as overwhelming. **1913** BASSETT *Short Hist. U.S.* 410 On February 1 [1833] the leading nullifiers met and decided to suspend the execution of the ordinance of nullification. **1948** *Reader's Digest* May 127/2 When the Nullifiers began to arm, Jackson at one time promised to march 200,000 troops into the rebellious state.

b. Great Nullifier, John C. Calhoun (1782–1850).

1850 *Quincy* (Ill.) *Whig* 12 Nov. 3/2, I speak of course of the Great

Nullifier as of a historical character. **1882** H. VON HOLST *J. C. Calhoun* 104 Hundreds of eyes closely scrutinized the face of the 'great nullifier' as he took the oath to support the Constitution.

2. (See quot. 1859.) *Obs.*

1840 *N.O. Picayune* 20 Sep. 2/3 His understandings [shoes] could not be legitimately called boots, brogans or nullifiers. **1859** BARTLETT 298 *Nullifier* . . . was also applied to a sort of shoe, made like a decapitated boot, brought into fashion in the 'nullification' times.

Nyantic naɪˈæntɪk, *n.* [Algonquian.] One of a tribe of Algonquian Indians formerly occupying the Connecticut coast from the Niantic River or inlet to the Connecticut River. Also attrib.

1647 in *Mass. H.S. Coll.* 4 Ser. VI. 346 It will be a mercy if a safe, and honorable peace may be settled . . . and a great addition to it, if the . . . Nyantick Indians bring in their wampum. *Ib.* 347 We desire . . . that you would send me to the Narraganset and Neyantick Sachems in the meane time. **1945** WEBSTER *Town Meeting Country* 11 The former were powerful and warlike, and held in subjection the Nyantics a little to the west and south.

O

*oat, *n.*

1. *pl.* (See quot.)

1804 in GATES *Fur Traders* (1933) 206 Richard brought a parcel of dried Meat, today, the Indians had not yet made any Oats. [Footnote:] Wild rice was ordinarily called 'oats' or 'wild oats' by the traders and voyageurs. It was gathered by Indian women in the late summer and was bartered by them for trade goods. Whenever it could be procured, 'oats' served as a staple article in the traders' diet.

2. oat chops, oats ground or chopped as food for stock. Cf. * **chop,** *n.* **2.**

1893 *Dly. Ardmoreite* (Ardmore, Okla.) 14 Dec. 1/4 Don't buy trash when you can get 100 pounds of fresh corn and oat chops for one dollar.

3. *To feel one's oats,* to feel frisky or lively, to feel "cocky," to enjoy a sense of importance. *Colloq.*

1831 *Boston Transcript* 22 Dec. 1/1 Whether the pony felt his oats, . . . He took a frightful canter. **1871** PINE *Beyond West* 225 Portland is yet young and simple-hearted—'feels its oats,' but its dignity more. **1947** *Hygeia* Nov. 939/1 A dynamic run-about met grandparents' eyes instead—boisterous, obstreperous, inclined to obstinacy, obviously feeling her oats.

ocelot ˈosəˌlɑt, *n.* [See note.] A large American spotted cat, *Felix pardalis*, of the Southwest.

The U.S. usage of this word is no doubt the result of a borrowing made from the Spanish in the Southwest. The *OED*, and subsequently other dictionaries, explain the term as derived f. Nahuatl *tlalocelotl*, the jaguar, the native name of the larger of two southwestern cats being thus conferred, in English, upon the smaller. Santamaría is prob. correct in suggesting that the Nahuatl term *ocelotl* designated the smaller cat.

[**1780** CLAVIGERO *Storia della Messico* II. 78 L' *Ocotochtli*, sare essere . . . della classe dei Gatti salvatachi.] **1809** KER *Travels* (1816) 243 An animal called ocstochly, a kind of wild cat, is remarkable, more for the fabulous account of it, than for any singular property with which it is endowed. **1867** *Amer. Naturalist* I. 286 Two other species of true long-tailed cats may possibly exist, particularly in the southeastern portions [of Ariz.]. These are the Ocelot . . . and the Jaguar. **1942** Nat. Pk. Service *Fading Trails* 109 Then there are the ocelots, once known as far north and east as Louisiana.

O-grab-me. [*Embargo* spelled backwards.] A facetious name applied to the embargo acts of 1807 and following years. Also attrib. Now *hist.*

1808 *Balance* 7 June 92 (Th.), As soon as O grab me! shall let go his end, I'll haste to relate the sweet tidings to you. **1810** LAMBERT *Travels* II. 506, I guess I shall soon be on the opposite side of the Line, in spite of their ograb-me laws. **1858** *S. Lit. Messenger* XXVII. 466/1 The war of 1812, and the famous 'O-Grab-Me,' as the wags of that day ana-grammatized the embargo measures of Mr. Madison.

Ohio idea. A scheme sponsored by Ohio Democrats between 1868 and 1876 whereby U.S. notes and bonds would be paid off with greenbacks. Also transf. *Obs.*

1880 in S. LEAVITT *Our Money Wars* (1894) 244 The defeat of Ewing will finally dispose of the Ohio Idea. **1881** *Cong. Rec.* 13 April 276/2 The Ohio idea is the absolute equality of all men before the law. **1886** POORE *Reminiscences* II. 349 Mrs. Hayes brought with her from her rural home what was known as 'the Ohio idea' of total abstinence from intoxicating drinks, and she enforced it at the White House.

Oklahoma ˌokləˈhomə, *n.* [Choctaw "red people." Name of a territory, later a state.]

1. A light, temporary hut or shanty, in allusion to such huts used in Oklahoma during the land rush of 1889. *Obs.* Cf. **eighty-niner.**

1889 *N.Y. Post* 21 Sep., A light fall of snow here [in Johnstown, Pa.] yesterday gave the people living in the Oklahomas a foretaste of what winter will be like in their shells.

2. *transf.* A large open space. *Humorous.* Cf. **Texas.**

1906 M. TWAIN *Speeches* 330 (R.), They placed Twitchell and me in a most colossal bedroom. There were six chairs in that Oklahoma.

3. In combs. of obvious meaning, as (1) **Oklahoma boom,** (2) **boomer,** (3) **colonist,** (4) **fever,** (5) **land,** (6) **pioneer,** (7) **run.**

(1) **1885** *Cent. Mag.* Aug. 603/2 An organized movement, known as 'the Oklahoma boom,' has been made to seize and colonize a larger body of the territorial lands. — (2) **1882** *Chi. Tribune* 28 Jan. 7/2 The petition . . . is regarded as an effort to make a little buncombe by the Oklahoma boomer. **1928** STANSBERY *Passing of 3D Ranch* 5 David L. Payne, the 'Oklahoma boomer,' had made such a hard fight for the opening of these lands for settlement, the United States government began negotiations for the purchase of the strip from the Cherokees. — (3) **1883** *Rep. Indian Affairs* p. xxiii, Notwithstanding his repeated expulsion from the Indian Territory, Payne and his party of 'Oklahoma Colonists' have twice during the present year made attempts at settlement in that country. — (4) **1891** O'BEIRNE *Leaders Ind. Territory* 98/1 Being struck, however, by the Oklahoma fever in 1889, he incautiously moved his herd to the promised land.
(5) **1920** DALE in *Amer. Hist. Assoc. Rep.* (1925) 320 Little newspapers grew up near the border, established apparently for the . . . purpose of 'booming' the opening of Oklahoma lands to settlement. — (6) **1923** *Chronicles of Okla* I. 176 The old time Oklahoma pioneer had his vision. — (7) **1930** *Publishers' Wkly.* 8 Feb. 697 On April 22, 1889, this strip was opened up with the land rush known as the famous Oklahoma Run.

Old Dominion. The state of Virginia. Also attrib.

"Dominion" was used by English sovereigns in referring to the possessions in America. In the course of time Virginia was known as the Ancient Dominion *q.v.* then the Old Dominion (see A. Mathews in *Notes & Queries* 2 Ser. XII. 31).

1778 *Va. State P.* I. 311, I should not see the old Dominion this winter. **1861** *Vanity Fair* 25 May 246/2 We will wrap the flag of our fathers around the 'Pan Handle' of Virginia and upset the entire dish of Old Dominion Secession. **1905** *N.Y. Ev. Post* 16 May 7 The Old Dominion is unlikely to send anybody else until his [Lee's] statute has been received there. **1949** *Newsweek* 1 Aug. 15/1 This constituted outside interference' in the affairs of the Old Dominion.

b. In full Old Dominion State.

1883 *Harper's Mag.* Dec. 110/2, [I had] passed across the boundaries of the Old Dominion State. **1947** *Times-Herald* (Wash., D.C.) 9 May D-3/1 We boated on to two hundred of these silver perch, as they are familiarly known by the natives in the Old Dominion State.

Old Ned. (See quots.) *Colloq.* Cf. * **Ned.**

1833 J. E. ALEXANDER *Transatlantic Sk.* II. 83 A snow-white cloth was spread, on which were placed bacon, or 'Old Ned,' as it is called in Tennessee. **1869** *Overland Mo.* Aug. 129 Southern smoke-cured pork, in distinction from the Northern salted article, in allusion to the famous negro song, was termed '*Old Ned*,' from its sable appearance. **1936** *Amer. Sp.* XI. 316 Old Ned, n. Home-cured bacon. The term is used to mean *boar* in Taney county, Mo. **1949** *Amer. Folk-Lore* Jan.-Mar. 63 The devil was referred to as 'Old Ned' or 'Old Scratch.'

b. *To raise old Ned*, to raise Cain. *Colloq.* See * **Cain.**

1859 *N.Y Wkly. Tribune* 10 Sep. 7/4 The accounts in The Tribune raise Old Ned. **1942** WARNICK *Dialect Garrett Co., Md.* 12 Raise old Ned, v. phr., to make a row (Slang).

olykoek ˈɑlɪˌkuk, *n.* Chiefly *N.Y.* [Du. *oliekoek*, in same sense.] (See quot. 1947.)

1809 IRVING *Knickerb.* III. iii, The table . . . was always sure to boast an enormous dish of balls of sweetened dough, fried in hog's fat, and called dough nuts, or oly koeks. **1831** *N.Y. Mirror* 31 Dec. 204/3 They had neither prepared mince pies, nor crullers, nor any of the good things consecrated to St. Nicholas. **1947** BEROLZHEIMER *Regional Cookbook* 138 The doughnut originated in Holland where it was called 'olie koeken,' which means oil cakes. While the Pilgrims were in Holland on their trip to the New World, they learned to make doughnuts and brought this knowledge to Plymouth Rock as did the Dutch themselves later when they settled in New Amsterdam.

* **once,** *adv.* **1.** *once and again,* (see quot.). **2. once-over,** a quick examination or consideration of a person, plan, etc. *Slang.*

(1) **1859** BARTLETT, Once and again, occasionally, sometimes. A Southern phrase, equivalent to 'once in a while.' — (2) **1916** H. L. WILSON *Somewhere in Red Gap* v. 202, I got just about the once-over from every brute there, and that was all. **1949** *Sky Line Trail* Oct. 19/1 At the creek-bank he halted, giving me the once-over, then ambled unconcernedly away.

optometrist ɑpˈtɑmətrɪst, *n.* [f. **optometry*+*-ist*.] One who is skilled in optometry. Also attrib. — **1904** *Optical Jrnl.* 23 June 69 (Cent. Supp.), One of the points to be thoroughly discussed will be the best name to give those who professionally test eyes for refractive errors. . . . In those States which have laws governing this line c *l* work the term used is 'Optometrist.' **1949** *Chi. D. News* 6 May 26/1 The optometry bill, for instance, would prevent any licensed optometrist from advertising his services.

* **ordinance,** *n.*

1. Ordinance of 1787, an Act of Congress of July 13, 1787, providing a system of government for the Northwest Territory.
[**1787** CUTLER in *Life & Corr.* I. 342 Was furnished with the ordinance establishing a government in the Western Federal Territory.] **1847** *Whig Almanac 1848* 33/2 The imperishable principle set forth in the ever-memorable Ordinance of 1787. **1857** *Congreg. Herald* (Chi.) 11 June 2/3 So Illinois, in spite of the ordinance of 1787, becomes a *Slave State,* by enslaving free citizens of the United States coming in from other States. **1948** *Pacific Spectator* Summer 255 Invoked in the discussion were the legal meaning and effect, as related to slavery, of . . . the Ordinance of 1787 for the government of the Northwest Territory, the Constitution . . . , the Missouri Compromise of 1820.

2. ordinance of secession, an enactment passed by a representative body in a seceding state signifying the intention of that state to withdraw from the Union. Now *hist.* Cf. **secession ordinance.**
1860 *Charleston* (S.C.) *Mercury* 22 Dec. 2/6 The Ordinance of Secession has been signed and ratified, and I pronounce the State of South Carolina an independent Commonwealth. **1948** *Chi. Tribune* 15 Feb. 1. 24/3 South Carolina had passed its ordinance of secession on December 20 of the year just gone.

organ cactus. =**giant cactus.** Also **organ pipe cactus.**

1883 *Harper's Mag.* March 502/2 The enormous saguaras, the organ-cactus which . . . bristle over the landscape like masts or columns. **1908** HORNADAY *Camp Fires on Desert* 352 The mines are quite the northern limit of the organ-pipe cactus. **1947** *Time* 10 March 18/2 Afterwards, behind a Military Academy cavalry squadron, the two Presidents rode between rows of organ cacti and Mexican foot troops over the newly paved city streets to the great, tomb-like U.S. Embassy.

organized labor. Workingmen who are organized into labor unions. Also attrib.

1885 in C. EVANS *Hist. U. M. W.* I. 131 To organized labor . . . and to the generous and sympathetic public . . . we return our sincere and heartfelt thanks. **1924** WOLMAN *Growth of Amer. Trade Unions* 82 The number of wage earners . . . would not be considered by some a thoroughly fair base for measuring the achievement in size of an organized labor movement. **1948** *Time* 15 March 27/2 He thought of himself as the leader of all the people, not just of organized labor.

otologist oˈtɑlədʒɪst, *n.* [See next.] An ear specialist.

1874 ROOSA *Diseases of Ear* (ed. 2) 47 The high character of the work that has been done by American otologists. **1876** BARTHOLOW *Materia Medica* (1879) 549 Glycerine is used by otologists to soften cerumen. **1949** *Archives of Otolaryngology* Oct. 507 It is important that otologists be frank and honest with patients who have hearing losses.

Ouija board. [F. *oui*, yes, +G. *ja*, yes, and *∗ board*.] A board bearing the trade-mark *Ouija* used with a planchette for spelling out mediumistic messages. Often not *cap*.

1895 RITTENHOUSE *Maud* 590 Once or twice he had referred to something a Ouija-board in Chicago had said, and how it had spelled my name in full. **1945** *Jefferson Co. Republican* (Golden, Colo.) 25 July 2/1 One had lost her mind from constant study of the ouija board. **1949** *U.S. Tobacco Jrnl.* 9 July 4/2 Taxation of cigarettes . . . has now reached such a stage of bewildering confusion as to defy an adding machine, a ouija board or a fortune teller.

∗ **outlaw,** *n.*

1. *W.* A horse that is incorrigibly vicious, either by temperament or because of brutal handling when being broken. Also attrib.

1885 ROE *Army Lett.* 337 Many a fine, spirited animal is ruined, made an 'outlaw' that no man can ride, just by the fiendish way in which they are first ridden. **1903** *Out West* Feb. 187 They'll take outlaws all right, but no broncos. **1927** SIRINGO *Riata* 140, I told him to trot out his outlaw horse. **1945** MATHEWS *Talking* 5, I remembered the colt, an iron-gray and a veritable outlaw that only a bolt of lightning had been able to subdue.

b. outlaw bronco, a bronco that is an outlaw.

1903 *Wide World Mag.* March 546 (*Cent. Supp.*), The whole Western country was scoured over for the wildest and most vicious 'outlaw'

bronchos that could be found. **1949** *N.Y. Times Book Review* 13 March 22/4 His brother Billy was thrown by an outlaw bronco.

2. (See quot.)

1920 *Harvey's Wkly.* 17 April 5/2 The 'outlaw' railroad strikes . . . are unjustifiabſe. *Ib.* 19 June 11/1 No man who is a member of the union has a right to quit work unless the union bids him to quit. If he does he is an 'outlaw.'

overcup ˈovə‚kʌp, *n.*

1. Short for next.

1817 BRADBURY *Travels* 288 Of the oak only, there are fourteen or fifteen species, of which the over cup (*Quercus macrocarpa*) affords the best timber. **1874** GLISAN *Jrnl. Army Life* 480 A few cotton-woods along the bottoms of the larger rivers; and overcup, pecan, sycamore, . . . and red elm, along the tributary streams.

2. overcup oak, any one of various trees, esp. *Quercus lyrata*, producing acorns deeply imbedded in their cups.

1804 DUNBAR *Life* 240 The margin of the river is clothed with such timber as generally grows on inundated lands, particularly a species of the whiteoak called vulgarly the overcup-oak. **1948** *Life* 5 April 57/1 The squat over-cup oaks of the South spread out to touch the northern red oaks.

3. overcup white oak, the mossy-cup oak, *Quercus macrocarpa.*

1795 MICHAUX *Journal* 15 June, Quercus glandulibus magnis, capsula includentibus, nommé *Overcup White Oak.* **1798** DUNBAR *Life* 93 Vegetable productions of the Swampy Grounds or such as are much exposed to the Annual Inundation. . . . Over cup White Oak. **1897** SUDWORTH *Arborescent Flora* 155 *Quercus macrocarpa. . . .* Overcup White Oak (Vt.).

Ozark ˈozɑrk, *n.* [See last quots.] *pl.* A local band of Quapaw Indians, so called from their residence in the Ozark Mountain region of Missouri and Arkansas.

1819 NUTTALL *Travels Ark.* (1821) 81 The aborigines of this territory, now commonly called Arkansas or Quapaws and Osarks, do not at this time number more than about 200 warriors. [**1910** HODGE *Amer. Indians* II. 180/2 The spelling *Ozark* is an American rendering of the French *Aux Arcs*, intended to designate the early French post among the Arkansa (Quapaw) about the present Arkansas Post, Ark. **1946** *St. Louis Globe-Democrat* 9 June, Ozarks must have originated, not from the French term 'arc' or 'arque' with the sense of 'curve' or 'bend' or 'bow,' as has been so often maintained, but as an abbreviation of the great tribal name Arkansas. The French were in the habit of shortening the long Indian names by using only their first syllables. There are frequent references in their records to hunting or trading expeditions 'aux Kans,' or 'aux Os,' or 'aux Arcs,' meaning up into the territory of the Kansas, Osage, or Arkansas tribes. **1948** *Dallas Morn. News* 2 May 11. 6/2 'Aux Arcs' means 'with bows,' and it referred to the Indian tribe native to that region.]

b. *attrib.* With reference to the region.

1831 PECK *Guide for Emigrants* II. 129 The Gasconade hills, im-

properly called the Ozark mountains. **1856** *Rep. Comm. Patents: Agric.*
308 The varieties referred to above are . . . the 'Ozark' seedling [etc.].
1927 *Haldeman-Julius Quart.* Jan. 77/1,. I have dwelt among the
Ozark hill-billies up near the Missouri line.

P

Paas pɑs, *n.* N.Y. [Du. *Paasch*, in same sense. An
Amer. borrowing.] Easter. Also attrib. *Obs.*

1809 IRVING *Knickerb.* VII. i, Under his [Stuyvesant's] reign was first
introduced the custom of cracking eggs at Paas or Easter. **1830**
COOPER *Water Witch* I. i, Thou canst lighten thy heart in the Paus
merrymakings. **1858** *N.Y. Tribune* 7 April 7/3 The St. Nicholas
Society [will] on Easter Sunday celebrate the festival of Paas. **1859**
BARTLETT 307 *Paas Eggs.* Hard-boiled eggs cracked together by New
York boys at the Easter season. They are often dyed of various
colors in boiling.

b. Paas blummie, (see quots. and cf. **blummie**).

1859 BARTLETT 307 *Paas Bloomachee,* i.e. Easter-flower. (*Narcissus
pseudo-narcissus.*) Not the Pasque Flower of botanists, but the com-
mon Yellow Daffodil. **1921** H. QUICK *Vandemark's Folly* 111 The
hillsides were thick with the woolly possblummies in their furry spring
coats protecting them against the frost and chill, showing purple-
violet on the outside of a cup filled with golden stamens. [Note:
Paasbloeme one suspects is the Rondout Valley origin of this term
applied to a flower . . . the American pasqueflower.]

* **padlock,** *v.* Used in combs. having to do with the
closing by an injunction, state law, or administrative
order, of a shop, storeroom, tavern, theater, etc., as a
means of enforcing a law, esp. of a law against a liquor
nuisance, prostitution, indecent exhibitions, etc., as (1)
padlock court, (2) **injunction,** (3) **judge,** (4) **law.**

(1) 1925 *Lit. Digest* April 55/1 All such cases will be transferred from
the Admiralty Court to the padlock court. — **(2) 1928** *Lit. Digest* 12
May 12/2 The padlock injunction procedure will henceforth be used
to the fullest possible extent throughout the United States. — **(3)**
1925 *N.Y. Times* 9 March 1/8 By April 1 I expect to have one padlock
Judge sitting continuously to hear nothing but padlock cases and to
issue padlock orders. — **(4) 1925** *N.Y. Times* 9 March 1/8 He had
been urging incessantly the policy of proceeding under the padlock
law. **1928** *Observer* 26 Feb. 18/3 The New York police had banned the
play and shut up the theatre under the 'Padlock Law.'

Also **padlocking court, judge.**

1925 *N.Y. Times* 6 March 6/5 A padlocking court operates without

[175]

a jury. *Ib.* 7 March 1/3 A padlocking court with a padlocking Judge to sit during the Summer drying up New York was the plan announced yesterday.

* **paleface,** *n.*

1. A white man as distinguished from an Indian. A term usu. employed by Indians or in imitation of them.

1823 McCall *Lett. from Frontiers* (1868) 72 An Indian chief . . . thus accosted him,—'Ah, *Paleface!* what brings you here? you seem to take pleasure in saying rude impertinencies.' **1868** Whymper *Alaska* 36 It is very rare to find those who are the better for intercourse with the 'pale faces.' **1948** *Chi. D. News* 18 March 20/7 Income tax is a devilish invention of the paleface, brothers.

attrib. **1841** Cooper *Deerslayer* xi, 'This is the paleface law,' resumed the chief. **1850** Glisan *Jrnl. Army Life* 18 The right and wrong of these cruel encounters will . . . [rest at] one time with the red man—at another with his pale-face brother. *a***1861** Winthrop *Canoe & Saddle* 240 He had even condescended to take lessons in cookery from the pale-face squaws of the Willamette. **1899** Cushman *Hist. Indians* 464 The young warrior resolved in the coming future to make the pale-face maiden his wife. **1949** *Sat. Ev. Post* 2 July 29/1 Those [Indians] who had been exposed to college did sleep in the cabins on paleface beds.

Hence * **pale-faced,** *a.,* white, white-skinned.

1832 Durfee *Works* (1849) 68 Confounding pale-face friends with warring foes. **1881** *Rep. Indian Affairs* 113 They compare favorably with their pale-faced brothers. **1902** *Atlantic Mo.* Dec. 803/2 The pale-faced missionary and the hoodooed aborigine are both God's creatures.

2. Whisky. *Slang. Obs.* Cf. * **bald face 2.**

1846 *Spirit of Times* (N.Y.) 11 July 234/3 Provided well with bread, meat, and a bottle of pale-face, which were stowed away in a pair of leather saddle bags.

3. (*cap.*) (See quots.)

1868 *Nashville* (Tenn.) *Union & Dispatch* 8 March, Another mysterious order, it would seem, has been organized in this city—the Pale Faces. **1872** *42d Cong. H. Rep.* 2 Sess. Rep. 22, I. 6 Some called them Pale Faces, some called them Ku-Klux. I believe they went under two names. **1939** Horn *Invisible Empire* 348 By December, 1869, the Pale Faces had grown so strong that they had a paper of their own in Nashville known as 'The Pale Face.'

* **palm,** *n.*

1. The hemlock. *Obs.*

1625 Morrell *N. Eng.* 15 All ore that Maine the Vernant trees abound. . . . The Hasel, Palme, and hundred more are there. **1791** Long *Voyages* 44 [Near Lake Superior] the palm, birch, ash, spruce, and cedar grow large.

b. = **Joshua palm.**

1879 Williams *Pacific Tourist* 289/1 It is palm-like, and often called a 'palm' and 'cactus,' but *it is neither.*

2. In combs.: (1) **Palm Beach,** [f. *Palm Beach,* Fla.], a light fabric of cotton and wool or mohair bearing the

trade-mark name *Palm Beach,* also attrib.; (2) **garden,** a place decorated with potted palms where meals and other refreshments are served; (3) **grill,** = prec.; (4) **leaf,** see as a main entry; (5) **warbler,** the American warbler, *Dendroica palmarum,* or the subspecies, *D. p. hypochrysea.*

(1) **1922** H. L. FOSTER *Adv. Trop. Tramp* 1, I had just applied for a job as stoker, but a Palm Beach suit, a Panama hat, and a cane did not seem to be convincing costume on the figure of an applicant for the position. **1949** *N.O. Times-Picayune Mag.* 3 April 11 Slacks for champions tailored of Palm Beach get the votes of golf's greats. — (2) **1900** GEORGE ADE *More Fables in Slang* 164 They dined at a Palm-Garden that had Padding under the Table-Cloth and a Hungarian Orchestra in the Corner. — (3) **1920** WILSON *Red Gap* 377 At this he looks around at the crowded tables in this palm grill.

(5) **1828** BONAPARTE *Ornithology* II. 12 The Palm Warbler, *Sylvia Palmarum,* . . . is found during winter in Florida . . . and in other parts of the territory wherever the orange-tree is cultivated. **1949** *Chi. Tribune* 14 Sep. 1/4 Bird students have identified more than a dozen varieties there this fall, including the rare golden winged, the black and white, the myrtle, magnolia, redstart, palm, black throated green, Tennessee, and water thrush.

palomino ˌpælo'mino, *n.* [Sp. in unrecorded Amer. Sp. sense shown here. Cf. prec.] (See quot. 1932.) Also attrib.

1914 *Sunset* May 995/1 A Palomino stallion with arching neck and muscle-ridged barrel led the dozen brown and mottled mares of his seraglio up a silent hillside. **1932** BENTLEY *Sp. Terms* 176 Palomino. . . . A term commonly used in the Southwest and California to describe a horse of a silver yellow color. Such a horse often is given no other name but is known as the *palomino. Palominos* are favorites with Western riders and are supposed to be intelligent and enduring. **1939** ROLLINS *Gone Haywire* 128 He pointed to a small *palomina* (cream-colored) horse which was tethered in the foreground. **1949** *Esquire* March 29/1 They'll reserve a golden palomino horse for you— all yours for the length of your stay.

pandowdy pæn'daʊdɪ, *n.* [See note.] A dessert of apples prepared in various ways. Cf. **apple dowdy, apple pandowdy.**

Pandowdy is usu. a deep-dish apple pie, freq. one sweetened with molasses. The crust may be of pastry, biscuit dough, or cake dough. Sometimes it is steamed, sometimes baked. The name is also applied to brown betty. See *Ling. Atlas,* Map 292, for further discussion and for other names for pandowdy.

The origin of the term is obscure. *EDD* lists an obs. *pandoulde,* custard, from Somerset. Also cf. *EDD's dowl,* a verb meaning to knead or mix dough in a hurry, and *dowler,* a cake or a dumpling made in a hurry.

?**1805** *Pocumtuc Housewife* (1897) 25 (Ernst). **1830** S. SMITH *Life J. Downing* 101 You dont know how queer it looks to see . . . politics and pan-dowdy . . . jumbled up together. **1893** LELAND *Memoirs* I. 74 Pan-dowdy—a kind of coarse and broken up apple-pie. **1895**

COFFIN *Daughters of Revolution* 55 Pandowdy was a compote of apples, with several layers of pastry, made from rye meal, baked in a deep earthen dish and eaten with milk. **1947** BEROLZHEIMER *Regional Cookbook* 142 Both the Pandowdy and Cob Pie are served by cutting out squares of the biscuit, turning the squares upside down on the crust, adding butter, and covering with the apple mixture, then with thick unbeaten cream.

b. (See quot.) *Obs.*

[**1856** HALL *College Words* (ed. 2) 342 The band [Pandowdy, noise-making band of Bowdoin] corresponds to the *Calliathump* [*sic*] of Yale.]

* **panning,** *n.*

1. The action of washing auriferous dirt in a pan; an instance of this. Also with *out*. Cf. **gold panning.**

1839 *Amer. R.R. Jrnl.* VIII. 99 This operation is continued until all the sand is removed, and nothing but the gold left. It is called 'panning out.' **1848** DANA *Mineralogy* 317 The operation of hand washing is called in Virginia *panning*. **1876** *Grass Valley* (Calif.) *Union* 19 Sep. 3/3 Not a single panning has been made but shows plenty of gold. **1908** E. S. MEADE *Story of Gold* 39 A small amount of gold is still taken out by the simple process of panning.

attrib. **1850** KINGSLEY *Diary* 122 Stoped down to day and made a panning trough to pour quicksilver from the riffler into. **1880** INGHAM *Digging Gold* 54 The Panning Process, consists of a tin or sheet-iron pan [etc.]. **1882** *47th Congress* 1 Sess. H.R. Ex. Doc. No. 216, 568 F. A. Huntington of San Francisco, manufactures this rocking and panning amalgamator for saving fine gold and floured mercury.

2. Severe criticism. *Colloq.* Cf. * **pan,** *v.* 5.

1852 *Marysville* (Calif.) *Herald* 7 Aug. 1/5 We apprehend that the candidates will undergo a system of panning, tomming and sluicing too thorough to pass current, if they should prove light or worthless. **1949** *Time* 7 March 58/3 The campus paper even set itself to a brisk panning.

pantie 'pænti, *n.* [Dim. of * *pants*.] A pair of drawers or small trousers. Usu. **panties.**

1845 *Knickerb.* XXVI. 433 If your panties weren't sheeted home at the bottom, you'd out-jump a monkey. **1848** BURTON *Waggeries* 19, I hadn't on nothin' . . . only a blue cotting shirt and sail-cloth pantys. **1945** MACDONALD *Egg & I* 18 A little boy named Waldo wet his panties while we were standing in front of the class for reading. **1949** *Dly. Ardmoreite* (Ardmore, Okla.) 23 Feb. 2 A new low price on a good well-made pantie in this popular long wearing fabric.

transf. **1909** *Sat. Ev. Post* 24 April 15/3 New York and Pennsylvania would be inhabited by cow-persons in décolleté leather panties. **1949** *Ib.* 26 March 35/2 Large bottles in woven straw panties stood on the checked table top.

* **pap,** *n.* Political patronage; revenue from public office. Also in combs. See also **cider pap.**

1841 *Cong. Globe* App. 29 Jan. 300/2 The very new States are nursed from their chrysalis territorial condition into existence upon Federal pap from the Executive spoon. **1863** *Rio Abajo Press* 17 Feb. 2/2 Our good-for-nothing, Government pap-sucking goslings. **1894**

Voice 6 Sep., The Prohibition Party is the only party that is not controlled by public pap-seeking politicians and the debauching power of the saloon.

Parent-Teacher Association. A local organization for social and educational purposes, composed of teachers and parents of elementary and high-school pupils, and functioning in connection with a school.

1915 CHURCHILL (*title*), Parent-teacher Associations in the Rural and Village Schools of Oregon. **1916** *Ann. Amer. Acad.* Sep. 141 The Parent-Teacher Association has passed its experimental stage. **1946** *Chi. D. News* 20 Feb. 14/4 The Parent-Teacher Association is by all odds the organization best able to clean up the Chicago schools.

Often **P.-T.A.** Also attrib.

1925 *K.C. Star* 4 Feb. 11/1. **1945** *Suburban List* 8 Feb. 17/2 Founders Day was observed Monday evening at the local PTA meeting held at Union school. **1947** *Democrat* 6 Nov. 1/1 It is proposed to organize a County Council of the P.-T.A.

parfleche ˈpɑrflɛʃ, *n.* [f. Can. F. in same sense, app. f. F. *parer*, to parry, and *flèche*, arrow, from its use sometimes as a shield.] A hide, usu. of buffalo, that has been haired and dried; an article, as a robe, made of this. Also attrib.

1844 FRÉMONT *Exped.* 237 Some of us had the misfortune to wear moccasins with parfleche soles, so slippery that we could not keep our feet. **1882** R. I. DODGE *Our Wild Indians* 254 (*footnote*), Among almost all the Plains tribes, the thing made of it is also 'parfleche.' **1947** DEVOTO *Across Wide Mo.* 434 To the trapper 'parfleche' meant 'rawhide,' the stuff itself, not objects made of it.

Parfleche used by Plains Indians

b. A box or envelope of rawhide for storing dried meat and, occasionally, for carrying clothing and other things.

1910 HODGE *Amer. Indians* II. 203/1 Parfleche. . . . The ordinary skin box of the Plains and Rocky mtn. tribes, made of stiff-dressed rawhide from which the hair has been removed. It is usually of rectangular shape, varying from 2 by 3 ft in size for the largest boxes.

parka ˈpɑrkə, *n.* [Of Eskimo origin. Cf. Aleut. Esk. *parka*, outside garment made of skin.] A long shirt or jacket made originally of skins, now of wool, heavy drill, or the like, with a hood. Also transf.

1868 WHYMPER *Alaska* 144 The men had very naturally a strong desire to obtain skin clothing for winter use. . . . This was generally known as the 'Parka mania' (from *parka*, Russian for skin shirt or coat). **1902** LONDON *Daughter of Snows* 168 He . . . took in the priests and choir-boys in their surplices,—*parkas*, he called 'em. **1948** *Sierra Club Bul*. March 6 Hands disappeared into gloves and parkas blossomed out in full force.

b. A pointed hood.

1944 *Sears Cat*. (ed. 189) 231 Pixie Parka—Furry looking brushed fabric (55% rayon, 45% cotton) with cunning peaked top, chin ties. One size, fits 3 to 6 years. **1949** *This Week Mag*. 17 Sep. 15/4 When it spoke through layers of fur and parka I recognized the voice.

parlay 'pɑrlɪ, *v*. Also **parlee**. [F. f. It. *paroli*.] *tr*. To wager (money) on a horse race, cards, etc., and to continue to wager the original stake plus the winnings on subsequent races, hands, etc. Also absol. and transf.

1828 *Richmond Whig* 20 Feb. 1/3 (Th.). As well, sir, might you ask the adventurer at Faro, who paralees (I believe, sir, that most of us are old enough to remember the term, although I trust that with the practice it is quite obsolete), who paralees I say [etc.]. **1892** QUINN *Fools of Fortune* 194 Almost all [faro] bankers will allow a player to 'parlee,' as the percentage is largely in favor of the bank. **1895** *How to Make Money on Small Cap*. 63 Were he, however, to what is termed 'parley' his money—that is to say, if . . . he put his $5 on his choice on the first race, and, if the horse should win, put all the winnings and his original $5 on the next race, and so on. **1949** *Sat. Ev. Post* 25 June 32 H. J. Heinz . . . parlayed a pickle into one of the most valuable family heirlooms in America.

partridgeberry 'pɑrtrɪdʒ‚bɛrɪ, *n*.

1. A trailing plant, *Mitchella repens*, common throughout the eastern U.S. Also the wintergreen, *Gaultheria procumbens*. Cf. **checkerberry**.

1714 *Phil. Trans*. XXIX. 63 Another Plant, . . . Partridge-berries, excellent in curing the Dropsy; a Decoction of the Leaves being drank several days as a Tea. **1784** CUTLER in *Mem. Amer. Acad*. I. 410 *Mitchella*. . . . Partridgeberry. The stems trailing. . . . Blossoms white. In thick woods and swamps. **1814** BIGELOW *Florula Bostoniensis* 101 *Gaultheria procumbens*. Partridge berry. . . . A plant universally known for its pleasant aromatic flavour. **1948** *Green Bay* (Wis.) *Press-Gazette* 30 June 2/2 We hoped to find twinflowers and partridge-berries to record in moving pictures.

2. The fruit of such a plant.

1810 in WILSON *Ornithology* III. 109 A favourite article of their diet is the heath-hen plum, or partridge-berry. **1905** WIGGIN *Rose* 112 Partridge-berries glowed red under their glossy leaves.

3. partridgeberry vine, the partridgeberry, *Mitchella repens*.

1868 BEECHER *Norwood* 91 Here the little queen took on airs, and sent her Ethiop . . . [for] some partridge-berry vines from the edge of the wood. **1910** EATON *Barn Doors & Byways* 245 We have come

upon ferns still flaunting through the snow and partridge berry vines scratched up into sight by some hungry bird.

passenger pigeon. A wild pigeon, *Ectopistes migratorius*, once common throughout North America, but now extinct.

1802 BINGLEY *Anim. Biog.* (1813) II. 225 Passenger Pigeons visit, in enormous flocks, the different parts of North America. **1857** *Rep. Comm. Patents 1856: Agric.* 148 The passenger pigeon, or wild pigeon, ... is very rarely met with except in communities of millions or billions. **1917** *Birds of Amer.* II. 44 The last passenger pigeon. She died in the Cincinnati Zoological Park in 1914. **1947** *Democrat* 27 March 4/3 The passenger pigeons, once here by the millions, are gone never to return.

patented land. Any land the title to which exists through a patent. *Obs.*

1711 BYRD *Secret Diary* (1941) 400, I ordered that every week two troops should range at the head of the river and if they found any Indians on patented land to take away their guns. **1774** *Pa. Gazette* 14 Dec. Supp. 2/3 To be sold ... One tract of patented land. ... **1796** *Ann. 4th Congress* 2 Sess. 2691 The revenues of this State [N.C.] are derived from taxes on ... all patented lands, except lots in towns [etc.].

* **pattern,** *n.* A quantity of material sufficient for a garment.

1695 SEWALL *Letter-Book* I. 152 Send my wife a Pattern of Silk for a gown. **1782** *Essex Inst. Coll.* XXXVIII. 54 A Patton for two Pare of overalls and two Westcoats—and a patton of White Ribed Stuf for a Wescoat & Briches. **1806** LEWIS in *L. & Clark Exped.* IV. (1905) 186 One beaver skin, or two of those of the Raccoon or tiger catt forms the pattern of the robe. **1876** in GUILD *Old Times* (1878) 403 Six yards was a big pattern for a gown when I was courting.

Paul Bunyan. In folklore, a celebrated mythical lumberjack who performed amazing feats of lumbering in the Northwest. Also **Paul Bunyan-like.**

1924 *Frontier* Nov. 18 The winter that Paul Bunyan had the contract to log off Eastern Montana was an exceptionally bad one. **1946** R. PEATTIE *Pac. Coast Ranges* 279 Gone, too, is the bunkhouse where loggers made their own entertainment, gambling for tobacco or telling Paul Bunyan yarns. **1947** *So. Sierran* Nov. 3/2 There are pine, fir and spruce forests, wildflower meadows (with Paul Bunyan-like larkspurs seven feet high!) oak woods, ... colorful cliffs, and deserts.

Paxton boys. [f. *Paxton*, Pa.] A band of Pennsylvania frontiersmen, headed by Lazarus Shaw, which became a political force after the massacre of the Conestoga Indians in 1763. Now *hist.*

1764 (*title*), The Paxton Boys. **1811** GRAYDON *Memoirs* (1846) 46 The unpunished ... massacre of certain Indians at Lancaster ... had so encouraged their murderers, who called themselves Paxton boys, that they threatened to perpetrate the like enormity upon a number of other Indians. **1831** WITHERS *Chron. Border Warfare* 79

The Paxton boys twice assembled in the neighborhood of the city, for the purpose of assaulting the barracks and murdering the Indians. **1833** WATSON *Hist. Tales of Phila.* 66 [The Indians] were . . . massacred . . . at mid-day by an armed band of ruffians, calling themselves the 'Paxtang boys.' **1949** *Pa. Mag. Hist.* Jan. 76.

pay gravel. Gravel containing a mineral, as gold, in such quantities as to justify mining.

1871 HARTE *Poems* 30, O, why did papa strike pay gravel In drifting on Poverty Flat? **1899** ―― *Mr. Jack Hamlin's Mediation* 99 Hardly a cartload of 'pay-gravel' ever arrived safely at its destination. **1948** JOHNSTON *Gold Rush* 32/1 A prospector climbed the brush fence, sank a shaft through the soil, and struck 'pay gravel.'

fig. **1884** MATTHEWS & BUNNER *In Partnership* 63 It appears the young woman had refused to have anything to do with him for a long period; but he seems to have struck pay gravel about two days before my arrival.

peach orchard.

1. An orchard of peach trees.

1676 GLOVER *Va.* in *Phil. Trans.* XI. 628 Here are likewise great *Peach-Orchards*, which bear such an infinite quantity of Peaches, that at some Plantations they beat down to the Hoggs fourty bushels in a year. **1758** *Va. State P.* I. 257 We overtook them at a peach orchard. **1849** *31st Congress* 1 Sess. Sen. Ex. Doc. No. 64, 103, I noticed the ordinary Navajo hut, (a conical lodge,) and close by it a peach orchard. **1906** LYNDE *Quickening* 19 It was goin' to . . . run right smack thoo' you-uns' peach orchard. **1949** *Democrat* 27 May 1/6 A hillside with suitable soil is the ideal place for a peach orchard.

2. peach orchard coal, a superior variety or grade of coal. *Obs.*

1830 *Providence D. Advt.* 14 Aug. 1/5 The *North American Coal Company*, are daily receiving large quantities of their superior *Peach Orchard* or *Centerville Coal.* **1874** COLLINS *Kentucky* I. 210 The Peach Orchard coal, the cannel coal, and the block coal . . . are among the finest in the world.

peanut butter. A paste or spread made from ground roasted peanuts to which seasoning, etc., has been added.

1903 *Harper's Bazaar* Oct. 981 Two [sandwiches] of wholewheat bread with peanut butter. **1935** MITCHELL *America* 211 If you are stupid enough to ask for sandwiches with your afternoon tea you will get a tremendous triangle with a wobbly upper deck . . . or even peanut butter. **1948** *Mazama* Dec. 6/1 Peanut butter flew thick, and cries for more bread and 'Where's another knife?' were heard.

b. Also (1) **peanut butter cooky,** (2) **peanut butter sandwich.**

(1) **1941** FARMER *Boston Cook Book* 674 Peanut Butter Cookies. ½ cup butter, ½ cup peanut butter [etc.]. **1941** *Dly. Oklahoman* (Okla. City) 7 Oct., Peanut butter cookies are rich and crunchy, delicious to eat and fun to make. — (2) **1927** HALLIBURTON *Glorious Adventure* 331 We never even got to our stuffed eggs and peanut-butter sandwiches. **1948** *Savings News* Jan. 11/1 I'll be eating a peanut butter sandwich for lunch every day this month.

* **peekaboo**, *n. attrib.* Designating garments of eyelet-embroidered material, or of other decorative effect involving small holes. Also transf.

1906 *Springfield W. Republican* 10 May 13 In San Francisco there is no winter suit and summer suit. The same medium-weight garment is worn the year round and the peek-a-boo waist is unknown. **1908** YESLAH *Tenderfoot S. Calif.* 14 All I had in that blamed trunk of mine was some peek-a-boo underwear and drop stitched stockings. **1948** *Ariz. Republic* (Phoenix) 1 March 14/2 Mela Armstrong modeled . . . the black cocktail dress featuring a peek-a-boo bodice and open back of the bodice.

Penitentes ˌpɛnɪˈtɛntɪz, *n. pl.* [Sp.] Members of a religious order of flagellants among certain Spanish-American natives of New Mexico and southern Colorado who practice self-castigation, esp. during Holy Week.

1838 TEXIAN *Mexico vs. Texas* 79 [The procession] is rendered shocking and repulsive by *penitentes*, who walk at the head of the *cortege*, naked from the waist upwards, and bare-legged. **1900** *Independent* 26 April 1008/1 This inversion of sensation is the basis for the extraordinary mania which shows itself . . . among those sects who call themselves Flagellantes and Penitentes. **1949** *Nat. Geog. Mag.* Dec. 824/1 Penitentes are a living counterpart of the santos.
attrib. **1881** CHASE *Editor's Run in N. Mex.* 114 At the lower end of the habitations [in the Cimarron] we found the Penitente church, a mud house.

peppermint candy. Candy, usu. in small striped sticks, flavored with peppermint.

1843 *Knickerb.* XXII. 46 Her red lips contrast with her white skin as do red stripes with the white in Stewart's peppermint candy. **1916** WILSON *Somewhere* 355 He's having a high old time with a sack of peppermint candy and a copy of the *Scientific American*. **1949** *Sat. Ev. Post* 19 March 157/2 It's to buy things with: striped peppermint candy, and fire crackers and balloons.

Also **peppermint-candy-striped dress**, **peppermint stick**.

1948 *Sat. Ev. Post* 23 Oct. 29/1 She paused before a shop window of flaxen-pigtailed mannikins, wearing peppermint-candy-striped dresses. **1949** *Lisle* (Ill.) *Eagle* 31 March 3/3 From the mathematical standpoint, he says he has tried all the angles—from roulette to hunting the red centered piece of candy that would entitle him to a free peppermint stick.

* **pepperpot**, *n.* (See quot. 1890.) Cf. **Philadelphia pepperpot.**

*a*1790 MACPHERSON *Memoirs* 205 'And what have you got for dinner, Quashiba (said my uncle)?'—'Me have got peppa pot, Massa.' **1832** *Boston Transcript* 23 Jan. 1/1 O! then farewell, hot pepperpot, Since I, alas! may taste thee not. **1890** *Cent.* 4384/2 *Pepper-pot.* . . . Tripe shredded and stewed, to the liquor of which small balls of dough are added, together with a high seasoning of pepper. (Pennsylvania.) **1946** HIBBEN *Cookery* 35 Lay in Dumplings for Pepperpot and cook as directed.

Pequot 'pikwɒt, *n.* [App. a contraction of *paquata-nog*, destroyers.] An Indian of a warlike Algonquian tribe at one time holding sway over most of southern New England; also *pl.*, the tribe.

1631 *N.H. Hist. Soc. Coll.* IV. 226 Wee heare their numbers exceed any but the Pecoates and the Narragansets. **1637** *Conn. Rec.* I. 10 To parle w[i]th the bay aboute o[u]r settinge downe in the Pequoitt Countrey. **1714** SEWALL *Diary* III. 12 Commissioners met to give Govr. Saltonstall an Opportunity to vindicate himself relating to the Pequot and Mohegan Indians. **1848** HOLMES *Poetical Works* (1895) 30/1 He heard the Pequot's ringing whoop. **1945** WEBSTER *Town Meeting Country* 11 The Pequots were probably the bravest and most ferocious of all the New England tribes.

b. The language of the Pequot Indians.

1848 LOWELL *Biglow P.* I Ser. p. xiii, Colds in the head . . . Transformed the helpless Hebrew thrice a week To guttural Pequot or re-sounding Greek.

Perkinism 'pɜkɪnˌɪzəm, *n.* (See 1st quot. and cf. **tractor 1.**) Also **Perkinist.** Now *hist.*

1842 O. W. HOLMES *Medical Essays* (1892) IX. 15 Metallic Tractors, invented by one Dr. Perkins, an American, and formerly enjoying great repute for the cure of various diseases. . . . For more than thirty years this great discovery . . . has been sleeping undisturbed in the grave of oblivion. . . . Very few know anything of its history, and hardly even the title which in its palmy days it bore of Perkinism. *Ib.* 19 One Dr. Fuller, . . . himself a Perkinist, thus expressed his opinion. **1949** GORDON *Æsculapius Comes to Colonies* 228 A patent was obtained; doctors and philosophers greatly approved, and professors of three American universities said they believed in Perkinism.

petrolatum ˌpɛtrə'letəm, *n.* [**petrol*+*atum*, as in *acetatum, sulphatum.*] A tasteless, odorless pharmaceutical substance consisting essentially of the refined residue resulting from the distillation of petroleum.

1887 *Scientific Amer.* 7 May 293/3 With a silk handkerchief apply petrolatum evenly. **1890** WEBSTER 1073/2 *Petrolatum* is the official name for the purified product. *Cosmoline* and *vaseline* are commercial names for substances essentially the same, but differing slightly in appearance and consistency or fusibility. **1944** *Sears Cat.* (ed. 189) 877A/4 Plain Petrolatum. . . . Clear, odorless. Use on cows' teats to resist chapping.

Ph.D. [Abbrev. of L. *Philosophiae Doctor.*]
According to the evidence at present available, *Ph.D.* was known in British academic circles before it made its appearance in Amer. use, but app. British holders of the degree secured it from Germany. It was prob. from Germany that the practice of granting such degrees came to be an established procedure in American education, and the use of *Ph.D.* appears to have a German rather than a British background. The term as first used here, just as in England, had reference to Germany, but later to American institutions. Yale was app. the first American school to grant such a degree. See ***doctor,** *n.* **4,** and

the first chapter in Ernest V. Hollis, *Toward Improving Ph.D. Programs*.

1. A Doctor of Philosophy.

1869 *Atlantic Mo.* Jan. 89/2 His cousin, the Ph.D. from Göttingen, cannot help despising a people who do not grow loud and red over Aryans and Turanians. **1911** HARRISON *Queed* 218 There were only three Ph.D.'s among them. **1949** *Sat. Ev. Post* 2 April 26/3 They are all addressed as 'Mister,' apparently on the theory that a Ph.D. is a dead scholar.

2. The academic degree granting a person the status of a Doctor of Philosophy. Also transf.

1903 W. JAMES *Memories & Studies* 331 A Ph.D. in philosophy would prove little . . . as to one's ability to teach literature. **1925** *Scribner's Mag.* Oct. 2/2 He awards Barnum a Ph.D. in humbugology. **1949** *N.O. Times-Picayune Mag.* 20 Nov. 2/3 He is now working on his Ph.D.

Phi Beta Kappa. An honorary Greek-letter society, orig. a secret society founded at William and Mary College in 1776, having chapters in many American colleges.

1776 in *Wm. & Mary Coll. Quart.* IV. 214 A list of Members who have been Initiated into the S. P. *alias* ΦBK Society. **1831** *N.Y. Mirror* 3 Sep. 71/2 Chancellor Kent will deliver an oration before the Phi Beta Kappa Society, at the annual commencement of Yale College. **1912** NICHOLSON *Hoosier Chron.* 278 Sylvia . . . just walked through everything and would be chosen for the Phi Beta Kappa. **1949** *Newsweek* 5 Dec. 54/2 Selby won a Phi Beta Kappa key at Northwestern.

picayune ˌpɪkɪˈjun, *n.* and *a.* [F. *picaillon*.]

1. *n. S.* A coin of small value, as a five-cent piece or bit. Often as a symbol of something of very slight value. Cf. **fip(p)enny bit,** * **fourpence.**

1805 *Amer. Pioneer* II. 228 One can't buy any thing [at New Orleans] for less than a six cent piece, called a *picayune*. **1835** AUDUBON *Ornith. Biog.* III. 160 Not a 'pecayon' would they receive in return. **1948** *Reader's Digest* Dec. 148/1 Don't care a picayune how you waste that boy's time, do you?

transf. **1903** *Scribner's Mag.* April 508 The very fathers of our country were a pack of jealous picayunes, who bickered while the army starved.

2. *a.* = next.

1813 *Cramer's Alman. 1814* (Pittsburgh) 60 The incessant hum of the blabbering (coloured) market women, seated on the ground, . . . by the side of their picaroon (six cent) piles of vegetables. **1892** *Chi. Tribune* 7 April 4/1 The picayune Democratic majority in the House has taken $300,000 off the appropriations for Indian education. **1947** PEATTIE *Sierra Nevada* 39 It is a mountain-top wilderness little affected by the picayune busy-ness of human activities.

* **picnic,** *n.* A small piece of shoulder bacon cut somewhat in the shape of a ham. In full **picnic ham.**

1910 L. D. HALL *Market Classes of Meat*, Picnics or Calas (formerly termed California hams) are cut 2-½ ribs wide. . . . They . . . are sold almost entirely as sweet-pickled, smoked and boiled meats. **1944** *Chi. D. News* 13 July 21/2 A picnic ham may be boned, rolled and tied before roasting to make carving easier. **1949** *New Harmony* (Ind.) *Times* 5 Aug. 6/2 Smoked Picnics, 3 to 5 lb. average lb. 45 c.

pictured rocks. Rocks upon which quaint designs have been produced by weathering, usu. applied as a proper name to sandstone cliffs about 300 feet high in Alger County, Michigan, along the shore of Lake Superior.

1820 in NUTE *Lk. Superior* (1944) 73 It is only 12 miles from LaGrand Sable to the Pictured Rocks, one of natures works of grandeur and sublimity. . . . They are called the pictured rocks from the circumstance of their being variegated with the veins of different kinds of ore running through, and colouring the surface. **1857** CHANDLESS *Visit Salt Lake* 121 Travelling . . . over steep ridges, beside pictured rocks (on the right hand, never on the left). **1902** HULBERT *Forest Neighbors* 158 From Lake Huron to the Pictured Rocks. **1946** NEWTON *P. Bunyan* 180 They came out on the shore of Lake Superior, on the high plateau of the Pictured Rocks.

pieplant ˈpaɪˌplænt, *n*.

1. The garden rhubarb, *Rheum rhaponticum*, the tender esculent leafstalks of which are used in making pies.

1847 WEBSTER 825/2 *Pie-plant, Pie-rhubarb*, the garden rhubarb, used as a substitute for apples in making pies. **1930** FERBER *Cimarron* 44 Mother Bridget was in the Mission vegetable garden, superintending the cutting of great rosy stalks of late pie plant. **1949** *Hobbies* Sep. 114/2 With all their new-found modus-operendis they do not hold a candle to Grandma's pie plant.

transf. and *attrib.* **1870** MARK TWAIN *Screamers* 58 (R.), You are the loser by this rupture, not me, Pie-plant. **1884** NYE *Baled Hay* 207 Afterward pulverize and spread over the pie plant bed. **1908** DAVENPORT *Butte Beneath X-Ray* 17 The conversation finally drifted upon the subject of Butte's favorite dessert—cream pie, mince pie, pieplant pie.

2. A preparation of rhubarb, esp. one that can be spread like butter. In full **pieplant butter.**

1855 *Amer. Inst. N.Y. Trans.* 401 The following list of the prices of the preserved fruits. . . . Pie-plant, in square glass bottles, holding over 2 lbs. weight, [cost] $5.00 [per dozen bottles]. **1885** *Buckeye Cookery* 251 *Pie-plant Butter* . . . is a nice preserve, and children should be encouraged to eat it during the winter.

pigeon roost. An extensive area, sometimes as much as 100,000 acres, where passenger pigeons roosted and nested. Also as a place-name. *Obs.*

[**1634** WOOD *N. Eng. Prospect* (1898) 30 Many of them [i.e., passenger pigeons] build amongst the Pine-trees, thirty miles to the North-

east of our plantations; joyning nest to nest, and tree to tree by their nests, so that the Sunne never sees the ground in that place, from whence the Indians fetch whole loades of them.] **1808** Pike *Sources Miss.* 104 At some islands about 10 miles above Salt river . . . there were pigeon roosts, and in about fifteen minutes my men had knocked on the head and brought on board 298. **1899** Cushman *Hist. Indians* 387, I first heard a sermon by Mr. Bell at the Pigeon roost about twelve years ago. **1923** *Arrow Points* 5 Jan. 18 This locality might have been a pigeon roost in the days when hordes of wild pigeons passed this way en route to feeding grounds south of here.

transf. **1861** Stowe in *Independent* 21 Nov. 1/1 A whole pigeon-roost of yet undreamed-of fancies.

piki ˈpikɪ, *n.* [Hopi Indian.] (See the later quots.) Cf. **hoecake.**

1859 T. H. Haskell *MS Diary* in Brigham Young Univ. Lib. 16 Nov., He spent the day trading for peak, dried peaches, &c. *Ib.* 27 Nov., We feasted with old Thur on peak, hominy, beef soup, sweet mush and red pepper. **1893** Donaldson *Moqui Pueblo Indians* 72 Piki, or corn bread of many colors, is plentiful, and the evidences of a feast are on every hand. **1922** Curtis *N. Amer. Indian* 43 The commonest food derived from corn is *piki*, a paper-thin bread baked on a smoothly polished stone moderately heated by a fire beneath it. **1948** *Southwestern Jrnl. Anthrop.* Winter 376 Corn, flour, breadstuffs— especially piki (wafer bread)—melons, chili, and dried fruit were most sought after.

attrib. **1936** Stephen *Hopi Jrnl.* II. 1197 The men quarry out and roughly dress the *piki* stone to required dimensions, but the women finish and smooth it by rubbing. **1938** *Southwestern Lore* June 7 Tortillas and tamales, of Mexican provenience, are festal foods among the Tarahumara, while pici-bread is not known. **1949** *Desert Mag.* June 24/3 Piki bread is made by the Hopi Indians.

Pilgrim Father.

1. One of those who founded the Plymouth colony in 1620. Usu. *pl.*

"This restriction, however, of the terms Pilgrims and Pilgrim Fathers exclusively to the Plymouth settlers is recognized at the present time only in the Old Colony itself" (1914 A. Matthews in *Mass. Col. Soc. Pub.* XVII. 362).

1799 *Columbian Centinel* 25 Dec. 3 Hail Pilgrim Fathers of our race, With grateful hearts your toils we trace. **1876** Crofutt *Transcontinental Tourist* 157 What American man, woman or child, does not feel a heart-throb of exultation as they think of the glorious achievements of Progress since the landing of the Pilgrim Fathers, on stanch old Plymouth Rock! **1908** O. Henry *Options* 89 One brother . . . came in the *Mayflower* and became a Pilgrim Father. **1949** *Oak Leaves* (Oak Park, Ill.) 24 Nov. 3/1 The Pilgrim Fathers were mindful of that same great truth.

2. In transf. and allusive uses (see quots.).

1824 Hodgson *Lett. from N. Amer.* II. 11, I am surprised by the proofs which are presented to me of the learning of the 'Pilgrim Fathers,' as they call the first settlers. **1842** in *Mass. Col. Soc. Pub.* XVII. 371 Thus much for the public career of this great Indian bene-

factor to the Pilgrim Fathers of Connecticut. **1880** CABLE *Grandissimes* 27 The pilgrim fathers of the Mississippi Delta with Gallic recklessness were taking wives. **1906** in *Mass. Col. Soc. Pub.* XVII. 372 The early efforts of Josh Billings and Artemus Ward, the Pilgrim Fathers of Phonetics, . . . were not taken seriously.

pinder 'pɪndə, *n.* Also **pindar.** *S.* [Kongo *mpinda*, in same sense.] The peanut or goober. Also attrib.

[**1707** SLOANE *Jamaica* I. p. lxxiii, I was assured that the Negroes feed on Pindals or Indian Earth-nuts, a sort of pea or bean producing its pods under ground.] **1848** *Rep. Comm. Patents 1847* 190 The ground pea of the south, or . . . the gouber or pindar pea, is highly recommended in the Tallahassee Floridian. **1907** *Suburban Life* May 263/2 Other common names are pindar, goober, ground-nut, ground-pea and monkey-nut. **1948** MATHEWS *Southernisms* 111 In colloquial speech we call peanuts *pinders, goobers,* and *ground peas.*

pine knot.

1. A knot of pine wood. Also attrib.

1670 *Plymouth Rec.* 119 There shalbe noe pine knot picked. **1808** BARKER *Indian Princess* III. i, [She] lit me with her pine-knot torch to bedward. **1830** *Mass. Spy* 26 May (Th.), At night parties collect by pine-knot fire, and play cards for the earnings of the day. **1945** BOTKIN *My Burden* 62 When the boys would start to the quarters from the field, they would get a turn of lider [lightwood] knots. I 'specks you knows 'em as pine knots.

2. In transf. and fig. senses, usu. having reference to the toughness, hardness, etc., of such knots.

1812 PAULDING *J. Bull & Bro. Jonathan* 5 Jonathan, though as hard as a pine-knot . . . could bear it no longer. **1856** MACLEOD *F. Wood* 48 The human pine-knot John C. Calhoun. **1876** WARNER *Gold of Chickaree* 360 Relaxation! . . . When you know as well as I do, that you are a pine knot for endurance. **1885** *Cent. Mag.* March 680 Have you got anything like a good mellow iron wedge, or a fried pine-knot in your pocket? **1904** STRATTON-PORTER *Freckles* 95 He was as tough as a pine-knot and as agile as a panther.

pin oak. Any one of various American oaks, orig. *Quercus palustris* of the eastern states, but later used, often locally, of oaks somewhat resembling this or confused with it.

1813 MUHLENBERG *Cat. Plants* 87 Swamp or Pin Oak. **1847** COYNER *Lost Trappers* 23 The young trapper was relieved by the arrival of two of the company, one of whom climbed a pin-oak tree, that stood in the edge of the brush. **1949** *Mo. Bot. Garden Bul.* April 92 Pin oak (*Quercus palustris*) . . . [is] a very good tree for city planting.

Pious Fund. *Hist.* A large sum of money collected by the Jesuits in the seventeenth century and later for missionary work among the Indians of the Californias. Also attrib.

After 1848 Mexico refused to pay any part of the income from this fund to beneficiaries in upper California. The case was brought by

the U.S. before the Hague Tribunal which in 1902 decided it in favor of the U.S., this being the first case to be tried before the Permanent Court of Arbitration of the Hague.

1847 SIMPSON *Overland Journey* 169 In addition to their annual stipends of four hundred dollars each, the monks possessed in Mexico a considerable property in lands and money, composed of donations and bequests, and known as the 'Pious Fund of California.' **1902** *Out West* Oct. 466 John T. Doyle [is] dean of the California bar, hero of the historic 'Pious Fund' litigation now arbitrating between the United States and Mexico. **1929** WILBUR *Juan María de Salvatierra* 31 This is the famous Pious Fund, still extant, which was founded to support Jesuit missions [in California].

piskun ˈpɪskʌn, *n.* Also **pishkun**. [See note.] A pound or corral, often making use of a **V** shaped barrier terminating at the top of a cliff, into which Indians, esp. the Blackfeet, lured or drove buffalo to slaughter them. Cf. **surround,** *n.*

This term is said to be from the language of the Blackfeet Indians and to mean "deep-blood-kettle." Mathew Cocking (see quot. 1949 below), a Hudson's Bay Company trader, described such a pound he saw in Saskatchewan in 1772. See John C. Ewers in *Jrnl. Wash. Academy of Sciences* XXXIX. (1949) 355–60.

[**1805** LEWIS in *L. & Clark Exped.* (1904–5) II. i. 94 Today we passed on the Star'd side the remains of a vast many mangled carcasses of Buffalow which had been driven over a precipice 120 feet by the Indians & perished.] **1892** *Scribner's Mag.* Sep. 281 In the later days of the *piskŭn,* the man who brought the buffalo went to them on horseback, riding a white horse. **1943** HOWARD *Montana* 23 Often buffalo were driven over cliffs, and the 'buffalo runs' or 'pishkuns' under which Montanans still find rich hoards of arrowheads and other Indian implements. **1949** *Jrnl. Wash. Acad. Sci.* XXXIX. 360/1 We can date the last bison drive of the Blackfoot at about the year 1872. This was a full century after Mathew Cocking's first description of the use of the piskun by Indians of the northwestern plains.

pitahaya ˌpitəˈhajə, *n. S.W.* [Amer. Sp. in same sense.] Any one of various cacti, esp. the giant cactus, or its edible fruit.

1759 tr. VENEGAS *Nat. Hist. of Calif.* I. 43 And as the pitahaya is very juicy, it is chiefly found in a dry soil. **1847** *23rd Congress* 1 Sess. Sen. Ex. Doc. No. 7, 158 It [a cactus plant] is called in California pitahaya, but it appears that the Mexicans call by that name all large columnar cacti, the fruit of which is edible. **1901** VAN DYKE *Desert* 146 In summer, . . . the cholla, the ocatillo, the pitahaya come along with pink or gold or red or blue flowers. **1942** CASTETTER & BELL *Pima & Papago Agric.* 59 Pitajaya or pitaya here refers to the fruit of either or both *Carnegiea gigantea* and *Lemaireocereus Thurberi;* sahuaro invariably refers to *Carnegiea gigantea.*

attrib. **1925** BRYAN *Papago Country* 46 The pitahaya dulce or organ-pipe cactus (*Cereus thurberi*) consists of a clump of columns, each 3 to 4 inches in diameter and 3 to 8 feet high.

pixilated ˈpɪksəˌletɪd, *a.* [See note.] Led astray as if by

pixies, confused, bewildered. Also intoxicated. *Colloq.*

The *OED* has *Pixy-led*, *Pixy-leading*, and the *EDD* has *Pixy-led*, *-laid*, *-laden*, meaning led astray or bewildered. The form here, first reported from Marblehead, Mass., may, therefore, not have originated in this country.

1848 in *Amer. Sp.* XVI. (1941) 79/2 You'll never find on any trip That he'll be pix-e-lated. **1886** BYNNER *Agnes Surriage* 56 'We'll be pixilated 'n' driven on to th' rocks an ye don't wake up.' **1891** *Amer. Folk-Lore* IV. 159 Words from the dialect of Marblehead. . . . Pixielated. Confused, bewildered. **1938** *Our Army* Feb. 9/1 To make a bad matter pixilated, Glumbo is on guard and can't ride herd on the exfarmer. **1949** *Chi. Tribune* 22 Oct. 10/3 Our American variant 'pixilated,' with the generalized meaning of eccentric, confused, crazy or intoxicated, has long been familiar in Essex county, Mass.

placer gold. Gold occurring in more or less coarse grains or flakes and obtainable by washing the sand, gravel, etc., in which it is found. Also in combs.

1848 *Californian* (S.F.) 29 May 1/2 Those who find it necessary to have the correct standard can be accommodated by the subscriber, who will take Placera Gold in payment. **1872** *Harper's Mag.* Dec. 22 This is 'sluicing,' a variety of placer gold digging or gulch mining. **1902** McKEE *Land of Nome* 1 The rich placer-gold deposits were discovered by a small party of prospectors in the late autumn of 1898. **1948** A. K. WILLIAMS *Gold Rush Days* 51 Quartz mining had come into prominence in California and it was taking the people by storm, just the same as the placer gold had a few years before.

Plan of Union. An agreement adopted by the American Presbyterian and Congregational churches early in the nineteenth century, permitting their members in the Middle West to unite. Also **Plan of Unionism.** *Obs.*

1808 in SWEET *Religion on Amer. Frontier* II. 469 It was voted unanimously, that this body acceed to the plan of union with the Presbyterian church in the United States. **1856** W. S. KENNEDY *Plan of Union* 144 The last half century has . . . developed a new type or modification of ecclesiasticism . . . which we may call co-operative Presbyterianism, Plan of Unionism, or Presbyterialized Congregationalism. *Ib.* 152 The missionary, with the Plan of Union in his hand and the love of God in his heart.

✳ **platter**, *n.* **1.** = ✳ **bowl**, *n.* **1.** *Obs.* Cf. **la platte. 2.**

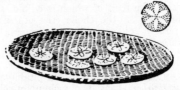

Articles used by Indians in platter, la platte, bowl, or pugasaing

twirl the platter, = *spin the plate,* see *break, *v.* 12. b. (2).

(1) 1778 [see *bowl, *n.* 1]. 1833 CATLIN *Indians* I. 88 Groups of Indians are engaged in games of the 'moccasin' or the 'platter.' — (2) 1868 *Ballou's Mag.* Dec. 518/1 'Blindman's Buff,' 'Copenhagen,' 'Twirl the Platter,' all claim attention, and old and young continue in the scene of noisy enjoyment.

pocosin pə'kosn̩, *n.* Also **pocoson, pocosen, poquoson,** etc. ["The name is from Renape *pákwesen,* a verbal adjective meaning 'it (the land) is in a slightly watered condition' " (Hodge).] An area of low ground or swamp, miry in summer, and covered with shallow water in winter. Cf. **black, blind pocosin.**

See *Amer. Anthropologist* Jan. 1899, ns. I. 162–70, and *Reader's Digest* Feb. 1934, 6 ff., for discussions of this word and the places designated by it. See also R. M. Harper in *Bul. Torrey Bot. Club* 41 (1914) 209–20.

1643 in *Amer. Sp.* XV. 296 Nigh unto a reedy Swampe or Poquoson. 1713 *N.C. Col. Rec.* II. 69 John Burkett took up and surveyed . . . a certaine parcell of Land . . . beginning at a Gume by ye side of a great Swamp . . . [running] to ye pocosson [etc.]. 1893 *Outing* Jan. 271/1 The drive is one of the large pocosons so common in the lower pine country. 1944 *Sat. Ev. Post* 9 Sep. 13/1 The Indians called these queer round swamps pocosins. The white hunters and woodsmen, differentiating them sharply from the more typical swamps of irregular shape along the creeks and rivers, called them bays, . . . perhaps because the bay tree or shrub abounds in them.

attrib. 1691 in *Amer. Sp.* XV. 296/2 To a small red oake by ye side of ye said pocoson swamp. 1720 *Ib.,* So Down ye Pocoson branch to William Evans his line. 1811 *Mass. Spy* 23 Jan. (Th.), A considerable extent of that kind of flat, wet pine lands, which is known in N. Carolina by the name of poccooson lands. 1883 SMITH *Geol. Survey Ala.* 522 East of Troy, . . . in the 'Pocoson' region, the valleys, which have the luxuriant growth and appearance of swamps, are surrounded on three sides by ridges of snow-white sand. 1949 *Highway Traveler* Feb. 33/1 First blossoms appear in January in the coastal pocosin country with flowering of camellias and azaleas at Orton and Airlie Gardens.

b. In proper names.

1631 in *Amer. Sp.* XV. 296/2 A river called the Pocoson river. 1763 WASHINGTON *Writings* I. 194 From Suffolk to Pocoson Swamp is reckoned about 6 miles. 1836 W. B. ROGERS *Rep. Geol. Reconnoissance Va.* 23 At Pocosin, a flat swampy country, which is often inundated by the tides, this deposite is uniformly met with by digging a few feet below the surface.

Poinsettia pɔɪn'sɛtɪə, *n.* [Joel R. *Poinsett* (1779–1851), Amer. minister to Mexico where he discovered the plant in 1828.] A genus of tropical, alternate-leaved plants of the spurge family; (not *cap.*) a plant of this genus.

1836 in *New Philos. Jrnl.* (Edinburgh) April 412 Poinsettia pulcherrima. . . . By whom this truly splendid plant was communicated

to Willdenow's Herbarium, I am not informed, but it was again discovered by Mr. Poinsette in Mexico, and sent by him to Charleston in 1828, and afterward to Mr. Buist of Philadelphia. **1868** GRAY *Field Botany* 294 *Euphorbia pulcherrima*, or Poinsettia, of Mexico. **1948** *Home Helper* (Oak Park, Ill.) Dec. 18/3 The poinsettia is a sensitive plant which will drop its leaves when conditions of soil moisture or temperature displease it.

poison ivy. Any one of several vinelike sumacs, poisonous to the touch, having trifoliate leaves, greenish flowers, and white berries. Also attrib.

[**1624** J. SMITH *Virginia* V. 170 The poysoned weed is much in shape like our English Ivy.] **1784** CUTLER *Amer. Acad. Mem.* I. 422 *Hedera.* . . . Poison Ivy. . . . It produces the same kind of inflammations and eruptions . . . as the poison wood tree. **1869** *Rep. Comm. Agric. 1868* 204 The Poison ivy (*Rhus toxicodendron*) is sometimes mistaken for the Virginia creeper, but they can be easily distinguished by the leaf. **1949** *Sat. Ev. Post* 5 March 89/3 Her brother, who was with her, had climbed a tree covered with a poison-ivy vine.

b. (See quot.)

1897 SUDWORTH *Arborescent Flora* 315 *Kalmia latifolia.* . . . Poison Ivy (Tenn , Ala.).

pokeroot 'pok,rut, *n.* The American hellebore, or the pokeweed. Also the root of either of these plants.

1687 CLAYTON *Va.* in *Phil. Trans.* XLI. 150 Poake-root, i.e. *Solanum bacciferum*, a strong Purge, and by most deemed Poison. **1784** CUTLER in *Amer. Acad. Mem.* I. 492 *Veratrum.* . . . White Helebore. Poke-root. Indian Poke. Common wet meadows and swamps. June. **1891** *Memphis Appeal-Avalanche* 23 April 8/1 For Rheumatism, Malaria and Syphilis, P.P.P. (Prickly Ash, Poke Root and Potassium) is the best known remedy. **1905** VALENTINE *H. Sandwith* 65, I'm sure I'd never trust him after he nearly poisoned you all, mistaking poke-root for burdock.

b. A medicinal preparation from the root of such a plant.

1883 HARRIS *Nights* (1911) 84 Yer I is, gwin on eighty year, en I aint tuck none er dat ar docter truck yit, ceppin' it's dish yer flas' er poke-root w'at ole Miss Favers fix up fer de stiffness in my j'ints.

* **police,** *v. tr.* To clean up (a camp). Also * **policing,** *n.* Cf. * **police,** *n.* 2.

1862 TROLLOPE *N. Amer.* II. vii. 192 Of the camps . . . 44 per cent. [were] fairly clean and well policed. **1865** *Atlantic Mo.* March 289/1 The sickening, pestilential odor of a huge camp without sewerage or system of policing, made the air a horror. **1908** *Pacific Mo.* Feb. 209/2 Their camps are like those of an army, their tents in rough rows and well policed. **1946** NEWTON *P. Bunyan* 62 Napoleon policed the camp area in a gentlemanly way.

polio 'pol:o, *n.* Poliomyelitis. Also one who has had this disease. *Colloq.*

1931 *Survey* 15 Oct. 93/1 (*heading*), Panic and Polio. *Ib.* 15 Nov. 202/3 The Puzzle of Polio. **1934** *Ladies' Home Jrnl.* Feb. 107/1

Health departments of cities and states poured out money to buy serum from recovered polios to try to cure already sick babies by shooting that serum into their spines. **1949** *New Harmony* (Ind.) *Times* 5 Aug. 1/5 The Town of New Harmony was doused very efficiently last Thursday afternoon by a spraying plane . . . as a precautionary measure against polio.

attrib. **1934** *Ladies' Home Jrnl.* Feb. 10/1 How did the polio fighter— a hulking hundred and seventy-five pounds, and six feet in his socks— come to catch it? **1949** *News-Herald* (Marshfield, Wis.) 19 July 9/3 The polio scare is believed to be the reason [attendance has fallen off].

Pollyanna ˌpɑlɪˈænə, *n.* A highly optimistic, good-humored girl, so called in allusion to the heroine of stories by Mrs. John Lyman Porter (1868–1920). Also transf. and attrib.

1921 *Collier's* 11 June 11/1, I should not like to hold stock in a company with Pollyanna as president. **1929** *Variety* 10 April 23/2 He wrings the jury's heart and makes a dribbling Pollyanna out of a hard-boiled New York judge. **1948** *Chi. Tribune* 8 Aug. (Comics) 8 Jack is such a sap that he's taken in by all of Jato's phony, goody-goody, Pollyanna act.

Also **Pollyannaish,** *a.*

1923 *Grey Towers* 277, I wrote a paper for English 198 and the reader put on the outside, 'All right but Polly-Annaish.' **1948** *Time* 6 Dec. 90/2 Mildly Saroyanesque throughout and a trifle Pollyannaish at the end, in its best scenes *The Silver Whistle* is genuinely funny.

pony express.

1. A rapid postal and express system employing relays of ponies, esp. the system operated 1860–62 from St. Joseph, Mo., to Sacramento, Calif. Now *hist.*

1847 *N.Y. Wkly. Tribune* 18 Dec. 4/5 By our Pony Express from the South, we have intelligence from New Orleans to the afternoon of the 2d. **1849** in ADAMS *Pioneer Hist.* (1923) 154 Accordingly we established a private 'pony express' on our own hook between Mason and Jackson. **1860** *S.F. National* 19 March 2/3 Pony Express. . . . The Central Overland Pony Express Co. will start their Letter Express from San Francisco to New York and intermediate points, on Tuesday, the 3rd day of April next. **1948** *Democrat* 8 January 6/2 The Pony Express . . . first charged $5 for each letter.

2. Attrib. with **line, rider, route, service, stable.**

1869 J. R. BROWNE *Adv. Apache Country* 481 In May, 1862, William Talcott, an employe in the Pony Express service, went to look for his ponies in the nearest ranges of mountains. **1880** *Scribner's Mo.* July 456/1 Both offices established pony-express lines to the principal camps in the mountains. **1890** LANGFORD *Vigilante Days* (1912) 29 Tracy & Co., of Lewiston, had a pony express route from that town to Salmon River. **1893** MAJORS *70 Years on Frontier* 180 'Pony Bob' was employed by Wells, Fargo & Co., as a pony express rider, in the prosecution of their transportation business. **1948** *Chi. D. News* 26 Aug. 4/1 St. Joseph, Mo. . . . The original Pony Express stable was put up for sale for $442.32 but no one bid on it.

poppycock ˈpɑpɪˌkak, *n.* [Du. *pappekak,* lit. "soft

dung."] Nonsense, foolish talk, bosh. Also attrib. *Colloq.*

1865 BROWNE *A. Ward; His Travels* 35 You won't be able to find such another pack of poppycock gabblers as the present Congress of the United States. **1902** PIDGIN *Q. A. Sawyer* 152 'Oh, that was all poppycock,' said Hiram. 'He said that just to get even with you, when you were telling about your grandfathers and grandmothers.' **1949** *Newsweek* 21 Nov. 93/1 The story verges on sheer poppycock.

Populism 'pɑpjə‚lɪzəm, *n.* The principles and policy of the Populist party. Now *hist.*

1893 *Forum* Oct. 244 The doctrinal basis of Populism is socialism. **1910** *Sat. Ev. Post* 3 Sep. 26/3 The insurgency of 1910 is merely a passing recrudescence of the populism of 1892. **1949** *Miss. Valley Hist. Rev.* March 585 As an enthusiast for Populism . . . he helped to contribute to the victory of the People's party in Colorado.

* **porterhouse,** *n.*

1. Short for next.

1854 *Harper's Mag.* Jan. 269/2 Will you have it rare or well-done? Shall it be a porter-house? **1913** LONDON *Valley of Moon* 410 Good things all the way up from juicy porterhouse and the kind of coffee Mrs. Hall makes.

2. porterhouse steak, a choice beefsteak cut from the loin next to the sirloin, allegedly so called because this kind of steak was made popular about 1814 by Martin Morrison, a N.Y. porterhouse keeper. Cf. **family, ward porterhouse.**

1841 MATHEWS *Writings* 206/2, I guess I'll take a small porterhouse steak without the bone. **1948** *Time* 21 June 26/3 In New York City last week the average for porterhouse steak was $1.03 a pound.

* **portfolio,** *n.* A position in the cabinet of the President of the U.S. — **1884** BLAINE *20 Years of Congress* I. 40 Robert J. Walker . . . [was] already indicated for the portfolio of the Treasury in the new administration. **1925** BRYAN *Memoirs* 408 Secretary Bryan . . . resigned his portfolio rather than sign the second note to Germany.

Port Orford cedar. [*Port Orford*, Oregon.] A large and valuable evergreen tree, *Chamaecyparis lawsoniana,* found in western North America. Also **Port Orford cypress.**

1873 MURPHY *Ore. Business Directory* 98 The Port Orford cypress (*cupressis lawsoniana*), grows luxuriantly west of the Coast Range, along the shores of the Pacific. **1884** SARGENT *Rep. Forests* 8 The change from the northern to southern forest is marked by the . . . Port Orford Cedar (*Chamæcyparis Lawsonia*). **1946** *Mazama* Dec. 69/1 Port Orford cedar on the other hand is probably doing the best of the conifers.

b. The wood of this tree.

1948 *Chi. Purchasor* March 23/2 Port Orford cedar is a white, or very pale, yellow wood, with a rather sour, cedar-like odor.

post note. A promissory note payable to order at a specified future date, as distinguished from a note payable to bearer on demand. Now *hist.*

Issued by banks and other financial institutions before the Civil War as a circulating medium and especially "resorted to by many banks during the great commercial revulsions in 1836–7" (B. '48).

1791 JEFFERSON in *Harper's Mag.* LXX. 534/2 Rec'd. from bank a post note . . . for 116 2/3 D. **1852** GOUGE *Fiscal Hist. Texas* 32 Nearly a page of the Journal [is] devoted to a report and resolution of the Committee of Finance on a branch post-note of the United States Bank. **1912** DREISER *Financier* 20 Steemberger . . . used to come to the elder Cowperwood's bank . . . with . . . post-notes of the United States Bank in denominations of one thousand, five thousand, and ten thousand dollars.

Powhatan ˌpauəˈtæn, *n.* [See quot. 1927 in **2**. below.]

1. *collect* or *pl.* (See quot. 1910.) In full **Powhatan Indians.**

1800 JEFFERSON *Notes* 96 Of these the *Powhatans*, the *Mannahoacs*, and *Monacans*, were the most powerful. **1881** MORGAN *Houses Amer. Aborigines* 34 The Long House was not peculiar to the Iroquois, but used by many other tribes, as the Powhattan Indians of Virginia, the Nyacks of Long Island, and other tribes. **1910** HODGE *Amer. Indians* II. 302/2 Powhatan. The tribe which gave name to the Powhatan confederacy. Its territory was in what is now Henrico co., Va., and the tribe numbered about 150 in 1608.

attrib. **1800** JEFFERSON *Notes* 99 The older ones among them preserve their language in a small degree, which are the last vestiges on earth, as far as we know of the Powhatan language. **1946** *Nat. Geog. Mag.* Jan. 54/1 The Powhatan confederacy of Tidewater Virginia consisted of Algonquian-speaking tribes.

b. Powhatan pipe, ?a tobacco pipe thought to be of the type used by the Powhatan Indians. *Obs.*

1866 COOKE *Surry* 61 On the table lay pipes of every form, . . . and the plain but excellent Powhatan pipe of Virginia. **1869** TOURGEE *Toinette* (1881) 221 Geoffrey . . . was fairly settled to a smoke with one of the old man's genuine 'Powhatan' pipes.

2. (See quot.)

1927 READ *La. Place-Names* 55 *Powhatan* is derived from Algonquian *pow'waw* or *po'wah*, 'priest,' 'sorcerer,' or 'medicine-man,' and *-atan*, 'Hill,' 'mountain.' Compare the etymology of *powwow*. *Powhatan* signifies the 'hill of the medicine-man.' It was on a hill, then, that Powhatan, who was himself the chief sorcerer or medicine-man, conducted his mysterious rites. [**1947** *Reader's Digest* April 92/2 The Powhatan was temporizing until he could form a confederacy to sweep the palefaces into the sea.]

*** practitioner,** *n.* In Christian Science, an authorized or recognized healer.

1883 EDDY in *Christian Science Jrnl.* I. 3 The most of our practitioners have plenty to do and many more are needed. **1915** DREISER *Genius* 710 Angela had somehow concluded . . . that Christian Science, as demonstrated by its practitioners, might help her through this crisis, though she had no real faith in it. **1946** *Christian Science Jrnl.* LXIV. (Dec.) 616 We called on a practitioner to learn what this Science was.

prairie lily. A plant of the lily family growing on the prairies. Also applied to non-liliaceous plants (see quots.).

1907 Lyons *Plant Names* 520 Mentzelia laevicaulis ... Golden Prairie-lily. **1918** Visher *So. Dakota* 82 Abundant Monocotyledons, other than the grasses, are wild onion and prairie lilies. **1947** *Iowa Acad. Sci. Proc.* LIV. 29 Phlox, pasque flower, ... spiderwort, prairie lilies, prairie smoke, and paint brush, may yet be seen in fragmentary grassland patches.

prep prɛp, *n.* [Abbrev. of * *prep*aratory.]

1. A student in a preparatory school. Also attrib.

1890 *Cent.* 4695/1 *Prep*, a student who is taking a preparatory course of study; especially, one who is preparing for college. (College slang, U.S.) **1947** *Sat. Ev. Post* 15 March 23/3 Unless you get written credits for two years of high school, I can't nominate you for the prep class. **1948** *Chi. D. News* 6 Dec. 23/4 (*caption*), 2 Preps Die In Oregon Bush Crash.

2. prep school, a preparatory school. Also attrib.

1895 Williams *Princeton Stories* 128 After awhile he found himself walking with the freshman way out toward the Prep. school. **1903** *Chi. Record-Herald* 7 June III. 1/1 A crowd of nearly 4,000 university, 'prep' school and grammar school rooters cheered from the bleachers. **1949** *Woodlawn Booster* (Chi.) 14 Sep. 1/5 In 1903 ... Hyde Park traveled to Brooklyn to meet the Brooklyn Poly for the Prep school championship of the country.

* **previous,** *a.* and *adv.*

1. Hastily, precipitously. *Too previous*, too hasty, premature. *Colloq.*

1883 Peck *Bad Boy* 85 When I saw Pa feeling under the bed for a bed slat I got upstairs pretty previous now. **1890** *Boston Jrnl.* 21 June 2/2 The grumbling in this matter has been too previous. **1900** Hale *Letters* 356 Carla Atkinson is coming here to lunch with me, ... but I'm too previous, and she won't be here for half an hour.

2. previous question, in a deliberative body, the question of whether the immediate pending question or questions shall be voted on at once with little or no further debate.

In the U.S. the previous question is now used as a device to limit debate and bring the immediate question to a vote. In England it is used to postpone action on the main question.

1739 *Boston Rec.* 220 A previous Question was putVoted in the Affirmative. **1840** *Boston Transcript* 19 March 2/3 The previous question was called for and sustained. **1896** *Internat. Typog. Union Proc.* 2/1 Upon the previous question being ordered, [they] were unanimously adopted by a rising vote.

* **primitive,** *a.*

1. primitive area, a large area in a national forest set aside for preserving the natural conditions which it exhibits.

1934 Webster. **1936** *Collier's* 9 May 84/2 When you go into a primi-

tive area you're on your own—just as much as Kit Carson or Jim Bridger or Lewis and Clark were a century or more ago. **1947** *So. Sierran* July 1/1 The boundaries of the San Gorgonio Primitive Area will remain practically undisturbed.

2. Primitive Baptist, a Hard-Shell or Old School Baptist. Also attrib.

1851 *Polly Peablossom* 143 Brethren Crump and Noel were both members of the Primitive Baptist Church. **1901** *Harper's Mag.* Dec. 99, I am ashamed of being a Primitive Baptist! **1948** *Dly. Ardmoreite* (Ardmore, Okla.) 15 July 14/1 The Washita Valley Primitive Baptist association will meet at the Primitive Baptist church here, July 22.

printing telegraph. (See quot. 1890.)

1847 *Rep. Comm. Patents 1846* 351, I therefore characterize my invention as the first recording or printing telegraph by means of electro-magnetism. **1860** PRESCOTT *Telegraph* 402 The printing telegraph . . . was proposed in September, 1837. **1890** *Cent.* 4733/3 *Printing-telegraph,* . . . any form of automatic self-recording telegraph, as the 'ticker' of a stock-reporting telegraph.

Pulitzer Prize. Any one of various annual prizes in arts and letters established by Joseph Pulitzer (1847–1911), an American (Hungarian born) author and publisher. Also attrib.

1918 *N.Y. Times* 3 June 9/7 The annual Pulitzer Prize of $1,000 for the best play written and produced by an American playwright in 1917 . . . [has] been awarded to Jesse Lynch Williams for his comedy, 'Why Marry?' **1921** *New Republic* 22 June 114/2 The University is not bound to distribute the Pulitzer Prizes according to any particular method of award. **1947** *Newsweek* 12 June 63/3 The Pulitzer Prize committee demonstrated its concern for things Russian in its journalistic awards for 1946.

Also **Pulitzer.**

1950 *Time* 23 Jan. 38/3 In 1941, Herblock drew the cartoon for N.E.A. that won him a Pulitzer.

pumpkin bread. Bread made of pumpkin and corn meal.

[**1704** S. KNIGHT *Journal* 47 But the Pumpkin and Indian mixt Bred had such an Aspect, and the Bare-legg'd Punch so awkerd or rather Awfull a sound, that we left both.] **1819** *Western Rev.* I. 185 Pumpkin bread and cakes are as much used in the interior of Kentucky, as pumpkin pies in New-England. **1909** *Pioneer Days Southwest* 252 We would stew our pumpkins till done and put it in meal and salt it . . . work it up into a dough making it into small thin cakes called pumpkin bread. **1944** DUNCAN *M. Graham,* She had to grind dried pumpkin to make flour for pumpkin bread because the cornmeal was out.

punky ˈpʌŋkɪ, *a.* [f. * **punk,** *n.*] Of wood: Partially decayed, resembling punk. Also fig.

1872 HUNTINGTON *Road-Master's Ass't* 117 A bridge may . . . have a small knot partially decayed, or 'punky,' as it is termed. **1904** *N.Y. Times* 5 May 8 Written by another man Mr. Austin would doubtless find these verses as amusing as the rest of us do, . . . would appreciate

their punky pretentiousness. **1926** RICKABY *Ballads* 63 Were you punky, were you hollow, You had been a lucky fellow.

Pyrex 'paɪrɛks, *n*. [A trade-mark name coined from * *pie* and * *-ex*.] Glass that is especially resistant to heat, chemicals, and electricity; utensils made of this. Also attrib.

1917 *Ladies' Home Jrnl*. May 92/1 All women today welcome enthusiastically Pyrex. **1921** *Ib*. Feb. 80/1 Pyrex does not chip, discolor, nor wear out. **1940** EILMANN *Medicolegal & Indust. Toxicology* 19 Transfer this distillate to a 500 c.c. Pyrex flask. **1949** *Highway Traveler* Feb. 14/2 The casting of the 200-inch pyrex mirror at Corning, N.Y., and its shipment to the West Coast . . . received national attention.

pyxie 'pɪksɪ, *n*. [f. genus name *Pyxi*danthera (in allusion to the lidlike opening of the anthers).] (See quot. 1882.) — **1882** *Harper's Mag*. June 65 The delicate pyxie (*Pyxidanthera barbulata*), a little prostrate trailing evergreen, forming dense tufts or masses, . . . is strictly a pine-barren plant, and its locality is confined to New Jersey and the Carolinas. **1892** *Amer. Folk-Lore* V. 100 *Pyxidanthera barbulata*, pyxie moss. N.J.

Q

qua-bird 'kwɑˌbɜd, *n*. [f. its cry.] (See quot. 1917.) Cf. * **quawk**.

1791 W. BARTRAM *Travels* (1793, ed. 3) 291 A[rdea] clamator, corpore subcæruleo; the quaw bird, or frogcatcher. **1834** NUTTALL *Water Birds* II. 56 About the middle of October, the Qua birds begin to retire from this part of Massachusetts, toward their southern winter quarters. **1917** *Birds of Amer*. I. 194 Black-crowned Night Heron. *Nycticorax nycticorax nævius*. . . . [Also called] American Night Heron; Qua-bird; Quawk.

* **quarantine**, *v. tr*. To isolate (a disease), to protect (a place) by restricting access to it. Also * **quarantined**.

1879 *Diseases of Swine* 163, I desired to make an effort to quarantine the disease and confine it to his herd. **1890** *Stock Grower & Farmer* 24 May 7/3 The state [of Neb.] is strictly quarantined against all cattle from Texas. **1950** *Calif. Citrograph* Jan. 99/1 Shipment of host fruit into other quarantined areas would be possible only on condition that they be subjected to treatment that would destroy 100% of the flies.

quarter post. *Surveying*. A post or marker set up at a corner of a quarter section of land. Also attrib.

1849 *31st Congress* 1 Sess. H.R. Ex. Doc. No. 5, 11. 508 After descend-

ing the precipice, the descent was gradual till we came to the quarter-post which is in a cedar swamp. **1881** *Mich. Gen. Statutes* I. 210 The surveyor as above employed shall sink into the earth at all section and quarter-post corners from the surface to a depth of at least three feet, a column of broken brick. **1947** *Mich. Hist.* June 186 I'll run compass lines across sections from quarter post to quarter post until I know that my compass work is all right.

quebrada ke'brada, *n. S.W.* [Sp. in same sense.] (See quot. 1890.) Cf. **barranca.**

*a*1861 WINTHROP *J. Brent* 211 We took breakneck leaps across dry quebradas in the clay. **1890** *Cent.* 4903/1 *Quebrada,* . . . a gorge; a ravine; a defile: a word occasionally used by writers in English on Mexican and South American physical geography, and by the Spanish Americans themselves, with about the same meaning as *barranca.* **1894** *Outing* Feb. 357/1, I knew a little tree that bridged a deep *quebrada.* **1949** *Américas* Sep. 17 The men wore rags and undoubtedly lived in one-room shanties in the quebradas along with their families of six or eight.

Quincy granite. Granite quarried in Quincy, Mass.

1835–7 HALIBURTON *Clockmaker* (1937) 150 (We.), I thought that are Quincy granite was so amazin strong all natur wouldn't break it. **1857** VAUX *Villas* 63 A range of stores, called Commercial Block . . . is now erected in Quincy granite on Commercial Wharf, Boston. **1882** McCABE *New York* 236 Quincy granite is extensively used.

* **quinine,** *n.* **1. quinine bush,** (see quot. 1909). **2.** * **quinine tree,** (see quots.).

(1) 1909 *Cent. Supp.* 1100/1 quinine-bush. . . . The bear-brush, *Garrya Fremontii:* so called because its leaves served pioneers in the place of quinine. **1934** *N. Mex. Agric. Exp. Station Press Bul.* 713, 1 This shrub has many common names, among them being chaparral, coffee-berry, fever bush, gray-leaf dogwood, and quinine bush. — **(2) 1897** SUDWORTH *Arborescent Flora* 267 *Ptelea trifoliata.* Hoptree. . . . [Also called] Quinine-tree (Mich.). **1931** CLUTE *Plants* 122 Among other plants reputed to be a cure for malaria were . . . the ague-bark or quinine tree (*Ptelea trifoliata*). The latter, however, is not the species from which true quinine is obtained.

quota 'kwota, *v. tr.* To impose in accordance with a quota. Also **quotaing,** *n. Obs.*

1784 E. GERRY in *N. Eng. Hist. & Gen. Reg.* XLIX. 431 Their places should be speedily supplied by Troops to be *required* & quotied on the several States by Congress. **1786** JEFFERSON *Writings* (1905) V. 367 A convention might be formed between Portugal, Naples and the United States, by which the burthen of the war might be quota-ed on them, according to their respective wealth. **1798** *Ib.* VII. (1896) 267 They shall be free hereafter to tax houses separately, as by an indirect tax. This is to avoid the quotaing of which they cannot bear the idea.

R

*** rabbit-foot.** Also *** rabbit's-foot.**

1. A clover, *Trifolium arvense*, having soft, furry flower heads. In full **rabbit-foot clover.**

1817–8 EATON *Botany* (1822) 491 Rabbit-foot, field clover. . . . Grows in dry pastures or barren fields. **1889** *Cent.* 1060/1 Other species, mostly weeds of little value, are the yellow or hop clover, . . . the stone, hare's-foot, or rabbit-foot clover [etc.].

2. The foot of a rabbit carried as a charm or good-luck token. Also *to work a rabbit's-foot on* (someone), to steal a march on, get the better of. *Colloq.*

1876 HEARN *Amer. Miscellany* (1924) I. 185 After the girl told that [ghost] story, Banjo Jim seldom passed along the Row at night without a rabbit's foot in the breast pocket of his woolen shirt. **1902** HARBEN *A. Daniel* 309 Pole worked the rabbit-foot on them back there. **1948** *Salt Lake Tribune* 17 Dec. 34/6 A dimestore rabbit's foot paid off with one of 1948's biggest football surprises and landed his team in the Delta bowl.

transf. **1922** *Sunset* Dec. 10/2 Presently the word went round that I was a 'rabbit's foot'—a bringer of good luck—and the gamblers began to give me money to place for them.

radar ˈredɑr, *n.* [See note.]

This term is derived from *r*adio *d*etecting *a*nd *r*anging. It arose in the U.S. Army to distinguish the American device from a similar locator developed by the British and called by them a *radiolocator*.

A device for ascertaining, by means of properly focused radio waves, the distance, altitude, and direction of motion of an object out of sight or hearing. Also attrib.

1941–2 *Gen. Marshall's Rep. to Sec'y of War*, Process of building up ground service forces and supplies (mechanics, ordnance and radio technicians, signal personnel, radar warning detachments [etc.]). **1943** *N.Y. Herald Tribune* 12 Dec. (Book Sect.) 6 Mr. Shenton defines pleasant nouns such as . . . recent entries like radar and photogrammetry. **1950** *L.A. Times* 3 Jan. 11. 1/2 The radar truck, trailer and power generator are stationed on the edge of the landing field.

*** ragged,** *a.* In combs.: (1) **ragged edge,** the verge, *colloq.;* (2) **island,** ?an island having an irregular shore line, *obs.*, cf. **ragged plain;** (3) **orchis,** (see quot. 1909); (4) **plain,** (see quot.), *obs.*

(1) **1878** BEADLE *Western Wilds* 91 He is constantly in trouble, and sometimes on the ragged edge of starvation. **1911** LINCOLN *Cap. Warren's Wards* 254 The Dunns are dangerously close to the ragged

edge. — (2) **1639** in *Amer. Sp.* XV. 381/1 Lying towards the head
of a bay behind the ragged islands. **1642** *Ib.*, Lying before the ragged
Islands commonly known by the name of the Long ponds. — (3)
1814 BIGELOW *Florula Bostoniensis* 206 *Orchis psycodes.* Ragged
Orchis. . . . This is our common species. **1909** *Cent. Supp.* 905/1
Ragged orchis, Blephariglottis lacera, of the eastern United States,
with greenish-yellow flowers, the lip deeply fringed or lacerate. —
(4) **1634** in *Pub. Col. Soc.* III. 186 Certain rivers stopping the fire from
coming to clear that place of the country, hath made it unuseful and
troublesome to travel through, insomuch, that it is called 'ragged
plain,' because it tears and rents the cloaths of them that pass.

rail fence.

1. A fence made of wooden rails, usu. constructed in
zigzag fashion, but sometimes straight with posts at the
joints.

Rail fences differ considerably in structure. See *L. A.* Map 117
for the different names and different types of such fences. See also
stake and rider(ed) fence, ten-rail fence.

1649 *Charlestown Land Rec.* 110, I doe sell . . . five Akers of planting
Land . . . [bounded] on the North by the ould raile fence. **1761** *Boston Selectmen* 161 Mr. Cushing is desired to repair the Rail Fence
round the Common. **1880** *Scribner's Mo.* Feb. 503/2 The pole fence
was laid after the same fashion of a rail fence, only the poles were
longer than rail-cuts. **1949** *Chi. D. News* 9 Aug. 6/2 Floyd and Joe find
themselves straddling a rail fence.

b. crooked rail fence, = worm fence.

1831 J. FOWLER *Tour New York* 79 The usual description of fences
are *worm*, or crooked rail fences. **1856** *Rep. Comm. Patents 1855: Agric.*
20 Formerly, cattle were kept here through the winter with very
little protection except a crooked rail fence.

c. rail and stake fence, a stake and ridered fence.

1869 *Rep. Comm. Agric. 1868* 258 This form of thorn fence is similar
to the old time 'herring-bone' rail and stake fence.

2. A fence of the post-and-rail type having a designated number of rails, as **five, four, six rail fence.**

[**1640** in SHURTLEFF *Log Cabin* (1939) 119 Fencing with 5 rails, substantiall posts, good railes, well wrought, sett vp and rammed, that
pigs, swine, goates and other cattel may be kept out.] **1669** *Groton Rec.* 28 We order that all the out side fences about all corn-feilds
orchards and gardens in towne shalbe a sufficient five Rail fence.
1829 *Yankee* April 120/2 Saw three bipeds in gowns jump over a 'four
rail fence' without touching—conjectured they had practised the
Italian gymnastics. **1945** *Chi. Tribune* 12 Aug. VII. 1/3 Then she . . .
climbs a six-rail fence, walks thru a watermelon patch, a cornfield,
and a patch of weeds, opens a stock gate, and is on the highway.

rail-splitter ʹrelˌsplɪtɚ, *n.* One who splits rails, often
in allusion to Abraham Lincoln and his supporters. Cf.
Illinois rail-splitter.

1860 *Cong. Globe* App. 19 June 462/2 They call him 'Uncle Abe,'
'Old Abe,' 'Honest Old Abe,' 'The old rail-splitter,' 'The flat-boatman,' &c. **1860** *Charleston* (S.C.) *Mercury* 20 Dec. 4/2 The latter was

to catch the 'free speech' portion of the community, and the former the 'sleekish' element of the railsplitters; and the game was well played. **1935** *Ada* (Ohio) *Herald* 1 Nov., But the day and generation of railsplitters is behind us. **1949** J. MONAGHAN *This is Ill.* 76 The Lincoln-Douglas Debates gave the Rail Splitter a national reputation.

b. *Rail-splitter of the West*, Abraham Lincoln, a nickname.

1860 *Charleston* (S.C.) *Mercury* 29 Nov. 1/3 That you will quail before the lank Rail-splitter of the West,—I *cannot believe it.*

∗ **raising**, *n.*

1. = next.

[**1672** in ROADS *Hist. Marblehead* (1880) 26 Paid for rum and charges about fish with wine at raising the Lentoo at the Meeting House . . . 2 s. 6 d.] **1758** in J. F. HAGEMAN *Hist. Princeton* (1879) I. 12 Princeton first named at the raising of the first house built there by James Leonard, A.D. 1724. **1877** *Harper's Mag.* May 821/2 Husking bees, quiltings, and raisings are yet the enthusiastic occasions of tremendous labor and equal fun. **1947** DOWNEY *Lusty Forefathers* 106 Most of the meeting-houses, houses, and barns in New England would never have gone up if it had not been for good folk gathering from all over the countryside for the raising.

attrib. **1779** E. PARKMAN *Diary* 162 In Northboro [I] was compelled to go into Deacon Paul Newton's to raising Supper. **1786** HILTZHEIMER *Diary* (1893) 7 April 83 Afterward went to a raising frolic at Robert Erwin's. **1790** *Ib.* 31 July 162 Was present at the raising dinner of the high house on the north side of Market Street, . . . belonging to Henry Seckel. **1929** SHELTON *Salt-box House* ix. 63 There was feasting, with . . . 'raising-cake' and other appropriate viands.

2. raising bee, a house-raising by friends and neighbors who assemble at the invitation of one of their number, and usu. enjoy a social evening at the close of their labors. *Obs.*

1833 SHIRREFF *Tour* (1835) 159 While at Brantford, we observed a raising bee, that is, raising the frame of a house by a collection of people. **1852** REGAN *Emigrant's Guide* 309 These 'raising bees,' as they are called, have the salutary effect of bringing the people together, for the cultivation of friendly feelings, and as large numbers turn out, the work is light to each. **1887** KIRKLAND *Zury* 13 When the 'raising bee' took place, the refreshments . . . had to be cooked by Selina.

rambunctious ræm'bʌŋkʃəs, *a.* [*EDD*, Vol. VI, attributes *rambunkshus* to Ireland. Irish emigrants may have brought it to this country.] Fierce, wild, uncontrolled, rampageous. *Slang.*

1830 *Boston Transcript* 1 Sep. 3/1 If they are 'rumbunctious' at the prospect, they will be 'riproarious' when they get a taste, for a 'copious acquaintance' with Vinegar. **1900** NICHOLSON *Hoosiers* 54 The word *rambunctious*, reported from New York State as expressing impudence and forwardness, cannot be peculiar to that region, for it is used in Indiana in identically the same sense. **1949** *Travel* Dec. 3/2

It is pleasant to find traces, however slight, of that rambunctious delight in grotesque exaggeration which has been a characteristic part of American humor since frontier days.

ranching 'rænt∫ɪŋ, *n. W.* Operating a ranch, esp. a cattle ranch, working on a ranch. Also attrib.

1863 in *Frontier & Midland* XVII. (1936) 288/1 A ranch is properly a grazing farm and the term 'ranching' sometimes means farming but is generally applied in this country [Idaho] to taking care of stock. It is not at all safe to allow cattle to run on account of the Indians. **1873** BEADLE *Undevel. West* 267 'Ranching' came next and all this industry is not lost. **1949** *Amer. Cattle Producer* April 4/2 We have had one of the worst winters . . . in all my ranching experience.

✳**range,** *v.*

1. *intr.* Of cattle: To forage on a range.

1746 *Georgia Col. Rec.* VI. 155 All Cattle belonging to Ebenezer that he found ranging with those of the Trust should be drove up together. **1885** *Cent. Mag.* April 841 The snow lies on them too deeply in winter for cattle to range, as in Montana, all the year through. **1930** *Denver Post* 22 June II. 9/3 Those cattle were branded with a beer mug brand and ranged around Freeze Out mountain.

2. *tr.* To allow (cattle) to graze over an area. Also fig.

1857 OLMSTED *Journey through Texas* 184 They ranged their cattle over as much of the adjoining prairie as they chose. **1909** WASON *Happy Hawkins* 197, I got nine hundred dollars I wish you'd range out with the rest o' my herd.

rathskeller 'rɑts͵kɛlɚ, *n.* [G., an eating and drinking place in a city hall, usu. in the cellar.] A beer saloon or a restaurant, usu. below street level.

1900 ADE *More Fables* 159 Mr. Byrd . . . happened to be in a Rathskeller not far away. **1903** *Current Lit.* April 495/2 The first rathskeller was established in New York in 1863 by Fred. Hollander **1928** *Amer. Mercury* Oct. 175/2 It's called the rathskeller. **1947** BEEBE *Mixed Train Dly.* 291 You go downstairs through the cocktail lounge and through the men's bar and through the rathskeller.

✳**rattler,** *n.*

1. A rattlesnake. *Colloq.*

1827 COOPER *Prairie* xxxiii, It would be no easy matter to judge of the temper of the rattler by considering the fashions of the moose. **1914** BOWER *Flying U Ranch* 132 Say, they hang together like bull snakes and rattlers, don't they? **1948** *Duncan* (Okla.) *D. Banner* 2 July 7/8 Those who can get up enough courage to bite into the fried rattler say it tastes like chicken.

2. A train, esp. a fast one (see also quot. 1945). *Slang.*

1900 FLYNT *Notes Itin. Policeman* 178 Hustle, Cigarette, there's our rattler. **1945** *Tracks* June 29/2 *Battle-wagon* for coal wagon, *rattler* for freight car.

rattlesnake root. Any one of various plants regarded as efficacious in cases of rattlesnake bite. Cf. **fern snakeroot, Seneca rattlesnake root.**

1682 Ash *Carolina* 11 They have three sorts of the Rattle-Snake Root which I have seen; the Comous or Hairy, the Smooth, the Nodous, or Knotted Root: All which are lactiferous, or yielding a Milkie Juice. **1792** Pope *Tour S. & W.* 97 Rattle-Snake Root, . . . from its strong aromatic Smell, the Rattle-Snake will never approach, and [it] is accordingly used by the Indians to banish that and other Serpents from their Lodgments. **1806** *Mass. Spy* 30 April (Th.), *Seneca,* or *rattle snake root:* . . . has been celebrated as a specific in the cure of croup. **1941** R. S. Walker *Lookout* 48 Among the wild plants once employed as antidotes for the bites of poisonous reptiles are . . . Samson snakeroot, . . . Virginia snakeroot, button snakeroot, and rattlesnake-root.

rayon ʼrean, *n.* and *a.* [f. *ray,* beam, light, +-*on.*] A glossy silklike textile thread or yarn, produced chemically from cellulose, or a fabric made of such thread. Also attrib.

1924 *Drapers' Rec.* 14 June 685/2 'Glos' having been killed by ridicule, the National Retail Dry Goods Association of America has made another effort to produce a suitable name for artificial silk. This time their choice has fallen on 'rayon.' **1931** *Chi. Tribune* 18 Jan. 11. 8/1 Rayon yarns were being bought steadily by knitters and weavers. **1947** *Democrat* 26 June 3/2 Summer cottons and rayons may be wonderfully freshened by using plain gelatin.

***Rebekah,** *n.* A member of the organization known as the Daughters of Rebekah. Also **Rebekah degree, lodge.** Cf. ***Daughters** (2).

1913 *Chi. Record-Herald* 16 March v. 6/5 The staff of Maple Leaf Rebekah Lodge, No. 369, will confer the Rebekah degree on a large class of candidates. **1930** *Randolph Enterprise* (Elkins, W.Va.) 16 Jan. 5/4 They sure have a fine bunch of Odd Fellows and Rebekahs down there. **1949** *Milwaukie* (Ore.) *Review* 28 July 6/3 Mrs. Wanda Million and Mrs. Esther Lineagar were initiated into the Milwaukie Rebekah lodge at last week's meeting in the city hall.

***reclamation,** *n.* In combs.: (1) **reclamation engineer,** an engineer engaged in reclaiming the arid or alkali lands in the West; (2) **plow,** (see quot.), *obs.;* (3) **Service,** a bureau in the Department of the Interior that has charge of improving desert lands in the West.

(1) 1919 Hough *Sagebrusher* 250 The camp of the reclamation engineers and construction men lay upon a bench or plateau. — **(2) 1883** Knight *Supp.* 745/2 *Reclamation Plow,* a plow for breaking new land. — **(3) 1906** *Out West* Feb. 84 The work of the Reclamation Service is greater than the mere watering of certain acres of land. **1947** Cleland *Calif. in Our Time* 172 The Reclamation Service next filed on four million miners' inches of the 'unappropriated' waters of the Colorado.

***red,** *n.*

1. *pl.* Red men, Indians. *Colloq.*

1804 C. B. Brown tr. Volney *View* 351 A body might have been

formed capable of defending itself both against whites and reds, the savage on the one hand, and the land jobber on the other. **1881** *Cimarron News & Press* 17 Feb. 2/2 It is high time that the reds receive some punishment on account of their various misdeeds. **1927** SIRINGO *Riata* 137 Then one of the reds pulled his gun and shot a deer dead.

2. = red cent. *Colloq.*

1849 *Alta California* (S.F.) 12 July 1/5 Silver is not Plenty on the Pharaoh and his host's Tables, and any body can sea it, and bet a red on any card he chuses. **1936** MCKENNA *Black Range* 267 Many who came into Frisco had not a dad-blasted red left to their name.

3. *In the red,* (*a*) (see quots.), (*b*) in debt. Also *out of the red,* out of debt. *Colloq.* or *slang.*

(*a*) **1838** GOSSE *Letters* 266 Deer-hunting has now commenced. . . . The animal is now said to be 'in the grey,' as in the summer he is 'in the red.' **1877** CATON *Antelope & Deer of Amer.* (1881) 149 Frontiersmen and hunters . . . say the deer is in the *red* or the *blue*, as it may be in the summer or the winter coat. (*b*) **1929** WITWER *Yes Man's Land* 248 The big Broadway picture cathedrals ain't where the producers get their epics out of the red. **1948** *Mazama* June 1/1 Rigid enforcement of economies in running expenses will lift the club's balance sheet out of the red where it now is.

red ear. An ear of a red variety of corn, traditionally prized at corn huskings as entitling its finder to kiss the girls present.

1714 S. SEWALL *Diary* 8 April II. (1879) 434 Jonas Aosoe, saith that he took up the Govr Dungan's Terms, brought a Red-Ear of Indian Corn to Mr. Thomas Mayhew to signify it. **1793** BARLOW *Hasty Pudding* III. 19 For each red ear a gen'ral kiss he gains. **1844** *Lowell Offering* IV. 63 The red ear was industriously sought, as its happy finder was allowed the privilege of saluting each fair girl in the room. **1948** *Chi. Tribune* 24 Oct. 36/3 The ultimate aim of the corn husking was the same as ever—the discovery of a red ear.

Hence **red-ear kiss.**

1828 *Yankee* Sep. 288/1 As for their delightful good old fashioned wheel-barrow kisses, I think, they are all of a piece with red-ear kisses, field-beds and bundling.

red stick.

1. One of the sticks, painted red, used about 1812 by the Indian chief Tecumseh (?1768–1813) as the magic symbol of his war party. Also transf. *Obs.*

1819 *Niles' Reg.* XVI. *Supp.* 102/2 [Tecumseh] carried with him a red stick, to which he attached certain mystical properties, and the acceptance of which was considered as the joining of his party; from hence the name red stick applied to all Indians hostile to the United States. **1854** *S. Lit. Messenger* XX. 400 The red sticks were lifted by the Catawbas against the Shawnese.

2. Orig. an Indian who accepted one of Tecumseh's red sticks and thus joined his war party; later any Indian warrior. Also attrib.

1817 *Niles' Reg.* XIII. 296/1 The number of hostile Indians, including the 'Red-Sticks' and Seminoles, [is estimated] at more than two thousand. **1845** SIMMS *Wigwam & Cabin* 1 Ser. 121 He had proved his skill and courage in several expeditions against the Chowannee red sticks. **1846** McKENNEY *Memoirs* I. 164 The sticks he [Tecumseh] distributed on that occasion being painted red, secured for those who agreed to co-operate with him, the title of 'Red-sticks.'

3. Attrib. with **class, dancing, party, tribe.**

1817 *State P.* (1819) XII. 339 From below where the Red Stick class reside. *Ib.*, I have heard . . . that the Red Stick party have commenced their Red Stick dancings again. **1817** *Niles' Reg.* XII. 336/1 Never one of them has been known to join the red stick party. **1938** MATSCHAT *Suwannee River* 40 His mother belonged to the Red Sticks Tribe, a branch of the Creek Indians.

* **referendum,** *n.* The practice or principle of submitting a legislative act to a vote of the people or members of an organization.

1870 *Mass. Statistics Labor Rep.* I. 358 We want the referendum. **1911** *Okla. Session Laws* 3 Legisl. 236 When a citizen, or citizens, desire to circulate a petition . . . invoking a referendum upon legislative enactments, such citizen or citizens shall [etc.]. **1948** *Chi. D. News* 18 Dec, 6/4 He got the measure submitted to a referendum and it won.

regal moth. A large, handsome moth, *Citheronia regalis*, the larva of which is known as the hickory horned devil *q.v.* Also **regal walnut moth.** See also **royal walnut moth, walnut moth.**

1854 EMMONS *Agric. N.Y.* V. 238 *Ceratocampa regalis*. . . . Regal Walnut-moth. . . . It feeds on the walnut. **1887** DENTON *Naturalist's Diary* (1949) 121, I have . . . caught eight sphinx moths, and many others, one like the regal walnut moth. **1912** *Country Life* 1 Aug. 38 The blue horned hickory devil which turns into the Regal moth.

* **registered,** *a.* In combs.: (1) **registered bond,** a bond issued with the name of the holder written on the bond and recorded in a register; (2) **debt,** a part of the national debt which, after the Assumption Act, was registered with the treasury but not funded by bonds; (3) **nurse,** a trained nurse who has passed a state board examination for registration in that state.

(1) **1861** *Statutes at Large* XII. 259 The Secretary of the Treasury . . . is authorized to issue coupon bonds, or registered bonds, or treasury notes. **1914** *Cyclo. Amer. Govt.* I. 142/2 The holder of a registered bond cannot suffer loss if the security be stolen. — (2) **1794** *Ann. 3d Congress* 26 A statement of the Domestic Debt of the United States . . . 2d. The Registered Debt. — (3) **1934** WEBSTER. **1949** *Reader's Digest* June 91/1 They passed with flying colors the examinations for registered nurse.

* **relocation,** *n.* The action or fact of locating again. Also attrib.

1873 *Ill. Dept. Agric. Trans.* X. 371 The court shall appoint three

viewers to examine and make the necessary re-location. **1901** WHITE *Claim Jumpers* (1916) 232 Under the terms of a relocation, we can use the old stakes and 'discovery.' **1948** *Sierra Club Bul.* Dec. 5/1 A general relocation of the road was thereupon planned, including a higher crossing of Yosemite Creek.

b. relocation center, a place to which, when the U.S. entered World War II, those on the West Coast who were born in Japan or were of Japanese descent were removed by the government in what was then felt to be the public interest.

1943 MENEFEE *Assignment* 68 Hearst reporters got anti-Japanese statements from Mayor Fletcher Bowron and other prominent figures in Los Angeles and played up the Dies Committee's 'exposures' of the relocation centers. **1949** Calif. Acad. Sci. *News Letter* April 3 After the indignity of wartime relocation centers, he was engaged in 1947 as preparator in paleontology at the California Institute of Technology.

Republican Pawnee. (See quot. 1907.)

1813 STUART *Narratives* 240 The Republican Panees generally bring out the same quantity and kind as their relations the Big village of the Platte. **1838** PARKER *Exploring Tour* 50 On the third, [we] passed the village of the Tapage and Republican Pawnee Indians. **1907** HODGE *Amer. Indians* I. 707 Kitkehahki. . . . One of the tribes of the Pawnee ɔonfederacy . . . sometimes called Republican Pawnee, as their villages were at one time on Republican r. **1946** FOREMAN *Last Trek* 182 This treaty was signed by representatives of the . . . Republican Pawnee.

restaurant rɛstərənt, *n.* [F. in same sense.] A public dining room; an establishment in which meals are sold to the public. Also attrib. Cf. **restaurat, restorator.**

[**1827** COOPER *Prairie* xix, Those delicious and unrivalled viands . . . are unequalled by anything that is served . . . at the most renowned of the Parisian *restaurants*.] **1836** *N.Y. Mirror* 30 July 39/3 The Boston place is called the Albion; and consists of chambers for repose, with a 'restaurant' for refection. **1873** *Newton Kansan* 20 Feb. 3/2 Mr. Critchfield . . . has taken possession of Col. Irving's old restaurant stand. **1950** *Chi. Tribune* 9 Jan. 25/1 My father wants me to take over his restaurant when he gets old.

R.F.D. Abbreviation of **rural free delivery.** Often attrib.

1916 H. L. WILSON *Somewhere in Red Gap* ix. 361 These here poor R.F.D. stage drivers had to do the extra hauling for nothing. **1946** WILSON *Fidelity* 198 The rural postoffice has practically disappeared because of the R.F.D. **1947** ROBINSON *Great Snow* 67 The R.F.D. mailman also delivered the *Times*, which he wanted for further news of the storm.

riata riˈætə, *n.* Also **reata.** *W.* [Sp. *reata*, in the Amer. Sp. sense shown here.] A rope, esp. one of leather or rawhide, a lariat. Cf. **hair, rawhide lariat.**

Rickettsia

1846 *Californian* (Monterey) 12 Sep. 1/1 A riata (rope) was made fast to the broken bone and the jaw dragged out. **1924** BECHDOLT *Tales* 103 They had failed to take into account . . . a skill with the reata. **1949** GANN *Tread of Longhorns* 37 These reatas were so popular that many men clung to them as late as the 1920's.

b. *To coil up one's riata, to die. Rare.*

1871 *Overland Mo.* March 285/2, I'm a-coilin' up my *riata*, Jim.

c. *Knights of the Riata,* cowboys. *Jocose.*

1889 *Oregonian* (Portland) 4 Oct. 5/1 The tournament . . . promises to develop some exciting contests between the visiting 'Cow Punchers' and the Oregon 'Knights of the Riatta.'

Rickettsia rɪ'kɛtsɪə, *n.* [f. H. T. *Ricketts* (1871–1910) Amer. pathologist.] A genus of bacteria-like organisms which cause certain diseases, as Rocky Mountain spotted fever; also (not *cap.*) an organism of this genus.

1921 *Jrnl. Amer. Med. Assoc.* 17 Dec. 1968/1 The same Rickettsia-like bodies were isolated from the blood, brain and kidneys of guinea-pigs suffering from the experimental disease induced by this Polish virus. **1948** *Hygeia* Jan. 19/1 The laboratory reported they had found rickettsia in the blood of one of the patients. **1949** *Time* 7 Nov. 75/1 Like Chloromycetin, it deals with many of the rickettsias.

Hence **rickettsial,** *a.*

1949 *Time* 14 March 99/1 Aureomycin has been successful against many rickettsial and virus-like diseases: Q-fever, rickettsial pox, parrot fever, typhus fever.

rincon rɪŋ'kon, *n. S.W.* [Sp. *rincón,* corner, nook of land.] A piece of land, esp. a small round valley or nook suitable for a house or village site. Also as a place-name.

1847 *Calif. Star* (S.F.) 20 March 4/2 All the ungranted tract . . . lying and situated between Fort Montgomery and the Rincon, and known as the water Lots, . . . will be surveyed and divided into convenient building Lots. **1888** *Outing* Nov. 129/2 Halting for lunch at the *rincon* (Spanish for inner corner) of the range, [we] eyed some of the finest scenery outside a modern theatre. **1932** *D.N.* VI. 232 Rincon. Originally meaning a piece of ground or part of one's property, the term is now used for a little round valley, pocket, or hole, generally one in which a man has his house and corrals. **1950** *L.A. Times* Midwinter 3 Jan. 23/1 We acquired a little cabin on the Rincon.

attrib. and *transf.* **1881** in *Amer. Sp.* XXIV. (1949) 266/1 On our right, in the 'rincon,' we find a large table groaning under liquors and confectionery free for all. **1884** in LINDLEY *Calif. of South* 205 The message from the Rincon Indians made my heart ache.

ritzy 'rɪtsɪ, *a.* Orig. **Ritzy.** [f. César *Ritz,* a Swiss (d. 1918), and the palatial hotels bearing his name which he built or assisted in building in Paris, London, N.Y., etc.] Smart, vulgarly ostentatious. *Slang.*

1924 *Collier's* 4 Oct. 41/1 Gentleman George dropped his Ritzy manner like it was a hot poker. **1948** *Chi. Tribune* 11 Jan. I. 21/1 In other countries women prefer the long, ritzy Parisian product because it's so pretty. **1949** *Ib.* 30 Sep. III. 6 That's the ritziest club in school!

Also **ritzily,** *adv.*

1928 *Amer. Sp.* III. 349 With one indifferent glance 'round, they whirl ritzily out to Beverly Hills.

roach rotʃ, *n.*[1] [A euphemism for * *cockroach.* See quot. 1837.] Any one of the various annoying or destructive insects usu. called cockroaches, as *Blattella germanica* and *Periplaneta americana.* Also attrib.

1837 B. D. WALSH tr. *Comedies Aristophanes* (1848) 89 (*footnote*), 'Cock-roaches' in the United States . . . are always called 'roaches' by the fair sex, for the sake of euphony. **1853** P. PAXTON *Yankee in Texas* 163 Texas, in fact, may be entomologically divided into . . . the ant country and the roach and flea country. **1950** *N.O. Times-Picayune Mag.* 15 Jan. 5/2 It's a lucky thing that the species of scorpion found in the South is not as deadly to humans as it is, say, to a roach.

* **roadster,** *n.*

1. A highwayman, a tramp, a wanderer.

1890 LANGFORD *Vigilante Days* (1912) 315 Henry Plummer was chief of the band; . . . Cyrus Skinner, fence, spy, and roadster. **1901** *Scribner's Mag.* April 427/1 [He] was already a confirmed roadster, with an inordinate love for tobacco, and a well-developed taste for drink. **1936** *Reader's Digest* Nov. 31, I myself went on the road at 17, and remained there till I was 20; I thus met hundreds of 'tourists,' [i.e., tramp printers] or 'roadsters,' as they called themselves.

2. A buggy or light carriage suited to travel on the road. Also an automobile, esp. an open, single-seated car with a place for baggage or a rumble seat in the back.

1892 *York Co. Hist. Rev.* 68 The former [repository and office] carries a fine line of . . . everything in light and heavy work from the most substantial farm truck to the lightest finished roadster. **1908** *Scientific Amer.* 8 Feb. 104 Cadillac. . . . Model G—Roadster, $2000. **1925** *Sat. Ev. Post* 4 July 51 Chevrolet for Economical Transportation. . . . Roadster, $525.

roasting ear. An ear of corn roasted or suitable for roasting.

1650 in ALVORD & BIDGOOD *Trans-Allegheny Region* (1912) 123 Some of the Inhabitants came, and brought us roasting eares. **1705** BEVERLEY *Virginia* III. 15 They delight much to feed on Roasting-ears; that is, the Indian Corn, gathered green and milky, . . . and roasted before the Fire, in the Ear. **1949** *World-Herald Mag.* (Omaha) 18 Sep. 2/1 A motorist came out of a cornfield with an armful of roasting ears.

attrib. **1812** MARSHALL *Kentucky* 128 [They] had exhausted all that kind of supply [i.e., corn] long before the succeeding crop was fit for use, even in the roasting-ear state. **1854** DAVIS *Farm Bk.* 43 Spread manure in the roasting ear patch. **1946** FOREMAN *Last Trek* 67 Later in June they promised to be ready at 'roasting-ear time'—after the middle of August.

rockahominy ˌrakəˈhamənɪ, *n.* [f. Algonquian, cf. Virginian *rokahamĕn,* meal from parched corn. **Hominy**

is from the same source.] Indian corn parched and pounded into a fine powder; hominy. Now *hist.*

1674 in JILLSON *Dark & Bl. Ground* 18 [They] gave him Rokahamony for his journey. **1738** BYRD *Dividing Line* (1901) 144 Rockahominy . . . is parcht Indian Corn reduc'd to powder. **1913** *Outing* Jan. 448/1, I am too sybaritic to relish John Muir's diet of dried and pulverized bread crumbs or Horace Kephart's famous rockahominy. **1942** in *Amer. Sp.* XIX. 71 'An he'd look for other powerful, simple food,' Mr. Travis goes on, 'such as *rockahominy*, or *pinole* or *coalflour.* Under whatever name, it's corn, parched in clean ashes until it bursts, then sifted and blown clean and pounded to a coarse flour.'

rockaway ˈrɑkəˌwe, *n.* [*Rockaway*, N.J. (f. Lenape *regawihäki*, sandy land), where such carriages were made.]

1. A four-wheeled pleasure carriage, orig. one having a standing canopy top and removable side curtains. Also attrib. Now *hist.* Cf. **Germantown 1.**

Rockaway or Germantown (sense 1)

1845 NOAH *Gleanings* 174, I keep a little Rockaway wagon. **1846** LOWELL *Letters* I. 121 Dr. Liddon Pennock has driven by me in his rockaway. **1895** *Outing* XXVII. 5/2 The rockaway shaft had been broken only the day before. **1944** CLARK *Pills* 292 Everywhere carriage makers turned out fancy . . . 'cutunders,' 'rockaways,' . . . and 'heavy duties.' **1948** RITTENHOUSE *Vehicles* 19 Rockaway or depot wagon. The name of this wagon indicates its customary use. Body was 36 inches wide on floor; wider across top.

2. a. rockaway carriage, =**rockaway 1. b. Rockaway clam,** a clam from Rockaway Beach, New Jersey.

(a) **1846** *Spirit of Times* 9 May 121/1 The price of a 'Rockaway' carriage which will carry eight persons depends very much on its finish. **1904** T. E. WATSON *Bethany* 210 In the old-fashioned rockaway carriage, the young preacher was driven . . . to the Roberts home. — (b) **1878** *Billings' Farmer's Allminax* 10 If i could hav mi coice, to be thoroly kontented with things az i find them in this world, or be a Rockaway klam, i would be the klam. **1944** *N. & Q.* Sep. 84/1 He walked from the theater to his hotel 'full ov munny all over, and az well ballasted az tho i had a bushell and a half ov Rochaway klams on mi boddy.'

Rogerene ˈrɑdʒəˌrin, *n.* [John *Rogers*, (1648–1721), a nonconformist of colonial Conn.] A member of a small religious sect of Baptist origin in Connecticut, whose doctrines and practice are opposed to some of the formal usages of churches, participation in military service, etc. Also **Rogerene Quaker.**

1754 HEMPSTEAD *Diary* 625 A Co[m]pany of the Rogerens . . . held their meeting after our meeting was over. **1820** *Niles' Reg.* XVIII. 366/1 A contagious disorder is now raging among the sect known by the name of Rogereen Quakers in Grotan. **1865** *Mass. H.S. Coll.* 4 Ser. VII. 584 [John Rogers was] the founder of the sect of Rogerenes, of whom a small number still remain. **1943** *N. Eng. Quart.* March 3 On a wooded hill above Mystic, Connecticut, live the remnants of a little-known religious sect called the Rogerenes, or sometimes Rogerene Quakers.

Roosevelt elk. An elk or wapiti, *Cervus canadensis roosevelti*, found on Vancouver Island and in the Olympic Mountains region.

1902 STONE & CRAM *Amer. Mammals* (1922) 34 Roosevelt's Elk. *Cervus occidentalis* Smith. Larger and darker coloured, with heavier horns. **1923** *Outing* April 3/1 The Olympic peninsula . . . contains vast, unmapped forests. . . . teeming with the lordly Roosevelt elk. **1947** *Mazama* Dec. 43/1 Herds of Roosevelt elk, estimated at between 4,000 to 5,000 head, roam there.

Rotarian roˈtɛrɪən, *n.* and *a.* [f. * *Rotary*, used in the name of the organization.] A member of a Rotary Club. Of or pertaining to such a club.

1915 *Chi. Herald* 9 Nov. 10/5 The Rotarians will observe 'Moving Picture day' at a luncheon in the crystal room of the Hotel Sherman. **1923** R. HERRICK *Lilla* 181 Lilla, on opening the newspapers, often found his name and a brief report of his remarks at a Rotarian lunch. **1949** *Telephone Reg.* (McMinnville, Ore.) 4 Aug. 5/2 Over 100 Rotarians and their wives took part in the annual Rotary picnic held by the McMinnville club Friday night.

Hence **Rotarianism.**

1922 *Nation* 19 April v, Do you know your state? How it stands in intelligence, rotarianism, bootlegging, evangelism, crime?

* **roundabout,** *n.* **1.** An armchair the arms and back of which are made on two adjacent sides. In full **roundabout chair. 2.** A wrapper or dressing gown worn by women.

(1) **1840** *Knickerb.* XVI. 115, I sat in my roundabout chair the other evening. **1844** *Lowell Offering* IV. 175 [He sat] in a large flag-bottomed 'roundabout' on the opposite side of the fireplace. **1936** F. C. MORSE *Furniture* 170 'Roundabout' chairs are met with in inventories from 1738 under various names,—'three-cornered chair,' 'half round chair,' 'round about chair.' — (2) **1841** *S. Lit. Messenger* VII. 525/1

Roundabout chair

The garment is a long, loose roundabout, connecting in front with strings, and is much worn, even at the present time. **1895** WIGGIN *Village Watch-Tower* 103 Mother had let her slip on her new green roundabout over her nightgown.

rural free delivery. The free delivery of mail on routes passing through rural districts. Also attrib.

1892 *Cong. Rec.* 28 May 481/1 [Mr. Watson of Ga.] is perfectly consistent in advocating a rural free delivery system which would mount carriers on horseback and send them to every habitation in the land to deliver and collect the mails. **1908** *Sat. Ev. Post* 5 Dec. 18/1 They couldn't cold deck anybody on the rural free delivery routes. **1944** CLARK *Pills* 255 These included arbor days, famous southern battles, the birthdays of southern statesmen and military figures, and days on which there was to be no rural free delivery.

∗ **rye,** *n.*

1. =**rye whisky.** Also a drink of this.

1890 *Buckskin Mose* 248 But for the quantity of rye we had all of us been swallowing, the others must have seen through this impudent operation. **1913** LONDON *Valley of Moon* 392 Some drink rain and some champagne . . . ; But I will try a little rye. **1949** *Sat. Ev. Post* 23 April 26/1 He ordered a double rye, downed it before I was halfway through my drink.

2. In combs.: (1) **rye-and-cornmeal,** =next, *obs.;* (2) **rye and Indian,** (*a*) bread made of a mixture of rye and cornmeal, in full **rye and Indian bread,** also **rye and Indian pudding,** (*b*) designating a region where such bread is commonly used, *obs.,* (*c*) **rye and Indian cloth,** cloth made of cotton and linen, *obs.;* (3) **coffee,** a drink prepared from roasted grains of rye or from toasted rye bread, now *hist.,* cf. **coffee essence;** (4) **drop-cake,** a drop-cake made of rye meal; (5) **gin,** gin made from rye, *obs.;* (6) **jack and bitters,** a drink made of rye, *obs.;* (7) **mush,** (see quot.); (8) **whisky,** whisky made from rye or from rye and malt, cf. **Monongahela rye whisky.**

(1) **1892** *Nation* 3 March 168/2 The receipts which I selected were mush, Johnny cake, and Boston rye-and-cornmeal bread. — (2) (a) **1805** *Pocumtuc Housewife* 6 Johnny cake or hoe cakes are a good change from Rye and Indian bread. *c***1880** HAZARD *Jonny-Cake P.* (1915) 27 This bread ['Rhineinjun'], vulgarly called nowa-days rye and Indian bread, in the olden time was always made of one quart of unbolted Rhode Island rye meal to two quarts of the coarser grained parts of ambrosia [i.e., corn meal]. **1947** BEROLZHEIMER *Regional Cookbook* 52 Corn alone made too dry a bread, so it was combined with rye to make a bread called 'rye 'n' Injun.' **1949** *Sat. Ev. Post* 12 March 26/2 We had brown bread, johnnycake, rye and Indian pudding, and many other things that I would like to taste just once more. (b) **1839** *N.O. Picayune* 9 April 2/2 Hardly a mail arrives but we receive some 'rie-and-injun' country paper from the 'Far West' or 'Down East' with [Please Exchange] . . . written on the margin. (c) **1867** *Beadle's Mo.* May 431/1 The best rye an' indian cloth we could make, they wouldn't allow more'n a shillin' a yard for, pay out o' the shop. — (3) **1769** *Boston Gazette* 16 Oct. 1/3 And as true Daughters of Liberty, they made their Breakfast upon Rye Coffee, and their Dinner was partly made of that sort of Venison called Bear. **1877** RUEDE *Sod-House Days* 99 Most people out here don't drink real coffee, because it is too expensive. . . . So rye coffee is used a great deal—partched brown or black according to whether the users like a strong or mild drink. [**1898** HARPER *S. B. Anthony* I. 14 A drink of 'coffee' [was] made by browning crusts of rye and Indian bread, pouring hot water over them and sweetening with maple syrup.] — (4) **1891** JEWETT in *Atlantic Mo.* May 617 Rye drop-cakes, then, if they wouldn't give you too much trouble.

(5) **1858** *Harper's Mag.* May 854/2 Prior to the period of the general Temperance Reformation in New England, . . . every shopkeeper sold codfish and rye gin. — (6) **1830** SANDS *Writings* II. 240 All her aches and symptoms had disappeared, in consequence of having taken . . . a glass of rye-jack and bitters. — (7) **1871** DE VERE 41 In some parts of the West, another mush is frequently used, but as it is made of rye after the manner of a Hasty Pudding, it is called *Rye Mush.* — (8) **1785** in RAMSEY *Tennessee* (1853) 297 Good distilled rye whiskey, at two shillings and six pence per gallon. **1853** *S. Lit. Messenger* XIX. 88/2 Ned Ellet . . . had taken in charge one Nash, a horse-thief, and also a tickler of rye whisky. **1948** *New Yorker* 6 Nov. 62/2 A glass, to them, is simply a *glass,* . . . rye whiskey is *rye.*

S

Sabbaday ˈsæbəˌde, *n. N. Eng.*
1. A colloquial contraction of "Sabbath day."
*c***1772** *Essex Inst. Coll.* LVI. 292 Thare was in the yeare 1738 a great

athcak one sabbady. **1841** *N.O. Picayune* 7 April 2/2, I go to meetin twice every Sabba-day. **1935** LINCOLN *Cape Cod Yesterdays* 5, I knew that, when I next dressed, it would be in the prim and stiff and spotless garments befitting what Grandmother often said her mother used to call 'Sabba' Day.'

2. Sabbaday house, (see quot. *a*1870). *Obs.*

*a*1870 CHIPMAN *Notes on Bartlett* 375 *Sabba'day-Houses.* Cottages near a church had for warmth, &c., at recess of public worship.—Old New England use. **1891** EARLE *Sabbath* 102 The 'noon-house,' or 'Sabba-day house' or 'horse-hows' . . . was a place of refuge in the winter time, at the noon interval between the two services.

* **Sabbatical,** *a. Educ.* Denoting a time of absence from duty for purposes of study and travel given to school teachers at certain intervals. Also absol. and transf.

1903 *N.Y. Ev. Post* 19 Sep., Professors Willcox and Kendall will be absent during the year on sabbatical leave. **1946** HOWE *We Happy Few* 18 Then when Papa had his sabbatical, we went to Paris. **1949** *Time* 18 Dec. 12/2 Kennan announced that he was leaving the State Department 'on sabbatical leave.'

* **sack,** *v. Logging. tr.* and *intr.* To follow a log drive and roll into deep water those logs that have grounded or lodged (see also 2nd quot. 1905). Also **sacking,** *n.* and *attrib.*

1860 *Harper's Mag.* XX. (*OED*), Another frequent and laborious part of the drive is sacking. **1902** WHITE *Blazed Trail* 334 Intense rivalry existed as to which crew 'sacked' the farthest down stream in the course of the day. **1905** *Forestry Bureau Bul.* No. 61, 45 *Sack the rear, to,* to follow a drive and roll in logs which have lodged or grounded. *Ib., Sack the slide, to,* to return to a slide logs which have jumped out. **1908** WHITE *Riverman* 12 The moving of them [*sc.* stranded logs] was deferred for the 'sacking crew.'

* **saddlery,** *n.* Saddles and other articles made by a saddler. Also attrib.

1711 *Boston News-Letter* 22 Oct. 2/2 To be Sold . . . Pipes, Sadlery, Bunting, Millenary Goods [etc.]. **1787** *Md. Gazette* 1 June 3/3 Saddlery tools, in sets. **1815** *Niles' Reg.* IX. 35/2 Plated saddlery and carriage mounting of all kinds . . . are manufactured. **1894** *Scribner's Mag.* May 603/2 The sewing-machine . . . has been followed [on ranches] by . . . revolvers, saddlery, and cotton goods.

sagamore ˈsægəˌmor, *n.* [f. the Abnaki name for the chief or ruler of a tribe.] An Indian chief or leader. Now *hist.* Cf. **Indian sagamore** *s.v.* * **Indian,** *a.* **6,** and see **sachamaker.**

1613 PURCHAS *Pilgrimage* 628 The said Sagamos lost the pipe. *c*1618 STRACHEY *Virginia* 160 Many provinces . . . [are] governed in chief by a principall commaunder or prince . . . who hath under him divers petty kings, which they call Sagamoes. **1751** GIST *Journals* 72 This Beaver is the Sachemore or Chief of the Delawares. **1843** HAYWARD *Gazetteer of Maine* 88 Each tribe, however, had its own sagamore, subject or tributary to the Bashaba. **1919** *Maine My State* 104

At Mattawamkeag, the Sagamores of the Indian village welcomed them with hospitality.

b. Used as a title with the given name of a particular Indian.

1632 *Mass. Bay Rec.* I. 102 [He] shall give Saggamore John a hogshead of corne for the hurt his cattell did him in his corne. **1677** HUBBARD *Narrative* I. 76 Sagamore Sam, old Jethro, and the Sagamore of Quohaog, were taken by the English. **1758** J. WILLIAMS *Redeemed Captive* 25 An Indian came to the City (Sagamore George of Pennacook) from Cowass. **1834** WHITTIER *Poetical Works* (1894) 496/1 He who harms the Sagamore John Shall feel the knife of Mogg Megone.

c. Sagamore's head, app. some American tree not now identifiable. *Rare.*

1741 P. COLLINSON in *Mem. Bartram* (1849) 148 The butter-nut . . . with the Medlar and Sagamore's head.

salary grab. (Also *cap.*) An act of Congress, March 3, 1873, by which the members made substantial retroactive increases in their own salaries. Also **salary grabber, salary grab session.** Now *hist.* Cf. **back salary grab, grabber.**

1873 *Tribune Almanac 1874* 25 The Salary Grab. . . . The back pay dates from March 4, 1871. **1875** *Chi. Tribune* 5 Oct. 2/3 Tipton, the Nebraska salary-grabber, and a young man named Weir, . . . have been advertised for weeks by monster posters, personal drumming, etc. **1886** ALTON *Among Law-Makers* 138 The people of the country were furious when they heard of this 'salary-grab.' **1887** *Nation* 8 Dec. 452/3 A notorious illustration of what may happen . . . was the once renowned 'salary-grab session,' when the retiring members voted to increase their salaries retroactively just before Congress expired. **1895** MYERS *Bosses & Boodle* 126 The 'Salary grab,' was passed by this Congress.

Salish 'selɪʃ, *n.* [f. a native word meaning "people."] (See quot. 1910 and cf. *flathead.)

1910 HODGE *Amer. Indians* II. 415/2 Salish. . . . Formerly a large and powerful division of the Salishan family, to which they gave their name, inhabiting much of w. Montana and centering around Flathead lake. **1938** THOMPSON *High Trails* 160 Tribes on the Columbia River practiced such a custom, considered themselves in consequence as having pointed heads, and therefore distinguished the Salish whose heads were not thus deformed as 'flatheads.' **1947** DEVOTO *Across Wide Missouri* 10 The Flatheads . . . were the principal group or tribe of a people who called themselves the Salish, meaning 'the people.'

attrib. **1849** in *Ann. 31st Cong.* 1 Sess. Sen. Ex. Doc. 52 (1850) 170 The *Salisk* or *Flat Head* Indians occupy from Bitter Root river, a fork of the Columbia, all the country drained by that stream down to what is called the Hell Gate. **1940** *Mt. Hood Guide* 25 The lands of these mid-Columbia people . . . felt the full force of conflict of three tribal families: the Salish tribes of the east, the lower Chinook tribes of the west, and the Sahaptin tribes to the south. **1950** *Nat. Hist.* Feb. 52/2 The rigid stylization and stark simplicity of Salish sculpture echo recent trends in modern art.

b. The language of these Indians.

1940 SMITH *Puyallup-Nisqually* 20 Although the language of the
Puyallup-Nisqually is classified as Salish, the people themselves used
no special language names.

saloonist səˈlunɪst, *n.* A saloonkeeper.

1870 *Terr. Enterprise* (Virginia, Nev.) 3 March 3/2 (*heading*), New
Saloonists. **1888** *Seattle Post-Intelligencer* 13 Nov. 3/1 A number of
vagrants . . . had taken possession of the place, and the saloonist
was afraid to eject them. **1946** *Chi. D. News* 8 Nov. 18/2 Saloonists
voted out of business in the Woodlawn local option election talk of
going to court to upset the vote.

salt lick. A place to which animals resort to lick the
ground for impregnated saline particles (see quot. 1796).

1751 GIST *Journal* 42 Upon the N Side of Licking Creek . . . are
several Salt Licks, or Ponds, formed by little Streams or Dreins of
Water. **1796** MORSE *Amer. Geog.* I. 663 The terms Salt Lick and Salt
Spring are used synonymously, but improperly, as the former differs
from the latter in that it is dry. **1802** ELLICOTT *Journal* 15 The salt
lick, or spring, is situated in the bed of a small creek. **1949** *Tenn. Hist.
Quart.* March 3 The country abounded in sulphur springs and likewise
the salt 'licks' around which congregated buffalo, deer, and elk.

attrib. **1755** L. EVANS *Anal. Map Colonies* 29 Great Salt Lick Creek
is remarkable for fine Land.

salt rising. A batter or dough of salt, flour, or corn
meal and water or milk, used for leavening.

1833 TRAILL *Backwoods of Canada* (1846) 137 [The wife of a
Canadian settler] must know how to manufacture *hop-rising* or *salt-
rising* for leavening her bread. **1846** FARNHAM *Prairie Land* 333 They
make a large loaf in their iron ovens which is fermented by what they
call *salt-rising*. **1898** HARPER *S. B. Anthony* I. 161 The process of
yeast-making was . . . not well understood by the average house-
keeper, so a substitute was found in 'salt-risings.'

b. Attrib. with **biscuit, bread, loaf.**

1907 *N.Y. Ev. Post* (s.-w. ed.) 20 June 4 The general suffrage seems
to go to . . . Virginia ham, salt-rising biscuits, apple dumpling. —
1865 *Atlantic Mo.* April 400/1 Maggie . . . described the process of
making 'salt-rising' bread. **1947** *Atlantic Mo.* Dec. 112/2 Gone, too,
with these luscious homemade loaves are other substantial and tasty
favorites: 'salt rising' bread [etc.]. — **1846** FARNHAM *Prairie Land* 138
When tea-time approached, . . . the 'salt risin' loaf . . . [was] put to
baking. **1890** *Harper's Mag.* Jan. 282/2 The rich brown salt-rising
loaf.

samp sæmp, *n.* [See quot. 1895.]

1. Corn broken into a coarse, ricelike form, boiled
and eaten, usu., with milk and sugar.

1643 WILLIAMS *Key* (1866) 41 From this the English call their Samp
. . . eaten hot or cold with milke or butter. **1783** PATTEN *Diary* 474, I
took 3 bushels of corn to Deacon Smiths Mill and two of it ground
and one made into Samp. **1895** GERARD in *N.Y. Sun* 30 July, Samp,
from 'nasaump,' 'softened by water,' A Narragansett name for a
pottage made of unparched meal. **1948** *Chi. Tribune* 11 Jan. VII. 16/1

She reached up to her cookbook shelf and took down her collection of hearty cold weather recipes: . . . samp pinked with paprika and cooked slowly and carefully, sukiyaki with paper thin steak, . . . chowders and stews.

2. In combs. now obs. or hist.: (1) **samp mill,** a mill in which corn intended for samp was ground; (2) **mortar,** a mortar in which corn was reduced to a coarse meal (see also quot. 1856); (3) **pan,** a pan in which samp was cooked; (4) **porridge,** (see quot.).

(1) **1761** *Huntington Rec.* II. 448 Jacob Brush should have Lyberty to Build a samp Mill in the Meeting house Brook. — (2) **1713** HEMPSTEAD *Diary* 30 I was at home al day fixing Sampmorter & killing Sheep. **1825** WOODWORTH *Forest Rose* I. ii, Didn't you get up softly and put the big samp-mortar in your place? **1856** FERGUSSON *America* 492 Our kind friends carried us to a place [near Fairfield, Conn.] called 'The Samp Mortar.' There is . . . a deep, roundish, but irregular cavity in the rock nigh a foot broad, and as deep, in which it is said the Indians were wont to pound their maize. *c*1887 in *Amer. Sp.* (1948) April 115/2 The sound of the samp-mortar might be heard resounding through the woods in the evening or early morning. — (3) **1850** *Harper's Mag.* Nov. 729/2 Among the relics preserved . . . [is] a samp-pan that belonged to Metacomet, or King Philip. — (4) **1935** *Col. of Conn.* 12 Samp porridge: . . . The corn meal was boiled in water. . . . Salt was added. . . . Sometimes dried huckleberries were added. . . . It was eaten hot or cold with milk.

sandbagger ˈsændˌbægɚ, *n.*

1. A robber or ruffian who uses a sandbag to stun his victim. Also transf.

1882 PECK *Sunshine* 203 Suppose all the men that have been robbed in the past year by cowardly sandbaggers, could have 'put up their hands.' **1893** *Chi. Tribune* 26 April 6/4 One of the Chicago papers recently complained that Illinois had no first-class highwaymen. It must have overlooked the legislative 'sand-baggers.' **1929** C. E. MERRIAM *Chicago* 343 A matter to be carefully watched here [in subcommittees of the city council] is room for blackmail, even in the case of worthy measures unless the sandbaggers are offset by those of an opposite persuasion.

2. A sailboat upon which bags of sand are used as ballast.

1894 *Outing* XXIV. 477/2 [He] enjoys the sea in every form, whether racing in a sandbagger, cruising in a schooner, or taking his ease beneath the shady awning of a big steam yacht. **1948** *Sat. Ev. Post* 9 Oct. 140/3 Several smaller craft have been acquired, including . . . the racing sloop Annie—one of the fastest Long Island 'sandbaggers.'

sand lot. An unoccupied piece of sandy ground or vacant lot in or adjacent to a city, freq. serving as the scene of unorganized games and sports. Also attrib.

The term first came into use in San Francisco from the fact that the followers of Dennis Kearney held meetings on a lot of this kind on the west side of the city. Cf. **Kearneyism, Kearneyite.**

1882 G. A. SALA *Amer. Revisited* II. 201 Colossal fortunes, illimitable speculations, and sand-lot agitators. **1885** *Mag. Amer. Hist.* Feb. 201/2 One Dennis Kearny . . . made his headquarters in what were known as the 'Sand Lots,' near San Francisco. **1898** ATHERTON *Californians* 37 She drew Helena into a sand lot opposite. **1949** *Highway Traveler* Feb. 20 These 'nobs' were the target of Dennis Kearney, famous sandlot orator of the 70's.

b. sandlotter, a Kearneyite, or a member of any radical political element. *Slang.*

1887 *Advance* 17 Feb. 107 [The California Chinese Mission] raised the last year in California $3,756, hoodlums, sandlotters and politicians to the contrary notwithstanding. **1894** *Nation* 12 July 20/2 The decent people . . . outnumber the Sand-lotters and other anarchists by five to one.

San Jose scale. [f. *San Jose*, Calif., where this scale (of Asiatic origin) was first introduced into the U.S.] A scale insect, *Aspidiotus perniciosus*, injurious to fruit trees.

1887 *Calif. State Bd. Agric. Biennial Rep. 1885–86* 12 Reports come in rapidly from various sections of the State of the appearance of the San José scale, even so far north as Geyserville, in Sonoma County. **1915** HAWORTH *G. Washington* 150 Being untroubled by San José scale and many other pests that now make life miserable to the fruit grower. **1938** C. S. BRIMLEY *Insects of N.C.* 110 A. perniciosus Comst. San Jose Scale. State-wide on apple, peach, plum, etc.

Santa Claus. [f. Du. *sinterklaas* (< *Sant Nikolaas*).]

1. Saint Nicholas, according to the modern conception, a jolly old man clad in a characteristic fur-trimmed red costume, represented as the bringer of gifts, esp. to children, on Christmas Eve. Cf. **Belshnickle.**

1773 [see *Saint Nicholas]. **1823** COOPER *Pioneers* iv, Remember there will be a visit from Santa-claus to-night. **1949** *Chi. D. News* 8 Dec. 20/2 Americans have transformed Santa Claus from a sad-eyed, generous St. Nicholas of 1,600 years ago into a smaller, jollier, plumper red-suited Christmas hero.

attrib. and *transf.* **1886** STAPLETON *Major's Christmas* 201 Papas and mammas . . . planned the Santa Claus performance which was to come when the inquisitive eyes were closed in slumber. **1934** *Amer. Mercury* May 5/2 The Santa Claus theory of relief may be appropriate to a genuine emergency like an earthquake or a big fire.

b. The U.S. thought of as a Lady Bountiful to other nations.

1909 *Chi. D. News* 10 Aug. 8/3 Uncle Sam is by no means an impartial Santa Claus. **1948** *Time* 19 Jan. 19/3 The Federal Government comes forward again as Santa Claus himself. **1949** *L.A. Times* 16 May 11. 4/5 Citizens still allow our government to be a Santa Claus to the whole world.

2. a. Christmas time. *Rare.* **b.** Gifts, presents, etc., such as are exchanged at Christmas. *Colloq.*

(a) **1830** WATSON *Philadelphia* 242 The 'Belsh Nichel' and St. Nicholas . . . is the same also observed in New York under the Dutch name·of St. Claes. — (b) **1939** *These Are Our Lives* 22 One Christmas we ask him for fifty dollars for some clothes and a little Santy Claus for the chil'en.

Santee sæn'ti, *n.*[1] [Of obscure origin. App. a native word.]

1. *pl.* or *collect.* (See quot. 1910.)

1714 LAWSON *Hist. Carolina* (1903) 33/1 There happened also to be a burial of one of them, which ceremony is much the same as that of the Santees. **1854** SCHOOLCRAFT *Indian Tribes* IV. 155 After passing the settlement of the French Huguenots, . . . he visited the 'Seretees or Santees,' (Zantees), some of whose customs he described in passing. **1910** HODGE *Amer. Indians* II. 461/1 Santee. A tribe, probably Siouan, formerly residing on middle Santee r., S.C., where Lawson in 1700 found their plantations extending for many miles.

2. A kind of cotton. *Obs.*

1820 *Western Carolinian* 25 July, *Cotton*—Sea-Island, 35 a 37½ cts. lb.—Santee, 30 a 32. **1824** *Catawba Journal* 7 Dec., Santees [have been sold] at 19 a 21.

*** sarsaparilla,** *n.* A beverage flavored with sarsaparilla. Also **sarsaparilla soda.**

1844 UNCLE SAM *Peculiarities* I. 43 On the outside . . . is printed the following thirsty announcement: . . . Congress Water, Sarsaparilla Soda, Ginger Champaign [etc.]. **1865** *Atlantic Mo.* Jan. 59/1 I have not heard his opinions concerning . . . sarsaparilla, or gingerpop. **1940** MENCKEN *Happy Days* 233, I . . . even gagged at drinking more than two or three bottles of sarsaparilla.

sauerkraut 'saur₁kraut, *n.* Also **sourcrout.** [The quots. indicate that this is an Amer. borrowing f. Germans in this country.] Finecut cabbage slightly fermented in a brine of its own juice.

1776 LEACOCK *Fall Brit. Tyranny* III. v, Don't leave me, and you shall have plenty of porter and sour-crout. *a*1813 WILSON *Foresters* 9 Torrents of Dutch from every quarter came, Pigs, calves, and *saurcraut* the important theme. **1863** P. S. DAVIS *Young Parson* 48 [You] eat the best of roast beef, while I have to put up with sauerkraut and spec. **1946** HIBBEN *Cookery* 135 Wash the sauerkraut in several waters.

Hence **sauerkrauter,** a German. *Slang.*

1869 *Terr. Enterprise* (Virginia, Nev.) 24 April 3/1 The man handed it over, but could not speak English (he was a regular 'sour-krauter').

b. *To look sauerkraut at,* to look at in an exceedingly displeased manner. *Rare.*

1846 CORCORAN *Pickings* 11 Here the Dutchman looked· sourcrout at the tall, thin gentleman in the seedy black suit.

*** sausage,** *n.* Used to designate various implements for cutting or grinding meat and forcing it into suitably prepared intestines or casings, as (1) **sausage cutter,** (2)

filler, (3) grinder, (4) gun, (5) machine, (6) stuffer.

(1) **1854** *Pa. Agric. Rep.* 127 A model of a Sausage cutter was exhibited. — (2) **1848** D. P. THOMPSON *L. Amsden* 104 Jim Walker ... was to our house ... to borrow a sassage-filler for his wife. — (3) **1876** KNIGHT 2031/2 *Sausage-grinder*, ... a machine for mincing

Early (*c*1875) type of sausage stuffer

meat for sausages. **1949** *Chi. Tribune* 20 Feb. VII. 6/7 See this sausage grinder. Just like new. — (4) **1869** *Overland Mo.* III. 130 Swine's flesh, bread, sage, and other matters of nourishment and seasoning, chopped fine, ... [are] squirted out into links from the end of a sausage-gun. **1933** *Old-Time N. Eng.* July 14/1 The meat division contains many kinds of grinding mills, mincing knives, sausage 'guns' for forcing the chopped meat into the casings.

(5) **1859** BARTLETT 380 *Sausage-machine*. A machine for chopping or mincing meat for the purpose of making sausages. — (6) **1845** *Knickerb.* XXV. 406 It is ten to one that there lurks beneath it [the Yankee countenance] the knowledge of ... some 'self-acting back-action sausage-stuffer.' **1876** KNIGHT 2032/1 *Sausage-stuffer*. ... A device for stuffing cleaned intestines with sausage-meat. **1946** *Agric. Hist.* April 97/1 In that process two implements were used, the sausage grinder, which was fastened to a table and turned by hand, and the sausage stuffer, likewise operated by hand.

＊**saw,** *v.* In slang phrases: (1) *To saw gourds*, to snore; (2) *to saw the air*, in baseball, to swing at and miss a pitched ball; (3) *to saw wood*, to continue at what one is about, unmindful of what others are doing.

(1) **1870** LUDLOW *Heart of Continent* 91 In five minutes ... we were all 'sawing gourds' together in the land of Nod. **1934** in WENTWORTH. — (2) **1880** *Chi. Inter-Ocean* 19 May 2/5 Shaffer sawed the air three times without hitting anything, and retired. — (3) **1894** *Cong. Rec.* 24 Jan. 1347/2 Is it possible that the framers of the bill hold a grudge against the voters who 'sawed wood' last November? **1908** O. HENRY *Options* 75 During all these wintry apostrophes, Barbara, cold at heart, sawed wood—the only appropriate thing she could think of to do.

Saybrook platform. A platform of church discipline and polity adopted by a synod of the Connecticut Congregational Church at Saybrook in 1708. Now *hist.*

1825 NEAL *Bro. Jonathan* I. 5 [He had been] defeated at his own game—Divinity—with his own weapons—the Saybrook platform, and Bible. **1879** *Cong. Rec.* 21 Feb. 1715/2 The 'Saybrook platform' was the formula into which the really liberal . . . principles of their religion had been cramped and crowded. **1945** WEBSTER *Town Meeting Country* 44 In 1708, the General Court called delegates to a synod at Saybrook. These twelve clergymen and four laymen drew up the famous Saybrook Platform.

* **scaled,** *a.* In the names of birds: (1) **scaled dove,** (see quot. 1891), also **scale dove;** (2) **partridge,** a partridge, *Callipepla squamata,* found in the Southwest; (3) **quail,** =prec.

(1) **1884** COUES *Key to Birds* (ed. 2) 570 *Scardafella inca.* . . . Inca Dove. Scaled Dove. **1891** *Cent.* 5370/1 *Scale-dove,* . . . an American dove of the genus *Scardafella,* as *S. inca,* or *S. squamata,* having the plumage marked as if with scales. **1917** *Birds of Amer.* II. 52. — (2) **1858** BAIRD *Birds Pacific R.R.* 646 Scaled or Blue Partridge. . . . Valley of Rio Grande of Texas. . . . Most abundant on the high broken table lands and mezquite plains. **1880** *Cimarron News & Press* 30 Dec. 1/5 The scaled partridge or blue quail has a short, full, soft crest. — (3) **1874** COUES *Birds N.W.* 441 Blue Quail . . . is also called the Scaled Quail, from the peculiar appearance of the plumage of the under parts. **1917** *Birds of Amer.* II. 8/1 The Scaled Quail is a desert species.

scarehead ˈskɛrˌhɛd, *v. tr.* To give (a story) a prominent headline, to place (an item) in such a headline. Also **scareheaded,** *a.*

1889 HOWELLS *Hazard of Fortunes* II. 281 He read . . . the deeply scareheaded story of Conrad's death. **1902** NORRIS *Responsibilities of Novelist* 300 The name of the leading lady or leading man is 'scareheaded' [on theater bills] so that the swiftest runner cannot fail to see. **1911** HARRISON *Queed* 219 The *Chronicle* . . . scareheaded a jaundiced account of the affair.

Schenectady skəˈnɛktədɪ, *n.* [f. Du. *Scheaenhechstede,* f. native Indian name.] Used attrib. with reference to various river craft built in Schenectady, N.Y., as **Schenectady barge, bateau, boat.** *Obs.*

1768 JOHN LEES *Journal* (1911) 43 The Schenectady Batteaus are navigated with but three men, they hold at most 14 Rum Barls. generally only 12, Cost usually from 8 to 9 pounds N.Y. Currency a Batteau. **1805** PIKE *Sources Miss.* I. App. 3, I have therefore hired two Schenectady barges. **1807** C. SCHULTZ *Travels* I. 4 Those called Schenectady boats are generally preferred. . . . These boats are built very much after the model of our Long Island round-bottom skiffs, but proportionable larger, being from forty to fifty feet in length. **1836** IRVING *Astoria* I. 144 Another [boat] was of a larger size, . . . and known by the generic name of the Schenectady barge.

schnitz ʃnɪts, *n.* Also **snits.** *local.* [G., chip, piece cut off, in the Pa.-G. (and south G.) sense shown here.] Apples cut up and dried. Also **schnitz pie.**

1848 *Knickerb.* XXXI. 222 A Dutchman smiles when he sees snits and scralls. **1869** *Atlantic Mo.* Oct. 483/1 The rest of the family gathered in the kitchen, and labored diligently in preparing the cut apples, so that in the morning the 'schnitz' might be ready to go in. **1940** *Sat. Ev. Post* 30 March 42/3 No account of the Amish is complete without a mention of shoo-fly pie and schnitz pie. **1945** *Amer. Sp.* Dec. 254 A good housewife of York, Pennsylvania, in an interview with a radio commentator, replied to his question, 'But just what are snits?' with a laugh and the answer, 'Why everybody knows what snits is.'

b. *schnitz and knep,* [*schnitz un knepp,* quartered apples and dumplings], dried apples and dumplings boiled with pork or, more often, ham.

1869 *Atlantic Mo.* Oct. 484/1 'Schnitz and knep' is said to be made of dried apples, fat pork, and dough dumplings, cooked together. **1929** *Sat. Ev. Post* 23 March 166/3 'What are you having for supper, mom?' 'Schnitz and kneps,' said Mrs. Holzoppel heavily. **1947** BEROLZHEIMER *Regional Cookbook* 282, I would like to eat again a dish my boyhood knew . . . we called it Schnitz and Knepp.

school district.

1. An area established as the unit for the local administration of schools.

1809 KENDALL *Travels* I. 128 There are thirteen school districts [in Berlin, Conn.]. **1851** *Fox River Courier* (Elgin, Ill.) 12 Nov. 2/2 The Directors of School District No. 6 in West Elgin would say to the inhabitants thereof, that the Schoolhouse is now undergoing thorough repairs. **1948** *Hungry Horse News* (Columbia Falls, Mont.) 17 Sep. 2/1 This is one of Montana's largest school districts for area, stretching to the continental divide, and exceeding 100 miles in a north-west-southeast direction.

2. In combs. of obvious meaning, as (1) **school district board,** (2) **election,** (3) **library,** (4) **meeting.**

(1) **1898** *K.C. Star* 21 Dec. 2/2 A case . . . involved the question whether, as to railroad legislation, the legislatures of theoretically sovereign states should be reduced to the level of city councils or school district boards. — (2) **1893** *Harper's Mag.* April 708/1 The right of suffrage [for women] . . . is confined to municipal and school-district elections. — (3) **1910** BOSTWICK *Amer. Pub. Library* 6 Similar to these [town libraries], . . . were school-district libraries. — (4) **1830** S. SMITH *Life J. Downing* 92 Resolved, That it be recommended . . . [to call] school district meetings.

* **Scientist,** *n.* Short for **Christian Scientist.**

1895 *Amer. Art Jrnl.* 26 Jan., The solo singer, however, was a Scientist, Miss Elsie Lincoln. **1914** E. STEWART *Lett. Woman Homesteader* 12, I certainly got as warm as the most 'sot' Scientist that ever read Mrs. Eddy could possibly wish. **1946** *Christian Sci. Sentinel* 26 Jan. 162 We had just concluded our Sunday services and another young Scientist and I had gone up on deck together.

* **score,** *v.*

1. *tr.* To prepare (a log) for hewing by slabbing off the outer part of it with an ax. Also absol.

1752 in *Travels Amer. Col.* 320 Four hands schooring. *Ib.* 320, I finished hewing in the forenoon three at schooring. **1852** REGAN *Emigrant's Guide* 85 John Adams and I scored the timber . . . that is, cut it diagonally with our axes to the depth of the hewer's chalk lines, each stroke of the axe about four inches distant. **1923** ADAMS *Pioneer Hist.* 310 Logs were cut and hauled by some, scored and hewed by others.

2. To castigate (a person or thing), to berate or denounce severely. *Colloq.*

1812 PAULDING *J. Bull & Bro. Jon.* 107 [She] fell upon Beau Napperty, and scored him at such a rate, that [etc.]. **1892** LOUNSBERRY *Studies in Chaucer* III. 223 Even poor Lipscomb . . . was soundly scored for his grossness and vulgarity. **1903** *N.Y. Times* 5 Dec. 5 Bishop Burgess in a sermon which he delivered yesterday plainly scored 'Parsifal,' although he did not once mention the name of the opera.

scow skaʊ, *n.* [f. Du. *schouw*, in same sense.] A large, flat-bottomed river boat, usually serving as a ferryboat or lighter.

1669 in MUNSELL *Ann. Albany* IV. 10 The Governor hath given me Orders . . . to provyde a scow to help ye souldiers in their provision of fire wood. **1714** HEMPSTEAD *Diary* 34, I workt at huttons al day about ye horse Boat or Scow. **1843** CARLTON *New Purchase* 230 But whether the embarkation has been in skows, or 'perogues,' and other troughlike vessels, was uncertain. **1947** *Reader's Digest* Oct. 162/2 They made the trip to Fort Yukon in two open motorboats, with a small scow.

b. Attrib. with **boat, gang, load, schooner.**

1828 FLINT *Geog. Miss. Valley* I. 230 The ferry flat is a scow-boat. — **1891** *Scribner's Mag.* Oct. 483/1 The oyster next falls into the hands of the 'scow-gang,' men whose specialty it is to remove them from the floats. — **1714** HEMPSTEAD *Diary* 38, I fetched ye Scow load of Railes & Posts. **1947** *Mich. Hist.* Dec. 438 It was in this same never-say-die spirit that he got a scowload of horses ashore. — **1913** LONDON *Valley of Moon* 269 At the foot of Castro street . . . the scow schooners, laden with sand and gravel, lay hauled to the shore in a long row.

* **scrape,** *v.* **1.** *tr.* To level (ground) or clear its surface of weeds, grass, etc., preparatory to planting a crop. *Obs.* **2.** To cultivate (cotton) to a shallow depth and thin with hoes or special plows.

(1) 1647 WILLIAMS *Letters* (1874) 146 The Indian hills . . . [are] only scraped or levelled. **1772** *Md. Hist. Mag.* XIV. 150 We want a good Season much, most of our tob[acc]o ground being Scraped. — **(2) 1827** *Western Mo. Rev.* I. 82 The cotton . . . is thinned carefully, and plows, in the form of scrapers, are used, as the technical phrase is, to scrape it out. **1867** *Harper's Wkly.* 2 Feb. 69/2 This makes it easy to follow with the hoes and 'scrape' the cotton, which means to cut out

the surplus growth to the width of the hoe, technically called a half stand.

* **screech owl.** Any one of various small American owls of the genus *Otus*, esp. *O. asio* of the eastern states. Cf. **Florida, Mexican, red screech owl.**

1671 OGILBY *America* 147 The Bird both common and peculiar {to N.E.] are thus recited:... The long-liv'd Raven, th' ominous S⸍reech-Owl, Who tells, as old Wives say, disasters foul. **1812** WILSON *Ornithology* V. 83 Red Owl. ... This is ... well known by its common name, the Little Screech Owl. **1884** HARRIS in *Cent. Mag.* Nov. 121 The screech-owl would shake and shiver in the depths of the woods. **1949** *Amer. Forests* Oct. 23/2 The weird call of the more or less familiar screech owl is probably the best known of all the owls.

scrod skrɑd, *n.* [Origin unknown.] (See quots. and cf. **escrod.**)

1841 *Spirit of Times* 16 Oct. 396/2 (We.), Supplied with a few ship biscuit, a dried scrod, a bottle of good swizzle [etc.]. *c*1870 CHIPMAN *Notes on Bartlett* 388 Scrod. ... In Mass. pronounced *scrōde* and used to designate a small fish split and slightly salted. Comp. Ger. *schroeder.* **1884** GOODE *Fisheries* I. 201 In the vicinity of Cape Ann the young Cod, too small to swallow a bait, are sometimes known to the fishermen as 'Pickers,' and throughout all Eastern Massachusetts the name 'Scrod,' or 'Scrode,' is in common use. **1949** *Chi. Tribune* 25 Feb. II. 4/6 As served in famous Boston restaurants, scrod is simply a tail piece of filleted haddock or cod dipped in oil, then bread crumbs and broiled in a moderate oven.

scuppaug skə'pɔg, 'skʌpɔg, *n.* Also **skippaug.** [f. native Narraganset name, *mishcùppaûog,* given in allusion to its scales being close together.] A marine fish, *Stenotomus versicolor,* of the Atlantic Coast, or a related fish, *S. chrysops.*

1807 *Mass. H.S. Coll.* 2 Ser. III. 57 The skapaug in shape somewhat resembles the roach. **1842** *Nat. Hist. N.Y., Zoology* IV. 260 The Mossbonker. *Alosa menhaden.* ... At the east end of the island, they are called *Skippaugs* or *Bunkers.* **1860** *Harper's Mag.* Nov. 755/1 We ... spent two hours or more in pulling out scupping. This is a species of perch, plump and white, weighing from one to three pounds. **1911** *Rep. Fisheries 1908* 315/2 Scup, (*Stenotomus chrysops*). ... Common local names are 'scuppaug,' 'paugy,' ... etc. **1949** KURATH *Word Geog. Eastern U.S.* 21/2 *Pogy* rimes with *stogy* ... and denotes an entirely different fish—the *scup* or *scupaug* of southeastern New England.

Also **scupping,** *n.*

1882 E. K. GODFREY *Nantucket* 146 If you like fishing, ... go out for a day's sport,—either bluefishing, sharking, or scupping, or all combined.

* **seaboard,** *n.*

1. The area or land adjacent to the Atlantic Coast. Cf. **Atlantic, Pacific seaboard.**

1788 Asbury *Journal* II. 37 The Gnats are almost as troublesome here, as the mosquitoes in the lowlands of the seaboard. **1838** Stevenson *Sketches* 122 This class includes all . . . those which run to and from Boston, New York, Philadelphia, Baltimore, Charleston, Norfolk and the other ports on the eastern coast of the country, or what the Americans call the Sea-board. **1949** *Amer. Sp.* XXIV. 252 On the seaboard there is a multiplicity of words [for this custom].

2. a. seaboard cotton, (see quot.). **b. seaboard slave states,** those slave states on the Atlantic seaboard. Both *obs.*

(a) **1812** Melish *Travels* I. 27 The principal islands where it is raised are St. Symons and Cumberland; but it is planted, and comes to maturity, in all the other islands along the coast . . . and is thence called *seaboard cotton.* — (b) **1859** J. Redpath *Roving Editor* 155 But, in the Seaboard Slave States, I have yet to meet the first Southerner who believes that the condition of the Northern negroes is superior to the condition of the Southern slaves.

* **seasoning,** *n.* A fever or other illness often suffered during the first year of settling in a new country. *Obs.*

[**1670** Denton *Brief Descr. N.Y.* 17 The Climate [of N.Y.] hath such an affinity with that of England, that . . . the name of seasoning, which is common to some other Countreys hath never there been known.] **1705** Beverley *Virginia* IV. 69 The first Sickness that any New-Comer happens to have there, he unfairly calls a Seasoning. **1724** Jones *Virginia* 50 Abundance of Damps and Mists . . . makes the People subject to Feavers and Agues, which is the Country Distemper, a severe Fit of which (called a *Seasoning*) most expect, some time after their Arrival in that Climate. **1843** in Mary Cone *Life Rufus Putnam* (1886) 130 In the midst of all this the mumps and perhaps one or two other diseases prevailed and gave us a seasoning.

Sebago sɪˈbego, *n.* **1. Sebago salmon,** a landlocked salmon, *Salmo sebago*, found in Lake Sebago, Me. **2. Sebago trout,** =prec.

(1) **1883** *Nat. Museum Bul.* No. 27, 425 Sebago Salmon. . . . Saint Croix River and lakes of Maine. Extensively introduced into other lakes and into streams southward. **1911** *Rep. Fisheries 1908* 315/1 The land-locked salmon, or fresh-water salmon, or Sebago salmon . . . , is found in fresh waters, generally landlocked. — (2) **1884** Goode *Fisheries* I. 470 The 'Land-locked' or 'Fresh-water' Salmon, known also . . . in different parts of Maine as 'Schoodic Trout,' 'Sebago Trout,' or 'Dwarf Salmon,' probably never visit salt water.

secessionist sɪˈsɛʃənɪst, *n.* One who during the Civil War period advocated the secession of a state from the Union, a supporter of the Southern Confederacy.

1851 *Harper's Mag.* Dec. 120/1 The same division prevailed in the Congressional contest, the nominees being Unionists and Secessionists. **1861** *Alexandria* (Va.) *Gaz.* 2 May 2/7 The secessionists sunk several vessels in New Inlet, blocking up the channel. **1943** DeVoto *Yr. of Decision* 480 Then in that dawn Edmund Ruffin, the most honored Virginia secessionist, pulled the lanyard of a cannon on Mor-

ris Island that was trained on a fort in Charleston Harbor, and the military phase began.

b. Also attrib. or as adj.

1869 BRACE *New West* 277 The region about Los Angeles . . . was somewhat secessionist, or at least opposed to the Government, during the war. **1944** PENNELL *Rome Hanks* 328 [The name] was that of a Pro-Slavery Vice-President of the United States and as black-hearted a Secessionist Brigadier as ever mounted an overbred hunter.

transf. **1948** *Time* 5 July 20/3 The secessionist Dixiecrats might stay hitched if the Democratic platform went no further on civil rights than the generalizations of the 1944 plank.

second bottom. The second or higher level of bottom land by a stream. Also **second bottom land. Cf. second bank.**

1691 in *Amer. Sp.* XV. 390/1 On ye second bottom of ye upper back Creek. **1788** Lett. in IMLAY *Western Territory* (1797) 595 Next to these are what is called second bottoms, which are elevated plains, and gentle rising of the richest uplands, and as free from stone as the low or first bottom. **1808** F. CUMING *Western Tour* 377 When wide they [benches] constitute what are called bottoms, as first, second and third bottom counting from the river upwards. **1926** *Hutchinson* (Kans.) *News* 19 June, Fritz Tarnstrom of Roxbury, . . . has a good test crop of a new variety of wheat on second bottom land. . . . John Hahn of Inman has another very good test on second bottom land.

* **Secret Service.** A branch of the U.S. Treasury Department concerned with discovering and preventing counterfeiting, with protecting the President, and, in wartime, with espionage.

1867 BAKER *Hist. U.S. Secret Service* 34 There is nothing in the Secret Service that demands a violation of honor, or a sacrifice of principle, beyond the ordinary rules of warfare. **1945** *Athol* (Mass.) *D. News* 14 May 6/2 Not since the lethargic days . . . has the Secret Service had to deal with any one like Truman. **1949** *Dly. Ardmoreite* (Ardmore, Okla.) 4 Dec. 5/2 To combat this the secret service was established on July 5, 1865.

attrib. **1880** LAMPHERE *U.S. Govt.* 66/2 The Secret Service Division sprung from an annual appropriation made for the prevention and punishment of counterfeiting. **1900** *Westm. Gaz.* 25 May 7/3 Secret service agent Brown took the accused man in charge [at San Francisco]. **1950** *Nature Mag.* March 168/1 The nation is divided into fifteen Secret Service Districts for the suppression of counterfeiting and related tasks.

sectionalism ˌsɛkʃənlˌɪzəm, *n.* Confinement of interest to a particular section, sectional feeling or interests.

1855 *N.Y. Wkly. Tribune* 14 July 4/3 As well attempt to reason with a north-east storm as with this narrow sectionalism. **1903** *Out West* March 370 This magazine . . . keeps its oar in for no sectionalism. **1949** *Americas* Sep. 13/1 Sectionalism has its . . . ideological, political, and social aspects.

* **sedge grass.** Also * **sage grass.** *S.* (See quot. 1903 and cf. **broom sedge.**)

1886 *Consular Rep.* Jan. 40 Those hundreds of thousands of acres of once valuable Southern lands . . . [are] now lying to waste in worthless 'sage grass.' **1902** MOORE *Songs & Stories* 21 With a bundle of 'sage-grass' in his arms, as evidence that he had been on the errand on which he had been sent. **1903** *D.N.* II. 328 *Sage-grass,* sedge-grass. Also called 'broom-sage.' [s. e. Mo.] **1949** *Chi. Tribune* 27 Feb. VII. 1/1 It must be a very special kind of dog that will run swiftly thru sage grass, briars, cornstalks and other hampering vegetation, smelling out the pretty little striped birds.

sego 'sigo, *n.* [Shoshonean Indian.] A showy-flowered perennial plant, *Calochortus nuttalli,* or its edible bulb (see also quot. 1875). Also **sego lily.**

1851 HOWE *Hist. Coll. Great West* 432 Hogs fatten on a succulent bulb or tuber, called the Seacoe, or Seegose Root, which is highly esteemed as a table vegetable by the Mormons. **1852** STANSBURY *Gt. Salt Lake* 160 *Sego* . . . is much used by the Indian tribes as an article of food. **1875** *Amer. Naturalist* IX. 18 The general Indian name of 'Sego' is applied indiscriminately to all the edible bulbs of [s. Utah]. **1947** *L.A. Times* 2 Jan. 1. 2/1 Utah's beautiful float depicted a beehive and the flower of the State of Utah, the sego lily.

selectman sə'lɛktmən, *n.*

1. In N. Eng., one of a board of town officers elected to execute the orders of the town meeting.

1635 in FROTHINGHAM *Hist. Charlestown, Mass.* 51 An order [was] made by the inhabitants of Charlestowne at a full meeting for the government of the Town by Selectmen. **1776** M'ROBERT *Tour* 24 Boston . . . is governed by seven men chosen yearly, called *select men.* **1885** *Boston Jrnl.* 8 Jan. 1/6 The Selectmen [of Watertown] have voted to protest against the action of Cambridge in using the streets of the town to lay out their Stony Brook water main. **1948** *Reader's Digest* May 23/2 The selectmen are handling town business in a freight car down where the station was.

2. (See quot. 1789.) *Obs.*

1789 ANBUREY *Travels* II. 236 *Select Men* . . . are a kind of overseers to their meeting-houses, who regulate the affairs of the parish, and report persons for non-attendance at worship, compelling those walking in the streets, or travellers, on a Sunday, to go to some place of worship. **1804** *Ga. Republican* 15 May 4/2 The select men of the Church and society of Midway will receive proposals.

semester sə'mɛstɚ, *n.* [G., in related sense.] One of the two periods of instruction into which the school year of approximately thirty-six weeks is usually divided.

In modern usage this term is used with varying significations in different schools. See Kemp Malone in *Amer. Sp.,* Dec. 1946, p. 267.

1881 *Missouri Univ. Cat.* 40 The Juniors and Seniors . . . spent the balance of the semester in studying simple methods of teaching physics. **1895** *Univ. Nebraska Calendar 1895–6* 33 The year is divided upon the semester plan. Each semester has eighteen weeks. **1949** Univ. Okla. *News of Mo.* April 1/1 The new scholarships will provide $75 a semester for those who are chosen.

b. semester hour, (see quots.).

1946 *Amer. Sp.* Dec. 267 Alongside *semester* there has arisen, in the jargon of registrars, the expression *semester hour* as a name for a unit of measure used in recording and certifying academic 'credits' for courses taken. **1949** Univ. Okla. *News of Mo.* April 7/3 A semester hour . . . represents one hour per week of class work and at least 2 hours of additional study, for half the school year.

senior class. 1. A class in college or high school made up of those in the fourth year of the regular academic course. **2.** (See quot.)

(1) **1766** T. CLAP *Hist. Yale College* 14 The Senior Class were removed to Milford. **1871** CUTTING *Student Life Amherst* 40 For the Exhibition, four orators are now chosen in each society from the Senior class. **1900** WINCHESTER *W. Castle* 25 Wesley and Chester went to the city of Dorchester on some business for the Senior class. **1946** *Democrat* 13 June 3/3 They recently cabled the senior class. — (2) **1816** *Ann. 14th Congress* 2 Sess. 270 Those [in the militia] over thirty-one, and under forty-five years of age, shall be called the senior class of militia.

* **sensitive,** *a.* In combs.: (1) **sensitive brier,** any one of various plants, esp. prostrate herbs of the genus *Schrankia,* as *S. uncinata,* that are sensitive to the touch; (2) **fern,** a North American fern, *Onoclea sensibilis,* the leaves of which tend to fold together when plucked or when wilting; (3) **pea,** any one of various North American plants of the genus *Chamaecrista,* as *C. fasciculata* and *C. nictitans,* having leaflets that droop or wilt upon being touched; (4) **rose,** = sensitive brier.

(1) **1802** ELLICOTT *Journal* 287 The sensitive briar, (*mimosa instia.*) this beautiful and singular plant, is common to the poor, sandy land. **1869** *Amer. Naturalist* III. 163 Along the steep banks of the creeks and ravines, the sensitive Brier (*Schrankia*) is to be found. **1941** R. S. WALKER *Lookout* 58 Sensitive brier's runners cling to the ground and are tough and spiny. — (2) **1814** BIGELOW *Florula Bostoniensis* 257 Sensitive fern. . . . Low grounds. Perennial. **1943** SMITH *Explor. Biology* 90/2 In some species, such as the sensitive fern, these spore-making organs are borne on a special branch. — (3) **1843** TORREY *Flora N.Y.* I. 190 *Cassia Chamæcrista.* Partridge Pea. Sensitive Pea. . . . Sandy fields: Staten Island; Long Island. rare in the interior of the State. **1907** BAILEY *Cyclo. Amer. Agric.* II. 309/2 Partridge pea, Sensitive pea, Magothy Bay bean (*Cassia Chamæcrista*). — (4) **1892** *Amer. Folk-Lore* V. 95 *Schrankia uncinata,* sensitive rose. West and South.

* **seventeen,** *a.* and *n.*

1. (See quot.) *Obs.*

*a***1827** in *Pub. Col. Soc.* XXV. 47–8 In the beginning of the year 1768, . . . the house of Representatives of Massachusetts voted to send a circular letter to the legislatures of the several provinces, upon the alarming state of affairs with the mother country. . . . Seventeen members only voting for it, & ninety two against. These numbers

therefore were used in a political manner—Seventeen being called the Tory number.

2. seventeen-year locust, the periodical cicada, *Cicada septendecim*, which remains underground seventeen years (in the South, thirteen) before maturity.

1817 *Columbian Centinel* 14 May 1/4 The southern papers have announced that the present is the year for the appearance of what is called, in rural language, the Seventeen Years Locust. . . . The insect lives above ground about two months, and 17 years in it. **1843** *Farmers' Cabinet* 15 July 368/1 Some discussion in regard to the exact year in which the seventeen year locusts make their appearance is now going on in the various newspapers. **1907** *St. Nicholas* June 746/2 Seventeen-year locusts in emerging from their long life in the ground build similar chimneys or turrets. **1950** Calif. Acad. Sci. *News Letter* March 1 The new film, 'Animals Unaware,' contains, among other things, the interesting life history of the seventeen-year 'locust' or cicada.

Also **seventeen-year cicada.**

1870 *Amer. Naturalist* III. 106 The eggs and young of the seventeen-year Cicada. **1950** *Chi. D. News* 13 Jan. 42 The periodic or 17-year cicada lives the longest of any known insect, spending most of its life underground in the nymph stage before emerging.

sewellel sə'wɛləl, *n.* [f. *shewallal*, Chinook name for a robe or blanket made of the skins of these animals, erroneously understood by Lewis and Clark as the name of the animal, which was really called *ogwoollal*.] The mountain beaver, *Aplodontia rufa*, found in a limited area in the Pacific Northwest.

1806 LEWIS in *L. & Clark Exped.* IV. (1905) 109 *Sewelel* is the Chinook and Clatsop name for a small animal found in the timbered country on this coast. **1833** *Polit. Examiner* (Shelbyville, Ky.) 9 Feb. 2/1 The sewellel is an animal resembling the squirrel, the fur of which is highly valued by the natives. **1940** *Mt. Hood Guide* 21 Not a true beaver, the sewellel or mountain beaver, . . . finds his natural abode in burrows in the earth.

shadbush 'ʃæd‚buʃ, *n.* [See note.]

"It was called shad-bush by the settlers along the Atlantic coast because its blooming was supposed to mark the season when the shad ascended the rivers to spawn" (Clute, 23).

Any one of various American shrubs, or small trees of the genus *Amelanchier*. Cf. **Maybush, May cherry, June berry.**

1817–8 EATON *Botany* (1822) 181 *Aronia botryapium*, shad-bush, june-berry. *a*1862 THOREAU *Cape Cod* 152 The Shadbush (*Amelanchier*), Beach Plums, and Blueberries, . . . were very dwarfish. **1905** *N.Y. Ev. Post* 29 July 5 The only tree which has buds at all like that of the beech, is the shadbush or June berry, *Amelanchier Canadensis*. **1942** WEYGANDT *Plenty of Penna.* 121 That shadbush had been left for love of its bloom by some backwoodsman clearing here a hundred years ago.

b. (See quot.)

1891 *Cent.* 5539/3 *Shad-bush.* . . . The name is sometimes given (erroneously) to the flowering dogwood, Cornus florida.

Shahaptan ʃəˈhɑptən, *n.* Also **Sahaptin.** [f. *Sáptini*, *pl. Saháptini*, the Salish name for these Indians. See also quot. 1918.] *pl.* or *collect.* The Nez Percé Indians. Also the language they spoke.

1845 *Quincy* (Ill.) *Whig* 6 Dec. 2/3 The Keyuse and Nezperces, or Seheptans, . . . are represented as having made most commendable advancement in agriculture. **1918** REES *Idaho* 109 Their earliest home was upon the Columbia River and when they were pushed southward the Salish called them 'Shahaptans,' meaning 'strangers from up the river.' **1940** SMITH *Puyallup-Nisqually* 22 If he spoke Sahaptin, it is also certain that he spoke Salish. **1947** DEVOTO *Across Wide Missouri* 11 Ethnologists use the name which the Flatheads bestowed on them, the Shahaptan, of uncertain meaning but perhaps a designation of the country they lived in.

Hence **Shahaptian,** *a.*, of or pertaining to these Indians.

1903 JAMES *Indian Basketry* 261 These rare and beautiful baskets were made by the different tribes belonging to the Shahaptian linguistic stock. **1940** *Mt. Hood Guide* 25 The lands of these mid-Columbia people . . . felt the full force of conflict [with] . . . the Sahaptin tribes to the south.

Shakerism ˈʃekəˌrɪzəm, *n.* (See quot. 1859.)

1807 R. MCNEMAR *Ky. Revival* 95 If *Shakerism* were properly understood, there is no man in his senses could persecute it. **1859** GRATTAN *Civilized Amer.* II. 351 Shakerism, although the word is not legitimately adopted into the language by any good authority, is the generally received designation applied to the belief and practices of the singular sect of Christians, called Shakers, from the strange agitations and movements of their religious dances, but who call themselves the Millennial Church, or United Society of Believers. **1948** *Chi. Tribune* 23 May 13/1 Shakerism always has emphasized equality of sexes, labor, and property.

shaped notes. Also **shape notes.** *Music.* Notes whose heads are shaped (triangle for *fa*, oval for *sol*, square for *la*, diamond for *mi*, etc.) to assist those learning to sing by the old sol-fa system. Cf. **buckwheat notes.**

1932 RANDOLPH *Ozark Mt.* 248 Right hyar is whar I get in some good licks for shape-notes, too. **1943** PEATTIE *Great Smokies* 220 Presently prizes were offered in ballad and folk-song singing, fiddle contests were encouraged, the shape-note singers were received with open arms. **1945** *Chi. Tribune* 18 Nov. VII. 1/5 We sang from song books printed with old time shaped notes. **1949** *Nat. Geog. Mag.* July 23/2 So you want to know something about shape notes, do you?

sharpie ˈʃɑrpɪ, *n.* [f. the adj. *sharp*.]

1. "A long, sharp, flat-bottomed sailboat. (*Local U.S.*)" (W. '64). Also attrib.

[230]

1860 in *Outing* (1913) March 688/2, I took some of the skiffs and sharpies behind the Emma S. . . . and we went down to Whig Inlet. **1895** *Outing* XXX. 488/1 A balance-lug sail . . . was subsequently replaced by a sharpie sail and jib. **1948** *Sat. Ev. Post* 9 Oct. 140/3 Several smaller craft have been acquired, including . . . a seventy-five-year-old New Haven sharpie.

2. A sharper or cheat. *Slang.*

1942 BERREY & VAN DEN BARK *Amer. Thesaurus Slang* 422 Clever Crook . . . sharper, sharpie, sharpshooter, slicker, etc. **1944** *Chi. D. News* 4 Nov. 6/1 Central characters of both plays are engaging highbinders and sharpies who are not exactly thieves, but more than slightly overoptimistic in their use of the mails and other people's money.

Shawnee ʃɔ'ni, *n.* Also **Shawano, Shawonese,** etc. [Shawnee *Shawunogi,* southerners.]

1. A member of an important Algonquian tribe of Indians, orig. resident on the Savannah River; in *pl.* the tribe. Also attrib. and collect.

1728 in HILDEBURN *Cent. of Printing* 94 Two Indian Treaties . . . between the Honourable . . . Lieut. Governour of the Province of Pennsylvania, . . . And The Chiefs of the Conestogoe, Delaware, Shawanese and Canawese Indians. **1755** *Lett. to Washington* I. 149 The Cherokees have taken up the Hatchet against the French & Shawnesse. **1786** *Mag. Amer. Hist.* I. 177/2 Some few Shawness . . . come in frequently. **1837** BIRD *Nick of Woods* I. 15 The Shawnee and the Wyandot still hunted the bear and buffalo in the cane-brake. **1949** *Democrat* 30 June 7/4 Several Shawnee towns were set up in various places over the state [of Alabama].

b. The language of these Indians. *Obs.*

1792 BRACKENRIDGE *Mod. Chivalry* (1937) 61 It will be necessary for him only to talk Irish, which he might pass for the Shawanese.

2. In special combs.: (1) **Shawnee haw,** (see quots.); (2) **salad,** (see quot. 1822); (3) **tree,** (see quot.); (4) **wood,** (see quots.).

(1) **1909** *Cent. Supp.* 1208/3 *Shawnee-haw,* . . . the larger withe-rod, *Viburnum nudum. Shawnee-wood,* . . . the western catalpa or catawba-tree, *Catalpa speciosa.* **1948** YOUNGKEN *Pharmacognosy* 843 Substitutes and Adulterants [are] the barks of other species of *Viburnum* notably *V. nudum* L. commonly known as Shonny Haw or Shawnee Haw, *V. cassinoides* L. or With-rod, *Viburnum Lentago* L. or Sheepberry. — (2) *c*1780 in COATES *Outlaw Yrs.* 8 Gathered some herbs on the bottoms which some of the company called Shawnee Sallad. **1822** *London Hort. Soc. Trans.* 1 Ser. IV. 445 *The Hydrophyllum Virginicum* is called by the Americans of the Western States, *Indian Sallad,* or *Shawanee Sallad,* because these Indians eat it as such, when tender. Some of the first settlers do the same. **1931** CLUTE *Plants* 31 At least three plants commemorate them: the Shawnee haw (*Viburnum nudum*), the Shawnee salad (*Hydrophyllum Virginicum*), and the Shawnee tree, also called Shawnee wood (*Catalpa speciosa*). — (3) **1931** [see prec.]. — (4) **1852** *De Bow's Review* XII. 272 Shawnee wood or big-leaved cucumber (magnolia glauca)

is found. **1907** HODGE *Amer. Indians* I. 213 The western catalpa, larger Indian bean, or Shawnee wood (*C. speciosa*). **1931** [see **Shawnee salad**].

Sheep-Eaters ˈʃipˌitəz, *n. pl.* [Referring to mountain sheep.] "A division of Shoshoni said to have lived in w. central Idaho on the Lemhi fork of Salmon r., and on the Malade. . . . They numbered 90 in 1904, but are no longer separately enumerated" (Hodge). Also attrib.

1865 *Rep. Indian Affairs 1864* 175 These [Tukuarika] bands are generally known as 'the Sheep-Eaters,' and their number is estimated at one thousand. **1890** LANGFORD *Vigilante Days* (1912) 135 That notorious scoundrel . . . bought a squaw from the Sheep Eater tribe of Bannack. **1940** *Places to See in Wyo.* xiii/1 Only the Sheepeaters . . . were known to inhabit the region permanently.

shelled corn. Corn removed from the cob.

1676 *Md. Archives* II. 560 No ordinary keeper shall demand above . . . 4 lib. Tob[acco], ffor a Peck of Indian shell'd Corn. **1809** CUMING *Western Tour* 175 The usual produce of an acre of this . . . soil, is from forty to fifty bushels of shelled corn. **1950** *Chi. Tribune* 20 March IV. 1/3 The class of Illinois shippers primarily affected would be those who consign shelled corn to far western states.

*shimmy, *n.* A formerly popular jazz dance somewhat like the fox-trot accompanied by simulated shivering. Also *to shake a shimmy. Slang.*

1919 *N.Y. Sun* 16 Jan., I was dancing the shimi shiver. **1924** P. MARKS *Plastic Age* 275 That music was enough to make a saint shed his halo and shake a shimmy. **1947** PAUL *Linden* 347 Big Julie was singing 'The Old-Time Religion' with a voluptuous shimmy as part of the accompaniment.

attrib. **1948** *Time* 23 Feb. 21/2 Gilda Gray, famous oldtime shimmy dancer and *Ziegfeld Follies* star, was seriously ill at Sedalia, Colo. **1949** *Chi. Tribune* 15 Sep. 7/4 The former shimmy queen said she was married at 11, a mother at 12.

shinleaf ˈʃɪnˌlif, *n.* "A plant of the genus *Pyrola*, properly *P. elliptica*, said to be so named from the use of its leaves for shinplasters" (*Cent.*).

1817–8 EATON *Botany* (1822) 416. **1821** *Mass. H.S. Coll.* 2 Ser. IX. 154 Plants, which are indigenous in the township of Middlebury, [Vt., include] . . . *Pyrola rotundifolia*, Shin leaf. *Pyrola secunda*, One-sided shin leaf. **1903** AUSTIN *Land of Little Rain* 193 Pines raise statelier shafts and give themselves room to grow gentians, shinleaf, and little grass of Parnassus in their golden checkered shadows. **1948** *Green Bay* (Wis.) *Press-Gazette* 13 July 11/4 Huge clumps of ostrich ferns and the shin leaf could be found.

*shipper, *n.*

1. One who ships goods by land.

1840 *Niles' Reg.* 4 April 80/2 Principal transportation lines have resolved to give the shipper or owner the full advantage of the reduction of twenty cents per barrel [of flour]. **1923** BLAISDELL *F. T. Comm.* 268

In the case at issue the steel companies were held to be only shippers —customers of the railroads. **1950** *Chi. Tribune* 21 March 4/6 Dr. O. W. Seher, head of federal meat inspection in Chicago, said his department . . . would ask indictment of two of the shippers.

2. A commodity that is shipped or suitable for shipping.

1881 *Tenth Census* III. III. 19 English s ippers consist of leaf and strips. **1887** *Courier-Journal* 19 Jan. 8/1 For the best quality Clarksville or Harkinsville district shipper, $50 [was] awarded to Mr. Hana.

shivaree ˌʃɪvəˈri, *n.* [Variant of * *charivari, n.*] A noisy demonstration, esp. as a serenade for a newly wedded couple, a racket, a confused medley of noises.

"The present distribution of *shivaree* and other terms for the custom is shown on the accompanying map. It is common to all of Canada and much of the United States. Only in the Eastern seaboard states and parts of the South is the word seldom encountered" (*Amer. Sp.* Dec. 1949, 251).

1843 CARLTON *New Purchase* II. 231 The musicians . . . [let] off at each repetition of the demand peals of shiver-ree. **1850** A. T. JACKSON *Forty-Niner* (1920) 23 The boys . . . gathered and gave the couple a shivaree. **1949** *Time* 25 July 34/2 The custom of noisily serenading a couple on their wedding night is called a *shivaree* (from the French *charivari*) in the Mississippi Valley, *belling* in Western Pennsylvania, *skimmelton* in the Hudson Valley, *horning* in Rhode Island.

shoepack ˈʃuˌpæk, *n.* Also **shoepac.** [Rationalized f. Lenape *shipak* (<*machtschipak*, bad shoe, as compared with a moccasin).] A shoe somewhat like a moccasin (see quots. 1824, 1917). Cf. **pack,** *n.*

1755 *Lett. to Washington* I. 99 It would be a good thing to have Shoe-packs or Moccosons for the Scouts. **1824** J. DODDRIDGE *Notes* 144 Those who could not make shoes, could make shoepacks. These like mocassons were made of a single piece of leather with the exception of a tongue piece on the top of the foot. This was about two inches broad and circular at the lower end. To this the main piece of leather was sewed, with a gathering stich. The seam behind was like that of a mocasson. To the shoepack a soal was sometimes added. **1917** KEPHART *Camping* I. 157 A 'shoe-pac' or 'larrigan' is a beef-hide moccasin with eight to ten-inch top, and with or without a light-flexible sole. **1949** *Boston Globe Mag.* 18 Dec. 8/1 Pulling on high, laced shoe-packs, he studied the pre-dawn sky with thoughtful brown eyes.

* **shop,** *v.*

1. *tr.* To dismiss or "fire" (a person). *Slang.*

1915 H. L. WILSON *Ruggles of Red Gap* iv. (1917) 76 It seemed probable that I should be shopped by Mrs. Effie for what she had been led to believe was my rowdyish behaviour. *Ib.* xvii. 308, I would have shopped the fellow in an instant, . . . had it been at any other time. He was most impertinent. **1928** E. WALLACE *Gunner* xiv, If you'd done any jobs with him, as sure as death he would have shopped you.

2. *To shop around*, to look around in quest of something.

1922 J. D. HACKETT in *Management Engineering* Feb., During the war, although orders greatly exceeded production, absentism increased. Men took days off to 'shop around,' knowing that if unsuccessful they would be welcomed back. **1931** *K.C. Times* 8 Aug., Aw, well then, we'll shop around a bit.

Shoshoni ʃəˈʃonɪ, *n.* [See note.]

"The origin of the term Shoshoni appears to be unknown. It apparently is not a Shoshoni word, and although the name is recognized by the Shoshoni as applying to themselves, it probably originated among some other tribe" (Hodge, II. 556/2). Cf. quot. 1918 below.

An Indian of a northern tribe of the Shoshonean branch of the Uto-Aztecan family; also, *pl.*, the tribe.

1805 LEWIS in *L. & Clark Exped.* II. (1904) The Shoshoenes may be estimated at about 100 warriors. **1848** BRYANT *California* xi. 152 One of the men called himself a Utah, the other a Shoshonee or Snake. **1918** REES *Idaho* 111 The name comes from two Indian words, 'Shawnt,' meaning 'abundance,' and 'shaw-nip,' 'grass,' which was etymologically changed to the euphonious name Shoshoni and in English conveys the thot of 'abundance of grass.' **1947** *Desert Mag.* Dec. 32/3 The Washoes . . . have long been of interest to anthropologists because their language differs so radically from that of the Paiutes and Shoshones.

attrib. **1806** LEWIS in *L. & Clark Exped.* V. (1905) 4 The Shoshone man was displeased because we did not give him as much venison as he could eat. **1881** ROMSPERT *Western Echo* 358 Small parties of Indian squaws, girls, papooses, and some old men, of the Shoshone and Winnemucca tribes, . . . would run along each side of the train and ask for biscuits. **1944** ROSS *Westward* 93 Sacajawea helped to guide the Lewis and Clark Expedition across America and back in 1804–6. It is now accepted as historical fact that without this young Shoshone slave President Jefferson's two adventurous envoys, with their twenty-nine picked men, would never have come through to the Western Ocean. **1950** *L.A. Times* 19 Feb. v. 8/1 The savage Shoshone Indians finally came over from Lake Hughes, drove out the Paiutes and slaughtered their herd of sheep.

b. The language of these Indians. *Obs.*

1843 MARRYAT *M. Violet* xiv, I addressed him in Shoshone, which beautiful dialect is common to the Comanches, Apaches, and Arrapahoes.

Shriner ˈʃraɪnɚ, *n.* A member of the Order of Nobles of the Mystic Shrine, established in the U.S. in 1872.

1889 in *Hist. Imperial Council* (2nd. ed. 1921) 92 His name was used as 'one of the original Thirteen Shriners' that were mentioned as the formative Body who instituted the Mystic Shrine in 1871. **1904** *Pittsburgh Gaz.* 14 July 10 Many bands were composed entirely of Shriners, robed in gaudy yet beautiful costumes of the lands of Mohammed. **1949** *Chi. D. News* 13 Aug. 5/7 We saw many out-of-town visitors—Shriners and Legionnaires.

shuck collar. *S.* A cheap homemade horse collar of selected shucks plaited into heavy strips which are then suitably placed beside each other and securely sewed. Also **shuck horse collar.** Cf. **flag collar.**

1781 *Va. State P.* I. 589 Many of these horses are sent with 'shuck-collars.' **1841** [see **shuck-bottomed chair**]. **1896** READ *Jucklins* 128, [I saw] . . . a red-looking negro, with a string of shuck horse collars. **1944** CLARK *Pills* 278 A fifty-cent shuck collar was good enough for an ordinary plow mule, but a sturdier collar was desirable for heavier work.

shyster 'ʃaɪstə, *n.* [Prob. f. some G. slang term based on *scheisse,* excrement. Cf. *scheisserei, scheisser, scheiss-kerl.*]

1. A term of contempt for an unscrupulous, tricky, mean person, often applied to lawyers. *Slang.*

1846 *Subterranean* (N.Y.) 11 July 2/4 *Shyster.* 'That we can't do, you know, as it is opposed to all precedent.' **1857** *Spirit of Times* 1 Aug. 344/1 A party guilty of suing for his stakes back, when given up by the stake-holder of his opponent, is a 'shyster,' and should be put in Coventry, and warned off the course. **1876** *Wkly. Comanche* (Tex.) *Chief* 22 June 2/1 It costs an editor $15 to call a Buffalo lawyer a 'shyster.' **1923** CATHER *Lost Lady* 104, I suppose it takes longer to make an architect than it does to make a shyster. **1949** J. MONAGHAN *This is Ill.* 90 He had known . . . shysters, pickpockets, loafers.

attrib. **1870** MEDBERY *Men Wall St.* 123 Not a few individuals of the 'shyster' class . . . are ready to break their word. **1872** MARK TWAIN *Roughing It* 487 Next we come to his Excellency the Prime Minister, . . . a lawyer of 'shyster' caliber. **1875** *Chi. Tribune* 2 Nov. 4/6 There are also some miscellaneous provisions directed against shyster corporations.

2. shyster lawyer, a lawyer of a low, pettifogging type, devoid of professional honor. *Colloq.*

1849 G. G. FOSTER *N.Y. in Slices* 20 He must . . . wait next day for the visits of the 'shyster' lawyers—a set of turkey-buzzards whose touch is pollution and whose breath is pestilence. **1923** VANCE *Baroque* 176 His shyster lawyer . . . called on me one day to protest against what he was pleased to term my persecution of his client. **1950** *Dly. Oklahoman* (Okla. City) 23 March 18/3 Behind this commercialized vice racket were grafting politicians . . . , shyster lawyers . . . , and unscrupulous property owners.

side judge. (See quot. 1889.)

1846 *Knickerb.* Oct. 360 The attorneys . . . in company of the supreme court judge and the 'side-judge,' take the opportunity of having a bit of fun. **1889** *Cent.* 3247/1 *Side judge,* a designation sometimes given to a magistrate, or each of two magistrates, of inferior rank, associated with a magistrate of higher grade for the purpose of constituting a court. **1914** *Cyclo. Amer. Govt.* III. 308/2 In Pennsylvania there has been from early times a system of judges not learned in the law, who sit beside the regular judge. . . . The side judges have little influence on the decision of cases, for they cannot lay down any principles of law before the jury.

Sierran sɪˈɛrən, *a.* and *n.*

1. *n.* A native or inhabitant of the Sierra Nevada Mt. region; also a member of the Sierra Club.

1906 *Out West* May 393 About one hundred Mazamas, Appalachians and Sierrans were gathered around a camp-fire. **1923** *Outing* April 28/2 Equipped with these data, a compass and a set of maps, the dauntless, city-bred Sierran plunged daily into the fastnesses of the mountains. **1948** *So. Sierran* Feb. 1/3 Many Sierrans who hiked the trails twenty and more years ago, will be interested to know what has happened to one of their favorite gathering places, Colby's Ranch.

2. *a.* Of or pertaining to the Sierra Nevada Mts.

1873 HARTE *Stories & Poems* (1914) 216 It was in a Sierran solitude, where I had encamped. **1886** ——— *Snow-bound* 3 Darkness had accompanied a Sierran stage-coach towards the summit. **1902** *Out West* Oct. 440 The tender herbage of the high Sierran meadows is not sustaining. **1947** *Sierra Club Bul.* March 7/2 The earlier expedition followed one of the heaviest of recent winters, and was more arctic than Sierran.

* **silent,** *a.* In combs.: (1) **silent partner,** a partner who is not active in the management of a firm; (2) **system,** (see quot. 1891), cf. **Auburn system;** (3) **vote,** the vote of those whose choice cannot be predicted, also **silent voter.**

(1) **1828** WEBSTER, *Silent, . . .* not acting; not transacting business in person; as a silent partner in a commercial house. **1898** *McClure's Mag.* X. 499/1 In this firm J. D. Fish, president of the Marine Bank, was to be a silent partner. **1946** FOREMAN *Last Trek* 127 The collections in the Indiana State Library are replete with references to 'silent partners.' — (2) **1836** T. POWER *Impressions of Amer.* I. 226 Auburn, celebrated for its prison, regulated upon what is called the 'silent system.' **1891** *Cent.* 5628/1 *Silent system,* a system of prison discipline which imposes entire silence among the prisoners, even when assembled together. — (3) **1884** *Judge* 12 Nov. 149/2 To the Silent Voter, who was to make himself Felt for Cleveland: Tell me where you are and all will be forgiven. **1934** WEBSTER. **1936** *Durant* (Okla.)*D. Democrat* 2 Nov. 2/4 The regents and police pensions amendments have the best chances of carrying, but even they are endangered by the 'silent vote.'

silvertip ˈsɪlvɚ͵tɪp, *n.* A grizzly bear with hairs silvery-colored at the tips. Also **silver-tipped bear, silvertip grizzly.**

1880 *Rep. Supt. Yellowstone Nat. Pk.* 40 Silver-tipped bear.—This animal is nearly destitute of a mane, and is somewhat smaller, less powerful and ferocious than the true grizzly. **1890** *Outing* Aug. 381/1 The 'silver tip' was surprised at a banquet of 'service berries' and killed by a single well directed bullet. **1923** J. H. COOK *On Old Frontier* 138, I caught sight of a very large silver-tip grizzly lying down. **1947** DEVOTO *Across Wide Missouri* 113 Their companions succeeded in killing the silver-tip with four more shots.

Sioux su, *n.* [F., shortening of *Nadowessioux,* from

Chippewa *Nadowessi*, "little snake, enemy."] *pl.* The largest and best-known of the Indian tribal groups of the Siouan stock. Cf. * cutthroat 2, Yankton Sioux.

1805 LEWIS in *L. & Clark Exped.* I. (1904) 258 The Indians in our neighbourhood are frequently pilfered of their horses by the Ascares, Souixs and Assinniboins. **1865** *Cin. D. Gazette* 3 Oct. 3/6 It is thought, however, that the Sioux and Cheyennes are not half whipped. **1946** *Sat. Review* 8 June 37/3 The historical section also shows how the Sioux could weather the disappearance of the buffalo.

attrib. **1808** PIKE *Sources Miss.* 14 His design was to winter with some of the Sioux bands. **1853** *La Crosse Democrat* 17 May 2/6 Persons wishing to locate in the valley of the Root River [in eastern Minnesota] or on any part of the 'Sioux Purchase' will find the route . . . far more convenient. **1872** *Chi. Tribune* 25 June, The characters are a mixed set having among them guerrillas, trappers, Sioux braves [etc.]. **1949** *10 Story Western* May 39/1 The little party of Sioux hunters stopped by the Yellowstone, just below its confluence with the Rosebud.

Also, *sing.*, an Indian belonging to a tribe of this group. In full **Sioux Indian.**

1827 COOPER *Prairie* xxx, The keen weapon . . . meeting the naked breast of the impetuous Sioux, the blade was buried to the buck-horn haft. **1945** *Reader's Digest* April 69 In Deadwood, S.D. Mike Turning Bear, a Sioux Indian, was charged with stealing 20 head of horses.

b. The language of these Indians. In full **Sioux language.**

1915 YOUNG *Hard Knocks* 78 My Indian friend . . . began to talk Sioux to them in an excited manner. **1932** VESTAL *Sitting Bull* 22 The meadowlark, in particular, speaks such good Sioux that it is known as the Sioux bird. **1949** *Amer. Photography* Jan. 40/1 Following a speech in Sioux language, in which God was asked for rain, the real Sun Dance now started.

sixteenth section. In a surveyed township, the section numbered sixteen, granted to the state by the federal government for school purposes. Also attrib. Cf. **reserved section, school section.**

1785 *Jrnls. Cont. Cong.* XXVIII. 378 There shall be reserved the lot N 16, of every township, for the maintenance of public schools, within the said township. **1837** WETMORE *Gaz. Missouri* 72 This mine is on a tract of school-lands, commonly called sixteenth section. **1880** *Cimarron News & Press* 9 Sep. 2/1 Under our organic law each 16th and 32d section of public land is reserved for school purposes. **1914** *Cyclo. Amer. Govt.* III. 256/1 The states admitted between 1802 and 1848, except Texas, received the 16th section in each surveyed township of public domain. **1949** *Democrat* 8 Sep. 8/3 All state-owned lands, including the sixteenth section school lands, are public and are sanctuaries for wild life.

skijoring skɪˈdʒorɪŋ, *n.* [Norwegian *skigjöring*, "skidoing."] A winter sport in which a skier is pulled along

over ice or snow by a horse or an automobile. Also attrib. or as adj.

1910 *Country Life* Dec. 205/1 In January . . . there are skee-jumping, . . . skee-joring and horse racing. **1935** *Denver Post* 25 Feb. 16/4 Thor Groswold, well known in the skiing world, captured the *ski-joring* race, an added event. **1939** Union Pac. R.R. *Snow Sports* 17 Charges for sports in the valley are, . . . ski-joring (horses for ski-joring, with experienced driver) $2.00 per hour or $1.00 for half hour.

Also **skijor,** *v. intr.*

1942 PEATTIE *Friendly Mts.* 293 At Saranac Lake they skijor by automobile. **1947** *Steamboat* (Colo.) *Pilot* 13 Feb. 2/8 Some of the boys skijored into town from there.

skoke skok, *n.*[1] [Massachuset *m'skok*, that which is red.] = **pokeweed.** Also attrib.

1778 CARVER *Travels* 517 Gargit or Skoke is a large kind of weed, the leaves of which are about six inches long. **1846** WHITCHER *Bedott P.* v. 50 She said he must take skoke berries and rum right off. **1949** *Nature Mag.* April 194/1 Folklore has it that the young shoots of skoke, or inkberry, or pokeweed are delicious.

skunkery ˈskʌŋkərɪ, *n.* A place where skunks are bred for their furs.

1890 *Stock Grower & Farmer* 21 June 6/2 The skunkery is paying 200 per cent on the capital invested. **1897** *Boston Transcript* 11 Sep. 24/3 Minks have been bred for their skins in so-called minkeries, just as is being done with the skunks in what might be termed skunkeries. **1902** *Amer. Folk-Lore* 258 Interesting also are *skunkery* and *skunk*-farm, applied to places where skunks are kept or raised for profit.

slapstick ˈslæpˌstɪk, *n.* A large paddling implement consisting of two boards hinged at one end but loose at the other, used by clowns and actors in low comedy to deal other performers light but resounding whacks. Also low comedy or farce such as that in which such contrivances are used.

1896 *N.Y. Dramatic News* 4 July 9/3 What a relief, truly, from the slap-sticks, rough-and-tumble comedy couples abounding in the variety ranks. **1907** *Weekly Budget* 19 Oct. 1/2 The special officer in the gallery, armed with a 'slap-stick,' the customary weapon in American theatre galleries, made himself very officious amongst the small boys. **1949** *Sky Line Trail* Oct. 27/1 A laugh-laden pageant of everything from mock tragedy to slap stick comedy, the show brought out talents hitherto unsuspected.

* **sleep,** *n.* Among Indians or in imitation of them: A day, the measure of time between one sleeping period and the next.

1670 *S.C. Hist. Soc. Coll.* V. 166 The Caseeka . . . was within one sleep of us. **1761** NILES *Indian Wars* II. 582 He proposed . . . to return in 10 nights, or sleeps. **1844** GREGG *Commerce of Prairies* II. 298 Distances are represented by days' journey, which are oftener designated

by camps or 'sleeps.' **1919** CODY & COOPER *Buffalo Bill* 312 It was many sleeps away. **1947** *Steamboat* (Colo.) *Pilot* 2 Jan. 6/4 He held up two fingers and said in a voice that did not seem to waver: 'Maybe so. Two sleeps more, you git out.'

sleighing \'sle·ɪŋ, *n.*

1. Riding in a sleigh for pleasure; the condition of the snow or ice that permits this.

1764 J. ROWE *Diary* (1903) 71 Went with Mrs Rowe a Slaying. **1772** *Boston Gaz.* 3 Feb. 3/2 Another considerable Quantity of Snow falling, enough to give us the prospect of Sledding, and also Sleying (as it is called) again, brings to my mind a scene I was witness to about three weeks ago past. **1832** WILLIAMSON *Maine* I. 100 During the whole of it [January], in many years, the sleighing is poor. **1947** *N.Y. Times Mag.* 2 Feb. 18/3 Grandfather, with whom I did my sleighing, had a Morgan horse.

2. In combs.: (1) **sleighing party,** a number of people taking a sleigh ride together, the occasion of such an amusement; (2) **time,** a time suitable for sleighing.

(1) **1775** BURNABY *Travels* 88 In the winter, when there is snow upon the ground, it is usual to make what they call sleighing parties. **1807** *transf.* **1948** *Nat. Geog. Mag.* Aug. 213/1, I stood up . . . to see if the riffle had a 'slick,' an opening in the rocks where most of the water pours through in a smooth V pointed downstream. **1949** *Sat. Ev. Post* 14 May 102/4 Each of 'em's got a rubber bag full o' bright yeller, stain—marker dye, I think they call it. An' when a flier's forced down he releases it an' it makes a bright yeller slick, so's he can be spotted easy from the air an' mebbe picked up. See?

4. *W.* (See quots.) Also **slick ear.**

1890 *Stock Grower & Farmer* 12 July 6/3 Seven of them were branded, the remainder were 'slicks,' or horses which had run wild from birth. **1926** BRANCH *Cowboy* 52 They found in their herds 'slick ears,' as they called those yearlings that had been missed in the round-ups of the season before. **1934** LOMAX *Amer. Ballads* 411 No Maverick or slick will be tallied In that great book of life in His home. **1947** PRICE *Trails I Rode* 72 Any man not belonging to the big outfits that got a slick ear (a maverick) was branded in a lot of people's minds as a cattle rustler.

5. = **laurel slick.**

1934 WEBSTER. **1949** *Nature Mag.* Nov. 422/2 In North Carolina the rhododendron jungles go by the name of 'slicks.'

✳ **slit,** *a.* **1. slit skirt,** a divided skirt, for use by women when cycling or riding horseback. **2. slit work,** *collect.* thin boards cut from larger boards or from logs. *Obs.*

(1) **1934** WEBSTER. **1944** CLARK *Pills* 202 Slit skirts came into style with the bicycle and ladies began riding their horses like men. — (2) **1636** *Springfield Rec.* I. 160 For ye sawinge of all ye boards & slit worke [etc.]. **1713** *Topsfield Rec.* I. 180 Carry Logs to Saw-Mills to make . . . Slit work. **1815** *Mass. H.S. Coll.* 2 Ser. IV. 55, 70,000 feet of boards, plank and slitwork were cut at the saw mill in the same year.

*** slough,** *n.* Also †**slow,** †**slew,** †**sloo,** †**slue.**

1. A comparatively narrow stretch of backwater; a sluggish channel or inlet, a pond.

1665 *Springfield Rec.* II. 216 There is grannted to Inhabitants of Skeepmuck a highway from ye Slow beyond the Swan pond. **1714** *Charlestown Land Rec.* 217 The said Hunewell hath incroached & inclosed of the high way against his Orchard: between his old house & the Slough or Small Bridge. **1845** N. F. MOORE *Diary* (1946) 22 We entered the slough (pronounced here sloo) which brought us out into the Mississippi. **1950** *Chi. Tribune* 10 Jan. 18/3 At 11:57 a.m. on New Year's day, I saw my first robin, near Katydid slough at Willow Springs.

2. In combs.: (1) **slough bass,** (see quot. 1888); (2) **grass,** any one of various tall, stout grasses suited to low, wet lands (see quots.); (3) **hay,** hay made of slough grass; (4) **shooting,** shooting (birds, etc.) in a low, wet region.

(1) **1881** J. A. HENSHALL *Bk. Black Bass* 142 Slough bass. **1888** *Wildwood's Mag.* (Chi.) June 64 In the north and west both species are known as 'bass,' with the addition of various adjectives expressive of gameness, coloration, or habitat, as 'tiger-bass,' . . . Yellow-bass; . . . moss, slough, or marsh-bass. — (2) **1860** *Ill. Agric. Soc. Trans.* IV. 488 Then [I] make a band of whatever material I have at hand, (slough grass is preferable). **1880** BESSEY *Botany* 355 *Muhlenbergia glomerata* and *M. Mexicana* constitute the 'Fine Slough Grass' of the Mississippi valley prairies. **1948** *Annals Iowa* July 380 On top of the banked-roof was a layer of loose 'slough grass,' to keep out the rain. — (3) **1871** *Ill. Agric. Soc. Trans.* VIII. 172 The entire bed should be covered with coarse prairie or slough hay. — (4) **1894** *Harper's Mag.* Aug. 457/1 If slough-shooting has a drawback, it is its lack of action.

b. Also **slough bridge, pig, soil, water.**

1874 LONG *Wild-Fowl* 150 Lager-beer . . . is much better to drink than slough-water. **1883** SMITH *Geol. Survey Ala.* 269 *Black prairie slough soil,* eight miles south of Montgomery. *Ib.* 272 The bottom soils . . . [vary] from the stiff black prairie slough lands . . . to light and rather sandy loams. **1905** *Forestry Bureau. Bul.* No. 61, 48 *Slough pig,* usually a second-rate river driver who is assigned to picking logs out of sloughs in advance of the rear. (N[orthern] F[orest].) **1945** BOTKIN *My Burden* 20 They pass the Ku Kluxes right on the slough bridge.

*** slush,** *n.*

1. Rubbishy literature. Also attrib.

1896 *Daily News* 23 Jan. 6/1 Two stout volumes of what the American editor would have called 'delirious slush.' **1916** B. M. BOWER *Phantom Herd* vii. 112 You want those stories worked up in a lot of darned, sickly slush melodramas.

2. In special combs.: (1) **slush fund,** in the Army and Navy, a fund derived from selling refuse fat, grease, etc., and used to get small luxuries for the men, also a contingent fund appropriated by Congress, and ad-

ministered at the discretion, usu., of the Secretary of the Treasury, in later use, a fund for bribery, corruption etc.; (2) **investigation,** an investigation with reference to funds for bribery and corruption; (3) **money,** money for surreptitious purposes.

(1) **1864** *Rio Abajo Press* 5 July 2/2 The polite Commissary informed us that they received twelve dollars a barrel for the [coffee] grounds, and thus added materially to the 'slush fund.' **1874** *Cong. Rec.* 17 April 3166/1 We have had this 'slush-fund' since 1866. **1938** ASBURY *Sucker's Prog.* 299 They gave liberally to a slush fund which he collected periodically and distributed where it would do the most good. — (2) **1929** *Chi. Tribune* 30 Jan. 1/8 The state capital shared with Chicago in the developments of the Sanitary district pay roll slush investigation yesterday. — (3) **1842** J. F. COOPER *Wing-and-Wing* II. 20 They were only put there yesterday . . . a little slush-money did it all.

smarty 'smɑrtɪ, *n.* and *a.*

1. *n.* A smart aleck *q.v. Colloq.*

1861 *Calif. Mag.* Aug. 39/2 'Juvenile smartys' are interesting, even to a vagabond. **1903** *Outing* April 51/2 Grace turns her head on those 'smarties.' **1947** *Atlantic Mo.* Oct. 60/2, I called him Smarty because he was an awful sassy customer and used to talk back a lot.

2. *a.* Having the characteristics of a smarty. *Colloq.*

1883 MARK TWAIN *Life on Miss.* xxxiii. 370 In the old times, the barkeeper owned the bar himself, and was gay and smarty and talky. **1913** *Good Housekeeping* Nov. 202/2 Once I was 'smarty' just to see How *very* 'smarty' I could be.

smearcase 'smɪr‚kes, *n.* [G. *Schmierkäse,* cheese for smearing on (something).] = **cottage cheese.**

1829 ROYALL *Pennsylvania* I. 171 A dish, common amongst the Germans, . . . is curds and cream. It is very palatable, and called by the Germans *smearcase.* **1835** *Vade Mecum* (Phila.) 31 Jan. 2/7 Drink Champagne, and eat smear-cases. **1894** *Harper's Mag.* Jan. 218/2 The 'cookey' (koekje), noodles, hodgepodge, smearcase, rullichies, cold-slaw, and other dishes that survive in New England. **1949** *Sat. Ev. Post* 23 April 80/3, I took large helpings of ham and potatoes, *schmierkase,* and green salad with tomatoes.

*** smithy,** *n.* A blacksmith. Also **village smithy.**

This sense apparently has arisen through a misunderstanding of the word in Longfellow's "The Village Blacksmith" (see quot. 1839 below, and *Amer. Sp.* XVI. 151–2).

[**1839** LONGFELLOW *Poetical Works* (1893) 14/2 Under the spreading chestnut tree The village smithy stands.] **1847** *Graham's Mag.* April 262/1 Was he some Smithy, grim and old, Whose anvil iron changed to gold? **1900** *Everybody's Mag.* Jan. 36/2 The smithy and his mate opened their 'establishment' within a few hours of their arrival, and did a 'roaring trade.' **1945** *Nat. Geog. Mag.* Jan. (*advt.*), Far more wondrous is his mastery over metals than that of his storied ancestor . . . the village smithy.

*snail, *n.* 1. Any oyster drill, as *Urosalpinx cinerea.*
Also snail bore. 2. snail bird, hawk, the everglade kite,
Rostrhamus sociabilis plumbeus, which feeds on snails.

(1) 1881 INGERSOLL *Oyster Industry* 248 *Snail-Bore.*—Mollusks of
the genus *Urosalpinx,* etc. (New Jersey.) 1884 GOODE *Fisheries* I. 696
These small 'Snails,' 'Drills,' 'Borers,' and 'Snail-bores,' as they are
variously called, belong to several species. — (2) 1917 *Birds of Amer.*
II. 63 Everglade Kite. . . . Snail Hawk. . . . Tropical Florida. 1942
Nat. Pk. Service *Fading Trails* 167 Cne victim of the sudden recession
of 'glades water was the Everglade kite or snail bird.

snake feeder. A dragonfly (see also quot. 1891).

1861 *Ill. Agric. Soc. Trans.* IV. 34 [Suppose] we wished to multiply,
artificially, the number of a particular species of *dragon-fly,* or *snake-
feeder.* 1883 RILEY *Old Swimmin'-H'ole* 11 The snake-feeder's four
gauzy wings fluttered by. 1891 *Cent.* 5725/2 *Snake-doctor,* . . . the
dobson or hellgrammite. . . . Also [in Ohio] *snake-feeder.* 1904
STRATTON-PORTER *Freckles* 219 The snake-feeders are too full to feed
anything—even more sap to themselves. 1949 KURATH *Word Geog.
Eastern U.S.* 14/1 The line of demarcation over against the Midland
snake feeder is remarkably clear and sharp.

*snatcher, *n.* 1. The conductor of a horsecar. *Slang.
Obs.* 2. (See quot. 1932.) *Slang.*

(1) 1885 WHITMAN in *N. Amer. Rev.* Nov. 434, What did you do
before you was a snatcher? 1886 ——— *November Boughs* 406 The
conductor is often call'd a 'snatcher' (i.e. because his characteristic
duty is to constantly pull or snatch the bell-strap, to stop or go on). —
(2) 1932 *Tulsa D. World* 7 March 10/5 'Snatchers' or kidnapers have
not been as busy in Tulsa as they have in other cities. 1949 *L.A. Times*
17 May IV. 4/6 He owned the car used by the snatchers.

*snipe, *n.*

1. In miscellaneous colloq. and slang uses: a. (See
quot. 1900.) b. A cigar or cigarette butt. c. (See quot.)

(a) 1870 MEDBERY *Men Wall St.* 131 In street *argot,* they are
'snipes' and 'lame ducks.' 1900 NELSON *A B C Wall St.* 159 *Snipe,* an
obsolete term for a curbstone broker. — (b) 1889 *N.Y. Herald* 2 Jan.
4/4 Farewell, old year; adieu, dear pipe; Goodbye, cigar; goodbye,
old 'snipe.' 1899 FLYNT *Tramping* 397 *Snipe,* cigar-butts. 1931 *K.C.
Star* 9 July, He'll be darned if he is going to shoot cigarette snipes. —
(c) 1906 *N.Y. Ev. Post* 21 Feb., 'Snipes,' in the vernacular of the Pan-
handle and the Santa Fé, are . . . section men.

2. snipe hunt, hunting, a prank played upon one
not familiar with the sport in which, under the guise of
having him hold a bag for snipes to run into, he is left at
night in a lonesome or disagreeable place. Also fig.

1904 FLEMING *Documents re. Reconstruction* No. 2. 3 And one of the
night games was much like 'snipe hunting.' 1934 *Chi. D. News* 10 Jan.
7/1 There are times when reporters are holding the bag in an off the
record snipe hunt.

snowplow 'sno͵plau, *n.*

1. Any one of various plowlike contrivances for removing snow from a road or railroad.

1792 BELKNAP *Hist. New-Hampshire* III. 79 When a deep snow has obstructed the roads, they are in some places opened by an instrument called a snow plough. It is made of planks, in a triangular form, with two side boards to turn the snow out on either hand. **1848** *Amer. R.R. Jrnl.* 13 May 305 This apparatus is said, by the inventor, to answer for a *snow-plough* as well as *cow-remover.* **1950** *L.A. Times* 26 March 1/3 Snowplows were used to clear roads in the San Jacinto Mountains.

attrib. **1943** *Amer. City* Aug. 47/3 There are also 46 water sprinklers to which snow-plow blades are attached in winter for this work.

2. In skiing, an act or instance of slowing down or stopping by spreading the rear ends of the skis outward from the line of progress, pressure being exerted on the heels. Also attrib.

1939 WEBSTER (*New Words*). **1947** *Mazama* Jan. 1/2 This could be a giant slalom with wide gates that a good snowplow can negotiate, but stiff enough so there will be real competition. **1948** *Ib.* Feb. 1/1 The class was well attended and all were doing snowplow turns at the end of the session.

social library. A library maintained, either by ownership of shares or by payment of subscription fees, by the particular group of persons entitled to use it. Cf. **society library** (*a*).

*c*1765–80 *N. Eng. Hist. & Gen. Reg.* XXII. (1868) 446 We the Subscribers being desirous of purchasing a *Social Library* . . . do severally promise and engage to pay Four Dollars a piece for this purpose. **1809** E. A. KENDALL *Travels* II. 244 In Franklin Place, apartments are occupied by the Boston Social Library, and by the Massachusetts-Historical Society. By *social* is here intended *society;* for, by a perversion of language, the *society-libraries*, of which some account has been given in a former chapter, are so called. **1910** BOSTWICK *Amer. Pub. Library* 7 The joint-stock form of library is in its simplest form a book club, as in the so-called 'social libraries' of Massachusetts.

soda fountain.

1. A container from which soda water is drawn off by faucets. Also a counter at which soda water and other soft drinks, as well as light meals, are served.

1824 *Independent Chron.* (Boston) 9 Oct. 3/3 This luxury in a hot and dusty season, together with an ever-flowing Soda Fountain, . . . he flatters himself will ensure a continuance of public patronage. **1855** *Chi. W. Times* 5 July 3/5 The kind-hearted knight of the soda fountain . . . handed her $5. **1920** LEWIS *Main Street* 34 In the Greek candy-store was . . . a greasy marble soda-fountain. **1950** *N.O. Times-Picayune Mag.* 16 April 6/3 About the most striking gadget inside is the soda fountain, nearly 100 years old, originally used in Philadelphia.

attrib. **1876** *Napa* (Calif.) *Reg.* 29 July 4/2 A Woodward avenue drug-store hired a new soda-fountain boy the other day. **1950** *Lincoln Co. Advt.* (Brookhaven, Miss.) 12 Jan., Bill flunked out and has since held jobs briefly as car salesman, oil-station attendant, soda-fountain clerk, hotel night-desk man.

2. *W.* A spring of mineral water containing soda. Also as a proper name.

1842 J. BIDWELL *Trip to Calif.* 10 A distance of 10 miles took us to the Soda Fountain, where we stopped the remainder of the day. This is a noted place in the mountains and is considered a great curiosity. **1878** BEADLE *Western Wilds* 372 The soda-fountains . . . boil furiously with a loud, bubbling noise.

Soledad pine. [f. *Soledad* (Sp., solitude) River, Calif.] = **Torrey pine.**

1908 SUDWORTH *Forest Trees Pacific Slope* 41 Torrey Pine; Soledad Pine. **1927** ———— *Check List Forest Trees* 16 Torrey Pine. Range. — Southern California (coast near Soledad River in San Diego County); also on Santa Rosa Island. Names in use Soledad Pine (Calif.) [etc.]. **1950** *Amer. Forests* Jan. 19/2 Known also as Soledad pine, Del Mar pine and lone pine, this rare tree is found only in open, scattered stands on the highlands adjacent to the sea.

soot tea. (See quots. 1877, 1926.)

For an indication of the antiquity and prevalence of the idea that soot is a healing agent see *Handwörterbuch des Deutschen Aberglaubens s.v.* Russ. Cf. *cinder tea* in *OED.*

1842 C. M. KIRKLAND *Forest Life* I. viii. 71 We stick to thoroughwort,—balmony,—soot tea,—'number six,'—and the like, and avoid, as if for the very life, all 'apothecary medicines.' **1877** BARTLETT 627 *Soot-Tea*, a decoction of soot taken from a chimney, believed by some old grannies to be a sovereign remedy for the colic or cholera. **1926** *Bur. Amer. Ethnology Rep.* XLIII. 267 'Soot tea' is given [by Mohegan Indians] to infants to relieve colic. It is prepared by pouring boiling water over a small quantity of soot.

sots sɑts, *n. local.* [G. *satz*, sediment, dregs, in Pa.-G. sense shown here.] A leavening agent made from hops.

1799 WELD *Travels* 65 They raise it with what they call sots; hops and water boiled together. **1817** *Niles' Reg.* XII. 165/2 The result was . . . that kind of rising called here 'sotts,' a Dutch term, I presume. **1902** CLAPIN 377 *Sots.* Yeast is so called, in Virginia and Pennsylvania. **1945** *Amer. Sp.* Dec. 254 In their own home district the regionalisms *ponhaus, snits, sots* . . . and a host of others are accepted by the natives of Southern Pennsylvania quite as naively as quaint New England provincialisms.

sousaphone ˈsuzəˌfon, ˈsusəˌfon, *n. Music.* A form of tuba used in brass bands, so called after J. P. Sousa (1854–1932), the American bandmaster who originated it.

1934 WEBSTER. **1936** *Sears Cat.* (ed. 173) 785 Supertone Sousaphones . . . Double B-flat—Full, rich sonorous tone. Bell and mouthpiece are adjustable . . . 52 inches high, 24-inch detachable bell, playing weight

$26\frac{1}{2}$ pounds. **1950** *World-Herald Mag.* (Omaha) 16 April 18/2 The sousaphone was likewise named for the famous march king, John Philip Sousa.

Southern Confederacy.

1. A discussed or contemplated confederacy embracing the southern portion of the U.S. *Obs.*

1788 MADISON *Writings* V. 80, I have for some time considered him as driving at a Southern Confederacy. **1837** *S. Lit. Messenger* III. 84 He regarded every attempt to unite the South, in support of a Southern President, as a prelude to the formation of a Southern Confederacy. **1860** ABBOTT *South & North* 307 The Southern confederacy shall again have its free North, and its slaveholding South, as now.

2. The Confederate States of America. Now *hist.*

1860 *Charleston* (S.C.) *Mercury* 15 Nov. 2/5 The 'Lone Star' was very suggestive of the additions which may hereafter be made to the Independent Southern Confederacy. **1891** *Harper's Mag.* Dec. 46/2 If England had recognized the Southern Confederacy [etc.]. **1943** DALE *Cow Country* 11 The Five Civilized Tribes . . . had made an alliance with the Southern Confederacy and fought on the side of the South throughout the war.

Spanish dollar. A Spanish or Spanish-American silver coin worth eight reals. Now *hist.* Cf. **silver dollar.**

1684 *N.H. Hist. Soc. Coll.* VIII. 162 Spanish dollars of Seville and Mexico should pass at six shillings the piece. **1756** ROGERS *Journals* 14 Ten Spanish dollars were allowed to each man towards providing cloaths, arms, and blankets. **1818** *Niles' Reg.* XV. 125/1 *Spanish Dollars* appear to be in great demand at this moment. **1894** S. LEAVITT *Our Money Wars* 34 In 1792, . . . people reckoned in pounds, shillings, and pence, and paid in Spanish dollars. **1950** *L.A. Times Home Mag.* 8 Jan. 12/4 This was the quality used in the Spanish dollars, or pieces of eight (worth 8 *reales*), which were everywhere accepted in trade in the early days.

*✴ **specie,** n.* In combs.: (1) **specie basis,** an amount of specie serving as a basis or reserve for paper money, also fig.; (2) **Circular,** an order issued at the instance of President Jackson in July, 1836, instructing officers of the Treasury to accept only gold and silver in payment for public land; (3) **dollar,** a coined dollar; (4) **-paying bank,** a bank which redeemed its notes in specie, *obs.*

(1) 1832 D. WEBSTER *Works* 397 The general circulation has been extended too far for the specie basis on which it rests. **1863** LOWELL *Biglow P.* 2 Ser. vii. 180 To make a sneakin' truce Without no moral specie-basis. — **(2) 1837** *Cong. Globe* App. 29 Sep. 339 [The money flowed to Mobile] by the aid of the far-famed Specie circular, in 'mint drops' and 'hard currency.' **1894** LEAVITT *Our Money Wars* 69 Mr. Webster [in 1837] ascribed the distress to the interference of the Government with the currency, and to the 'Specie Circular.' — **(3)** *a***1821** BIDDLE *Autobiog.* 238 State Island money [in Pa.] . . . soon de-

preciated to eight for one specie dollar. **1900** *Cong. Rec.* 1 Feb. 1385/2
The standard specie dollar ... is the standard and medium by which
other things ... are redeemed. — **(4) 1818** *Niles' Reg.* XIV. 207/2
The incorporated banks of Maryland ... whose bills are 12 per cent.
below the paper of what are called specie-paying banks. **1845** *Big
Bear Ark.* 143 It can boast of the only specie-paying bank in the State.
1875 *Chi. Tribune* 6 Oct. 4/4 The Whigs ... proposed that the Gov-
ernment should receive in payment of public lands the notes of *specie-
paying banks*.

spook spuk, *n.* [Du., in same sense.] A ghost or
specter. Also attrib.

1801 *Mass. Spy* 15 July (Th.), Mine horses I'll to Vaggon yoke, Und
chase him quickly;—by mine dunder I fly so swift as any spoke. **1884**
Lisbon (Dak.) *Star* 31 Oct. 7/4 He was really run out of a fine position
by spooks. **1946** *Democrat* 31 Oct. 6/1 Ghosts Abandon Gloomy
Mansions ... New Spook Crop Devotes Their Attention to Ordinary
Homes.

b. spook-dancing, dancing by those masquerading
as ghosts. *Rare.*

1904 *Charleston News & Courier* 26 Oct. 9 The programme was not
confined to corn shucking, but 'spook dancing,' games, etc. played a
prominent part.

***Sprague,** *n.* [Isaac *Sprague* (1811–95), Amer. illustra-
tor.] **Sprague's lark, pipit, = Missouri skylark.**

1875 *Amer. Naturalist* IX. 78 There is something I have not quite
made out respecting the breeding range of Sprague's lark, *Neocorys
Spraguei.* **1917** *Birds of Amer.* III. 171/1 The best known is Sprague's
Pipit, called the Missouri Skylark, or sometimes the Prairie Skylark.
1948 *Audubon Mag.* July–Aug. 249/2 The song of Baird's sparrow
leads you up to a gently-rolling short grass prairie, where a small
colony of Sprague's pipits is discovered.

spruce pine. The bog spruce, *Picea mariana*, of the
northeastern states, also any one of various American
pines or hemlocks having light, soft wood.

1684 I. MATHER *Providences* (1856) x. 223 Passing through a thick
swamp of spruse pine ..., [the wind] laid all flat to the ground. **1765**
J. BARTRAM *Diary* 25 Sep., Yᵉ 2 leaved or spruice pine grows very
large in swamps. **1842** *Jrnl. Medorem Crawford* (1897) 19, I noticed
the White Pine and the Spruce Pine. **1949** *Boston Globe Mag.* 4 Dec.
11/2 He went up to the white 'Honor Roll' board nailed to a big
spruce pine.

squash skwɑʃ, *n.*¹ [f. Algonquian. Cf. the Narraganset
word in quot. 1643 below and **squanter-squash.**]

1. The fruit of any one of various species of *Cucurbita*,
or the plant producing this.

1643 WILLIAMS *Key* (1866) 125 *Askútasquash*, their Vine aples ...
the English ... call Squashes. **1705** BEVERLEY *Virginia* II. 17 The
same Use is made also of ... Vetches, Squashes, Maycocks [etc.].
1819 *Plough Boy* I. 183 A squash, taken from the garden of Mr. Wm.
Chouty, Londonderry, N.H. on the 2d inst. weighed 311 lbs. **1949**

Nat. Geog. Mag. Aug. 162 All three species of squashes and pumpkins
are native to the Western Hemisphere.

b. With specifying term.

1814 *Bentley Diary* IV. 280 This squash . . . is also called the
African Squash. **1847** DARLINGTON *Weeds & Plants* (1860) 142 *Cucur-
bita Melopepo* . . . Round Squash.

c. The flesh of this fruit cooked as food.

1758 C. REA *Journal* 70 I've eat this Summer one meal of Squash.
one of Turneps, one of Potatoes & one of Onions & no more. **1872**
POWERS *Afoot & Alone* 254 At dinner he plumped a spoonful of squash
on his plate. **1949** *Nat. Geog. Mag.* Aug. 234/2 There were squash,
string beans, and mashed potatoes.

d. Also **squash pie, soup.**

1751 J. BARTRAM *Observations* 62 We dined on Indian corn and
squash soop, and boiled bread. **1805** *Pocumtuc Housewife* (1906) 24
Squash Pie with Raisins. **1917** MATHEWSON *Second Base Sloan* 22,
I ain' never eat any of that squash pie.

2. In the names of insect pests: (1) **squash beetle,** a
striped beetle, *Diabrotica vittata,* injurious to the leaves of
the squash; (2) **borer,** (see quot. 1909), also **squash vine
borer;** (3) **bug,** an insect injurious to squash plants, esp.
Anasa tristis, which feeds upon the leaves of the plant.

(1) **1867** *Amer. Naturalist* I. 163 The Squash Beetle . . . now at-
tacks the squash plants before they are fairly up. **1902** *Amer. Folk-
Lore* 259 Squash-beetle (*Diabrotica vittata*) squash-borer (*Trochilium
cucurbitae*). — (2) **1891** *Cent.* 5878/1 Squash-borer . . . the larva of
an aegerian or sesiid moth . . . which bores the stems of squashes in
the United States. **1909** *Cent. Supp.* 1422/2 *Squash vine-borer,* the
larva of an American sesiid moth, *Melittia satyriniformis.* It bores into
and excavates the stems of squash-vines, especially near the roots.
1945 *Athol* (Mass.) *D. News* 5 July 5/3 The squash vine borer, how-
ever, is a creature which does more damage and which is apt to do its
damage before you realize what is taking place. — (3) **1846** WORCES-
TER 689/1 *Squash-Bug,* . . . a fetid insect destructive to squashes.
1948 *Pacific Discovery* Jan.–Feb. 19/1 The highly magnified photo-
graphs show . . . a member of the order of true bugs, the Hemiptera,
of which the squash bug is a familiar—and more typical—example.

squatter sovereignty.

1. The right of settlers in a territory to make their
own laws, popular sovereignty. Also attrib. Now *hist.*

1854 *Cong. Globe* App. 9 May 586/2 It has been assumed that this
bill embraces the principle of squatter sovereignty. **1878** BEADLE
Western Wilds 371 The 'squatter sovereignty' doctrine of Stephen A.
Douglas had suited their position. **1898** *Mo. So. Dakotan* I. 58 [A
temporary government] would be a practical application for 'squatter
sovereignty' in its best sense, and certainly preferable to lynch law.

2. The right of settlers to the lands upon which they
have settled. Also fig.

1855 *Knickerb.* XLV. 422 In that part of that beautiful state [Illi-
nois] known as 'Egypt,' many of these wise men have exercised their
'squatter sovereignty' for the last forty years. **1858** *Ill. Agric. Soc.*

Trans. III. 645 There are the sixty varieties of plant lice. . . . Their ideas of 'squatter sovereignty' conform to no true democratic or republican platform. **1892** *S. Dak. Hist. Coll.* I. 59 [A] surveyor general . . . was greatly needed when land-seekers preferred not to depend on the rights of 'squatter sovereignty.'

squawbush ˈskwɔˌbuʃ, *n.* Any one of various shrubs (see quots.).

1832 WILLIAMSON *Maine* I. 125 *Indian Tobacco*, called by the Natives '*Squaw-bush*,' is a perennial herb, or shrub. **1894** *Amer. Folk-Lore* VII. 90 *Cornus stolonifera*, squaw-bush, Penobscot Co., Me. **1909** *Cent. Supp.* 1261/2 *Squaw-bush*, . . . a name of *Cornus stolonifera, C. serica.* and *C. Canadensis.* **1909** WEBSTER 2025 *Squaw bush. a.* The cranberry tree. *b.* A sumac of the western United States (*Rhus trilobata*), with unpleasantly scented trifoliate leaves. **1942** STEGNER *Mormon C.* 307 A sheepwagon slept by a squawbush [i.e., a sumac] and a horse grazed on the withered grass.

* **stanchion,** *n.* A fixed or stationary device, usu. of metal, fitting loosely around a cow's neck so as to limit the forward and backward motion. Also attrib.

1868 BRACKETT *Farm Talk* 101 What do you think of slip stanchions? **1896** *Vt. Agric. Rep.* XV. 72 The cows in general seem to like swinging stanchions much better than the stationary. **1950** *Hoard's Dairyman* 10 April 272/3 Ceilings and upper walls of his compact, concrete block, 8-stanchion milking parlor and adjoining milk house are lined with 3-8-inch veneer.

statehood ˈstetˌhud, *n.* The condition or status of a state. Also attrib.

1868 *N.Y. Times* 8 June, Why indeed should the Federal Senate . . . be organized on the basis of an extinct statehood? **1893** *Dly. Ardmoreite* (Ardmore, Okla.) 20 Nov. 1/1 A Statehood convention will be held at Kingfisher, O.T., on the 28th of this month. **1950** *L.A. Times Midwinter* No. 3, Jan. 7/1 It was on Oct. 18, 1850, that news of Statehood reached San Francisco.

state's evidence.

1. One who, to lessen his own punishment, turns informer on his associates in crime.

1827 *Spirit of Seventy-Six* (Frankfort, Ky.) 1 Nov. 3/1 Having failed in making a tool of Mr. Buchanan, he thinks it necessary to find a *states evidence* somewhere. **1842** COOPER *Wing-and-Wing* II. 61 Still he gagged a little at the idea of passing for one who peached—or for a 'State's-evidence' as he called it; that character involving more of sin, in vulgar eyes, than the commission of a thousand legal crimes. **1898** CANFIELD *Maid of Frontier* 73 Stealing a hand down now and then to feel the Winchester hugged close under his knee, State's Evidence sped along.

b. The evidence in behalf of the state given by such an informer.

1890 LANGFORD *Vigilante Days* (1912) 300 Long John was admitted to testify under the rule of law regulating the reception of State's evidence. **1905** *Forum* April 532 The public accepted the ar-

ticles as state's evidence, provided from motives of revenge or penitence.

2. *To turn state's evidence,* to become state's evidence, to give evidence in behalf of the state to obtain leniency.

1796 A. BARTON *Disappointment* 86 Ye turn'd eenformer, and statesevedence, to get the ane half till yere sel. **1806** FESSENDEN *Democracy Unveiled* II. 105 Lyon, ... by turning States' evidence, has brought out his friend Duane. **1903** *N.Y. Tribune* 20 Sep., He was turning State's evidence and saving himself from punishment. **1949** *Sat. Ev. Post* 5 March 113/3 He helped convict Ford by turning state's evidence.

***steering,** *a.* **1. steering committee, group,** a committee or group, esp. in a legislative assembly, that directs or prescribes the order in which business shall be considered. **2. steering oar,** an oar by which a boat, esp. a broadhorn or river flatboat, is steered. *Obs.*

(1) **1887** *Courier-Journal* 6 Feb. 2/2 A steering committee upon the order of business for the remainder of the session was appointed. **1945** *Reader's Digest* Jan. 54/2 A local Committee of 21 was organized, with a steering group of three members. **1950** *Chi. D. News* 7 Feb. 6/5 He was one of the 'steering' committee of four men. — (2) **1808** KER *Travels* (1816) 30 In endeavouring to run the outside of a sawyer, I ran with my stern athwart it, and unshipped my steering oar, which I lost. **1884** MARK TWAIN *H. Finn* xiii, They lost their steering-oar.

stenographer stə'nɑgrəfɚ, *n.* [Prob. f. * *stenography.*] One skilled in stenography, a shorthand writer. Cf. **court stenographer.**

1796 *Ann. 4th Cong.* 2 Sess. 1607 He also adverted to the attempt at the last session to introduce a stenographer into the House, which failed. **1813** *Ann. 13th Cong.* 1 Sess. 125 Under an order of the House directing stenographers to be admitted by the Speaker ... the petitioner made application to be received as such. **1906** QUICK *Double Trouble* 147 A stenographer and bookeeper were employed in the counting-room of the Brassfield Oil Company. **1949** *This Week Mag.* 2 April 27/2 Here is this office full of pretty stenographers.

Also **stenographer-typist.**

1918 M. S. OWEN *Typewriting Speed* 59 After a careful study of the poor style of operation of hundreds of stenographer-typists.

stereopticon ˌstɛrɪ'ɑptɪkən, *n.* [f. Gk. *stere-* (combining form of *stereos,* solid), +*optikon,* relating to sight.] An improved type of projector or magic lantern. Also attrib.

1863 *Hunt's Merch. Mag.* XLVIII. 430 Although the stereopticon was exhibited for a time in the Polytechnic Institute, and in the Hall of Illustration, Regent's Park, London, yet it did not advance beyond the first discovery. J. Fallon, Esq., of Lawrence, Mass., ... who has devoted thirty years to photology, imported from England one of these instruments for his own family. But under his hands it was developed into something so perfect that his friends desired that

others might have the pleasure which he enjoyed. **1894** *Outing* Sep. 49/1, I had seen it projected by a stereopticon lantern fifteen years before, when a boy in America. **1929** E. W. Howe *Plain People* 47 There was a side show displaying stereopticon views of the war.

⁕ **Stiegel**, *n*. Exceptionally beautiful blown glass made by Henry William Stiegel at Manheim, Lancaster County, Pennsylvania, *c*1765–74. Also any glass somewhat resembling this or made in imitation of it.

[**1906** *Country Life* Dec. 208/3 Among the first successful works and perhaps the most famous, was that at Manheim, Pa. Here Baron Stiegel established a factory about 1769.] **1922** *Ib*. May 49/2 I'd rather have it than any other piece of Stiegel I ever saw. **1949** *Hobbies* June 104/1 Until quite recently the majority of our collectors were in the habit of calling all old blown glass either Stiegel or Wistar.

attrib. **1942** Weygandt *Plenty of Penna*. 233, I find fully half as much Stiegel glass in central New Hampshire in the summer as I do cruising hither and yon in Pennsylvania Dutchland the other nine months of the year. **1949** *Hobbies* June 104/2 All can not be the proud possessors of Stiegel sugar bowls in sparking cobalt, creamers in lovely shades of amethyst.

stirpiculture ˈstɜpɪˌkʌltʃə, *n*. [f. L. *stirps*, *stirpis*, stock, stem, + ⁕ *culture*.] The production of an improved race or stock by careful breeding.

This term appears to have been first used by J. H. Noyes (see below) in connection with the efforts made at Oneida *q.v.* to produce the best possible offspring. In the *OED* *s.v.*, in a quot. of 1904, the British scientist Sir Francis Galton claims that he coined the word *stirpiculture* and later discarded it for the term *eugenics*. No evidence is at hand to substantiate this claim.

1870 J. H. Noyes *Sci. Propagation* 12 It is one thing to seek in any existing race the best animals we can find to breed from . . . ; and it is another thing to start a distinct family and keep its blood pure by separation from the mass of its race. It is this last method that has produced the Ayrshires, the short-horns, and the Leicesters. It deserved a distinct name, and we will take the liberty to call it stirpiculture. **1900** Estlake *Oneida Community* 101 Until the subject of intuition has become better understood, people will be liable to mistakes in stirpiculture. **1950** *Amer. Mercury* Feb. 205/2 He also published and circulated an immense number of copies of his lectures on Stirpaculture.

Hence **stirpicultural**, *a*., **stirpiculturist**, *n*.

1891 *Amer. Naturalist* Oct. 932 Of the stirpicultural children only one has since died. **1903** A. J. McLaughlin in *Pop. Sci. Mo.* Jan. 231 (*Cent. Supp.*), The stirpiculturist, noting the poor physique . . . of some of the immigrants, fears race degeneration. **1948** *Antioch Rev.* Fall 277 It was a major disappointment when the stirpicultural babies turned out to be only a normal, and unusually healthy, batch of kids.

⁕ **studio**, *n*. **1. studio apartment**, orig. an apartment having high ceilings and a maximum of natural light, like an artist's studio; now freq. a one-room attic apartment.

2. studio couch, a flat couch upholstered like a davenport, usu. with three matching pillows, capable of being opened into a full-sized bed.

(1) **1934** WEBSTER. **1944** *Chi. Tribune* 1 March 25/2 Beau. 2–3 rm. studio apts. — (2) **1936** *Sears Cat.* 506 A studio couch that looks like a beautiful davenport . . . broad comfortable arms and magazine rack in the end. **1946** *Sat. Ev. Post* 3 Aug. 30/1 But you remember my two-room flat And the studio couch on which you sat.

* **stumpy,** *a.* Abounding in stumps.

1673 *Southampton Rec.* II. 253 All the meadow and mowing land . . . standing on the west side of the stumpy marsh. **1875** MARK TWAIN *Old Times* iv. 71 We were shaving stumpy shores. **1897** *Outing* XXX. 328/2 We were passing a cabin surrounded by a few acres of stumpy pasture.

sundae ˈsʌndɪ, *n.* Also **sundi, Sunday.** [Time and place of origin obscure, but accepted as an obscuration of Sunday. See Mencken, *Supp.* I. (1945) 376–7.] An individual portion of ice cream served with a sweet sauce, fruit, nuts, whipped cream, etc.

1904 *N.Y. Ev. Post* 21 May, The Sundi, so popular at the confectioner's, can be prepared at home. **1921** TUCKER *Amer. English* 306 *Sunday*, sometimes misspelled 'sundae.' . . . Name said to have been first used, about 1897, at Red Cross Pharmacy, State Street, Ithaca, N.Y. **1948** *Ice Cream Trade Jrnl.* Oct. 80/2 The loss in the sale of ice cream can be traced to the soda fountains where the quantity of ice cream in sodas, sundaes, and milk shakes has been reduced 10 to 30 per cent.

swamp white oak. An oak found in the eastern states, *Quercus bicolor;* also the overcup oak, *Q. lyrata,* and the cow oak, *Q. prinus.*

1725 *Cambridge Prop. Rec.* 314 We have Settled ye Line . . . to a Swamp white Oak tree mark'd. **1897** SUDWORTH *Arborescent Flora* 155 Overcup Oak. . . . Swamp White Oak (Tex.). *Ib.* 158 Cow Oak. . . . Swamp White Oak (Del., Ala.). **1945** DARLINGTON *Higher Plants Mich.* 12 Common species are silver maple . . . , swamp white oak . . . , sycamore.

switchel ˈswɪtʃəl, *n.* [Origin unknown. Cf. * *swizzle,* a name for various intoxicating drinks.] A drink of molasses and water, often seasoned with vinegar and ginger, and sometimes with rum.

1790 FRENEAU *Poems* (1795) 375 For such attempts men drink your high-proof wines, Not spiritless switchel and vile hogo drams. **1834** *Mt. Carmel* (Ill.) *Sentinel* 15 Sep. 1/5 The first go off I took a leetle less New England in my switchell. **1946** *Yankee* Aug. 9 Our grandfathers would be drinking Switchel for refreshment: a mixture of water, ginger, molasses or vinegar, and sometimes rum.

* **Sydney,** *n. Pacific Coast.* [*Sydney,* Australia.] *attrib.* Designating an undesirable or criminal immigrant from

Australia who came to California just after the discovery of gold there, as (1) **Sydney bird,** (2) **duck.** Now *obs.* or *hist.*

(1) **1851** in *One Man's Gold* (1930) 197 Chilians, Chinese, British convicts from New South Wales, known as 'Sidney Birds,' Englishmen, Frenchmen. **1935** BUCKBEE *Saga of Old Tuolumne* 22 The discontent quickly spread . . . to the Australian immigrants, who were known as 'Sydney Birds,' and 'clipped ears.' — (2) **1851** *S.F. Dispatch* 13 July 3/3 On board the Senator last Tuesday evening a Sidney duck was taken to the windless [*sic*] and received three dozen lashes for theft on board. **1880** BURNETT *Recollections* 342 The immigrants from Australia consisted in part of very bad characters, called 'Sydney Ducks.'

T

* **T,** *n.* **1. T dagger,** a type of dagger formerly used by ruffians in New Orleans. *Obs.* **2. T.D.** (pipe), (see quot. 1889). Now *hist.*

(1) **1867** LATHAM *Black and White* 161 The dagger was a remarkable one, with a cross handle like a corkscrew, whence they are called 'T,' or 'cotton-hook' daggers. — (2) **1889** *N. & Q.* II. 114 'T.D. Pipes.' . . . It is said that they took their name from Timothy Dexter, an eccentric capitalist, who in his will left a large sum of money to be expended in the erection of a factory where cheap clay pipes, such as those that now bear the name of 'T.D.'s,' were to be manufactured. **1947** PAUL *Linden* 27 Deacon Parker, known to the boys as T.D., because he smoked the one-cent clay pipes of that name.

tabby 'tæbɪ, *n.* [See note.] (See quot. 1885.)

This word is app. chiefly confined to the Gullah region along the coast of Georgia and South Carolina. No doubt African slaves brought it to this region. Cf. Gullah *tabi hæus* in Turner 202/1. Arabic *tabix*, cement, mortar, brick, is the source of the African word. The term here shown is app. a different word from *OED Tabby, q.v.,* with esp. attention to the note and sense 6.

1775 *S.C. Hist. Mag.* VI. 91 [The Council of Safety ordered that Fort Lyttelton be repaired with] tappy. **1802** ELLICOTT *Journal* 267 That part of [Frederica] lying immediately on the water . . . was defended by a small battery of tabby work. **1833** SILLIMAN *Man. Sugar Cane* 36 The walls [of the draining rooms] are all constructed of tabby. **1885** EGGLESTON in *Cent. Mag.* April 874/2 A concrete of oyster shells, called 'tabby,' was much used on the southern coast; a wall and columns of this material, built before the Revolution, are still standing. *c*1943 *Flags of Five Nations* 27 The old 'tabby' house, which it is thought Gwinnett built and where he made his home with his wife.

* **taffy,** *n.*

1. Flattery, cajolery. Also as verb. *Colloq.*

1879 *Cong. Rec.* 15 April 462/1, [I wish to prevent them from] denouncing me as the coadjutor of the South, distributing 'taffy' to the South. **1889** *Texas Siftings* (N.Y.) 12 Jan. 11/3 I've advertised freely and taffied the editors, and stood beers to the reporters, but I've never had a decent report yet. **1904** *Buffalo Comm.* 2 Sep. 4 Watson the Populist takes no taffy from the democrats.

2. taffy bake, pull, pulling, an occasion upon which young people assemble to make taffy. *Colloq.*

1877 PHELPS *Story of Avis* 31 There were twenty-five candy-pulls and taffy-bakes in that town that winter. **1912** *Out West* March 166/2 He wrote with beautiful flourishes, little notes of regret . . . declining all socials, taffy pullings and croquet parties. **1949** *Chi. Tribune* 11 Nov. III. 4/3 There is nothing like an old fashioned taffy pull.

talkie ˈtɔkɪ, *n.* A motion picture accompanied by sound effects, such as spoken words, music, etc.

[**1913** *Munsey's Mag.* March 957/1 The 'movie' had received its full brother in the 'talkie' [i.e., Edison's kinetophone], and a new era had begun in the progress of one of the most amazing of modern amusement enterprises.] **1928** *Ladies' Home Jrnl.* Nov. 25/1 There are already a confusing number of devices for making the talkies. **1949** *Chi. Tribune* 21 Sep. 30/5 He made 218 pictures in all, topped by such epics as the silent 'Vanishing American' and the talkie 'Cimarron.'

tanglewood ˈtæŋglˌwʊd, *n.* A region of thick, bushy woods. Also attrib.

1853 N. HAWTHORNE (*title*), Tanglewood Tales, for Girls and Boys. **1863** MITCHELL *My Farm* 158 Within this tangle-wood, I have set a few graftlings upon a wild-crab. **1894** *Advance* 26 April, [The bird] scuttled off in a wild panic through the thick tanglewood.

* **taps,** *n. pl. Mil.* A signal given orig. with a drum but now usu. with a bugle, for extinguishing lights and going to bed. Also used at the conclusion of a soldier's burial.

1824 *18th Cong.* 1 Sess. H. Doc. 111. 8 March 35 It is his [the orderly's] duty . . . to visit his rooms, at the taps; see that the lights are extinguished; the fires properly secured; the occupants present, and in bed. **1887** HINMAN *Corp. Si Klegg* 331 Their ears caught the music of the bugles sounding 'lights out,' or 'taps.' **1919** HOUGH *Sagebrusher* 300 'Blow "taps," ' he ordered of the bugler near by. **1949** *Oak Leaves* (Oak Park, Ill.) 24 Nov. 22/5 Gathered in their cabins the boys then played the old reliable Ghost game and others until 'Taps.'

Tarzan ˈtɑrzən, *n.* In the adventure stories of Edgar Rice Burroughs (1875–1950), a white man of great strength and agility reared by African apes and hence uncorrupted by civilization. Also **Tarzan-like,** and attrib.

1919 MORLEY *Haunted Bookshop* (1921) 142 Posters announcing The Return of Tarzan showed a . . . scene with an Eve in a sports

suit. **1931** *K.C. Times* 4 Nov., The Raytown News believes Tarzan should write a testimonial for some safety razor company. **1943** *Copper Camp* 214 Butt Block gazed pridefull at his partner, smiled and then with brawny fists pounded, Tarzan-like, upon his hairy chest. **1949** *Chi.Tribune* 5 Dec. IV. 1/1, I know some guys Who possess Tarzan eyes—Eyes that keep swinging from limb to limb.

tautog 'tɔtɑg, *n.* [Narraganset *tautauog*, pl. of *tautau*, blackfish, but thought by Roger Williams to mean "sheep's-head."] A highly esteemed food fish, *Tautoga onitis*, abundant on the Atlantic Coast. Cf. **blackfish 2.**

1643 WILLIAMS *Key* (1866) 138 Of Fish and Fishing. . . . *Taut-auog*, sheeps-heads. **1775** BURNABY *Travels* 121 Fish are in the greatest plenty and perfection, particularly the tataag or black-fish. *a*1841 HAWES *Sporting Scenes* I. 37, I once crossed over to Faulker's island, to fish for tautaugs, as the north side people call black fish. **1947** COFFIN *Yankee Coast* 296 Near the shore, we have . . . the vast tautogue, which fights like a bull and fills a whole oven with·his strong-flavored roasting hulk.

T-bone steak. Strictly, a steak containing a T-shaped bone, from the middle portion of the short loin, but often used loosely for a porterhouse steak.

1934 WEBSTER. **1943** *Copper Camp* 92 Where the former two welcomed any stray handout, Dynamite frowned on any contribution less than T-bone steaks and chicken or turkey scraps. **1947** DALRYMPLE *Panfish* 154 Although you don't eat scallops or clams or frogs' legs, or even T-bone steaks every day, you still jump at the chance to tie into such a meal when the opportunity is afforded.

Technicolor 'tɛknɪ͵kʌlɚ, *n.* [See quots.] The trademark name of a system of making color motion pictures.

1944 *Reader's Digest* Aug. 63 By 1917, however, they thought they had a satisfactory process. Kalmus had named it Technicolor—'Tech' for his alma mater. **1948** *Time* 22 March 85/3 Herbert T. Kalmus, . . . the co-inventor, developer, majority stockholder and president of Technicolor, . . . is a graduate of Massachusetts Institute of Technology (after which Technicolor was named).

Hence **technicolored,** *a.*

1949 *House & Garden* July 60 The West is a magnificent overstatement, designed to order for the picture post card trade, technicolored movies and carefree life. **1949** *Time* 12 Dec. 101/1 The Story of Seabiscuit offers impeccable Technicolored performances by several horses.

telegram 'tɛlə͵græm, *n.* [f. combining forms (<Gk.) *tele-+-gram*, denoting that which is written at a distance.] A message sent by telegraph.

1852 *Albany* (N.Y.) *Ev. Jrnl.* 6 April (W.), A friend desires us to give notice that he will ask leave . . . to introduce a new word into the vocabulary. It is telegram, instead of telegraphic dispatch, or telegraphic communication. **1852** *Lantern* (N.Y.) I. 184/2 Our Boston correspondent says, that the new name for Telegraphic Despatches, now called Telegrams, should be written *Tell-a-cram.* **1924** H. CROY

R.F.D. No. 3 233 Josie had expected that they would have to go to the railroad station, the 'depot'—it was the way her father had always sent telegrams. **1945** MENCKEN *Supp.* I. 243 But *telegram*, first recorded in 1852, seems to be an American invention, as is *cablegram*, first recorded in 1868.

* **telescope,** *n.* A traveling bag consisting of two cases of which the larger slips over the smaller.

Telescope

1896 *Chi. Tribune* 28 June 4/1 A set of the best safe-boring tools were put into a 'telescope' for the Ohio job. **1914** *Outing* June 312/1 The telescope was made of hydraulic canvas (a very heavy, stiff canvas,) with no pasteboard. **1949** *Boston Globe* 5 June (Fiction Mag.) 1/2 Other bundles, valises and telescopes were ranged beyond.

tenderloin ˈtɛndɚˌlɔɪn, *n.*

1. A strip of tender meat close to the backbone of a beef, hog, etc., a piece of this. Also attrib. Cf. **pork tenderloin.**

1828 WEBSTER, *Tenderloin*, a tender part of flesh in the hind quarter of beef. [Probably an inexact definition.] **1883** *So. Hist. Soc. P.* XI. 84 Tenderloin steaks are tough behind iron gratings. **1944** *Newsweek* 16 Oct. 107 Thus, a tenderloin chop for the lieutenant becomes an elevenerloin chop.

2. In New York City, a police precinct, orig. one west of Broadway between Twenty-third and Forty-second streets, affording police officers luscious opportunities for graft. Also transf. to similar districts in other cities where gambling, prostitution, etc., flourish. Also attrib.

A policeman named Williams is said to have first used "tenderloin" with reference to the N.Y. vice area. See *Amer. N. & Q.* Oct. 1945, 107–8.

1887 *Harper's Mag.* March 500/2 His precinct is known as the 'Tenderloin,' because of its social characteristics. **1898** *Voice* 6 Jan. 4/3 If laws generally suitable to a city do not suit some slavic, Polish, or other quarter, or some 'tenderloin' district, the local police must pass upon those laws, . . . and give a 'liberal' enforcement. **1903** *S.F. Argonaut* 2 Nov. 273 Portland is not a puritanic city. In fact, its tenderloin is extensive and worse than anything in San Francisco. **1949** *L.A. Times* 15 May 11. 5/1 The 1st Ward had most of the city's tenderloin and flop houses.

Teton 'titn̩, *n.*² *W.* [F. *téton,* a woman's breast.] A mountain of a form suggestive of a woman's breast, often in allusion to the Teton Range in northwestern Wyoming. Cf. **mamelle.**

1855 J. MULLAN *Pac. R.R. Explor.* I. 331 The word 'butte' is 'applied to high elevations of land . . . which occur, as a general thing, in a prairie country.' The Tetons, on the contrary, occur in a mountainous country. **1910** *Out West* Feb. 134 The lonely snow-capped Tetons call to you. **1949** *Mazama* Jan. 1/1 Some of America's finest climbers have explored the Tetons and have established many routes, ranging from the utmost difficulty to simple climbs within the reach of all.

b. Esp. in proper names.

1832 *Ev. & Morning Star* (Independence, Mo.) Oct. 7/1 On the 17th five were again attacked by these Indians at Jackson's hole, near the Three Tetons, and 3 of them were killed. **1872** RICHARDSON *Wonders of Yellowstone* 222 In front of me, at a distance of fifty miles away, in the clear blue of the horizon, rose the arrowy peaks of the Three Tetons. **1949** *Mazama* Jan. 1/1 Teton National Park is a wild-life refuge, with moose, elk, bighorn sheep, deer and many other forms of wild life in abundance.

thermos 'θɜːməs, *n.* [Gk., hot.] A bottle so made that liquids may be kept at a desired temperature for a considerable time. Usu. **Thermos bottle,** a trade-mark name for a bottle of this kind.

1908 *Sat. Ev. Post* 15 Aug. 21/1 The Thermos Bottle keeps baby's sterilized milk at feeding temperature day or night. **1948** *Nat. Geog. Mag.* Aug. 233/1 Our host walked down from his house with a gallon thermos of hot coffee. **1950** *Time* 3 April 24/3 Simon began to pack blankets and Thermoses for a fishing trip.

Also **thermos jug.**

1938 NORRIS *Bricks Without Straw* 350 He poured a glass of water from his thermos jug.

*** thorn,** *n.* In combs.: (1) *** thorn apple,** any one of various haws or their fruit; (2) **fence,** a fence or hedge of some thorny plant or shrub, *rare,* cf. **Osage orange hedge;** (3) **-tail(ed) snake,** = **horn snake,** *obs.*

(1) **1817** S. BROWN *Western Gazetteer* 322 The plants and shrubs [include] . . . pennyroyal, thorn apple, wild hops. **1844** LEE & FROST *Oregon* 89 The natural fruit of this valley is much the same . . . as that upon the Clatsop Plain . . . with the addition of wild cherries, red and black, and the thorn-apple. **1949** *Chi. Tribune* 24 Sep. 10/3 As one bird hopped out to shake itself dry, one or two more would drop down from neighboring thornapples. — (2) **1843** *Farmers' Cabinet* 15 Jan. 184/1 Our fences are either the worm, post-and-rail, or thorn. — (3) **1778** CARVER *Travels* 486 The Thorn-Tail Snake . . . receives its name from a thorn-like dart in its tail, with which it is said to inflict a mortal wound. **1836** EDWARDS *Hist. Texas* 76 One will meet with . . . a speckled snake, or a thorn-tailed snake.

* **thrasher,** *n.* Any one of several American birds of the family Mimidae, related to the mockingbird, esp. a bird of the genus *Toxostoma.*

1810 WILSON *Ornithology* II. 84 The Thrasher is a welcome visitant in spring. **1877** *Harper's Mag.* April 662/1 [The catbird] brings forth sounds as mellow and as powerful as those of the thrasher and mocking-bird. **1949** *Democrat* 27 May 4/4 He is soon joined by the thrasher, whose fussy, scolding note indicates that he is peeved at having been awakened so early.

* **ticker,** *n.*

1. (See quot. 1851.) *Slang. Obs.*

1836 *Harvardiana* III. 123 If any 'Ticker' dare to look, A stealthy moment, on his book. **1851** HALL *College Words* 301 *Ticker,* one who recites without knowing what he is talking about; one entirely independent of any book-knowledge.

2. = **stock ticker.** Also attrib.

1882 McCABE *New York* 338 Thanks to these 'tickers,' . . . men can watch the market, and buy and sell, miles away from the Stock Exchange. **1885** *Wkly. New Mexican Rev.* 7 May 3/2 The ticker service was partially restored this morning. **1948** *Time* 5 April 83/1 All week long, stock exchange brokers watched the ticker.

b. ticker tape, the paper ribbon upon which stock quotations are printed by a stock ticker. Cf. * **ribbon,** *n.* **2. b.**

1902 WILSON *Spenders* 407 For two days he clung to the ticker tape as to a life line. **1950** *Time* 8 May 11/1 The prices are chalked up on the quote board as they come through on the ticker tape.

tidytips ˈtaɪdɪˌtips, *n.* (See quot. 1891.) Also with specifying term.

1888 LINDLEY *Calif. of South* 329 All through the months of March, April, and May, plants of *Layia platyglossa* are scattered over the ground as thickly as star-dust in the sky. The children call it 'tidytips,' each golden petal being daintily fringed with white. **1891** *Cent.* 6331/1 *Tidytips,* a Californian composite plant, *Layia (Callichroa) platyglossa:* a showy plant with bright-yellow rays, frequently cultivated as a half-hardy annual. **1949** *Desert Mag.* May 29/2 An abundance of senecio, white tidytips, . . . and sand blazing star are among the flowers in bloom.

tinhorn ˈtɪnˌhɔrn, *n.* [See quot. 1931.] A gambler of a cheap, flashy, pretentious kind. In full **tinhorn gambler.** *Slang.*

1885 *Wkly. New Mexican Rev.* 26 Feb. 4/2 We have been greatly annoyed of late by a lot of tin horn gamblers and prostitutes. **1931** WILLISON *Here They Dug Gold* 216 Chuck-a-luck operators shake their dice in a 'small churn-like affair of metal'—hence the expression, 'tinhorn gambler,' for the game is rather looked down upon as one for 'chubbers' and chuck-a-luck gamblers are never admitted within the aristocratic circle of faro-dealers. **1950** *Chi. D. News* 6 Feb. 6/1 Run fast, little girl. You're mixed up with a tinhorn.

attrib. **1886** *San Juan Prospector* (Del Norte, Colo.) 4 Sep. 3/7 The Silverton vigilantes have notified the tin-horn element to meander.

tipple ʹtɪpl, *n.* [f. ∗ *tip, v.*] A device for tipping and thus unloading coal cars; a place where such cars are weighed and unloaded. Also attrib. Cf. **coal tipple, ore tipple.**

1880 *Harper's Mag.* Dec. 55/1 Noisy cars . . . rush down the 'incline,' bang against the 'tipple,' and discharge their contents. **1917** SINCLAIR *King Coal* 134 The tipple-boss reappeared. **1949** *Chi. D. News* 16 Nov. 1/5 The victim was . . . a tipple dust cleaner for the Pennsylvania Coal and Coke Co.

tobacco house.

1. An open, airy house in which tobacco is cured. Also **tobacco-curing house.**

1652 *Southhold Rec.* I. 17 The Neck over against the east side of the Tobacco house in Oysterpond Meadows. **1705** BEVERLEY *Virginia* IV. 53 Their Tobacco-Houses are all built of Wood, as open and airy as is consistent with keeping out the Rain; which sort of Building is most convenient for the curing of their Tobacco. **1820** *Amer. Farmer* I. 395 The most common size of a tobacco house formerly was 40 feet long by 24 feet wide. **1897** MARK TWAIN *Autobiog.* I. 99 (R.), The woody hill fell sharply away, past the barns, the corn-crib, the stables and the tobacco-curing house.

attrib. **1691** *Va. State P.* I. 27, I have searched in such places as it was suspected ye broad-arrow was unduly putt on ye toba. housedoores. **1760** WASHINGTON *Diaries* I. 134, [I] set a course for the head of the drain that Runs into my Meadow which leaves in the Tobo. House Field. **1775** J. ADAMS in *Warren-Adams Lett.* I. 115 Coll. Harrison of Virginia . . . is very confident that they are making large Quantities [of saltpeter] from Tobacco House Earth in his Colony.

b. A tobacco warehouse.

1887 *Courier-Journal* 13 Jan. 8/5 Mike Billings . . . was apprehended at Levy's tobacco house, in Portland.

2. A business concern dealing in tobacco.

1900 WINCHESTER *W. Castle* 166, I was traveling for a large tobacco house.

toddy stick. A small stick for stirring toddy. *Obs.*

1840 *N.O. Picayune* 4 Oct. 2/5 A 'toddy stick' is as spirit-stirring an article as any poet can boast. **1865** *Atlantic Mo.* May 597/1 Old Boody stirs with an appetizing rattle of the toddy-stick. **1867** LACKLAND *Homespun* 179 [The landlord] was twirling the toddy-stick in his customer's punch.

∗ **tolling,** *n.* The luring or decoying of ducks, fish, etc. Also attrib.

[**1813** WILSON *Ornithology* VIII. 104 The dog, if properly trained, plays backwards and forwards along the margin of the water. . . . This method is called *tolling them in.*] *a***1835** in AUDUBON *Ornith. Biog.* IV. 6 The usual mode of taking these birds has been . . . by *toling.* **1857** *Spirit of Times* 12 Dec. 227/1 The dog had evidently been well

trained in *toling,* for he understood perfectly what he was about. *a*1888 ATWOOD in Goode *Amer. Fishes* 180 The present mode of catching mackerel by drifting and tolling with bait did not come into general use until 1812. **1944** *N. & Q.* May 21/1 George Bird Grinnell . . . remarks that tolling has been out of favor 'for many years,'—and, he adds, 'naturally so, since it is so very destructive.'

tomahawk **'tɑmə͵hɔk,** *v. tr.* To strike or kill with a tomahawk. Also **tomahawked,** *a.* Now *hist.*

1711 *N.C. Col. Rec.* I. 813 The Baron de Graffenried . . . was still alive but supposed only reserved for a more solemn execution, to be tomahawked and tortured. **1795** *Pittsburgh Gaz.* 13 June 3/1 They were scalped and tomahawked in a most shocking manner. **1899** CUSHMAN *Hist. Indians* 440 Sixteen warriors . . . were led out and, in cold blood, tomahawked. **1947** *Nat. Geog. Mag.* July 105/2 Eventually his tomahawked head was spiked on the Indian palisades.

fig. **1852** *Lantern* (N.Y.) I. 223/2 The article in question was fired by a young *savage* in the office, whom they kept for the purpose of tomahawking and scalping the Fogies, one of the most annoying of the literary tribes. **1946** *Dly. Ardmoreite* (Ardmore, Ókla.) 15 Dec. 14/3 Four previous times the Bears have battered their way to the top seat, the last time in 1943 when they tomahawked the Redskins from Washington 41–18.

Hence **tomahawking,** *n.*

1835 BIRD *Hawks* I. 120 I'll allow you to be a complete master of the science of tomahawking, skinning, and scalping. **1883** *Harper's Mag.* Feb. 423/1 After a great deal of tomahawking and scalping . . . , the united forces . . . crushed the Tuscaroras.

* **tooth,** *n.* In combs.: (1) * **toothache,** see as a main entry; (2) * **brush,** *S.* (see quots.), *colloq.;* (3) **carpenter,** a dentist, *colloq.;* (4) **paste,** a paste used in cleaning the teeth, also attrib.; (5) * **pick,** see as a main entry; (6) **saw,** (see quot. 1876), *obs.;* (7) **soap,** a soap for the teeth.

(2) 1913 MORLEY *Carolina Mts.* 170 When a mountain woman refers to her 'toothbrush' the snuff-stick is what she means. **1926** *D.N.* V. 404 *tooth-brush,* n. A chewed twig used in dipping snuff. — **(3) 1846** *Freeman's Journal* (N.Y.) 31 Oct. 137/2 How shocked the gentlemen aforesaid would be, if they heard, as we did the other day, one of their brethren, a dentist, called a 'tooth-carpenter.' **1888** *Chehalis* (Wash.) *Bee* 18 May 3/4 Dr. Boyce, besides being a physician and druggist, is a 'tooth carpenter.' — **(4) 1832** *Amer. R.R. Jrnl.* I. 607/3 *(advt.),* Seidlitz Powders, chloride of Soda, Chlorine Tooth Paste. **1949** *Reader's Digest* July 141/1 The tube virtually turned the dentrifrice business into the tooth-paste business.

(6) 1868 *Ore. State Jrnl.* 31 Oct. 2/2 He is engaged with a company in New York in the manufacture of Brown's patent adjustable tooth saws. **1876** KNIGHT 2596/1 *Tooth-saw.* The dental saw is a fine frame-saw, used for cutting off the natural teeth for the attachment of pivot teeth; for sawing between teeth; or for sawing off the wires of artificial teeth to detach them from the plate. — **(7) 1944** CLARK *Pills* 299 Scattered in with these items were razors, razor straps, tooth soap and brushes.

✻ **tornado,** *n.* "A destructive rotatory storm under a funnel-shaped cloud like a water-spout, which advances in a narrow path over the land for many miles" (*OED*).

1804 *Fredericktown* (Md.) *Herald* 16 June 2/2 Within the vortex before the cloud a column of thick vapour, very black, extending from the earth to the heighth of about 40 feet, and advancing rapidly in the direction of this place was discovered by several inhabitants. . . . The Tornado passed through the centre of the village . . . and was observed to break on a neighboring hill. **1946** *This Week Mag.* 3 Aug. 16/2 Every newspaper reader in America knows of the terrible destructive force of the tornado. **1950** *World-Herald Mag.* (Omaha) 8 May 15/2 Least extensive, but most violent and sharply defined of all storms, the tornado is characterized by the vortex cloud sometimes likened to a funnel, an elephant's trunk or a rope.

attrib. **1815** *N. Amer. Rev.* II. 38 The strength of the wind, and its tornado character, was principally felt . . . between New-London and Newburyport. **1898** C. B. DAVIS *Borderland of Soc.* 92 Wait till you marry and can't get even a tornado insurance company to put a cent on your frizzled self. **1905** *Springfield W. Republican* 19 May 7 Inhabitants of the 'new country' in Oklahoma are digging 5000 tornado cellars.

tortilla tɔr'tija, *n.* *S.W.* [Sp. in Amer. Sp. sense shown here.] A very thin griddlecake, usu. made from cornmeal.

1831 PATTIE *Personal Narr.* 42 She then brought forward some tortillas and milk. **1884** *Gringo & Greaser* 1 Jan. 2/3 [We] munch our tortiers and sheepmeat on the wing. **1949** *Nat. Geog. Mag.* Dec. 820 (*legend*), Tortillas and Coffee Are Spread on the Linoleum-covered Adobe Floor.

✻ **tourist,** *n. attrib.*

1. tourist camp, a camp providing such accommodations as tourists need.

1923 *Outlook* Aug. 591/3 The University of Iowa has published a bulletin on the tourist camps of that State. **1934** *Lit. Digest* 9 June 40/2 These tourist camps . . . gradually are becoming more attractive.

2. tourist car, sleeper, sleeping car, (see quot. 1895).

1895 WAIT *Car-Builder's Dict.* 134 Tourist-car. A car roughly built and furnished for the transportation of men alone, such as bodies of troops, parties of excursionists, emigrants, etc. Frequently they are *flat* or *box-cars* furnished with roof sides, seats and doors. . . . The *emigrant sleeping-car* is now usually called a *tourist-car*, the latter being preferred by those who patronize them. **1898** *Chi. Times-Herald* 4 April 9/3 The tourist sleeping car . . . was avoided by all save immigrants and homeseekers. **1929** J. PARKER *Old Army* 195 From there we journeyed on tourist sleepers.

town ball. [See quot. 1909.] A form of ball game somewhat resembling baseball in that bases were used

and the players consisted of a pitcher, catcher, batter, and fielders.

1852 *Calif. Dispatch* (S.F.) 18 Jan. 2/4 A game of 'town ball' which was had on the Plaza during the week, reminded us of other days and other scenes. **1867** *Ball Players' Chron.* 18 July 4/2 Sometimes the name of 'town ball' was given to it, because matches were often played by parties representing different towns. **1909** *Collier's* 8 May 12/1 In America the corresponding game generally went under the name of 'rounders,' and because it was played at the time of town meetings, 'townball.' **1946** *Greenville* (Ala.) *Adv.* 26 Sep., The same game, with variations, was known in other Alabama communities as 'Town Ball.'

attrib. **1903** *Outing* July 455/1 Before the collegians the stalwart citizens organized baseball, the first recorded body for the pure purpose of contest being that of the 'Town Ball' Club . . . in Philadelphia, 1831.

trackage 'trækɪdʒ, *n.*

1. *collect.* The tracks of a railroad or railroad system.

1880 *Bradstreet's* 24 Nov. 2/4 The Reading will receive compensation on two-thirds of the trackage. **1946** *Trail & Timberline* May 67/1 Up behind the Front Range lies almost as much abandoned trackage as there is in operation today, abandoned because of heavy snows, grades which were too steep, diminishing population, exhausted mines or lack of traffic. **1949** *Lubbock* (Tex.) *Morn. Avalanche* 23 Feb. II. 8/5, I have the best business and trackage locations in town—also business buildings.

2. a. trackage charge, a charge for the use of a railway line by another company. **b. trackage rights,** certain rights secured by one railway company of making use, esp. at terminals, of the tracks of another company.

(a) 1884 *Morning Herald* (Reading, Pa.) 17 April, Our general agent has, therefore, advanced this trackage charge. — **(b) 1898** *K.C. Star* 21 Dec. 1/4 Trackage rights will be obtained over roads entering Chicago. **1947** *Time* 3 Feb. 80/2 As for trackage rights to San Francisco, he said airily: 'There's always ways of picking them up.'

*** trade,** *v.*

1. *tr.* To obtain or dispose of by barter. Also with *away, for, off.*

1636 *Conn. Rec.* I. 1 Henry Stiles . . . had traded a piece . . . with the Indians for Corne. **1793** *Mass. H.S. Coll.* 1 Ser. III. 1 Their land . . . produces good crops of corn and rye, which they trade off for spirituous liquors. **1802** *Steele P.* 250, [I] have not traded the mare away yet. **1939** PINKERTON *Wilderness Wife* 162 Now he saw one already killed, and at once offered to trade a large lake trout he had just landed for a haunch of meat.

2. a. *To trade in,* to give an automobile, radio, etc., as part payment for another, also **trading in. b.** *To trade out,* to take commodities to the amount of a sum due.

(a) 1927 *Observer* 21 Aug. 19/2 Americans . . . call him the 'junk' man because he buys what they call 'traded-in' cars for the purpose of scrapping them. *Ib.*, Dealers . . . who have taken old cars in part

purchase of new ones, which is called trading-in. **1931** *Randolph Enterprise* (Elkins, W.Va.) 1 Jan. 3/6 The old pieces which you trade in will be new to the one who buys them. — **(b)** *c*1847 Whitcher *Bedott P.* xi. 109, I make a practice o' lettin' on 'em *trade* it out.

* **traffic,** *n.* **1. traffic artery,** a road over which much traffic passes. (Cf. * **artery 2.**) **2. traffic cop,** a policeman who enforces laws regulating road and street traffic.

(1) **1927** *New Masses* June 7/4 In a side street, close to one of the main traffic arteries of the City of the Angels, hangs a sign which reads: 'Arcadia Dairy Lunch.' **1948** *Chi. Tribune* 1 April 1. 20/2 Chicago is already choking to death because of long failure to provide traffic arteries within the city. — (2) **1915** *Chi. Herald* 18 Nov. 11/4 If a traffic cop bawls you out, you speak to him gently. **1943** Damon *Sense of H.* 24 Samule and his Fanny surprise the traffic cop so much that he can't think of anything to say.

* **transcendentalist,** *n.* An adherent of the transcendentalism of Emerson and his followers. Now *hist.*

1838 Longfellow in S. Longfellow *H. W. Longfellow* I. 306 He is something of a Transcendentalist, and a friend of Emerson. **1843** *N.Y. Wkly. Tribune* 11 Feb. 2/5 Mr. Emerson is known, here and elsewhere, as a 'transcendentalist,' deeply imbued with the philosophy of the school thus denominated. **1893** *Harper's Mag.* May 849/1 Lowell shared in the efforts of the Transcendentalists to enlarge the bounds of spiritual freedom. **1950** *Harvard Alumni Bul.* 8 April 540/1 The reasons for Emerson's current lack of favor are understandable. He was a transcendentalist.

* **transient,** *n.*

1. One who passes through a place, or stays at a hotel or boardinghouse for a short time only.

1748 in Earle *Curious Punishments* 41 The officer shall take the said transient forth-with to some publick place in this town and . . . whyp him twenty strypes well layd on his naked back. **1880** Rollins *N. Eng. Bygones* 60 Sudden showers brought over willing neighbors and now and then a traveller would stop a day or two to lend a helping hand. My grandmother held these 'transients' in low esteem. **1948** *Chi. D. News* 13 Jan. 12/7 The hayseed jaypees work in the South exclusively for Yankee transients.

2. A steamboat not belonging to a regular line or not having a fixed route.

[**1841** in Albion *Square-Riggers* (1938) 261 Our packet ships will continue to receive their share of the traveling community, so long as they continue to run regularly. But if they make themselves 'transient' they must lose thereby ultimately.] **1893** Mark Twain *P. Wilson* i, The big Orleans lines stopped for hails only or to land passengers or freight; and this was the case also with the great flotilla of transients.

* **transom,** *n.* **1.** A seat at the side of a cabin or stateroom aboard a ship. **2.** A window above a door.

(1) **1851** Melville *Moby Dick* 88 To my astonishment, he sat down again on the transom very quietly. **1883** Crawford *Dr. Claudius* ix,

He sat down on the transom. — (2) **1880** HEALY *Lett. & Leaders* I.
141 Get a step ladder to reach over the 'transom.' **1932** *Atlantic Mo.*
CXLIX. 600 One will often need . . . a small can of thick black
paint to smear over the transom to keep the hall light out.

* **trashy,** *a.* **1.** Of persons: Of poor physical constitu-
tion or inferior social standing. **2.** Of land: Covered with
refuse, as the waste and discarded matter from an earlier
season.

(1) **1852** STOWE *Uncle Tom* xxxi, Stout fellers last six or seven years;
trashy ones get worked up in two or three. **1862** E. KIRKE *Among
Pines* 167 He regarded the white man as altogether too 'trashy' to be
treated with much ceremony. — (2) **1861** *Ill. Agric. Soc. Trans.* IV.
250 The wheat drill . . . is designed to do this work rapidly and per-
fectly, on ground however rough and trashy. **1905–6** *Trade Cat. (Cent.
Supp.*), The high curve of the beam prevents fouling in trashy land.

trestlework ˈtrɛslˌwɜk, *n.* A structure, esp. a rail-
road bridge, supported by trestles. Also transf.

Trestlework on railway

1848 *Knickerb.* XVIII. 153 The thick tressel-work of an hundred
Lombardy poplars screened it. **1863** F. MOORE *Rebellion Rec.* V. I. 29
A force from Gen. Sherman's command . . . destroyed several pieces
of tressel-work on the Mississippi Central Railroad. **1896** SHINN
Story of Mine 210 Nothing better can be found in the way of con-
crete illustration than the . . . trestle works, machinery, and all.

troupe trup, *n.* [F. in the sense shown here.] A com-
pany or band, esp. one of performers or entertainers. Cf.
minstrel, variety troupe.

1825 *N.Y. Ev. Post* 6 Dec. 2 The whole troupe were equally excel-
lent. **1885** *Life* 2 April 186/1 Bob Ingersoll has found his level as a
side show to a Burlesque Troupe. **1946** *This Week Mag.* 10 Aug. 5/1
Both he and his troupe took their art in deadly earnest.

truant officer. An officer charged with investigating
the absence of children from school.

1872 BRACE *Dangerous Classes N.Y.* 348 The Massachusetts system
of 'Truant-schools'—that is Schools to which truant officers could
send children habitually truant—does not seem so applicable to New
York. **1911** PERSONS *Mass. Labor Laws* 181 The truant officer finds

that no certificate has been issued from the central office. **1950**
Desplaines Valley News (Summit, Ill.) 7 April 2/1 Our Platform. . . .
Employ a truant officer, school doctor and dentist.

* **tucking,** *n*. and *a*. **1. tucking bush,** (see quot.). **2.
tucking comb,** (see quot. 1909). **3.** *the whole twist and
tucking,* the entire group or company. *Colloq.*

(1) **1890** SHIELDS *Big Game N. Amer.* 88 Large patches of 'tucking-
bushes,' or dwarf juniper, which grow about breast-high, with strong
branches stiffly interlaced. — (2) **1822** *Receipt by Daniel McDowell*
11 April (Pettigrew P.), Bot of D McDowell one tucking Comb at
$4.50. **1895** *Outing* XXVII. 11/2 He stopped and held up a gold-
tipped tucking comb. **1909** *D.N.* III. 384 tuck(ing)-comb, *n*. A comb
used to hold the hair on the back of the head. [e. Ala.] — (3) **1835**
LONGSTREET *Ga. Scenes* 124 No man's to make a grab till all's been
once round— . . . then the whole twist and tucking of you grab
away, as you come under.

tularemia ˌtuləˈrimɪə, *n.* [Coined by Dr. Edward
Francis. See quot. 1921.] An acute infectious disease of
animals and man caused by *Bacterium tularense* and
transmitted by the bites of blood-sucking ticks and flies,
esp. the deer fly *q.v.*, and by contact with the raw flesh
and blood of infected animals.

1921 EDWARD FRANCIS in *Public Health Rep.* 29 July 1731 (*foot-
note*), The name tularæmia is based on the specific name *Bacterium
tularense*, plus *æmia*, from the Greek, and has reference to the
presence of this bacterium in the blood, on the analogy of leukæmia
or bacteræmia, etc. The names thus far used for this disease are
strictly vernacular and do not lend themselves to international usage
as easily as a name in Latin form. Accordingly, the name tularæmia
is proposed as a technical international name. **1942** *Keeping Live-
stock Healthy, Yrbk. Agric.* 1219 Among the diseases of wildlife trans-
missable to man, tularemia, caused by the organism *Pasteurella
tularense*, has attracted Nation-wide attention. **1949** *Reader's Digest*
April 54/2 He proved for the first time that the lemming, that prodi-
giously spawning ground rat of the north, was the source of a myste-
rious ailment, which he also proved to be tularemia.

tump tʌmp, *n.* [f. an Algonquian word meaning a
pack strap. Cf. Mass. *tàmpàn*, Abnaki *mádûmbî*.] (See
quot. 1848.) In full **tumpline.**

1796 *Captivity of Mrs. Johnson* 66, I was a novice at making canoes
. . . and tumplines, which was the only occupation of the squaws. **1848**
BARTLETT 367 *Tumpline*, a strap placed across the forehead to assist
a man in carrying a pack on his back. Used in Maine, where the cus-
tom was borrowed from the Indians. **1917** KEPHART *Camping* II. 121
The tump or head-band is a good addition not only to a pack harness
but to almost any other kind of pack used for carrying heavy weights.
. . . When fording a swift stream, crossing on a foot-log or fallen tree,
going over windfalls . . . the shoulder straps may be dropped.

Tumpline in use and in detail

Also **tump-pack, tumpstrap.**

1939 PINKERTON *Wilderness Wife* 26 The heavier [packsack], with cooking kit and grub, hung on his back, supported by leather bands over his shoulders and steadied by a tumpstrap across his forehead. **1949** *Boston Globe* 15 May (Fiction Mag.) 7/1 He nodded, tapping a small pack of furs which he had unslung from his tump-pack.

Tweed Ring. [f. W. M. *Tweed* (1823–78), a notorious Democratic boss in N.Y. City.] The group comprising W. M. Tweed and his associates, who, from 1858 to 1871, controlled the municipal government of N.Y. City. Now *hist.*

1882 McCABE *New York* 297 It was the chief means used by the Tweed Ring in carrying out their stupendous frauds. **1899** BREEN *Thirty Years* 37 Shortly after the close of the Civil War, when what is known as the 'Tweed Ring' was being formed, it was found necessary by the members of that combination, in order to secure absolute control of the Democratic organization, and to promote their schemes, to capture the Tammany Society. **1946** ADAMS *Album Amer. Hist.* III. 269 In New York City the Tweed Ring robbed the municipality of over $100,000,000.00 through padded payrolls, fraudulent contracts and the sale of political favors.

typewriter ˈtaɪpˌraɪtɚ, *n.*

1. A machine for writing by means of type characters similar to those of printers.

1868 C. LATHAM SHOLES Specifications accompanying application for patent 11 May 14 Thus made, the Type-Writer is the simplest, most perfectly adapted to its work. **1876** KNIGHT 2677/1 The Sholes typewriter . . . is about the size of the sewing-machine, and is worked with keys arranged in four banks or rows. **1923** DUTTON *Shadow on Glass* 76 The only thing that seemed to have caused it was the typewriter. **1949** *New Yorker* 9 July 54/3 They seem so good partly, I think, because of Mr. Mencken's advantages . . . of hitting a typewriter fast to make an edition.

attrib. **1884** HOWELLS *Silas Lapham* 24, I want you should put these in shape, and give me a type-writer copy to-morrow. **1902** MARK TWAIN in *Harper's Mag.* CIV. 258/1 She took from the drawer of the

type-writer table several squares of paper. **1903** *Christendom* 13 June 393 Please furnish . . . 12 typewriter ribbons. **1918** M. B. OWEN *Typewriting Speed* 115 The typewriter cabinet is one of the things that should receive attention.

2. A typist. Now *hist.*

1884 *N.Y. Herald* 27 Oct. 7/2 Situation Wanted—By Lady, Rapid Stenographer, and typewriter. **1901** *Denver Republican* 26 Aug. 8/5 That the company should get no more than the customer is hardly fair; because it has to pay office rent and typewriters' salaries. **1947** *Newsweek* 10 Feb. 94/2 She was one of the world's first 'female typewriters.'

Also **typewriter girl.** *Obs.*

1884 HOWELLS *Silas Lapham* xxiii. 410 One of them was Miss Dewey, the type-writer girl. **1904** A. DALE *Wanted, a Cook* 82 Have you ever heard of a typewriter girl who has come to grief, and who wasn't beautiful?

typo ˈtaɪpo, *n.* A typographer or typesetter.

1816 *Mass. Spy* 7 Aug. (Th.), [Printers] will confer a favour on a brother typo [by publishing an advertisement of a runaway apprentice]. **1872** *Chi. Tribune* 21 Oct. 7/3 Governor Warmouth . . . became a typo in the St. Louis Republican office. **1948** *Chi. D. News* 20 Aug. 12/1 (*heading*), Typos Act On New Processes.

U

Uchee ˈjutʃi, *n.* Also **Euchee, Yuchi.** [f. a native word meaning "situated yonder" and prob. given by some member of the tribe in answer to some such question as "Who are you?" or "Where do you come from?" See Hodge.] An Indian of a tribe first encountered by Europeans in eastern Carolina or Georgia; also, *pl.*, the tribe of such an Indian.

1738 W. STEPHENS *Proc. Georgia* 75 He understood they were a Party of the Euchies. **1818** *Lynchburg* (Va.) *Press* 25 Dec. 3/1 The captain . . . reports to have taken three warriors, a Creek, a Choctaw, and a Uchee. **1851** DRAKE *Indians N. Amer.* 16 The *Uchees* are said to speak a primitive language. **1910** HODGE *Amer. Indians* II. 1005/1 In material culture the Yuchi are typical of the agricultural hunting tribes of the s.e. Atlantic and Gulf coast area.

attrib. **1744** F. MOORE *Voy. Georgia* 102 Part of these cattle belonged to the Saltzburghers, who had passed over the Ebenezer river into the Uchee lands. **1746** *Ga. Col. Rec.* VI. 170 [They] had petitioned the

Trustees to obtain for them a Tract of Land said to belong to the Uchee Indians.

Hence **Uchean,** *a.*

1910 HODGE *Amer. Indians* II. 861/2 Uchean Family. A linguistic family limited, so far as is positively known, to a single tribe, the Yuchi.

unappropriated land. Public land not sold or set aside for a particular purpose. *Obs.*

1717 *Mass. H. Rep. Jrnl.* I. 196 A Petition . . . praying that 600 Acres of Land . . . may be laid out in some Unappropriated Land of this Province. **1780** in *Pres. Mess. & P.* III. 59 Unappropriated lands which may be ceded or relinquished to the United States by any particular State . . . shall be disposed of for the common benefit of the United States. **1836** *Mich. Gen. Statutes* (1882) I. 37 Five entire sections of land . . . from any of the unappropriated lands . . . are hereby granted to the state for the purpose of completing the public buildings of the said state.

underground railroad. (Also *cap.*) A system of co-öperation brought into existence *c*1832 by those actively opposed to slavery whereby they secretly assisted fugitive slaves to reach the North or Canada. Also attrib. Now *hist.*

1842 *N.Y. Semi-Wkly. Express* 28 Sep. 1/5 We passed 26 prime slaves to the land of freedom last week. . . . All went by 'the underground railroad.' **1857** *Lawrence* (Kans.) *Republican* 11 June 2 He is . . . charged with being in correspondence with underground railroad directors. **1946** ADAMS *Album Amer. Hist.* III. 51 'The Underground Railroad' a system by which runaway slaves were passed from one friendly Northern hideout to another until they were beyond capture, irritated the South.

transf. **1949** *Sat. Ev. Post* 4 June 29/2, I was escorted by a leader of a Russian underground railroad which helps escapees in their flight.

Also **U.G.R.R.** in transf. use. *Obs.*

1862 *Dly. Richmond* (Va.) *Enquirer* 3 Feb. 3/4 (*heading*), Our 'Local' Visits Lincolndom—A Trip to Baltimore and Back by the 'U.G.R.R.'

unicycle 'juni͵saikl], *n.* (See quot. 1883.)

1869 *Velocipede* (N.Y.) April 76 Hemming's Unicycle or 'Flying Yankee Velocipede.' **1883** KNIGHT *Supp.* 913/1 *Unicycle*, a one-wheeled vehicle for propulsion by foot-power. **1949** *Time* 16 May 71/2 Berle can sing, dance, juggle, act, do card tricks, imitations and acrobatics, ride a unicycle and mug under water.

union school. A school serving two or more contiguous school districts (see also quots. 1852, 1867). Also **union school district.**

1851 QUENTIN *Reisebilder* II. 56 Ich benutzte daher meine Anwesenheit an jenem Orte [N.Y. City], um die dortige 'Union-School' zu besuchen. **1852** *Ind. Hist. Soc. Pub.* III. 615 Union, or graded schools, for the terms are synonymous, are simply the schools of a given town-

ship, village or city, classified and arranged according to the attainments of the pupils. **1867** *Ore. State Jrnl.* 12 Jan. 2/3 In Michigan every town of 3,000 inhabitants is required to establish a Union school for both sexes. **1945** C. V. GOOD *Dict. Educ.* 138/1 district, union school: a type of local school unit formed by the uniting of two or more contiguous school districts for the purpose of providing elementary or secondary education, or both.

up and up. *on the up and up,* honestly, above board. *Colloq.*

1863 *Humboldt Reg.* (Unionville, Nev.) 4 July 2/1 Now that would be business, on the dead up-and-up. **1929** *Variety* 10 July 1/3 The show is run on the up and up. Six will not stand for any graft. **1948** *Time* 1 March 51/3 As proof that everything was on the up & up, Promoter Jack Harris pointed to the heavy side-betting between Riggs and Kramer.

*, **upstander,** *n.* An upright post or handlebar on a sledge. — **1856** KANE *Arctic Explor.* II. 98 It has two standards, or, as we call them, 'upstanders.' **1903** PEARY in *McClure's Mag.* Feb. 419/2, I had scarcely time to seize the upstanders when my dogs were off.

* **uptown,** *n.* The residential part of a city. Also attrib. or as adj.

1838 STEPHENS *Travels Greece* I. 83 Even I, . . . a quondam speculator in 'up-town lots.' **1844** *Ev. Mirror* (N.Y.) 12 Nov. 2/2 'Up-Town' and 'Down-Town.'—We see that these names of the different halves of the city are becoming the common language of advertisements, notices, etc. **1891** WELCH *Recoll. 1830–40* 27 It was a Saturday afternoon play-ground for the youngsters from up-town.

b. *adv.* In the residential part of a city.

1833 *Niles' Reg.* XLIV. 177/2 The property-holders, up-town would have the site of the building a mile or so from the present chief seat of business. **1917** MATHEWSON *Sec. Base Sloan* 57 They parted, agreeing to meet uptown at noon.

* **uvularia,** *n.* An herb of the genus *Uvularia*, a bellwort. — **1818** *Mass. H.S. Coll.* 2 Ser. VIII. 168 At the same time appear the blossoms of the alder, hazel, and poplar; soon after those of the uvularia or bellwort. **1850** S. WARNER *Wide, Wide World* xl, Wild columbine, the delicate corydalis, and more uvularias, which she called yellow bells, were added to her handful.

V

vaca ˈvɑkə, *n. S.W.* [Sp. in same sense.] A cow. **1846** MAGOFFIN *Down Santa Fé Trail* 91 They are inhabited by

rancheros as they are called, who attend solely to raising of vacas. **1897** HOUGH *Story of Cowboy* 26 Even cattle are sometimes called *vacas*, though this is not usual. **1944** ADAMS *W. Words* 172.

valedictorian ˌvælədɪk'torɪən, *n.* [f. * *valedictory*+*-an*.] A college or high-school senior, usu. the one of highest academic standing in his class, who delivers the valedictory oration at the graduation of his class.

1759 *Holyoke Diaries* 20 Officers of the Sophisters chose Valedictorians. **1852** *Harper's Mag.* Aug. 335/1, [I was] pointed out, to the classes, just entered, as the valedictorian. **1949** *Chi. Maroon* 4 Oct. 7/2 The college should be large and not limited to high-school valedictorians.

vaseline 'væslˌin, *n.* [See note.]

"*Vaseline* was coined by Robert A. Chesebrough in 1870 or thereabout. It was made of the German *wasser*, meaning water, and the Greek *elaion*, meaning oil. . . . *Vaseline* now appears in all the German and French dictionaries, but all rights to the name are still vested in the Chesebrough Company" (Mencken, *American Language*, 4th ed. 172).

A semisolid yellow-whitish petroleum product marketed under the trade-mark Vaseline and used as an ointment and for other medicinal purposes.

1874 *Eng. Mech.* 25 Sep. 36 A new petroleum product has been introduced into the trade under the name of vaseline. **1921** *Outing* Sep. 266/3 Thinner oil, as it is most frequently mixed, runs at the least provocation on the part of a heat ray; while the heavier vaseline will stay put. **1949** *Hoard's Dairyman* 25 Nov. 837/1 A ring of vaseline about an inch wide is then smeared completely around the clipped areas.

attrib. **1935** LINCOLN *Cape Cod Yesterdays* 164 There were at least half a dozen 'vaseline yellow' candlesticks pushed back out of the way in our closet, discarded, of course, when kerosene came to be burned for lighting purposes.

*** Venus,** *n.*

1. Venus' flytrap, an insectivorous plant, *Dionaea muscipula*, that grows wild on the coast of the Carolinas.

1770 J. ELLIS *Botanical Descr.* 39, I shall now give you a general description of the species of *Dionæa* before us, called *Muscipula*, or *Venus's Fly-trap*. **1802** DRAYTON *S. Carolina* 70 Venus's fly trap . . . grows near the sea shore road on the borders of North Carolina. **1949** *Nat. Hist.* June 278/3 The leaves of Venus's-flytrap are more spectacular, larger, and much more rapid in action than Drosera's apparatus.

2. Venus'-pride, (see quots.).

1784 *Amer. Acad. Mem.* I. 409 Venus Pride . . . spreads over pastures and fields, in large beds, and gives them a white appearance. **1829** EATON *Botany* (ed. 5) 246 *Houstonia cærulea*, Venus' pride, forget-me-not. **1931** CLUTE *Plants* 75 We have a number of other plants in our flora which escaped the notice of the devout entirely, among them. . . . Venus' pride (*Houstonia angustifolia*).

verdin ˈvɜdn̩, *n.* [F., yellowhammer.] A small yellow-headed titmouse, *Auriparus flaviceps*, of the Southwest.

1881 *Amer. Naturalist* XV. 217 Another minute species of the titmouse family [is] the verdin or yellow-headed titmouse. **1903** *Atlantic Mo.* July 103 The same fretful verdin was talking about something with the old emphatic monotony. **1939** PICKWELL *Deserts* 139/2 This is the voice of the Verdin, a true bird of the desert.

Victrola vɪkˈtrolə, *n.* Also **victrola.** [f. *Victor* Talking Machine Co., a trade-mark.] A phonograph bearing the trade-mark Victrola.

1917 LEACOCK *Frenzied Fiction* v. 70 The others were dancing the fox-trot to the victrola on the piazza. **1922** *Frontier* May 21 She likes to hear the victrola, and while it plays, she sits quietly. **1949** *Prairie Schooner* Spring 48 He put away the pistol and bought a Victrola for the bunkhouse.

vireo ˈvɪrɪˌo, *n.* [L. *vireo, -eonis* (Pliny) some small bird, perhaps the greenfinch. See also quot. 1917.] Any one of various small American birds constituting the family Vireonidae.

1834 AUDUBON *Ornith. Biog.* II. 287 The Vireos quench their thirst with the drops of dew or rain that adhere to the leaves or twigs. **1917** *Birds of Amer.* III. 102 Vireos are sometimes called Greenlets; the Latin word *Vireo* means 'I am green.' **1948** *Pacific Discovery* March–April 17/1 The vireo flitted away.

* **visor,** *n.* The stiff forepiece of a cap.

1847 PARKMAN in *Knickerb.* XXIX. 504 The water dropped from the vizors of our caps, and trickled down our cheeks. **1911** LINCOLN *Cap. Warren's Wards* 2 He was a big man . . . wearing a cloth cap with a visor. **1944** *Sears Cat.* (ed. 189) 355 The soft, thick shearling wool pelt on the visor adds the extra smart touch.

* **voting,** *a.* and *n.* In combs.: (1) **voting juice,** liquor used to influence voting, *slang, rare;* (2) **-list,** a list of the names of those entitled to vote in a particular ward or precinct; (3) **machine,** a machine for recording and counting votes; (4) **precinct,** = election district (*a*).

(1) **1919** C. R. RAHT *Romance of Davis Mts.* 196 By the time the first barrel of 'voting juice' was empty, all had voted. — (2) **1859** HALE *If, Yes, & Perhaps* 187, [I told] Dennis that he might use the record on the voting-list. **1889** *Cent. Mag.* Feb. 626/2 Might it not be practicable to forbid the board to enter upon the voting-lists the name of any man . . . habitually violating the law? — (3) **1901** *Everybody's Mag.* Oct. 489/1 There you see in operation the electrograph, the machine which transmits pictures by wire; . . . the voting-machine, the entertaining mutoscopes. **1947** *Chi. Sun.* 28 Jan. 3/1 The City Council's sub-committee on voting machines yesterday recommended that one of the machines be installed in each of the city's 50 wards. — (4) **1872** *Chi. Tribune* 9 Oct. 1/6 About 200 voting precincts heard from. **1949** *Summit Valley Times* (Argo, Ill.) 9 Nov. 7/1 For the purpose of said election said Pleasantview Fire Protection District has been constituted two voting precincts.

vum vʌm, *v.* [?f. ∗*vow.*] *intr.* To vow, swear. *Colloq.*
1785 *Mass. Spy* 13 Oct. 2/2 We all must dreadful mindful be That we must fight for liberty And vum we'll 'fend it, if we die. **1839** *Havana* (N.Y.) *Republican* 21 Aug. (Th.), I vum I cant contrive who *you* be. **1948** *Sat. Review* 26 June 26/1 In the Gadsooks novels, atmosphere is as thick as a London fog, with dialogue full of 'La, sir,' 'Gadsooks,' and 'I vum.'

b. *To be vummed*, to be darned or doggoned. *Colloq.*
1881 M. J. HOLMES *Madeline* 282 'She'd be vummed,' the indignant old lady said, 'if she would not write to Lucy herself.'

W

Wabash 'wɔbæʒ, *n.* [App. f. the native name, the meaning of which is not clear.] *attrib.* Of or pertaining to the Wabash River or country, as **Wabash corn, Indian, pearl, poor land, squash, water.**
1789 *Ann. 1st Congress* 80 The Governor of the Western Territory has made a statement to me of the reciprocal hostilities of the Wabash Indians, and the people inhabiting the frontiers bordering on the river Ohio. **1838** ELLSWORTH *Valley of Wabash* 46 It produced 120 bushels to an acre, and this on 'Wabash poor land,' which had supported successive exhausting crops without manure. **1843** MARRYAT *M. Violet* 204 The general was free with his 'Wabash water' [i.e., whisky.] **1852** FLEISCHMANN *Wegweiser* 171 Ein Kern von dem obern Theile einer Maisähre, *Wabashcorn.* **1940** WILSON *Wabash* 7 It flows over limestone or gravel and sand, yielding the famous Wabash pearls. *Ib.* 13 Near their homes, grew the first of the famous Wabash squash, pumpkins, and beans.

b. Used as an ejaculation. *Rare.*
1787 in G. O. SEILHAMER *Hist. Amer. Theatre* II. (1888) 231 *Jonathan* He was going to ask a young woman to spark it with him, and— the Lord have mercy on my soul—she was another man's wife. *Jessamy* The Wabash!

wagon boss. *W.* A man in charge of a wagon train. Now *hist.*
1873 BEADLE *Undevel. West* 98 Our 'wagon-boss,' absolute monarch of a train while on the road, rejoiced in the name of John Monkins. **1924** McCONNELL *Frontier Law* 15 Before leaving Atchison I asked the wagon boss how many pairs of blankets I would need, and he told me that one pair would be plenty, as I could double up with one of the other drivers. **1949** *10 Story Western* May 9/1 Big Rafe Rattery, ramrod and wagon boss, rode the point with Les Manders, his cronie and side-pardner.

* **wagtail,** *n.*

1. a. = **wiggletail.** *Obs.* **b.** Any one of various
American birds, esp. the oven bird and water thrushes of
the genus *Seiurus* that bob their tails as they walk. Also
with specifying terms.

(a) **1851** WM. KELLY *Across Rocky Mts.* 71 A large flash of water,
round which there was glorious feed; but the liquid was green and full
of wagtails. — (b) **1868** *Amer. Naturalist* II. 181 Audubon placed
them [i.e., water thrushes] among his *Motacillinœ* or wagtails. **1917**
Birds of Amer. III. 156 The Kentucky Warbler, like many other
ground birds, . . . bobs his tail in that peculiar manner which has
given them the vernacular name of Wagtail.

2. wagtail warbler, (see quots.).

1884 COUES *Key to Birds* (ed. 2) 309 *Siurus nævius.* Wag-tail
Warbler. *Siurus motacilla.* Large-billed Wagtail Warbler. **1917** *Birds
of Amer.* III. 149 Palm Warbler. *Dendroica palmarum palmarum.* . . .
[Also called] Wagtail Warbler; Tip-up Warbler.

As the last term in **water, wood wagtail.**

wahoo waꞌhu, ꞌwɑhu, *n.*¹ [f. Creek *ûhawhu,* in same
sense.] The cork or wing elm, *Ulmus racemosa* or *U. alata,*
or any one of various other trees of other genera similar
to these. Also attrib.

1770 MEASE *Narrative* 62 The Trees which I remark'd to be the
largest were Oaks of different Kinds, Wahoos, Button Wood [etc.].
1802 DRAYTON *S. Carolina* 65 [The] *wahoo,* affords a pliable bark, which
when strypped, and soaked in water, is made sometimes into strings
and ropes. **1829** EATON *Botany* (ed. 5) 428 *Ulmus alata,* whahoo. **1948**
Chi. Tribune 20 Nov. 10/3 The southern winged elm is also called
wahoo, but it is a regular tree, 40 or 50 feet high.

attrib. **1873** *Newton Kansan* 27 March 1/7 One ounce of wahoo
(winged-elm) bark, added to a quart of pure whiskey . . . is very
excellent in dyspepsia. **1881** MARSHALL *Through Amer.* 337 We Take
Wahoo Bitters.

wake-up ꞌwekₗʌp, *n.* A local name for the flicker, in
allusion to its note.

1844 *Nat. Hist. N.Y., Zoology* II. 192 This species . . . is called High-
hole, Yucker, Flicker, Wake-up and Pigeon Woodpecker. **1869** MUIR
First Summer in Sierra (1911) 233 The waycup, or flicker, so fa-
miliar to every boy in the old Middle West States, is one of the
most common of the woodpeckers hereabouts, and makes one feel at
home. **1893** *Scribner's Mag.* June 773/2 The flicker has a long array
of names, . . . like flicker, clape, wake-up, . . . derived from his
notes.

* **wallow,** *n.* A place to which animals resort for rolling
or wallowing; a depression in the earth caused by this (see
quot. 1947).

1796 in *Amer. Sp.* XV. 407/1 To four Chesnuts in the head of a deep
Wallow by a water Slip. **1827** WILLIAMS *W. Fla.* 27 But it is in the
wallows, large mud holes among the rushes, that the alligator appears

herself. **1876** J. A. ALLEN *Amer. Bisons* 65 These wallows thus become characteristic marks of a buffalo country. **1947** CAHALANE *Mammals* 78 After a few dust baths, the wallow is a saucerlike depression from eight to fifteen feet across and as much as sixteen or eighteen inches deep toward the center.

attrib. **1787** in *Amer. Sp.* XV. 407/2 At white oak & red oak near a wallow Hole. **1861** in *Ib.*, To a sugar tree (now fallen) by the Big wallow hole. **1882** BAILLIE-GROHMAN *Camps in Rockies* 37 All three [saddle blankets] were well soaked in the copper-coloured wallow water.

wanigan ˈwɒnəgən, *n.* [f. Abnaki *waniigan*, trap, a receptacle for stray objects.] (See quots.) Cf. prec. and see **wammikin.**

1902 WHITE *Blazed Trail* 323 Outside, the cook and cookee were stowing articles in the already loaded wanigan. **1910** HODGE *Amer. Indians* II. 910 *Wanigan.* A receptacle in which small supplies or a reserve stock of goods are kept; also a large chest in which the lumbermen of Maine and Minnesota keep their spare clothing, pipes, tobacco, etc. Called also *wongan*-box, and spelled *wangun* and *wangan.* (2) A boat used on the rivers of Maine for the transportation of the entire personnel of a logging camp, along with the tools of the camp and provisions for the trip. . . . (3) A place in a lumber camp where accounts are kept and the men paid. **1945** FUGINA *Upper Miss.* 221 Wanigans were small flatboats, built of natural crook knees and planked lengthwise. **1949** *Survey* June 303/2 The industry is based no longer in isolated logging camps, with lonely men living in 'wannigans' dragged through the forests on sled-like runners.

attrib. **1901** *Everybody's Mag.* June 565/2 The night, the wongan boat with its food and camp-kit for the men fell far behind the crew.

* **warm,** *a.* In combs.: (1) **warm air furnace,** a furnace which gives out heat by causing the circulation of heated air; (2) **blood,** unmixed thoroughbred blood, pure descent; (3) **slaw,** (see quot. and cf. "cold slaw," variant of **coleslaw**); (4) **spring,** see as a main entry.

(1) **1846** *Catholic Herald* (Phila.) 30 Aug. 272/3 Warm Air Furnaces, Kitchen Ranges, Gas Ovens, Bath Boilers, Grates, Stoves, &c. **1886** J. A. PORTER *New Stand. Guide Washington* 208 Chas. G. Ball & Son, . . . Warm-Air Furnaces. — (2) **1868** *Iowa State Agric. Soc. Rep. 1867* 120 With the exception of the one [stallion], there is not a drop of 'warm blood' in them. **1883** *Harper's Mag.* Oct. 724/2 The descendants of these [thoroughbred horses] constituted a stock of 'warm blood.' — (3) **1796** F. BAILY *Tour* 136 A dish of stewed pork was served up, accompanied with some hot pickled cabbage, called in this part of the country [a Dutch household in Pa.] 'warm slaw.'

* **warn,** *v.* * *To warn out,* of a N. Eng. town government: To serve official notice upon (a person) to withdraw from a town (see quot. 1911). *Obs.*

1758 in G. SHELDON *Hist. Deerfield, Mass.* (1895) I. 592 Voted that the Selectmen be directed to warn the two children of Margaret Choulton out of Town Immediately. **1770** in *Pub. Col. Soc.* XXVI. 20

November 14, 1770, Moses McEntosh Last from the Castel he has lived in Several towns in the Country or Provance But has been warned in his Majestys Name out of them all He says he was warned out of Boston abote 17 years ago By 2 men in Boston But he says he was born in Dedham warned in his Majestys name to Depart this town of Boston in 14 Days. **1911** J. H. BENTON *Warning Out* 116 The effect of warning out as thus practised upon persons who remained in the town after being warned was to relieve the town from all obligation to aid them if they became poor and in need of help or support.

✳ **warrior,** *n.*

1. *pl. transf.* The members of Tammany Hall. *Obs.*

1812 *Salem Gaz.* 5 June 3/3 The Warriors of the Democratic Tribe will hold a powow at Agawam on Tuesday next. **1861** *N.Y. Herald* 4 July 5/3 The chiefs, sachems and warriors will assemble in the Great Wigwam at twelve o'clock, noon, precisely, for the transaction of business.

2. Warriors' Path, any one of various paths (see quots.) used by Indian warriors. Now *hist.*

1770 WASHINGTON *Diaries* I. 425 At the Mouth of this Ck . . . is the Warriors Path to the Cherokee Country. **1910** HODGE *Amer. Indians* II. 801/1 The great highway leading from Cumberland gap to the mouth of the Scioto was known as the Warriors' Path. **1943** PEATTIE *Great Smokies* 27 One [trading path] led from Virginia west of the mountains, to the Overhill Cherokees by a 'warriors' path' that ran from present-day Roanoke, Virginia, and the Shenandoah, to Chattanooga, Tennessee.

Washoeite 'waʃoˌaɪt, *n.* [See **Washoe.**] One of those who flocked to the silver mines in the Washoe district upon the discovery of the Comstock lode in 1859. Also a Nevadan. *Obs.*

1860 *Harper's Mag.* Dec. 12/1 An almost continuous string of Washoeites stretched . . . as far as the eye could reach. **1867** *Terr. Enterprise* (Virginia, Nev.) 9 Feb. 3/1 Mr. L. Winn, so well known to all of us Washoeites, . . . is now once more manufacturing candy for the sweet-toothed residents of the Bay City. **1869** *Ib.* 24 Jan. 3/2 A brass band enlivened the scene, and the Washoeites had a 'rare old time.'

✳ **watcher,** *n.* In an election, a party representative authorized to be present at a polling-place to watch the conduct of officials and voters. See also **clock watcher, posy watcher.** — **1911** *Okla. Session Laws* 3 Legisl. 82 The challenger, pool book holder and watcher shall perform duties as provided by law, governing any general election. **1948** *New Yorker* 25 Sep. 25/3 Each party is entitled to have two watchers at each polling place.

water oak. Any one of various American oaks often found near water, esp. *Quercus nigra* of the southeastern states.

1687 in *Amer. Sp.* XV. 156/2 To a Water Oake Standing by ye side of ye black Swamp. **1765** J. BARTRAM *Jrnl.* 21 Dec. (1766) 2 So staid

at Mr. Davis's, who walked with us about his land, on which grew very large evergreen and water oaks, magnolia. **1867** MUIR *Thousand-Mile Walk* (1916) 47 The Chattahoochee River is richly embanked with massive, bossy, dark green water oaks. **1950** *Amer. Forests* Jan. 29/1 It is, however, . . . considered by some to be less desirable for planting than either the water oak or willow oak.

Wenham ice. Ice from a pond in the township of Wenham, near Boston, Mass., formerly an article of export. Also **Wenham lake ice.** *Obs.*

1846 *Niles' Reg.* 2 May 144/1 The barque Hannah Sprague, . . . has been chartered to carry a cargo of Wenham Lake ice from Boston to London. **1860** HOLMES *Professor* 103 'The Model of all the Virtues' had a pair of searching eyes as clear as Wenham ice. **1885** HOWELLS *Silas Lapham* 178 They were so many blocks of Wenham ice for purity and rectangularity.

＊**westernize,** *v. tr.* To make American or like the American West in manner or character, to settle or travel in the West. *Colloq.*

1837 PECK *New Guide* 107 Emigrants from Europe . . . are fast losing their national manners and feelings, and to use a provincial term, will soon become 'westernized.' **1882** *Advance* 22 June, After a month's residence [in Lawrence, Kans.], I have come to feel that it was a New England town *westernized*. **1902** *Nation* 23 Jan. 77/1 Its sphere will be wider than its own West, and it will win many to Westernize. **1949** *Trail Riders Bul.* March 7/1 A number [of dudes] go to nearby Kananaskis Ranch to get completely 'westernized' before the ride.

＊**Whiggery,** *n.* The principles or doctrines of the American Whig party. Now *hist.*

1835 C. P. BRADLEY *I. Hill* 163 Wherever there still lives a man, who was a prominent member of the old federal party, that man is an adherent of modern Whiggery. **1851** *Miss. Palladium* (Holly Springs) 23 May 1/5 History shows the remarkable affinities of *Whiggery* for *No-Party* hobbies. **1950** *Chi. Tribune* 28 Feb. 12/3 The Public Advertiser . . . thought the ball 'characteristic of Whiggery in every particular—so hollow, so empty, so foolish, so dependent upon uphill work.'

b. *collect.* The members of the Whig party. *Obs.*

1837 *New-Yorker* 2 Dec. 587/2 The oddest affair . . . appears to have been conducted altogether by the 'rank and file' of the Whiggery of the Metropolis.

＊**whistle,** *n.* In combs., some of which are based on the verb: (1) **whistle pig,** a local name for the ground hog *q.v.*; (2) **stop,** a small, insignificant railroad town, also attrib.; (3) **willow,** the striped maple (see next); (4) **wood,** (see quots.).

(1) **1929** *Randolph Enterprise* (Elkins, W.Va.) 28 Nov. 8/2 The whistle pig is taking his nap of six months. **1943** PEATTIE *Great Smokies* 271 Whether the ground hog (called 'whistle-pig' by the

mountain people of the Smokies) does or does not see his shadow on Candlemas Day isn't important. — (2) **1944** *Sat. Review* 2 Sep. 2/4 The frank, humorous, and, at the same time, challenging story of the men of the U.S. Foreign Service who represent America in the whistle-stops of the world. **1950** *Chi. Tribune* 15 May 16/3 The whistle-stop political orator says he stands for 'a bold, expanding economy.' — (3) **1935** H. L. DAVIS *Honey in Horn* 1 Around the springs were thickets of whistle-willow and wild crabapple. — (4) **1891** *Cent.* 6908/1 *Whistle-wood*, the striped maple, *Acer Pennsylvanicum*, thus named because used by boys to make whistles. . . . The name is also given to the basswood, *Tilia Americana*. **1931** CLUTE *Plants* 42 The willow has always been a favorite material with children for making whistles, but the striped maple (*Acer Pennsylvanicum*) is the real whistlewood because its bark is so easily loosened in spring when whistles are in season.

b. *To pay too dear for one's whistle*, and variants, to pay more for a thing than it is worth, to "pay the piper." *Colloq.*

1779 FRANKLIN *Writings* VII. 416 Poor man, said I, you pay too much for your whistle. **1837** *S. Lit. Messenger* III. 176 That, rejoined he, would be paying too dear for the whistle. **1878** *Harper's Mag.* Jan. 199 When respectable people like the Mayor of the city of Hot Springs and his friends got drunk, they should pay for their whistle. **1914** *Amer. City* Jan. 43/2 Lack of knowledge or care on the part of officials as to matters determinable only in the laboratory is the greatest reason why so many of our cities 'pay too much for their whistle.'

white buffalo. The Rocky Mountain goat or sheep. Also, rarely, an albino buffalo. Also attrib.

[**1801** A. MACKENZIE *Voyages* (1802) I. 202 Our conductor informed us that great numbers of bears, and small white buffaloes, frequent those mountains.] **1806** LEWIS in *L. & Clark Exped.* V. (1905) 165 The indians inform us that there is . . . an abundance of the mountain sheep or what they call white buffaloes. **1888** *Outing* May 130 The 'white buffaloes' alluded to by Mackenzie could not have been mountain sheep, as this species is dark brown. **1947** CAHALANE *Mammals* 76 A Mandan would offer the equivalent of ten to fifteen horses for a white buffalo hide, and consider himself lucky to close the deal.

white pine. A species of pine, *Pinus strobus*, found in the East and Middle West; one of several other species of pine, as the sugar pine and the lodgepole pine. Also a tree, or its wood, of one of these species. Cf. **western white pine.**

1682 *Providence Rec.* XIV. 113 [The boundary is] from ye said heape of stones . . . to a great white pine. **1723** *Doc. Hist. N.Y. State* I. 720 But suppose the People could be restrained from cutting any White Pines. a**1797** in IMLAY *Western Territory* (ed. 3) 149 The sap . . . is carried and poured into store troughs, . . . made of . . . white pine. **1815** DRAKE *Cincinnati* 83 The white pine . . . is said to be occasionally seen on the waters of the Muskingum. **1948** *Reader's Digest* Jan.

68/2 But of all American woods none has been more significant than white pine.
attrib. **1734** *Jrnl. Mass. H. Rep.* 120 The Acts of Parliament, . . . reserve and secure to His Majesty, the right of the White Pine Trees. **1771** *N.H. Gaz.* 30 Aug. (Ernst), This is to inform such persons as are desirous of contracting for white pine masts, yards and bowsprits, . . . to apply to me. *a*1817 DWIGHT *Travels* II. 160 The white-pine plains are of stiff loam. **1868** *Rep. Comm. Agric. 1867* 73 The white pine worm, *Lophyrus abbottii*, . . . lives principally on white pine. **1905** *Forestry Bureau Bul.* No. 63, 14 The white pine weevil (*Pissodes strobi*) is a reddish-brown snout beetle. **1950** *Amer. Forests* Jan. 21/2 For the first time a helicopter has been used to spray from the air in an attempt to control white pine blister rust.

* **whooping,** *a.*

1. whooping crane, the large white crane, *Grus americana*, or a related species, so called because of its loud raucous cry.

*c*1730 CATESBY *Carolina* I. 75 *Grus Americana Alba*, The hooping Crane, is about the Size of the common Crane. . . . A white man . . . [told me] that he hath seen them at the Mouths of the Savanna, Aratamaha, and other Rivers nearer St. Augustine, but never saw any so far North as the Settlements of Carolina. **1828** BONAPARTE *Synopsis* 302 The Hooping Crane, *Ardea americana*, . . . inhabits throughout North America and the West Indies. **1879** BISHOP *4 Months in Sneak-box* 108 Whooping-cranes . . . and Sand-hill cranes . . . in little flocks, dotted the grassy prairies. **1950** *New Yorker* 8 April 23/1 One of thirty-six whooping cranes known to be extant was recently spotted in that vicinity [Lafayette, La.].

2. whooping owl, a hoot owl.

1781 S. PETERS *Hist. Conn.* (1829) 197 The tree-frogs, whipperwills, and whooping-owls, serenade the inhabitants every night with music. **1837** WILLIAMS *Florida* 73 There are many birds in Florida, . . . Marsh Hawk, . . . Horned Owl, . . . Whooping Owl [etc.].

* **whortleberry,** *n.* The fruit of any one of various species of *Gaylussacia*, or the plant bearing such fruit.

In some of the quots. the reference may not be to this plant.

1702 C. MATHER *Magnalia* (1853) II. 357 Sometimes we liv'd on whortle berries, sometimes on a kind of wild cherry. **1853** *Harper's Mag.* VI. 586/1 The whortleberries, which are large and fine, are contained in large baskets. **1898** *Maine Exp. Sta. Ann. Rep.* 164 The terms whortleberry and bilberry, which are given prominence in American references to plants of this class, are never heard among the 'common people.' **1941** LEE *Stagecoach North* 113 Their real unconfessed interest was focused on maple sugar cakes, dried whortleberries, fiddle music, and wild geese.

attrib. **1830** *Bell's Life in N.Y.* 14 Sep. 1/1 We reached the village of Caldwell in safety, after a travel of several miles through pine woods and whortleberry swamps.

* **wide,** *a.* and *adv.* **1. wide loop,** *W.* used of the loop of a lariat in allusion to cattle stealing, also *to swing a wide loop.* **2.** * **wide open,** without concealment, openly,

characterized by overt lawbreaking. *Slang.* **3. wide open spaces,** regions, as the Great Plains, of ample room. *Colloq.*

(1) 1924 BECHDOLT *Tales* 4 It was . . . the era of a 'wide loop' and a Winchester. **1944** ADAMS *W. Words* 160/2 swing a wide loop To live a free life, to steal cattle. — **(2) 1896** *Works of T. Roosevelt* XIV. (1926) 216 By February everything would again 'be running wide open' . . . the gambler, the disorderly-house keeper, and the law breaking liquor-seller would be plying their trades once more. **1905** *St. Louis Globe-Democrat* 1 July 1/3 Under the license of several years of 'wide-open' sentiment in this country, gamblers . . . have sought to make betting open to all classes. **1949** *World-Herald Mag.* (Omaha) 12 June 4/1 In the field of municipal government, a myth has been developed and sustained in many cities that a wide-open town policy is good business. — **(3) 1935** *Denver Post* 4 June 7B/8 The wide open spaces and the open range are not mere picturesque phrases of western fiction. **1949** *L.A. Times* 10 May II. 4/4 We live out in the wide open spaces.

wild pea.

1. Any one of various plants, esp. the wild pea vine (see next), or their fruits, of the pea family.

1778 CARVER *Travels* 515 Herbs [include:] . . . Scabious, Mullen, Wild Pease. **1808** PIKE *Sources Miss.* 104 Their craws were filled with acorns and the wild pea. **1893** *Amer. Folk-Lore* VI. 140 *Crotalaria sagittalis*, wild pea. Ia.

2. wild pea vine, a trailing plant, *Strophostyles hélvola,* found from New York to Texas, the foliage and pods of which supplied abundant and nutritious forage to cattle and sheep in pioneer times.

1786 WASHINGTON *Diaries* III. 123 Some of the Wild Pea vine . . . had been pulled. **1851** *S. Lit. Messenger* XVII. 565/1 We will . . . let the horses eat the luxuriant wild pea-vine until the wagons come up. **1950** *Asheville* (N.C.) *Citizen-Times* 26 March VII. 12/5 His horse . . . had been turned out to graze during the night on cane and the wild peavines.

***winged,** *a.* **1. winged dam,** =wing dam. **2. winged elm,** the cork elm, *Ulmus alata.*

(1) 1850 *S.F. Picayune* 31 Aug. 3/1 From a winged dam, which was worked last year, and had filled up again, $6 to $10 a day was taken. — **(2) 1820** GILLELAND *Ohio & Miss. Pilot* 257 *U. alata* (winged elm) peculiar to the shores of French Broad river in Tennessee. **1901** MOHR *Plant Life Ala.* 89 Box elder, winged elm, willow, . . . shade the rocky banks of the swift mountain stream.

***wintering,** *n. attrib.*

1. Designating places occupied in the winter by Indians. *Obs.*

1804–5 CLARK in *Lewis & C. Exped.* VI. (1905) 61 [From Fort Mandan] to Menatarras Wintering Village. **1807** GASS *Journal* 51 At the mouth of this river is a wintering camp of the Rickarees of 60

lodges. **1817** BRADBURY *Travels* 51, I set out . . . at sunrise, for the wintering house.

2. a. wintering ground, the ground or place where an individual or party spends the winter. **b. wintering post,** a post or station at which a military force spends the winter. Both *obs.*

(a) **1808** PIKE *Sources Miss.* 33 This day's march made me think seriously of our wintering ground. **1852** REYNOLDS *Hist. Illinois* 190 Mr. Hay got out into the wintering ground, and erected his quarters for winter. — (b) **1823** in *S. Dak. Hist. Coll.* I. 192 Part of the men . . . deserted from their wintering post at the Big Horn. *c*1836 CATLIN *Indians* II. 149 [Camp Des Moines] is the wintering post of Colonel Kearney.

Wintun wɪnˈtun, *n.* [Native word meaning "Indians," "people."] *collect.* or *pl.* One of the two divisions of the Copehan family of Indians in California.

1874 in *Overland Mo.* 1 Ser. XII. 530 Their name Wintoon (accent the ultimate) denotes 'Indians,' or 'people,' and it is one of which they are somewhat proud. **1903** JAMES *Indian Basketry* 57 On the upper Sacramento and upper Trinity still remain the Wintuns, many of whom are known as Pitt River Indians. **1910** HODGE *Amer. Indians* II. 963/1 Powers thought the Wintun were originally a sort of metropolitan tribe for the whole of N. California below Mt Shasta.

wirework ˈwaɪrˌwɜk, *v. tr.* To persuade or make use of (a person) by wirepulling methods. Also **wire-working,** *a.* and *n.*, conniving, obtaining ends by underhanded means. *Obs.*

1831 *American* (Harrodsburg, Ky.) 28 Jan. 3/2 One of the *wireworking* writers in the Union, seems disposed to consider it a little less than treason. **1843** J. Q. ADAMS *Diary* 547 Mr. James Monroe was recalled by President Washington through Thomas Pickering, wireworked by Alexander Hamilton. **1857** HAYES *Pioneer Notes* (1929) 167, I have kept aloof from the wire-working as well as from the more stormy scenes of politics.

Wistaria wɪsˈtɛrɪə, *n.* [Caspar *Wistar* (1761–1818), Amer. anatomist.] A small genus of large woody vines belonging to the pea family. Also (not *cap.*) a plant or flower of this genus. Cf. **American wistaria.**

Nuttall (see 1st. quot.) through an error used the spelling *Wisteria,* which still sometimes occurs.

1818 NUTTALL *Genera N. Amer. Plants* II. 115 Wisteria. . . . In memory of Caspar Wistar, M.D. late professor of Anatomy in the University of Pennsylvania. **1833** EATON *Botany* (ed. 6) 259 *Wistaria tuberosa,* ground-nut. . . . Root very nutritious. . . . Ought to be generally cultivated. **1842** LOUDON *Suburban Hort.* 376 Vines, roses, Wistarias, or other luxuriant climbers. **1943** PEATTIE *Great Smokies* 166 Some, like . . . the black locust with its drooping clusters of flowers like some white wisteria's, are tall foresters. **1950** *Reader's Digest* Jan. 84/1 Their loud-speakers blared boogie-woogie into the jasmine and wistaria.

Also **wistaria vine.**

1888 HARRIS *Free Joe* 199 A wistaria vine running helter-skelter across the roof of the little cabin. **1950** *Newsweek* 10 April 77/1 It thereupon occurred to Logan to capitalize on the analogy between the disintegration of the Czarist Russia and the passing of the Old South, and substitute wisteria vines.

* **wolverine,** *n.*

1. (*cap.*) A native or resident of Michigan, the Wolverine State. A nickname.

1834 *Sun* (N.Y.) 23 Aug. 3/2 In Kentucky they are called Corn Crackers. Ohio Buckeyes. . . . Missouri Pukes. Michigan T. Woolverines. **1904** *Grand Rapids Ev. Press* 23 June 3 Wolverines At Fair Many Michigan Persons Enjoy the St. Louis Show. **1949** *Amer. Sp.* XXIV. 300/1 As a Wolverine myself I am interested in information concerning it.

2. *attrib.* Designating things relating or pertaining to Michigan.

1843 CARLTON *New Purchase* II. 239 Like all hoosiery and woolverine things, they are regardless of dignities. **1847** *Cong. Globe* 5 Feb. 332/2 Set up a great Government bank — . . . a full-grown undeniable Wolverine wild-cat. **1852** *Mich. Agric. Soc. Trans.* III. 332 We have . . . about 10,000 things which Wolverine audacity have denominated swine.

3. Wolverine State, Michigan, a nickname.

The reason for the application of this nickname is not altogether clear. Wolverines, now extinct in Michigan, were never numerous there, if indeed there were any at all. See *Amer. N. & Q.*, March, 1944, 181–2, and cf. Wm. H. Burt, *The Mammals of Michigan* (1946) 143 ff.

1846 *Knickerb.* XXVII. 360 In the Wolverine state, on one occasion, Judge M— . . . was alone upon the bench. **1948** *Chi. Tribune* 8 Aug. 1/6 Eight railroads serving the Wolverine state will sponsor the day-long celebration.

woodchuck 'wʊd₁tʃʌk, *n.* [f. Algonquian. See **we-jack** and cf. Cree *otchek*, Chippewa *otchig*, the name for the fisher (see * **fisher 1.**) but transferred by white traders to the ground hog.] = **ground hog. Cf. eastern, rock woodchuck.**

1674 *Cal. State P., Amer. & West Indies* VII. 581 The natural inhabitants of the woods, hills, and swamps, are . . . rabbits, hares, and woodchucks. **1778** CARVER *Travels* 454 The Wood-chuck is a ground animal of the fur kind. **1938** *N.O. Picayune* 17 Feb. 2/4 A man wasn't born like a *woodchuck* to live in the airth. **1946** *Democrat* 6 June 4/6 One woodchuck may eat as much as two pounds of greens in a day.

attrib. **1817** *Mass. Spy* 18 June (Th.), Woodchuck Hunt. Woodchucks have appeared in great numbers. **1845** JUDD *Margaret* I. 17 Vigorously plied he his whip of wood-chuck skin on a walnut stock. **1919** CADY *Rhymes of Vt.* (1923) 105 You've never peeled a hemlock log Or set a woodchuck trap.

b. In phrases of comparison.

1825 BIRD *Hawks* I. 170 Here's a dose for the dog will make him sleep like a woodchuck at Christmas. **1860** HOLMES *Professor* 104 He will come all right by-and-by, sir,—as sound as a woodchuck—as sound as a musquash! **1937** COFFIN *Kennebec* 229 Some have . . . the 'Old Boy in them bigger than a woodchuck.'

c. *land of woodchucks*, a country area.

1851 ROSS *In New York* 46 But what could a 'greenhorn,' right from the land of woodchucks do?

woodsy ˈwʊdzɪ, *a.* Of or pertaining to the woods, sylvan.

1860 in BREWSTER *Life J.D. Whitney* 179 Your gallery would be rather monotonously 'lake and wood'sy. **1883** MARK TWAIN *Life on Miss.* xxx, Ship Island region was as woodsy and tenantless as ever. **1917** *Ladies' Home Jrnl.* July 33/2 In woodsy browns and greens the Camp Fire Girls' booth, with its . . . paper-bead chains, attracts attention. **1949** *Nat. Hist.* Nov. 386/3, I retired to a woodsy, flat-floored dell in quest of the Dutchman's-breeches.

worm fence. A zigzag Virginia rail fence. Cf. **staked and ridered.**

1652 *East-Hampton Rec.* I. 22 It is ordered that Thomas Baker shall have . . . 7 akers . . . within the worme fence on the litel plaine. **1724** JONES *Present State of Va.* 39 *Tobacco* and *Indian Corn* are planted in *Hills* as *Hops*, and secured by *Wormfences*, which are made of Rails supporting one another very firmly in a particular Manner. **1802** DAVIS *Travels* (1803) 343 You must keep *strait* along the worm (i.e. *crooked*) fence, till you come to a barn. **1946** NIXON *Va. Words* 43 worm fence. . . . A zigzag rail fence; fairly common in the northern Piedmont and on the Eastern Shore.

attrib. and *transf.* **1836** SIMMS *Mellichampe* xx, A little cornfield, with its worm-fence enclosure, lay on one hand. **1867** HARRIS *Sut Lovingood* 41 The road wer sprinkled worm fence fashun. **1897** LEWIS *Wolfville* 193 That Remorse pony . . . gives way to sech a fit of real old worm-fence buckin' as lands Slim Jim on his sombrero. **1946** STODDARD *Horace Greeley* opp. 241 Extract from a Letter to Helen R. Marshall Dated February 6, 1868; a Good Example of Greeley's 'Worm Fence' Handwriting.

b. Hence **worm-fenced, worm fencing.**

1789 *Amer. Philos. Soc.* III. p. lx, Worm-fencing and similar expedients of infant cultivation, should never be seen. **1904** T. E. WATSON *Bethany* 8 [It] was striving, unsuccessfully, to look at ease among . . . negro cabins, and worm-fenced cotton fields.

✲ **worry,** *v.* **1.** *tr.* (See quot. 1828.) *Obs.* **2.** *To worry along*, to manage to keep going. *Colloq.*

(1) **1828** WEBSTER, Worry, . . . to fatigue; to harass with labor; a popular sense of the word. **1875** HOLLAND *Sevenoaks* 66 For three steady hours he went on, the horse no more worried than if he had been standing in the stable. — (2) **1871** MARK TWAIN *Sk. New & Old* 296 You seem to have pretty much all the tunes there are, and you worry along first rate. **1885** HOWELLS *Silas Lapham* 214, I think I can manage to worry along.

* **wrecker,** *n.* **1.** One appointed to recover as much as possible of the assets of insolvent firms. *Obs.* **2.** (See quot. 1904.)

(1) 1846 LYELL *Second Visit* II. 39 'A wrecker' . . . [had] the unenviable task . . . of seeking out and recovering bad debts. — **(2) 1904** *Booklovers Mag.* May 663 The special train . . . dubbed the 'Wrecker' . . . is a relief train, ready to respond to any call for aid in case of accident. **1948** *Chesterton* (Ind.) *Tribune* 28 Oct. 7/5 It took a wrecker to dislodge the car and a cutting torch to free the bent wreckage so the locomotive could continue its run.

W X Y Z, see **X.**

X

* **X,** *n.*

1. *Hist.* Used, in conjunction with 'W,' 'Y,' and 'Z,' to indicate one of certain French emissaries engaged in negotiations with three envoys sent to Paris by the U.S. Government in 1797. Also attrib.

1797 *Amer. State P.: For. Relations* II. 158 M. X. . . . said his communication was not immediately with M. Talleyrand but through another gentleman in whom M. Talleyrand had great confidence. This proved to be M. Y. **1798** *Ib.* 157 The names designated by the letters W. X. Y. Z. in the following copies of letters. **1841** TRUMBULL *Autobiog.* 222, [I] visited the American X, Y, Z negotiators, Pinckney, Marshall, and Gerry. **1945** ADAMS *Album Amer. Hist.* II. 82 As a result of the XYZ episode of 1797, came an outburst of patriotic feeling.

2. A ten-dollar bill. *Colloq.*

1834 *Richmond* (Ind.) *Palladium* 18 Jan. 4/2 Have you got ten dollars in small bills you will exchange for an X? **1840** *Louisville Pub. Adv.* 21 Aug. 2/1 Is there not a V or an X left to redeem the MSS? **1893** POST *Harvard Stories* 295 Perhaps you had better lend me an X now.

b. XX, a twenty-dollar bill. Also **double X.**

1852 *Yankee Notions* July 214/1 Seeing these dashing young fellows sporting their double X's in careless profusion, . . . one of them bantered B. for a game of poker. **1883** CRAWFORD *Dr. Claudius* 346 The Custom-House officials . . . know the green side of a XX.

3. X rail, a railroad rail or section of a rail shaped like an X, for use at switches or crossovers. *Obs.*

1832 *Amer. R.R. Jrnl.* I. 227/2 This takes place to a great extent upon the crossing or X rail.

Y

∗Yale, *n.* [f. Linus *Yale* (1821–68), a New England locksmith.] A trade-mark name applied to locks, esp. to a type having a revolving barrel. Hence **Yale key.**

1882 *Encycl. Brit.* XIV. 751/1. **1909** O. HENRY *Options* 113 His name sounded like a Yale key when you push it in wrong side up. **1946** *Coronet* Dec. 144/2, I began with three Yale locks and waited a month to sell the first one.

Yankee ˈjæŋkı, *v. tr.* To defraud, cheat, outsmart. Now *hist.* Cf. **out-Yankee.**

1801 in CIST *Cincinnati* (1841) 177, I ginerally yankees them once a month, and they stand that like lambs. **1859** BARTLETT 220 To *Jew* a person, is considered, in Western parlance, a shade worse than to 'Yankee' him. **1947** BOTKIN *Treasury N. Eng. Folklore* 5 To *yankee* . . . meant to cheat.

Also **Yankeed,** *a.* = **Yankeefied.** *Rare.*

1881 CARLETON *Farm Festivals* 78 'That was a sudden death, 'twill be allowed,' Said a half-Yankeed Scotchman in the crowd.

Yankee State.

1. *pl.* The northern, esp. the New England, states.

1842 *Amer. Sentinel* (Georgetown, Ky.) 8 Oct. 3/2 He has no probable support from any other than the Yankee States. **1857** *Spirit of Times* 19 Dec. 243/3 There was a feller come down to those parts from one of them cussed Yankee States—Bosting, I think it was. **1948–9** *N.W. Ohio Quart.* Winter 12 We of the Mission sent our gatherings to the friends of the Mission . . . in the then far off Yankee States.

2. Ohio, many of whose early settlers came from New England.

1826 FLINT *Recoll.* 45 This is properly designated 'the Yankee state.' **1884** *Harper's Mag.* June 125/1 Ohio was called 'the Yankee State.'

yardage ˈjɑrdıdʒ, *n.* The charge made for the use of a yard. Also attrib.

1868 *Ill. Agric. Soc. Trans.* VI. 322 Net cash receipts for yardage, and profit on feed, 1866. **1889** *Public Opinion* 16 Feb., The furnace-master paying the company yardage at the rate of 25 cents per ton. **1903** ADAMS *Log Cowboy* 201, I'll not ship any more cattle to your town, . . . until you adjust your yardage charges.

yegg ˈjɛg, *n.* [Origin uncertain. One theory attributes it to an alleged John Yegg, a safeblower. G. *jäger* has

been suggested. See quot. 1926.] A tramp, thief, safe-breaker, or criminal. In full **yeggman.** *Slang.*

1901 FLYNT *World of Graft* 27 The great majority are what certain detectives call 'yegg-men,' . . . the average tramp seldom uses the word. **1906** *Charities* 17 Feb. 695/2 The Goat is famous wherever pan-handlers, plain hoboes and yeggmen do congregate. **1926** J. BLACK *You Can't Win* 172 In speaking of the cook ovens I may say that it was there the word 'yegg' originated. . . . It is a corruption of 'yekk,' a word from one of the many dialects spoken in Chinatown, and it means beggar. **1949** *Chi. Tribune* 20 Dec. 20/3 Still other 'explana-tions' link the phrase [the real McCoy] . . . with an oil field wildcatter who supplied yeggs with nitroglycerin.

* **yelp,** *v.* and *n.* **1.** *n.* The short, repetitious, staccato note of the turkey hen, or a call imitative of this. **2.** *v. tr.* and *intr.* To imitate the note of a turkey hen, to call *up* (a wild turkey) by this means.

(1) 1846 THORPE *Myst. Backwoods* 63, I knew the critter's [a wild turkey's] 'yelp' as well as I know Music's, my dear old dog. **1885** *Outing* VII. 65/1 The yelp, or call, was answered by a gobbler. — **(2) 1838** GOSSE *Letters* 301 He [i.e., the turkey hunter] suffers five minutes to elapse in silence, then 'yelps' again. **1894** *Harper's Mag.* Nov. 885/2 The hunter hastily improvises a 'blind' of pine boughs, and 'yelps them up' if he can.

Yokut ʼjoˌkʌt, *n.* [See quot. 1873.] *pl.* Indians of a Mariposan family in California now numbering about 500.

1873 *Overland Mo.* Aug. 105/1 In the language of this nation, *yocut* is a collective word signifying 'people' in the aggregate, while *myu* or *nono* denotes 'man.' **1903** JAMES *Indian Basketry* 57 A few Yokets are still to be found on the San Joaquin and Kings Rivers, the Ka-weah and a portion of Tule River. **1921** HALL *Yosemite Nat. Park* 59 The Yokuts, to the south of Yosemite, did not erect earth lodges.

* **you-all,** *pron.* Also **you-alls.** You. Allegedly used colloquially in the South as a singular. See note and cf. **you-uns.**

"It is commonly believed in the North that Southerners use *you-all* in the singular, but this is true, if it is ever true at all, of only the most ignorant of them. The word may be addressed to individuals, but only when they are thought of as representative of a group. . . . The literature of the subject is extensive and full of bitterness" (1936 Mencken *Amer. Language* (ed. 4) 449 note). Cf. quot. 1947 below and see *Amer. Sp.* Oct., 1938, 163–8.

1824 SINGLETON *Letters* 82 They [Virginians] say . . . madam and mistress, instead of our abbreviations. Children learn from the slaves some odd phrases; as, every which way; will you *all* do this? for, will *one* of you do this? **1901** WHITE *Westerners* 8 Reckon you-all fills the bill. **1947** *Amer. Mercury* Jan. 69/1 As a matter of fact, the uneducated Southerner's feeling for the plurality of the expres-sion is so strong that he sometimes says *you-alls.*

b. Used as an indefinite pronoun.

1897 LEWIS *Wolfville* 54 When you-all stampedes a bunch of ponies that a-way they don't hold together like cattle. *Ib.* 179 You-alls can't run no brand on melodies.

Yurok ˈjurɑk, *n.* [See quot. 1851.] Indians, or a tribe of Indians, poss. an isolated branch of the Algonquians, living on the lower Klamath River and the adjacent coast of northwestern California.

1851 in SCHOOLCRAFT *Indian Tribes* (1853) III. 151 They do not seem to have any generic appelation for themselves but apply the term 'Kahruk,' up and 'Youruk,' down, to all who live above or below themselves. **1910** HODGE *Amer. Indians* II. 1013/1 The Yurok are fairly tall for Pacific Coast Indians (168 cm.) and considerably above the average Californian in stature. **1948** *Amer. Folk-Lore* Oct.–Dec. 350 These events took place among the neighboring Yurok.

Z

zaguan saˈgwɑn, *n. S.W.* [Sp. in same sense.] An entrance or vestibule. Also attrib.

1851 *Harper's Mag.* III. 465/2 Don Pedro was heard within, moving toward the 'Saguan.' **1863** *Rio Abajo Press* 28 April 1/2 She had just seen Juanito's ghost in the saguan door. **1880** CABLE *Grandissimes* 131 It was a long, narrowing perspective of arcades, lattices, balconies, *zaguans*, dormer windows, and blue sky.

zwieback ˈzwaɪˌbæk, *n.* Also **zweiback.** [G., "twice-baked."] A form of bread made in small loaves, cut into small pieces and toasted until quite brown and crisp.

1894 *N.Y. Wkly. Tribune* 14 March 5/3 These Zwieback will keep for a long time if put in a dry place. **1903** *Harper's Bazaar* Oct., At one year you can commence to give him gruels, broth, a little well-cooked cereal, and zwieback. **1917** *Ladies' Home Jrnl.* Nov. 62/2 He should be taught to eat dry bread, zwieback, or dry whole-wheat crackers. **1947** BEROLZHEIMER *Regional Cook Book* 535 Mix zwieback with ½ cup sugar, cinnamon and butter.

2

BIBLIOGRAPHY

Most of the sources from which quotations used in this dictionary come are sufficiently identified in the places where the quotations occur. Also, many of the authors drawn upon, such as Whittier, Jefferson, Washington, Lowell, Irving, and Longfellow, are so well known that they are not included here. What follows is a list of less easily identified sources.

The only abbreviation that may need explanation is "v.d.," which is often used in the bibliography. In some books, usually those containing letters, diaries, or journals, different passages have different dates of composition. The abbreviation "v.d.," "various dates," is used in connection with books of this kind.

In historical dictionaries, the date of a quotation is intended to be that of its composition, regardless of the publication date of the book from which it is taken.

– A –

Abbott, John S. C. *Christopher Carson* (1875); *South and North* (1860).
Abert, James W. *Report of His Examination of New Mexico* (1848, v.d.).
Adair, James. *History of American Indians* (1775).
Adams, Andy. *Log of a Cowboy* (1903).
Adams, James T. *Dictionary of American History* (1940).
Adams, Ramon F. *Western Words* (1944).
Ade, George. *Artie* (1896).
Albion, Robert G. *Square-Riggers on Schedule* (1938).
Aldrich, Thomas B. *Marjorie Daw* (1873).
Aldridge, Reginald. *Life on a Ranch* (1884).
Allen, Miss A. J. *Ten Years in Oregon* (1850).
Alton, Edmund. *Among the Law-makers* (1886).
Alvord, Clarence W., and Lee Bidgood. *First Explorations of the Trans-Allegheny Region* (1912, v.d.).
American Notes and Queries (1888–92).
American Speech (1926–).
Anburey, Thomas. *Travels through the Interior Parts of America* (1789).
Andrews, Christopher C. *Recollections* (1929).
Asbury, Francis. *Journal* (1921, v.d.).

Asbury, Herbert. *Gangs of New York* (1928); *Gem of the Prairie* (1940); *Sucker's Progress* (1938).

Ash, Thomas. *Carolina* (1682).

Ashcroft, John. *Railway Directory* (1862).

Ashe, Thomas. *Travels in America* (1808).

Aspinwall-Oglander, Cecil F. *Admiral's Widow* (1942).

Atherton, Gertrude F. *The Californians* (1898).

Audubon, John J. *Ornithological Biography* (1831–39).

Austin, Mary. *Land of Little Rain* (1903).

– B –

Bagg, Lyman H. *Four Years at Yale* (1871).

Bailey, Eli S. *Sand Dunes of Indiana* (1917).

Bailey, Florence M. *Birds of New Mexico* (1928).

Bailey, James M. *Life in Danbury* (1873).

Bailey, Liberty H. *Cyclopedia of American Agriculture* (1907–9); *Principles of Fruit-growing* (1897).

Bailey, Vernon. *Mammals . . . of Oregon* (1936).

Baillie-Grohman, William A. *Camps in the Rockies* (1882).

Baird, Spencer F. *Birds of North America* (1860).

Baker, LaFayette C. *History of the United States Secret Service* (1867).

Baker, Sidney J. *Australian Language* (1945).

Baldwin, Leland D. *Keelboat Age on Western Waters* (1941).

Barbour, Thomas. *Vanishing Eden* (1944).

Barker, James N. *Indian Princess* (1808).

Barlow, Joel. *Columbiad* (1807); *Hasty Pudding* (1793).

Barnard, Evan G. *A Rider of the Cherokee Strip* (1936).

Barnes, William C. *Western Grazing Grounds* (1913).

Bartholow, Roberts. *Practical Treatise on Materia Medica* (1879).

Bartlett, John R. *Dictionary of Americanisms* (1848, 1859, 1877).

Bartram, William. *Travels in Georgia and Florida 1773–74* (v.d.).

Bassett, John S. *Short History of the United States* (1913).

Beadle, John H. *Western Wilds* (1878).

Bechdolt, Frederick R. *Tales of Old-Timers* (1924).

Beck, James M. *Our Wonderland of Bureaucracy* (1932).

Beebe, Lucius M. *Mixed Train Daily* (1947).

Beecher, Henry W. *Norwood* (1868); *Sermons* (1869, v.d.).

Beechey, Fred W. *Narrative of a Voyage to the Pacific* (1831).

Belknap, Jeremy. *History of New-Hampshire* (1784–92).

Bell, Lillian L. *Carolina Lee* (1906).

Benét, Stephen Vincent. *John Brown's Body* (1928).

Bentley, Harold W. *Dictionary of Spanish Terms* (1932).

Bentley, William. *Diary* (1905–14, v.d.).

Benton, Thomas H. *Historical and Legal Examination . . . of the Decision of the Supreme Court . . . in the Dred Scott Case* (1857).

Berolzheimer, Ruth (ed.). *United States Regional Cook Book* (1947).

Beverley, Robert. *History and Present State of Virginia* (1705).

Bingley, William. *Animal Biography* (1813).

Binns, Archie. *Timber Beast* (1944).

Bird, Robert M. *Hawks of Hawk-Hollow* (1835); *Nick of the Woods* (1837).

Blaisdell, Thomas C., Jr. *Federal Trade Commission* (1932).

Bonaparte, Charles L. *American Ornithology* (1825–33).

Bostwick, Arthur E. *American Public Library* (1910).

Botkin, Ben A. *Lay My Burden Down* (1945); *A Treasury of New England Folklore* (1947).

Bourke, John G. Journals. MS at West Point Military Academy (1865–69, v.d.).

Bower, B. M. *Flying U Ranch* (1914); *Phantom Herd* (1916).

Bowles, Samuel. *Our New West* (1869).

Brace, Charles L. *Dangerous Classes of New York* (1872); *New West* (1869).

Brackenridge, Henry M. *Views of Louisiana . . . in 1811* (1814).

Brackenridge, Hugh H. *Modern Chivalry* (1846 v.d.).

Brackett, George E. *Farm Talk* (1868).

Bradbury, John. *Travels in the Interior of America* (1817).

Brayley, Arthur W. *Complete History of the Boston Fire Department* (1889).

Breakenridge, William M. *Helldorado, Bringing the Law to the Mesquite* (1928).

Breen, Matthew P. *Thirty Years of New York Politics Up-to-Date* (1899).

Brewerton, George D. *Overland with Kit Carson* (1853); *The War in Kansas* (1856).

Brininstool, Earl A. *Trail Dust of a Maverick* (1914).

Bristed, Charles A. *Upper Ten Thousand* (1852).

Brown, J. Hammond. *Outdoors Unlimited* (1947).

Browne, Charles Farrar. *Artemus Ward: His Book* (1862); *Artemus Ward: His Travels* (1865).

Browne, Daniel J. *Trees of America* (1846).

Browne, John R. *Adventures in the Apache County* (1867).

Bruncken, Ernest. *North American Forests . . .* (1900).

Bryan, Kirk. *Papago Country, Arizona* (1925).

Buchanan, James. *Sketches* (1924).

Buck, Albert H. (ed.). *Reference Handbook of Medical Sciences* (1885-93).

Buckbee, Edna B. *Saga of Old Tuolumne* (1935).

Buckingham, James S. *Eastern and Western States* (1842).

Buckmaster, Henrietta, pseud. Henrietta Henkle. *Let My People Go* (1941).

Buel, James W. *Metropolitan Life Unveiled* (1882).

Buel, Jesse. *Farmer's Companion* (1840).

Burdick, Arthur J. *Mystic Mid-Region . . .* (1904).

Burnaby, Andrew. *Travels through the Middle Settlements* (1775).

Burnett, Peter H. *Recollections . . . of an Old Pioneer* (1880).

Burnham, Clara L. *Jewel: A Chapter in Her Life* (1903).

Burroughs, John. *Winter Sunshine* (1875).

Busch, Moritz. *Wanderungen zwischen Hudson und Mississippi . . .* (1854).

Butler, Noble. *Goodrich Fifth School Reader* (1857).

Byrd, William. *Secret Diary* (1941, v.d.).

– C –

Cable, George W. *The Grandissimes* (1880).

Cady, Daniel L. *Rhymes of Vermont Rural Life* (1923).

Cahalane, Victor H. *Mammals of North America* (1947).

Carleton, Will. *Farm Festivals* (1881).

Carlton, Robert, pseud. Baynard R. Hall. *New Purchase* (1843).

Carver, Jonathan. *Travels through the Interior Parts of North America* (1778).

Castetter, Edward F. *Pima and Papago Indian Agriculture* (1942).

Cate, Wirt Armistead (ed.). *Two Soldiers: The Campaign Diaries of Thomas J. Key, C.S.A., . . . and Robert J. Campbell, U.S.A.* (1938, v.d.).

Catesby, Mark. *Natural History of Carolina, Florida, and the Bahama Islands* (*ca.* 1731–43; appendix, 1748).

Cather, Willa S. *One of Ours* (1922).

Catlin, George. *Illustrations of the Manners, Customs, and Conditions of the North American Indians* (1851).

Caton, John D. *Antelope and Deer* (1877).

Chalfant, Willie A. *Death Valley; the Facts* (1930).

Chalkley, Lyman. *Chronicle of the Scotch-Irish Settlement in Virginia* (1912–13, v.d.).

Chandless, William. *A Visit to Salt Lake* (1857).

Chaplin, Ralph. *Wobbly* (1948).

Chase, Annie. *Stories of Industry* (1891).

Chase, Charles M. *The Editor's Run in New Mexico* (1881).

Chesnutt, Charles. *Wife of his Youth* (1899).

Child, Lydia M. *Fact and Fiction* (1846).

Chipman, Richard M. MS notes in a copy of Bartlett's *Dictionary of Americanisms* (*ca.* 1870).

Christian, Ella Storrs. "The Days That Are No More." (Unpublished MSS, *ca.* 1898).

Churchill, J. A. *Parent-Teacher Associations in Oregon* (1915).

Churchill, Winston. *Crisis* (1901).

Cist, Charles. *Cincinnati in 1841* (1841).

Claiborne, John F. H. *Life and Correspondence* (1860, v.d.).

Clapin, Sylva. *New Dictionary of Americanisms* (1902).

Clark, Thomas D. *Pills, Petticoats and Plows* (1944).

Clavijero, Francisco Javier. *Storica antica del Messico* (1780).

Clayton, John. *Flora Virginica* (1739–43).

Cleland, Robert G. *California in Our Time* (1947).

Clute, Willard N. *Common Names of Plants* (1931).

Coates, Robert M. *Outlaw Years* (1930, v.d.).

Cobb, Irvin S. *Back Home* (1912).

Cody, Louisa. *Memories of Buffalo Bill* (1919).

Coffin, Charles C. *Daughters of the Revolution* (1895).

Coffin, Robert P. T. *Yankee Coast* (1947).

Colcord, Joanna C. *Sea Language Comes Ashore* (1945).

Collins, Lewis. *Historical Sketches of Kentucky* (1847).

Colton, Walter. *Three Years in California* (1850).

Commons, John R. *Documentary History of American Industrial Society* (1910–11, v.d.).

Conklin, Enoch. *Picturesque Arizona* (1878).

Cooke, John E. *Surry of Eagle's-Nest* (1866).

Cooke, Rose T. *Steadfast* (1889).

Cooper, James Fenimore. *Last of the Mohicans* (1826); *Pilot* (1823).

Corcoran, Denis. *Pickings from the Portfolio of the Reporter* (1846).

Coues, Elliott. *Birds of the Northwest* (1874); *Key to North American Birds* (1872).

Coulter, John M. *Botany of Western Texas* (1891–99).

Coyner, David H. *The Lost Trappers* (1859).

Crabb, George. *Universal Technological Dictionary* (1823).

Cramer, Zadok. *Navigator* (1806).

Crawford, Francis M. *Dr. Claudius* (1883).

Crevecoeur, Michael Guillaume. *Sketches of Eighteenth Century America* (1925, v.d.).

Crofutt, George. *Trans-Continental Tourist* (1876).

Crow, Carl. *Great American Customer* (1943).

Cuming, Fortesque. *Sketches of a Tour* (1810).

Cunningham, Albert B. *Chronicle of an Old Town* (1919).

Curtis, Edward S. *North American Indian* (1907–30).

Curtis, Moses A. *The Woody Plants of North-Carolina* (1860).

Cushman, Horatio B. *History of the Choctaw . . . Indians* (1899).

Cutler, Carl C. *Greyhounds of the Sea* (1930).

Cutler, William P. *Life, Journals and Correspondence* (1888, v.d.).

Cutting, George R. *Student Life at Amherst* (1871).

– D –

Dale, Edward E. *Cow Country* (1942).

Dalrymple, Byron W. *Panfish* (1947).

Damon, Bertha. *Grandma Called It Carnal* (1938).

Dana, Frances T. *How To Know the Wild Flowers* (1893).

Daniels, Jonathan. *Tar Heels* (1941).

Davenport, Warren G. *Butte and Montana* (1908).

Davis, Hugh. *Farm Book* (a plantation diary) (1854–55, v.d.).

Davis, John. *Travels . . . in the United States of America* (1803).

Dawson, Samuel E. *Hand-book for the Dominion of Canada* (1884).

De Groot, Henry. *Sketches of the Washoe Silver Mines* (1860).

[*Democrat*], *Clarke County Democrat* (Grove Hill, Ala.) (1856–).

Denton, Daniel. *Brief Description of New York* (1937).

Denton, Shelley. *Pages from a Naturalist's Diary* (1949, v.d.).

Derby, George H. *Phoenixiana* (1859).

D'Eres, i.e., Rouso D'Eres, Charles D. *Memoirs* (1800).

De Vere, i.e., Schele De Vere, Maximilian R. B. *Americanisms* (1872).

De Voe, Thomas F. *Market Assistant* (1867).

DeVoto, Bernard. *Across the Wide Missouri* (1947); *Year of Decision: 1846* (1943).
Dewees, William B. *Letters from . . . Texas* (1852, v.d.).
Dialect Notes. (1890–1939).
Dick, Everett N. *Dixie Frontier* (1948).
Dick, William B. *American Hoyle* (?1866, v.d.).
Ditmars, Raymond L. *Reptiles of the World* (1933).
Dodge, Richard I. *Black Hills* (1876).
Donaldson, Thomas. *Moqui Indians of Arizona* (1893).
Dorland, William A. *American . . . Medical Dictionary* (7th ed.; 1913).
Dorsey, Ella L. *Midshipman Bob* (1888).
Downey, Fairfax D. *Our Lusty Forefathers* (1947).
Drake, Samuel G. *Indians of North America* (1833, v.d.).
Drannan, William F. *Thirty-one Years on the Plains* (1900).
Drayton, John. *A View of South Carolina* (1802).
Dreiser, Theodore. *Genius* (1946).
Dunaway, Wayland F. *History of Pennsylvania* (1935).
Dunbar, William. *Life, Letters and Papers* (1930, v.d.).
Duncan, Kunigunde. *Mentor Graham* (1944).
Dunn, Jacob P. *Indiana and Indianans* (1919).
Dunning, Nelson A. (ed.). *Farmers' Alliance History* (1891).
Du Pratz, i.e., Le Page Du Pratz, Antoine S. *Histoire de la Louisiane* (1758)
Dutton, Charles J. *Shadow on the Glass* (1923).
Duval, John C. *Adventures of Big-foot Wallace* (1870).

– E –

Earle, Alice M. *Sabbath in Puritan New England* (1891).
Early, Eleanor. *New England Sampler* (1940).
Eastman, Nicholson J. *Expectant Motherhood* (1940).
Eaton, Amos. *Manual of Botany* (1822, v.d.).
Eaton, Walter P. *Barn Doors and Byways* (1913); *Green Trails and Upland Pastures* (1917).
Eddy, Mary B. *Science of Man* (1876).
Edward, David B. *History of Texas* (1836).
Eilmann, Henry J. *Medicolegal and Industrial Toxicology* (1940).
Ellicott, Andrew. *Journal* (1814).
Ellsworth, Henry W. *Valley of the Upper Wabash* (1838).
Emmons, Ebenezer. *Agriculture of New York* (1846–54).
Estlake, Allan. *Oneida Community* (1900).
Eubank, Kent. *Horse and Buggy Days* (ca. 1927).

– F –

Farmer, Fannie M. *Boston . . . Cook Book* (1909, 1941).
Farmer, J. S. (ed.). *Americanisms* (1889).
Farnham, Eliza W. *Life in Prairie Land* (1846).
Farrow, Edward S. *Dictionary of Military Terms* (1918).

Fearon, Henry B. *Sketches of America* (1818).

Ferber, Edna. *Cimarron* (1930).

Fergusson, Erna. *Our Southwest* (1940).

Fessenden, Thomas G. *Democracy Unveiled* (1806); *Pills, Political, Poetical, Philosophical* (1809); *Terrible Tractoration!* (1804).

Findley, Ruth. *Lady of Godey's* (1931).

Fithian, Philip Vickers. *Journal and Letters* (1900–1934, v.d.).

Flandrau, Charles M. *Harvard Episodes* (1897).

Fleischmann, Carl L. *Wegweiser und Rathgeber* (1852).

Fleming, Walter L. (ed.). *Documentary History of Reconstruction* (1906–7, v.d.).

Flick, Alexander C. *History . . . of New York* (1933, v.d.).

Flint, Timothy. *Condensed Geography* (1828); *Recollections of Ten Years* (1826).

Flynt, i.e., Willard, Josiah Flynt. *Notes of an Itinerant Policeman* (1900); *World of Graft* (1901).

Foote, Mary H. *Led-Horse Claim* (*ca.* 1883).

Footner, Hulbert. *Rivers of the Eastern Shore* (1944).

Force, Peter (comp.). *Tracts and Other Papers . . .* (1836–46).

Foreman, Grant. *The Last Trek of the Indians* (1946).

Foster, George G. *New York in Slices* (1849).

Fraser, Sir John F. *Round the World* (1899).

Frémont, John C. *Report of Exploring Expedition* (1845, v.d.).

Friederici, Georg. *Amerikanistisches Worterbuch* (1947).

Frothingham, Richard. *History of Charleston* (1845–49).

Fugina, Frank L. *Lore and Lure of the Upper Mississippi* (1945).

– G –

Gann, Walter *Tread of Longhorns* (1949).

Gates, Charles M. (ed.). *Five Fur Traders* (1933, v.d.).

Geist, Roland C. *Hiking, Camping and Mountaineering* (1943).

Geikie, James. *Outlines of Geology* (1886).

George, Charles B. *Forty Years on the Rail* (1887).

Gerhard, William P. *Water Supply* (1910).

Gibbons, Phebe H. *"Pennsylvania Dutch" and Other Essays* (1882).

Gilbreth, Frank B. and Carey, Ernestine G. *Cheaper by the Dozen* (1948).

Gilleland, J. C. *Ohio and Mississippi Pilot* (1820).

Gist, Christopher. *Christopher Gist's Journal* (1893, v.d.).

Glisan, Rodney. *Journal of Army Life* (1874, v.d.).

Glover, Thomas. *An Account of Virginia* (1676).

Goddard, Henry H. *Kallikak Family* (1912).

Godfrey, Edward K. *The Island of Nantucket* (1882).

Goode, George Brown. *Fisheries and Fishery Industries* (1884).

Gordon, Maurice B. *Aesculapius Comes to the Colonies* (1949).

Goss, Warren L. *Soldier's Story* (1867).

Gosse, Philip H. *Letters from Alabama* (1859, v.d.).

Gouge, William M. *Fiscal History of Texas* (1852).

Gould, George M. *Illustrated Dictionary of Medicine* (1894).

Gould, Nathaniel D. *Church Music* (1853).

Gray, Asa. *First Lessons in Botany* (1856).

Gray, James. *Pine, Stream and Prairie* (1945).

Gray, John C. *War Letters, 1862–1865* (1927, v.d.).

Graydon, Alexander. *Memoirs of His Own Time* (1846).

Grayson, Theodore J. *Leaders and Periods of American Finance* (1932).

Green, Bennett W. *Word-Book of Virginia Folk-Speech* (1899).

Greene, Asa. *Life and Adventures of Dr. Dodimus Duckworth* (1833); *Glance at New York* (1837).

Gregg, Josiah. *Commerce of the Prairies* (1844).

Grinnell, Joseph. *Gold Hunting in Alaska* (1901).

Guild, Josephus C. *Old Times in Tennessee* (1878, v.d.).

Gunter, Archibald C. *Miss Dividends* (1892).

– H –

Hadden, James M. *A Journal Kept . . . upon Burgoyne's Campaign . . .* (1884, v.d.).

Hadfield, Joseph. *An Englishman in America* (1933).

Hale, Susan. *Letters* (1919, v.d.).

Haliburton, Thomas C. *Clockmaker* (1838).

Hall, Ansel F. *Handbook of Yosemite* (1921).

Hall, E. Raymond. *Mammals of Nevada* (1946).

Halliburton, Richard. *Glorious Adventure* (1927).

Hambleton, James P. *Biographical Sketch of Henry A. Wise* (1856, v.d.).

Hammond, Samuel H. *Hills, Lakes, and Forest Streams* (1854).

Harben, William N. *Abner Daniel* (1902).

Hark, Ann. *Hex Marks the Spot* (1938).

Harlow, William M. *Trees of the Eastern United States and Canada* (1942).

Harper, Ida H. *Life and Works of Susan B. Anthony* (1898).

Harrington, Mark R. *Gypsum Cave, Nevada* (1933).

Harriot, Thomas. *Briefe and True Report . . .* (1588).

Harris, Bernice K. *Purslane* (1939).

Harris, George W. *Sut Luvingood* (1867, v.d.).

Harris, Joel C. *Nights with Uncle Remus* (1911); *Uncle Remus and His Friends* (1892); *Uncle Remus, His Songs and His Sayings* (1880); *Free Joe* (1888).

Harris, John. *Navigantium atque itinerantium* (1705).

Harrison, H. S. *Queed* (1911).

Hart, Fred H. *Sazerac Lying Club* (1878).

Hart, Smith. *New Yorkers* (1938).

Harte, Bret. *Luck of Roaring Camp* (1871, v.d.).

Haswell, Charles H. *Reminiscences* (1896).

Haworth, Paul L. *George Washington* (1915).

Haycraft, Samuel. *History of Elizabethtown, Kentucky* (1921).

Hayes, A. *New Colorado* (1881).

Hayes, Benjamin I. *Pioneer Notes* (1929, v.d.).

Hayward, John. *Hayward's Gazetteer* (1843).
Hazard, Thomas B. *Jonny-Cake Papers* ... (1915).
Healy, Timothy M. *Letters and Leaders* ... (1928, v.d.).
Hearn, Lafcadio. *American Miscellany* (1924, v.d.); *La Cuisine Creole* (1885).
Hempstead, Joshua. *Diary* (1901, v.d.).
Henry, John J. *Accurate ... Account* (1812).
Hertrich, William. *Huntington Botanical Gardens* (1949).
Hibben, Shelia. *American Regional Cookery* (1946).
Hicks, John D. *Short History of American Democracy* (1943).
Hildeburn, C. S. R. *Century of Printing* (1885–86).
Hill, Alice. *Tales of Colorado Pioneers* (1884).
Hiltzheimer, Jacob. *Extracts from the Diary* (1893, v.d.).
Hinman, Wilbur F. *Corporal Si Klegg* (1887).
Hittell, John S. *Resources of California* (1874).
Hodge, Frederick W. *Handbook of American Indians* (1907–10).
Hodgson, Adam. *Letters from North America* (1824).
Hoffman, Charles F. *Winter in the West* (1835).
Holbrook, Stewart H. *Lost Men of American History* (1946).
Holland, Josiah G. *Arthur Bonnicastle* (1873); *The Bay-Path* (1857); *Miss Gilbert's Career* (1866).
Holley, Mary A. *Texas* (1831).
Hornaday, William T. *Campfires on Desert and Lava* (1908).
Horwill, Herbert W. *Dictionary of ... American Usage* (1935).
Hostetter, Gordon L. *It's a Racket!* (1929).
Hough, Emerson. *Sagebrusher* (1919).
Howard, Joseph K. *Montana* (1943).
Howe, Helen. *We Happy Few* (1946).
Howe, Henry. *Historical Collections* (1947, v.d.).
Howison, John. *Sketches* (1821).
Hubbard, William. *A Narrative of Troubles with the Indians in New England* (1677).
Hulbert, William D. *Forest Neighbors* (1902).
Humboldt, Freiherr Alexander von. *Political Essays* (1811).
Hunt, James H. *History of the Mormon War* (1844).

– I –

Ide, William B. *California History* (1880, v.d.).
Imlay, Gilbert. *Topographical Description* (1792).
Ingham, George T. *Digging Gold* (1880).
Ives, Halsey C. *Dream City* (1893).

– J –

Jackson, George P. *White Spirituals* (1933).
Jackson, Sheldon. *Alaska* (1880).
Jaeger, Edmund C. *California Deserts* (1940); *Desert Wild Flowers* (1940).
James, Edwin. *Expedition ... of Major S. H. Long* (1823).
James, George W. *Indian Basketry* (1903).

James, Will. *Cow Country* (1927).
Jameson, John F. *Dictionary of United States History* (1931).
Jillson, Willard R. *Tales of Dark and Bloody Ground* (1930).
Johnston, Philip. *Lost and Living Cities* (1948).
Jones, Hugh. *Present State of Virginia* (1724).
Josselyn, John. *New England Rarities* (1672); *An Account of Two Voyages* (1674).

– K –

Kane, Elisha K. *Arctic Explorations* (1856).
Kendall, Edward A. *Travels through the Northern Parts of the United States* (1809).
Kendall, George W. *Narrative of the Texan . . . Expedition* (1844).
Kennedy, John P. *Swallow Barn* (1832).
Kennedy, Stetson. *Palmetto Country* (1942).
Kennedy, William. *Texas* (1841).
Kephart, Horace. *Camping and Woodcraft* (1917).
Ker, Henry. *Travels through . . . the United States* (1816).
Kerwin, Jerome G. *Civil-Military Relationships* (1948).
Killebrew, Joseph B. *Grasses of Tennessee* (1878).
King, Caroline H. *When I Lived in Salem* (1937).
Kingsley, Nelson. *Diary* (1914).
Kirkland, Joseph. *Zury* (1887).
Knight, Edward H. *Dictionary of Mechanics* (1874–76).

– L –

Lambert, John. *Travels through . . . the United States* (1810).
Lamphere, George N. *United States Government* (1880).
Langford, Nathaniel. *Vigilante Days* (1890).
Langsdorff, George H. *Voyages and Travels* (1817).
Lanman, Charles. *Summer in the Wilderness* (1846).
Latham, Henry. *Black and White* (1867).
Latrobe, Charles J. *Rambler in Mexico* (1836); *Rambler in North America* (1835).
Lawson, John. *New Voyage to Carolina* (1809).
Leacock, Stephen B. *Frenzied Fiction* (1918).
Lee, Daniel. *Ten Years in Oregon* (1844).
Lee, W. Storrs. *Stagecoach North* (1941).
Leland, Charles G. *Memoirs* (1893).
Lewinson, Paul. *Race, Class and Party* (1932).
Lewis, Alfred H. *Wolfville* (1897).
Lewis, Sinclair. *Main Street* (1920).
Lillard, Richard G. *Desert Challenge* (1942).
Lincoln, Joseph C. *Cape Cod Yesterdays* (1935); *Cap'n Warren's Wards* (1911); *Partners of the Tide* (1905).
Lindley, Walter. *California of the South* (1888).
Lofberg, Lila. *Sierra Outpost* (1941).

London, Jack. *Daughter of the Snows* (1902); *The Road* (1907).
Long, John. *Voyages and Travels* (1791).
Long, Joseph W. *American Wild-Fowl Shooting* (1874).
Longstreet, Augustus B. *Georgia Scenes* (1835).
Lorimer, George H. *Letters from a Self-made Merchant to His Son* (1902);
 J. Spurlock (1908).
Loudon, John C. *Suburban Horticulturist* (1842).
Lounsbury, Thomas R. *Studies in Chaucer* (1892).
Lucas, Eliza. *Journal and Letters* (1850).
Lummis, Charles F. *Tramp across the Continent* (1892).
Lumpkin, Katharine D. *The Making of a Southerner* (1947).
Lyell, Sir Charles. *Travels in North America* (1845, v.d.).
Lynde, Francis. *Quickening* (1906).
Lyon, Marguerite. *And So to Bedlam* (1943).
Lyons, Albert B. *Plant Names* (1907).

– M –

McCabe, James D. *New York* (1882, v.d.).
McClellan, George B. *McClellan's Own Story* (1887, v.d.).
McConnell, William J. *Frontier Law* (1924).
McCormac, Eugene I. *James K. Polk* (1922).
MacDonald, Betty. *The Egg and I* (1945).
McFaul, Alexander D. *Ike Glidden in Maine* (1902).
McGregor, John. *British America* (1832).
McKee, Lanier. *Land of Nome* (1902).
McKenna, James A. *Black Range Tales* (1936).
McKenney, Thomas L. *Memoirs* (1846).
Maclay, William. *Sketches of Debates* (1880, v.d.).
McLean, Sydney R. *Moment of Time* (1945).
MacLeod, Xavier D. *Biography of Hon. Fernando Wood* (1856, v.d.).
McPherson, Charles. *Memoirs of . . . Charles McPherson* (1800, v.d.).
MacRae, David. *Americans at Home* (1870).
M'Robert, Patrick. *Tour through Part of . . . America* (1776).
Manual of Style (University of Chicago Press) (1937, 1949).
Marryat, Frederick. *Frank Mildmay* (1877).
Marshall, Humphrey. *History of Kentucky* (1812, 1824).
Marshall, James L. *Santa Fe* (1945).
Marshall, Walter G. *Through America* (1882).
Massey, John. *Reminiscences* (1916).
Mathews, Catherine V. *Andrew Ellicott* (1908, v.d.).
Mathews, John J. *Talking to the Moon* (1945).
Mathews, Mitford M. (ed.). *Beginnings of American English* (1931, v.d.);
 Some Sources of Southernisms (1948).
Mathewson, Christopher. *Pitching in a Pinch* (1912).
Matschat, Cecile H. *Suwanee River* (1938).
Matthews, Brander. *In Partnership* (1884).
May, John. *Journal and Letters* (1783, v.d.).

Mease, Edward. *Narrative of a Journey* (1771).

Medbery, James K. *Men and Mysteries* (1870).

Meline, James F. *Two Thousand Miles on Horseback* (1867).

Melish, John. *Travels in the United States* (1812).

Mellick, Andrew D. *Story of an Old Farm* (1889).

Melville, Herman. *Moby Dick* (1851).

Menefee, Selden. *Assignment: U.S.A.* (1943).

Merwin, Samuel. *Calumet 'K'* (1905).

Michaux, François A. *Histoire des arbres* (1810–13).

Miles, Emma B. *Spirit of Mountains* (1905).

Miller, Joaquin. *Life amongst the Modocs* (1873).

Mitchell, Donald G. *My Farm* (1863).

Mitchell, Edwin V. *Horse and Buggy Age* (1937).

Mitchell, Ronald E. *America* (1935).

Moe, Alfred K. *History of Harvard* (1896).

Mohr, Charles T. *Plant Life of Alabama* (1901).

Moldenke, Harold N. *American Wild Flowers* (1949).

Molloy, Robert. *Pride's Way* (1945).

Moore, Frank (ed.). *Rebellion Record* (1862–71).

Moore, John T. *Ole Mistis* (1925).

Moore, Mabel R. *Hitchcock Chairs* (1933).

Moorehead, Warren K. *Stone Age North America* (1910).

Morgan, Forrest. *Connecticut* (1904).

Morgan, Lewis H. *Houses and House-Life of the American Aborigines* (1881).

Morley, Christopher. *Haunted Bookshop* (1919).

Morley, Margaret W. *Carolina Mountains* (1913).

Morrell, William. *New England* (1625).

Morris, Ann. *Digging in the Southwest* (1933).

Morse, Frances C. *Furniture of Olden Times* (1936).

Morse, Jedidiah. *American Geography* (1789).

Mowry, Sylvester. *Arizona and Sonora* (1864).

Muhlenberg, Henry. *Catalogus Plantarum . . .* (1813).

Muir, John. *My First Summer in the Sierra* (1911).

Munroe, Kirk. *Golden Days of '49* (1889).

Munsell, Joel. *Annals of Albany* (1850–59, v.d.).

Murphy, John M. *Oregon Business Directory* (1873).

Myers, Allen O. *Bosses and Boodle* (1895).

– N –

Neal, John. *Down-Easters* (1833).

Newton, Stan. *Paul Bunyan* (1946).

Nicholson, Meredith. *Hoosiers* (1900).

Niles, Samuel. *Indian Wars* (1837, 1861 v.d.).

Nixon, Herman C. *Forty Acres* (1938).

Nixon, Phyllis J. *Glossary of Virginia Words* (1946).

Noah, Mordecai M. *She Would Be a Soldier* (1819).

Norris, Charles G. *Bricks without Straw* (1938).

Norris, Frank. *Responsibilities* (1902).
Norton, Oliver W. *Army Letters, 1861–65* (1903, v.d.).
Nowland, John H. *Early Reminiscences* (1870).
Nute, Grace L. *Lake Superior* (1944).
Nuttall, Thomas. *Genera of North American Plants* (1818); *Journal of Travels* (1821); *Water Birds* (1834).
Nye, Edgar W. *Baled Hay* (1894).

– O –

O'Beirne, Harry F. *Leaders and Leading Men* (1891).
Ogilby, John. *America* (1671).
Olmsted, Frederick Law. *Journey in the Back Country* (1860).
Ottley, Roi. *New World* (1943).

– P –

Padover, Saul K. *The Complete Jefferson* (1943).
Palmer, John. *Journal of Travels . . .* (1818).
Parker, Samuel. *Journal of an Exploring Tour* (1838).
Parks, H. B. *Valuable Plants* (1937).
Partridge, Bellamy. *As We Were* (1946).
Patten, Matthew. *Diary* (1903, v.d.).
Paul, Elliot H. *Linden on the Saugus Branch* (1947).
Paulding, James K. *Diverting History of John Bull* (1813).
Peabody, William B. O. *Report of Ornithology* (1839).
Pearson, Haydn S. *Country Flavor* (1945).
Peattie, Roderick. *Friendly Mountains* (1942); *Great Smokies* (1943); *Sierra Nevada* (1947).
Peck, George W. *Peck's Bad Boy* (1883); *Peck's Sunshine* (1883).
Peck, John M. *Guide for Emigrants* (1831).
Pennell, Joseph S. *History of Rome Hanks* (1944).
Penniman, Major. *Tanner-Boy* (1864).
Perry, George S. *Cities of America* (1947).
Persons, Charles E. *Labor Laws* (1911).
Phelps, Elizabeth. *Story of Avis* (1877).
Philips, Shine. *Big Spring* (1942).
Pickering, John. *Vocabulary* (1816).
Pickwell, Gayle B. *Deserts* (1939).
Pidgin, Charles F. *Quincy Adams Sawyer* (1902).
Pike, Zebulon M. *An Account of Expeditions* (1810, v.d.).
Pine, George W. *Beyond the West* (1871).
Pinkerton, Kathrene S. *Wilderness Wife* (1939).
Pittman, Philip. *Present State of the European Settlements on the Mississippi* (1770).
Plukenet, Leonard. *Opera Botanici* (1700).
Poe, Sophie. *Buckboard Days* (1936).
Poore, Benjamin P. *Perley's Reminiscences* (1886).
Powell, Arthur G. *I Can Go Home* (1943).

Prescott, G. B. *History . . . of Electric Telegraph* (1860).
Purchas, Samuel. *Purchas His Pilgrimage* (1613).
Putnam, Rufus. *Memoirs* (1903, v.d.).

– Q –

Quentin, Karl. *Reisebilder und Studien* (1851).
Quinn, John P. *Fools of Fortune* (1890).

– R –

Ramsey, James F. M. *Annals of Tennessee* (1853, v.d.).
Randall, Henry S. *Practical Shepherd* (1864).
Randolph, Vance. *Ozark Mountain Folks* (1932).
Rawlings, Marjorie. *Cross Creek* (1942).
Ray, John. *Historia Plantarum* (1686, 1688).
Raymond, Rossiter W. *Glossary of Mining* (1881); *Sixth Report of Mines* (1874); *Eighth Report of Mines* (1876).
Read, Opie P. *The Jucklins* (1896).
Read, William A. *Louisiana Place Names* (1927).
Rees, John E. *Idaho Chronology* (1918).
Regan, John. *Emigrant's Guide* (1852).
Rice, Alice C. *Mr. Opp* (1909).
Rich, Louise. *We Took to the Woods* (1948).
Richter, Conrad. *Fields* (1946); *Sea of Grass* (1936).
Ridgway, Robert. *Manual of North American Birds* (1887).
Ridings, Sam P. *Chisholm Trail* (1936).
Riley, James W. *Eccentric Mr. Clark* (1913); *Old Swimmin' Hole* (1883).
Rittenhouse, Isabella M. *Maud* (1939, v.d.).
Rittenhouse, Jack D. *American . . . Vehicles* (1948).
Roads, Samuel. *History . . . of Marblehead* (1880).
Robb, John S. *Streaks of Squatter Life* (1847).
Roberts, Elizabeth M. *The Time of Man* (1926).
Robinson, Henry M. *The Great Snow* (1947).
Robinson, J. S. *Journal of the Santa-Fe Expedition* (1848).
Robsjohn-Gibbings, Terence H. *Good-bye Mr. Chippendale* (1944).
Roe, Edward P. *Nature's Serial Story* (1885).
Roe, Frances M. A. *Army Letters* (1909, v.d.).
Rollins, Philip A. *Gone Haywire* (1939).
Romspert, George W. *Western Echo* (1881).
Roosa, Daniel B. St John. *Practical Treatise on the Diseases of the Ear* (1874).
Rose, George. *Great Country* (1868).
Ross, Joel H. *What I Saw in New-York* (1851).
Royall, Ann. *Mrs. Royall's Pennsylvania* (1829).
Ruede, Howard. *Sod-House Days* (1937, v.d.).
Russell, Charles M. *Trails Plowed Under* (1927).
Russell, William. *My Diary North and South* (1863).
Ruttenber, Edward M. *Indian Geographical Names* (1906).
Ryan, Marah E. *That Girl Montana* (1901); *Told in the Hills* (1891).

– S –

Sage, Rufus B. *Rocky Mountain Life* (1846).

Sala, George A. H. *America Revisited* (1882); *My Diary in America* (1865); *Life* (1895).

Sands, Robert C. *Writings* (1834, v.d.).

Santleben, August. *Texas Pioneer* (1910).

Sargent, Charles S. *Report on Forests* (1884).

Saunders, Charles Frances. *Southern Sierras* (1923).

Saunders, Ripley D. *Colonel Todhunter* (1911).

Schoolcraft, Henry R. *Indian Tribes* (1853).

Seton, Ernest T. *Trail of an Artist Naturalist* (1940).

Sewall, Samuel. *Diary . . . 1674–1729* (1878–82, v.d.).

Shelton, Jane D. *Salt-Box House* (1900, v.d.).

Shepard, Esther. *Paul Bunyan* (1924).

Shields, George O. *Big Game* (1890).

Shinn, Charles H. *Story of the Mine* (1897).

Shurtleff, Harold R. *Log Cabin Myth* (1939).

Silliman, Benjamin. *Manual on the Cultivation of the Sugar Cane* (1833).

Simms, William G. *Mellichampe* (1836); *Wigwam and Cabin* (1845).

Simpson, Sir George. *Overland Journey* (1847).

Sinclair, Upton B. *The Jungle* (1906).

Singleton, Arthur. *Letters from the South and West* (1824).

Siringo, Charles A. *Riata and Spurs* (1931); *A Texas Cow-Boy* (1885).

Sloane, Sir Hans. *Jamaica* (1896).

Small, John K. *Manual of Southeastern Flora* (1933).

Smallwood, Mary L. *Historical Study of Examinations* (1935, v.d.).

Smith, Eugene A. *Geological Survey of Alabama* (1883).

Smith, Marian W. *Puyallup-Nisqually* (1940).

Smith, Richard. *Tour of Four Great Rivers* (1906).

Snyder, Laurence H. *Blood Grouping* (1929).

Somers, Robert. *Southern States since the War* (1871).

Springer, John S. *Forest Life and Forest Trees* (1851).

Stanley, Edwin J. *Rambles in Wonderland* (1878).

Stansbery, Lon R. *The Passing of 3D Ranch* (1928).

Stansbury, Howard. *Exploration . . . of the Great Salt Lake* (1853).

Stanwell-Fletcher, Theodora M. *Driftwood Valley* (1946).

Stapleton, Patience. *Major's Christmas* (1886).

Steedman, Charles J. *Bucking the Sagebrush* (1904).

Stegner, Wallace. *Mormon Country* (1942).

Stephen, Alexander M. *Hopi Journal* (1936).

Stephens, Ann S. *High Life in New York* (1844).

Stephens, John L. *Incidents of Travel* (1838).

Sterling, Ada (ed.). *Belle of the Fifties* (1904).

Stirling, James. *Letters from Slave States* (1857).

Stoddard, Henry L. *Horace Greeley* (1946).

Stone, Witmer. *American Animals* (1902).

Stork, William. *Account of East-Florida* (1766).
Strachey, William. *Historie of Travaile into Virginia* (1849).
Stratton-Porter, Gene. *Freckles* (1904).
Strong, George C. *Cadet Life at West Point* (1862).
Stuart, Jesse. *Men of the Mountains* (1941); *Trees of Heaven* (1940).
Sudworth, George B. *Nomenclature of Arborescent Flora* (1897).
Sullivan, Mark. *Our Times* (1930).
Swasey, William F. *Early Days and Men of California* (1891).
Sweet, Alexander E. *Sketches from "Texas Siftings"* (1882).
Sweet, William W. *Religion on the American Frontier* (1931).

– T –

Taliaferro, Harde E. *Fisher's River* (1859).
Tallant, Robert. *Voodoo in New Orleans* (1947).
Tanner, H. S. *Map of Florida* (1823).
Taylor, Bayard. *Hannah Thurston* (1864).
Tehon, Leo R. *Fieldbook of Native Illinois Shrubs* (1942).
Terhune, Mary V. *An Old-Field School-Girl* (1897).
Thanet, Octave. *Stories of a Western Town* (1897).
Thomas, David. *Travels through the Western Country* (1819).
Thompson, Harold W. *Body, Boots and Britches* (1940).
Thompson, Margaret. *High Trails* (1938).
Thoreau, Henry D. *Walden* (1854).
Thorpe, Thomas B. *Mysteries of the Backwoods* (1846); *Master's House* (1854).
Titus, Harold. *"Timber"* (1922).
Torrey, John. *Flora . . . of New York* (1843).
Townsend, John K. *Narrative of a Journey* (1839).
Traill, Catherine P. *Backwoods Canada* (1836).
Trowbridge, John T. *Cudjo's Cave* (1864).
Trumbull, John. *Autobiography, Reminiscences and Letters* (1841, v.d.).
Tucker, Gilbert M. *American English* (1921).

– V –

Valentine, Edward A. *Hecla Sandwith* (1905).
Van Dersal, William R. *Ornamental American Shrubs* (1942)
Van Dyke, Theodore S. *Southern California* (1886).
Vasey, George. *Agricultural Grasses* (1884).
Vaux, Calvert. *Villas and Cottages* (1857).
Venegas, Miguel. *Natural and Civil History of California* (1759).
Vestal, Stanley. *Old Santa Fe Trail* (1939); *Sitting Bull* (1932).
Viele, Teresa. *"Following the Drum"* (1858).
Visher, Stephen S. *Geography of South Dakota* (1918).

– W –

Wagner, Leopold. *More about Names* (1893).
Wait, John C. *Car-Builder's Dictionary* (1895).
Walker, Robert S. *Lookout* (1941).

Wallace, Edward T. *Barington* (1945).

Waller, Mary E. *Wood-Carver of 'Lympus* (1904).

Warner, Charles D. *On Horseback* (1896).

Warner, Susan B. *Gold of Chickaree* (1876).

Warnick, Florence. *Dialect of Garrett County, Maryland* (1942).

Wason, Robert A. *Happy Hawkins* (1909).

Watson, John F. *Annals of Philadelphia* (1830).

Webster, Clarence M. *Town Meeting Country* (1945).

Webster, Noah. *American Dictionary* (1828, 1841, etc.); *Revolution in France* (1794).

Weems, Mason L. *Letters* (1817).

Weld, Isaac. *Travels through the States* (1799).

Wetmore, Alphonso. *Gazetteer of . . . Missouri* (1837).

Weygandt, Cornelius. *The Plenty of Pennsylvania* (1942).

Wheeler, Arthur O. *Selkirk Mountains* (1912); *Selkirk Range* (1905).

Whitcher, Frances M. *Widow Bedott Papers* (1856, v.d.).

White, Elwyn B. *One Man's Meat* (1942).

White, Stewart E. *Arizona Nights* (1916); *Claim Jumpers* (1916); *Riverman* (1916).

Whymper, Frederick. *Travel and Adventure in . . . Alaska* (1868).

Wiggin, Kate Douglas. *Polly Oliver's Problem* (1894); *Rebecca of Sunnybrook Farm* (1903); *Village Watch-Tower* (1895); *My Garden of Memory* (1923).

Wilbur, Marguerite E. (trans.). *Juan Maria* (1929).

Williams, Ben Ames. *It's a Free Country* (1945).

Williams, Henry T. *Pacific Tourist* (1880).

Williams, Jesse Lynch. *Princeton Stories* (1895).

Williams, Roger. *Key into the Language of America* (1643).

Williamson, William D. *History of . . . Maine* (1832).

Willison, George F. *Here They Dug Gold* (1931).

Wilson, Alexander. *American Ornithology* (1808–14, v.d.); *Foresters* (1818).

Wilson, Charles M. *Aroostook* (1937).

Wilson, Edmund. *American Jitters* (1932).

Wilson, Gordon. *Fidelity Folks* (1946).

Wilson, Harry L. *Somewhere in Red Gap* (1920); *Spenders* (1902).

Wilson, William E. *The Wabash* (1940).

Winchester, C. W. *Victories of Wesley Castle* (1901).

Winter, Alexander. *New York State Reformatory* (1891).

Winthrop, Theodore. *John Brent* (1862).

Withers, Alexander S. *Chronicles of Border Warfare* (1895).

Witwer, Harry C. *Roughly Speaking* (1926); *Yes Man's Land* (1929).

Wolcott, Imogene B. *Yankee Cook Book* (1939).

Wolman, Leo. *Growth of American Trade Unions* (1924).

Wood, Alphonso. *Class-Book of Botany* (1850).

Wood, John G. *Illustrated Natural History* (1859).

Wood, William. *New England Prospect* (1634).

Woodworth, Samuel. *Forest Rose or, American Farmers* (1825).

Wooton, Elmer O. *Native . . . Plants of New Mexico* (1904).

Wright, Harold B. *Winning of Barbara Worth* (1911).
Wright, William. *History of the Big Bonanza* (1877).
Wynn, Marcia R. *Desert Bonanza* (1949).

– Y –

Yeslah, M. D., pseud. Halsey, Mina D. *Tenderfoot in Southern California* (1908).
Young, Harry. *Hard Knocks* (1915).

PHOENIX BOOKS
Literature and Language

PHOENIX BOOKS
in History

PHOENIX BOOKS

in Sociology

Ref.
427.973
Am35

DATE DUE